OCTOBER

OCTOBER Books

Rosalind Krauss, Annette Michelson, Yve-Alain Bois, Benjamin H. D. Buchloh, Hal Foster, Denis Hollier, and Silvia Kolbowski, editors

OCTOBER
The Second Decade, 1986–1996

edited by
Rosalind Krauss
Annette Michelson
Yve-Alain Bois
Benjamin H. D. Buchloh
Hal Foster
Denis Hollier
Silvia Kolbowski

An OCTOBER Book
The MIT Press
Cambridge, Massachusetts
London, England

This book was set in New Baskerville and
Garamond by The MIT Press.

Printed and bound in the United States of
America.

Library of Congress Cataloging-in-Publication
Data

OCTOBER : the second decade, 1986–1996 /
 edited by Rosalind Krauss . . . [et al.].
 p. cm.
 "An OCTOBER book."
 Includes bibligraphical references and
 index.
 ISBN 0-262-11226-4 (alk. paper)
 1. Arts and society. 2. Popular culture.
3. OCTOBER (Cambridge, Mass.) I. Krauss,
Rosalind E. II. OCTOBER (Cambridge,
Mass.)
NX180.S6029 1997
700'.1'03—dc21 97-19453
 CIP

Contents

Contents

Acknowledgments

A magazine, particularly a "little" one, involves a special dynamic between its writers and its readers, the production of the journal—particularly over anything like a sustained period of time—being inconceivable without a heightened level of excitement in the field of its reception. Since this volume marks twenty years of OCTOBER's staying power, it is first of all to our readers that we offer our thanks.

MIT Press has, as well, invested faith and energy in our project, having assumed its publication and distribution beginning with its fifth issue. We are extremely grateful to Janet Fisher, head of the Journals Department, and to her staff, for all their guidance, as we are to Roger Conover, for his support and editorship of OCTOBER Books, the series within which we are proud to present this volume, and finally, but in no way least, to Frank Urbanowski, the Press's director, whose belief in us meant that he was willing to wait over troubled times for our ship to touch shore.

For many years we were the proud beneficiary of grants from the National Endowment for the Arts; this has meant that we have also been one of the targets of the censorial interventions by politicians and religious interest groups into the policies of the National Endowment. Without the assistance of others who have helped us to fill this gap, we would never have been able to continue our project. For the considerable support generated by the OCTOBER Portfolios we wish to thank the artists who so generously donated their work: Louise Lawler, Sherrie Levine, Richard Prince, Cindy Sherman, Laurie Simmons, and James Welling for OCTOBER Portfolio One; and Sol LeWitt, Robert Rauschenberg, Gerhard Richter, and Edward Ruscha for OCTOBER Portfolio Two. To the individuals and organizations that have supported us during the last ten years, we cannot express our thanks warmly enough: Richard Black, Constance R. Caplan, Joanne Leonhardt Cassullo, Leo Castelli, Phoebe Cohen, Susan Crile, Sam Francis, Arne and Milly Glimcher, Marian Goodman, Marieluise Hessel, Ellsworth Kelly, Pentti J. K. Kouri, Werner Kramarsky, Roy and Dorothy Lichtenstein, Martin Lipschultz, Mrs. Annalee Newman, Timothy Nye, Claes Oldenburg and Coosje van Bruggen, Joseph Pulitzer, Jr., Richard Serra and Clara Weyergraf-Serra, Robert Shapazian, Mr. and Mrs. Walter Thayer, Councilman Joel Wachs, Mr. and Mrs. Bagley Wright, The Charles Engelhard Foundation, The Florence Gould Foundation, The Uris Brothers Foundation, the New York State Council on the Arts, and for several special issues, the J. Paul Getty Trust. We wish, finally, to thank The Pinewood Foundation for its faithful assistance during the formative years of the journal.

The articles anthologized in this book all appeared originally in OCTOBER. They are reprinted with permission.

Surrealist Precipitates © 1994 no. 69, pp. 110–132.

Introduction to Lygia Clark © 1994 no. 69, pp. 85–88.

Nostalgia of the Body © 1994 no. 69, pp. 89–109.

In Defense of Abstract Expressionism © 1994 no. 69, pp. 22–48.

Before *Bed* © 1993 no. 63, pp. 68–82.

"Where Is Your Rupture?": Mass Culture and the Gesamtkunstwerk © 1991 no. 56, pp. 42–63.

Conceptual Art 1962–1969: From the Aesthetic of Administration to the Critique of Institutions © 1990 no. 55, pp. 105–143.

Bad Enough Mother © 1995 no. 71, pp. 70–92.

AIDS Timeline © 1990 no. 54, pp. 134–135.

Reading Africa Through Foucault: V. Y. Mudimbe's Reaffirmation of the Subject © 1990 no. 55, pp. 79–92.

Which Idea of Africa? Herskovits's Cultural Relativism © 1990 no. 55, pp. 93–104.

"Fireflies Caught in Molasses": Questions of Cultural Translation (originally published as Freedom's Basis in the Indeterminate) © 1992 no. 61, pp. 46–57.

The Public Sphere and Experience: Selections © 1988 no. 46, pp. 60–82.

Cupid's Pencil of Light: Julia Margaret Cameron and the Maternalization of Photography © 1996 no. 76, pp. 114–141.

The Body's Shadow Realm © 1989 no. 50, pp. 3–29.

Is the Rectum a Grave? © 1987 no. 43, pp. 197–222.

The Freudian Subject: From Politics to Ethics © 1986 no. 39, pp. 109–127.

Death in America © 1996 no. 75, pp. 36–59.

Aesthetics and Anaesthetics: Walter Benjamin's Artwork Essay Reconsidered © 1992 no. 62, pp. 3–41.

Spectacle, Attention, Counter-Memory © 1989 no. 50, pp. 96–107.

The Cultural Logic of the Late Capitalist Museum © 1990 no. 54, pp. 3–17.

Postscript on the Societies of Control © 1992 no. 59, pp. 3–7.

Like the difference between Autumn/Winter '94/'95 and Spring/Summer '95 © 1996 no. 75, pp. 83–98.

Introduction

At the outset, OCTOBER's project was defined as an intensive effort to reassess and analyze a range of cultural practices, always understanding their place at a particular historical juncture. This was a connection that invited us to call into question an existing canon, its presuppositions, and the instruments of its intellectual establishment. It was in the intersection of these that we recognized the problematic of postmodernism in the era of late capitalism.

As we then saw it, the time was one of continued struggle to radicalize cultural practices, and to resist the revival of traditional artistic and discursive tendencies that would marginalize those attempts. As well, an effective probing of these developments would, we claimed, require recognition of shifts in modes of artistic production and the deployment of more powerfully explanatory theoretical models and methods than were generally in use in the 1970s.

Our task as originally defined now seems to us to have an intensified urgency. The ensuing decade has produced an extension and sharpening of cultural and political contradictions, now seen as most unhappily systemic. The catastrophic state of our urban economies, manifest in the decay of their very physical infrastructures, the continuing crisis of education, the precarious state of welfare legislation, its consequent projections of growing child poverty, its repercussions for questions of ethnicity, immigration policy, and complex issues of cultural identity—all these evidence the extraordinary fragility of what is now termed The World's Sole Remaining Superpower.

More generally, the transformation of the geopolitical configuration of the past half-century during this second decade of our publication has entailed more than the dissolution of Soviet power as fueled by the United States's hegemonic imposition (through the World Bank) of a market economy; that process forms but one major episode in the intensifying predicaments of a postcolonial era.

The impact of these internal and international developments on the cultural and discursive practices that are OCTOBER's concern has been inescapable. The ending of the Cold War has not generated the vital effort at reduction of our own vastly swollen defense budget; rather, it is this immense expenditure, permanently installed as a bulwark against a critical mass of unemployment, that blocks the provision of social services, including the minimal support afforded cultural projects, both artistic and discursive, and extending to that of this journal.

The evisceration of the socialist tradition throughout Europe has confirmed, moreover, the massive retreat of the American Left (whose alliance with organized labor has not recovered from the blows suffered during the war in Vietnam) into the Academy. Although the feminist struggle has largely succeeded within the Academy, on every other parameter it remains to be won. And it is faced with renewed threats of repression. For the steady rise of the Militant Right and of its "fundamentalist" discourse means not only that the struggle for radicalized cultural practices persists but also that reactionary activism forces a confrontation with its call for a "culture war" and its promotion of antisecularism, its demands for a repressive censorship, its program of restoration of a puritanical patriarchal order.

Within this framework, our efforts have been directed toward extending the work of our first decade, but with an intensified sense of the role of cultural production within the public sphere and with a sharper focus on the modes of intersection of cultural practices with institutional structures. Four texts describe a central axis of our reflection: Deleuze's late tracing of the transition from the society of discipline to that of control; Crary's interrogation of Situationism's status within a developing "non-spectacular global system arranged primarily around the control and flow of information"; Buchloh's analysis of the role of Conceptual art, "the last significant paradigmatic change of postwar artistic production as it mimes the operating logic of late capitalism" and its transformation of that production "into a tool of ideological control and cultural legitimation." Within this continuum, Krauss's analysis of the museum in the era of late capitalism interrogates a specific instance of institutional mediation.

This sense of a generalized and exacerbated crisis having determined an entire range of artistic and discursive practices provides a second intersecting axis of our concern and gives its range of issues to our view of Body Politics. Ten years ago we claimed the need for an effort to analyze the construction of the speaking and the spoken body. We defined the category of the body as the place that had not finished speaking, the point from which theory must develop further. And indeed the sense of pervasive panic and trauma, analyzed by Bersani and Foster, provide other points of entry, and will undoubtedly continue to generate a continuing psychoanalytically informed analysis of representation in the modes—sculptural, photographic, filmic, among others—presented here. The publication of the essays and round-table discussion in issue no. 70, *The Duchamp Effect*, confirms our own retrospective sense of the looming and enduring generative force of an artistic practice we must count as the most seminal for our own time.

Wishing to expand our arena of debate, we initiated a series of round-table discussions on *The Politics of the Signifier*, *The Reception of the Sixties*, and *Conceptual Art and the Reception of Duchamp*, among others. While not represented directly in this volume, they have stimulated and extended the texts included herein. And we have, of course, continued our policy of special issues that provide a relational form or context for published texts. Among them are our presentation of *The Humanities as*

Social Technology, The Identity in Question, Guy Debord and the Internationale situationniste, *feminist issueS,* and psychoanalytic debates in *The Rendering of the Real.*

Our presentation through additional special issues of the work of Marcel Broodthaers, that of Alexander Kluge, and the debates around Helke Sander's cinematic analysis in *Liberators Take Liberties* of the traumatic consequences for women of the Allies' entry into Berlin (published on the fiftieth anniversary of the event) represents, together with that of many other single texts including those on Kiefer, Jünger, and Riefenstahl, our interest in the general retrospection and reassessment of German cultural practices within an analytic framework not wholly indebted to the vital theoretical developments in France during the postwar period.

Aware of the distance between project and accomplishment, we are cognizant, as well, of the intensified effort required, within a climate of continuing crisis, to maintain a journal as a site of critical/theoretical debate. We have come to understand, however, through our unanticipated twenty-year span of existence, OCTOBER's role within a proliferation of confusion and contradiction, as one of analysis and, above all, as a response to the perseverance of the artists of this problematic era.

Art/Art History

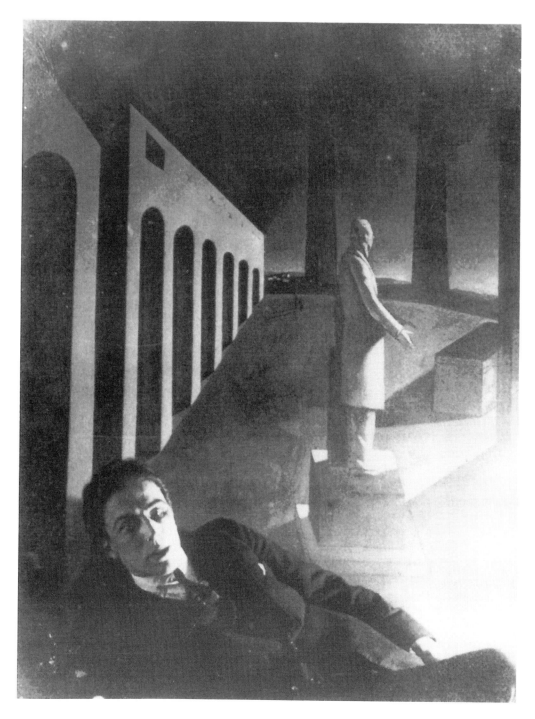

André Breton in front of Giorgio de Chirico's The Enigma of a Day. *1914. (Photo: Man Ray. Circa 1925.)*

Surrealist Precipitates

Shadows Don't Cast Shadows*

DENIS HOLLIER

translated by ROSALIND KRAUSS

> *Orient, beautiful bird of prey and of innocence, from the depths of the realm of the Shades, I implore you! Inspire me, that I might be someone who no longer has a shadow.*
>
> —André Breton, "Introduction au discours sur le peu de réalité"

I'd like to take off from a famous pronouncement, the "This will kill that," not as declared by Claude Frollo in *Notre-Dame de Paris,* but instead as restated by Claude Lantier in *Le ventre de Paris.* Zola has his painter utter it, not very far from Beaubourg, at the point where he passes in front of Baltard's recently constructed pavilions for Les Halles. Claude has just noticed the rose window of Saint-Eustache, framed by the arcades of a passageway. It's then that he repeats Victor Hugo's prophecy. Or rather he subverts it. For while Hugo's pedagogical idealism announced that the book would sound the death knell of the cathedral, so that once the scholar replaced the priest, democratic knowledge would replace hierarchical learning, Zola's message has nothing to do with secular freedom of thought; what he proclaims is a future of materialist satiety: at the same time that iron replaces stone, Les Halles supplants the church and consumption displaces redemption; it's earthly nourishment that will sweep away the opiate of the people.

Zola was wrong, of course. This, in fact, didn't kill that. Contrary to what the naturalist manifesto prophesied, Baltard lost on all fronts—that of form and that of content. His pavilions have disappeared. And, dominating a newly opened esplanade, the church's massive volume holds sway as it would never before have done, even during the most religious epochs.

Zola was wrong. But that's not the point. The difference between Hugo's "This will kill that" and Zola's is that for the former death is—like the book

* This is a translation of "Précipités surréalistes (à l'ombre du préfixe sur)," from *Les Cahiers du Musée national d'art moderne* 38 (Winter 1991), pp. 39–58.

itself—a spiritual instrument; for the latter it is a slide into pure matter. Zola was obsessed by the desire of making this slide irreversible. His Lazarus, when Jesus wants to bring him back to the world of the living, declines the favor: thanks, but once was enough. Against an aesthetic of rebirth, for which everything, even evil, exists in order to return in the form of a book, Zola announced what Léon Bloy would soon call, speaking of Lautréamont, "the Good Tidings of damnation." The same aesthetic of the holocaust, of the unpardonable, the same *refus d'inhumer*, appears in Breton: on the second page of the 1924 *Manifesto*, he begins the hymn to imagination with this apostrophe: "Beloved imagination, what I most like in you is your unsparing quality."[1] Five years later in the *Second Manifesto*, he exalts poetic determinism and dialectical materialism because, he says, *"they are both unsparing."*[2]

Sade and Lautréamont are the two master figures of the anti-gospel of the unforgiven. Two figures who don't pardon, but above all who must not themselves be pardoned either. The Surrealists' investment in Sade is a function of the decision to prevent him from being exonerated; and it's surely the reason why they reacted so violently when Klossowski published his *Sade, mon prochain*. Rimbaud had his Claudel; one had to keep Sade from suffering the same fate. One had to protect him against his redeemers. To defend his right to die. Nothing must lead one to believe that in the mind a point exists where Rimbaud and Claudel, or where Sade and Saint Benoît Labre, would cease being perceived as opposites. Nothing must lead one to believe that a point exists where literature and what refuses literature would cease to be taken as contraries. To keep Sade from becoming literature as usual is one of Surrealism's fundamental moral imperatives. He wasn't liberated from the Bastille in order to be imprisoned in the Pléiade.

Very early on, for example, Breton defends Sade for the absolute quality of his language: "This language, ladies and gentlemen, is very beautiful. . . . Since the Marquis de Sade, it has served for nothing but inducing extraordinary feelings. Literature has not yet succeeded in incorporating it and on the sly he still revolts almost everyone. Let's entertain the illusion for this evening that he will save us from *literature,* this terrible god . . . come, all of literature, beginning with yours, Mr. Flaubert."[3] The same attitude but even more possessive, even more jealous, when it's a question of Lautréamont. We only have to recall the sentence from the *Second Manifesto:* "With one exception—Lautréamont—I do not see a single one of them who has not left a questionable trace in his wake."[4] An unquestionable trace, a nonequivocal mark is a sign that could not be read and then pardoned and blessed by Claudel, Paul. In 1925 Breton answers a survey in *Le disque vert* that asks various living writers to rate Lautréamont: "What do you want, great God? The

1. André Breton, *Manifestoes of Surrealism,* trans. Richard Seaver and Helen R. Lane (Ann Arbor: University of Michigan Press, 1969), p. 4.
2. Ibid., p. 156.
3. Breton, "Mise en accusation d'Arthur Meyer," *Oeuvres complètes,* vol. 1, ed. Marguerite Bonnet (Paris: Gallimard, 1988), p. 638.
4. Breton, *Manifestoes,* p. 127.

one who has for so long a time warded off all stain, what are you thinking about in delivering him to the literary types, to the pigs?"[5] Lautréamont is becoming the victim of an admiration that transforms into "a precious exchange-value" what should remain "the negation of all social forms." Five years later, Bataille would use the same words against Breton, probably without noticing that he was borrowing them from him, and to the very same effect. This would be in "The Use-Value of D. A. F. de Sade," where Bataille accuses the Surrealists of degrading the life and works of Sade by commodifying them as an exchange-value. Everything happens as though Bataille could no more stand that Breton should read Sade than Breton could stand that Claudel should read Rimbaud. There are authors one wants to hoard, that one wants to reserve for oneself like a woman one doesn't want to share. They must be protected against those who are in danger of loving them, against their admirers even more than against their detractors.

Indeed, Breton often identifies aesthetic experience with use-value, which is to say with resistance to exchange-value. In *Nadja*, for example, he speaks of sensations "whose share of incommunicability is itself a source of pleasures that have no equal."[6]

Pleasure (use-value) is thus literally a break in communication. For it's not a question of agreeable sensations that would become incommunicable beyond a certain threshold; rather, pleasure is the result of incommunicability itself; the unexchangeable is what gives rise to the enjoyment that is the most characteristic feature of use-value. Which is another way of saying, according to Leiris's formulation, that only a monstrous aberration allows men to believe that language was born to facilitate their mutual relations. In his lecture of 1922 at the Barcelona Athenaeum, after a brief eulogy to avant-garde provocation, Breton adds, in the same spirit: "Whatever my point of view, I am not obsessed by the desire to impose it; this point of view matters to me only insofar as I have not succeeded in having it shared by others."[7] It's only my point of view as long as I am able to strip it of all exchange-value. If I share it, it would no longer be mine.

<div align="center">*</div>

Breton's early texts, *Les pas perdus,* the *Manifestoes,* are full of sarcasms directed against the secular cliché of salvation through art. For example, in "Two Dada Manifestoes": "It is inadmissible that a man should leave any trace of his passage on earth." In "For Dada": "Jacques Vaché was not the man to leave a testament! . . . He always kicked aside the work of art, that ball and chain that hold back the soul

5. Breton, "Réponse à l'enquête du 'Disque vert': 'Le cas Lautréamont,'" *Oeuvres complètes,* p. 916.
6. Breton, *Nadja,* trans. Richard Howard (New York: Grove Press, 1960), p. 23.
7. Breton, "Caractères de l'évolution moderne et de ce qui en participe," from *Les pas perdus, Oeuvres complètes,* p. 291. This confidence is all the more disdainful in that Breton spoke it aloud, in the course of a lecture. In any case, the fact that he was speaking French in front of a Catalan audience considerably reduced the risk that such a sharing would take place.
An example of the fantasy of broken communication that occurs most frequently in Breton is

after death."[8] Equivocation stains every sign that survives the act, the gesture, the performance. It spares only the signs that are consumed on the spot, that manage not to survive the thing of which they are the trace. In his 1948 essay on Breton, Gracq is still evoking "the extraordinary blast of fresh air [that] opens before modern imaginations the unrecorded trail of those who refrained from throwing the smallest bottle into the sea."[9]

In *Political Position of Surrealism* (1935) this condemnation leads Breton to make a diagnosis of Western culture that is close to Artaud's. "In whatever direction I turn," he writes, "there is in the functioning of this world the same appearance of cold and hostile irrationality, the same outer ceremony beneath which it is immediately obvious that the sign survives the thing signified."[10] Once again, then, survival doesn't get good press. There is nothing it can pride itself on. It's the name of a cultural sickness, the symptom of civilization's discontent. The survival of a sign translates first of all as the loss of its "circumstantial-magic" beauty. If a ceremony seems cold, distant, disaffected, it's because its meaning has vanished; it survives but without it, as the sign of a dead thing, as a sign that has outlived what it signified and no longer has the energy to make sense. From two things: one. Either signs prevent their thing from dying. Or they wane along with it. Only what is incapable of living, survives.[11]

<div align="center">*</div>

Cast shadows are one of the rare types of sign that escape what Breton calls ambiguity. They are the very exemplar of a nondisplaceable sign: rigorously contemporary with the object it doubles, it is simultaneous, nondetachable, and, because of this, without exchange-value. It is only cast *on the spot*, without the possibility of a proxy. With it, the relation of sign to the thing signified escapes the metaphor of the separation of body and soul: cast shadow is a sign that doesn't survive.

that of the nocturnal and solitary taking over of the public space of a museum. In *Nadja* (on the occasion of the visit to the Château de Saint-Germain-en-Laye): "How much I admire those men who decide to be shut up at night in a museum in order to examine at their own discretion, at an illicit time, some portrait of a woman they illuminate by a dark lantern" (Breton, *Nadja*, p. 112). And, in "Introduction au discours sur le peu de réalité": "Museums at night, as capacious and luminous as music halls, guard the chaste and audacious nude from the great whirlwind" (*Point du jour*, p. 15).

With his strictures against cultural cocktails mixing "admiration with promiscuity," des Esseintes is the prototype of this brand of radical aestheticism for which aesthetic pleasure is what results from the subtraction of art from the space of public consumption (Joris-Karl Huysmans, *A rebours*, chap. 9, [Paris: Gallimard, Folio, 1977], p. 207).

8. In *Les pas perdus*, 1924 (*The Dada Painters and Poets: An Anthology*, ed. Robert Motherwell, trans. Ralph Manheim [Cambridge: Harvard University Press, 1989], pp. 203 and 199).

9. Julien Gracq, *André Breton*, in *Oeuvres complètes*, vol. 1, ed. Bernhild Boie (Paris: Gallimard, 1989), p. 469.

10. Breton, *Political Position of Surrealism*, in *Manifestoes*, p. 216.

11. See Georges Bataille's formulation at the time of *Acéphale:* "The joy in front of death against all immortality," *Oeuvres complètes*, vol. 2 (Paris: Gallimard, 1971), p. 386.

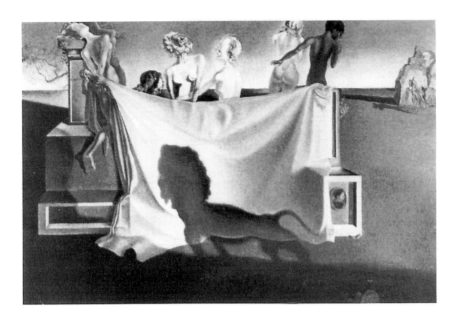

Salvador Dali. The Old Age of
William Tell. *1931.*

This semiological property made it the object of a deep interest for Surrealist painters. From de Chirico to Dali and Magritte, they all played with shadows, using them as a motif of experimentation that remains without equal in the history of art. Yet, curiously, most of these experiments brush against the grain of the semiological properties that protect cast shadows against semiological equivocation. As though it were necessary to reintroduce ambiguity in the only sign that escapes it, as though the Surrealist shadows constantly hesitated to cross the threshold of the index.

Cast shadow is in fact one of the clearest examples of the category of sign that, since Peirce, the semiologists have called deictics. The index is a sign that is less the representation of an object than the effect of an event. Smoke is caused by fire; cast shadow by the sun. Alexander the Great, in placing himself between the sun and Diogenes, casts a shadow on him. The day when this eclipse took place, that shadow was an index. In the paintings that represent that scene, it becomes an icon: a represented body, be it that of Alexander, is no more able to cast a shadow than the idea of a dog to bark. Due to the fact that the painter is restricted to the bidimensional plane of projection, all real shadow is excluded from painterly representation. The only shadows it will offer will be dis-indexed, shadows less cast than broadcast, reported on.

One must in fact distinguish two interventions of shadow in the visual arts: as a medium, shadow has the status of an index; as a motive, the status of an icon. And passing from index to icon, one passes from a three-dimensional to a two-dimensional art, from sculpture to painting; it's around this line that certain of Surrealism's most interesting interventions in the plastic domain have been

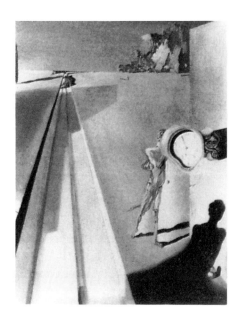

Left: Salvador Dali. Premature Ossification of a Train Station. *1930.*

Opposite left: Joan Miró. Spanish Dancer. *1928.*

Opposite right: Pablo Picasso. Guitar. *1926.*

played.[12] They introduce an indecision that makes it difficult to know if one is faced with a real shadow or a represented one, if one is looking at a cast shadow or its image, if one is inside a space of the indexical type or looking at a space of the iconic kind.

The inclusion of real cast shadows in the painting is a first form of insertion of indexical marks in an iconic space. It goes without saying that the surface of a painting, just like any surface, can receive cast shadows from time to time—those thrown by a window's mullions, by a cloud outdoors, by a column in the room, by the beholder. And, even before the late 1920s fashion for Surrealist objects, Surrealist painters invented all sorts of constructions that brought this exteriority back into play. While the shadows that fall on a painting are accidents that affect it no more than, for example, the noises or odors that occur along with its perception, Surrealist montages would integrate the shadows cast upon them into the work itself. Shadow ceases to be adjacent to the painting, settling onto it. Instead of being the shadow of an object, it enters into the object itself, it participates in the work.

This is the case with Miró's *Spanish Dancer.* Not only does its hatpin cast a shadow onto its surface, but this shadow changes in length, direction, and intensity according to the lighting the picture receives, and, if it's the sun that illuminates it, this will change according to the time of day. The same thing goes for the nails of

12. Rosalind Krauss, "The Photographic Condition of Surrealism," in *The Originality of the Avant-Garde and Other Modernist Myths* (Cambridge: MIT Press, 1985).

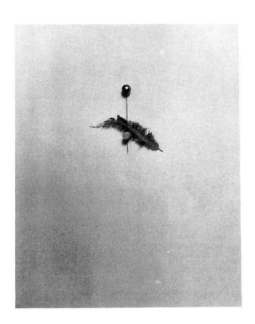 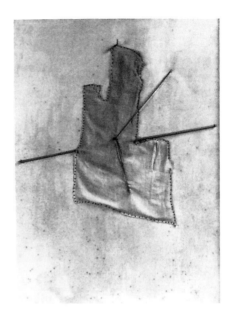

Picasso's 1926 *Guitar.* Their shadow cast onto the picture is a variable determined by the context of its exhibition. We would then have a right to expect the captions that accompany the reproductions of these works to specify the time and place of the photograph. By articulating the work with the context of its reception, the index gives the work its "circumstantial-magic" dimension, lighting it with a time-colored beauty that comes to it from beyond its frame. "And besides, is not the proper meaning of a work," Breton asks in "La confession dédaigneuse," "the one the work is likely to assume in relation to what surrounds it, and not the one the author believes he has given it?"[13]

But among the Surrealist works that put real shadows into play, the relief constructions of Arp are foremost, and in particular the series of his *Nombrils* (Navels). Among them, some are horizontal, placed on the floor, but others, crafted onto vertical panels, belong to the paradigm of the picture. They inspired Breton in *Surrealism and Painting* to engage in a series of untranslatable puns prompted by the homophony that in French allows the shift from *shadow* to *navel,* from *ombre* to *nombril:* "Pronounce the last word *ombril.* There is nothing gratuitous about Arp's strange insistence that this word should be conjugated thus : *un nombril, des ombrils.*"[14] With these navels, the index crosses the work like the ephemeral wake of time. The umbilical cord of the shadow roots the work into the soil of

13. Breton, "La confession dédaigneuse," in *Les pas perdus* ("The Disdainful Confession" in *The Autobiography of Surrealism,* ed. Marcel Jean [New York: Viking Press, 1980], p. 115).
14. Breton, *Surrealism and Painting,* trans. Simon Watson Taylor (New York: Harper & Row, 1965), p. 47.

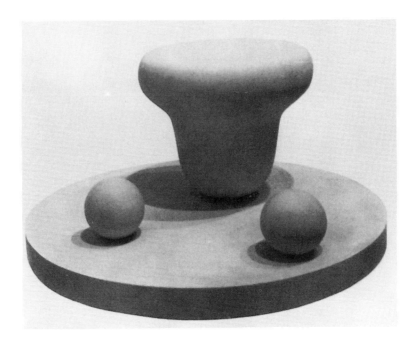

Jean Arp. Bell and Navels. *1931.*

time. A final example: time again is an important component of Giacometti's encaged clock-work constructions, whether it be *Suspended Ball* or *Hour of the Traces.* Here again, advancing without needing to be rewound, their cast shadows give the trace of time.[15]

With Miró, Picasso, Arp, or Giacometti, it is a matter of a real cast shadow of the work registered on the work; even while changing according to the site and circumstances of its exhibition, it remains part and parcel of the work within which it is encaged. With photography, the status of cast shadow is different. Here, the cast shadow gains iconic autonomy; it is separated and liberated from the object that causes it: it enters the realm of ambiguity and survives its cause, its referent. Beginning with a real shadow, it makes it leave the indexical plane for an iconic space. Shifting from causality to resemblance, from metonymy to metaphor, these doubles, in addition to being the effect of their cause, merge with it in order to resemble a third thing. Uprooted from its context, the indexical system composed by the internal relationship between object and shadow gains autonomy and becomes grafted into a metaphorical, external relation with absent objects which the composite indexical hybrid resembles, as in Man Ray's most successful photos, such as the 1919 *Integration of Shadows,* or even more, *Woman* of 1920. In the latter example, a symmetrical image (the woman) is composed from the play of

15. From this point of view, shadow and dust constitute types of temporal deposits that, if not identical, are at least comparable. And Duchamp's and Man Ray's *Elevage de poussière* is also, in its way, a kind of chronometric sedimentation, what one could call a chronograph.

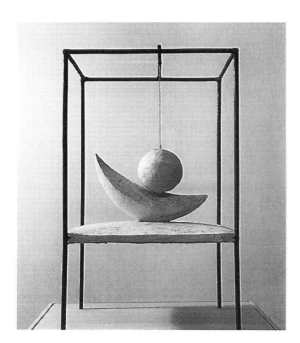

a single object with its shadow. As in Miró's *Spanish Dancer,* the shadow is integrated into the pictorial object; but instead of imprinting an index on it, it merges with it in an icon.

The shadows put in play by the foregoing examples are all, or have all been at one point, real ones. This is no longer true of the shadows represented in the Surrealist pictures by de Chirico and Dali that I will now evoke. These are iconic shadows, painted by a painter instead of being cast by an object. Nevertheless, they are submitted to distortions that are not without similarity to those we have just examined. One of the most important among them is the production of what I would call orphan shadows, shadows detached from their indexical origins, shadows cut off from their cause, shadows thrown by an invisible object, shadows of objects repressed outside the frame. They use the iconic detachment of the photographic index to produce pictorial catachreses: they represent an object that has never been presented. De Chirico and Dali, and later Magritte, made a specialty out of this.

This description does not seem to apply to the shadows in *Enigma of a Day.* There shadows extend from the bases of objects that are all visible. This painting by de Chirico had a lasting fetish value for the Surrealists. In 1925 Breton had himself photographed by Man Ray lying in front of it. In 1933 in *Le surréalisme au service de la révolution,* it would be the occasion of a survey on "the irrational possibilities of penetration and orientation within a painting." This survey was made up of fifteen questions, of which I will only cite the first twelve: "1. Where is the sea?—2. Where will a ghost appear?—3. Where will an elephant appear?—

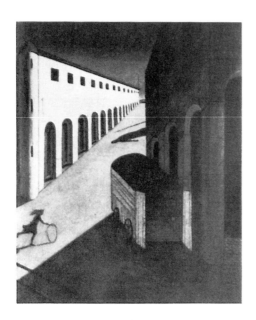

Giorgio de Chirico. The Mystery and Melancholy of a Street. *1914.*

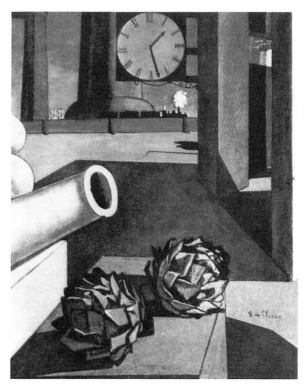

Giorgio de Chirico. The Philosopher's Conquest. *1914.*

4. Where will a seagull?—5. Describe the landscape that surrounds the city.—
6. Where will one find water?—7. Where will one make love?—8. Where will one
masturbate?—9. Where will one defecate?—10. Arriving in the square, what will
you see first?—11. Who does the statue represent?—[and here is the twelfth,
which comes to the point, striking noon] 12. What time is it?"

The answer should be simple. The shadows are planted on the ground by a
low sun that projects its light from a point beyond the frame on the right. And
indeed, some of the replies follow this reasonable, realist reading. César Moro
gives "4:30 in the afternoon"; Yolande Oliviero "five in the evening in summer";
Benjamin Péret "between six and seven o'clock on a June evening." However,
three of the participants, Caillois, Eluard, and Maurice Henry, answer "noon."
This reply is all the more remarkable in that Caillois was then working on his the-
sis on noon-day ghosts, in which, after having mentioned Jensen's *Gradiva*
(among others), he analyzes the legends that dramatize the dangers associated
with the hour where objects lose their shadow. A reply like his infers a perceptual
disturbance: it demands in fact that one perceive as shadowless what the iconic
code nonetheless represents as shadow. These horizontal silhouettes can't be
shadows for someone who says it's noon. Which immediately implies the
Magritte-effect of: this is not a . . . These shadows are not shadows but images of
shadows, or shadows dis-indexed. Caillois's answer thus makes one perceive the
cast shadows that stretch onto the square—that of the statue, of the arcade, and
of the two little figures—as false shadows, as shadows that, for example, have
been painted onto the ground. The noontime ghosts don't have a watch; it's by
means of sundials that they read local time. So the square has been camouflaged;
noon has been disguised as four o'clock, so that the ghosts will believe it's not yet
or no longer their hour.

The Enigma of a Day produces the pictorial equivalent of jet lag, a jet lag all the
more surprising in that it shows up not on watches but on sundials. For if a watch,
with the autonomy of its works, might indicate the time it is now, elsewhere, this
type of liberty is forbidden to the sundial, condemned as it is to mark local time:
the index and its cause, the real and its shadow belonging, by definition, to the
same time.[16]

The other replies to the questionnaire also refrained from sticking with what
was seen. For some of the participants night had fallen. Tzara, for example,
answers: "Midnight sun." Or Giacometti: "Three in the morning. It's a fake sun."

16. One should bring into play here the many clocks depicted in de Chirico's metaphysical paint-
ings, the hands of which generally indicate a far less advanced hour than the cast shadows imply. See
The Philosopher's Conquest (1914) and *Gare Montparnasse* (1914), where the clock indicates 1:27, and *The
Enigma of the Hour*, where it stands at 2:55.
 In Dali's work, the soft watches are thermometric (rather than photographic) chronometers
that, under the heat, revert to the indicial condition: the wax melts in the shadowless noon sun—and
this, independently from the way shadow is treated in other parts of the same painting (including, of
course, his variations on the sunset of Millet's *Angélus*).

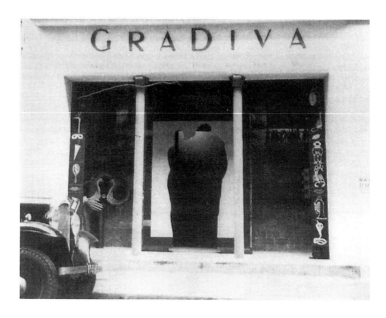

Breton's own response: "Eleven at night," is of the same type, reminding one of the title of his first volume of poetry, *Clair de terre (Earthlight)*. Finally, for Monnerot, there are no more hours, no more time; an entropic catastrophe has put a stop to the alternation of day and night: "the level of the earth's recooling no longer allows for the manifestation of time," he says.

In 1937 Breton opened an art gallery on the Left Bank, 31 rue de Seine, christening it with the title of Jensen's novel: *Gradiva*. Several photos of the premises give an idea of what the front looked like. Duchamp designed it, giving the door the form of a double cast shadow, the silhouette of a couple seen from behind, in the act of moving toward the wall, the man—larger—on the right, holding the woman by the shoulder. They are about to enter Gradiva or to move through the wall.[17]

1937 is the year when *Mad Love* came out, and we can see an allusion to this book in the choice of subject. This shadow/entry in fact condenses the two doors Breton had evoked, at the opening to *Nadja* in the anecdote (pre-Lacanian with his doors marked "men" and "women") about the daily drive taken by Victor Hugo and Juliette Drouet in front of two unequal-sized gates: "Bridle gate,

17. This is the first of many doors by Duchamp, who, for the 1959 Surrealist Exhibition at the Cordier Gallery, would conceive an entryway "in the shape of a vagina out of rubber, badly done but evocative" (*André Breton*, ed. Isabelle Monod-Fontaine [Paris: Centre Georges Pompidou, 1992], p. 421).

In 1937, the year of Gradiva's opening, Breton mentions in his essay on Mexico published in *Minotaure* "a walled-up door condemned to be nothing any longer but its shadow" (p. 35).

Madam," Hugo would say, to which she would unfailingly answer, "Pedestrian gate, Sir." So that Duchamp suggested that one add, for the gallery on the rue de Seine: "Entry-gate, ladies and gentlemen." But the code is obvious. To open the door of Gradiva, there is only one secret: love, and if possible, mad. It's the password, the combination to the lock. When two shadows join the walls will crumble. But they stay closed to solitary shadows.

So much for the myth.

In fact, there was no shadow but instead, an opening. There was a false shadow, a cut-out in the image of a shadow. Here again it was a question of a dis-indexed shadow, a bachelor, an iconized index. But the symbolic functioning of the door specifically implies its reindexation: if a couple arrives, then, for a moment, this door will once again become a shadow. The exact opposite of the faucet that stops dripping when no one is there to hear it, this door conceived by Duchamp, once it is in working condition, drops from the level of the icon to that of the index.

What difference is there between a shadow and a door? Both of them interrupt the wall. But these are two distinct interruptions: the shadow leaves it intact while the door pierces it. Shadow on the wall; door in the wall. Shadows don't breach walls. But a body doesn't breach its shadow either. In the announcement Breton wrote for the opening of Gradiva, we read this invitation: "Like the bellows that connects two cars of a train, these shadows you love await you to lead you to the threshold of Gradiva." Breton knows how to master suspense and its ambiguities. Do the shadows wait for the visitors at the threshold of Gradiva in order to guide them across, or is it to the threshold itself that they want to guide them, a threshold without a beyond? It's no longer a question in the latter case of passing from one car to another. One enters less by means of the shadow than into the shadow. We have to imagine a continuous, whole, virgin wall, before which no one, not even André Breton, can pass. Until a couple appears who let themselves be sucked into their own shadow. The thing is seduced by its shadow. It turns itself into a sign. This is the moment described in *Mad Love* when "what is already no longer the shadow and not yet prey: the shadow and the prey mingled into a unique flash."[18]

<p style="text-align:center">*</p>

The most important literary experiments conducted by Surrealist writers put in play the same type of preoccupations. However, the motif of the shadow, of its indexical value, is, beyond Surrealism, an allegorical theme to which the novels of the period have frequent recourse. I'll give but one example of it, taken from Malraux's *Man's Hope*. The scene takes place in Madrid, where a shell has just fallen on the central post office where foreign correspondents are trying to send

18. Breton, *Mad Love,* trans. Mary Ann Caws (Lincoln: University of Nebraska Press, 1987), p. 25.

news of the war out to the world at large. Once the scare is over, Malraux writes, "an old moustached newsman unglued himself from the wall; then all of them, one after another: they scanned the wall as if they were looking there for their own traces." What is the meaning of this look backward? Does the journalist wonder if he has not become his own Eurydice? Does he want to check if, on the wall, the mark of the event has survived the passing of the event? Or is he asking if the violence of the event has not severed bodies from their shadows?

Breton's conception of automatic writing as a *precipitate* (which is pervasive in his early writing) gives it the same properties as a cast shadow: automatic writing is to invisible objects what photography is to visible ones.[19] But I will restrict myself to another, less studied area, of Surrealist literary exploration, the autobiographical narrative generated by the condemnation of the novel. I will introduce it by recalling the famous image by Michel Leiris when he presents *L'âge d'homme,* a book whose avowed model is *Nadja:* in this book, which is the "contrary of a novel," the author hopes, Leiris writes, "to introduce a bull's horn into a work of literature if only as a cast shadow." Of course, it is a question here of a shadow that isn't an orphan: the thing itself, the horn itself, with the mass of the bull it belongs to, is welded to its index. A real shadow, falling onto Miró's *Spanish Dancer,* opens the internal space of the work to the context of its reception, mixing it with that of its beholder; in the same way, what Leiris called the literary equivalent of the shadow of the bull's horn should propel the autobiographical text in the shared space of history. The appearance of the shadow would imply the space of a literature without reserve. It's the possibility of its appearance that, for Leiris, makes autobiography, contrary to the novel, the leading genre of commitment, committed literature being first and foremost the search for what, in literary space, would be the equivalent of what a shadow is in pictorial space: an index that makes the work lose all virtuality, that forever disturbs the calm of the image, the solidity of the object.

This equivalent is the first person. The cast shadow of the subject of enunciation onto its utterance, the I opens up language to its performative circumstances. As Rosalind Krauss has demonstrated, this affinity—shadow is to thing or object what pronoun is to noun or subject—is articulated in the most literal manner in Duchamp's *Tu m'* of 1918, which represents, on the pictorial level, the projection onto a canvas of the cast shadows of various readymades (a bicycle wheel, a corkscrew, a hat rack), while, on the linguistic front, its very title reduces to the pure and simple conjugation of the linguistic index the only two pronouns that can truly be called personal, those of the first and second person, *tu* and *me,* you and me.[20] It's exactly the same articulation that Breton, for his part, puts to work

19. "The invention of photography has delivered a mortal blow to the old forms of expression, painting as well as poetry for which automatic writing, appearing at the end of the nineteenth century, is a true photography of thought" (André Breton, "Max Ernst" [1921], *Les pas perdus,* p. 81).
20. Krauss, "Notes on the Index," in *The Originality of the Avant-Garde.*

Marcel Duchamp. Tu m'. *1918.*

in his prewar autobiographical texts, *Nadja, Communicating Vessels, Mad Love,* which also, as we know, combine the two types of index, linguistic and plastic, with their first-person narrative interlaced with photographs. These two components are the decisive elements of the antinovelistic subversion attempted by the Surrealist story.

Why this opposition to the novel? And what does it consist of? Here, I will only refer to one of Breton's many justifications for it, one which not only emphasizes the specifics of Surrealist narrative, but also links it to the most emblematic features of the narrative experimentations of his time, which can be characterized as a militantly anti-Proustian era.

"Literary speculation," writes Breton in "Introduction to the Discourse on the Paucity of Reality," "oversteps its bounds whenever it confronts an author with characters with whom he supposedly agrees or disagrees, having made them up out of whole cloth. 'Speak for yourself,' I would say to him, 'Speak of yourself, you will teach me much more. I do not grant you the right of life or death over these sham human beings who have issued armed or disarmed from your fancy. Just limit yourself to leaving me your memoirs; provide me with the real names, prove to me that you in no way had free reign over your heroes."[21] That Surrealism refuses the novel is not surprising. Nothing is more logical than to see Breton attack the most realist of literary genres, the genre submitted more than any other to the rhetoric of the reality principle. However, it's the opposite argument that

21. Breton, "Introduction au discours sur le peu de réalité," *Point du jour,* p. 9.

Breton develops in these lines. He doesn't castigate the novel for its submission to reality, but to the contrary, for the paucity of its reality. It is not realistic enough. Your ghosts don't cast shadows, says Breton. The capital crime of novelists who nonetheless pretend to be realists is to kill off beings that don't even exist. Breton, however, moves away from the opposition between real characters and imaginary ones. Shifting the angle of his argument, he replaces it by that of the third and first person. After having criticized novelists for the unglorious way they dispose of their inexistent characters at will, Breton doesn't send them into the street to carry out the famous "Surrealist act" *par excellence* on a real passerby. He doesn't say: Go out and kill me some characters who really exist; he says: Give me your memoirs. Leave the third person for the first. Thus the heart of the matter is not a change in the referent, a passage from imaginary to real characters as one would do by leaving the novel for historiography. Rather it is a change in the mode of enunciation; the passage to the real must be inferred not by a change of object as much as by the entry onto the stage of the subject and its index: "Prove to me that you in no way had free reign over your heroes." This is, word for word, the criticism that opened *Nadja's* narration, where Breton scorns "the empiricists of the novel who," he says, "claim to give us characters separate from themselves. . . . I do not regard such a thing as childish, I regard it as monstrous. I insist on knowing the names, on being interested only in books left ajar, like doors."[22]

"What is admirable about the fantastic is that there is no longer anything fantastic: there is only the real."[23] Contrary to a superficial Surrealist logic, and repeating the paradox that, in the plastic domain, led Surrealism to favor photography as the medium and even the model of its experiments, Breton wants tales that would be more realistic than the novel. Thus, the simultaneous use of proper names and photographs in *Nadja* belong to one and the same antinovelistic strategy, since a character in a novel can be defined (among other qualities) as someone who can't be photographed. Shadows don't cast shadows. Breton gives both the names and the snapshots of the beings who enter his book. But the real function of photography is not so much, as Breton claims, that of allowing the narrator to dispense with the tiresome naturalistic ritual of the description of settings. It begins with the indexation of the tale. It makes it pass from a descriptive realism to a performative one.

Here we must return to Peirce's definitions. The status of the novelistic character fits, literally, in his definition of the icon. An index, Peirce writes, is a sign that has a relation to what it represents that is physical. In other words, an index allows one to infer the existence of its referent. On the other hand, Peirce writes, "an icon is a sign that refers to the object it denotes in virtue of qualities that belong only to itself, qualities it possesses, indifferently, whether such an object exists somewhere or not. . . . An icon is a sign that would continue to possess

22. Breton, *Nadja,* pp. 17–18.
23. Breton, *Manifestoes,* p. 15.

Man Ray. Woman. *1920.*

Man Ray. Integration of Shadows.
1919.

the properties that make it signifying, even if the object to which it refers had no existence." A sign is thus iconic when it has no existential debt to the object it designates. When it has no real relation to it. It defines itself as sign in total independence of what it designates, even independently of the fact that such an object exists or doesn't. And it's this indifference that Breton reproaches the novelistic character for: Julien Sorel doesn't need to exist in order to be ambitious; he doesn't even need to exist in order to be beheaded, no more than Madame de Rénal needs to exist to move sensitive souls to tears. It's not the same with the characters in his own stories, *Nadja, Communicating Vessels, Mad Love:* they are all existing. It is there, according to Breton, that their most precious, most remarkable quality is to be found, by means of which they are inscribed in the narrative. We should recall the lines that, at the end of *Nadja,* welcome her who has just appeared through the book's opened door and who has not sprung, armed or disarmed, from the fancy of its author: Breton greets her as someone who, unlike Stendhal's heros, exists and whose primary quality this is. You exist, he says in the second person, "as you alone know how to *exist,*" italicizing the verb with a vibrato that gives it an already existentialist undertone.[24] We are faced here with a sort of ontological argument, a proof of the existence of X, or of Suzanne, by the disturbances—an equivalent to her cast shadow—she produces on the text.[25]

This final event, the arrival of Suzanne, or X, which happens and is recounted in the last part of *Nadja,* is emblematic of the anti-Proustian inspiration of Breton's narratives. If they transgress the redemptive logic of the novel, this is not only because they permit themselves to invade the space of private life, giving names and printing photos; it's above all because of the surprise that this event constitutes: indexical signs leave doors ajar through which the *demain joueur,* the gambling tomorrow, does or does not make its entry.

Clearly, when during the summer of 1927 Breton goes to the Manoir d'Ango to write the narrative of his encounters with Nadja, something in his life is finished which he wants to turn into a book. But he doesn't know how this book will end. Breton knows that Nadja's story has finished and finished badly, since he has just learned that she has been committed to a space, that of a psychiatric institution, where the doors are not left ajar. Yet the narrative of *Nadja* doesn't close with her internment. When the doors of the asylum shut around Nadja, with "the jarring noise of a key that turns in a lock," those of the book stay ajar. It's through them that X will arrive, spontaneously, having issued from anywhere one wants except the head of the author. Breton has begun to write *Nadja* without knowing what its ending was going to be.

This precipitatedness is to be connected to the Surrealist refusal to make

24. Breton, *Nadja,* p. 158.
25. Just as, for Descartes, the presence of the idea of God in man's mind implies the existence, outside of the mind, of the being who is its cause, so the photographic image implies the existence (present or past) of an object of which it is the effect, and the first person pronoun that of a subject who supports it.

plans, to the taste for expectation without knowing the object, to aimless wandering without a predetermined goal. "Pursuit of what I do not know, but *pursuit.*"[26] Above all it allows one to attach Breton's narratives to the general structure of Surrealist writing, and particularly automatic writing. This relationship might be described by means of Breton's definition of automatism in the *Manifesto:* "To you who write," he says, "these elements are, on the surface, *as strange to you as they are to anyone else.*"[27] The specific feature of Surrealist writing, whether it be autobiographical or automatic, is, in fact, less the lack of knowledge of its final destination as such than the identical position into which this lack places both the reader and the author in the face of a text whose unfolding neither the one nor the other controls, and about which both of them know neither the future nor the ending.

They are, both author and reader, on the same side of the events, on the same side of the page. The one who writes has no privilege, no advance over the one who reads. He doesn't know any more about it than the other. Automatic writing is in this sense first and foremost the form of writing that reduces the advantage of writer over reader to the minimum. It puts the writer in the reader's place. This is what happens in Breton's autobiographical narratives. Suzanne's arrival at the end of *Nadja* is one of the most spectacular illustrations of Surrealism's basic narrative imperative: you must not begin to tell a story unless you don't know how it will end.

We have too often limited the concept of committed writing to works that transmit a political message, which is only a late, narrow, and derivative modality. Committed writing should be defined not in terms of content but on formal or structural grounds, based on the respective position of writer and reader: they belong to the same time, to the same space, finding themselves next to each other, sharing the same ignorance, the same fears, experiencing the same shocks. It's in these terms, moreover, that Sartre, in *What is Literature?* opposed the narrator of traditional and committed novels. The former only tells a story when it is finally finished, buried; he only tells a story if from its very first line it smacks of its conclusion. The business is over, the doors have stopped being ajar. "Neither the author nor the reader runs any risks; there is no surprise to be feared; the event is a thing of the past; it has been catalogued and understood."[28] That is already, in its essentials, the criticism Roquentin formulated in *Nausea,* when he rebukes novelistic openings as nothing but the echoes of their conclusions. The ending is there, "invisible and present, it is the one which gives to words the pomp and value of a beginning."[29]

On the contrary, the committed novel corresponds to a tale in which the

26. Breton, *Nadja,* p. 108.
27. Breton, *Manifestoes,* p. 24.
28. Jean-Paul Sartre, *"What Is Literature?" and Other Essays,* trans. Bernard Frechtman (Cambridge: Harvard University Press, 1988), p. 129.
29. Sartre, *Nausea,* trans. Lloyd Alexander (New York: New Directions,), p. 57.

teller is forced to index his story to his ignorance: this story is his own and it is incomplete. But he has to tell it anyway. It is not, as for the Battle of Waterloo in *The Charterhouse of Parma*, a question of describing Fabrice's consciousness awash in a sea of fragmentary information. It's not a matter of extending the omniscience of the narrator to the point where he has access to the very ignorance of his characters. What the novelist must put in play here is his own ignorance, the unavoidable zones of shadow of his own destiny: "To leave doubts, expectations, and the unachieved throughout our works, leaving it up to the reader to conjecture for himself."[30] The model is that of journalistic writing: the journalist must follow from one day to another a history whose conclusion he knows no more than do those he addresses. But the same narrative spurts, tied to an indexation onto external time, occur in a diary such as the one Roquentin keeps in *Nausea*. From day to day it records events whose future he knows nothing about. The same temporality is at work in Breton's autobiographical accounts. Think of the narrative dead end of April 5, 1931, from the second part of *Communicating Vessels*: "This is going to be one of those stories that stops short! No sooner is one character given than it is dropped for another—and, who knows, perhaps for another? So what is the use, after all, of putting on this whole show?"[31] The conclusion of *Nadja*—the entry of Suzanne—was not inscribed in its beginning, but even less was it foretold there what would happen between *Nadja* and *Communicating Vessels*, thus preventing *Mad Love* from being the simple, natural unfolding of what was laid out in the first volume. This autobiographical precipitate of the index over the icon is what most clearly engages Breton's stories in an anti-Proustian narrative temporality.

Proustian narration presupposes the revelation toward which it is driving. From the publication of the first volume of *The Remembrance of Things Past*, Proust has done everything to make his readers aware that he has an edge over them. He has multiplied the messages informing the critics that a last volume will explain all. They should wait until the publication of *The Past Recaptured* to give their opinions. There is nothing of this on the part of Breton, who didn't say, when *Nadja* came out, wait for *Communicating Vessels*—of which, however, he had not written a word, nor had the slightest idea—to find out what will happen with my love story with X. In other words, the hero of *The Remembrance of Things Past* doesn't write, and that's his problem or his shame, up to the moment when, in *The Past Recaptured*, he receives the revelation that will put a stop to his procrastination. In the logic of Proust's work, it is out of the question that a section of the *Remembrance* has been written before this final revelation. The composing of the novel can't be a part of the events it relates. As well, one will never find in Proust a sentence of the type that, in *Mad Love*, prompts the appearance of Jacqueline

30. Sartre, *"What Is Literature?"* p. 184.
31. Breton, *Communicating Vessels*, trans. Mary Ann Caws and Geoffrey T. Harris (Lincoln: University of Nebraska Press, 1990), p. 75.

Lamba: "I had just some days earlier written the initial text of this present book."[32] Because in his apartment, all the doors shut, walls lined in cork, nothing will happen to him who has ended up starting to write.

Breton's autobiographic haste thus has nothing to do with Proustian impatience. At the end of the *Remembrance* the narrator anxiously wonders if he will be able to complete the task he has just given himself, if he will be able to share his discovery, to transmit it. If, now that he knows where to go, he will have the time to get there. If, now that he has the message, he will be able to find an envelope. Proust's impatience is that of the writer who fears not being able to finish: he has just realized all he has left to do and wonders if he has enough time. *Ars longa, vita brevis.* He is afraid that time will deprive him of the possibility of finishing the sentence he has begun. But, whether Proust sends it or not, whether the time to write it is granted him or not, he knows the last word, he has received the final revelation. His impatience has nothing to do with the revelation but with its transmission: will he have the time to bring to the reader the knowledge he realizes he is the possessor of? In Breton's case, it's just the opposite. What's at issue in his autobiographical rush is precisely the impatience of one who doesn't want to wait to know in order to begin to write. He wants, on the contrary, to profit from the fact that the revelation has not yet occurred in order to throw himself into writing; and even, perhaps, to throw himself into it to prevent it from occurring, to delay its hour of coming. (As if the narrator were motivated by the jealousy he feels toward the reader and above all toward the naive reader; the writer is jealous of his reader's ignorance.)

I wouldn't like to insist on the purely accidental coincidence that placed the date of publication of *The Past Recaptured,* the conclusion of the *Remembrance,* a few weeks apart from the moment when Suzanne walked through the open door of *Nadja.* But it is difficult not to feel something Proustian in the tone Breton adopts to describe the revelation she brought with her. To the point where in their retrospective, recapitulative quality the words he uses might evoke the final revelation of the *Remembrance.* "For me," Breton writes, addressing Suzanne, "it was for all eternity that this succession of terrible or charming enigmas was to come to an end at your feet."[33] But if this revelation is retrospective, it is not retroactive: it changes nothing in the pages that precede it and which have been written in total ignorance of what will come to end them. Furthermore, this surprise would not have occurred if these pages hadn't been written: we know that it's as a reader that Suzanne is first introduced in *Nadja.* Reading the part of the manuscript that preceded her arrival, she decided that it was for her that the door stayed ajar.

There is a final, more important difference between the two final revelations.

32. Breton, *Mad Love,* p. 43. Whereas in Proust, as Gérard Genette remarks, "temporal markers of the type 'we have already said,' 'we will see later,' etc., don't in fact refer to the temporality of the narration, but to the space of the text (= we saw above, we will see further down) and thus to the temporality of reading." *Figures III,* 1972, note on p. 234.

33. Breton, *Nadja,* p. 158.

That of the *Remembrance* justifies the writing of the novel; that of *Nadja* would rather have the contrary effect. For Proust it justifies both the itinerary that precedes it and the narration that follows it. But Suzanne, in coming through *Nadja's* open door, does not justify *Nadja*. Much to the contrary. Breton would have preferred not to believe—as Mallarmé did—that everything exists in order to end up in a book. "Since you exist, as you alone know how to *exist*, it was perhaps not so necessary that this book should exist."[34] This is not the first time that *Nadja's* narrator hopes something will happen that will prevent him from writing. We might recall from the beginning of the book Breton's wish to see a woman appear "beautiful and naked" at night in a wood. "It seems to me that everything would have stopped short—I would not even be writing what I am writing."[35] Proust's final revelation confirms the necessity of his book; Breton's makes him lose it. It's not quite a "this" that will kill "that." But close.

34. Ibid.
35. Ibid., p. 39.

LYGIA CLARK

Introduction

 Shortly after Lygia Clark's death in 1988, I was asked to write her obituary, and, despite my initial acceptance, given immediately and without the slightest hesitation, I found it impossible to do. Once again asked to write a short critical article on her work five years later, and despite my feeling that, should I fail to do so, I would somehow be shirking a duty, I cannot find a way of doing it. For the time being it is impossible to don my professional robes with regard to her and play the university scholar. That may come later, once my mourning is over and once I am able to abstract my imagination from the huge burst of laughter with which she would have greeted this notion. What I can do today, however, is provide a few memories of Lygia as I knew her. I am not in the habit of dwelling on the personalities of artists or on my personal relations with them, but, although her entire oeuvre aims in some way at the disappearance of the author, it seems justified to me in this case. I believe that Lygia lived her art like no one has ever done.

 Flash One: I met Lygia Clark for the first time in her studio apartment in the Cité des Arts, a building on the banks of the Seine where the City of Paris houses foreign artists. It was in 1968, shortly after the events of May, and she had just returned from the Venice Biennale, where she had represented Brazil. The excellent dossier Jean Clay had devoted to her in Robho *had not yet appeared, and I had no idea what I was going to find. The studio was filled with boxes of all sizes, and Lygia was visibly very depressed (depression for her assumed a monumental, oceanic character; it was not rare but abrupt, falling like a bag on her head and quite out of proportion to its apparent reason). Very quickly, however, I witnessed a kind of transfiguration: touched perhaps by my youth (I was sixteen), irritated no doubt by my respectful attitude (I had heard her spoken of too often as a great lady), Lygia began to show me her things, that is, to let me feel them, handle them, inhabit them. First what was scattered over the tables, then the contents of the boxes she began to open for me one by one. I saw, yes, I literally saw the dark specter of depression vanish in a matter of minutes: I think that was what sealed our friendship and later made me one of her most called-upon (and most faithful) resources at times when the figure of melancholy would again swoop down on her.*

 Several tables were covered with pebbles connected by small rubber bands tied together,

one or two pebbles at each end. Lygia showed me what interested her in these precarious assemblies, and how to "use" them. You draw a pebble or a group of pebbles toward you, and, at a given, always unforeseeable moment, the mass at the other end of the elastic will follow, and will jump suddenly toward you as if moved by a spring, or will drag feebly like a slug. It was the interaction between different forces that moved Lygia (your own pulling, the extensibility of the elastic, and the weight of the pebbles), and the fact that the incommensurable action that results cannot fail to be perceived as a phenomenological metaphor for the relationship of your body with others in the world.

Lygia constructed a flashback, unpacking the oldest things first. What struck me in particular was her Dialogue *of 1966, an "object" designed with Hélio Oiticica: our two right hands joined in opposite directions, each in one of the loops of a little Möbius cloth ribbon (elastic, there again), and by joining or releasing them, we experienced the resistance of matter (our gestures were restricted), belying traditional topology. Lygia then told me about the beginning of the Neo-concrete movement in Brazil, her own polemical starting point— that of breaking with the universalist claims of geometric abstraction. She had turned one of Max Bill's most captivating sculptures, draped in its marmoreal autonomy, into the support for an experiment aimed at abolishing any idea of autonomy. For a moment I defended the art of Mondrian, my first love in painting, and I was surprised to see Lygia agree with enthusiasm, but she urged me to dissociate his work from the air of pontification manner with which it was spoken of in Paris. She told me it had nothing to do with Plato, and that all that Mondrian had aimed at, particularly since the 1930s, was the destruction of form (later I had a similar discussion with her in connection with Albers and his ambiguous spaces).*

Lygia continued to open boxes. Nothing that came out of them was made simply to be seen and not touched. A ritual always presided over the apprehension of these objects designed to be transitional (Lygia later read Winnicott and felt her intuitions confirmed). This nonexistence of the object as such is obvious in the "propositions" of the time (that was her word): what would they have been—these plastic bags, pebbles or shells, water pouches, scuba-diving air hoses looped onto themselves and so made useless, these "sensory cowls"— what would this entire sensory panoply have been without the rules of the game, of the acting out I was invited to perform? But the Animals (Bichos) *of 1960, her articulated metal sculptures with which, here again, you have to "converse," already signaled Lygia's tendency to conceive of the object as a mere vehicle for bodily experience. The* Animals *look like abstract sculptures; with the black-and-white paintings of the 1950s they are in appearance her most exhibitable and most photographic works. But one should not be deceived: they are inaccessible to anyone not engaged in combat with them, to anyone not unfolding them. The conflicting directions of the hinges connecting their many plates force you to make certain movements and prevent you from making others, and this always unexpectedly; they turn inside out like a glove, for example, without your wanting them to or even thinking it possible.*

After the Animals *come the* Trailings (Trepante) *(1964), that is, almost nothing: you make a Möbius strip out of paper (this "form" fascinated Lygia at the time, for it suspends the traditional oppositions of our geometry and our position in the world, left/right, front/back, etc.). Using scissors, poke a hole in the middle of the band and start cutting*

lengthwise; when you have worked your way back to the point of your original cut (which would have the effect of separating the strip into two), avoid it and choose another place to divide the strip, then go on, each time choosing right or left, until you cannot divide the strip again. Everything flows from the inescapable, ineffaceable moment of this choice: the unfolding is this moment, all or almost nothing. Once the "trail" of the Trailing *is followed, all that remains is a heap of paper spaghetti to be thrown in the trash.*

Lygia showed me a lot more of these objects, or missing objects, and made me put on her "sensory cover-alls"; once inside one of them, I performed a cesarean on myself. It was, moreover, the metaphor of childbirth that haunted the last upheaval of this initial meeting: just before my departure, Lygia placed in my hand a small transparent plastic bag which she had just blown up and sealed. She placed a pebble on one of its corners. It was balanced precariously and sank a little into the corner of the bag. It hung there, and nearly fell, but even the slightest change in the pressure of my hands caused it to rise again like a floater. The bag was still hot. I felt as though I were clumsily helping a very delicate animal to give birth. The delicate fort/da *of the little pebble stayed in my memory for a long time, partly because it was related to the idea of a bodily, transpersonal memory, a generic memory (Lygia called the series it belonged to, in 1966,* Nostalgia of the Body).

Flash Two: It was 1973, and Lygia (whom I saw almost daily for six years, from my arrival in Paris in 1971 until her return to Brazil) asked me to be present for a visit from a museum curator who wanted to propose a retrospective exhibition of her work. Polite chitchat sitting in a circle on the floor of her apartment on Boulevard Brune. Almost immediately there was a clash with the serious character (who, I could see, held me partly responsible for the fiasco). Lygia categorically rejected the idea of an exhibition, arguing that since 1968 all she had done was distance herself ever further from the object—that her current work, in which the individual bodies of participants became a collective body in the forming of an ephemeral architecture, no longer bore any relationship to art—particularly since the very notion of a spectator was entirely banished from it. She said that perhaps it had more to do with psychotherapy (Lygia was then going through a psychoanalysis—not fully orthodox but of the type called "existential" by Ludwig Binswanger; her discourse at the time was highly impregnated with Groddeck, whose essay on "the soul of the stomach" seemed to her of signal importance). Only one solution would suit her: if the museum would pay her for a three-month summer stay during which she could continue the "courses" she was "giving" at Saint Charles (a sinister warehouse belonging to the University of Paris). The curator was dismayed but asked for more information on the courses in question, and Lygia told him what went on—"rites without myths," as she said. For example, during the "experiment," which was then very recent and which she called the Dribble, *students each sucked a small reel of colored thread which they then unwound directly from their mouths onto one of their colleagues stretched out on the ground, the body of the latter gradually buried under a mottled web of regurgitations.*

Initially troubled by this symbolic act of vomiting, the curator nevertheless recovered his equanimity. Thinking he could categorize Lygia's work, he made the mistake of referring to "Body art" (particularly to the masochistic scenes of Gina Pane), and to Happenings. In an instant, the whole bittersweet irony with which Lygia had been playing in this conversation

(to the great incomprehension, and discomfort, of the visitor) became a torrent of furious abuse: her work had nothing to do with any performance whatsoever nor with the offering on a platter, for the secondary benefit of a voyeur, of her fantasies and her impulses. It was impossible to "attend" one of these "courses," to retreat from it as a spectator. Anyone not wishing to take part in the great collective body fabricated there, each time according to a different rite, was sent packing. She saw her practice as a type of social electric shock, at the limits of psychodrama: it had no relation to the padded space of the museum or the gallery (no object), or with the exhibitionism of the avant-garde (she saw no interest in shocking the bourgeois). The curator was quite simply shown the door, after which there was a gargantuan manic laugh, followed by an impromptu party to which many friends were invited to celebrate the irreversible divorce I had just witnessed: Lygia had dismissed the art world, once and for all.

Later when Lygia sadistically told this story, I was a bit ashamed at having participated in the general hilarity. After all, wasn't it possible to imagine, if not an exhibition, at least a display in which her journey would be shown in all its logic? The psychotherapeutic experiments conducted by Lygia during the last ten years of her life certainly did not lend themselves to any direct presentation, but at least they could be described (Lygia is a passionate writer). As for all the previous work from which they arose (from Neo-concretism to the Trailings, *and then from the "nostalgia of the body" to the "rites"), there is nothing to prevent people from experiencing it, provided the "objects" are not stuck on bases or hung on the wall. This work is certainly difficult to incorporate in a museum (where Lygia's "impossible not to touch" would be immediately understood either as a provocation or as demagogy), but not in any other place able to expunge the spectator's passivity. Lygia believed for a long time that this was unfeasible, seeing an insurmountable obstacle in the contraction of time necessarily required for an exhibition of that type. Two years before her death, however, she took the chance: for two months, in Rio de Janeiro, after having seen the paintings and reliefs of the 1950s and played with the* Animals, *crowds handled countless "objects" they had made themselves from models and materials set out on tables. This first attempt was a phenomenal success, and the demand for a sequel was considerable, so it was repeated the following year in São Paulo. It is important to understand that Lygia wanted her objects to be handled, and to realize that this is not monstrously unachievable: perhaps one day, on this side of the Atlantic, an institution will allow itself to take part in the game.*

—*Yve-Alain Bois*

Born of a "vitalist" reaction against Max Bill's systematic-concrete art, which had widespread influence in Brazil and Argentina, the Neo-concrete movement was formed in Rio in 1959. Here is the theoretical statement announcing the group's formation.

1959: Neo-concretist Manifesto

The term "Neo-concretism" marks a position taken relative to non-figurative, "geometric" art (Neoplasticism, Constructivism, Suprematism, the School of Ulm) and above all relative to *art concret,* which has succumbed to a dangerous hypertrophy of rationalism. Working as painters, sculptors, printmakers, and writers, the artists who join in this inaugural Neo-concretist exhibition have been led, through their own personal experience, to reevaluate the theoretical positions adopted by *art concret* up to now—in the sense that none of these allow for a satisfying response to the expressive possibilities onto which our experiences open.

Born of the Cubist reaction against Impressionism's dissolution of pictorial language, it was normal that so-called geometric art would take a position diametrically opposed to contemporary painting's facile technique and content. The new discoveries in physics and mechanics, opening the widest horizons for objective thought, could not but stimulate, in the heirs to this revolution, *a tendency to an ever-increasing rationalization of the processes and goals of painting greater at each stage than the last.*

A *mechanistic* notion of construction came to invade the language of painters and sculptors, giving rise in its turn to an equally extreme, retrograde reaction, as in the irrational or magic realism of the Dada artists and the Surrealists.

However, it is no less the case that beyond their theories in praise of the objectivity of science and the precision of technology, the true artists—Mondrian, Pevsner, for example—constructed their work through an *embrace of expression* that often bypassed the limitations imposed by theory. The work of these artists has thus far been interpreted, however, in the light of theoretical principles that the works themselves contradict. We propose a reinterpretation of Neoplasticism, of Constructivism, and of the various analogous movements, basing ourselves on their expressive gains and giving *precedent to the work rather than to the theory.*

If we were to understand Mondrian's work by means of his theories, then we would have to choose from among them. *Either the prophecy of a total integration of art into everyday life will seem possible, and Mondrian's work represents the first step in this direction; or such integration appears always more remote, and the work does not realize its goals. Either the vertical and horizontal truly constitute the fundamental rhythms of the universe, and Mondrian's work derives from the application of this universal principle; or if this principle is false, and then the work labors under an illusion.*

But beyond these theoretical contradictions, Mondrian's work is there: alive and fecund. What will it serve us to see Mondrian as nothing but the destroyer of the surface, of the plane, and of the line, if we are incapable of seeing the new space that arises from such destruction? The same holds for Vantongerloo or

Pevsner. What's the difference what mathematical equations determine a sculpture or painting by Vantongerloo—since only direct perception of the work allows one to grasp the "signification" of these rhythms and colors? Whether Pevsner started out from figures of descriptive geometry is a question without interest when faced with the new space that his sculptures sustain, and the cosmico-organic expression that these forms reveal by means of this space.

From a specifically cultural point of view it is interesting to determine the connections that occur between art objects and scientific instruments, between artistic intuition and the objective thought of the physicist or engineer. But from an aesthetic point of view, the work only exists from the moment when it transcends its external relationships—by means of the existential meanings that it reveals, at the very moment that it creates them.

By having given primacy to the "pure sensation of art," Malevich saved

his theoretical definitions from the limitations of rationalism and mechanism. He endowed his painting with a transcendental dimension that still continues to give it an extraordinary contemporaneity. But Malevich paid dearly for his courage in simultaneously opposing figuration and mechanistic abstraction, since today certain rationalist theoreticians consider him as a naïf who would have never really understood the true meaning of the new plastic order. In truth, *Malevich already expressed an incompleteness, a will to transcend the rational and the sensory, that lies at the heart of painting and that manifests itself in our time in an irrepressible way.*

Neo-concretism, born from the need to express the complex reality of modern man by means of the structural language of new forms, denies the validity of scientific and positivist attitudes in the arts, and reconvokes the problem of expression in incorporating the new conceptual dimensions created by Constructivist, non-figurative art. *Rationalism strips art of all its autonomy, by substituting notions of scientific objectivity for the irreplaceable qualities of the work of art.* In this way the concepts of form, space, time, structure—which in the language of the arts are tied to an existential, emotional, affective meaning—are confused with the theoretical application science makes of them. In fact, in the name of the prejudices denounced by the philosophy of today (Merleau-Ponty, Cassirer,

Suzanne Langer), prejudices that are crumbling in all fields—beginning with modern biology's advance over Pavlovian mechanism—*the concrete-rationalists still see man as a machine among other machines, and try to limit art to the expression of this theoretical reality.*

We neither consider the work of art a "machine" nor an "object," but rather, an *almost-body,* which is to say, a being whose reality is not exhausted in the external relationships between its elements; a being which, even while not decomposable into parts through analysis, *only delivers itself up wholly through a direct, phenomenological approach.*

For us, the work of art surpasses the materialist mechanics that serve as its support, and this is not at all for metaphysical reasons. If it transcends its mechanical relations (such as Gestalt psychology objectifies them), it's through the creation of an implicit meaning (Merleau-Ponty) which emerged by itself for the first time. *If we must look for an equivalent for the work of art, we will thus find it neither in the machine nor in the object as such, but rather, as Langer and Weidlé did, in living organisms.* However such a comparison would not suffice to express the specific reality of the aesthetic organism. It is because the work of art is not limited to occupying a place in objective space, but transcends it in order to found a new meaning, that the objective notions of time, space, form, structure, color, etc., are not sufficient to understand the work of art, to account for its reality.

The difficulty of finding a precise terminology to express a world that can't be reduced to formulae has led art criticism to adopt an imprecise vocabulary, the indiscriminate use of which has betrayed the complexity of the work of art. There the influence of technology and of science has again played a role—but in the opposite direction. Certain artists, offended by the critics' imprecise terminology, have tried—in a significant reaction—to make art on the basis of objective notions, trying to apply them as creative methods. This results in a simple illustration of methods given *a priori,* methods that prescribe the results the work is to realize in advance. Stripping itself of intuitive creation, limiting itself to an objective form in objective space, the painting of the concrete-rationalist evokes nothing but a reaction of stimuli and reflex responses from artist and spectator alike. The con-

crete work offers itself to the eye in the form of an instrument and *not as a human way of grasping the world and of giving oneself to it.* It addresses itself to the eye-machine and not to the eye-body.

It is because the work of art transcends mechanical space that the notions of cause and effect lose much of their validity in it. The notions of time, space, form, color, need to be integrated in such a way (in virtue precisely of the fact that as notions they do not preexist the work) that it would be impossible to speak of them as isolated terms. Neo-concrete art, in affirming the absolute integration of its elements, believes that the "geometrical" vocabulary it uses must take on the expression of complex human reality, in the way that many works by Mondrian, Malevich, Pevsner, Gabo, Sophie Taeuber-Arp, etc., demonstrate. Even if these artists sometimes confused the concepts of *mechanical form* with those of *expressive form,* it's a matter of clarifying that in the language of art *so-called geometrical forms lose the objective character of geometry in order to become a vehicle for the imagination.*

For its part, because it is a causal psychology, Gestalt psychology is not sufficient to explain the phenomenon that gives rise to the dissolution of space and form as causally determined realities, through the action of time and of "spatialization." What we mean by *spatialization* of the work is the fact that it is *always in the present, always in the process of beginning over,* of beginning the impulse that gave birth to it over again—whose origin and evolution it contains simultaneously. *And if this description also takes us back to a primal—total—experience of the real, it's because Neo-concrete art wants in fact to recreate this experience.* Neo-concrete art wants to found a new, expressive, "space."

This position holds equally for *Neo-concrete poetry,* which denounces in concrete poetry the mechanistic objectivity already denounced in painting. The concrete-rationalist poets have also set up an imitation of the machine as the ideal. And likewise space and time are nothing for them but the external relations between word-objects. If that were so, the page would reduce itself to a graphic space, and the word to an element of this space. As with painting, the visual is reduced here to the eye and the poem hardly goes beyond graphic dimensions.

Neo-concrete poetry rejects such counterfeit notions and, faithful to the

very nature of language, affirms *the poem as a temporal being*. It is in time and not in space that the word unfolds its complex, signifying nature. The page, in Neo-concrete poetry, is the "spatialization" of verbal time: it's *a pause, a silence, a temporality*. It's not a question, obviously, of returning to oral poetry's concept of time: whereas for the latter language unreels in a succession, in Neo-concrete poetry, language extends itself in a duration. Consequently, contrary to rationalist concretism, which takes the word for an object, transforming it into a simple visual sign, Neo-concrete poetry gives words back their condition of "verb," which is to say a human manner of presenting the real. In Neo-concrete poetry, language does not unreel, it continues.

For its part, Neo-concrete prose opens the field to new expressive experiences; it recuperates language as flux, surpasses its syntaxic contingencies and gives a new, more ample meaning to certain solutions equivocally held out for poetry until now. It is in this way, in painting as in poetry, in prose as in sculpture, that Neo-concrete art reaffirms *the independence of artistic creation in relation to objective knowledge (science) and practical knowledge (ethics, politics, industry, etc.)*.

The participants in this first Neo-concretist exhibition do not form a *group*. They are not linked to each other by dogmatic principles. The obvious affinity of the investigations they have carried out in the most diverse fields has brought them together and united them here. The engagement that keeps them connected connects first of all to their own experiences, and they will remain connected insofar as the deep affinity that has brought them together continues.

Rio de Janeiro. March 1959.

—Amilcar de Castro; Ferreira Gullar; Franz Weissmann; Lygia Clark; Lygia Pape; Reynaldo Jardim; Theon Spanudis.

1960: Death of the Plane

The plane is a concept created by humanity to serve practical ends: that of satisfying its need for balance. The square, an abstract creation, is a product of the plane. The plane arbitrarily marks off the limits of a space, giving humanity an entirely false and rational idea of its own reality. From this are derived the opposing concepts of high and low, front and back—exactly what contributes to the destruction in humankind of the feeling of wholeness. It's also the reason why people have projected their transcendent part outward and given it the name of God. In this way the problem of their own existence is raised—in inventing the mirror of their own spirituality.

The square took on a magical meaning when the artist understood it as carrying a total vision of the universe. But the plane is dead. The philosophical conception that humanity projected onto it no longer satisfies—no more than does the idea of an external God persist.

In becoming aware that it is a matter of an internal poetry of the self that is projected into the exterior, it is understood at the same time that this poetry must be reintegrated—as an indivisible part of the individual.

It is this introjection that has also burst the pictorial rectangle asunder. This rectangle in pieces has been swallowed up by us and absorbed into ourselves. Before, when artists situated themselves in front of the rectangle, they projected themselves onto it and in this projection they charged the surface with transcendent value. To demolish the picture plane as a medium of expression is to become aware of unity as an organic, living whole. We are a whole, and now the moment has come to reassemble all the pieces of the kaleidoscope into which humanity has been broken up, has been torn into pieces.

We plunge into the totality of the cosmos; we are a part of this cosmos, vulnerable on all sides—but one that has even ceased having sides—high and low, left and right, front and back, and ultimately, good and bad—so radically have concepts been transformed.

Contemporary humanity escapes the spiritual laws of gravity. It learns to

float in cosmic reality as in its own internal reality. It experiences vertigo. The crutches that held it up fall far from its arms. It feels like a child who needs to learn to balance itself in order to survive. The primal experience begins.

This is the name I gave my works of this period, due to their fundamentally organic character. And also, the hinge connecting the planes made me think of a dorsal spine.

The arrangement of the metal plates determines the beast's position, which at first glance seems limitless. When I am asked how many movements the *Beast* can execute, I reply: "I have no idea, nor do you; but the beast knows...."

The *Beasts* have no reverse side.

Each *Beast* is an organic entity that only reveals itself totally within its *internal expressive time*. It has affinities with the conch and shellfish.

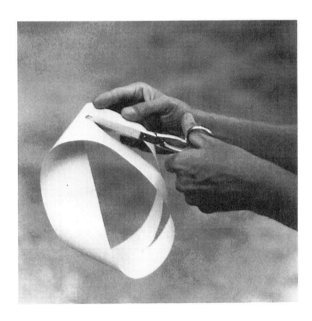

It's a living organism, an essentially active work. A total, existential integration is established between it and you. A passive attitude is impossible between you and the *Beast,* either on its part or on yours.

What occurs is a kind of embrace between two living entities. It's in fact a dialogue through which the *Beast* reacts—thanks to its own specific circuit of movements—to the spectator's stimulus. This relation between the work and the spectator—until now a virtual one—becomes effective.

The *Beast* is not composed of independent forms whose development one could pursue indefinitely at one's own will, as in a game. To the contrary: its parts work together harmoniously as in a real organism. When the parts are in movement an interdependence obtains between them.

In these relations between the *Beast* and yourself, there are two types of movement. The first, purely external, is what you do. The second, the *Beast's* own, is produced by the dynamic of its own expressiveness. The first movement (what you do) has nothing to do with the *Beast*—because it doesn't belong to it. But, on the other hand, the conjunction of your gesture with the immediate response by the *Beast* creates a new relationship, and that is possible only as a

function of the movement that the *Beast* knows how to execute itself: this is the *life proper to* the *Beast*.

 1964: Trailings

Trailings is the name I gave my latest proposition. Henceforth, I will give *an absolute importance to the immanently inscribed act that the participant will bring about.* The *Trailing* supplies all the possibilities attached to action itself: it allows for choice, for the unpredictable, for the transformation of a virtuality into a concrete undertaking.

Make yourself a *Trailing:* you take the band of paper wrapped around a book, you cut it open, you twist it, and you glue it back together so as to produce a Möbius strip.

Then take a pair of scissors, stick one point into the surface and cut continuously along the length of the strip. Take care not to converge with the pre-existing cut—which will cause the band to separate into two pieces. When you have gone the circuit of the strip, it's up to you whether to cut to the left or to the right of the cut you've already made. This idea of choice is capital. The special meaning of this experience is in the act of doing it. The work is your act alone. To the extent that you cut the strip, it refines and redoubles itself into interlacings. At the end the path is so narrow that you can't open it further. It's the end of the trail.

(If I use a Möbius strip for this experiment, it's because it breaks with our spatial habits: right/left; front/back, etc. It forces us to experience a limitless time and a continuous space.)

Each *Trailing* is an immanent reality that reveals itself in its totality during the expressive time of the spectator-author.

At the outset, the *Trailing* is only a potentiality. You are going to form, you and it, a unique, total, existential reality. No more separation between subject and object. It's an embrace, a fusion. The responses, diverse as they are, will be born of your choices.

To the dualistic relation of man and *Beast* that characterized my earlier experiments, there now succeeds a new type of fusion. The work, being the act of making the work, you and it become wholly indissociable.

There is *a single type of duration: the act.* The act is what produces the *Trailing.* There is *nothing before, nothing after.*

Each time I attack a new phase of my work, I feel all the symptoms of pregnancy. Once gestation begins, I have actual physical symptoms, dizziness for example, until the moment I manage to bring my new space-time into the world. That occurs to the extent that I arrive at *identifying, at recognizing this new expressiveness of my work in my everyday life.* The *Trailing,* for example, only took on meaning for me once, crossing the countryside by train, I experienced each fragment of the landscape as a temporal totality, a totality *in the process of forming,* of producing

itself before my eyes, in the immanence of the moment. The moment, that was the decisive thing.

Or another time, while watching the smoke from my cigarette: it was as though time itself were ceaselessly forging its path, annihilating itself, remaking itself, continuously . . . I already experienced that in love, in my gestures. And each time the expression *trailing* wells up in conversation, it gives rise to an actual space and integrates me into the world. I feel saved.

I also find that my architectural attempts, born at the same time as the *Trailings*, wanted to be a link with the collective world. At issue was the creation of a new, concrete, space-time—not only for myself, but for others.

In making them, these architectures, I felt a great fatigue, as though I had worked at it all my life. Fatigue due to the absorption of a new experience. From which, sometimes, this nostalgia to be a damp stone, a stone-being, in the shade of a tree, outside time.

1965: Concerning the Instant

The instant of the act is not renewable. It exists by itself: to repeat it is to give it another meaning. It doesn't contain any trace of past perceptions. It's another moment. At the very moment in which it happens it is already a thing-in-itself. Only the instant of the act is life. By its nature, the act contains in itself its own outstripping, its own becoming. The instant of the act is the only living reality in us. To become aware is already to be in the past. The raw perception of the act is the future in the process of making itself. The past and the future are implied in the *present-now* of the act.

1965: Concerning the Magic of the Object

The artist who transplants an object of everyday life (readymade) aims to give this object a poetic power. My *Trailings* are very different. In their case no need for the object: it's the act that gives rise to poetry.

What transpires then of such importance in the readymade? There, despite all transfer from the subject to the object, one still finds a *separation* of one from the other. With the readymade, we still need a support to reveal our internal

expressiveness. Now this is no longer necessary because poetry is expressed directly in *the act of making.*

What then is the role of the artist? To give the participant an object that has no importance in itself and which will only take on such to the extent that the participant will act. It's like an egg that only displays its substance when one opens it.

I wonder if after the experience of the *Trailing*, we won't become more aware of each of the gestures we make—even the most habitual. It might be that this is impossible since it would require that from the outset one suspend all practical and immediate meaning for one's gestures.

The first time I cut out a *Trailing*, I lived out a ritual that was very meaningful in and of itself. And I hoped that this same action would be lived with the maximum intensity by future participants. It was necessary that it be purely gratuitous, and that you not attempt to know—as you were cutting— what you were going to cut *after* nor what you had *already* cut.

Concentration and will— naive perhaps—are needed to grasp *the absolute* through the act of making the *Trailing*, in holding onto the gratuitousness of the gesture. The *Trailing's* act is an aesthetic idea, a proposal, that is addressed to the person for whom labor, increasingly mechanized, automated, has lost all the expressiveness it used to have, when the artisan would enter into a dialogue with his work. Perhaps this loss of expressiveness in the relation to labor—to the point of being totally alienated—has occurred so that one can now rediscover all the better one's own gesture filled with new meaning. So that just such a change might truly take place in contemporary art, *something else is needed besides the simple manipulation and participation of the spectator. It's crucial that the work not count in and of itself* and instead be a simple springboard for the freedom of the spectator-author. The latter will become aware by means of the proposal offered by the artist. *It is not a question here of participation for participation's sake, nor of aggression for its own sake, but rather for the participant to invest his or her gesture with meaning and for this act to be nourished by thought, in the process of bringing the participant's freedom of action to light.*

When the work was offered up completely finished (as "the work of art") the spectator could only attempt to decode it—and sometimes this took several

generations to do. It was a problem for the elite. Henceforth, with the *Trailings*, it's in the very instant that the spectator acts that the meaning of the action is perceived. Communication is more direct. This is no longer a problem for the privileged.

Moreover the older type of work—the object closed on itself—reflected an experience already *past*, already lived by the artist. Whereas now, what's important is the act of making in the *present*. "Art becomes the spiritual exercise of freedom. The advent of freedom is also what art accomplishes" (Mario Pedrosa). We are opening onto the anonymous work—whose signature is nothing but the participant's action.

The artist is dissolved into the world. One's mind is grounded in the collective even while staying the same. For the first time, instead of interpreting a fact of the preexisting world, *one changes this very world,* through a direct action.

Even if this proposition isn't considered a work of art, and if one remains skeptical about what it implies, we still need to undertake it. By means of it, we transform and deepen ourselves, whether or not we know or want it. Of course, the artist thereby gives up a little of his or her personality, but at least the artist helps the participant create a personal image and reach, by means of this image, a new concept of the world. This is an extremely important development in that it is diametrically opposed to the depersonalization that is one of the features of our age.

If the loss of individuality, so to speak, is imposed on the modern subject, the artist offers an alternative and the occasion for finding oneself again. Simultaneously with being dissolved into the world, with being grounded in the collective, the artist loses his or her uniqueness and expressive power. He or she is content to propose to others that they be themselves and that they achieve *the singular condition of art, but without art.*

1965: About the Act

For the first time I have discovered a new reality not in myself but *in the world.* I encountered a *Trailing,* an internal journey *outside myself.* Before, the *Beast* emerged from me, bursting out in an obsessional explosion, in all directions. Now, for the first time, with the *Trailing,* it's just the opposite. I perceive the whole of

the world as a single, global rhythm that stretches from Mozart to the footwork of a soccer game on the beach.

Architectural space overwhelms me. To paint a picture on a surface or to make a sculpture is so different from living in architectural terms! Now, I am no longer alone. I am pumped up by others. Perception so powerful that I feel myself torn up from my roots. Unstable in space. I feel as though I were in the process of disintegrating. To live perception, *to be* perception . . .

These days I am almost continually ill. I can swallow nothing and my body deserts me. Who is the *Beast*—myself? I become an abstract existence. I sink in real depths, without connections to my work—which looks at me from a distance and from outside myself. "Is it I who did that?" Upheavals. A hysterical sense of leaking. Only a thread holds me fast. My body has left me—*trailing*. Dead? Living? I am extinguished by odors, sensations of touch, the heat of the sun, dreams.

A monster surges up from the sea, surrounded by living fish. The sun shines intensely when suddenly it begins to go out. The fish: dead, their white bellies upward. Then the sun shines again, and the fish are alive. The monster has disappeared into the depths, the fish along with him. I am saved.

Another dream: in the inside which is the outside, a window and myself. Through this window I want to pass to the *outside* which is the *inside* for me. When I wake up, the window of my room is the one from my dream; the *inside* I was looking for is the space outside. The *Beast* which I called "inside and outside" was born from this dream. It's a stainless-steel structure, supple and deformable. There's a void at the center of the structure. When you manipulate it, this inner void gives the structure completely new aspects. I consider "inside and outside" as the completion of my experiments with the *Beasts* (just before "inside and outside," I worked out another *Beast* without hinges which I called "before and after").

Often I awaken before the window of my room—looking for the exterior space as though it were "inside." I am afraid of space—but I reconstruct myself by means of it. During crises, it escapes me. It's as though we played—myself and it— at cat and mouse, at winner loses.

I am before and after, I am the future now.

I am inside and outside, front and back.

What strikes me in the "inside and outside" sculpture is that it transforms my perception of myself, of my body. It changes me. I am elastic, formless, without definite physiognomy. Its lungs are mine. It's the introjection of the cosmos. And at the same time it's my own ego crystallized as an object in space. "Inside and outside": a living being open to all possible transformations. Its internal space is an affective space.

In a dialogue with my "inside and outside" work, an active subject encounters his or her own precariousness. No more than does the *Beast,* the subject no longer has a static physiognomy that is self-defining. The subject discovers the ephemeral in opposition to all types of crystallization. Space is now a kind of *time ceaselessly metamorphosed through action.* Subject and object become essentially identified within the act.

Fullness. I am overflowing with meaning. Each time I breathe, the rhythm is natural, fluid. It adheres to action. I have become aware of my "cosmic lungs." I penetrate the world's total rhythm. The world is my lung. Is this fusion death? Why does this fullness have the taste of death? I am so incredibly alive . . . How to connect these two poles always? Often in my life I have discovered the identity of life and death. A discovery which nonetheless has a new flavor each time. One night, I had the perception that the absolute was this "full-void," this totality of the interior with the exterior I've spoken of so often. The "full-void" contains all potentialities. It's the *act* which gives it meaning.

The act in the process of happening is time. I wonder if the absolute is not the sum of all acts? Would this be space-time—where time, trailing along, continually makes and remakes itself? This absolute time would be born of itself.

We are a spatio-temporal totality. In the immanent act we see no temporal limit. Past, present, future, mix together. We exist before the afterward—but the afterward anticipates the act. The afterward is implied in the act in the process of happening. If time lives in the instant of the act, what comes out of the act is incorporated into the perception of absolute time. There is no distance between the past and the present. When one looks backward, the distant past and the recent past fuse.

Perhaps none of this is clear. But the proof of the perception I had is the only thing I cling to.

I've thought about the parallel that exists between religious and artistic evolution. From ancient art until the present-day art that calls for the spectator's participation, the psychic distance between subject and object has not stopped narrowing, to the point that they now melt into one another. Thus the *trailing.*

For its part, religion has witnessed the same progressive fusion. We have passed from God-the-Father, all powerful, to Christ who already has a human dimension. Likewise in the Greek religion, where the gods on Olympus gradually draw close to humanity to the point of taking on its physical appearance. With Nietzsche, all religious projections of humanity toward the outside are rejected, and religious feeling is introverted: humanity is divine. The same thing occurs in art: the proposition, formerly felt by spectators as external to themselves, enclosed within a strange object, is now lived as a part of them, as fusion. Everyone is creator.

Art is not bourgeois mystification. What has changed is the form of communicating the proposition. It's you who now give expression to my thoughts, to draw from them whatever vital experience you want.

This experience lives in the moment. Everything takes place as though humanity, today, could capture a fragment of suspended time, as if an entire eternity were secreted within the act of participation. This feeling of totality captured within the act should be encountered with joy, in order to learn how to live on the ground of precariousness. This feeling of the precarious must be absorbed for one to discover in the immanence of the act the meaning of existence.

1966: We Refuse . . .

What's happening around me? A whole group of people clearly sees that modern art doesn't communicate, is increasingly becoming an elitist issue. So they turn to popular art, hoping to fill the gulf that separates them from the majority. Result: they cut the ties that attach them to the development of universal art and fall back onto a form of expression that is local in character.

I see another group that clearly feels the enormous crisis of modern expression. Those who compose it try to deny art—but this negation, they find no other way to express it except, precisely, works of art.

For myself, I belong to a third group that tries to elicit the public's participation. This totally changes the meaning of art as one has understood it up to now. That's why:

We refuse representational space and the work as passive contemplation.

We refuse all myth external to humanity.

We refuse the work of art as such, and we place the emphasis on the act of realizing the proposition.

We refuse duration as a means of expression. We propose the very time of the act as a field of experience. In a world in which the subject has become a stranger to its labor, we use experience to incite awareness of the alienation in which one lives.

We refuse all transference to the object—even to an object that seems to be there only to underline the absurdity of all expression.

We refuse the artist who pretends by means of the object to give a total communication of his or her message, without the spectator's participation.

We refuse the Freudian idea of the subject conditioned by its past and we emphasize the idea of freedom.

We propose precariousness as a new idea of existence against all static crystallization within duration.

1968: We Are Proposers

We are proposers: we are the mill. It's up to you to blow into it the meaning of our existence.

We are proposers: our proposal is that of dialogue. Alone, we don't exist, we are at your mercy.

We are proposers: we have buried the "work of art" as such and we call out to you so that thought will live by means of your action.

We are proposers: we are proposing neither the past nor the future to you, but the "now."

1968: Are We Domesticated?

If I were younger, I would be in politics. I feel a bit too at ease, too integrated.

Before, artists were marginalized. Now, we, the proposers, are too well placed in the world. We are able to live—just by proposing. There is a place for us in society.

There is another type of person who prepares what will happen, other precursors. They, they continue to be marginalized by society. When there is a struggle with the police and I see, in Brazil, a seventeen-year-old killed (I put his photo on my wall, in my studio), I realize that he dug a place with his body for the generations that will succeed him. These young people have the same existential attitude as we, they unleash processes whose end they can't see, they open a path whose exit is unknown. But society resists them, and kills them. It's thus that they work all the more. What they try to force is perhaps more essential. They are incendiaries. It's they who shake up the world. We, sometimes I wonder if we are not a bit domesticated. That annoys me . . .

1968: Four Recent Propositions

The "Mine Field": Many high-powered magnets are hidden at different points in the ground which is itself covered over with a carpet of foam rubber. A group of spectators are invited to put on magnetized boots. In the course of their wandering through the work, they are abruptly nailed to the ground—from which they have a hard time disengaging themselves.

Dialogue-Belts: The participants are invited to put on magnetized belts, one a positive, the other a negative pole. According to their circulation, they will be violently projected toward one another, or, to the contrary, will not succeed in joining one another, when the play of the magnets will be contrary to them.

Film: Man at the Center of Events. Four cameras are focused on the head of a walking man. Having begun to roll at the same time, they record everything that takes place around him, in front, behind, to the left, to the right—and particularly the reactions of the people who observe him, ask questions, want to interrupt, etc. After being developed, the four films are simultaneously projected on the four walls of a little room, at exactly life-size. The spectator enters this room, reliving the event as though he or she had provoked the reactions that are inscribed on the walls.

Film: Invitation to a Voyage. Two rooms. In the first, sandwiches, newspapers, soft drinks, etc. In the second, a movie screen, and in front of it, plants, sand, shrubs, etc. And in the room, some stationary gym bikes. After having bought all the nourishment they need in the first room, the spectators get on the bikes.

The lights dim, a cyclist seen from behind appears on the screen and by his gesture invites the participants to follow him. Everyone begins to pedal, while the screen shows a road that passes by beneath our wheels.

Second sequence: the cyclist is stopped at the foot of a tree, to have a picnic. The spectators get off their bikes, spread out in the room, in the midst of the green plants—and make merry in complete freedom.

Third sequence: the cyclist is once more pedaling on the screen—followed by the spectators. He stops in front of a bar where young people are dancing. From the screen, they invite the cyclists to join them. The participants begin to dance against backdrop of the image.

Object of the Film: Through a precise, temporal disjunction in our imagination, to make us aware of the gestures and attitudes of everyday life.

Works

Pages 92–96: *Beast,* 1960 (Photos: Sergio Zallis).

Page 97: *Going,* 1964 (Photo: Beto Felicio).

Page 98: Three phases of *Going,* 1964 (Photo: Beto Felicio).

Page 100: *Breathe with Me,* 1968, from *Nostalgia of the Body,* 1965–88 (Photo: Photos Carlos).

Page 101: *Breathe with Me,* 1968 (Photo: Photos Carlos).

Page 102: *Breathe with Me,* 1966 (Photo: Photos Carlos).

Page 103: *Mask with Mirrors,* 1967, from *Nostalgia of the Body.*

Page 104: *Sensorial Glove,* 1968, from *Nostalgia of the Body.*

Page 105: *Relational Object,* 1968, from *Nostalgia of the Body.*

Pages 106–8: Lygia Clark and Hélio Oiticica, *Dialogue,* 1966 (Photos: Sascha Harnisch).

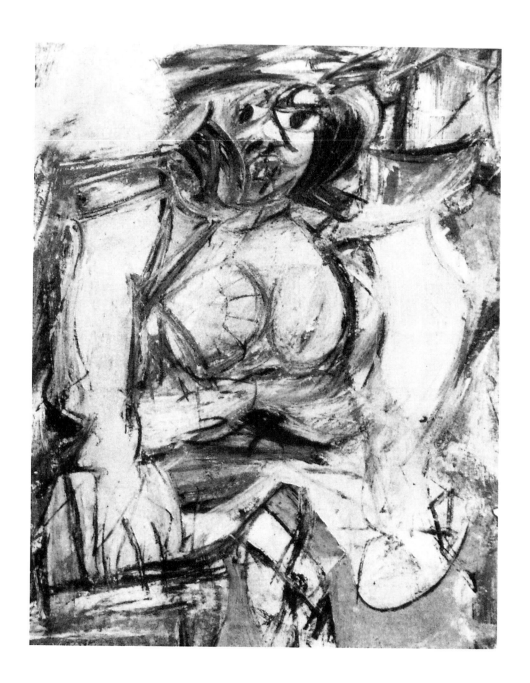

Willem de Kooning. Woman, IV. *1952–53.*

In Defense of Abstract Expressionism

T. J. CLARK

1. We have come a certain way from Abstract Expressionism, and the question of how we should understand our relationship to it gets to be interesting again. Awe at its triumphs is long gone; but so is laughter at its cheap philosophy, or distaste for its heavy breathing, or boredom with its sublimity, or resentment at the part it played in the Cold War. Not that any of those feelings have gone away or ever should, but that it begins to be clear that none of them—not even the sum of them—amounts to an attitude to the painting in question. They are what artists and critics once had because they did not *have* an attitude—because something stood in the way of their making Abstract Expressionism a thing of the past.

2. Not being able to make a previous moment of high achievement part of the past—not to lose it and mourn it and if necessary revile it—is, for art under the circumstances of modernism, more or less synonymous with not being able to make art at all. Because ever since Hegel put the basic proposition of modernism into words in the 1820s—that "art, considered in its highest vocation, is and remains for us a thing of the past"—art's being able to continue has depended on its success in making that dictum specific and punctual. That is to say, fixing the moment of art's last flowering at some point in the comparatively recent past, and discovering that enough remains from this finale for a work of ironic or melancholy or decadent continuation to seem possible after all. The "can't go on, will go on" syndrome. I think of the relation of nineteenth-century orchestral and chamber music to the moment of Mozart and Beethoven; or of how nineteenth- and twentieth-century literature managed to continue living on the idea of "the Romantics," or on the terminal images it fashioned of Baudelaire and Rimbaud, or of the past that "Impressionism" went on providing for French painting deep into the twentieth century (till the deaths of Bonnard and Matisse), or of the feeding of later modernisms on the myth of the Readymade and the Black Square.

Hegel's dictum had to be localized, that is to say. And to point to the fact that it can be localized, and therefore in a sense evaded, is, of course, to confirm the Hegelian thesis, not refute it. For Hegel did not anticipate any literal ceasing, or

Jackson Pollock. Phosphorescence.
1947.

Clyfford Still. 1949. *1949.*

even withering-away, of activities calling themselves art. He just did not see that they could possibly remain the form in which men and women articulated the relations of mind and body to possible worlds. Or I should say, articulated them to good effect. What he did not see, as I understand it, was that the full depth and implication of that inability—the inability to go on giving Idea and World sensuous immediacy, of a kind that opened both to the play of practice—would itself prove a persistent, maybe sufficient, subject. That was because he had a naive hubris about philosophy, and because he could not detach himself from the sense of world-historical beginnings and endings that came with an adulthood passed in the shadow of the French Revolution. And other reasons besides. He could never have guessed that the disenchantment of the world would take so long.

Modernism, as I conceive it, is the art of the situation Hegel pointed to, but its job turns out to be to make the endlessness of the ending bearable, by time and again imagining that it has taken place—back there with Beethoven scratching out Napoleon's name on the Eroica symphony, or with Rimbaud getting on the boat at Marseilles. Every modernism has to have its own proximate Black Square.

Therefore our failure to see Jackson Pollock and Clyfford Still as ending something, or our lack of a story of what it is they were ending, is considerably more than a crisis in art criticism or art history. It means that for us art is no longer a thing of the past; that is, we have no usable image of its ending, at a time and place we could imagine ourselves inhabiting, even if we would rather not. Therefore art will eternally hold us with its glittering eye. Not only will it forego its role in the disenchantment of the world, but it will accept the role that has constantly been foisted upon it by its false friends: it will become one of the forms, maybe *the* form, in which the world is reenchanted. With a magic no more and no less powerful (here is my real fear) than that of the *general* conjuror of depth and desirability back into our world—that is, the commodity form. For the one thing the myth of the end of art made possible was the maintaining of some kind of distance between art's sensuous immediacy and that of other (stronger) claimants to the same power.

3. Of course the situation I have been describing may not be remediable. It may be that we have lost Abstract Expressionism because we have lost modernism *tout court*, and therefore the need to imagine art altogether—whether continuing or ending. I have my doubts. But in any case my object in this essay is limited. I am going to mount a defense of Still and Pollock and others, couched in historical terms. Whether the defense makes any of them usable, in the sense I have been proposing—whether it makes them a thing of the past—depends on whether what I have to say tallies in the long term with art practice. At the moment I see no reason that it should; but, equally, I find it hard to believe that the present myth of post-ness will sustain itself indefinitely. All this remains to be seen; it is not art historians' business. I only bring it up because it would be futile to pretend that I do not think a great deal hinges on somebody, eventually, giving this painting its due.

4. To talk of interpretations, then. There has been a feeling in the air for some time now that writing on Abstract Expressionism has reached an impasse. The various research programs that only yesterday seemed on the verge of delivering new and strong accounts of it, and speaking to its place (maybe even its function) in the world fiction called America, have run into the sand. Those who believed that the answer to the latter kind of question would emerge from a history of Abstract Expressionism's belonging to a certain Cold War polity, with patrons and art world institutions to match, have proved their point and offended all the right people. But the story, though good and necessary, turned out not to have the sort of upshot for interpretation that the storytellers had been hoping for. It was one thing to answer the question, "What are the circumstances in which a certain national bourgeoisie, in the pride of its victory, comes to want something as odd and exotic as an avant-garde of its own?" It is another to speak to the implications of that encounter for the avant-garde itself, and answer the question, "To what extent was the meeting of class and art practice in the later 1940s more than just contingent? To what extent does Abstract Expressionism really belong, at the deepest level—the level of language, of procedure, of presuppositions about world-making—to the bourgeoisie who paid for it and took it on their travels?" It is not that answers to these questions are simply no longer being tried for. Work is getting done. And certainly they seem to me the *kind* of questions still most worth asking of the paintings we are looking at—far more so than going through the motions of discovering for the umpteenth time that here, in Jackson Pollock's *Phosphorescence* or Clyfford Still's *1949*, "by means of their sensory reality, paintings are made to impede the impulse to construct an imaginary object, the eye being constantly led back to the paintings' constitutory elements—line, color, plane."[1] Once upon a time even this semiotic fairy tale provoked a faint sensation of wonder. But that was in another country. At least the tellers of the historical story recognize that their researches have landed them in a quandary; at least they are aware that their objects resist them. The semiologists, it seems to me, are frozen in the triumph of their prearranged moments of vision.

5. Sometimes the way out of this kind of impasse in historical work comes from proposing another set of possible descriptions that the paintings in question might be seen to "come under"—making the proposal, especially in the beginning, with no very clear sense of where it may lead. How would it alter things, one asks, what sorts of new orders in the objects would be set up, if we chose to look at them *this* way? How different would they look? Would they look better? Or properly *worse*? (Sometimes the way out of an impasse of understanding involves putting an end to a false, or even true, cathexis of the object. Eliot and Leavis said more about

1. Hubert Damisch, "L'éveil du regard," in *Fenêtre jaune cadmium ou les dessous de la peinture* (Paris: Seuil, 1984), p. 69. The subject here is Mondrian, but much the same verdict and form of words are applied, by Damisch and others, to Pollock, Newman, Rothko, etc.

Willem de Kooning. Collage. *1950.*

Milton, and Fénéon about Monet, than all Milton's and Monet's admirers put together.) The theses that follow are offered in a similar speculative spirit.

 6. I think we might come to describe Abstract Expressionist paintings better if we took them above all to be *vulgar*. The word for us is pejorative, and to be understood as such in the arguments to come. But this should not present an insuperable problem, especially for those of us used to thinking about modernism. After all, modernism has very often been understood as deriving its power from a range of characteristics that had previously come under the worst kind of pejorative descriptions—from ugliness, for example, or the merely fragmentary and disheveled; from the Material as opposed to the Ideal; from the plain and limiting fact of flatness; from superficiality; from the low and the formless. Nonetheless there still may be a slight *frisson* to the idea that the form of Abstract Expressionism's immersion in *bassesse* was vulgarity. It is not clear how saying of Willem de Kooning's *Collage* for instance, or Bradley Walker Tomlin's *All Souls' Night, No. 2,* that they are vulgar is to do anything besides denigrate them. That is fine by me. Not to be certain for once that the negative term brought on to describe a modernist artifact can ever be made to earn its positive keep—to emerge transfigured from the fire of discourse—may mean we are on to something. To call an art work vulgar is obviously (at least for now) to do something more transgressive than to call it low or *informe*. To have *made* it vulgar—to have had that be the quality in it (the only quality) that raised it from inertness and had it speak a world—must have been difficult. Pollock's drip paintings, for

Left: Bradley Walker Tomlin. All Souls'
Night, No. 2. *1949.*

Opposite left: Hans Hofmann. The
Garden. *1956.*

Opposite right: Adolph Gottlieb. Black,
Blue, Red. *1956.*

instance, seem to have been begun at the end of 1947 in a mood of triumphant
access to the gaudy and the overdone—*Phosphorescence* is typical in this regard, and
Ralph Manheim's title, beautiful as it is, somewhat naturalizes the painting's
essential tackiness.[2] The drip paintings came to an end three years later when
their maker discovered that even here, or especially here (on the floor, flicking his
Duco and aluminum), true vulgarity was beyond his reach.

7. It is an advantage to the term "vulgar," as far as I am concerned, that
discursively it points two ways—to the object itself, to some abjectness or absurdity
in its very makeup, some telltale blemish, some atrociously visual quality that the
object will never stop betraying however hard it tries; and to the object's existence
in a particular social world, for a set of tastes and styles of individuality that have
still to be defined, but are somehow *there,* in the word even before it is deployed.
Herein, I hope, lies the possibility of class ascription in the case of paintings like
Pollock's *Cut-Out* and de Kooning's *Woman*—the possibility of seeing at last, and
even being able to describe, the ways they take part in a particular triumph and
disaster of the petty bourgeoisie. But I am coming to that.

8. In Abstract Expressionism, and here is the painting's continuing (maybe
intensifying) difficulty for us, a certain construction of the world we call "individu-

2. On Manheim's titling of works for Pollock's first show at Betty Parsons's, see Ellen Landau,
Jackson Pollock (New York: Abrams, 1989), pp. 169–77.

ality" is revealed in its true, that is to say contingent, vulgarity. And so is *painting;* or rather, paintings like Hans Hofmann's *The Garden* and Adolph Gottlieb's *Black, Blue, Red*, done under the sign or spell of such a construction, by "individuals" in search of the gratifications and austerities it provides.

9. I should try to define my terms. It will not be easy. The entries under the word "vulgar" and its cognates in the *Oxford English Dictionary* revel, really a bit vulgarly, in the slipping and sliding of meaning over the centuries, and in the elusiveness (but for that very reason the intensity) of the panics and snobberies built into them. The three quotations that seem to me to help most with what we are looking at are, first, Jane Austen in 1797, in *Sense and Sensibility,* turning on "the vulgar freedom and folly" of the elder sister in the novel and declaring it "left her no recommendation"—I think it was the freedom even more than the folly that Austen objected to, and needed the word "vulgar" to dispatch. Then, Matthew Arnold in 1865, making the link between vulgarity and expressiveness that particularly concerns us here: "*Saugrenu* is a rather vulgar French word, but like many other vulgar words, very expressive." And lastly, George Eliot, quoted in Cross's *Life* as saying of Byron, in a letter of 1869, that he seemed to her "the most *vulgar-minded* genius that ever produced a great effect in literature." Everyone will have his or her own favorite candidate—Still, de Kooning, Kline, Hofmann, Pollock when things went best for him—for the proper substitution in the case of painting.

10. Scanning the columns, the eye stops at OED usage 13: "having a common

and offensively mean character; coarsely commonplace; lacking in refinement or good taste; uncultured, ill-bred." Of actions, manners, features, recorded from 1643; of persons from 1678; of language from 1716; of mind or spirit from 1764. The key idea from our point of view is of vulgarity as *betrayal,* on the part of those who by rights ought to be above it. The OED does not seem quite cognizant of this shift, though it provides the evidence for its taking place. It is there already in Coleridge's complaining in 1833 of the "sordid vulgarity of the leaders of the day!" and it becomes a nineteenth-century commonplace. Ruskin, in volume five of *Modern Painters,* has a great climactic chapter, "Of Vulgarity," struggling with the shades of Quilp and Chadband and Mrs. Gamp, and of Dickens himself behind them, and speaking to his deepest fears and hopes for art. The noun "vulgarian"— "a vulgar person; freq., a well-to-do or rich person of vulgar manners"—is coined around 1800. I guess it is what Ruskin and George Eliot most have in mind.

11. I am proposing that one main kind of intensity in Abstract Expressionism is its engagement with the dangers and falsehoods just catalogued. And what is special about Abstract Expressionism—what marks it off from all other modernisms—is that the engagement is with the vulgar as opposed to the "popular" or "low." I think we should understand the "popular" in nineteenth- and twentieth-century art as a series of figures of *avoidance* of the vulgar; that is, figures of avoidance of art's actual belonging to the pathos of bourgeois taste, a perpetual shifting and conjuring of kinds of simplicity, directness, naïveté, sentiment and sentimentality, emotional and material force, in spite of everything about art's actual place and function that put such qualities beyond its grasp. Abstract Expressionism does little or no such conjuring. That is what makes it hard to bear. We are used to an art that always sets off again in search of the *true* underlying the tawdry, and where the tawdry may divulge the true (to the artist) just because the tawdriness is someone else's, out there in the mass or the margin. But Abstract Expressionism does not go elsewhere for its language, and at its best (its most appalling) it seems in search of the *false* underlying the vehement, where the point is that cheap vehemence, or easy delectation, are what painting now is—the only values, the only forms of individuality, that it can stage without faking. Only those Abstract Expressionist canvases will do that are truly consumed with their own empty intensity, with painting as posturing, with a ludicrous bigness and lushness and generality. (Pollock's big paintings of 1950 are no longer ludicrous and self-consuming enough; they have become almost comfortable with their scale and degree of generalization of touch; the true is leaking back into the paintings, giving them depth and coherence, displacing the great empty performatives of 1948 and 1949. This again is one way of saying why the big paintings could not be continued.)

12. Nobody would expect the terms and issues I am claiming as most deeply Abstract Expressionism's own to be simply present in the discourse of the time,

any more than the issues of flatness and modernity, say, were for even the best of Manet's critics. But one would at least expect to find the traces in discourse of the issues being avoided. Here is a New York critic in 1951, writing of an artist he greatly admires:

> In this case the background is without question the most outrageously overwhelming the artist has ever contrived. Inspired by the most flagrant and bombastic French Baroque wallpaper, [he has] intensified to a maximum its brown and orange arabesque which surrounds areas of the harshest blue in the centers of which cluster pink and red roses. . . . All these gratuitous incidents superimposed on the wall and floor serve to break up and confuse the patterns on these surfaces so that the eye can find no security even in the repetition of ornamental motif—a comfort afforded in . . . earlier compositions . . .
>
> Visually the *Decorative Figure* is a garish, violent, and upsetting picture. The rather mild problems which [the painter] had been posing for himself during the previous five years are here suddenly exacerbated almost to the point of burlesque. *Luxe, calme et volupté* have disappeared and in their places discomfort, excitement, and tension reign. The . . . *Seated Nude* of the year before had expressed [the painter's] rebellion against ease and softness; this big odalisque adds a revolt against charm and good taste. It represents a triumph of art over factitious vulgarity. Yet because the picture is so clearly an act of will in a field of artifice, the victory seems Pyrrhic.[3]

The last two sentences in particular—"It represents a triumph of art over factitious vulgarity. Yet because the picture is so clearly an act of will in a field of artifice, the victory seems Pyrrhic"—seem to me to provide the terms for a description of Abstract Expressionism. The key question, of course (which this critic understandably skirts round) is whether the victory over vulgarity is *meant* to seem Pyrrhic—whether the hollowness of the victory is what the picture wants to figure most urgently. But of course it is right and proper that even though these words were written at the height of Abstract Expressionism, and from the very seat of the movement's institutional power—by Alfred H. Barr in a MOMA catalogue—they precisely could not be written of Gottlieb or Hofmann or de Kooning, but only of Matisse, of his *Figure décorative sur fond ornemental* done a quarter of a century earlier.

13. I realize that it is still not clear what Barr or I mean by the word "vulgarity" as applied to paintings. And I do not think it ever will be. The word is opaque: it points, as Ruskin knew, to a deep dilemma of bourgeois culture; it is as close to an

3. Alfred Barr, *Matisse: His Art and His Public* (New York: Museum of Modern Art, 1951), p. 214.

ultimate term of ethics or metaphysics as that culture maybe will ever throw up. "Two years ago," ends Ruskin's chapter "On Vulgarity" in *Modern Painters,*

> when I was first beginning to work out the subject, and chatting with one of my keenest-minded friends (Mr. Brett, the painter of the *Val d'Aosta* in the Exhibition of 1859), I casually asked him, "What is vulgarity?" merely to see what he would say, not supposing it possible to get a sudden answer. He thought for about a minute, then answered quietly, "It is merely one of the forms of Death." I did not see the meaning of the reply at the time; but on testing it, found that it met every phase of the difficulties connected with the inquiry, and summed the true conclusion. Yet, in order to be complete, it ought to be made a distinctive as well as conclusive definition; showing *what* form of death vulgarity is; for death itself is not vulgar, but only death mingled with life. I cannot, however, construct a short-worded definition which will include all the minor conditions of bodily degeneracy; but the term "deathful selfishness" will embrace all the most fatal and essential forms of mental vulgarity.[4]

I do not bring this passage of Ruskin on in hopes of solving our problem of definition, but more because it shows (more clearly than anyone nowadays would dare to) what the problem is—what terrible cocktail of class ascriptions and bodily disgust the word "vulgar" is an empty container for, and how fatal and essential is the sliding within it between a handy form of class racism and a general sense of class doom. Vulgarity is foulness and degeneracy; it is a "dulness of bodily sense," "all which comes of insensibility." "The black battle-stain on a soldier's face is not vulgar, but the dirty face of a housemaid is."[5] But Brett's dictum is ultimately impatient of such distinctions. We are all housemaids now.

14. "Vulgarity is merely one of the forms of Death." Beware of taking Brett's dictum too literally in the case of Abstract Expressionism, and above all beware of converting it back into some ridiculous (vulgar) retelling of Abstract Expressionists' life stories. I think there may be some kind of fatal connection between this painting's deep vulgarity and its incessant courting of Death; but that is not to be understood as a biographical proposition but a formal one. It is a way of thinking again about Pollock's or Still's repetition compulsion, their constant (fruitful) drive toward emptiness, endlessness, the nonhuman and the inorganic. "Perhaps the last paradox these works contain is that of death," writes the novelist Parker Tyler of Pollock's drip paintings some time early in 1950, before the last show of them at Betty Parsons's:

4. John Ruskin, *Modern Painters* (Boston and New York: Colonial Press Company, n.d.), vol. 5, pp. 347–49.
5. Ibid., p. 344.

For in being a conception of ultimate time and space, the labyrinth of infinity, Jackson Pollock's latest work goes beyond the ordinary processes of life—however these might be visualized and recognized— into an absolute being which must contain death as well as life. Hence the spatial distinctions achieved by lines and spots of color within Pollock's rectangles go as much beyond mere optical vision as seems possible to painting....

Jackson Pollock has put the concept of the labyrinth at an infinite and unreachable distance, a distance beyond the stars—a non-human distance.... If one felt vertigo before Pollock's differentiations of space, then truly one would be lost in the abyss of an endless definition of being. One would be enclosed, trapped by the labyrinth of the picture-space. But we are safely looking at it, seeing it steadily and seeing it whole, from a point outside. Only *man,* in his paradoxical role of the *superman,* can achieve such a feat of absolute contemplation: the sight of an image of space *in which he does not exist.*[6]

It would be easy to make fun of this. Its metaphysics are vulgar. But the terms and the tone seem to me as close as Pollock got to appropriate criticism in his own life-time. It is fitting, again, that these were paragraphs deleted from Tyler's article in 1950 by Robert Goldwater, editor of the *Magazine of Art.* They only survive at all as part of Pollock criticism because the artist seems to have been given a typescript by the writer at the time, and kept it in his files.

15. Maybe the Death in Brett's dictum is simply or mainly that of *painting.* Maybe it always was, for Brett and Ruskin as much as Pollock and Parker Tyler.

16. Death makes a bad metaphor. Pictures that summon it up too readily— Newman's *passim,* Rothko's from 1957 on—get to look Gothic before their time. That we are meant to take the portentousness as ultimately having to do with "painting" or "signification" or some such only makes matters worse. Death is enlisted to make vulgarity look deep.

17. The trouble with Barnett Newman is that he was never vulgar *enough,* or only vulgar on paper.

18. The great Rothkos are those that everybody likes, from the early 1950s mainly; the ones that revel in the new formula's cheap effects, the ones where a

6. Parker Tyler, unedited text of "Jackson Pollock: The Infinite Labyrinth," in Archives of American Art, Pollock Papers 3048, pp. 548–49. (The edited text was published in *Magazine of Art,* March 1950.) My thanks to Michael Leja for pointing me to the deleted paragraphs and sorting out the circumstances of their disappearance. For full discussion of the text(s), see Michael Leja, *Reframing Abstract Expressionism* (New Haven and London: Yale University Press, 1993), pp. 313–16.

hectoring absolute of self-presence is maintained in the face of absence, void, nothing, devouring simplicity: with vulgarity—a vulgar fulsomeness of reds, pinks, purples, oranges, lemons, lime greens, powder-puff whites—acting as the transform between the two possibilities of reading. *The Birth of Tragedy* redone by Renoir.

19. "When they are hung in tight phalanx, as he would have them hung, and flooded with the light he demands that they receive, the tyranny of his ambition to suffocate or crush all who stand in his way becomes fully manifest. . . . It is not without significance, therefore, that the surfaces of these paintings reveal the gestures of negation, and that their means are the devices of seduction and assault. Not I, but himself, has made it clear that his work is of frustration, resentment and aggression. And that it is the brightness of death that veils their bloodless febrility and clinical evacuations": Clyfford Still to Sidney Janis, April 4, 1955.[7] This is very like Fénéon on Monet: mean-spirited, partial, and tendentious, but somehow for that very reason (because it steps out of the circle of deference for once) the best criticism Rothko ever received.

20. And so to the question of class. "While formal analysis," says Adorno in his *Introduction to the Sociology of Music*, "was learning to trace the most delicate ramifications of [a work's] manufacture, . . . the method of deciphering the specific social characteristics of music has lagged behind pitifully and must be largely content with improvisations."[8] Quite so, and maybe improvisation will turn out to *be* its method. But equally—this is Adorno in the same paragraph—"If we listen to Beethoven and do not hear anything of the revolutionary bourgeoisie—not the echo of its slogans, the need to realize them, the cry for that totality in which reason and freedom are to have their warrant—we understand Beethoven no better than does the listener who cannot follow his pieces' purely musical content, the inner history that happens to their themes."

21. What remains to be thought about Abstract Expressionism (though the thought haunts everything written on the subject, especially those texts most anxious to repress it) is the painting's place in a determinate class formation; one which, though long prepared, took on the specific trappings of cultural power in the years after 1945. I said its place in a determinate class formation—not in a State apparatus or a newly improvised system of avant-garde patronage or a museum/art world superstructure. Not that the latter are irrelevant. But they

7. Archives of American Art, Alfonso Ossorio papers, quoted in James Breslin, *Mark Rothko, A Biography* (Chicago and London: University of Chicago Press, 1993), p. 344. Copies of the letter seem to have been circulated at the time, either by Still or Janis.
8. Theodor Adorno, *Introduction to the Sociology of Music* (New York: Seabury Press, 1976), p. 62 (translation slightly modified).

cannot be what we mean, fundamentally, when we talk about a certain representational practice inhering in the culture of a class. We mean that the practice somehow participates in that class's whole construction of a "world." We are talking of overlap and mutual feeding at the level of representational practice, at the level of symbolic production (ideology). When we say that the novel is bourgeois, the key facts in the case are not eighteenth-century subscription lists or even the uses early readers made of *Young Werther.*

22. Clement Greenberg begins a review of an exhibition of Courbet at Wildenstein's in January 1949 by saying that "Bosch, Brueghel, and Courbet are unique in that they are great artists who express what may be called a petty bourgeois attitude."[9] Like Barr, he seems to me to be averting his eyes from Pollock and Clyfford Still. What is new in their case, of course, is that now a particular (hybrid) form of petty bourgeois culture—I am including in the term "culture" a set of political and economic compromise formations, with myths and duplicities to match, as well as a set of established styles of personhood—has become the form, the only viable medium, of bourgeois class power. It is not that the petty bourgeoisie in America *has* power, but that its voice has become, in the years after 1945, the only one in which power can be spoken; in it, and only in it, can be heard the last echoes of what the bourgeoisie had once aspired to be—"the echo of its slogans, the need to realize them, the cry for that totality in which freedom [no longer reason] is to have its warrant."[10]

9. Clement Greenberg, *The Collected Essays and Criticism* (Chicago and London: University of Chicago Press, 1986), vol. 2, p. 275, from *The Nation,* January 8, 1949. A month later, on February 19, Greenberg reviews Gottlieb and Pollock. "I feel that Gottlieb should make the fact of his power much more obvious," he writes (ibid., p. 285), though he welcomes the painter's *Totemic Fission* (my choice for the perfect Abstract Expressionist title), *Ashes of Phoenix,* and *Hunter and Hunted* as pointing in the right direction. His review of the Pollock show at Betty Parsons's is that in which he takes *Number One, 1948*—"this huge baroque scrawl in aluminum, black, white, madder and blue"—as final proof that Pollock has become a major artist. The words "baroque scrawl" seem to me to be feeling for the qualities in Pollock's work that I am insisting on here.
10. This is not the place to enter into the difficulties involved in making, and sustaining, the distinction between bourgeois and petty bourgeois as terms of class analysis. Obviously I believe the distinction is real, and I do not want my talk in the text of class "cultures" and "formations" to give the impression that I do not believe the distinction is ultimately one of economic power. A bourgeois, for me, is someone possessing the wherewithal to intervene in at least some of the important economic decisions shaping his or her own life (and those of others). A bourgeois, for me, is someone expecting (reasonably) to pass on that power to the kids. A petty bourgeois is someone who has no such leverage or security, and certainly no such dynastic expectations, but who nonetheless identifies wholeheartedly with those who do. Of course this means that everything depends, from age to age and moment to moment, on the particular *forms* in which such identification can take place. The history of the petty bourgeoisie within capitalism is therefore a history of manners, symbols, subcultures, "lifestyles," necessarily fixated on the surface of social life. (Chapters 3 and 4 of my *Painting of Modern Life* try to begin such a history for the late nineteenth century. The material on "Modern Man discourse" in Leja's *Reframing Abstract Expressionism* strikes me as providing some of the elements for a parallel description of the 1940s and '50s.)

23. Abstract Expressionism, I want to say, is the style of a certain petty bourgeoisie's aspiration to aristocracy, to a totalizing cultural power. It is the art of that moment when the petty bourgeoisie thinks it can speak (and its masters allow it to speak) the aristocrat's claim to individuality. Vulgarity is the form of that aspiration.

24. Or could we say: Abstract Expressionism is the form of the petty bourgeoisie's aspiration to aristocracy, at that fateful moment when the bourgeoisie itself no longer so aspires; when the petty bourgeois has to *stand in* for a hidden—nay, vanished—bourgeois elite. (Of course we are dealing here with two class *formations*, two fictions or constructions, not two brute sociological entities. We are dealing with forms of representation—which is not to say that the kind of representational doubling described here does not have specific, sometimes brutal, sociological effects. McCarthyism was one of them, in which the bourgeois Frankenstein was for a while really paralyzed by its petty bourgeois Monster.)

25. Vulgarity, then (to return to our subject), is the necessary form of that individuality allowed the petty bourgeoisie. Only that painting will engage and sustain our attention which can be seen to recognize, and in some sense to articulate, this limited condition of its own rhetoric. Maybe it will always be a painting which struggles to valorize this condition *quand même*—for here we touch, as Adorno never tired of telling us, on some constitutive (maybe regrettable) link between art and an ethics of reconciliation or transcendence—but what we shall value most in the painting is the ruthlessness of (self-)exposure, the courting of bathos, the *unapologetic* banality. The victory, if there is one, must always also be Pyrrhic.

26. You see now why the concept "vulgarity" has more and more the notion of betrayal written into it as the nineteenth century goes on. For the bourgeoisie's great tragedy is that it can only retain power by allowing its inferiors to speak for it, giving them the leftovers of the cry for totality, and steeling itself to hear the ludicrous mishmash they make of it—to hear and pretend to approve, and maybe in the end to approve without pretending.

27. If this frame of reference for Abstract Expressionism turns out to work at all, one of the things it ought to be best at is a rethinking of the stale comparison

There is no need to be oversubtle about this. Sometimes symbols and lifestyles still have class inscribed on them in letters ten feet tall. What could be more disarmingly bourgeois, in the old sense, than the first-class section on an airplane crossing the Atlantic? And what more dismally petty bourgeois than coach? (Those in business—or what my favorite airline calls Connoisseur—class would take a bit more *ad hoc* class sorting, some going up, some going down. A lot depends on particular styles of corporate reward to middle management, for instance, which varies from country to country and phase to phase of the business cycle.) Anyway, the rough balance of numbers in this case seems to me quite instructive for the balance of numbers in the world at large.

Asger Jorn. Paris by Night. *1959.*

between America and Europe. European painting after the war, alas, comes out of a very different set of class formations. Vulgarity is not its problem. In Asger Jorn, for example—to turn for a moment to the greatest painter of the 1950s—what painting confronts as its limit condition is always *refinement.* Painting for Jorn is a process of coming to terms with the fact that however this set of qualities may be tortured, exacerbated, or erased they still end up being what (European) painting is; and the torture, exacerbation, and erasure are discovered in practice to *be* refinement, that is, the forms refinement presently takes if a painter is good enough; they are what refines painting to a new preciousness or dross (it turns out that preciousness and dross are the same thing).

28. In calling Jorn the greatest painter of the 1950s I meant to say nothing about the general health of painting in Europe at the time. On the contrary. The clichés in the books are true. Jorn's really was an endgame. Vulgarity, on the other hand, back on the other side of the Atlantic, turned out to be a way of keeping the corpse of painting hideously alive—while *coquetting* all the time with Death.

29. An Asger Jorn can be garish, florid, tasteless, forced, cute, flatulent, overemphatic; it can never be vulgar. It just cannot prevent itself from a tampering and framing of its desperate effects which pulls them back into the realm of painting, ironizes them, declares them done in full knowledge of their emptiness. American painting, by contrast—and precisely that American painting that is

closest to the European, done by Europeans, by Germans and Dutchmen steeped
in the tradition they are exiting from—does not ironize and will never make the
(false) declaration that the game is up. Hofmann and de Kooning, the closer they
get to Jorn's vocabulary, are Jorn's direct opposites.

30. It is my hope that conceiving of Abstract Expressionism as vulgar will
lead to a new set of discriminations between particular painters within the group,
and between moments in the work of a single artist. I have already referred to
one or two such possibilities—for instance, the difference between Pollock's drip
paintings in 1947 and 1948 and their final appearance in 1950. I have tried also
to give a preliminary sense of the new priorities, and the new kinds of belonging
together under the general (too capacious) banner, by means of the pictures
accompanying my text. Let me say a word or two more on this subject.

Gottlieb, you will have noticed, emerges as the great and implacable *maestro*
of Abstract Expressionism. He is Byron to Greenberg's George Eliot—the most
vulgar-minded genius that ever produced a great effect in oils. A Mantovani or a
Lawrence Welk. Charlie Parker playing insolent variations on the theme of "I'd
Like to Get You on a Slow Boat to China"—feeling for a way to retrieve, and make
properly unbearable, the song's contempt for those it was written for. Gottlieb is at
his best when he goes straight for the cosmological jugular, straight for the pages
of *Time* or *Life*—his worlds on fire like atomic-age parodies of Lissitzky's *Story of
Two Squares,* ghastly in their beautification of destruction.

31. Certain moments and sequences of work in Abstract Expressionism that
everyone, then and since, agrees to have been a turning point for the new
painting begin, in this light, to make a bit more sense. For example, de Kooning's
Woman series and the vehemence of Greenberg's reaction to it. What Greenberg
was recoiling from, I think, is the way choosing Woman as his subject allowed de
Kooning to extrude a quality of perception and handling that stood at the very
heart of his aesthetic and fix it onto an Other, a scapegoat. "The black battle-stain
on a soldier's face is not vulgar, but the dirty face of a housemaid is." For "dirty
face of a housemaid" read "perfect smile of the model in the Camels advertise-
ment." Greenberg drew back from this not, need I say it, out of concern at de
Kooning's misogyny, but from an intuition that such splitting and projection
would make it impossible for de Kooning's *painting* to go on sustaining the right
pitch of tawdriness, ironic facility, overweening self-regard. I think he was right.
Only when de Kooning found a way to have the vulgarity be his own again—or
rather, to half-project it onto cliché landscape or townscape formats that were
transparently mere props—did he regain the measure of meretriciousness his art
needed. The male braggadocio, that is to say, had to be *unfocused* if he was to paint
up a storm. It had to be a manner in search of an object, and somehow aggrieved
at not finding one. What was wanted was general paranoia, not particular war of
the sexes.

Adolph Gottlieb. Under and Over. *1959.*

32. Vulgarity is gendered, of course. At the time we are examining, it belonged (as a disposable property) mainly to men, or more precisely, to hetero-sexual men. Not that this meant that the art done under its auspices was closed to reading from other points of view. What Cecil Beaton and Alfonso Ossorio and Parker Tyler and Frank O'Hara did to Pollock, with or without Pollock's permis-sion, would have to be part—sometimes, as I have said, a central part—of any defensible history of the New York School. It seems important that, apart from Greenberg, the strongest early readings of Pollock's work (the strongest, not necessarily the best) all came from gay men. Namuth's films and photographs partake of the same homosocial atmosphere. Perhaps the deep reason why Greenberg was never able to realize his cherished project of a book on Pollock was that he found no way to contain, or put to use, the erotic hero worship that sings in the prose of his shorter pieces.[11]

33. I do not mean to give the impression, by the way, that the set of isssues I am pointing to never appeared in critical discourse at the time, or did so only in utterly displaced form. Now and again they surface directly, but what is striking when that happens is how the writer seems not to know what to do with the issues and terms once they show up. The terms are embarrassing. Greenberg, for instance, had the following to say about Clyfford Still's color and paint handling in his great essay "'American-Type' Painting," published in *Partisan Review* in 1955:

> I don't know how much conscious attention Still has paid to Monet and
> Impressionism [Greenberg has just been musing on the power within
> Abstract Expressionism of "an art like the late Monet's, which in its
> time pleased banal taste and still makes most of the avant-garde
> shudder"], but his . . . art likewise has an affiliation with popular taste,
> though not by any means enough to make it acceptable to it. Still's is
> the first really Whitmanesque kind of painting we have had, not only
> because it makes large, loose gestures . . . but just as much because, as
> Whitman's poetry assimilated, with varying success, large quantities of
> stale journalistic and oratorical prose, so Still's painting is infused with
> that stale, prosaic kind of painting to which Barnett Newman has given
> the name of "buckeye." Though little attention has been paid to it in

11. It would be too easy to catalogue the more flagrant phrases here—"His emotion starts out pictorially; it does not have to be castrated and translated in order to be put into a picture," etc.—and the result would inevitably have the flavor of Freudian "now-it-can-be-told." Whereas the point is the obviousness of the verbal love affair, and the fact that that very obviousness—which is integral, I think, to Greenberg's insights and descriptions from 1943 to 1955—was only allowable (or manageable) when it went along with a no-holds-barred, take-it-or-leave-it tone about *everything*—the tone Greenberg perfected as a writer of fortnightly columns and occasional aphoristic surveys. In a book— even one as brief and essayistic as Greenberg's on Miró had been—there would have been too obvious a seam between the documentary mode (Greenberg, understandably, was more and more anxious to disinter Pollock from under a mountain of biographical filth) and the awe at Pollock's energy and maleness.

print, "buckeye" is probably the most widely practiced and homogeneous kind of painting seen in the Western world today. . . . "Buckeye" painters, as far as I am aware, do landscapes exclusively and work more or less directly from nature. By piling dry paint—though not exactly in impasto—they try to capture the brilliance of daylight, and the process of painting becomes a race between hot shadows and hot lights whose invariable outcome is a livid, dry, sour picture with a warm, brittle surface that intensifies the acid fire of the generally predominating reds, browns, greens, and yellows. "Buckeye" landscapes can be seen in Greenwich Village restaurants (Eddie's Aurora on West Fourth Street used to collect them), Sixth Avenue picture stores (there is one near Eighth Street), and in the Washington Square outdoor shows. . . . I cannot understand fully why [these effects] should be so universal and so uniform, or the kind of painting culture behind them.

Still, at any rate, is the first to have put "buckeye" effects into serious art. These are visible in the the frayed dead-leaf edges that wander down the margins or across the middle of so many of his canvases, in the uniformly dark heat of his color, and in a dry, crusty paint surface (like any "buckeye" painter, Still seems to have no faith in diluted or thin pigments). Such things can spoil his pictures, or make them weird in an unrefreshing way, but when he is able to succeed with, or in spite of them, it represents but the conquest by high art of one more area of experience, and its liberation from *Kitsch*.[12]

There is a lot going on here, and no one interpretation will do it justice (the tangents and redundancies in the text, which I have left out for the sake of brevity, are actually vital to its detective-story tone). But what I see Greenberg doing essentially is struggling to describe and come to terms with a specific area of petty bourgeois taste. He rolls out the place names and pieces of New York City geography with a cultural explorer's relish, all the better to be able to plead class ignorance in the end—"I cannot understand fully . . . the kind of painting culture behind them." Readers of Greenberg will know that the final enlistment of the word *kitsch* is heavily loaded. Kitsch equals vulgarity, roughly. In Greenberg's original Trotskyite scheme of things the word had strong class connotations. But 1955 is too late, by several years, for Greenberg to be willing to pursue this any further than he does. It is interesting (this is my argument) that he pursues it at all—that Still's painting seemingly forces him to think again, at some length, about high art's courting of banality. And he is in no two minds, at this point, about the importance of such a tactic, for all its risk. The next sentence after the one on Still and kitsch reads as follows: "Still's art has a special importance at this time because it shows abstract painting a way out of its own academicism."

12. Greenberg, *Collected Essays and Criticism*, vol. 3, pp. 230–31 (from *Partisan Review*, Spring 1955).

Clyfford Still. Untitled. *1951–52.*

This sentence is altered out of all recognition in the version of "'American-Type' Painting" Greenberg put in his book *Art and Culture* six years later.[13] All of the section on Still is given heavy surgery. The word *kitsch* gives way to "one more depressed area of art," where surely "depressed" is exactly the wrong word. Kitsch is manic. Above all it is rigid with the exaltation of *art*. It believes in art the way artists are supposed to—to the point of absurdity, to the point where the cult of art becomes a new Philistinism. That is the aspect of kitsch which Still gets

13. See Clement Greenberg, *Art and Culture* (Boston: Beacon Press, 1961), pp. 223–24. Part of the reason for the changes was the vehemence of Still's and Newman's reaction to Greenberg's original wording. See Greenberg's reply to a typical blast from Still (dated April 15, 1955, which suggests that Still's original letter may have been sent off at much the same time as the one to Sidney Janis on Rothko), quoted in ed. Clifford Ross, *Abstract Expressionism: Creators and Critics* (New York: Abrams, 1990), pp. 251–53. The term "buckeye" is one of the main bones of contention in the exchange. Still suspects that Greenberg borrowed not only the term from Newman (which Greenberg acknowledges) but also its application to his work. Greenberg says no. "Barney was the first one I heard name a certain kind of painting as buckeye, but he did not apply the term to yours. When I, some time later, told Barney that I thought there was a relation between buckeye and your painting, or rather some aspects of it, he protested vehemently and said your stuff was too good for that" (p. 252). Since Greenberg regularly gets told off these days for being waspish and superior about the Abstract Expressionists (as conversationalists and letterwriters) in retrospect, it is worth pointing to the well-nigh saintly patience of his 1955 dealings with Still on the rampage.
 Marnin Young points out to me that in his spirited attack on Still in *The Nation,* "Art," January 6, 1964, Max Kozloff seizes on Greenberg's comparison to "Greenwich Village landscapists" (he quotes a few sentences from the *Art and Culture* text) and goes on: "Critical attempts to portray [Still] as an artist who bursts forth into a new freedom, or as an exponent of the 'American sublime,' overlook his terribly static, one ought to say, vulgar, exaltedness" (p. 40). But is not that what *makes* him an exponent? (Of course, given the date, one sympathizes with Kozloff's distaste.)

horribly right. The "buckeye" of the *Partisan Review* text is abandoned in favor of "demotic-Impressionist" or "open-air painting in autumnal colors." (Abandoned almost completely—Greenberg cannot resist a single, unexplained appearance of the word toward the end.) There are no more names and addresses on Eighth Street, no more baffled talk of a separate, impenetrable "painting culture." This is a critic in flight from previous insights, I feel. And I think I see why.

34. Then, finally, there is the problem of Hans Hofmann. You will not be surprised to hear that it was in coming to terms with Hofmann in particular that the vocabulary of the present argument first surfaced. For everyone who has ever cared at all about Hofmann (including Greenberg, who cared very much) has always known that in Hofmann the problems of taste in Abstract Expressionism come squawking home to roost. A good Hofmann is tasteless to the core— tasteless in its invocations of Europe, tasteless in its mock religiosity, tasteless in its Color-by-Technicolor, its winks and nudges toward landscape format, its Irving Stone title, the cloying demonstrativeness of its handling. Tasteless and in complete control of its decomposing means.

35. Seen in its normal surroundings, past the unobtrusive sofas and the calla lilies, as part of that unique blend of opulence and spareness which is the taste of the picture-buying classes in America, a good Hofmann seems always to be blurting out a dirty secret that the rest of the decor is conspiring to keep. It makes a false compact with its destination. It takes up the language of its users and exemplifies it, running monotonous, self-satisfied riffs on the main tune, playing it to the hilt— to the point of parody, like Mahler with his sentimental Viennese palm-court melodies. A good Hofmann has to have a surface somewhere between ice cream, chocolate, stucco, and flock wallpaper. Its colors have to *reek* of Nature—of the worst kind of Woolworth forest-glade-with-waterfall-and-thunderstorm-brewing. Its title should turn the knife in the wound.[14] For what it shows is the world its users inhabit in their heart of hearts. It is a picture of their "interiors," of the visceral-*cum*-spiritual upholstery of the rich. And above all it can have no illusions about its own status as part of that upholstery. It is made out of the materials it deploys. Take them or leave them, these ciphers of plenitude—they are all painting at present has to offer. "Feeling" has to be fetishized, made dreadfully (obscenely) exterior, if painting is to continue.

36. I do not believe that what I have just offered is an account of Hofmann's intentions, any more than if I had been arguing for the coldness and hardness of Matisse's hedonism, say, or the pathos of Picasso's late eroticism. (Of course it would be possible to give an account of all three which argued that our under-

14. . . . *And Thunderclouds Pass* comes from a poem by the Austrian Romantic Nikolaus Lenau, *And, Out of the Caves* from Rilke's *Sonnets to Orpheus*, 2, 11.

Hans Hofmann. "And, Out of the Caves, the Night Threw a Handful of Pale Tumbling Pigeons into the Light." *1964.*

Hans Hofmann. "...And Thunderclouds Pass." *1961.*

Douglas M. Parker Studio. Marcia Simon Weisman Residence. *Circa 1962.*

standing of their intentions had been deficient up to now, and ought to include the pathos or the coldness or the capacity for self-parody. I just do not think the inclusions are necessary or plausible in Hofmann's case.) No doubt Hofmann "believed in" his own overblown rhetoric. (What would it be like to go in for it at this pitch of intensity *without* believing in it? Like Asger Jorn, maybe; not like ... *And Thunderclouds Pass*.) I dare say he thought his titles were wonderful. (Who is going to quarrel with Nikolaus Lenau and the Sonnets to Orpheus? Only a modernist cynic like me.) And as for the place of his paintings in Marcia Weisman's sitting room? He surely assumed that at the level that really mattered—the level of taste, as opposed to day-to-day preference—there was a profound community of interest between himself and the best of his clients. And so there was. He could not have painted their interiors if they were not his interior too.

These are not the matters at issue, finally. The task for the critic is to find an adequate language for the continuing *effect* of, say, Hofmann's overblownness (I am not even saying that this is the only or primary quality of Hofmann's version of Abstract Expressionism, but it is the one that gets more interesting over time). The overblownness only matters because it seems to be what lends the pictures their coherence, maybe their depth. I am not meaning to congratulate Hofmann on getting a quality of petty bourgeois experience somehow "right." The quality is not hard to perceive and mimic. What is hard (what is paradoxical) is to make paintings out of it. That is what Hofmann did. Of course I am saying that doing so involved him in an encounter with the conditions of production and consumption of his own art. That is my basic hypothesis. But the encounter could only take place at the level of work, of painterly practice—the encounter *was* getting the overblownness to be pictorial, or discovering that it was the quality out of which paintings now had to be made. Even to call this an "encounter" is to give it too much of an exterior or discursive flavor. It was what Hofmann did, not what he discovered.

37. This is not an argument, *a fortiori*, about Abstract Expressionists' social or political opinions. Of course I relish the fact that Clyfford Still supported McCarthy, or that Pollock was "a Goddamn Stalinist from start to finish,"[15] in much the same way that I like to know Manet was a frightful Gambettist and Renoir believed that "siding with the Jew Pissarro is revolution."[16] But I know my interest does not count for much in understanding what any of the four did as *painters*. At best the facts may strike us as dimly consonant with one or another

15. On Still's McCarthyism, see Susan Landauer, "Clyfford Still and Abstract Expressionism in San Francisco," in *Clyfford Still 1904–1980: The Buffalo and San Francisco Collections*, ed. Thomas Kellein (Munich: Prestel, 1992), p. 93. The verdict on Pollock's politics is Greenberg's, in an interview with me in 1981. I think he meant it seriously.
16. Rough draft of letter to Paul Durand-Ruel, February 26, 1882, discussing participation in that year's Impressionist exhibition. See Lionello Venturi, *Les Archives de l'Impressionisme* (Paris and New York: Durand-Ruel, 1939), vol. 1, p. 122. (The sentence was omitted in Renoir's final draft.)

aspect (usually a surface aspect) of their subject matter or handling—with Manet's epigrammatic brittleness, say, or Renoir's over-anxiousness to please. But they get us nowhere with what really matters, which is the artists' ability to have these surface qualities coexist with others seemingly at odds with them: Manet's pessimism and compassion, for instance, or Renoir's deadly economy of means.

38. I am not saying that Abstract Expressionists' social attitudes are just irrelevant. No doubt it helps to know that Rothko, for instance, had his own vision of the petty bourgeois future; and again, the fact that he saw it in the shape of the University—the University of Colorado at Boulder—is for me irresistible:

> The University . . . is on the hill. At its base are the faculty apartments which are shells around appliances facing a court into which the children are emptied. Two hundred yards away is Vetsville, in which the present faculty itself had lived only four or five years ago when they were preparing to be faculty. Vetsville itself is occupied by graduates from army headquarters, already married and breeding who will be faculty in faculty quarters three or four years hence. They breed furiously guaranteeing the expansion which will perpetuate the process into the future.
>
> The faculty itself is allowed to stay here only 2 years whereupon they must assume mortgages in similar housing slum developments where thereafter they must repair their own cracks and sprinkle their grass. . . .
>
> Here is a self-perpetuating peonage, schooled in mass communal living, which will become a formidable sixth estate within a decade. It will have a cast of features, a shape of head, and a dialect as yet unknown, and will propagate a culture so distorted and removed from its origins, that its image is unpredictable.[17]

Anyone familiar with nineteenth-century styles of irony at the expense of the *nouvelles couches sociales* will recognize this as generic (solecisms and all). Condescension just *is* the form of the petty bourgeoisie's self-recognition. Look at the recent literature on yuppies. All the same, even this passage does not help me with what is really interesting, and ultimately baffling, about Rothko as an artist: why the same banal loftiness could lead to the brightness of death at one moment (1950), and to clinical evacuation at another (1965).

39. My title "In Defense of Abstract Expressionism" was not meant ironically. I have offered what I think is the best defense possible of this body of work, and of course I am aware that in doing so the noun "vulgarity" has turned into a term of

17. Archives of American Art, Herbert Ferber papers, letter to the Ferbers, July 7, 1955, quoted in Breslin, *Mark Rothko*, p. 352.

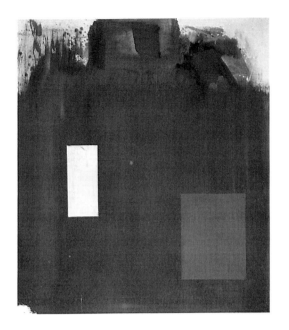

Hans Hofmann. Memoria in
Aeternum. *1962.*

Adolph Gottlieb. Coalescence. *1961.*

value, whether I wanted it to or not. If the formula were not so mechanical, I would be prepared to say that Abstract Expressionist painting is *best* when it is most vulgar, because it is then that it grasps most fully the conditions of representation—the technical and social conditions—of its historical moment.

The moment was brief. By the time of the two paintings I choose to end with—1961 and 1962—it was almost over. The mode and indeed the titles of the two pictures—Hofmann's *Memoria in Aeternum* and Gottlieb's *Coalescence*—are nothing if not valedictory. Death puts in its usual appearance. The coffin is straight out of Evelyn Waugh. And this overstuffed, overwrought, end-and-beginning-of-the-world quality seems to me, to repeat, the key to these paintings' strength. They have a true petty bourgeois pathos. One can see why art in New York felt obliged to retreat from such dangerous ground in the years that followed, and why a last effort was made to restabilize avant-garde practice in its previous (exhausted) trajectory. The popular was easier to handle than the vulgar—it had more of the smell of art about it. Reduction was a better way to generate recognizable modernist art works than this kind of idiot "Ripeness is all." The site-specific was preferable to the class-specific. Art had to go on, and that meant returning art mainly to normal avant-garde channels.[18] But for some of us—certainly for me—the price paid for this accommodation in the 1960s and after seems prohibitively high.

18. This defense is not intended as a covert attack, and these few sentences do not claim to characterize what was most productive (and genuinely excessive) in the art of the 1960s, especially from 1967 onward. But I let them stand, because I do think that part of the history of the 1960s will have to be written in terms of art's withdrawal from Abstract Expressionism's impossible class-belonging—its

The ridiculous moment of coalescence, or of mourning, or of history, is what we still want from painting, and what Abstract Expressionism manages to provide.

40. So now I think I understand what I have been defending all along. It seems that I cannot quite abandon the equation of Art with lyric. Or rather—to shift from an expression of personal preference to a proposal about art history—I do not believe that *modernism* can ever quite escape from such an equation. By "lyric" I mean the illusion in an art work of a singular voice or viewpoint, uninterrupted, absolute, laying claim to a world of its own. I mean those metaphors of agency, mastery, and self-centeredness that enforce our acceptance of the work as the expression of a single subject. This impulse is ineradicable, alas, however hard one strand of modernism may have worked, time after time, to undo or make fun of it. Lyric cannot be expunged by modernism, only repressed.

Which is not to say that I have no sympathy with the wish to do the expunging. For lyric in our time is deeply ludicrous. The deep ludicrousness of lyric is Abstract Expressionism's subject, to which it returns like a tongue to a loosening tooth.

This subject, of course, is far from being the petty bourgeoisie's exclusive property. That is not what I have been arguing. Anyone who cares for the painting of Delacroix or the poetry of Victor Hugo will be in no doubt that the ludicrousness of lyric has had its *haut bourgeois* avatars. But sometimes it falls to a class to offer or suffer the absurdities of individualism in pure form—unbreathably pure, almost, a last gasp of oxygen as the plane goes down. That was the case, I think, with American painting after 1945.

horrible honesty about art and its place. Only *part*. Because the point is that the project of "returning art mainly to normal avant-garde channels" was and remains a hopeless one in America. The grounds (always shaky) for an enduring avant-garde autonomy, or even the myth of one, simply do not exist. In the later 1960s and early '70s the project imploded. Frantic efforts have subsequently been made to reconstitute the project around some "new" technology, or set of art forms, or refurbished critical discourse; but what is striking is the way these phenomena cannot escape the gravitational pull of the later 1960s. And I am saying that the later 1960s are a satellite, or a form of anti-matter, to the preponderant black star of *Coalescence* and *Memoria in Aeternum*.

A final thing I do not want to be taken as saying or implying is that art could make Abstract Expressionism a thing of the past by *imitating* it, or trying to go one better than it in the vulgarity stakes. That has been a popular, and I think futile, tactic in the last ten years or so.

Robert Rauschenberg. Untitled (Black Painting). *1953.*

Before *Bed**

HELEN MOLESWORTH

> *Like the smell of a barn: when I see only the
> bust of the sitters (Hendrijke, in the Berlin
> Museum) or only the head, I cannot refrain
> from imagining them standing on manure.
> The chests breathe. The hands are warm.
> Bony, knotted, and warm. The table in* The
> Syndics *rests on straw, the five men smell of
> cow dung. Under Hendrijke's skirts, under
> the fur-edged coats, under the painter's ex-
> travagant robe, the bodies are performing
> their functions: they digest, they are warm,
> they are heavy, they smell, they shit. However
> delicate her face and serious her expression,*
> The Jewish Bride *has an ass. You can tell.
> She can raise her skirts at any moment. She
> can sit down, she has what it takes.*
>
> —Jean Genet, "What Remains of a
> Rembrandt Torn in Four Equal Pieces,
> and Flushed Down the Toilet . . ."

The "White Paintings": simple, rectangular canvases, painted a flat, stroke-less white and hung side by side, their edges butting tightly up against one another. Robert Rauschenberg made them in 1951 during his second sojourn at Black Mountain College. They were painted after a prolific summer during which he completed the *Night Blooming* series (c. 1951): large canvases six by eight feet that Rauschenberg took outside, saturated with wet oil paint, and

* Special acknowledgments must be made to the invaluable comments and criticisms of Roddy Bogawa and Miwon Kwon.

pressed into the ground, where they picked up the heavy gravel from the road. Night blooming in North Carolina . . . jasmine, honeysuckle, sweet gardenia.

John Cage once said, "The white paintings caught whatever fell on them; why did I not look at them with my magnifying glass?"[1] They hung on the wall ready for viewers to cast their shadows upon them. Cage's question was incomplete, for dust played second fiddle to shadows. The completion of the white paintings demanded the mark of a bodily form—why else would they have needed to be so large? so smooth? so supplicant? so available? Ultimately shadows would not be enough, not because they were too arbitrary but rather because they were too ephemeral. They lacked the full texture and the heady smell of the *Night Bloomers*. The first "Black Painting," made at Black Mountain in 1951, mimicked its white counterparts: black matte paint applied to the canvas with a roller. Rauschenberg knew an uninteresting failure when he saw one. He quickly returned to texture for a sense of touch, an excitation of the senses. The problem emerged: how to create a texture more bodily in nature than gravel, to register the body more concretely than a shadow?

First produced at Black Mountain between 1951 and 1952 and then, after a nine-month hiatus, in 1953, the "Black Paintings" are patterned canvases with dense, crackling surfaces, laboriously made by tearing sheets of newspaper, dipping them in glue, and affixing them to the canvas in a random fashion, where they would be covered by several hues of viscous black paint.[2] In the earliest paintings the newspaper remains hidden under thick paint, resulting in an ambiguous surface texture. *Untitled* (Black Painting with *Asheville Citizen*, c. 1952) was the first work to expose the newspaper. Rotating the sports and classified pages of the local paper 180 degrees, Rauschenberg spread the full sheets across two joined canvases and painted matte black around their edges. Revealing the newspaper opened a whole new register of meaning for the paintings. For the newspaper is a paradigm of an economy of endless repetition marked by daily consumption and disposability, perhaps best explicated by the popular expression "same shit, different day." Its disposability ensures its dailiness, repetition, and regularity. In the *Asheville Citizen* painting Rauschenberg exaggerates these aspects of the newspaper by using the sports and classified sections, perhaps the most daily parts of the newspaper (they contain information pertinent only to the immediate present). The "Black Paintings" became quite repetitious in both appearance and production,[3] mirroring the structure

1. John Cage, *Silence* (Middletown: Wesleyan University Press, 1973), p. 108.
2. Calvin Tompkins, *Off the Wall: Robert Rauschenberg and the Art World of Our Time* (Garden City, N.Y.: Doubleday and Co., 1980), p. 71. Tompkins claims that Rauschenberg would randomly drop glue-soaked newspaper onto the canvas, implying that the canvas was horizontal, but no other scholarship makes that assertion.
3. Rauschenberg made at least nine "Black Paintings" during 1952 while at Black Mountain and at least seven at his Fulton Street studio in New York during the spring and summer of 1953.

of their ground. Given the number of the paintings, the shadowy newspaper datelines, which almost always remain legible, impart a diaristic quality to the works, linking the paintings even more directly to the dailiness and repetition of the newspaper.

Simultaneously, Rauschenberg assiduously photographed the progress of the "Black Paintings." The photograph's ability to repeat endlessly and the need to repeat the painting through a photograph of it, as well as the indexical capability of the photograph to record the specificity of time and place, has a parallel relation to the newspaper's signification of dailiness. For this purpose, Rauschenberg continually framed the "Black Paintings" in doorways and door-frames. "More than simple scaling devices," Walter Hopps has remarked, "they suggest human presence and establish a literal conjunction of abstract art and the physical factum of everyday life."[4] Is the "physical factum of everyday life" merely newspaper and doorways? Or do those traces stand in for dailiness and "human presence" in another form?

It is hard for me to overlook the way the paintings' textures and colors resonate with fecal matter: the smeared quality of the paint, the varying degrees of viscosity, and the color—shit brown and black. After all, repetition and cycles of consumption and disposal have as much to do with anality as they do with newspapers. And the relation between the two is not so far-fetched. Ernest Jones's landmark essay "Anal-Erotic Character Traits" discusses the various objects that can signify excrement in unconscious life, with newspapers prominent among them (think of those black smudges left on your hands). "Books and other printed matter are a curious symbol of feces," he writes, "presumably through the association with paper and the idea of pressing (smearing, imprinting)."[5] The dirtiness and dailiness, the visual similitude, and the compulsive documenting of the paintings against heavily textured brick walls suggest an "excremental reading" of these works.

In this essay I give an account of Rauschenberg's early work that engages the uneasiness and disgust that accompany the intense visual pleasure of these paintings. I will also attempt to recapture the profound sense of experimentation with which these works were undertaken. Furthermore I hope to challenge the codification of several standard formalist/biographical/descriptive/iconographical readings of Rauschenberg.[6] My intention is not to psychoanalyze

4. Walter Hopps, *Robert Rauschenberg: The Early 1950s* (Houston: Houston Fine Arts Press, 1991), p. 62.
5. Ernest Jones, *Papers on Psycho-Analysis* (New York: William Wood and Company, 1918), p. 676.
6. Two examples are: Roni Feinstein's "Random Order: The First Fifteen Years of Robert Rauschenberg's Art, 1949–1964" (Ph.D. diss., New York University, 1990), as primarily descriptive; and Mary Lynn Kotz's monograph *Rauschenberg: Art and Life* (New York: Harry N. Abrams, 1990), as biographical.

Rauschenberg or to conflate anality with his sexuality. On the contrary, I feel that "the body" is presented in Rauschenberg's oeuvre as polymorphously perverse. In this regard, my reading engages certain questions concerning the body and the anxieties, fantasies, and problems it raises (arouses), especially in the work of artists during the 1950s.[7] Despite the dearth of literature on the topic,[8] Rauschenberg was not alone in this exploration; the problem of registering the body was shared by (at least) two other key figures at Black Mountain, John Cage and Charles Olson.[9]

"The white paintings came first," Cage once said, "My silent piece came later."[10] Yet the exact chronology is not as important as the concern with how to mediate and discuss the body within artistic production. In this regard Cage's recollection of his discovery of silence in a soundproof chamber at Harvard University is striking:

> I entered one at Harvard University several years ago and heard two sounds, one high and one low. When I described them to the engineer in charge, he informed me that the high one was my nervous system in operation, the low one my blood in circulation. Until I die there will be sounds. And they will continue following my death. One need not fear about the future of music.[11]

This revelation locates Cage's most generative musical, artistic, and compositional idea within the body itself—more importantly, within the interior of the body, the nervous and circulatory systems, realms of bodily experience of which we are usually not aware. Cage's silence is both located within and driven by the desire to know the body more intimately, to listen to its interior.

Charles Olson takes up the question of the body in a prose poem titled "Proprioception" (1959).[12] The text has fanciful moments when Olson longs to (re)attribute specific organs' emotional characteristics, such as desire to the heart, sympathy to the bowels. Speculating on the possibility of the unconscious

7. The importance of the desire to mark bodily form in 1950s art practice is an idea that had its genesis in the context of Rosalind Krauss's seminar "The Transgressive '50s" at the CUNY Graduate Center. Krauss's work on Jackson Pollock and Pam Lee's work on Cy Twombly created the space out of which this article grew.
8. The exception is Jonathan Weinberg's "It's in the Can: Jasper Johns and the Anal Society," *Genders* 1 (Spring 1988).
9. The relationship between Rauschenberg and John Cage has been well documented. See Calvin Tompkins, *The Bride and the Bachelors* (London: Penguin, 1976). The relationship between Rauschenberg and Olson is much less clear. They were both, however, part of *Theater Piece No. 1*, a multimedia event that is often referred to as the first performance-art piece. Among many other activities, Olson read poetry, and Rauschenberg's *White Painting* was included.
10. Cage, *Silence*, p. 98.
11. Ibid., p. 8.
12. I must thank Charles Molesworth, who brought this text to my attention and who initially suggested the link between the concerns of Olson and Rauschenberg.

being situated in the "cavity of the body, in which the organs are slung," as opposed to the brain, the poem puzzles over the meanings that our bodies present to us. The viscosity of the poem turns violent at times when it explores the possibility (and perhaps the ramifications) of gathering information from the body:

<pre>
 Violence:
 knives/anything, to get the body in.
 To which the data of depth sensibility/the 'body' of us as
 PROPRIOCEPTION: object which spontaneously or of its own order
 produces experience of, 'depth' Viz
 SENSIBILITY WITHIN THE ORGANISM
 BY MOVEMENT OF ITS OWN TISSUES[13]
</pre>

Here the body is a source of experience. Similar to Cage's work, the external surface of the body is less important than its hidden interior, an interior that is marvelous as it both produces and stores experience as information.

It is within this historical milieu that the "Black Paintings" were first exhibited at the Stable Gallery in New York in 1953, where Dore Ashton's review saw them as "black as beasts . . . they stir up vaguely primordial sensations, and anxiety. But that is all."[14] A decade later the Jewish Museum gave Rauschenberg his first retrospective. In the catalogue essay Alan Solomon discussed the paintings' use of color: "It supplies an enigmatic field, at once opaque and deep to the furthest reach of space. Shadowed and secretive, it proposes all and discloses nothing, and it became the plasma out of which his present style was formed."[15] The excremental look of these paintings lay barely beneath the surface of these sensual and tentative descriptions of the "deep" and the "primordial"—but the "anxiety" that it produces is dismissed (Ashton's "But that is all"; Solomon's it "discloses nothing").

Rauschenberg's anxiety took a rather different form. Telling an interviewer he went to Black Mountain to be disciplined by Albers, he says:

> I could have gone on painting with my hands, I think, and making messes forever because I really loved painting. I guess the physicality of my personality was emerging, and so I had to paint with my hands. I couldn't stand a brush coming between me and the canvas. Naturally I cleaned my "brushes," which were my hands, on my clothes.[16]

13. Charles Olson, *Additional Prose*, ed. George F. Butterick (Berkeley: Four Seasons Foundation/ Book People, 1974), p. 17.
14. Dore Ashton, "Robert Rauschenberg," *Art Digest* (September 1953), pp. 20 and 25.
15. Alan Solomon, *Robert Rauschenberg* (New York: The Jewish Museum, 1963), n.p.
16. Barbara Rose, *Robert Rauschenberg* (New York: Vintage Books, 1987), p. 23.

Rauschenberg does not want to be in the painting—as in Jackson Pollock's famous pronouncement that he could "literally be *in* the painting"[17]—as much as he wants to have the painting be on his body and, conversely, to have his physicality be on the canvas.

Excremental Fantasies

In Dennis Cooper's novel *Frisk* (1991) the main character (also named Dennis) finds his ultimate sexual pleasure in the murder of other young men. Or so it would seem, for in *Frisk* it is all a fantasy, elaborated through letter writing, the great literary form of self-disclosure. Beyond the trope of sex and death (better known as "sex 'n meth" in certain punk film quarters) there lies a deeper probing in this novel. The title gives it all away: what Dennis wants is knowledge. Sitting in a hotel room with hooker/porn star Pierre, Dennis combs every inch of his body with his mouth, gathering minute pieces of information: tastes, smells, changes in skin texture. He is logging them for future reference. Dennis requests that Pierre shit and not flush; this too is information he desires.

> "I'm not being abject," I say. "It's not, 'Ooh, shit, piss, how wicked,' or anything. It's, like I said, information." Pierre nods. "Then what are you going to do with it?" he asks. "I don't mean with my shit, I mean with the information." My face scrunches up. "Uh, create a mental world . . . uh, wait. Or a situation where I could kill you and understand . . ."[18]

Yet Cooper is fully cognizant as to how such information refuses to add up; certainly in the novel it never equals a satisfactory situation for murder. But what drives *Frisk*'s main character is the fantasy of knowing another person so thoroughly that one would be intimate with the interior of that body. "I'm sure I've idealized brutality, murder, dismemberment, etc.," Dennis says to Pierre during their second hotel meeting, "But even slicked up, there's an unknow-ableness there that's so profound or whatever, especially when I combine it with sex."[19] Sex, that fantasy moment where two bodies merge as one, is an idealized form of the desire to know the inside, or to be inside someone else's body. The act is the idealized form of gathering knowledge about the other. But murder offers another version of "getting to know you"; it offers the "real" stuff, the secret hidden stuff that no one else knows, not even its subject. An existentialist novel, *Frisk* is about the aching desire to know the self and the ultimate impos-

17. Ellen Johnson, ed., *American Artists on Art from 1940 to 1980* (New York: Harper & Row, 1982), p. 4.
18. Dennis Cooper, *Frisk* (New York: Grove Weidenfeld, 1991), p. 69.
19. Ibid., p. 78.

sibility of self-knowledge. No amount of nausea, it seems, reduces the foreignness of one's own body. What is in there, what is it doing, what relation does it have to me and I to it?

For Freud, desire for knowledge awakens when the child asks: Where do babies come from?[20] Initially these "infantile sexual researches" center on the mother's body, with the child assuming that babies are born from her bowels. Yet, Freud argues, the child has a vague notion of birth's sexual component, although the child is unable to understand it fully. The problem of information exceeding comprehension continues throughout adult life (accounting, he adds, for the brooding of many intellectuals); but it is reactivated most importantly for Freud in the Oedipal conflict.[21]

Perhaps the experience of representing the body through excrement in the "Black Paintings" (both for the viewer and the maker) problematizes the speed with which Freud passes over the child's relation to the interior of the mother's body in his rush to get to the genital and Oedipal configurations of the subject. Melanie Klein, however, lingers and elaborates upon the young child's fantasies regarding the interior of the mother's body. For Klein, the child's earliest relationship to the mother is one of "sucking and scooping" at the breast, voiding the mother of her interior substances. Soon the child begins to take pleasure in its ability to master the process of defecation, a pleasure derived from the interior of its own body. When the child learns that it came out of the mother's body the initial fascination with the mother's interior becomes interwoven with the child's pleasurable sense of its own. Hence, the child equates itself and excrement as products of the mother's body. "In the imagination of the small child these multiple objects are situated inside his mother's body and this place is also the chief objective of his destructive and libidinal tendencies and also of his awakening *epistemophilic* impulses (emphasis added)."[22]

The child's desire to explore the interior of the mother's body, a desire that extends to the child's relationship to his or her own body and its products, is the awakening of *epistemophilic impulses*. It is on this crucial point that Freud and Klein diverge. For Klein sees the activation of the desire for knowledge as intensely and intrinsically related to the body and the question of its interior and its by-products. Freud does not engage the child's relation to its own or the mother's body outside of the realm of the genitalia. The interior of the body and the mystery that surrounds it, both for the child and the adult, are never quite broached.

20. See Sigmund Freud, *Leonardo da Vinci and a Memory of His Childhood*, trans. Alan Tyson (New York: Norton, 1989) and "On the Sexual Theories of Children," in *The Standard Edition of the Complete Psychological Works of Sigmund Freud*, vol. 9, trans. and ed. James Strachey (London: Hogarth, 1959).
21. See Jean Laplanche, "To Situate Sublimation," trans. Richard Miller, *October* 28 (Spring 1984), pp. 7–26.
22. Melanie Klein, *The Psycho-Analysis of Children* (London: Hogarth Press, 1963), p. 208.

For Western civilization, however, the body ultimately is an obstacle to be overcome. Civilization, as Freud has noted, requires the control of bodily functions and the sublimation of instinctual drives. In *Civilization and Its Discontents* he writes: "The diminution of the olfactory stimuli seems itself to be a consequence of man's raising himself from the ground, of his assumption of an upright gait."[23] By pulling his nose away from the ground, Freud argues, man lifts his senses away from the smells of excrement and genitalia, divorcing his senses from his body. Likewise, children are taught to repress their initial means of gathering information: groping, sucking, smearing. Subsequently, the drive for knowledge that prompts the questions: Where do babies come from? Where do I come from? will need to be sublimated.

But if we read the "Black Paintings" as excremental, as the daily expulsion from the body's interior, can the implications of this instance of *de*sublimation, an instance of a body not successfully overcome, transform the question "Where do I come from" into "What is inside of me"? They manifest the desire to explore the interior body through what might be called "bodily knowledge"— the knowledge, pleasure, curiosity, and disgust surrounding that primary bodily product—shit.

Rauschenberg has indeed attempted to turn himself inside out to mark his own body on the canvas.[24] His immersion in an indexical art practice can be well documented by surveying his investment in imprinting the corporeal senses onto the artistic surface. Placing a nude body directly onto light sensitive paper, Rauschenberg and Susan Weil made the *Blueprints* (1950). Taking the wet paintings outside and pressing them in the dirt, he made the *Night Blooming* series. But the questions the "Black Paintings" ask are: What kind of knowledge do our bodies produce about ourselves? Can knowledge be desublimated and "returned" to its origin? These are the questions that the "Black Paintings" end up sharing with *Frisk*. The "Black Paintings" mark the canvas with the body in the basest of ways. "The body begins to exist where it *repugnates*, repulses, yet wants to devour what disgusts it and exploits that taste for distaste . . ."[25] The paintings enact the body liberated through excretion. They are a narcissistic fantasy of self-birth; they give way to the delirium of the body producing its own knowledge.

23. Sigmund Freud, *Civilization and Its Discontents*, trans. James Strachey (New York: W. W. Norton and Company, 1961), p. 54. In the same passage Freud notes that despite sublimation we are rarely repulsed by our own excrement.
24. Roland Barthes, *The Responsibility of Forms*, trans. Richard Howard (Berkeley: University of California Press, 1985), p. 207. Barthes establishes this idea of turning oneself inside out to discuss the work of the French painter Requichot.
25. Ibid., pp. 210–11.

Robert Rauschenberg and Susan Weil. Female Figure. *c. 1950.*

The Stain

A *macciato* is an Italian espresso, preferably quite strong. The black coffee is tinged by dark brown that rims the cup; a dollop of light airy foam from steamed milk floats on top. *Macciato* comes from the Italian word *macchia*, which means to stain. (See antonym: *immacolato*, meaning immaculate, as in the Conception.)

At the end of a summer of "Black Paintings" at Black Mountain, Rauschenberg and Cy Twombly left together for Rome. During the seven-month

Robert Rauschenberg. Untitled (Frog and Turtle). *c. 1952.*

Robert Rauschenberg. Untitled (Palm of Hand). *c. 1952.*

trip, which included a stay in North Africa, Rauschenberg made Cornell-like boxes, fetishes that he threw into the Arno River, and a series of collages that he packed up and didn't exhibit for more than twenty years. These delicate collages (all are untitled and dated to c. 1952) fall between the two periods of the "Black Paintings." Repetitive in size, structure, and material, the collages pull back from the initial viscous explosion onto the canvas of Rauschenberg's interior. The mottled paperboards were collected from the insides of shirts as they were freshly returned from the cleaners: the very support for these collages is bodily through contact and scale. The cardboard is preciously torn, rough edges insisting upon the hand that ripped it; each is topped by a sheet of fluttering paper. Engraved images culled from old books that Rauschenberg found at the local flea markets are pasted on top, the lumpy glue creasing the fine paper, or staining the thin cardboard. The images are decidedly "scientific," an eccentric dictionary of various animals, body parts, and microorganisms. The scientific dissections are brief glimpses into biological interiors: interiors devoid of any fluids, interiors that are dry and empty, interiors where the space between skin and bones is discreetly marked off as a void—as nonpresence. Yet the glue stains on the cardboard are an indexical moment of the artist's hand smearing and pressing in the act of collage. Ernest Jones postulates that the sublimation of the smearing impulse leads to the "impulse to stain or contaminate." The stain implies uncleanliness: sweat, semen, mucus, the remains of sex on linen or clothing.

With regard to the Shroud of Turin, Georges Didi-Huberman has argued that it is through "the absence of figuration therefore [that the stain] serves as proof of existence. Contact having occurred, figuration would appear false."[26] The use of the stain as an index, Didi-Huberman insists, affirms the place of contact as a place of origin. These simple early collages are, in this sense, a pedantic object lesson. The origin of the work of art is the artist's body—in the pressing and the smearing, in the dailiness of bodily functions, in the question "What kinds of marks can I make?" If, as Didi-Huberman argues, collage is indexical, then, for Rauschenberg, the absence that the collage signifies is the body of its maker.

Toward Bed

The intolerance for disorder is closely related
to another trait, the intolerance for waste.
This has more than one source. It represents

26. Georges Didi-Huberman, "The Index of the Absent Wound (Monograph on a Stain)," trans. Thomas Repensek, *October* 29 (Summer 1984), p. 68.

a dislike of anything being thrown away
(really from the person)—a manifestation of
the retaining tendency under consideration
—and also a dislike of the waste product
because it represents refuse—i.e., dirt—so
that every effort is made to make use of it.
Such people are always pleased at discovering
or hearing of new processes for converting
waste products into useful material, in sew-
age farms, coal-tar manufactories and the
like.

—Ernest Jones, "Anal Erotic
Character Traits"

The "Red Paintings" (1954) begin Rauschenberg's lifelong investment in found objects. Moving beyond printed matter, the paintings incorporate a large array of fabrics, found wood, and trinkets. When asked why he used the color red, Rauschenberg replied, "I was trying to move away from the black and white . . . So I picked the most difficult color for me to work in. If you're not careful, red turns to black when you're dealing with it."[27]

The Latin root of scrutiny is *scruta*, meaning rags or trash. Originally, to scrutinize an area meant to investigate so thoroughly as to search through the rags. The domestic nature of the use of fabrics such as lace and brocade in the "Red Paintings" has been noted by several critics. That these traditional emblems of femininity should be so inundated within the bloody surface of these paintings gives pause in light of this text. If the "Black Paintings" are an attempt to know the interior through the autoerotic pleasures of shit, then the "Red Paintings" are the horror of the body exploded, dispersed, and flowing over the surfaces of everything. The extreme agitation of the "Red Paintings" is perversely heightened by the attempts to modulate their "bloodiness." Their grounds are built up from cartoons and comic strips. The playful polka-dot fabric in *Yoicks* (1954) or the three childlike hearts drawn into the surface of *Red Import* (1954) seem to make the violence more macabre. Their viscosity oozes even beyond that of the "Black Paintings," and their incorporation of found objects blurs any clear distinction of interior/exterior, found object/painting. As Andrew Forge has put it, "The frames and battens of *Charlene* (1954) articulate the *inside* of the picture; they also throw its boundaries far and wide."[28] This struggle over boundaries is what is continued so persuasively in the "Com-

27. Rose, *Robert Rauschenberg*, p. 52.
28. Andrew Forge, *Robert Rauschenberg* (Amsterdam: Stedelijk Museum, 1968), p. 65.

bines," and perhaps *Bed* (1955) is the ultimate moment of blissful and terrifying confusion.

Anality is less a matter of actual feces than of the fantasies surrounding them—their production and disposal.[29] If one of sublimation's definitions is the displacement of the low functions of the body onto its higher faculties, then Rauschenberg radically reinserts the lower body into art. He desublimates the hand of the artist, allowing it to smear and rub, press and glue, privileging tactility over sight. Rauschenberg's work cataloged the body through its products—shit, stain, blood—but ultimately the body produces a limited amount of knowledge about itself. Rauschenberg even told Billy Klüver that the "Black Paintings" interested him "in their complexity without their revealing anything—the fact that there was a lot to see but not much showing."[30]

"Sublimation is a search in the outside world for the lost body of childhood," Norman O. Brown has written. Rauschenberg's art is this search. And yet this body is not reconstituted until the advent of the "Red Paintings." They start to participate in "the totality of the disorder in the human body."[31] For anality is never isolated; it too is being continually displaced onto other sites in the body. The body's entire sexual organization is one of displacement from one region and/or function to another.[32] In this regard the "Red Paintings," and subsequently the "Combines," come closer than the "Black Paintings" to "knowing" the body, by enacting its nonhierarchical displacement onto a conglomerate of heterogeneous objects. Inasmuch as they achieve this, they simulate the fantasy space that surrounds the body's functions, desires, and organization. For it is there, in the realm of fantasies which surround the interior body, that "body knowledge" is actually constructed.

Brown argues that culture functions dualistically: as a denial of the body, and as a projection of that repressed body into things. Despite this, "the child knows consciously, and the adult unconsciously, that we are nothing but body" and that "all values are bodily values."[33] Rauschenberg's radical inclusion of "things" in the "Red Paintings" allows the body to be reconstituted at its *limit*, in the space of fantastic disorganization. Perhaps the "Red Paintings" are best described by a passage from Roland Barthes: "Collages are not decorative, they do not juxtapose, they conglomerate . . . their truth is etymological, they take

29. Norman O. Brown, *Life Against Death* (Middletown: Wesleyan University Press, 1959). Brown makes a distinction between the neo-Freudian definition of anality as "an attitude in interpersonal relationships" and orthodox Freudians who relate it directly to toilet training. He argues that anality is a function of fantasy life connected to the anal zone, of fantasies that are subsequently projected onto the world.
30. Forge, *Robert Rauschenberg*, p. 64.
31. Brown, *Life Against Death*, p. 289.
32. See Sandor Ferenczi, *Further Contributions to the Theory and Technique of Psycho-Analysis* (New York: Brunner/Mazel, 1980), especially "Composite Formations of Erotic and Character Traits."
33. Brown, *Life Against Death*, p. 293.

literally the *colle,* the glue at the origin of their name; what they produce is the glutinous, alimentary paste, luxuriant and nauseating."[34]

A Dream

I dreamt that after reading in bed I fell asleep, book across my chest. My lover came to bed and woke me. He seduced me and entered me from behind. Never having had intercourse this way before, I was surprised. Afterwards I felt elation, lightness; for by having this sex my lover had voided me of all my interior substances. He had emptied me, and I drifted off into a sleep more peaceful than any I had ever known.

34. Barthes, *The Responsibility of Forms,* p. 211.

Andy Warhol. Where is Your Rupture? *1960.*

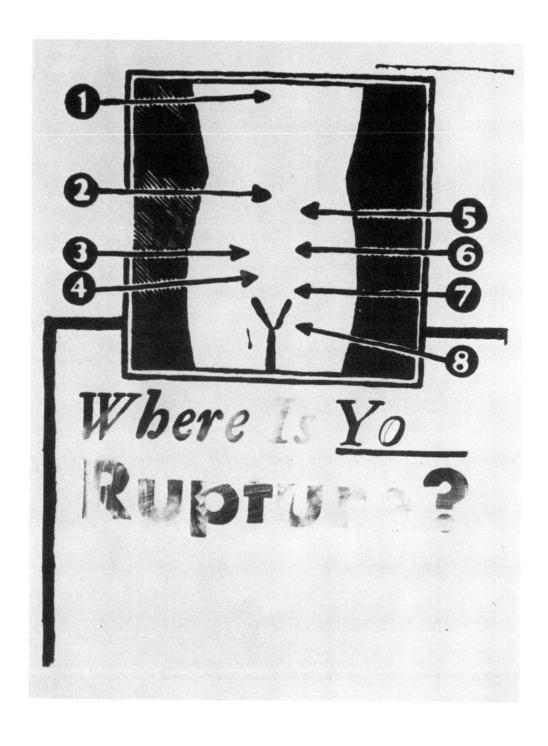

"Where Is Your Rupture?": Mass Culture and the Gesamtkunstwerk

ANNETTE MICHELSON

And if the body were not the soul, what is the soul?

— Walt Whitman

A specter haunts the theory and practice of the arts throughout our century: the specter of the *Gesamtkunstwerk*, a notion born of late romanticism, nurtured and matured within the modernist moment, and never wholly exorcised in the era of postmodernism and of electronic reproduction. To Adorno, writing in 1944, television promised a synthesis of radio and film that would so impoverish artistic production that "the thinly veiled identity of all industrial products" would reveal itself,

> derisively fulfilling the Wagnerian dream of the *Gesamtkunstwerk*—the fusion of all the arts in one work. The alliance of word, image, and music is all the more perfect in *Tristan* because the sensuous elements which all approvingly reflect the surface of social reality are in principle embodied in the same technical process, the unity of which becomes its distinctive content. This process integrates all the elements of the production, from novel (shaped with an eye to film) to the last sound effect. It is the triumph of invested capital, whose title as absolute master is etched deep into the hearts of the dispossessed in the employment line; it is the meaningful content of every film, whatever plot the production team may have selected.[1]

To the specter of the *Gesamtkunstwerk*, already somewhat faint and failing, Moholy-Nagy had delivered, in 1925, a telling, though not fatal, blow. It is in the text of *Painting, Photography and Film*[2] that he says, when speaking of the projects

1. Max Horkheimer and Theodor W. Adorno, *Dialectic of Enlightenment*, trans. John Cumming (London: Allen Lane, 1973), p. 124.
2. Laszlo Moholy-Nagy, *Painting, Photography, Film*, trans. Janet Seligman (Cambridge: MIT Press, 1969).

of cubism and constructivism, that they attempted a purification of the expressive component of "art" (one notes the quotation marks); that they led an attack upon the subjectivism of a previous generation, whose relegation of art to preoccupations of leisure time went hand in hand with an excessively sublimated notion of artistic production, issuing in an art that was trivial and derivative, severed from its roots in social collectivity. He then evokes a second line of protest, described as "the attempt to bring together into one entity, singular works or separate fields of creation that were isolated from one another. This entity was to be the *Gesamtkunstwerk* in the form of architecture as the sum of all arts." Such was the project of de Stijl and of the Bauhaus in its first period.[3] But this project Moholy defines as produced within a specific historical moment, that of the triumph of specialization. And this we understand retrospectively as the consequence of the division of labor as the dynamic of the industrial revolution. It is with characteristic acuteness that Moholy perceives this ideal as a compensatory reaction to a general fragmentation of existence and therefore incapable of providing the ground for an art of social collectivity, an art of necessity. For it provides, as it were, merely an addition to the present state of things, an increment.

"What we need," he says, "is not the *Gesamtkunstwerk* alongside and separate from which life flows by, but a synthesis of all the vital impulses spontaneously forming itself into the all-embracing *Gesamtwerk* (life) which abolishes all isolation, in which all individual accomplishments proceed from a biological necessity and culminate in a universal necessity."[4]

There would seem to have been two major, antithetical programs for the achievement of this radically utopian aesthetic in our century. One might call them, roughly speaking, those of the Yogi and the Commissar, casting Eisenstein as Commissar and recasting (with the respect and apologies due a Zen Master) John Cage as the Yogi. I wish, however, to consider a third attempt of the recent past, one whose deviant logic was preeminently of our time, producing a mediate or degraded version of this project. I have in mind a site of artistic production perspicuously exempt, if only for a brief period of time, from industrial criteria of production, modes of distribution, and forms of commodification. It was, as it happens, a film studio. I shall not, however, be proposing, in the manner of Moholy's contemporaries, the cinema as the ultimate *Gesamtkunstwerk*. Rather, I shall consider the structure and dynamics of this site of production as a late variant upon Moholy's model, subject, however, to the powerful constraints and perversions of its particular moment within late capitalism.

The site and period, then, are those of Andy Warhol's old Factory, described by Warhol himself as those in which "we made movies just to make them" rather than that in which he was producing "feature-length movies that

3. Ibid., p. 17.
4. Ibid.

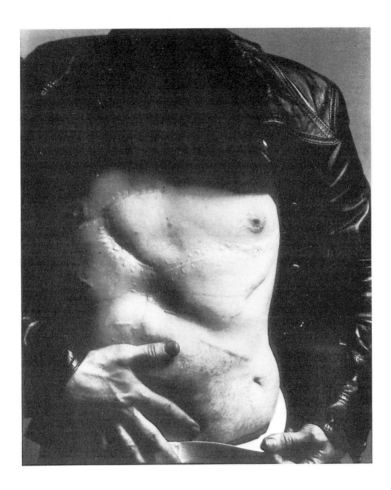

regular theaters would want to show." It is the shot from Valerie Solanis's gun in 1968 that marks the boundary between two sites and modes of production, the moment of replacement of a previous artisanal mode of production by a systematic division of labor. When, as has been noted, Warhol began increasingly to delegate authority as in the later films, his participation was limited to the work of financing and publicity. *The Chelsea Girls* is the major work that concludes the first period. After 1968, Warhol assumed the role and function of the *grand couturier*, whose signature sells or licenses perfumes, stockings, and household linens manufactured elsewhere.[5] Warhol's "business art" found its apogee in the creation of a label that could be affixed to the feature films made under the

5. Warhol is known to have placed the following advertisement in *The Village Voice* in 1966: "I'll endorse with my name any of the following; clothing, AC-DC, cigarettes, small tapes, sound equipment, Rock 'N Roll records, anything, film and film equipment, Food, Helium, WHIPS. Money; love and kisses Andy Warhol. EL 5-9941." This text is reproduced in Patrick S. Smith, *Andy Warhol's Art and Films* (Ann Arbor: U.M.I. Research Press, 1986), p. 167.

Richard Avedon. Andy Warhol, Artist, New York City, 8/20/69. *1969.*

direction of Paul Morrissey. And Morrissey's role in the suppression of films made prior to his accession to power is linked to the marketing of the new product, coded with an eye to industrial norms.

*

Consider, then, the image that provides the title of this text. Dated 1960, this work is, of course, the rendering of an advertisement for surgical trusses, an early instance of Warhol's deployment of the found image; he was to rework it more than once. It is, as well, an image of poignantly proleptic resonance, and we may therefore quite appropriately juxtapose it with *Andy Warhol, Artist, New York*, Richard Avedon's portrait, made in 1969, in which the artist displays the surgical scars that memorialize the assault upon his life made the preceding year by the Executor-in-Chief of the Society to Cut Up Men.

I shall, however, in what follows, be rehearsing neither the Orphic nor the hagiographic iconography that this juxtaposition may appear to generate. More significantly, these two images mark the limits of Warhol's intervention as a major and pivotal force within American independent cinema. And it is through that intervention that one may trace the passage, within that cinema, from the body's analytic representation to one of synthetic incorporation.

Most simply put, the notion of rupture will center on the break within American independent cinema in the representation of the body as effected by Warhol and the consequences of that break: the passage from a cinema postulated on the primacy of the part object to that of the whole body, in its parallel passage from one of assertive editing to that of long shot/*plan séquence*. What later followed was the development of a cinema tending to incorporeality, as in the work of Snow and Frampton—to "the taste's quick glance of incorporeal sight," a cinema of literal textuality.[6]

If it may be claimed that the desire for the mode of representation which came to be that of cinema is grounded in the phantasmic projection of the female body,[7] we may see confirmation of that claim in a founding myth of cinematic practice, that of Kuleshovian montage. One of its powerfully constituent elements posits the desiring gaze of the male subject, directed at the female object as inferred, synthesized by, the spectator from a sequence of shots of the actor Mosjoukine and an anonymous female. We have, however, an even more impressively demonstrative instance of cinema's synthetic properties, its construction of the female body, the ideal object of desire as synthesized, once again, by the viewer, as if inevitably, from the juxtaposition of part objects.

6. The increasingly sublimated erotics of avant-garde film practice in the 1970s and '80s culminates in the production of Hollis Frampton's *Poetic Justice* and Michael Snow's *This is*, both films composed entirely of text to be read from the screen.
7. This claim is advanced in Annette Michelson, "On the Eve of the Future: The Reasonable Facsimile and the Philosophical Toy," *October* 29 (Summer 1984), pp. 3–20.

This second, alternative founding moment is inscribed within a tradition of Russian literature that extends from Gogol to Bely. Indeed, in Bely's *Petersburg* (1912), we find the following: "Alexander Ivanovich was thinking that features of Zoya Zacharovna's face had been taken from several beautiful women: the nose from one, the mouth from another, the ears from a third beauty. But all brought together, they were irritating."[8] In this passage Bely anticipates, as well, the early spectator's uneasy reaction to assertive editing and the extreme close-up.

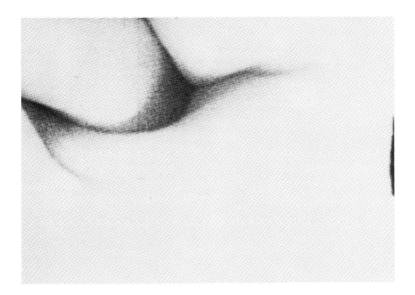

In the United States, a new era in the representation of the body begins in the period following the Second World War, with the early films of Maya Deren, to be sure, but perhaps more pertinently for present purposes, in the work of collaboration between the filmmaker Willard Maas and the British poet George Barker, at that time resident in New York. Through the succession of extreme close-ups in which skin, fold, membrane, hair, limb, and member are transformed into plateaus, prairies, pools, caves, crags, and canyons of uncharted territory, *Geography of the Body*, produced, like *Meshes in the Afternoon*, in 1943, develops the grand metaphor of the body as landscape. Estranged, the body

8. Andrei Bely, *Petersburg*, trans. Robert Maguire and John Malmsted (Bloomington: Indiana University Press, 1978), p. 210.

appears as an "America," a "Newfoundland," its lineaments suffused with the minatory thrill of exploration. Through close-up, magnification, and patterns of editing, this film text works to disarticulate, to reshape and transform the body into landscape, thereby converging, in a manner that is both curious and interesting, with that filmic microscopy which now offers us passage through the canals of the reproductive and cardiovascular systems.

It was the project of Stan Brakhage to chart this landscape, and, through hyperbolization of montage, radical suppression of the establishing shot, and systematic use of close-up, to expand, with a view to its cosmic extrapolations, the disarticulated body's analogical virtuality, as in *Prelude, Dog Star Man* (1964). And we can now clearly see that the trajectory initiated in *Window Water Baby Moving* (1958), the early masterwork produced to document the birth of his first child, culminates in *The Act of Seeing With One's Own Eyes* (1974), filmed in the Pittsburgh morgue. Brakhage now offered the autopsist's literal, manual dismembering of the human cadaver: the cutting up of men and women.

There is a dominant trend toward this representation of a body-in-pieces, of what is in Kleinian theory termed the part object, that runs, like an insistent thread, a sustained subtext, through much of American artistic production (and through its painting and sculpture in particular) in the decades of the 1950s and '60s. Art objects as part objects, then. Locating the sources, we encounter, once again, in a surprisingly wide range of work, the haunting and seminal presence to whom artists of that period paid, in varying forms and degrees of intent, a

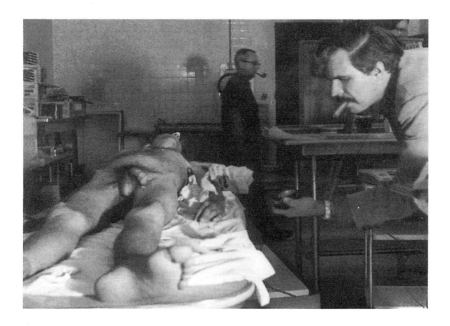

Mike Chikiris. Stan Brakhage filming
The Act of Seeing. . . .

steadily intensifying tribute: that of Marcel Duchamp. This effort of location entails consideration of a few works of emblematic import.

The first of these is *11, rue Larrey*, that door which, in defiance of the apothegm, stands both open and closed, at one and the same time. Reflecting now, more than a quarter century later, upon the old Factory, one recalls that site whose threshold was indeed marked by a door both open and closed: the space in which one could, as the saying goes, "swing both ways," where stern imperatives of choice, the strict polarity of either/or, reified in the austere ethos of abstract expressionism, were abrogated, displaced by what is currently termed "sexual preference." In this arena, whose ecumenicity accommodated homosexuality, heterosexuality, bisexuality, asexuality, *MARiée* and *CELibataire* were daily conjoined, and frequently within the prototypical single body, single persona.

Duchamp has offered us, however, in addition to this emblem of indifference, another set of images, representations of that supreme part object, the prime object of infantile identification and projection: the breast. *Prière de toucher* (1947) was to be followed by the sculptural renderings of the male and female sexual parts, *Objet-Dard* (1951) and *Feuille de Vigne Femelle* (1950). And we are, I shall want to claim, justified in seeing *Rotary Demi-Sphere (Precision Optics)* (1925) as a prototype of *Anemic Cinema* (1927), which conflates, in its spirals' alternately receding and projecting movement, penis and breast—often identified by the infant as one and split off in impulses of rage and/or love. I

Marcel Duchamp. Marginal notation from
The Green Box.

Marcel Duchamp. 11 rue Larrey. *1927.*

refer here to the theorization of the part object by Melanie Klein, founded upon that of Karl Abraham in his attribution of the importance for the child of the relation to part objects such as the breast (or feces) in his work on Melancholia.

Klein later posits the initial introjection, by the child, of the mother's breast and a constant splitting of its good (giving) and bad (rejecting) aspects, aimed at introjection of a good breast and the projection and annihilation of a bad one. Moreover — and this will have bearing upon one's readings of Duchamp and of other artists whose work concerns us — the cannibalistic relation to the breast is, during the second oral stage, transferred to the penis as well; both are revealed in significant case histories as the objects of deepest oral desires. Klein was to go on to observe that the sadistic, cannibalistic fantasies and anxieties aggravated by weaning would lead the child to displace its interest onto the whole of the mother's body, so that a primitive Oedipal envy and jealousy is thereby added to the oral sadism. And a urethral and anal sadism, added to the oral, would lead to the stage described by Melanie Klein as the stage of maximum sadism.

> Every other vehicle of sadistic attack that the child employs, such as anal sadism and muscular sadism is, in the first instance, leveled against its mother's frustrating breast, but it is soon directed to the inside of her body, which thus becomes at once the target of every highly intensified and effective instrument of sadism. In early analysis, these anal-sadistic, destructive desires of the small child constantly alternate with desires to destroy its mother's body by devouring and wetting it, but their original aim of eating up and destroying her breast is always discernable in them.[9]

9. Hanna Segal, *Melanie Klein* (New York: Viking Press, 1980), p. 46.

Marcel Duchamp. Prière de toucher. *1947.*

Marcel Duchamp. Feuille de Vigne Femelle. *1951.*

Marcel Duchamp. Rotative Demi-sphère (Optique de Precision). *1925.*

The Kleinian scenario of infantile development is, of course, that of a horror feature, the longest-running one known to us. Klein and Hanna Segal were to go on to elaborate upon the notion of children's art and art in general as involving the desire to repair and make restitution to the object of destructive fantasies.

Our most compelling point of entry into the consideration of the role of the part object within the art of the mid-1950s through the '60s is to be found in the work of Eva Hesse. This choice is dictated by the conviction that it was the major achievement of a woman artist, through her obsessive constitution of a repertory of part objects (and this within the minimalist moment) to have produced the elements of a radical renewal of the sculptural enterprise, of its grammar and its materials. It is this primal image, the archetypal part object, that is more generally inscribed within the broadest range of late 1950s and '60s American artistic production, in forms and variations so diverse as almost to defy inventory. Even as it ranged from the work of Kenneth Noland to that of Jasper Johns, its presence was effectively masked by the dominant critical and theoretical discourse of the period. In reading Johns's celebrated and enigmatic *Target with Plaster Casts* (1955), we discern, in addition to the part objects cast and placed in the upper-level compartments, the image of the main panel as more than a representation of "surface."

It is therefore interesting to consider the reading Leo Steinberg offers of this work in 1963, engaged as he then was in a pioneering critique of the claims of "formalist" criticism. Remarking on the manner in which Johns's subjects tend to be "whole entities" or complete systems seen from no particular angle, Steinberg infers a refusal to manifest subjectivity. Turning to *Target* and noting Nicholas Calas's criticism — "One-ness is killed either by repetition or fragmentation" — Steinberg records Johns's explanation of the inserted anatomical frag-

ments as the casual adoption of readymades (they "happened" to be around in the studio), and goes on to remark on "the fact that these anatomical parts are not whole, that only so much of them is inserted as will fit in each box, that they are clipped to size." From this he concludes that "the human body is not the ostensible subject. The subject remains the bull's-eye in its wholeness, for which the anatomical fragments provide the emphatic foil."[10]

What then follows is the account of a verbal jousting between Steinberg and Johns, with Johns characteristically insisting on the absence of either overt or implicit emotional content, of his desire (as seen by Steinberg) to excise meaning from them.

10. Leo Steinberg, "Jasper Johns: The First Seven Years of His Art," in *Other Criteria* (New York: Oxford University Press, 1972), p. 37.

But Steinberg is characteristically uncomfortable with this position, for "when affective human elements are conspicuously used, and yet not used as subjects, their subjugation becomes a subject that's got out of control. At any rate, no similar fracturing of known wholes has occurred since in Johns's work."[11] And "the assumption of a realism of absolute impersonality always does fail — if taken literally. That assumption is itself a way of feeling; it is the ascetic passion which sustains the youthful drive of a youthful Velásquez, or a Courbet, while they shake the emotional slop from themselves and their models."[12]

Against Steinberg's reading of his paintings as works of absence, Johns's contention leaves Steinberg with a feeling of almost palpable dissatisfaction. He has certainly circled in closer to these elusive works, but he has not, as it were, quite grasped them. But hasn't he passed too rapidly over the central panel, that of the target, the bull's-eye? For the target is surely another conventionalized variant of that primal object whose interest is, in this instance, heightened for us in that it is represented as the implicit object of aggression.

11. Ibid.
12. Ibid., p. 52.

Bearing in mind this consideration of the part object, epitomized in a range of practices — in those, among others, of Duchamp, Johns, Noland, Hesse, and in the editing patterns of Brakhage, as inheritor of the "classical" or postrevolutionary tradition of montage — I return to the Factory, reentering through that swinging door. I do so, however, by way of a detour.

<div align="center">*</div>

There is a story — apocryphal perhaps — of Verlaine's impoverished last years, of the Paris garret and its meager furnishings, entirely covered in gilt paint. To the visitor, bewildered as to the how and why of this fancy, Verlaine's reply was, "But this is how poets should live!" Grandeur, as tribute to and warrant of the artist's vocation, was not, one imagines, the point of Billy Linich's decoration of Warhol's studio walls. That would, in fact, have been distinctly at odds with the aesthetic of the tacky which prevailed in this latter-day version of Bohemia. Rather, tin foil bestowed, as gold would not, the minimal reflective potential upon surfaces, which could transform the Factory into a dim Hall of

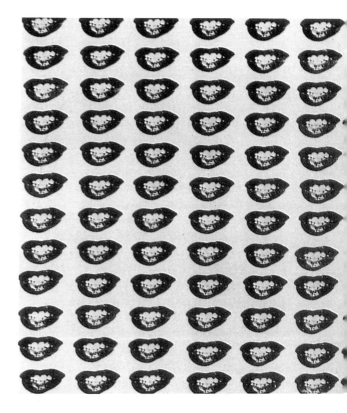

Andy Warhol. Marilyn Monroe's Lips. *1962.*

Mirrors, redoubling in its confusion of actor and audience the narcissistic dynamic of the site's theatrical economy.

Here was a factory located outside the codes and standards that govern and sustain industrial labor. To understand the old Factory is to absorb that paradox and to reconstruct a world in which the prohibitions and restrictions that determine and sustain the structures of production are bracketed.

We reconstruct, then, a milieu in which, as well, the prohibitions and restrictions that govern the structure of everyday life are suspended, together with the decorum that underwrites traditional forms of social hierarchy. From this world are excised the pity, piety, and etiquette linked to those forms. Here distances between persons are abrogated and eccentricity is exalted. Parodistic expression defines the center, the core of a continuous representation governed by a principle of inversion. Here the world is seen in reverse, as it were, or askew, or upside down. Travesty and humiliation are central tropes of representation. And through this place, from time to time, came the sound of laughter, shrill and ambivalent, both mordant and revitalizing, both aggressive and self-destructive.

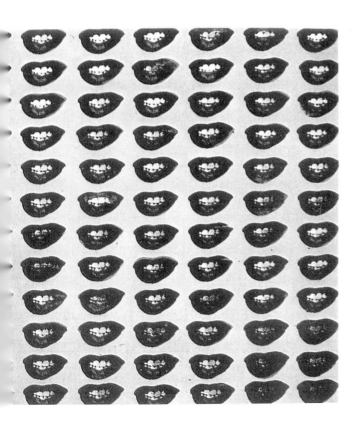

Such was the milieu of the old Factory in its prelapsarian era (1960–68), the site of Warhol's most productive period. In that world, choice, risk, transgression had lost their ground; the enveloping air breathed, sanctioned, enabled, the abolition of those interdictions that constitute their terrain. The old Factory of East Forty-seventh Street was, in the expansionist climate of the early 1960s, preeminently the site upon which Duchamp's door of *11, rue Larrey* opened to reveal the din and clutter, the revelry and theatrics of Bakhtinian carnival, as described in the great works on Rabelais and Dostoyevsky. The old Factory, the site of Warhol's recasting of the *Gesamtkunstwerk*, solicits analysis in terms of Bakhtin's master category, defined as the "sum total of all diverse festivities of the carnival type."[13]

One recalls the manner in which carnival, in its most general form, is defined as syncretic pageantry of a ritualistic sort, producing variants and nuances that vary with period and with differences of cultic origin and individual festivity. As Bakhtin puts it, carnival has "worked out an entire language of symbolic concretely sensuous forms — from large and complex mass actions to individual gestures." And most significantly, "As theatrical representation, it abolishes the dividing line between performers and spectators, since everyone becomes an active participant and everyone communes in the carnival act, which is neither contemplated nor, strictly speaking, performed; it is lived."

Within this life, several particular modalities are distinguished. Those of especial relevance here are: 1. Abolition of distance and establishment of free and familiar contact and exchange; 2. Eccentricity; 3. Mésalliance; 4. Profanation. In carnival, behavior and discourse are unmoored, as it were, freed from the bonds of the social formation. Thus, in carnival, age, social status, rank, and property lose their powers, have no place; familiarity of exchange is heightened.

Linked to this is the possibility of "carnivalistic mésalliances": "All things that were once self-enclosed, disunified, distanced . . . are drawn into carnivalistic contacts and combinations. Carnival brings together, unifies, weds, and combines the sacred with the profane, . . . the great with the insignificant, the wise with the stupid." And, of course, the high with the low.

It thus becomes that nexus within which mésalliances are formed. As Kathy Acker has pointed out in a recent account of the Factory, "the uptown world of society and fashion" here joined that of prostitution and the general "riffraff of Forty-second street, that group which at the same time no decent person, even a hippy, would recognize as being human." It was in this social nexus that Edie Sedgewick (among other "girls of good family") enjoyed her brief celebrity. Here the hustler could play Tarzan to Jane, "sort of."

And since in carnival, parodistic images parody one another, variously and

13. Mikhail Bakhtin, *Problems of Dostoevsky's Poetics*, trans. Caryl Emerson (Minneapolis: University of Minnesota, 1984), p. 122. This and succeeding characterizations of carnival are drawn from pp. 122–24 of chapter four.

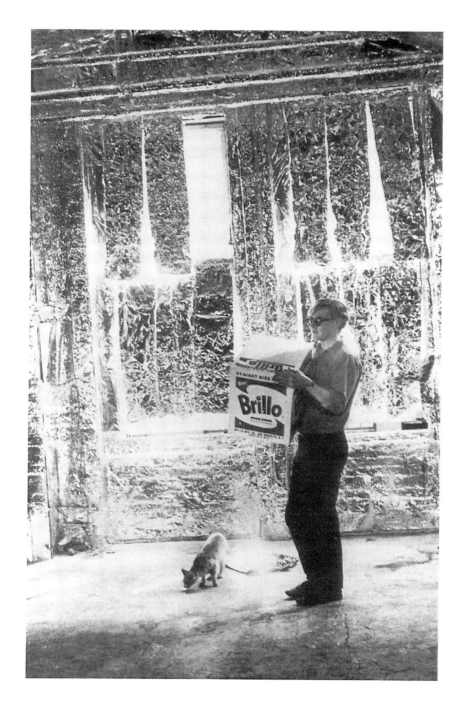

Andy Warhol in the old Factory.

from varying points of view, Roman parody is described as resembling "an entire system of crooked mirrors, elongating, diminishing, distorting in various directions and to various degrees." We may say that the tinfoiled studio literalized this practice. More than that, it was Warhol's strength to have revised the notion of the *Gesamtkunstwerk*, displacing it, redefining it as site of production, and recasting it in the mode of carnival, thereby generating for our time the most trenchant articulation of relation between cultures, high and low. In the picture of carnival as a system of representation, we can recognize the old Factory, that hall of mirrors whose virtual space generated improbable encounters and alliances, eliciting the extravagant acts, gestures, "numbers," that composed the serial parody of Hollywood production that overtakes the Warholian filmography of 1960–68.

It is, however, Bakhtin's definition of the essential and defining carnivalistic act that completes and confirms one's characterization of the old Factory as carnivalistic system. That act is *"the mock crowning and subsequent decrowning of the carnival king."* Italicizing the phrase, he insists upon its presence in all festivities of the carnival type — in the saturnalia as in European carnival and festival of fools.

> Under this ritual act of decrowning a king lies the very core of the carnival sense of the world — *the pathos of shifts and changes, of death and renewal*. Carnival is the festival of all-annihilating and all-renewing time. Thus might one express the basic concept of carnival. But we emphasize again: this is not an abstract thought but a living sense of the world, expressed in the concretely sensuous forms . . . of the ritual act.

The crowning ritual is, however, invested with a dualism, and ambivalence; its shifts celebrate the "joyful relativity of all structure and order, of all authority." For

> Crowning already contains the idea of immanent decrowning: it is ambivalent from the very start. And he who is crowned is the antipode of a real king, a slave or a jester; this act, as it were, opens and sanctifies the inside-out world of carnival. In the rituals of crowning . . . the symbols of authority that are handed over to the newly crowned king and the clothing in which he is dressed — all become ambivalent and acquire a veneer of joyful relativity; they become almost stage props. . . . From the very beginning, a decrowning glimmers through the crowning.

And Bakhtin stresses the manner in which, for the medieval festival of fools, mock priests, bishops, and popes were chosen *in place of* a king. It is indeed in the climactic sequence of *The Chelsea Girls* (1968) — the crowning work of Warhol's significant film production — that the Factory, which generated the continuous

parodistic procession of divas, queens, and "superstars," produces, like the world of the medieval carnival, as its culminating ritual its own *parodia sacra*: the election of a pope. Ondine, the virtuoso performer at the center of the film's most brilliantly pyrotechnical sequence, does indeed insist that he has been *elected* Pope.

He comes on with his paper bag,

> from which (with much noisy crinkling on the sound track) he extracts a syringe. Using his belt to tie his arm, he proceeds through the methodical ritual of giving himself a shot of Methedrine. . . . Ondine then turns to the camera and asks if he should begin. "Okay? Okay. Well now, let's see." He arranges himself more comfortably. "As you are all well aware, uh, I am the Pope. And, uh, the Pope has many duties. It's a crushing job. I can't tell you. And — uhhh — I've come down here today in order to give you all some kind of inside view of my life, and what I've been doing with my uhhhhh" — there is a long tracking pause — "Popage? Right, my Popage. Not just the Pope as Pope, but the Pope as a man. Right? First of all, you will undoubtedly want to know who, or what, I am Pope of. Well, uhhhh," a mock faggot groan, running his fingers through his hair. "Jesus! There's nobody left. Who's left?"
>
> Time is being filled. . . . But now, back on the left, a woman walks on; somebody new has come to give her confession to Ondine, as Ingrid Superstar did at the beginning of the film. As she sits down and begins to talk, something seems slightly wrong, slightly off . . . somewhat smirkily, she sets out to question the Pope's spiritual authority. She announces that she is hesitant to confess. Exactly Ondine's meat. "My dear, there is nothing you cannot say to me. Nothing. Now tell me, why can't you confess?" The inattentive ear hears the remark fall: "I can't confess to you because you're such a phony. *I'm* not trying to be anyone."

Ondine replies,

> "Well, let me tell you something, my dear little Miss Phony. You are a phony. You're a disgusting phony. May God forgive you," and Ondine slaps her again, more violently, then leaps up in a paroxysmic rage. With his open hands he begins to strike the cowering bewildered girl around the head and shoulders. "You Goddamned phony, get the hell off this set. Get out."

Ondine then breaks down and

> circles the room, hysterical — "I'm sorry, I just can't go on, this is just too much, I don't want to go on" — it is the longest camera movement

in the film. Her husband is a loathsome fool, she is a loathsome fool, and so it goes. Phase by slow, self-justifying phase, Ondine, who has been beside himself, slowly returns to himself—that is, to the camera. And, as he calms himself, the camera reasserts its presence."[14]

Ondine's interlocutor, in questioning his papal authenticity, has transgressed the limits, violated the canon, opened a breach in the regime of carnival, the ground of Ondine's papal incarnation. If Ondine cannot go on, it is because that breach is, indeed, a grave one, involving not merely an error of style, a *faux pas*, a loss of "cool," but a radical assault upon the Factory's regime of representation and, by implication, upon its spatiotemporal axes.

The time of carnivalistic representation is that of undifferentiated distension. This carnivalistic Factory constructed, enclosed within a world where time is indeed money, suspended, annulled, in turn, the spatiotemporality of productivity's *ratio*. Carnival time is indeed expended, not clocked or measured. Day and night succeeded each other in scarcely visible sequence within the tinfoiled precinct of the old Factory. And this was fundamental to the sense in which its production had introduced a rupture within filmic practice as well.

The cinema of part objects, epitomized in the hyperbolic montage of Brakhage, had, as we know, been that of aspiration to a continuous present, one image succeeding another at a pace that allows no space or time for recall or anticipation. The spectator is positioned within an hallucinated *now*. Warhol's films generate another kind of temporality, for they take, as it were, their time, the distended time of contemplation and expectation: Robert Indiana slowly, slowly eating what appears to be a single mushroom; a man receiving a blowjob; John Giorno sleeping; the light changing on the Empire State Building. That time, punctuated only by the flares of successive reel endings, is also time in which to wonder: "What's going to happen? Do I have time to go and buy some popcorn or to go to the bathroom without missing anything? How long, oh Lord, how long?" In an industrial film—say Douglas Sirk's *Written on the Wind*—the gap is not irreparable; in *Window Water Baby Moving* it is; for Brakhage's categorical rejection of the narrative codes has, in fact, as one of its primary purposes, to insure that irreparability.

Brakhage saw in Warhol's work an elimination of subjectivity. He, Brakhage, had insisted on a preeminence of subjectivity that required a radical assault upon the space of representation, upon the radical separation of signifier and signified. Not simply the suppression of objects, actors, and actions, but the radical transformation of the spatiotemporality which was their precondition: the elision of their determinant coordinates. In his filmic perpetual present, inspired

14. This account of the climactic sequence of *The Chelsea Girls* is drawn from Stephen Koch's exceptionally fine study, *Stargazer: Andy Warhol's World and his Films* (New York: Marion Boyers, 1985), pp. 94–96.

by the poetics of Gertrude Stein, images and sequences thus follow in the most rapid and hyperbolic fluidity of editing, eliminating anticipation as vector of cinematic construction. Both memory and anticipation are annulled by images as immediate and fugitive as those we call hypnagogic, that come to us in a half-waking state. Like them, Brakhage's films present a nonstop renewal of the perceptual object which resists both observation and cognition. The hypnagogic, as Sartre had noted, can excite attention and perception; "one sees something, but what one sees *is* nothing."

This is a vision that aspired to a pure presence in which the limits separating perception and eidetic imagery dissolve in the light of vision as Revelation, uncorrupted by the Fall that is called the Renaissance, as perpetuated in the very construction of the camera lens.

Brakhage is known to have uttered a howl of rage at the emergence of Warhol's film work—largely, one surmises, because *it seemed not to be work.* But surely, mainly because the old Factory regenerates, as it were, through the

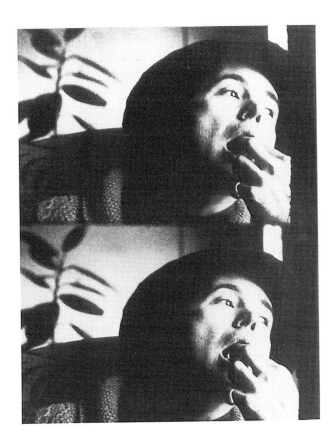

Andy Warhol. Eat. *1963.*

celebrated unblinking voyeuristic stare of Warhol's camera, the time, the temporal axis of expectation along which narrative can be reinstated. What Brakhage foresaw, no doubt (with an anticipatory shudder rather reminiscent of Eisenstein's, just three decades before, at the approach of sound) was that along the temporal axis the narrative syntagma could be restored, and with it the space of the whole body as erotic object of narrative desire.

Warhol's parody of the film factory stands, nevertheless, as a powerful gloss on the Frankfurt analysis of the culture industry. To reread that text is to recall to what degree it focuses upon film production as the paradigmatic mode of the culture industry, and how sharply its critique is directed at what we now see as the construction and positioning of the spectator.

For the last decade and a half the discipline of cinema studies has worked to analyze and theorize that positioning. There is, however, a sense in which the recent ascension of cultural studies begins to work against this theorization through its determination to valorize the spectator, now cast as resistant. (One thinks of a recent characterization of Madonna's body as "site of semiotic struggle.") For Warhol, stars were, in Horkheimer and Adorno's phrase, "a pattern around which the world embracing garment is cut," a pattern they warn us "to be followed by those shears of legal and economic justice with which the last projecting ends of thread are cut away." For as they put it, in the note entitled "Mass Society,"

> The opinion that the leveling-down and standardization of men is accompanied on the other hand by a heightened individuality in the "leader" personalities that corresponds to the power they enjoy, is false and an ideological pretense. [Rather they are] focal points at which identical reactions of countless citizens intersect . . . a collective and overexaggerated projection of the powerless ego of each individual.
>
> They look like hairdressers, provincial actors, and hack journalists. Part of their moral influence consists precisely in the fact that they are powerless in themselves but deputize for all the other powerless individuals, and embody the fullness of power for them, without themselves being anything other than the vacant spaces taken up accidentally by power. They are not excepted from the break-up of individuality; all that has happened is that the disintegrated form triumphs in them and to some extent is compensated for its decomposition. The "leaders" have become what they already were in a less developed form throughout the bourgeois era: actors playing the part of leaders.[15]

15. Horkheimer and Adorno, pp. 236–37.

It is the supposedly resistant spectator of cultural studies, "glued," as they say, to the television, who, having somehow converted the family living room into a site of resistance, elected—not once, but twice—just such an actor to the presidency of the United States of America.

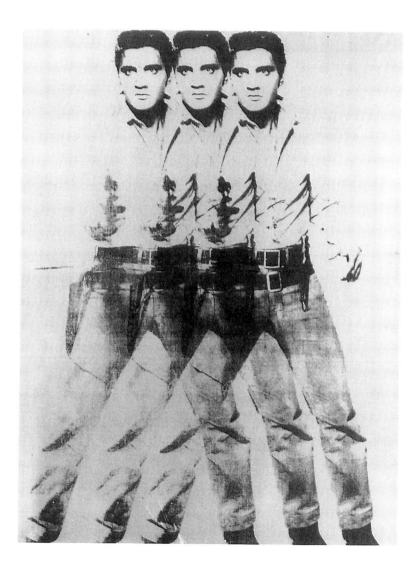

Andy Warhol. Elvis. *1964.*

Conceptual Art 1962–1969: From the Aesthetic of Administration to the Critique of Institutions*

BENJAMIN H. D. BUCHLOH

This monster called beauty is not eternal. We know that our breath had no beginning and will never stop, but we can, above all, conceive of the world's creation and its end.

— Apollinaire, *Les peintres cubistes*

Allergic to any relapse into magic, art is part and parcel of the disenchantment of the world, to use Max Weber's term. It is inextricably intertwined with rationalization. What means and productive methods art has at its disposal are all derived from this nexus.

— Theodor Adorno

A twenty-year distance separates us from the historical moment of Conceptual Art. It is a distance that both allows and obliges us to contemplate the movement's history in a broader perspective than that of the convictions held during the decade of its emergence and operation (roughly from 1965 to its temporary disappearance in 1975). For to historicize Conceptual Art requires, first of all, a clarification of the wide range of often conflicting positions and the mutually exclusive types of investigation that were generated during this period.

But beyond that there are broader problems of method and of "interest." For at this juncture, any historicization has to consider what type of questions an art-historical approach — traditionally based on the study of visual objects — can legitimately pose or hope to answer in the context of artistic practices that explicitly insisted on being addressed outside of the parameters of the production of formally ordered, perceptual objects, and certainly outside of those of art history and criticism. And, further, such an historicization must also address the

* An earlier version of this essay was published in *L'art conceptuel: une perspective* (Paris: Musée d'art moderne de la Ville de Paris, 1989).

à Juliette MEEROVITCH, amicalement

Sonatine Bureaucratique

(BUREAUCRATIC SONATINA)

Erik SATIE

Copyright 1917 by S.Chapelier Paris

L. PHILIPPO, Editeur, 24, Bᵈ Poissononnière, Paris.

r. 669

Erik Statie. Bureaucratic Sonatina. *1917.*

currency of the historical object, i.e., the motivation to rediscover Conceptual Art from the vantage point of the late 1980s: the dialectic that links Conceptual Art, as the most rigorous elimination of visuality and traditional definitions of representation, to this decade of a rather violent restoration of traditional artistic forms and procedures of production.

It is with Cubism, of course, that elements of language surface programmatically within the visual field for the first time in the history of modernist painting, in what can be seen as a legacy of Mallarmé. It is there too that a parallel is established between the emerging structuralist analysis of language and the formalist examination of representation. But Conceptual practices went beyond such mapping of the linguistic model onto the perceptual model, outdistancing as they did the spatialization of language and the temporalization of visual structure. Because the proposal inherent in Conceptual Art was to replace the object of spatial and perceptual experience by linguistic definition alone (the work as analytic proposition), it thus constituted the most consequential assault on the status of that object: its visuality, its commodity status, and its form of distribution. Confronting the full range of the implications of Duchamp's legacy for the first time, Conceptual practices, furthermore, reflected upon the construction and the role (or the death) of the author just as much as they redefined the conditions of receivership and the role of the spectator. Thus they performed the postwar period's most rigorous investigation of the conventions of pictorial and sculptural representation and a critique of the traditional paradigms of visuality.

From its very beginning, the historic phase in which Conceptual Art was developed comprises such a complex range of mutually opposed approaches that any attempt at a retrospective survey must beware of the forceful voices (mostly those of the artists themselves) demanding respect for the purity and orthodoxy of the movement. Precisely because of this range of implications of Conceptual Art, it would seem imperative to resist a construction of its history in terms of a stylistic homogenization, which would limit that history to a group of individuals and a set of strictly defined practices and historical interventions (such as, for example, the activities initiated by Seth Siegelaub in New York in 1968 or the authoritarian quests for orthodoxy by the English Art & Language group).

To historicize Concept Art (to use the term as it was coined by Henry Flynt in 1961)[1] at this moment, then, requires more than a mere reconstruction of the

1. As is usual with stylistic formations in the history of art, the origin and the name of the movement are heavily contested by its major participants. Barry, Kosuth, and Weiner, for example, vehemently denied in recent conversations with the author any historical connection to or even knowledge of the Fluxus movement of the early 1960s. Nevertheless, at least with regard to the invention of the *term*, it seems correct when Henry Flynt claims that he is "the originator of concept art, the most influential contemporary art trend. In 1961 I authored (and copyrighted) the phrase 'concept art,' the rationale for it and the first compositions labeled 'concept art.' My document was first printed in *An Anthology*, ed. La Monte Young, New York, 1962." (La Monte Young's *An Anthology* was in fact published in 1963.)

movement's self-declared primary actors or a scholarly obedience to their pro-claimed purity of intentions and operations.[2] Their convictions were voiced with the (by now often hilarious) self-righteousness that is continuous within the tradition of hypertrophic claims made in avant-garde declarations of the twen-tieth century. For example, one of the campaign statements by Joseph Kosuth from the late 1960s asserts: "Art before the modern period is as much art as Neanderthal man is man. It is for this reason that around the same time I replaced the term 'work' for *art proposition*. Because a conceptual *work* of art in the traditional sense, is a contradiction in terms."[3]

It seems crucial to remember that the oppositions within the formation of Conceptual Art arose partly from the different readings of Minimal sculpture (and of its pictorial equivalents in the painting of Mangold, Ryman, and Stella) and in the consequences the generation of artists emerging in 1965 drew from those readings—just as the divergences also resulted from the impact of various artists within the Minimalist movement as one or another was chosen by the new generation as its central figures of reference. For example, Dan Graham seems to have been primarily engaged with the work of Sol LeWitt. In 1965 he organized LeWitt's first one-person exhibition (held in his gallery, called Daniels Gallery); in 1967 he wrote the essay "Two Structures: Sol LeWitt"; and in 1969 he concluded the introduction to his self-published volume of writings entitled *End Moments* as follows: "It should be obvious the importance Sol LeWitt's work has had for my work. In the article here included (written first in 1967, rewritten in 1969) I hope only that the after-the-fact appreciation hasn't too much sub-merged his seminal work into *my* categories."[4]

A second contestant for the term was Edward Kienholz, with his series of *Concept Tableaux* in 1963 (in fact, occasionally he is still credited with the discovery of the term. See for example Roberta Smith's essay "Conceptual Art," in *Concepts of Modern Art*, ed. Nikos Stangos [New York: Harper and Row, 1981], pp. 256–70).

Joseph Kosuth claims in his "Sixth Investigation 1969 Proposition 14" (published by Gerd de Vries, Cologne, 1971, n.p.) that he used the term "conceptual" for the first time "in a series of notes dated 1966 and published a year later in a catalogue for an exhibition titled *Non-Anthropomorphic Art* at the now defunct Lannis Gallery in New York."

And then there are of course (most officially accepted by all participants) Sol LeWitt's two famous texts from 1967 and 1969, the "Paragraphs on Conceptual Art," first published in *Artforum*, vol. V, no. 10, pp. 56–57 and "Sentences on Conceptual Art," first published in *Art & Language*, vol. 1, no. 1 (May 1969), pp. 11–13.

2. For a typical example of an attempt to write the history of Conceptual Art by blindly adopting and repeating the claims and convictions of one of that history's figures, see Gudrun Inboden, "Joseph Kosuth—Artist and Critic of Modernism," in *Joseph Kosuth: The Making of Meaning* (Stutt-gart: Staatsgalerie Stuttgart, 1981), pp. 11–27.

3. Joseph Kosuth, *The Sixth Investigation 1969 Proposition 14* (Cologne: Gerd De Vries/Paul Maenz, 1971), n. p.

4. Dan Graham, *End Moments* (New York, 1969), n.p. The other Minimalists with whose work Graham seems to have been particularly involved were Dan Flavin (Graham wrote the catalogue essay for Flavin's exhibition at the Museum of Contemporary Art in Chicago in 1967) and Robert Morris (whose work he discussed later extensively in his essay "Income Piece" in 1973).

Mel Bochner. Working Drawings and Other Visible
Things on Paper Not Necessarily Meant to Be
Viewed as Art. *Installation, School of Visual Arts
Gallery, December, 1966.*

Mel Bochner, by contrast, seems to have chosen Dan Flavin as his primary
figure of reference. He wrote one of the first essays on Dan Flavin (it is in fact a
text-collage of accumulated quotations, all of which relate in one way or the
other to Flavin's work).[5] Shortly thereafter, the text-collage as a presentational
mode would, indeed, become formative within Bochner's activities, for in the
same year he organized what was probably the first truly conceptual exhibition
(both in terms of materials being exhibited and in terms of presentational style).
Entitled *Working Drawings and Other Visible Things on Paper Not Necessarily Meant
to Be Viewed as Art* (at the School of Visual Arts in 1966), most of the Minimal
artists were present along with a number of then still rather unknown Post-Mini-
mal and Conceptual artists. Having assembled drawings, sketches, documents,
tabulations, and other paraphernalia of the production process, the exhibition
limited itself to presenting the "originals" in Xeroxes assembled into four loose-
leaf binders that were installed on pedestals in the center of the exhibition space.
While one should not overestimate the importance of such features (nor should
one underestimate the pragmatics of such a presentational style), Bochner's
intervention clearly moved to transform both the format and space of exhibi-
tions. As such, it indicates that the kind of transformation of exhibition space and
of the devices through which art is presented that was accomplished two years

5. Mel Bochner, "Less is Less (for Dan Flavin)," *Art and Artists* (Summer 1966).

later by Seth Siegelaub's exhibitions and publications (e.g., *The Xerox Book*) had already become a common concern of the generation of post-Minimal artists.

A third example of the close generational sequencing would be the fact that Joseph Kosuth seems to have chosen Donald Judd as his key figure: at least one of the early tautological neon works from the *Proto-Investigations* is dedicated to Donald Judd; and throughout the second part of "Art after Philosophy" (published in November, 1969), Judd's name, work, and writings are invoked with the same frequency as those of Duchamp and Reinhardt. At the end of this essay, Kosuth explicitly states: "I would hastily add to that, however, that I was certainly much more influenced by Ad Reinhardt, Duchamp via Johns and Morris,

Sol LeWitt. Wall Floor Piece (Three Squares). *1966.*

and by Donald Judd than I ever was specifically by LeWitt. . . . Pollock and Judd are, I feel, the beginning and end of American dominance in art."[6]

Sol LeWitt's Structures

It would seem that LeWitt's proto-Conceptual work of the early 1960s originated in an understanding of the essential dilemma that has haunted artistic production since 1913, when its basic paradigms of opposition were first formulated — a dilemma that could be described as the conflict between structural specificity and random organization. For the need, on the one hand, for both a systematic reduction and an empirical verification of the perceptual data of a visual structure stands opposed to the desire, on the other hand, to assign a new "idea" or meaning to an object randomly (in the manner of Mallarmé's "transposition") as though the object were an empty (linguistic) signifier.

This was the dilemma that Roland Barthes described in 1956 as the "difficulty of our times" in the concluding paragraphs of *Mythologies:*

> It seems that this is a difficulty pertaining to our times: there is as yet only one possible choice, and this choice can bear only on two equally extreme methods: either to posit a reality which is entirely permeable to history, and ideologize; or, conversely, to posit a reality which is *ultimately* impenetrable, irreducible, and, in this case, poetize. In a word, I do not yet see a synthesis between ideology and poetry (by poetry I understand, in a very general way, the search for the inalienable meaning of things).[7]

Both critiques of the traditional practices of representation in the American postwar context had at first appeared mutually exclusive and had often fiercely attacked each other. For example, Reinhardt's extreme form of self-critical, perceptual positivism had gone too far for most of the New York School artists and certainly for the apologists of American modernism, mainly Greenberg and Fried, who had constructed a paradoxical dogma of transcendentalism and self-referential critique. On the other hand, Reinhardt was as vociferous as they — if

6. Joseph Kosuth, "Art after Philosophy" (Part II), in *The Making of Meaning*, p. 175. The list would seem complete, if it were not for the absence of Mel Bochner's and On Kawara's name, and its explicit negation of the importance of Sol LeWitt. According to Bochner, who had become an instructor at the School of Visual Arts in 1965, Joseph Kosuth worked with him as a student in 1965 and 1966. Dan Graham mentioned that during that time Kosuth was also a frequent visitor to the studios of On Kawara and Sol LeWitt. Kosuth's explicit negation makes one wonder whether it was not precisely Sol LeWitt's series of the so-called "Structures" (such as *Red Square, White Letters*, for example, produced in 1962 and exhibited in 1965) that was one of the crucial points of departure for the formulation of Kosuth's *Proto-Investigations.*
7. Roland Barthes, *Mythologies*, trans. Annette Lavers (New York: Hill and Wang, 1972), p. 158.

not more so — in his contempt for the opposite, which is to say, the Duchampian tradition. This is evident in Ad Reinhardt's condescending remarks about both Duchamp — "I've never approved or liked anything about Marcel Duchamp. You have to chose between Duchamp and Mondrian" — and his legacy as represented through Cage and Rauschenberg — "Then the whole mixture, the number of poets and musicians and writers mixed up with art. Disreputable. Cage, Cunningham, Johns, Rauschenberg. I'm against the mixture of all the arts, against the mixture of art and life you know, everyday life."[8]

What slid by unnoticed was the fact that both these critiques of representation led to highly comparable formal and structural results (e.g., Rauschenberg's monochromes in 1951–1953 and Reinhardt's monochromes such as *Black Quadruptych* in 1955). Furthermore, even while made from opposite vantage points, the critical arguments accompanying such works systematically denied the traditional principles and functions of visual representation, constructing astonishingly similar litanies of negation. This is as evident, for example, in the text prepared by John Cage for Rauschenberg's *White Paintings* in 1953 as it is in Ad Reinhardt's 1962 manifesto "Art as Art." First Cage:

> To whom, No subject, No image, No taste, No object, No beauty, No talent, No technique (no why), No idea, No intention, No art, No feeling, No black, No white no (and). After careful consideration I have come to the conclusion that there is nothing in these paintings that could not be changed, that they can be seen in any light and are not destroyed by the action of shadows. Hallelujah! the blind can see again; the water is fine.[9]

And then Ad Reinhardt's manifesto for his own "Art as Art" principle:

> No lines or imaginings, no shapes or composings or representings, no visions or sensations or impulses, no symbols or signs or impastos, no decoratings or colorings or picturings, no pleasures or pains, no accidents or ready-mades, no things, no ideas, no relations, no attributes, no qualities — nothing that is not of the essence.[10]

Ad Reinhardt's empiricist American formalism (condensed in his "Art as Art" formula) and Duchamp's critique of visuality (voiced for example in the

8. The first of the two quotations is to be found in Ad Reinhardt's Skowhegan lecture, delivered in 1967, quoted by Lucy Lippard in *Ad Reinhardt* (New York, 1981), p. 195. The second statement appears in an interview with Mary Fuller, published as "An Ad Reinhardt Monologue," *Artforum*, vol. 10 (November 1971), pp. 36–41.
9. John Cage (statement in reaction to the controversy engendered by the exhibition of Rauschenberg's all-white paintings at the Stable Gallery, September 15–October 3, 1953). Printed in Emily Genauer's column in the *New York Herald Tribune*, December 27, 1953, p. 6 (section 4).
10. Ad Reinhardt, "Art as Art," *Art International* (December 1962). Reprinted in *Art as Art: The Selected Writings of Ad Reinhardt*, ed. Barbara Rose (New York: Viking, 1975), p. 56.

famous quip: "All my work in the period before the *Nude* was visual painting. Then I came to the idea. . . ."[11]) appear in the historically rather unlikely fusion of Kosuth's attempt to integrate the two positions in the mid-1960s, leading to his own formula, which he deployed starting in 1966, "Art as Idea as Idea." It should be noted, however, that the strange admixture of the nominalist position of Duchamp (and its consequences) and the positivist position of Reinhardt (and its implications) was not only accomplished in 1965 with the beginnings of Conceptual Art but was well-prepared in the work of Frank Stella, who in his *Black Paintings* from 1959 claimed both Rauschenberg's monochrome paintings and Reinhardt's paintings as points of departure. Finally, it was the work of Sol LeWitt — in particular work such as his *Structures* — that demarcates that precise transition, integrating as they do both language and visual sign in a structural model.

The surfaces of these *Structures* from 1961 to 1962 (some of which used single frames from Muybridge's serial photographs) carried inscriptions in bland lettering identifying the hue and shape of those surfaces (e.g., "RED SQUARE") and the inscription itself (e.g., "WHITE LETTERS"). Since these inscriptions named either the support or the inscription (or, in the middle section of the painting, both support and inscription in a paradoxical inversion), they created a continuous conflict in the viewer/reader. This conflict was not just over which of the two roles should be performed in relation to the painting. To a larger extent it concerned the reliability of the given information and the sequence of that information: was the inscription to be given primacy over the visual qualities identified by the linguistic entity, or was the perceptual experience of the visual, formal, and chromatic element anterior to its mere denomination by language?

Clearly this "mapping of the linguistic onto the perceptual" was not arguing in favor of "the idea" — or linguistic primacy — or the definition of the work of art as an analytic proposition. Quite to the contrary, the permutational character of the work suggested that the viewer/reader systematically perform all the visual and textual options the painting's parameters allowed for. This included an acknowledgment of the painting's central, square element: a spatial void that revealed the underlying wall surface as the painting's *architectural* support in actual space, thereby suspending the reading of the painting between architectural structure and linguistic definition.

Rather than privileging one over the other, LeWitt's work (in its dialogue with Jasper Johns's legacy of paradox) insisted on forcing the inherent contradictions of the two spheres (that of the perceptual experience and that of the linguistic experience) into the highest possible relief. Unlike Frank Stella's response to Johns, which forced modernist self-referentiality one step further into the ultimate *cul de sac* of its positivist convictions (his notorious statement "what

11. Marcel Duchamp, interview with Francis Roberts (1963), *Art News*, (December 1968), p. 46.

Sol LeWitt. Untitled (Red Square, White Letters).
1962.

you see is what you see" would attest to that just as much as the development of
his later work),[12] Sol LeWitt's dialogue (with both Johns and Stella, and ulti-

12. Stella's famous statement was of course made in the conversation between Bruce Glaser,
Donald Judd, and himself, in February 1964, and published in *Art News* (September 1966), pp.
55–61. To what extent the problem of this dilemma haunted the generation of Minimal artists
becomes evident when almost ten years later, in an interview with Jack Burnham, Robert Morris
would still seem to be responding (if perhaps unconsciously) to Stella's notorious statement:

> Painting ceased to interest me. There were certain things about it that seemed very
> problematic to me. . . . There was a big conflict between the fact of doing this thing,
> and what it looked like later. It just didn't seem to make much sense to me. Primarily

mately, of course, with Greenberg) developed a dialectical position with regard to the positivist legacy.

In contrast to Stella, his work now revealed that the modernist compulsion for empiricist self-reflexiveness not only originated in the scientific positivism which is the founding logic of capitalism (undergirding its industrial forms of production just as much as its science and theory), but that, for an artistic practice that internalized this positivism by insisting on a purely empiricist approach to vision, there would be a final destiny. This destiny would be to aspire to the condition of tautology.

It is not surprising, then, that when LeWitt formulated his second text on Conceptual Art—in his "Sentences on Conceptual Art" from the spring of 1969—the first sentence should programmatically state the radical difference between the logic of scientific production and that of aesthetic experience:

1. Conceptual artists are mystics rather than rationalists. They leap to conclusions that logic cannot reach.
2. Rational judgments repeat rational judgments.
3. Irrational judgments lead to new experience.[13]

Robert Morris's Paradoxes

The problem has been for some time one of ideas—those most admired are the ones with the biggest, most incisive ideas (e.g., Cage & Duchamp) . . . I think that today art is a form of art history.

—Robert Morris, letter to Henry Flynt, 8/13/1962

Quite evidently, Morris's approach to Duchamp, in the early 1960s, had already been based on reading the readymade in analogy with a Saussurean model of language: a model where meaning is generated by structural relationships. As Morris recalls, his own "fascination with and respect for Duchamp was related to his linguistic fixation, to the idea that all of his operations were ultimately built on a sophisticated understanding of language itself."[14] Accordingly, Morris's early work (from 1961 to 1963) already pointed toward an understanding of Duchamp that transcended the limited definition of the ready-

because there was an activity I did in time, and there was a certain method to it. And that didn't seem to have any relationship to the thing at all. There is a certain resolution in the theater where there is real time, and *what you do is what you do.* (emphasis added)

Robert Morris, unpublished interview with Jack Burnham, November 21, 1975, Robert Morris Archive. Quoted in Maurice Berger, *Labyrinths: Robert Morris, Minimalism, and the 1960s* (New York: Harper & Row, 1989), p. 25.
13. Sol LeWitt, "Sentences on Conceptual Art," first published in *0-9*, New York (1969), and *Art-Language*, Coventry (May 1969), p. 11.
14. Robert Morris as quoted in Berger, *Labyrinths*, p. 22.

made as the mere displacement of traditional modes of artistic production by a new aesthetic of the speech act ("this is a work of art if I say so"). And in marked distinction from the Conceptualists' subsequent exclusive focus on the unassisted readymades, Morris had, from the late 1950s when he discovered Duchamp, been particularly engaged with work such as *Three Standard Stoppages* and the *Notes for the Large Glass (The Green Box)*.

Morris's production from the early 1960s, in particular works like *Card File* (1962), *Metered Bulb* (1963), *I-Box* (1963), *Litanies*, and the *Statement of Aesthetic Withdrawal*, also entitled *Document* (1963), indicated a reading of Duchamp that clearly went beyond Johns's, leading towards a structural and semiotic definition of the functions of the readymade. As Morris described it retrospectively in his 1970 essay "Some Notes on the Phenomenology of Making":

> There is a binary swing between the arbitrary and the nonarbitrary or "motivated" which is . . . an historical, evolutionary, or diachronic feature of language's development and change. Language is not plastic art but both are forms of human behavior and the structures of one can be compared to the structures of the other.[15]

While it is worth noticing that by 1970 Morris already reaffirmed apodictically the ontological character of the category "plastic" art versus that of "language," it was in the early 1960s that his assaults on the traditional concepts of visuality and plasticity had already begun to lay some of the crucial foundations for the development of an art practice emphasizing its parallels, if not identity, with the systems of linguistic signs, i.e., Conceptual Art.

Most importantly, as early as 1961 in his *Box with the Sound of Its Own Making*, Morris had ruptured both. On the one hand, it dispenses with the Modernist quest for medium-specific purity as much as with its sequel in the positivist conviction of a purely perceptual experience operating in Stella's visual tautologies and the early phases of Minimalism. And on the other, by counteracting the supremacy of the visual with that of an auditory experience of equal if not higher importance, he renewed the Duchampian quest for a nonretinal art. In *Box with the Sound of Its Own Making*, as much as in the subsequent works, the critique of the hegemony of traditional categories of the visual is enacted not only in the (acoustic or tactile) disturbance of the purity of perceptual experience, but it is performed as well through a literalist act of denying the viewer practically all (at least traditionally defined) visual information.

This strategy of a "perceptual withdrawal" leads in each of the works from the early 1960s to a different analysis of the constituent features of the structured object and the modes of reading it generates. In *I-Box*, for example, the viewer is confronted with a semiotic pun (on the words *I* and *eye*) just as much as

15. Robert Morris, "Some Notes on the Phenomenology of Making: The Search for the Motivated," *Artforum*, vol. 9 (April 1970), p. 63.

with a structural sleight of hand from the tactile (the viewer has to manipulate the box physically to *see* the *I* of the artist) through the linguistic sign (the letter *I* defines the shape of the framing/display device: the "door" of the box) to the visual representation (the nude photographic portrait of the artist) and back. It is of course this very tripartite division of the aesthetic signifier — its separation into object, linguistic sign, and photographic reproduction — that we will encounter in infinite variations, didactically simplified (to operate as stunning tautologies) and stylistically designed (to take the place of paintings) in Kosuth's *Proto-Investigations* after 1966.

In *Document (Statement of Aesthetic Withdrawal)*, Morris takes the literal negation of the visual even further, in clarifying that after Duchamp the ready-made is not just a neutral analytic proposition (in the manner of an underlying statement such as "this is a work of art"). Beginning with the readymade, the work of art had become the ultimate subject of a legal definition and the result of institutional validation. In the absence of any specifically visual qualities and due

to the manifest lack of any (artistic) manual competence as a criterion of distinction, all the traditional criteria of aesthetic judgment—of taste and of connoisseurship—have been programmatically voided. The result of this is that the definition of the aesthetic becomes on the one hand a matter of linguistic convention and on the other the function of both a legal contract and an institutional discourse (a discourse of power rather than taste).

This erosion works, then, not just against the hegemony of the visual, but against the possibility of any other aspect of the aesthetic experience as being autonomous and self-sufficient. That the introduction of legalistic language and an administrative style of the material presentation of the artistic object could effect such an erosion had of course been prefigured in Duchamp's practice as well. In 1944 he had hired a notary to inscribe a statement of authenticity on his 1919 *L.H.O.O.Q.*, affirming that ". . . this is to certify that this is the original

Robert Morris. Untitled (Statement of Aesthetic Withdrawal). *1963.*

'ready-made' *L.H.O.O.Q.* Paris 1919." What was possibly still a pragmatic maneuver with Duchamp (although certainly one in line with the pleasure he took in contemplating the vanishing basis for the legitimate definition of the work of art in visual competence and manual skill alone) would soon become one of the constituent features of subsequent developments in Conceptual Art. Most obviously operating in the certificates issued by Piero Manzoni defining persons or partial persons as temporary or lifetime works of art (1960–61), this is to be found at the same time in Yves Klein's certificates assigning zones of immaterial pictorial sensibility to the various collectors who acquired them.

But this aesthetic of linguistic conventions and legalistic arrangements not only denies the validity of the traditional studio aesthetic, it also cancels the aesthetic of production and consumption which had still governed Pop Art and Minimalism.

Just as the modernist critique (and ultimate prohibition) of figurative representation had become the increasingly dogmatic law for pictorial production in the first decade of the twentieth century, so Conceptual Art now instated the prohibition of any and all visuality as the inescapable aesthetic rule for the end of the twentieth century. Just as the readymade had negated not only figurative representation, authenticity, and authorship while introducing repetition and the series (i.e., the law of industrial production) to replace the studio aesthetic of the handcrafted original, Conceptual Art came to displace even that image of the mass-produced object and its aestheticized forms in Pop Art, replacing an aesthetic of industrial production and consumption with an aesthetic of administrative and legal organization and institutional validation.

Edward Ruscha's Books

One major example of these tendencies—acknowledged both by Dan Graham as a major inspiration for his own "Homes for America" and by Kosuth, whose "Art after Philosophy" names him as a proto-Conceptual artist—would be the early book work of Edward Ruscha. Among the key strategies of future Conceptual Art that were initiated by Ruscha in 1963 were the following: to chose the vernacular (e.g., architecture) as referent; to deploy photography systematically as the representational medium; and to develop a new form of distribution (e.g., the commercially produced book as opposed to the traditionally crafted *livre d'artiste.*

Typically, reference to architecture in any form whatever would have been unthinkable in the context of American-type formalism and Abstract Expressionism (or within the European postwar aesthetic for that matter) until the early 1960s. The devotion to a private aesthetic of contemplative experience, with its concomitant absence of any systematic reflection of the social functions of artistic production and their potential and actual publics, had, in fact, precluded any exploration of the interdependence of architectural and artistic production, be it

Edward Ruscha. Four Books. 1962–1966.

Andy Warhol. From Thirteen Most Wanted Men 1964.

even in the most superficial and trivial forms of architectural decor.[16] It was not until the emergence of Pop Art in the early 1960s, in particular in the work of Bernd and Hilla Becher, Claes Oldenburg, and Edward Ruscha, that the references to monumental sculpture (even in its negation as the *Anti-Monument*) and to vernacular architecture reintroduced (even if only by implication) a reflection on public (architectural and domestic) space, thereby foregrounding the absence of a developed artistic reflection on the problematic of the contemporary publics.

In January 1963 (the year of Duchamp's first American retrospective, held at the Pasadena Art Museum), Ruscha, a relatively unknown Los Angeles artist, decided to publish a book entitled *Twenty-Six Gasoline Stations*. The book, modest

16. It would be worthwhile to explore the fact that artists like Arshile Gorky under the impact of the WPA program would still have been concerned with the aesthetics of mural painting when he was commissioned to decorate the Newark Airport building, and that even Pollock tinkered with the idea of an architectural dimension for his paintings, wondering whether they could be transformed into architectural panels. As is well known, Mark Rothko's involvement with the Seagram Corporation to produce a set of decorative panels for their corporate headquarters ended in disaster, and Barnett Newman's synagogue project was abandoned as well. All of these exceptions would confirm the rule that the postwar aesthetic had undergone the most rigorous privatization and a reversal of the reflection on the inextricable link between artistic production and public social experience as they had marked the 1920s.

in format and production, was as removed from the tradition of the artist's book as its iconography was opposed to every aspect of the official American art of the 1950s and early '60s: the legacy of Abstract Expressionism and Color Field painting. The book was, however, not so alien to the artistic thought of the emerging generation, if one remembers that the year before an unknown artist from New York by the name of Andy Warhol had exhibited a serial arrangement of thirty-two stenciled paintings depicting Campbell Soup cans arranged like objects on shelves in the Ferus Gallery. While both Warhol and Ruscha accepted a notion of public experience that was inescapably contained in the conditions of consumption, both artists altered the mode of production as well as the form of distribution of their work such that a different public was potentially addressed.

Ruscha's vernacular iconography evolved to the same extent as Warhol's had from the Duchamp and Cage legacy of an aesthetic of "indifference," and from the commitment to an antihierarchical organization of a universally valid facticity, operating as total affirmation. Indeed, random sampling and aleatory choice from an infinity of possible objects (Ruscha's *Twenty-Six Gasoline Stations*, Warhol's *Thirteen Most Wanted Men*) would soon become essential strategies of the aesthetic of Conceptual Art: one thinks of Alighiero Boetti's *The Thousand Longest Rivers*, of Robert Barry's *One Billion Dots*, of On Kawara's *One Million*

Years, or, most significantly in this context, of Doug Huebler's life-long project, entitled *Variable Piece: 70.* This work claims to document photographically "the existence of everyone alive in order to produce the most authentic and inclusive representation of the human species that may be assembled in that manner. Editions of this work will be periodically issued in a variety of topical modes: '100,000 people,' '1,000,000 people,' '10,000,000 people,' . . . etc." Or again, there are the works by Stanley Brouwn or Hanne Darboven where in each case an arbitrary, abstract principle of pure quantification replaces traditional principles of pictorial or sculptural organization and/or compositional relational order.

In the same manner that Ruscha's books shifted the formal organization of the representation, the mode of presentation itself became transformed: instead of lifting photographic (or print-derived) imagery from mass-cultural sources and transforming these images into painting (as Warhol and the Pop Artists had practiced it), Ruscha would now deploy photography directly, in an appropriate printing medium. And it was a particularly laconic type of photography at that, one that explicitly situated itself as much outside of all conventions of art photography as outside of those of the venerable tradition of documentary photography, least of all that of "concerned" photography. This devotion to a deadpan, anonymous, amateurish approach to photographic form corresponds exactly to Ruscha's iconographic choice of the architectural banal. Thus at all three levels —iconography, representational form, mode of distribution—the given forms of artistic object no longer seemed acceptable in their traditionally specialized and privileged positions. As Victor Burgin put it with hindsight: "One of the things Conceptual Art attempted was the dismantling of the hierarchy of media according to which painting (sculpture trailing slightly behind it) is assumed inherently superior to, most notably, photography."[17]

Accordingly, even in 1965–66, with the earliest stages of Conceptual practices, we witness the emergence of diametrically opposed approaches: Joseph Kosuth's *Proto-Investigations* on the one hand (according to their author conceived and produced in 1965);[18] and a work such as Dan Graham's *Homes for*

17. Victor Burgin, "The Absence of Presence," in *The End of Art Theory* (Atlantic Highlands, 1986), p. 34.
18. In the preparation of this essay, I have not been able to find a single source or document that would confirm with definite credibility Kosuth's claim that these works of the *Proto-Investigations* were actually produced and existed physically in 1965 or 1966, when he (at that time twenty years old) was still a student at the School of Visual Arts in New York. Nor was Kosuth able to provide any documents to make the claims verifiable. By contrast these claims were explicitly contested by all the artists I interviewed who knew Kosuth at that time, none of them remembering seeing any of the *Proto-Investigations* before February 1967, in the exhibition *Non-Anthropomorphic Art by Four Young Artists,* organized by Joseph Kosuth at the Lannis Gallery. The artists with whom I conducted interviews were Robert Barry, Mel Bochner, Dan Graham, and Lawrence Weiner. I am not necessarily suggesting that the *Proto-Investigations* could not have been done by Kosuth at the age of twenty (after all, Frank Stella had painted his *Black Paintings* at age twenty-three), or that the logical steps

Dan Graham. Homes for America (Arts Magazine).
December 1966.

America on the other. Published in *Arts Magazine* in December 1966, the latter is a work which—unknown to most and long unrecognized—programmatically emphasized structural contingency and contextuality, addressing crucial questions of presentation and distribution, of audience and authorship. At the same time the work linked Minimalism's esoteric and self-reflexive aesthetics of permutation to a perspective on the architecture of mass culture (thereby redefining the legacy of Pop Art). The Minimalists' detachment from any representation of contemporary social experience upon which Pop Art had insisted, however furtively, resulted from their attempt to construct models of visual meaning and experience that juxtaposed formal reduction with a structural and phenomenological model of perception.

fusing Duchamp and Reinhardt with Minimalism and Pop Art leading up to the *Proto-Investigations* could not have been taken by an artist of Kosuth's historical awareness and strategic intelligence. But I am saying that none of the work dated by Kosuth to 1965 or 1966 can—until further evidence is produced—actually be documented as 1965 or 1966 or dated with any credibility. By contrast, the word paintings of On Kawara (whose studio Kosuth visited frequently at that time), such as *Something*, are reproduced and documented.

By contrast, Graham's work argued for an analysis of (visual) meaning that defined signs as both structurally constituted within the relations of language's system *and* grounded in the referent of social and political experience. Further, Graham's dialectical conception of visual representation polemically collapsed the difference between the spaces of production and those of reproduction (what Seth Siegelaub would, in 1969, call primary and secondary information).[19] Anticipating the work's actual modes of distribution and reception within its very structure of production, *Homes for America* eliminated the difference between the artistic construct and its (photographic) reproduction, the difference between an exhibition of art objects and the photograph of its installation, the difference between the architectural space of the gallery and the space of the catalogue and the art magazine.

Joseph Kosuth's Tautologies

In opposition to this, Kosuth was arguing, in 1969, precisely for the continuation and expansion of modernism's positivist legacy, and doing so with what must have seemed to him at the time the most radical and advanced tools of that tradition: Wittgenstein's logical positivism and language philosophy (he emphatically affirmed this continuity when, in the first part of "Art after Philosophy," he states, "Certainly linguistic philosophy can be considered the heir to empiricism . . ."). Thus, even while claiming to displace the formalism of Greenberg and Fried, he in fact updated modernism's project of self-reflexiveness. For Kosuth stabilized the notion of a disinterested and self-sufficient art by subjecting both — the Wittgensteinian model of the language game as well as the Duchampian model of the readymade — to the strictures of a model of meaning that operates in the modernist tradition of that paradox Michel Foucault has called modernity's "empirico-transcendental" thought. This is to say that in 1968 artistic production is still the result, for Kosuth, of artistic intention as it constitutes itself above all in self-reflexiveness (even if it is now discursive rather than perceptual, epistemological rather than essentialist).[20]

19. "For many years it has been well known that more people are aware of an artist's work through (1) the printed media or (2) conversation than by direct confrontation with the art itself. For painting and sculpture, where the visual presence — color, scale, size, location — is important to the work, the photograph or verbalization of that work is a bastardization of the art. But when art concerns itself with things not germane to physical presence, its intrinsic (communicative) value is not altered by its presentation in printed media. The use of catalogues and books to communicate (and disseminate) art is the most neutral means to present the new art. The catalogue can now act as the primary information for the exhibition, as opposed to secondary information *about* art in magazines, catalogues, etc. and in some cases the 'exhibition' can be the 'catalogue.'" (Seth Siegelaub, "On Exhibitions and the World at Large" [interview with Charles Harrison], *Studio International,* [December 1969].)
20. This differentiation is developed in Hal Foster's excellent discussion of these paradigmatic differences as they emerge first in Minimalism in his essay "The Crux of Minimalism," in *Individuals* (Los Angeles: The Museum of Contemporary Art, 1986), p. 162–183.

At the very moment when the complementary formations of Pop and Minimal Art had, for the first time, succeeded in criticizing the legacy of American-type formalism and its prohibition of referentiality, this project is all the more astounding. The privileging of the literal over the referential axis of (visual) language—as Greenberg's formalist aesthetic had entailed—had been countered in Pop Art by a provocative devotion to mass-cultural iconography. Then, both Pop and Minimal Art had continuously emphasized the universal presence of industrial means of reproduction as inescapable framing conditions for artistic means of production, or, to put it differently, they had emphasized that the aesthetic of the studio had been irreversibly replaced by an aesthetic of production and consumption. And finally, Pop and Minimal Art had exhumed the repressed history of Duchamp (and Dadaism at large), phenomena equally unacceptable to the reigning aesthetic thought of the late 1950s and early '60s. Kosuth's narrow reading of the readymade is astonishing for yet another reason. In 1969, he explicitly claimed that he had encountered the work of Duchamp primarily through the mediation of Johns and Morris rather than through an actual study of Duchamp's writings and works.[21]

As we have seen above, the first two phases of Duchamp's reception by American artists from the early 1950s (Johns and Rauschenberg) to Warhol and Morris in the early 1960s had gradually opened up the range of implications of Duchamp's readymades.[22] It is therefore all the more puzzling to see that after 1968—what one could call the beginning of the third phase of Duchamp

21. See note 5 above.
22. As Rosalind Krauss has suggested, at least Johns's understanding at that point already transcended the earlier reading of the readymade as merely an aesthetic of declaration and intention:

> If we consider that Stella's painting was involved early on, in the work of Johns, then Johns's interpretation of Duchamp and the readymade—an interpretation diametrically opposed to that of the Conceptualist group outlined above—has some relevance in this connection. For Johns clearly saw the readymade as pointing to the fact that there need be *no* connection between the final art object and the psychological matrix from which it issued, since in the case of the readymade this possibility is precluded from the start. The *Fountain* was not made (fabricated) by Duchamp, only selected by him. Therefore there is no way in which the urinal can "express" the artist. It is like a sentence which is put into the world unsanctioned by the voice of a speaker standing behind it. Because maker and artist are evidently separate, there is no way for the urinal to serve as an externalization of the state or states of mind of the artist as he made it. And by not functioning within the grammar of the aesthetic personality, the *Fountain* can be seen as putting distance between itself and the notion of personality per se. The relationship between Johns's *American Flag* and his reading of the *Fountain* is just this: the arthood of the *Fountain* is not legitimized by its having issued stroke-by-stroke from the private psyche of the artist; indeed it could not. So it is like a man absentmindedly humming and being dumbfounded if asked if he had meant that tune or rather another. That is a case in which it is not clear how the grammar of intention might apply.

Rosalind Krauss, "Sense and Sensibility," *Artforum*, vol. 12 (November 1973), pp. 43–52, n. 4.

reception—the understanding of this model by Conceptual Artists still fore-grounds intentional declaration over contextualization. This holds true not only for Kosuth's "Art after Philosophy," but equally for the British Art & Language Group, as, in the introduction to the first issue of the journal in May 1969, they write:

> To place an object in a context where the attention of any spectator will be conditioned toward the expectancy of recognizing art objects. For example placing what up to then had been an object of alien visual characteristics to those expected within the framework of an art ambience, or by virtue of the artist declaring the object to be an art object whether or not it was in an art ambience. Using these techniques what appeared to be entirely new morphologies were held out to qualify for the status of the members of the class "art objects."
>
> For example Duchamp's "Readymades" and Rauschenberg's "Portrait of Iris Clert."[23]

A few months later Kosuth based his argument for the development of Conceptual Art on just such a restricted reading of Duchamp. For in its limiting view of the history and the typology of Duchamp's oeuvre, Kosuth's argument —like that of Art & Language—focuses exclusively on the "unassisted ready-mades." Thereby early Conceptual theory not only leaves out Duchamp's painterly work but avoids such an eminently crucial work as the *Three Standard Stoppages* (1913), not to mention *The Large Glass* (1915–23) or the *Etants donné* (1946–66) or the 1943 *Boîte en valise*. But what is worse is that even the reading of the unassisted readymades is itself extremely narrow, reducing the readymade model in fact merely to that of an analytical proposition. Typically, both Art & Language and Kosuth's "Art after Philosophy" refer to Robert Rauschenberg's notorious example of speech-act aesthetics ("This is a portrait of Iris Clert if I say so") based on the rather limited understanding of the readymade as an act of willful artistic declaration. This understanding, typical of the early 1950s, continues in Judd's famous lapidary norm (and patently nonsensical statement), quoted a little later in Kosuth's text: "if someone says it's art, then it is art. . . ."

In 1969, Art & Language and Kosuth shared in foregrounding the "analytic proposition" inherent in each readymade, namely the statement "this is a work of art," over and above all other aspects implied by the readymade model (its structural logic, its features as an industrially produced object of use and consumption, its seriality, and the dependence of its meaning on context). And most importantly, according to Kosuth, this means that artistic propositions constitute themselves in the negation of all referentiality, be it that of the historical context of the (artistic) sign or that of its social function and use:

23. Introduction, *Art & Language*, vol. 1, no. 1 (May 1969), p. 5.

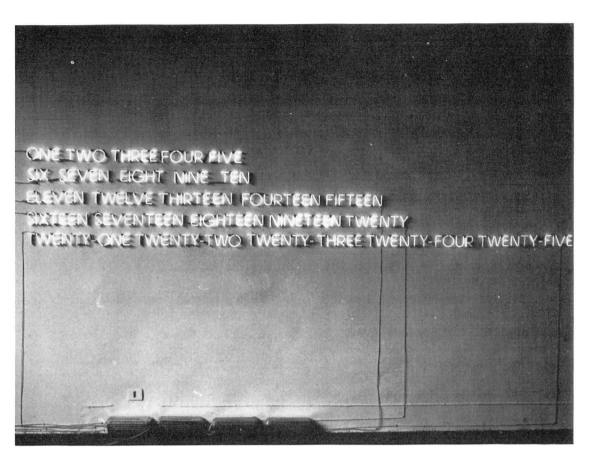

Works of art are analytic propositions. That is, if viewed within their context-as-art, they provide no information what-so-ever about any matter of fact. A work of art is a tautology in that it is a presentation of the artist's intention, that is, he is saying that that particular work of art *is* art, which means, is a *definition* of art. Thus, that it is art is true *a priori* (which is what Judd means when he states that "if someone calls it art, it's art").[24]

Or, a little later in the same year, he wrote in *The Sixth Investigation 1969 Proposition 14* (a text that has mysteriously vanished from the collection of his writings):

If one considers that the forms art takes as being art's language one can realize then that a work of art is a kind of proposition presented within the context of art as a comment on art. An analysis of proposi-

24. Joseph Kosuth, "Art after Philosophy," *Studio International*, nos. 915–917 (October–December 1969). Quoted here from Joseph Kosuth, *The Making of Meaning*, p. 155.

Joseph Kosuth. Five Fives (to Donald Judd). *1965 (?).*

tion types shows art "works" as analytic propositions. Works of art that try to tell us something about the world are bound to fail. . . . The absence of reality in art is exactly art's reality.[25]

Kosuth's programmatic efforts to reinstate a law of discursive self-reflexiveness in the guise of a critique of Greenberg's and Fried's visual and formal self-reflexiveness are all the more astonishing since a considerable part of "Art after Philosophy" is dedicated to the elaborate construction of a genealogy for Conceptual Art, in and of itself a historical project (e.g., "All art [after Duchamp] is conceptual [in nature] because art exists only conceptually"). This very construction of a lineage already contextualizes and historicizes, of course, in "telling us something about the world"—of art, at least; that is, it unwittingly operates like a synthetic proposition (even if only within the conventions of a particular language system) and therefore denies both the purity and the possibility of an autonomous artistic production that would function, within art's own language-system, as mere analytic proposition.

Perhaps one might try to argue that, in fact, Kosuth's renewed cult of the tautology brings the Symbolist project to fruition. It might be said, for example, that this renewal is the logical extension of Symbolism's exclusive concern with the conditions and the theorization of art's own modes of conception and reading. Such an argument, however, would still not allay questions concerning the altered historical framework within which such a cult must find its determination. Even within its Symbolist origins, the modernist theology of art was already gripped by a polarized opposition. For a religious veneration of self-referential plastic form as the pure negation of rationalist and empiricist thought can simultaneously be read as nothing other than the inscription and instrumentalization of precisely that order—even or particularly in its negation—within the realm of the aesthetic itself (the almost immediate and universal application of Symbolism for the cosmos of late nineteenth-century commodity production would attest to this).

This dialectic came to claim its historical rights all the more forcefully in the contemporary, postwar situation. For given the conditions of a rapidly accelerating fusion of the culture industry with the last bastions of an autonomous sphere of high art, self-reflexiveness increasingly (and inevitably) came to shift along the borderline between logical positivism and the advertisement campaign. And further, the rights and rationale of a newly established postwar middle class, one which came fully into its own in the 1960s, could assume their aesthetic identity in the very model of the tautology and its accompanying aesthetic of administration. For this aesthetic identity is structured much the way this class's social identity is, namely, as one of merely administering labor and production (rather than producing) and of the distribution of commodities. This class, having be-

25. Joseph Kosuth, *The Sixth Investigation 1969 Proposition 14.*

come firmly established as the most common and powerful social class of postwar society, is the one which, as H. G. Helms wrote in his book on Max Stirner, "deprives itself voluntarily of the rights to intervene within the political decision-making process in order to arrange itself more efficiently with the existing political conditions."[26]

This aesthetic of the newly established power of administration found its first fully developed literary voice in a phenomenon like the *nouveau roman* of Robbe-Grillet. It was no accident that such a profoundly positivist literary project would then serve, in the American context, as a point of departure for Conceptual Art. But, paradoxically, it was at this very same historical moment that the social functions of the tautological principle found their most lucid analysis, through a critical examination launched in France.

In the early writing of Roland Barthes one finds, simultaneously with the *nouveau roman*, a discussion of the tautological:

> *Tautologie.* Yes, I know, it's an ugly word. But so is the thing. Tauto-logy is the verbal device which consists in defining like by like (*"Drama is drama"*). . . . One takes refuge in tautology as one does in fear, or anger, or sadness, when one is at a loss for an explanation. . . . In tautology, there is a double murder: one kills rationality because it resists one; one kills language because it betrays one. . . . Now any refusal of language is a death. Tautology creates a dead, a motionless world.[27]

Ten years later, at the same moment that Kosuth was discovering it as the central aesthetic project of his era, the phenomenon of the tautological was once again opened to examination in France. But now, rather than being discussed as a linguistic and rhetorical form, it was analyzed as a general social effect: as both the inescapable reflex of behavior and, once the requirements of the advanced culture industry (i.e., advertisement and media) have been put in place in the formation of spectacle culture, a universal condition of experience. What still remains open for discussion, of course, is the extent to which Conceptual Art of a certain type shared these conditions, or even enacted and implemented them in the sphere of the aesthetic—accounting, perhaps, for its subsequent proximity and success within a world of advertisement strategists—or, alternatively, the extent to which it merely inscribed itself into the inescapable logic of a totally administered world, as Adorno's notorious term identified it. Thus Guy Debord noted in 1967:

> The basically tautological character of the spectacle flows from the simple fact that its means are simultaneously its ends. It is the sun

26. Hans G. Helms, *Die Ideologie der anonymen Gesellschaft* (Cologne, 1968), p. 3.
27. Roland Barthes, *Mythologies*, pp. 152–53.

which never sets over the empire of modern passivity. It covers the entire surface of the world and bathes endlessly in its own glory.[28]

A Tale of Many Squares

The visual forms that correspond most accurately to the linguistic form of the tautology are the square and its stereometric rotation, the cube. Not surprisingly, these two forms proliferated in the painterly and sculptural production of the early- to mid-1960s. This was the moment when a rigorous self-reflexiveness was bent on examining the traditional boundaries of modernist sculptural objects to the same extent that a phenomenological reflection of viewing space was insistant on reincorporating architectural parameters into the conception of painting and sculpture.

So thoroughly did the square and the cube permeate the vocabulary of Minimalist sculpture that in 1967 Lucy Lippard published a questionnaire investigating the role of these forms, which she had circulated among many artists. In his response to the questionnaire, Donald Judd, in one of his many attempts to detach the morphology of Minimalism from similar investigations of the historical avant-garde in the earlier part of the twentieth century, displayed the agressive dimension of tautological thought (disguised as pragmatism, as was usual in his case) by simply denying that any historical meaning could be inherent in geometric or stereometric forms:

> I don't think there is anything special about squares, which I don't use, or cubes. They certainly don't have any intrinsic meaning or superiority. One thing though, cubes are a lot easier to make than spheres. The main virtue of geometric shapes is that they are not organic, as all art otherwise is. A form that's neither geometric nor organic would be a great discovery.[29]

As the central form of visual self-reflexiveness, the square abolishes the traditional spatial parameters of verticality and horizontality, thereby canceling the metaphysics of space and its conventions of reading. It is in this way that the square (beginning with Malevich's 1915 *Black Square*) incessantly points to itself:

28. Guy Debord, *The Society of the Spectacle* (Detroit: Black & Red, 1970), n. p., section 13. First published, Paris, 1967.
29. Donald Judd, in Lucy Lippard, "Homage to the Square," *Art in America* (July–August, 1967), pp. 50–57. How pervasive the square actually was in the art of the early- to mid-1960s is all too obvious: the work from the late '50s, such as paintings by Reinhardt and Ryman and a large number of sculptures from the early 1960s onwards (Andre, LeWitt, and Judd), deployed the tautological form in endless variations. Paradoxically even Kosuth's work from the mid-1960s — while emphasizing its departure from painting's traditional object status and visual/formal design — continues to display the definitions of words on large, black, canvas *squares*. By contrast one only has to think of Jasper Johns's or Barnett Newman's work as immediate predecessors of that generation to recognize how infrequent, if not altogether absent, the square was at that moment.

as spatial perimeter, as plane, as surface, and, functioning simultaneously, as support. But, with the very success of this self-referential gesture, marking the form out as purely pictorial, the square painting paradoxically but inevitably assumes the character of a relief/object situated in actual space. It thereby invites a viewing/reading of spatial contingency and architectural imbeddedness, insisting on the imminent and irreversible transition from painting to sculpture.

This transition was performed in the proto-Conceptual art of the early- to mid-1960s in a fairly delimited number of specific pictorial operations. It occurred, first of all, through the emphasis on painting's *opacity.* The object-status of the painterly structure could be underscored by unifying and homogenizing its surface through monochromy, serialized texture, and gridded compositional structure; or it could be emphasized by literally sealing a painting's spatial transparency, by simply altering its material support: shifting it from canvas to unstretched fabric or metal. This type of investigation was developed systematically, for example, in the proto-Conceptual paintings of Robert Ryman, who employed all of these options separately or in varying combinations in the early- to mid-1960s; or, after 1965, in the paintings of Robert Barry, Daniel Buren, and Niele Toroni.

Secondly — and in a direct inversion and countermovement to the first — object-status could be achieved by emphasizing, in a literalist manner, painting's *transparency.* This entailed establishing a dialectic between pictorial surface, frame, and architectural support by either a literal opening up of the painterly support, as in Sol LeWitt's early *Structures,* or by the insertion of translucent or transparent surfaces into the conventional frame of viewing, as in Ryman's fiberglass paintings, Buren's early nylon paintings, or Michael Asher's and Ger-

hard Richter's glass panes in metal frames, both emerging between 1965 and 1967. Or, as in the early work of Robert Barry (such as his *Painting in Four Parts,* 1967, in the FER-Collection), where the square, monochrome, canvas objects now seemed to assume the role of mere architectural demarcation. Functioning as decentered painterly objects, they delimit the *external* architectural space in a manner analogous to the serial or central composition of earlier Minimal work that still defined internal pictorial or sculptural space. Or, as in Barry's square canvas (1967), which is to be placed at the exact center of the architectural support wall, a work is conceived as programmatically shifting the reading of it from a centered, unified, pictorial object to an experience of architectural contingence, and as thereby incorporating the supplementary and overdetermining strategies of curatorial placement and conventions of installation (traditionally disavowed in painting and sculpture) into the *conception* of the work itself.

And thirdly — and most often — this transition is performed in the "simple" rotation of the square, as originally evident in Naum Gabo's famous diagram from 1937 where a volumetric and a stereometric cube are juxtaposed in order to clarify the inherent continuity between planar, stereometric, and volumetric forms. This rotation generated cubic structures as diverse as Hans Haacke's *Condensation Cube* (1963–65), Robert Morris's *Four Mirrored Cubes* (1965), or Larry Bell's simultaneously produced *Mineral Coated Glass Cubes,* and

Sol LeWitt's *Wall-Floor Piece (Three Squares),* 1966. All of these (beyond sharing the obvious morphology of the cube) engage in the dialectic of opacity and transparency (or in the synthesis of that dialectic in mirror-reflection as in Morris's *Mirrored Cubes* or Larry Bell's aestheticized variations of the theme). At the same time that they engage in the dialectic of frame and surface, and that of object and architectural container, they have displaced traditional figure-ground relationships.

The deployment of any or all of these strategies (or, as in most cases, their varying combination) in the context of Minimal and post-Minimal art, i.e., proto-conceptual painting and sculpture, resulted in a range of hybrid objects. They no longer qualified for either of the traditional studio categories nor could they be identified as relief or architectural decoration — the compromise terms traditionally used to bridge the gap between these categories. In this sense, these objects demarcated another spectrum of departures towards Conceptual Art. Not only did they destabilize the boundaries of the traditional artistic categories of studio production, by eroding them with modes of industrial production in the manner of Minimalism, but they went further in their critical revision of the discourse of the studio versus the discourse of production/consumption. By ultimately dismantling both along with the conventions of visuality inherent in them, they firmly established an aesthetic of administration.

The diversity of these protoconceptual objects would at first suggest that their actual aesthetic operations differ so profoundly that a comparative reading, operating merely on the grounds of their apparent analogous formal and morphological organization — the visual topos of the square — would be illegitimate. Art history has accordingly excluded Haacke's *Condensation Cube,* for example, from any affiliation with Minimal Art. Yet all of these artists define artistic production and reception by the mid-1960s as reaching beyond the traditional thresholds of visuality (both in terms of the materials and production procedures of the studio and those of industrial production), and it is on the basis of this parallel that their work can be understood to be linked beyond a mere structural or morphological analogy. The proto-conceptual works of the mid-1960s redefine aesthetic experience, indeed, as a multiplicity of *nonspecialized* modes of object- and language-experience. According to the reading these objects generate, aesthetic experience — as an individual and social investment of objects with meaning — is constituted by *linguistic* as well as by *specular* conventions, by the institutional determination of the object's status as much as by the reading competence of the spectator.

Within this shared conception, what goes on to distinguish these objects from each other is the emphasis each one places on different aspects of that deconstruction of the traditional concepts of visuality. Morris's *Mirrored Cubes,* for example (once again in an almost literal execution of a proposal found in Duchamp's *Green Box*), situate the spectator in the *suture* of the mirror reflection: that interface between sculptural object and architectural container where neither element can acquire a position of priority or dominance in the triad between spectator, sculptural object, and architectural space. And in so far as the work acts simultaneously to inscribe a phenomenological model of experience into a traditional model of purely visual specularity and to displace it, its primary focus remains the sculptural object and its visual apperception.

By contrast, Haacke's *Condensation Cube* — while clearly suffering from a now even more rigorously enforced scientistic reductivism and the legacy of modernism's empirical positivism — moves away from a specular relationship to the object altogether, establishing instead a bio-physical system as a link between viewer, sculptural object, and architectural container. If Morris shifts the viewer from a mode of contemplative specularity into a phenomenological loop of bodily movement and perceptual reflection, Haacke replaces the once revolutionary concept of an activating "tactility" in the viewing experience by a move to bracket the phenomenological within the determinacy of "system." For his work now suspends Morris's tactile "viewing" within a science-based syntagm (in this particular case that of the process of condensation and evaporation inside the cube brought about by temperature changes due to the frequency of spectators in the gallery).

And finally, we should consider what is possibly the last credible transformation of the square, at the height of Conceptual Art in 1968, in two works by

Lawrence Weiner, respectively entitled *A Square Removal from a Rug in Use* and *A 36″ × 36″ Removal to the Lathing or Support Wall of Plaster or Wallboard from a Wall* (both published or "reproduced" in *Statements,* 1968), in which the specific paradigmatic changes Conceptual Art initiates with regard to the legacy of reductivist formalism are clearly evident. Both interventions — while maintaining their structural and morphological links with formal traditions by respecting classical geometry as their definition at the level of shape — inscribe themselves in the support surfaces of the institution and/or the home which that tradition had always disavowed. The carpet (presumably for sculpture) and the wall (for painting), which idealist aesthetics always declares as mere "supplements," are foregrounded here not only as parts of their material basis but as the inevitable future location of the work. Thus the structure, location, and materials of the intervention, at the very moment of their conception, are completely determined by their future destination. While neither surface is explicitly specified in terms of its institutional context, this ambiguity of dislocation generates two oppositional, yet mutually complementary readings. On the one hand, it dissipates the traditional expectation of encountering the work of art only in a "specialized" or "qualified" location (both "wall" and "carpet" could be either those of the home or the museum, or, for that matter, could just as well be found in any other location such as an office, for example). On the other, neither one of these surfaces could ever be considered to be independent from its institutional location, since the physical inscription into each particular surface inevitably generates contextual readings dependent upon the institutional conventions and the particular use of those surfaces in place.

Lawrence Weiner. A 36″ x 36″ Square Removal to the Wallboard or Lathing from a Wall. 1968.

Transcending the literalist or perceptual precision with which Barry and Ryman had previously connected their painterly objects to the traditional walls of display, in order to make their physical and perceptual interdependence manifest, Weiner's two squares are now physically integrated with *both* these support surfaces and their institutional definition. Further, since the work's inscription paradoxically implies the physical displacement of the support surface, it engenders an experience of perceptual withdrawal as well. And just as the work negates the specularity of the traditional artistic object by literally withdrawing rather than adding visual data in the construct, so this act of *perceptual* withdrawal operates at the same time as a physical (and symbolic) intervention in the institutional power and property relations underlying the supposed neutrality of "mere" devices of presentation. The installation and/or acquisition of either of these works requires that the future owner accept an instance of physical removal/withdrawal/interruption on both the level of institutional order and on that of private ownership.

It was only logical that, on the occasion of Seth Siegelaub's first major exhibition of Conceptual Art, the show entitled *January 5-31, 1969,* Lawrence Weiner would have presented a formula that then functioned as the matrix underlying all his subsequent propositions. Specifically addressing the relations within which the work of art is constituted as an open, structural, syntagmatic formula, this matrix statement defines the parameters of a work of art as those of the conditions of authorship and production, and their interdependence with those of ownership and use (and not least of all, at its own propositional level, as a *linguistic definition* contingent upon and determined by *all* of these parameters in their continuously varying and changing constellations:

> *With relation to the various manners of use:*
> *1. The artist may construct the piece*
> *2. The piece may be fabricated*
> *3. The piece need not to be built*
> *Each being equal and consistent with the intent of the artist the decision as to condition rests with the receiver upon the occasion of receivership*

What begins to be put in play here, then, is a critique that operates at the level of the aesthetic "institution." It is a recognition that materials and procedures, surfaces and textures, locations and placement are not only sculptural or painterly matter to be dealt with in terms of a phenomenology of visual and cognitive experience or in terms of a structural analysis of the sign (as most of the Minimalist and post-Minimalist artists had still believed), but that they are always already inscribed within the conventions of language and thereby within institutional power and ideological and economic investment. However, if, in Weiner's and Barry's work of the late 1960s, this recognition still seems merely latent, it was to become manifest very rapidly in the work of European artists of the same generation, in particular that of Marcel Broodthaers, Daniel Buren, and Hans

Haacke after 1966. In fact an institutional critique became the central focus of all three artists' assaults on the false neutrality of vision that provides the underlying rationale for those institutions.

In 1965, Buren—like his American peers—took off from a critical investigation of Minimalism. His early understanding of the work of Flavin, Ryman, and Stella rapidly enabled him to develop positions from within a strictly painterly analysis that soon led to a reversal of painterly/sculptural concepts of visuality altogether. Buren was engaged on the one hand with a critical review of the legacy of advanced modernist (and postwar American) painting and on the other in an analysis of Duchamp's legacy, which he viewed critically as the utterly unacceptable negation of painting. This particular version of reading Duchamp and the readymade as acts of petit-bourgeois anarchist radicality—while not necessarily complete and accurate—allowed Buren to construct a successful critique of both: modernist painting and Duchamp's readymade as its radical historical Other. In his writings and his interventions from 1967 onwards, through his critique of the specular order of painting and of the institutional

Daniel Buren. Installation at the Guggenheim International Exhibition. 1971.

Buren, Mosset, Parmentier, Toroni. Manifestation Number Four, September 1967, Fifth Biennale de Paris, Musée d'art moderne de la Ville de Paris.

framework determining it, Buren singularly succeeded in displacing *both* the paradigms of painting and that of the readymade (even twenty years later this critique makes the naive continuation of object production in the Duchampian vein of the readymade model appear utterly irrelevant).

From the perspective of the present, it seems easier to see that Buren's assault on Duchamp, especially in his crucial 1969 essay *Limites Critiques*, was primarily directed at the conventions of Duchamp *reception* operative and predominant throughout the late 1950s and early '60s, rather than at the actual implications of Duchamp's model itself. Buren's central thesis was that the fallacy of Duchamp's readymade was to obscure the very institutional and discursive framing conditions that allowed the readymade to generate its shifts in the assignment of meaning and the experience of the object in the first place. Yet, one could just as well argue, as Marcel Broodthaers would in fact suggest in his catalogue of the exhibition *The Eagle from the Oligocene to Today* in Düsseldorf in 1972, that the contextual definition and syntagmatic construction of the work of art had obviously been initiated by Duchamp's readymade model first of all.

In his systematic analysis of the constituting elements of the discourse of painting, Buren came to investigate all the parameters of artistic production and reception (an analysis that, incidentally, was similar to the one performed by Lawrence Weiner in arriving at his own "matrix" formula). Departing from Minimalism's (especially Ryman's and Flavin's) literalist dismemberment of painting, Buren at first transformed the pictorial into yet another model of opacity and objecthood. (This was accomplished by physically weaving figure and

ground together in the "found" awning material, by making the "grid" of vertical parallel stripes his eternally repeated "tool," and by mechanically— almost superstitiously or ritualistically, one could say with hindsight—applying a coat of white paint to the outer bands of the grid in order to distinguish the pictorial object from a readymade.) At the same time that the canvas had been removed from its traditional stretcher support to become a physical cloth-object (reminiscent of Greenberg's notorious "tacked up canvas [which] already exists as a picture"), this strategy in Buren's arsenal found its logical counterpart in the placement of the *stretched* canvas leaning as an object against support wall and floor.

This shifing of support surfaces and procedures of production led to a wide range of forms of distribution within Buren's work: from unstretched canvas to anonymously mailed sheets of printed striped paper; from pages in books to billboards. In the same way, his displacement of the traditional sites of artistic intervention and of reading resulted in a multiplicity of locations and forms of display that continuously played on the dialectic of interior and exterior, thereby oscillating within the contradictions of sculpture and painting and foregrounding all those hidden and manifest framing devices that structure both traditions within the discourse of the museum and the studio.

Furthermore, enacting the principles of the Situationist critique of the bourgeois division of creativity according to the rules of the division of labor, Buren, Olivier Mosset, Michel Parmentier, and Niele Toroni publicly performed (on various occasions between 1966 and 1968) a demolition of the traditional separation between artists and audience, with each given their respective roles. Not only did they claim that each of their artistic idioms be considered as absolutely equivalent and interchangeable, but also that anonymous audience production of these pictorial signs would be equivalent to those produced by the artists themselves.

With its stark reproductions of mug shots of the four artists taken in photomats, the poster for their fourth manifestation at the 1967 Biennale de Paris inadvertently points to another major source of contemporary challenges to the notion of artistic authorship linked with a provocation to the "audience" to participate: the aesthetic of anonymity as practiced in Andy Warhol's "Factory" and its mechanical (photographic) procedures of production.[30]

The critical interventions of the four into an established but outmoded cultural apparatus (represented by such venerable and important institutions as the Salon de la Jeune Peinture or the Biennale de Paris) immediately brought out in the open at least one major paradox of all conceptual practices (a paradox,

30. Michel Claura, at the time the critic actively promoting awareness of the affiliated artists Buren, Mosset, Parmentier, and Toroni, has confirmed in a recent conversation that the reference to Warhol, in particular to his series *The Thirteen Most Wanted Men*, which had been exhibited at the Ileana Sonnabend Gallery in 1967, was quite a conscious decision.

incidentally, which had made up the single most original contribution of Yves Klein's work ten years before). This was that the critical annihilation of cultural conventions itself immediately acquires the conditions of the spectacle, that the insistence on artistic anonymity and the demolition of authorship produces instant brand names and identifiable products, and that the campaign to critique conventions of visuality with textual interventions, billboard signs, anonymous handouts, and pamphlets inevitably ends by following the preestablished mechanisms of advertising and marketing campaigns.

All of the works mentioned coincide, however, in their rigorous redefinition of relationships between audience, object, and author. And all are concerted in the attempt to replace a traditional, hierarchical model of privileged experience based on authorial skills and acquired competence of reception by a structural relationship of absolute equivalents that would dismantle both sides of the equation: the hieratic position of the unified artistic object just as much as the privileged position of the author. In an early essay (published, incidentally, in the same 1967 issue of *Aspen Magazine* — dedicated by its editor Brian O'Doherty to Stéphane Mallarmé — in which the first English translation of Roland Barthes's "The Death of the Author" appeared), Sol LeWitt laid out these concerns for a programmatic redistribution of author/artist functions with astonishing clarity, presenting them by means of the rather surprising metaphor of a performance of daily bureaucratic tasks:

> The aim of the artist would be to give viewers information. . . . He would follow his predetermined premise to its conclusion avoiding subjectivity. Chance, taste or unconsciously remembered forms would play no part in the outcome. The serial artist does not attempt to produce a beautiful or mysterious object but functions *merely as a clerk cataloguing the results of his premise* (italics added).[31]

Inevitably the question arises how such restrictive definitions of the artist as a cataloguing clerk can be reconciled with the subversive and radical implications of Conceptual Art. And this question must simultaneously be posed within the specific historical context in which the legacy of an historical avant-garde — Constructivism and Productivism — had only recently been reclaimed. How, we might ask, can these practices be aligned with that historical production that artists like Henry Flynt, Sol LeWitt, and George Maciunas had rediscovered, in the early '60s, primarily through the publication of Camilla Gray's *The Great Experiment: Russian Art 1863–1922*.[32] This question is of particular importance since many of the formal strategies of early Conceptual Art appear at first glance

31. Sol LeWitt, "Serial Project #1, 1966," *Aspen Magazine*, nos. 5–6, ed. Brian O'Doherty, 1967, n. p.
32. The importance of this publication in 1962 was mentioned to me by several of the artists interviewed during the preparation of this essay.

to be as close to the *practices* and *procedures* of the Constructivist/Productivist avant-garde as Minimal sculpture had appeared to be dependent upon its *materials* and *morphologies*.

The profoundly utopian (and now unimaginably naive) nature of the claims associated with Conceptual Art at the end of the 1960s were articulated by Lucy Lippard (along with Seth Siegelaub, certainly the crucial exhibition organizer and critic of that movement) in late 1969:

> Art intended as pure experience doesn't exist until someone experiences it, defying ownership, reproduction, sameness. Intangible art could break down the artificial imposition of "culture" and provide a broader audience for a tangible, object art. When automatism frees millions of hours for leisure, art should gain rather than diminish in importance, for while art is not just play, it is the counterpoint to work. The time may come when art is everyone's daily occupation, though there is no reason to think this activity will be called art.[33]

While it seems obvious that artists cannot be held responsible for the culturally and politically naive visions projected on their work even by their most competent, loyal, and enthusiastic critics, it now seems equally obvious that it was precisely the utopianism of earlier avant-garde movements (the type that Lippard desperately attempts to resuscitate for the occasion) that was manifestly absent from Conceptual Art throughout its history (despite Robert Barry's onetime invocation of Herbert Marcuse, declaring the commercial gallery as "Some places to which we can come, and for a while 'be free to think about what we are going to do'"). It seems obvious, at least from the vantage of the early 1990s, that from its inception Conceptual Art was distinguished by its acute sense of discursive and institutional limitations, its self-imposed restrictions, its lack of totalizing vision, its critical devotion to the factual conditions of artistic production and reception without aspiring to overcome the mere facticity of these conditions. This became evident as works such as Hans Haacke's series of *Visitors' Profiles* (1969–70), in its bureaucratic rigor and deadpan devotion to the statistic collection of factual information, came to refuse any transcendental dimension whatsoever.

Furthermore, it now seems that it was precisely a profound disenchantment with those political master-narratives that empowered most of '20s avant-garde art that, acting in a peculiar fusion with the most advanced and radical forms of critical artistic reflection, accounts for the peculiar contradictions operating within (proto) Conceptual Art of the mid- to late-1960s. It would explain why this generation of the early '60s — in its growing emphasis on empiricism and its scepticism with regard to all utopian vision — would be attracted, for example, to

33. Lucy Lippard, "Introduction," in *955.000* (Vancouver: The Vancouver Art Gallery, January 13–February 8, 1970), n. p.

Buren, Mosset, Parmentier, Toroni. Installation at
Marcel Broodthaers's Museum (Plaque). 1971.

the logical positivism of Wittgenstein and would confound the affirmative petit-
bourgeois positivism of Alain Robbe-Grillet with the radical atopism of Samuel
Beckett, claiming all of them as their sources. And it would make clear how this
generation could be equally attracted by the conservative concept of Daniel Bell's
"end of ideology" and Herbert Marcuse's Freudo-Marxist philosophy of
liberation.

What Conceptual Art achieved at least temporarily, however, was to subject
the last residues of artistic aspiration toward transcendence (by means of tradi-
tional studio skills and privileged modes of experience) to the rigorous and
relentless order of the vernacular of administration. Furthermore, it managed to
purge artistic production of the aspiration towards an affirmative collaboration
with the forces of industrial production and consumption (the last of the totaliz-
ing experiences into which artistic production had mimetically inscribed itself
with credibility in the context of Pop Art and Minimalism for one last time).

Paradoxically, then, it would appear that Conceptual Art truly became the
most significant paradigmatic change of postwar artistic production at the very

moment that it mimed the operating logic of late capitalism and its positivist instrumentality in an effort to place its auto-critical investigations at the service of liquidating even the last remnants of traditional aesthetic experience. In that process it succeeded in purging itself entirely of imaginary and bodily experience, of physical substance and the space of memory, to the same extent that it effaced all residues of representation and style, of individuality and skill. That was the moment when Buren's and Haacke's work from the late 1960s onward turned the violence of that mimetic relationship back onto the ideological apparatus itself, using it to analyze and expose the social institutions from which the laws of positivist instrumentality and the logic of administration emanate in the first place. These institutions, which determine the conditions of cultural consumption, are the very ones in which artistic production is transformed into a tool of ideological control and cultural legitimation.

It was left to Marcel Broodthaers to construct objects in which the radical achievements of Conceptual Art would be turned into immediate travesty and in which the seriousness with which Conceptual Artists had adopted the rigorous mimetic subjection of aesthetic experience to the principles of what Adorno had called the "totally administered world" were transformed into absolute farce. And it was one of the effects of Broodthaers's dialectics that the achievement of Conceptual Art was revealed as being intricately tied to a profound and irreversible loss: a loss not caused by artistic practice, of course, but one to which that practice responded in the full optimism of its aspirations, failing to recognize that the purging of image and skill, of memory and vision, within visual aesthetic representation was not just another heroic step in the inevitable progress of Enlightenment to liberate the world from mythical forms of perception and hierarchical modes of specialized experience, but that it was also yet another, perhaps the last of the erosions (and perhaps the most effective and devastating one) to which the traditionally separate sphere of artistic production had been subjected in its perpetual efforts to emulate the regnant episteme within the paradigmatic frame proper to art itself.

Or worse yet, that the Enlightenment-triumph of Conceptual Art—its transformation of audiences and distribution, its abolition of object status and commodity form—would most of all only be shortlived, almost immediately giving way to the return of the ghostlike reapparitions of (prematurely?) displaced painterly and sculptural paradigms of the past. So that the specular regime, which Conceptual Art claimed to have upset, would soon be reinstated with renewed vigor. Which is of course what happened.

Louise Bourgeois. Cell (Eyes and
Mirrors). *1989–93.*
(Photo: Peter Bellamy.)

Bad Enough Mother

MIGNON NIXON

Mouths

We came to recognize the father's penis and a growing feeling of aggression against it in many forms, the desire to eat and destroy it being specially prominent. For example, on one occasion, [my four-year-old patient] Dick lifted a little toy man to his mouth, gnashed his teeth and said "Tea Daddy," by which he meant "Eat Daddy." He then asked for a drink of water.

—Melanie Klein

Once when we were sitting together at the dining table, I took white bread, mixed it with spit, and molded a figure of my father. When the figure was done, I started cutting off the limbs with a knife. I see this as my first sculptural solution.

—Louise Bourgeois

I was interested in the bite because it's both intimate and destructive; it sort of sums up my relationship to art history.

—Janine Antoni

Pondick's creatures seem to experience life through their mouths, rather than their eyes, as if they were babies.

—Elizabeth Hess

As Mary Jacobus has recently observed, "the current return to Klein ... feels like eating one's words."[1] Or, to put it another way, maybe it feels like eating

1. Mary Jacobus, "'Tea Daddy': Poor Mrs. Klein and the Pencil Shavings," *Women: A Cultural Review* 2 (Summer 1990), special issue, "Positioning Klein," p. 160.

Lacan. And how better to enact this cannibalistic desire to eat-Lacan-by-eating-his-words than through a return to Klein—the psychoanalyst whose object relations school Lacan himself deemed "incapable of even so much as suspecting the existence of the category of the signifier"—even if that return risks, as Jacobus says, "a kind of theoretical regression"?[2]

The putative regression of some feminist psychoanalytic theory from Lacanian to Kleinian modes of analysis is not so much my concern here, however, as are uses of the body in contemporary feminist art practices that also are often framed in terms of theoretical regression. This regression is charted as moving from an investigation of the signifier grounded in poststructuralist theory and a Lacanian account of sexual difference to a literal and essentialist conception of the body.

It will be my purpose here to read this recent shift as it appears in specific instances of feminist work in psychoanalytic terms: namely, as a turn to the drives.[3] Accordingly, I will be analyzing it not as a regression but as a repositioning and not as the revenge of the essentialized nineties body on the textual eighties body but as, in part, a critique of psychoanalytic feminist work of the 1970s and '80s as privileging pleasure and desire over hatred and aggression.[4] For as Jacqueline Rose observed in 1988, "If psychoanalysis is the intellectual tabloid of our culture ('sex' and 'violence' being its chief objects of concern), then we have recently privileged—ought indeed to base the politicization of psychoanalysis on that privilege—the first over the second."[5] And as Kobena Mercer noted in 1994, "There is no shortage of text-centered studies of pleasure and desire, but where are the analyses of pain and hatred as everyday structures of feeling too?"[6] I will suggest that the investigation of aggression in some recent feminist work can be related to this critique of Lacanian-based psychoanalytic studies. And I will propose that the shift in emphasis from neurosis to psychosis and from sexuality to the death drive effected by Melanie Klein's work in the 1940s and '50s offers a

2. *Ibid.* Jacobus's statement reads in full: "One response to the current return to Klein: it feels like eating one's words. Psychoanalytic feminism has been so thoroughly immersed in Lacanian theory for the past decade that taking Klein at her word—reading her literally, as she asks to be read—seems to risk a kind of theoretical regression."

3. Insofar as I will be arguing that this turn organizes a field that operates outside the binaries of gender, my analysis intends to open up a third option in the conflict between the operations of the signifier and of biological essentialism. In this sense, this text offers my own response to Question 1 as posed by Silvia Kolbowski and me as editors of this issue.

4. For a discussion of how recent reexaminations of Klein function as a critique of the Lacanian psychoanalytic model, see Ann Scott's "Melanie Klein and the Questions of Feminism" in "Positioning Klein," p. 129. As Scott observes, however, "This movement of thought remains dialectical, to-and-fro; Juliet Mitchell and Vivien Bar have reinstated the commentary on Klein from a Lacanian perspective and remind us that all theorisations within psychoanalysis set up their own counterpoint."

5. Jacqueline Rose, "Sexuality and Vision: Some Questions," in *Vision and Visuality*, ed. Hal Foster (Seattle: Bay Press, 1988), p. 121. Quoted in Kobena Mercer, "Fear of a Black Penis," *Artforum* vol. 32 (April 1994), p. 122.

6. Mercer, "Fear of a Black Penis," p. 122.

possible framework for analyzing this tension between Lacanian-based feminist projects of the 1970s and '80s and recent work that I will argue is Kleinian-based.[7]

The turn in some recent feminist art from a Lacanian-based semiotic analysis of the body to a Kleinian-based object-relations analysis does not enact a regression, at least in Kleinian terms, precisely because regression is no more operative in the Kleinian model than is the signifier. According to Klein, psychic life is structured by unconscious fantasies driven by bodily experiences, and these fantasies, present from early infancy, persist not as states into which the subject may regress, but as ever-present positions in which, as Juliet Mitchell has written, "one is sometimes lodged."[8] In the Kleinian model of subjectivity, then, regression, like the signifier, scarcely exists.

As Mitchell has noted, "for Klein the past and the present are one . . . what she is observing, describing, and theorizing is the very absence of history and of historical time."[9] For counter to a historical, or developmental, model of the psyche, Klein theorizes a nonlinear, horizontal play of positions in which the radically decentered subject, defined by its relation to objects, moves between positions that are never either secured or foreclosed. Thus, the move from the gendered to the infantile body that in a Lacanian framework would constitute a regression, functions in Kleinian terms simply as a shift of position along the horizontal axis of a model that theorizes, as Mitchell has written, "the very absence of history."[10]

Kleinian-based work, structured by object relations, operates in the atemporal field of infantile experience rather than the temporal-linguistic field of the Oedipal subject that is mapped by Lacanian-based work. A Kleinian-based analysis would, then, have to be grounded in Klein's theory of fantasy as produced by bodily drives, of such fantasy as the primary structuring principle of psychic experience. Constructing her model of subjectivity around the infant, and so in relation to an immediate and fragmented bodily experience unmediated by language, Klein places at the center of her model not the unconscious, but fantasy—fantasy understood not as a work of the unconscious mind, but as a bodily operation. The Kleinian subject relates to its environment as a field of objects to be fused or split, possessed or destroyed, by means of fantasies of introjection, projection, and splitting that are produced by bodily drives.

To return, then, to the epigraphs with which I began, eating, for example, might produce a complex fantasy of incorporating a good object and of devouring

7. This is not to suggest a fixed temporal or theoretical divide between body-centered feminist projects of the 1970s and '80s and those of the 1990s; in fact, feminist art practices of both periods are extremely diverse. But there does appear to be a shift away from a semiotic analysis of the body of pleasure and desire to an object-relations analysis of the body of aggression and the death drive in some recent work, and it is this move that I will consider here.
8. Juliet Mitchell, ed., *The Selected Melanie Klein* (New York: The Free Press, 1986), Introduction, p. 28.
9. *Ibid.*, p. 29.
10. *Ibid.*

a bad one—of cutting an object into bits that, once swallowed, might turn into a swarm of internal persecutors. Klein asserts that it is through infantile oral sadism that the subject experiences the destructive effects of its own aggression. In effect, subjectivity forms around an experience of loss enacted through destructive fantasies; it is, we could say, formed by the mouth in the act of biting. Using Klein's case history of her four-year-old patient Dick to mediate three exhibitions—a 1974 installation by Louise Bourgeois entitled *The Destruction of the Father*, Janine Antoni's 1992 *Gnaws*, and a 1994 exhibition of Rona Pondick's *Legs*, *Mouth*, and *Milk Milk*—I will examine the structuring of these works through oral-sadistic fantasy and will also consider how they position the subject of aggression.

Bourgeois's oral-sadistic fantasy of dismembering and devouring her father's body is the double of another one, the desire to eat his words, for the fantasy enacted in *The Destruction of the Father*, simply stated, is that in order to shut the father up it is necessary to eat him up. This is Bourgeois's now well-known description of the work:

> It is basically a table, the awful, terrifying family dinner table headed by the father who sits and gloats. And the others, the wife, the children, what can they do? They sit there, in silence. The mother of course tries to satisfy the tyrant, her husband. The children are full of exasperation. We were three children: my brother, my sister, and myself. There were also two extra children my parents adopted because their father had been killed in the war. So we were five. My father would get nervous looking at us, and he would explain to all of us what a great man he was. So, in exasperation, we grabbed the man, threw him on the table, dismembered him, and proceeded to devour him.[11]

In this fantasy of devouring the father, eating takes the place of naming in a substitution of oral sadism for speech that is at once Kleinian and anti-Lacanian.[12] The little girl's desire to speak and her frustration at being silenced is transposed into another desire for oral power and pleasure—the desire to bite, to cut, to devour the one who oppresses with his speech. The desire to talk back to the father is transformed in fantasy into the desire to turn the social ritual of the family meal with its sublimated conditions of cutting and biting into a cannibalistic ceremony in which the father's power, his words, are consumed and incorporated by the children in the eating of his flesh.

Thus, Bourgeois turns "a Kleinian account of eating (cannibalism, even), incorporation, and primary identification," as Jacobus describes the case of

11. Louise Bourgeois, quoted in Jean Frémon, *Louise Bourgeois: Retrospective* 1947–1984, exhibition catalogue (Paris: Galerie Maeght Lelong, 1984).
12. Bourgeois's vigorous criticism of Lacan is well known. It is worth noting in this context that her antagonism for him is specifically as a figure of the father.

Louise Bourgeois. The Destruction of the Father. *1974. (Photo: Peter Moore.)*

Klein's patient little Dick, against a Lacanian account of the entry into subjectivity via language.[13] Performed under the title *The Destruction of the Father*, this critique of Lacan through Klein, framed as an attack on language through biting, on Oedipal naming through pre-Oedipal oral sadism, stages an assault on patriarchy from the infantile position. Dragging the paternal body onto the table, and thus repositioning it on the horizontal axis of infantile experience where it functions as an object of oral-sadistic fantasy, Bourgeois subverts the name-of-the-father logic of Lacanian theory through a destruction-of-the-father, part-object logic based in the Kleinian model. And, as I will suggest, it is in part through the reception of Bourgeois's work that the Kleinian model has recently been taken up and employed critically by a number of artists in relation to 1970s and '80s Lacanian-based work.

The desire to eat the father and to eat his words is, as Bourgeois's statement makes explicit, turned into the desire for sculptural solutions or, we could say, for object solutions—a sculptural solution being, in Bourgeois's terms, one that performs an aggressive or desiring operation on an object. For as she demonstrates with her dinner table story, the sculpture comes into being as the object of aggressive fantasy—as something to bite or to cut, to incorporate or to destroy.[14]

13. Jacobus, "Poor Mrs. Klein," p. 162.
14. Bourgeois's sculptural operations may also be organized by fantasies of reparation, of restoring the object perceived to be damaged by destructive fantasies.

In Klein's case history of the affectless four-year-old boy named Dick (a case analyzed in great detail by Jacques Lacan), the little patient arrives at a similar object solution.[15]

Dick, Klein reported, seldom played or spoke, except to string sounds together in meaningless sequences, and seemed completely detached from the people around him, including his parents and nurse, whom he tended to treat, as Klein observed, like so many pieces of furniture. The analyst theorized that her little patient was the victim of an anxiety so intense it manifested itself as an eerie absence, the absence, precisely, of any trace of anxiety. Employing her model of infantile fantasy, Klein concluded that Dick had as a baby become deeply disturbed by his own sadistic impulses to attack his mother's body, a body that contained, in fantasy, the father's penis (among other things). Through an interplay that is the pivot point of the Kleinian model, Dick feared, according to Klein, both his own sadistic desires and retaliatory assaults from the object of those attacks. And in order to defend himself against this fantasied destruction by the father's penis, precipitated by his own sadistic fantasy, Dick closed himself off from all desire, and thus all anxiety.

One key symptom of Dick's inability to tolerate anxiety was his refusal to bite into food. Another was his inability to grip knives or scissors. On one occasion,

15. Melanie Klein, "The Importance of Symbol Formation in the Development of the Ego" (1930), in *The Selected Melanie Klein*. For Lacan's critique of this case study, see "Discourse Analysis and Ego Analysis" and "The Topic of the Imaginary" in *The Seminar of Jacques Lacan, Book I, Freud's Papers on Technique 1953–1954*, ed. Jacques-Alain Miller, trans. John Forrester (New York: W. W. Norton & Company, 1991). For discussions of Lacan's reading of Klein, see Shoshana Felman, *Jacques Lacan and the Adventure of Insight: Psychoanalysis in Contemporary Culture* (Cambridge: Harvard University Press, 1987), chapter 5, "Beyond Oedipus: The Specimen Study of Psychoanalysis" and Jacobus, "Poor Mrs. Klein."

Lacan's complex critique of this case study, which turns on his assessment that Klein has confused the registers of the symbolic and the imaginary, cannot be summarized here. But it should be noted that Lacan's analysis shifts between condemnation of what he sees as Klein's literalistic approach and acknowledgment of the breakthrough she achieves with her patient. He writes, for example:

> She slams the symbolism on him with complete brutality, does Melanie Klein, on little Dick! Straight away she starts off hitting him large-scale interpretations. She hits him a brutal verbalisation of the Oedipal myth, almost as revolting for us as for any reader— You are the little train, you want to fuck your mother.
>
> Quite clearly this way of doing things leads to theoretical discussions which cannot be dissociated from a case-diagnostic. But it is clear that as a result of this interpretation something happens. Everything is there. (p. 68)

It is this uneasy tension between Klein's "complete brutality" and the suspicion that "everything is there" that, as Jacobus notes, seems to drive Lacan's own aggressive reading of this case, a reading that seems to open the possibility of a greater role for the imaginary within the Lacanian model itself:

> What is it, then, that Lacan may fear to discover in his own ideas? Surely, nothing other than the crucial role of the imaginary, the domain which Lacan associates loosely with Klein's account of projective identification and its allied processes, but which in his system is subordinated to the symbolic and to language. (p. 170)

however, the analyst reported that her patient "lifted a little toy man to his mouth, gnashed his teeth and said 'Tea Daddy,' by which he meant 'Eat Daddy.' He then asked for a drink of water."[16] Turning tea into eat, he had turned the tables, turned the tea table into a scene of cannibalistic incorporation. This is how Jacobus describes the challenge to Lacan produced by the little boy's play with anxiety:

> Here little Dick, in Lacanian terms, acts out his foreclosure of 'the Name of the Father,' the big Dick of language. For little Dick, the paternal phallus is a penile body-part—a part that he wants to eat whole. Making a meal of the phallus, instead of naming the father, little Dick seems to say, in this primitive psychic gesture: I am both little Dick and daddy-Dick, Saturn's child and Saturn himself. The undifferentiated little Dick and daddy-Dick constitute a primitive, devouring identity.[17]

If little Dick became a subject by biting rather than by naming, and if he turned the father not into a name but into a part-object—something to eat and be eaten by—if, that is, he came into play via the logic of the part-object, then that is also what Louise Bourgeois did in her first sculptural solution and in the multiplicity of objects—part-objects—that followed in its train.

This destruction-of-the-father logic grounded in the drives that Bourgeois enacts in her 1974 work might also be expected to operate in Antoni's *Gnaws*, oral-sadistic works in which the artist repeatedly bit into large blocks of chocolate and lard, spitting out the mouthfuls and collecting the expelled fat and chocolate to produce tubes of lipstick and heart-shaped candy boxes. And the critical reception of the *Gnaws*, employing a range of psychoanalytic concepts that included regression, oral fixation, and repetition-compulsion, did place the *Gnaws* in the register of infantile experience. Relating the *Gnaws* to 1970s transgressive body-centered works by Bourgeois, Hannah Wilke, and Eva Hesse, critics tended to read her attack on Minimalism—her biting into art history—as a repetition of seventies feminist performative uses of the body.[18] But what was not discussed was the structure of the work in which the aggressive acts of biting and spitting or swallowing became a logic for producing not part-objects like those produced by Bourgeois or little Dick, but conventional objects of female masochistic desire, lipstick and candy boxes.

16. Klein, "The Importance of Symbol Formation," p. 104.
17. Jacobus, "Poor Mrs. Klein and the Pencil Shavings," pp. 165–66. Noting Lacan's analysis of little Dick that "everything is equally real for him, equally indifferent," Jacobus observes that "little Dick has grasped the principle of linguistic difference (to a T) without being able to apply it to his own condition" (p. 166). Dick's own condition, of course, is a psychosis within which difference is not operative. And as Jacobus reminds us, "The characteristic of Kleinian psychoanalysis is its empathy with—its feeling for—psychosis" (166).
18. See, for example, Simon Taylor's review of *Chocolate Gnaw* and *Lard Gnaw* in *Art in America*, vol. 80 (October 1992), p. 149.

Maxine Hayt. Lick #2. *1993.*
(Photo: Adam Reich.)

If, as I would like to suggest, performative practices grounded in a Kleinian model of infantile fantasy have the potential to construct representations of aggression that do not revert to essentialism, in the case of Antoni's Gnaws this possibility is foreclosed by turning the enactment of aggression into an essentializing spectacle of female masochism. The structure of this work, in which performative practices enacting infantile aggression (biting) lead to a compulsive behavior in the form of an eating disorder (gnawing and spitting out) that in turn is recuperated by the production of objects of conventionalized feminine desire (lipstick and chocolate displayed in mirrored cases) does, however, point to another crucial problem in Kleinian theory—the struggle to suppress aggression or to repair its perceived effects.

In the Gnaws, it is this effort to suppress aggression that, like little Dick's inability to grip scissors or bite into food, arrests what Klein calls the capacity for symbol formation. In the context of 1990s feminist art practice, this capacity might be thought of as the possibility of an enactment of aggression that does not fall back into essentialism. Antoni's use of her own body to produce works that reinforce rather than destabilize, or de-essentialize, the conventional construction of femininity however raises the question of how a Kleinian-based analysis, grounded in a theory of fantasy produced by bodily drives, might operate critically in relation to practices that are themselves enacted through the body in performative strategies hostile to the signifier. Would not such an analysis risk, if not regression, at least essentialism?

Klein's emphasis on innate drives, her elision of language and history in the

Rona Pondick. Mouth. *1992–93.*

foregrounding of pre-Oedipal, nonverbal experience, her indifference to the effects of social structures—all point to the biological essentialism, "incapable of even so much as suspecting the existence of the signifier," for which her work has so often been criticized. But the implicit biologism and insistent literalism of Kleinian theory have obscured one of its crucial insights—one that I will argue bears upon the recent feminist work I will consider here—and that is her analysis of aggression as deeply structuring unconscious fantasy in both sexes from infancy through life. For what interests Klein, in contrast to Freud, is not the neurotic symptom that is an effect of sexuality but the psychoses that arise as effects of the death drive. And through this shift of emphasis from sexual development to aggression and the death drive, the conventional construction of femininity and masculinity as opposed on axes of agency and passivity, aggression and nurturing—axes drawn to diagram the negotiation of the castration complex—is radically, if inadvertently, destabilized. I would, then, suggest that the significance of the Kleinian model for recent psychoanalytic feminist work is at least in part its analysis of aggression not as a function of sexual difference, but as structural to all subjectivities. For if the enactment of aggression in body-centered feminist work depends upon the possibility of constituting a female subject of aggression (just as other feminist work has confronted the problem of constituting a female desiring subject), then one way of producing such a subject is through a turn to the drives.

For Klein, aggression—and especially efforts to suppress it—rather than sexual development, is the pivotal psychic site of struggle. Thus, her most dramatic divergence from Freudian theory is her refusal of the primacy of castration. This

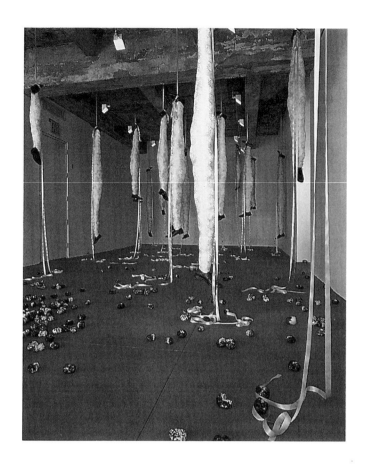

Rona Pondick. Legs *and* Mouth. *1993.*

Below: Milk Milk. *1993.*
(Photos: J. Kotter.)

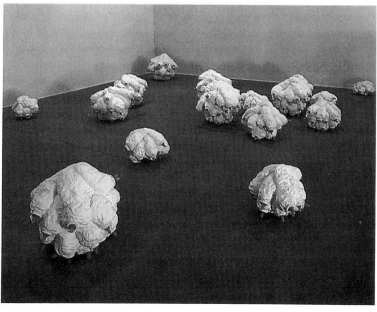

refusal has many implications, including the possibility of a less fixed model of sexuality. But what I would like to emphasize here is Klein's suggestion that the infant is plagued from the beginning with fantasies of destroying by its own violent means the objects of its love and envy, that is, that the infant fears not the loss of the mother to the father, or the loss of the penis, but the loss of all objects to its own destructive impulses. The first object of aggression is not, as it is in the Oedipal-centered Freudian model, the father, and not even the mother, but a series of part-objects—breast, milk, penis, children, womb—to which the infant fantasizes the connection of other part-objects—mouth, teeth, urine, feces—in frenzied attacks enacting, according to Klein, the force of the death drive.

Stringing, lumping, and sticking together, piling and hanging up rubber, plastic, and wax mouths, feet, legs, teeth, nipples, breasts, penises, vaginas, Rona Pondick all but speaks the name Melanie Klein. If critics have not spoken it for her, they have described its Kleinian operations, its enactments of biting, sucking, and excretion, its fragmentation of the body and conflations of its parts.[19] What I would like to consider here is the way in which these objects are structured by aggressive fantasy.

In Pondick's installations, oral-sadistic and anal-sadistic infantile fantasies are staged not only by the play of objects—as in the conflation of greedy tearing mouth and persecutory devouring breast in such works as *Mouth, Charms, Treats,* or *Little Bathers*—but by their structure and arrangement. Hung from the ceiling, spilling across the floor, piled in a corner, molded into the furniture, these part-object works resist the integrity and vertical orientation of the adult body, operating instead at the level of the infantile drive.

Pondick's 1993 installation, for example, included three works, *Legs, Mouth,* and *Milk Milk,* which functioned less as discrete objects than as object systems. In *Legs,* double-footed pink-upholstered tubular cushions conflating leg and penis were stuffed into men's ready-made shoes, tied by the foot, and suspended from the ceiling by ribbons that trailed onto the floor. Legs swinging at graduated heights from above, *Mouth* was strewn across the floor, its hundreds of teethed or nippled, sticky scratchy blotchy bloody balls randomly scattered around the room. Placed on the floor in a corner, *Milk Milk* in turn was a collection of white bulbous clusters of breasts fitted with baby-bottle nipples. The three accumulations of objects functioned not as series or as multiples but as interconnecting systems defined through their relations to the ceiling, the floor, and the corner, or in other words by their positions, and through their relations to other object systems—as in the connection of biting and sucking mouths to the breast/milk.

Organized by the logic of the part-object, this installation enacted the experience of the body riven by the drives, an experience that much other recent feminist work has also investigated. One might think of Maxine Hayt's *Licks,*

19. See especially Elizabeth Hess, "Basic Instincts," the *Village Voice,* June 1, 1993, p. 83, and "Nasty Girl," the *Village Voice,* May 7, 1991, p. 85.

gaping slippery lumpy mouths from which foamy tongues stick out; of the part-object assemblages of Nancy Bowen and Ava Gerber; of the inside-out constructions of the body in works by Rachel Whiteread; or of the evocation of a pre-Oedipal maternal voice in Maureen Connor's *Three Female Voices*, to cite just a few examples. The critical reception of this recent feminist work organized by the Kleinian logic of the part-object, however, places it within a specific lineage of transgressive body-centered practices of the 1960s and '70s, a lineage that is often framed in terms of return or regression, but at other times as a function of mothering. The recent "Bad Girls" shows staged in New York and Los Angeles, for example, constructed a genealogy of "bad girl" mothers of the 1960s and '70s and "bad girl" daughters of the 1990s. I would like now to consider this construction of feminist mothering within the context of the Kleinian model in which, as I am suggesting, much recent work is based as a model that both foregrounds and insistently problematizes the mother-infant relation.

Mothers

The artists in Bad Girls *and* Bad Girls West *have taken the examples of their foremothers to heart. Some make work that's parodic and satirical, "humoring" male tropes; some mischievously rewrite or revise the "master"'scripts from a different point of view. Others invent new narratives, images, and metaphors, new modes of representing and projecting their own specifically female experience—formally, stylistically, technically, conceptually—that circumvent paternal constructs altogether.*

—Marcia Tanner

Some feminist critics have expressed worry over the idea of the female subject, mother or not, playing with the boundaries of the self, given the difficulties women in our culture have in attaining a sense of selfhood to begin with. . . . I believe that women—women artists in particular—must be strong enough to allow themselves this kind of play; one way to achieve such strength is for girls to imagine (or see) their mothers playing.

—Susan Suleiman

In the widely discussed recent "Bad Girls" shows, the mother-daughter relation of feminist artists was framed primarily through the desire on the part of younger artists for bad enough mothers among older ones. In her catalogue essay for the exhibition, Marcia Tanner constructed a matrilineage of bad-girl mothers beginning with Artemisia Gentileschi and proceeding to Meret Oppenheim, Yoko Ono, Louise Bourgeois, Faith Ringgold, Linda Benglis, and Cindy Sherman

Robert Mapplethorpe. Louise
Bourgeois. *1982.*

to argue that through their identification with irreverent, transgressive artist
mothers the younger generation of bad-girl artists is able to subvert patriarchal
law, to "ignore the entire myth of male hegemony, of paternal lawgivers in art
and everywhere else."[20] The suggestion that through their relation to strong
individuated mothers these daughters are able to work outside the framework of
patriarchy, to evade the terms of the Oedipus and castration complexes, is of
course a claim grounded in feminist psychoanalytic work on the mother-
daughter relation that is anti-Lacanian both in its positing of an extrapatriarchal
relation and in its emphasis on pre-Oedipal experience. And this model of an
empowering mother-daughter relation structured the "Bad Girls" shows as the
profoundly liberatory display of mother-taught subversion, as the coming of age
of a new generation of feminist artists who, unlike their predecessors, are
positioned not only to produce critiques of the patriarchal construction of
gender but also to produce works that, as Tanner puts it, "circumvent paternal
constructs altogether."[21]

 If, then, Lacan is the bad father of this new generation of feminist artists,
the bad enough mother is a seventies feminist, herself a bad girl, with whom the
daughter can identify and in relation to whom she can position herself in a
genealogy. The Lacanian-based feminist work of the 1970s and '80s, a repressed

20. Marcia Tanner, "Mother Laughed: The Bad Girls' Avant-Garde," in *Bad Girls* exhibition cata-
logue (New York and Cambridge: The New Museum of Contemporary Art and MIT Press, 1994), p. 77.
21. *Ibid.*

term in the maternal genealogy constructed by the "Bad Girls" shows, meanwhile seems to function as a kind of parental foil to the transgressive tactics of the bad-girl generations. That is, the "Bad Girls" shows were organized not only through identification with bad enough mothers but also through rejection of bad feminist mothers.

But in the Kleinian model in which much recent body-centered work on aggression is grounded, the mother-infant relation is not one of positive identification but of radical alienation. Aggression toward the mother and depressive anxiety about the destructive effects of this aggression, rather than identification, structure the Kleinian mother-infant relation. In the "Bad Girls" shows, the girl is positioned in identification with a transgressive mother, but this identification is achieved only by rigidly separating transgressive and non-transgressive mothers. And this splitting of the "mother" into good and bad objects reproduces a central fantasy of the Kleinian subject.

In the "Bad Girls" shows, the division of good and bad mothers was portrayed very differently—as a disruption of stereotypes. And this use of a thematic of inverted stereotypes of good and bad girls as the principal curatorial strategy of the "Bad Girls" exhibitions—pervading not only the selection of works but also the extensive wall texts and the shows' catalogue essays—was striking in the context of exhibitions that explicitly rejected hierarchy and dichotomy, taking as their central theoretical model the Bakhtinian carnivalesque. For the strict oppo-sitionality through which the shows were structured seemed markedly at odds with the stated purpose of overturning hierarchies of gender, race, and class and of high and low cultural forms, and especially of displacing feminine and masculine stereotypes. So the question I would like to pose is whether this determination to separate the bad girls from the good can be seen as manifesting an anxiety of or about feminist practice. And if so, might the staging of this anxiety in exhibitions devoted to the display of aggression be seen as enacting what for Klein is the pivotal psychoanalytic problem—anxiety about one's own aggression?

The "Bad Girls" shows constructed a mother-daughter relation grounded in aggression in part by taking up Susan Suleiman's question about what happens to the avant-garde when the mother laughs. In answer to her own question, Suleiman imagines what she calls the displacement from the patriarchal mother to the playful mother as both subverting patriarchy and bringing into (psychoanalytic) existence the mother as a subject through the aggressive behaviors of laughter and play.[22] But while the "Bad Girls" shows seemed to want to make the mother laugh, she didn't laugh after all. For despite abundant references to the subversive power of humor, and the display of comic forms like cartoons and gag props like whoopie cushions, the compulsive splitting of bad and good objects—and bad and good

22. Susan Suleiman, "Playing and Motherhood; or, How to Get the Most of the Avant-Garde," in *Representations of Motherhood*, ed. Donna Bassin, Margaret Honey, and Meryle Mahrer Kaplan (New Haven: Yale University Press, 1994).

mothers—enacted in the shows blocked the doubling and crossing up of meaning through which humor is constructed.

The effect of a kind of structural elasticity or ambivalence, humor is itself produced by a split subject, humor being, according to Freud, a strategic use of denial, a comedy that deflects suffering by turning trauma into pleasure.[23] So with humor, play, or the movement between positions, displaces anxiety. Projective splitting, on the other hand, has the reverse effect of intensifying anxiety. Incapable of tolerating the ambivalence that is structural to humor, such splitting produces good and bad objects that are held very far apart. And it is this kind of splitting, set up by opposition, that I would suggest structured the presentation of the "Bad Girls" shows.

In constructing her matrilineage of a bad-girls avant-garde, for example, Marcia Tanner cites, almost, an emblematic pairing of icons from the history of feminist art: Linda Benglis's 1974 ad for *Artforum*, in which the nude Benglis, masked by dark glasses, deploys a double dildo between her legs, and a 1982 portrait of Louise Bourgeois by Robert Mapplethorpe in which Bourgeois, dressed in a fuzzy coat, clutches under her arm an outsized latex phallus-doll, her 1968 sculpture *Fillette*. What Tanner actually reproduces, however, is the Benglis ad and a photograph of *Fillette* alone, hanging on a hook as it is displayed in exhibition, rather than the Mapplethorpe photograph. And this omission of the grinning, phallus-toting Bourgeois allowed Tanner to claim that Benglis's work "displayed a theatrical flair, a degree of bold insouciance, mischief, and daring that might have made the shy Bourgeois recoil."[24] It facilitated, in other words, a repression of the playful, aggressive mother at the very site that was to be charged with her laughter.

Positioning herself as the mother of the phallus-doll she grips firmly under her elbow, Bourgeois, as we remember so well, laughed; and her laugh did effect a displacement from the patriarchal mother to the playful, aggressive mother. Performing a fantasy of aggression toward the phallus and the infant, she demonstrated how the artist/mother might be constituted as a subject through aggression. In Mapplethorpe's photograph, Bourgeois made herself the very image of the bad enough mother: the mother who grins at the patriarchal overvaluation of the phallus, who parodies the metonymy of infant and penis, and in whose hands the phallus becomes penis, or in other words slips from its status as privileged signifier to become one more object of aggression and desire.

This is not a Kleinian fantasy *per se*, but rather a fantasy of turning psycho-analysis against itself. For if in Kleinian theory the mother does not exist as a subject, but only as the object of the infant's aggressive projections, Bourgeois produces a maternal subject constituted, like the infant subject, through a play of introjections and projections. So by turning the mother against the infant, the

23. Sigmund Freud, "Humor," in *The Standard Edition of the Complete Psychological Works of Sigmund Freud*, ed. James Strachey (London: Hogarth Press, 1953–64), vol. 21, pp. 160–66.
24. Tanner, "Mother Laughed," p. 73.

Louise Bourgeois. Fillette. *1968.*

part-object against the phallus, and humor against the fetish—that is, by exploiting the tension between Kleinian, Lacanian, and Freudian psychoanalytic models— Bourgeois produces the playful, aggressive mother. And psychoanalysis, to borrow Lacan's phrase once again, is incapable of so much as suspecting her existence.

Nor does she exist in the "Bad Girls" catalogue, where she is displaced by an image of *Fillette* that stands fetish-like in place of the Mapplethorpe picture, a repression in reverse of the one performed a decade before in another museum catalogue. For this substitution of the object for the portrait is the reverse of the omission performed by the Museum of Modern Art in its catalogue for the 1982 Bourgeois retrospective: in that instance, *Fillette* was cropped out of the photograph, cutting off the grin from its gag to produce a more enigmatic smile for the catalogue's frontispiece.[25] Both of these deletions elide the playful mother by disrupting the object relation through which she is constructed, by dividing object and subject into discrete frames. And in both cases, one might suppose, it is an anxiety about the aggression registered in the figure of the playful mother that is defended by this insistent splitting of the image.

In the "Bad Girls" catalogue, the figure of the playful mother enacted by Bourgeois in the Mapplethorpe picture is displaced by the Benglis ad. There, aggression is enacted through a more straightforward appropriation of the phallus, which fully retains its conventional valences of power, virility, and aggression,

25. For a discussion of MOMA's cropping of the photograph, see my "Pretty as a Picture: Louise Bourgeois's *Fillette,*" *Parkett* 27 (March 1991), pp. 48–57.

albeit parodically exaggerated. In taking on the phallus (rather than taking it up, as Bourgeois does), Benglis's body itself becomes both phallic and aggressive, and this assumption of aggression through the phallus is indeed, as Tanner suggests, a central trope in the staging of the "Bad Girls" shows.

But I would like to turn now to the different problematic of aggression that I believe structures much recent feminist work, and that is anxiety about aggression and its destructive effects. For it will be my argument that recent work by Bourgeois and others points not in the direction of the thematic of liberatory aggression that was presented in the "Bad Girls" shows, but toward a more complex structural analysis of aggression. In that analysis, which is Kleinian-based in its organization through object relations, loss is a function of fantasied destructive actions performed by the subject, a subject that is also capable, in fantasy, of repairing its damaged objects.

Beds

The material was there taking all that room and bothering me, bothering me by its aggressive presence. And somehow the idea of the mother came to me. This is the way my mother impressed me, as very powerful, very silent, very judging, and controlling the whole studio. And naturally this piece became my mother. At that point, I had my subject. I was going to express what I felt toward her. . . . First of all I cut her head, and I slit her throat. . . . And after weeks and weeks of work, I thought, if this is the way I saw my mother, then she did not like me. How could she possibly like me if I treat her that way? At that point something turned around. I could not stand the idea that she wouldn't like me. I couldn't live if I thought that she didn't like me. The fact that I had pushed her around, cut off her head, had nothing to do with it. What you do to a person has nothing to do with what you expect the person to feel toward you. . . . Now at the end I became very, very depressed, terribly, terribly depressed.

—Louise Bourgeois

The ego's growing capacity for integration and synthesis leads more and more, even during these first few months, to states in which love and hatred, and correspondingly the good and bad aspects of objects, are being synthesized; and this gives rise to the second form of anxiety—depressive anxiety—for the infant's aggressive impulses and desires toward the bad breast (mother) are now felt to be a danger to the good breast (mother) as well.

—Melanie Klein

Having begun, then, with the father dragged onto the dinner table and eaten, I would like to end by returning to the table, the bed, the floor, which is to say to the horizontal field of the infant, to what Mitchell has called infancy's "perpetual present ... [a] horizontal, punctuated duration rather than a historical, vertical temporal perspective."[26] For if Kleinian fantasy is a structural space, vectored by the axis of the horizontal, this is a very different model of fantasy than that which forms around the gendered body. Enacted through processes of conflation, splitting, and multiplying performed on part-objects, the fantasies of the Kleinian subject are fantasies of the body riven by the drives and undifferentiated by gender.

To return to one of my earlier examples, Rona Pondick's installations are structured by a part-object logic in which the decentering of the body takes the form of a conflation and splitting of objects that function as part-object systems— hanging, scattered, or clustered in relation to the floor, the ceiling, and the corners of the room. Works like *Double Bed* (1989), an impossibly long twinned mattress tied up with a gridded network of cord to which baby bottles are attached, and *Loveseat* (1992), constructed of two facing breasted chairs with baby-bottle nipples, a raised pink plastic hole sunk between the seats, enact the projection of infantile drives onto external objects, or in other words the conflation through fantasy of the body and the structures that support and contain it. In the insistent literalness of their use of objects, and in the interaction of processes of introjection and projection through which the part-object logic of the infantile body structures object relations—so that, for example, the impulse to suck or to bite produces an entire sucking/biting system—these works construct the pre-Oedipal subject along the lines of what Klein called the paranoid-schizoid position.

Through this position, the subject produces the bad object, projecting its own aggression onto a destructive external object. These aggressive fantasies in turn set up the so-called depressive position, in which the subject is consumed with anxiety about the effects of these destructive fantasies and mourns the loss of the good object through its own aggression. Shifting between the aggressive paranoid-schizoid position and the depressive position, the subject produces fantasies of destroying its own good objects (as well as bad ones) and of restoring them in turn. And through the interplay of these two positions, and of the destructive and reparative fantasies in which they are articulated, Klein constructs subjectivity through loss—loss suffered through one's own aggression, but also potentially recoverable through one's own reparative work.

The paranoid-schizoid position, then, is acted out in a frenzy of aggression and the depressive position through inertia and despair, feelings that are over-come, temporarily, in fantasies of destruction and reparation. Pondick's work can

26. Mitchell, *Selected Klein*, Introduction, p. 26.

be seen as enacting the destructive fantasies of the infant in the grips of para-
noid anxiety. Rachel Whiteread's casts of bathtubs, beds, rooms, and other
abandoned objects bearing the impressions of bodily use—stains, cracks, dents,
and punctures—evoke, on the other hand, depressive anxiety's vacating of desire.

Through a literal process of evacuation, the object is lost, leaving the plaster
or rubber mold of its spatial container or core to function as the work, a work that
constitutes the loss of the object. In casts of the underside of a bathtub or a bed,
or the inside of a closet, drawer, room, or house—spaces that contain or
metonymically repeat the body—Whiteread materializes this loss literally as a
negative, an inert registration of the space the body once occupied.

These casts of space occupied and then vacated by the body also manifest
the collapse through which object and desire, like self and other, are enfolded by
infantile fantasy. The distinctions of inside and outside or body and environment
that are foundational for the gendered body are not observed by infantile fantasy.
So these works produced through conflation and splitting—the collapse of body
and environment, the peeling away of inside from outside—materialize a world
structured by the part-object.

In Whiteread's case, this logic is articulated less by the play of objects than by
the construction of a space that is the condition of infantile fantasy. For it is not
the part-object body itself that confronts us in Whiteread's work, but that elision
of body and environment, inside and outside, through which the infantile world is
made. Working, then, at the limits of the body, at the interface of the body and its
supports, Whiteread examines interstitial structures with evident parallels to the
in-betweenness of infantile experience.

The inside-out construction, in which, for example, a cast of the underside
of the bathtub that contains the body forms another tub, or the space beneath a
mattress makes a bed, in reversing the functions of object and container, of inside
and outside, performs a decentering of the body. In other pieces, such as a recent
series of beds in which the work sometimes is a cast of the object itself rather than
of its interior or surrounding space, the limit of the body is defined, or eroded,
not by its surrounding space but by the support it impresses and to which it molds
itself. The beds are foam, rubber, and plaster casts of mattresses and box springs
stacked or folded over, propped or slung against the wall, the tracery of springs
pushing up vein-like from under the stained surfaces of the amber, yellow, and
white skins. Dense and inert, these beds bear the hardened imprint of the body
stretched out in the horizontal field of infantile experience, the field structured,
according to Klein, by the death drive.

I have suggested that works by Pondick and Whiteread materialize infantile
fantasy through the interaction of the positions Klein called paranoid-schizoid
and depressive, both of which are functions of aggression (or the struggle to sup-
press it), and of loss. These are only two examples of recent feminist work that is
structured in these terms, and I have offered them together to evoke something of
the structural dimension of this model, a model that exceeds the thematics of the

Rachel Whiteread. Untitled (Double Amber Bed). *1991.*

Left: Untitled. *1991.*

infantile and the part-object through which it is often read. I have also attempted to demonstrate how the Kleinian model, with its emphasis on aggression as the pivotal psychoanalytic problem, has been employed critically by these artists and others in relation to Lacanian-based feminist work of the 1970s and '80s that centered on investigations of pleasure and desire. Organized structurally by position rather than temporally by stage, the Kleinian model displaces concepts of essentialism and regression to open a space in which fantasies of aggression can be examined as structural to the subject of either sex and of any gender, in which the subject of aggression is constituted not in essential but in relational terms.

The field of infantile fantasy as a space in which to investigate aggression in a feminist context has been articulated most fully in the work of Louise Bourgeois, and the practices I have discussed here must be read in relation to that body of work and as part of its delayed reception. The part-object logic of Pondick's work in particular closely follows Bourgeois's complex development of that logic, repeating many of its moves almost verbatim. Those moves include: strategies of inside-out construction and of multiplication, splitting, and conflation that subvert the phallic logic of gender and disarticulate the Oedipal body; techniques of pouring, cutting, scratching, and fragmentation that enact the ferocity of the drives—or alternatively of stitching, wrapping, and polishing that effect the repair of damage inflicted through aggression; and the staging of objects in installations or setups structured as part-object fantasy spaces. All of these are processes through which Bourgeois has enacted the subject of the drives and bodily fantasy and through which the current generation of feminist artists has received and reexamined the investigation of the drives as a project of feminist art.

For while Bourgeois's work received increasing critical attention following her retrospective at MOMA in 1982, it has been in the early 1990s in the context of critiques of Lacanian psychoanalysis and semiotics, and of intensive concentration focused on the body as subject to aggression and pain, that her work has assumed a pivotal position in mediating feminist practices. Bourgeois's recent exhibition of works from the past decade at the Brooklyn Museum, and especially the series of works called Cells (1989–94), staged the part-object logic of infantile fantasy as a play of position. In domestic spaces encaged by screens, doors, and broken and soot-covered windows occupied by part-objects—a giant pair of marble eyes, a pair of folded hands, glass globes, an ear—Bourgeois materialized the Kleinian notion of position as "a place in which one is sometimes lodged." With great insistence on the concreteness of the objects, the corporeality of the viewer, and the six sides of the cube as the markers of real space, she deployed objects to which pastness seemed to cling—weathered architectural remnants, broken mirrors, schoolroom chairs, and narrow beds—in the construction of memory itself as a "perpetual present."

As a number of feminist theorists have pointed out, Klein's object relations model, focusing as it does on the internal experience of the infant and fantasies of the mother, who always functions as an originary object and never as a real subject,

fails to open an intersubjective space.[27] This is also the case with Bourgeois's work, which concerns itself with a problem defined in the title of an early work as that of "figures who talk to each other without seeing each other." In the Cells, the fantasy screens occluding intersubjectivity are literalized in the meshed wire or gloss of dirt through which we viewers glimpse one another partially. When the space of the Cell is articulated by hinged mirrors angled to disrupt and cut up the field of vision, we inhabit a play of projections, staring back at our own faces reflected behind the emprisoning tracery of the screen. The experience of the Cells is of an interplay of introjection and projection in which it is structurally impossible to "see each other."

And this is the very condition of aggression, as Klein describes it. Loss, the loss of the other that is destroyed in fantasy, is embedded in the structure of one's own aggression. Thus, when Kobena Mercer complained recently of "a stubborn resistance to the recognition of unconscious fantasy as a structuring principle of our social, emotional, and political life," and called for analysis of "the oppressive and unhappy phantasies of love and hate that condition our mutual enmeshment," it was not surprising that he pointed toward Melanie Klein. For Klein, as he observed, "defined phantasy as merely the way we organize, perceive, and give form to our feelings, which are always conflicted by the coexistence of love and hate."[28]

Klein's model of unconscious fantasy as a structural space articulated by the infantile body offers only one possible approach to the problem of developing psychoanalytic feminist readings of aggression that are not grounded in concepts of essentialism or regression. But, as I have attempted to demonstrate here, a significant body of recent feminist work calls for readings of aggression as complex as the analyses of pleasure and desire offered in Lacanian-based feminist art and critical theory of the 1970s and '80s.

27. See, for example, Janice Doane and Devon Hodges, *From Klein to Kristeva: Psychoanalytic Feminism and the Search for the "Good Enough" Mother* (Ann Arbor: University of Michigan Press, 1992).
28. Mercer, "Fear of a Black Penis," p. 122.

This fragment of Group Material's AIDS TIMELINE is presented as a collaborative project for DAY WITHOUT ART 1990 by Visual AIDS and the following publications in their December issues: Afterimage, Art & Auction, Art in America, Art New England, Artforum, Arts, Contemporanea, High Performance, October, Parkett, and Sbtf.

The Names Project is founded by Cleve Jones in San Francisco.
The Names Project AIDS Memorial Quilt is displayed at the 1987 Gay and Lesbian March on Washington.

Extensive and conclusive medical evidence proves that HIV is not casually spread. It is only transmitted through needle sharing, blood transfusion, or unprotected sexual contact.

President Reagan asks for a $10 million cut in the Public Health Service's AIDS budget as well as massive cuts in Medicaid.

1987

The President orders mandatory AIDS testing for all immigrants and federal prisoners. His Education Secretary, William Bennet, presses for even more extensive mandatory testing while Surgeon General C. Everett Koop joins most public health authorities in opposing this as a wasteful process.

The federal government finally begins to deal with treatment and drug trials. But AIDS drug trials, like many others, exclude women, people of color, poor people, people in rural areas, I.V. drug users, hemophiliacs, prisoners, and children, many of whom die from preventable and treatable illness.

None of these will give you AIDS.

1-800-462-1884

SAFE SEX

Condom manufacturers produce their first television commercials and all three major national networks refuse to broadcast them.

FASCINATED

The proportion of women with AIDS increases between 1982 and 1986 from 12% to 26%. Even this statistic is low because most women with AIDS die undiagnosed, with infections specific to women such as severe vaginitis, pelvic inflammatory disease, or cervical cancer, all unrecognized as AIDS related by the Centers for Disease Control.

NEGATIVE

POSITIVE

The Names Project, photo by Tom Alleman · *"Black / White," Brad Melamed* · *"Anonymous and 5 Year Old Son", Ann Meredith* · *New York City Health Department subway poster* · *"Selections From The Disco, Various BPM, 1979-1990", Steven Evans* · *condom case: Keith Haring* · *art direction: James Morrow*

Postcolonial Discourse

Reading Africa Through Foucault: V. Y. Mudimbe's Reaffirmation of the Subject

MANTHIA DIAWARA

Everyone knows the famous words of the Sun-King to his godson, Aniaba, the Black Prince. On the Eve of Aniaba's departure for his states, as he was saying his farewell to the king, Louis XIV is said to have told him: "Prince, the only difference between you and me is the difference between black and white." We interpret: after the education that we have provided you at our court, you have become a Frenchman with a black skin.

—Léopold Sédar Senghor, "Vues sur l'Afrique noire, ou assimiler, non être assimiler"

Michel Foucault, because of his influence, his originality, and the significance of his work, may be considered a noteworthy symbol of the sovereignty of the very European thought from which we wish to disentangle ourselves.

—V. Y. Mudimbe, *L'odeur du père*

Mudimbe posits here, in a rather blunt manner, the place that Western thought occupies in non-Western discursive formations. For him, it is necessary for the theorist in Africa to appreciate what it takes to create an authentic statement that reflects African sociocultural practices and takes as its condition of possibility a local discursive space. Such a project must distinguish what is still Western in the discourse that denounces the West. Likewise, the non-Western theorist, in search of the enabling elements inside the Western canon, must be aware of the traps and reversibilities embedded in that same canon.

Mudimbe's theoretical books, *L'autre face du royaume* and *L'odeur du père*, and his novels, *Entre les eaux* and *L'écart*, engage as their subject the enabling as well as the regressive elements in Western discourse, thereby liberating spaces in Africa from which more empowered discourses can be uttered. In this essay, I will show how Mudimbe follows Michel Foucault's definition of the rules that subjugate discourse, and then apply a Foucauldian critique to *négritude* in order

to reveal the presence of the Western *ratio* in this first African literary movement; next I will show that Mudimbe's transformation of Foucault's thought is a necessary step in the creation of African essentialisms that in turn become targets for criticism.

Foucault's archaeological approach to discourse is doubly enabling: first, for thinking against the grain within the Western canon, and second, for proposing alternative discursive formations outside the West. On the one hand, Mudimbe uses Foucault's method to unmask and unmake the Western *ratio* that dominates the human sciences and, under the guise of universalism, duplicates Western man in Africa. On the other hand, Mudimbe creates a postcolonial and postimperialist discourse that posits a new regime of truth and a new social appropriation of speech, thereby raising the question of individual subjugation in postcolonial discourse.

Out of Foucault's subversive uncovering of the rules that govern discourse in the West, Mudimbe unmasks the Western *ratio* in the African literary canon. But first, let's read Foucault through Mudimbe. In *L'odeur du père*, he argues that, for Foucault, societies control discourse by first positing external rules. These include the construction of forbidden speech that bans certain words from certain statements; the designation of madness that opposes reason to insanity; and a regime of truth that determines the desire to know and practices a principle of discrimination based upon access to "education, books, publishing houses, and libraries, as well as the secret societies before and the laboratories today."[1]

Next there comes an internal system for tying down discourse. This internal system is aimed at classifying, ordering, and distributing discursive materials so as to prevent the emergence of the contingent, of the Other in all its nakedness. This internal system of discursive subjugation involves the concept of authorship, which serves to rarify the quantity of statements that can be made; the construction of the organization of disciplines as a delimiting force; and a notion of commentary that organizes discursive statements according to temporal and spatial hierarchies.

The third system for mastering the movements of discourse that Mudimbe finds in Foucault consists of positing the conditions of possibility for putting discourse into play through the subjugation to rules of the individuals involved in discursive deployment. The object, however, is neither to neutralize the return of that which was repressed nor to conjure out the risk of it appearing in discursive practices, but to make sure that "no one will enter the discursive space unless certain prerequisites are satisfied and one is qualified to do so."[2]

1. V. Y. Mudimbe, *L'odeur du père: Essai sur des limites de la science et de la vie en Afrique Noire* (Paris: Presence Africaine, 1982), p. 39. This and subsequent translations are by the author unless otherwise specified.
2. Mudimbe, *L'odeur du père*, p. 40.

It is this last system of control through discourse that serves to distribute and specialize the speakers. It involves four rules: the discursive rituals that place constraints on the manner of delivering a discourse; the presence of discursive groups that have as their mission the keeping of discourse from multiplying and losing authenticity; the discursive norms that, through their deployment in certain spaces, have the double function of linking the speakers to those spaces and of distributing them into specialized groups; and finally, the social appropriation of discourse that binds together discursive statements with such nondiscursive spaces as institutions, class interest, and political events.

For both Foucault and Mudimbe, societies put into play these discursive rules to repress the irruption of discontinuities, disorders, and the vengeful return of discourse as nonsense. At the same time, Foucault points out, the deployment of the rules coincides with the creation and the positioning of Western man, with all his positivity, at the center of discourse. Because Western man has been creating and recreating his positivity through discourse, a problem concerning traps and reversibilities arises whenever an African theorist uses the dominant canon to represent African realities. Paradoxically, then, African theorists who assume a violence toward the West run the risk of unwittingly reasserting the superiority of the Western nation of rationality if they lose themselves in a discourse derived from Western ethnocentric canons. As Foucault puts it, "there is a certain position of the Western *ratio* that was constituted in its history and provides a foundation for the relation it can have with all other societies."[3]

Mudimbe's reading of the Foucaldian criticism of discursive rules reveals both the position of the Western subject and the condition of possibility for its removal from the center of African discourse. The founders of *négritude*, for example, while aware of the duplication of French canons in their poetic statements, did not question the dangers of reproducing a French *ratio* in Africa that repressed the local epistemologies as its Other (i.e., "Nos ancêtres les Gaulois").

The word *négritude* was coined by Aimé Césaire in the 1930s to conceptualize a Black literary movement in Paris that was committed to freeing Blackness from the pathological and evil space reserved for it in Judeo-Christian discourse. The *négritude* poets such as Léopold Sédar Senghor, Aimé Césaire, David Diop, and Léon G. Damas wanted to restore to the word *Black* a "true" meaning and a sense of "dignity" that would correspond to the lived experiences, cultures, and civilizations of Black people throughout the world. For Senghor there is an objective and a subjective level to *négritude*: on the one hand, it stands for an inventory of the sum total of Black civilizations; and, on the other, it describes the way in which people of the African dispersion articulate their Blackness in their contact with the material and spiritual worlds. The *négritude* writers be-

3. Michel Foucault, *The Order of Things* (New York: Vintage Books, 1973), p. 377.

lieved in a complementary relation between civilizations and saw as their task the definition of Black values that were necessary for the Creolization (Senghor's word) of the world.[4] *Négritude* was a literature of emancipation that addressed itself to the oppressor in the language of the Parisian élite.

Négritude was inevitably an exotic literature. It was exotic both because it was written by Africans and Caribbeans who came from distant places and because the movement was inscribed in a tradition of exoticism that runs from Baudelaire's West Indian poems, to Victor Segalen's *Les immemoriaux*, and to Rimbaud's identification with Blackness in *Sang d'un poète*. However, the exoticism of the *négritude* writers differs from that of the French symbolists, who appropriated the distant object by describing it in a familiar language. With poets such as Senghor, we face a reverse exoticism: the "barbarian" assumes the position of the writer and defamiliarizes the French language for French readers. Thus the newness of the writings: the *négritude* poems are "authentic" and "unmediated" because they represent the primitive's own subjectivity. On the ideological level, the *négritude* writers' participation in the tradition of exotic literature only complicates further the definition of the movement.

Négritude vascillated between Black nationalism, which found its expression in French theories concerning Marxism as methodology for action, and the need to assimilate the Black world to the universal (i.e., French) culture. In short, the *négritude* poets, even as they sang about the "total sum of black values" and denounced European ethnocentrism, were reasserting the superiority of the West over Africa. As Mudimbe puts it, *négritude* was "a product of a historical moment proper to Europe, more particularly to the French thought which marked it."[5]

Perhaps this is best seen by the way in which Léopold Sédar Senghor, in a 1945 text that is formative for the ideas in *négritude*, addressed the manner in which the African canon may be constituted out of the study of French letters. For Senghor, just as such French authors as Racine shaped French values and styles out of their mastery of Greek fables and techniques of representation, Africans, too, must "discover their blackness and a style to express it through the study of French letters."[6] For Senghor, the knowledge of Africa must pass through a knowledge of France as recorded in literature. A mastery of "the most humane authors such as Corneille, Racine, Molière, and Hugo" imparts universal values like honesty to the African student and provides him with a language

4. See Léopold Sédar Senghor, *Liberté I: négritude et humanisme* (Paris: Editions du Seuil, 1964), p. 7.
5. V. Y. Mudimbe, *L'autre face du royaume: une introduction à la critique des languages en folie* (Geneva: L'Age d'homme, 1973), p. 101. Mudimbe argues that, ironically, the relativist discourse of European anthropologists such as Leo Froebenius gave fuel to the *négritude* poets to sing about the beauty of Blackness. See my essay, "The Other('s) Archivist," *Diacritics* 18 (Spring 1988).
6. Léopold Sédar Senghor, "Vues sur l'Afrique noire, ou assimiler, non être assimiler," *La communauté imperiale Française*, ed. Robert Lemagnen et al. (Paris: Editions Alsatia, 1945), p. 95.

and a style to express them. The French writers are not only the masters with which to think; they are also the masters of language and style. Senghor recommended them for an essential French quality, a French way of doing things that he was later known to call *la francité*: the "clarity, order, harmony of ideas" which the African needs in order to describe his feelings and the world around him.[7] Senghor defended the principle of *francité* as recently as 1985 against Captain Thomas Sankara, who staged a coup d'état and changed the name of Haute Volta to Burkina Faso. Senghor saw some originality in the name change itself, but was offended by the official adoption of "Burkinabe" instead of "Burkinais" or "Burkinois" as a way of referring to the people of Burkina Faso, for the latter would have "obeyed the rules of French grammar." Senghor concludes that, in this day and age, "*on aura tout vu*," but the refusal "to render adjectives and substantives in French [*franciser*] shows an inferiority complex."[8]

To create the "African Humanities," Senghor desired the assimilation of French classics to be accompanied by a teaching of ethnology that would make Africa known to Africans. The works of such French ethnologists as Leo Froebenius and Delafosse were necessary in the classroom, "because they are our ancestors who saved us from despair by revealing our rich tradition to us."[9] Thus ethnologists showed the world that Africans, too, had an art, a philosophy, and a history. With the tools and the disciplines thus imported from Europe, Africans could begin a new humanities with an African style, which Senghor defines "not so much as a technique, but a state of mind which takes its nourishment from the deep sources of the black soul; it is found in the traditional qualities, i.e., the warmth, the tension, and the rhythm."[10] For Senghor, the Black is, before everything else, a lyrical person with a strong sense of verbal imagery, rhythm, and the musicality of words. Finally, following Froebenius' opposition between the Hamite and the Ethiopian, Senghor posited Africa as the primitive contemporary of Europe and argued that the former could help the latter to rediscover ancient values that had been deformed by the loss of natural feelings since the industrial revolution.[11]

Note that Senghor's defense of assimilation rests on a view of the world centered around France. This is understandable given that he wished to transcend what he called the "false antinomy" between the terms of assimilation and association. According to Senghor, the concept of assimilation has always been embodied within French civilization. Moreover, it is a Cartesianism that transcends human passions in order to emphasize reasoning as the glue that unites all men, regardless of their skin color. "French universalism speaks of Man, not

7. Senghor, "Vues sur l'Afrique," p. 93.
8. "Négritude et Vaugelas," in *Le Monde* (August 18–19, 1985).
9. Cited in Mudimbe, *L'odeur du père*, p. 36.
10. Senghor, "Vues sur l'Afrique," p. 92.
11. Ibid., p. 98.

men." When this Cartesian notion is applied to politics and colonialism, it results in the "Declaration of Human Rights," the creation of "La Societé des Amis des Noirs," the abolition of slavery, and the assimilation of Africans to the universal French civilization.[12]

For Senghor, the concept of assimilation that requires Africans to espouse the French language as the universal tool does not contradict the concept of association that implies a relationship between two autonomous states. The doctrine of association seeks to undo hierarchies and to create the possibility for cultures and nations, diverse in origin, customs, religion, and race, to work together. It was a concept used by the opponents of assimilation during the period of the French Imperial Community, and it is used today by those in the Organization of Francophone countries to denounce France's cultural imperialism within the organization.

Senghor defends himself against the proponents of association by drawing an evolutionist scheme that has equality as its goal. To become uncolonizable, Africans must first assimilate that which would enable them to be as educated as their colonizers. By posing the problem in this manner, Senghor wishes to show that the proponents of association, in their radical demand for equality between Africans and French, are against much-needed education in Africa.[13] In place of the concept of association, Senghor prefers terms like universalism, Creolization, symbiosis, grafting—all of which posit France in the center and Africa on the margins.[14]

Let's now read this Senghorian statement through Mudimbe (and Foucault). To apply a Mudimbean reading to these Senghorian passages is not to deny the merit of *négritude*, which participated in the modernist movement of the 1930s and '40s and helped to undermine the dogmatic claims of the canons of Western civilization. In short, the goal of this approach is not to criticize assimilation as a bad object, but to show that assimilation is an unattainable goal because of the barriers inherent in French discourse between the West and Africa. Following Mudimbe, one reads Senghor in order to reveal the structures that create ambiguity and contradictions in his discourse and to posit the conditions of possibility necessary for getting rid of those structures. Thus, Senghor's intention to create the "African Humanities" through assimilation is debunked by the emergence of a French *ratio* at the center of the text that forces Senghor to construct the African as the European's Other.

Given that Senghor's only audience at that time was in France, it can be argued that he had no choice but to speak in an appropriated discourse that could recognize the African only as Other. Even his categories of the Black as

12. Ibid., pp. 57–65.
13. Ibid., pp. 63–64.
14. See also Léopold Sédar Senghor, "Pierre Teilhard de Chardin et la politique africaine," *Cahiers Pierre Teilhard de Chardin*, vol. 3, 1962.

warm, rhythmic, musical, and emotional come from a well-established source in French literature, extant since the Enlightenment and rethematized in the nineteenth century by the arch-racist Joseph Arthur Gobineau. As Christopher Miller has shown, Gobineau and other writers stripped the Black of reasoning faculties and depicted him as one who is moved only by a blind sensorial desire. Gobineau's *Essai sur l'inégalité des races humaines* "is at the origin of a notion that gained wide acceptance: that blacks are endowed with greater 'imagination' than whites and are thus the source of the arts. From the *Essai*, through Guillaume Appollinaire's theories on 'fetish-art' to Sartre's 'Orphée noir,' this assumption continually endows the Black with a type of thinking that simultaneously robs him of the ability to think as a fully reflexive intellect. The *Essai* often reads as a caricature of other, subtler texts."[15]

The *négritude* of Senghor, because it was only addressed to French People, and because it was removed from Africa, constituted a Black that never existed except as the Other in the unconscious of the French. Nevertheless, it was an Other that was presented as real, human, and beautiful. But the result of such a discourse is not only the impossibility of beautifying the Other — that is, of making it exotic and French — but also the impossibility of speaking of Africa without reasserting the superiority of the West over it. To paraphrase Mudimbe, this discourse has internal constraints, so that even if Senghor's discussion of African beauty leads one to believe that he is against Western ethnocentrism, he nonetheless maintains the binary oppositions that separate European and African, civilized and primitive, rational and emotional, religious and idolatrous.

This brings us to my initial epigraph — namely, that the only difference between prince Aniaba and Louis XIV is one of skin color. Senghor's assimilationist discourse, far from making the African the European's equal, and therefore uncolonizable, participates in a universalist concept of man that posits Western man as the model and the African as its aberration. Africa, according to the Senghorism described above, is the primitive contemporary of the West; and as such, it can help Europe to rediscover its lost traditional values. According to a Mudimbean reading, however, this overstatement of universalism at the expense of difference leaves unstated a construction of Africa that sees it as "the infancy of humanity which, when studied carefully, reveals certain trauma repressed in Western societies."[16]

A Mudimbean/Foucauldian analysis of discourse also reveals the way in which *négritude* duplicates themes and motives that are always already appropriated by social conditions in the West. As Mudimbe puts it, "Western discourse defines its space and takes its order from a specific socio-economic and cultural structure. It can address other societies and cultures only in reference to itself,

15. Christopher Miller, *Blank Darkness: Africanist Discourse in French* (Chicago: University of Chicago Press, 1985), p. 88.
16. Mudimbe, *L'autre face du royaume*, p. 81.

and never to specific systems that cannot be reduced to it."[17] Senghor, in an attempt to find African equivalents for European art and to valorize African culture in order to bring the West to respect it, has forced a reading upon Africa that estheticizes and deforms it by making it conform to the gaze of the West. That is, *négritude*, in the name of a French universalism, unleashes on the surface of Africa Europe's regime of truth (*la volonté de verité*), its notions of authorship and its disciplines. *Négritude*, for Mudimbe, "simply and faithfully takes categories, concepts, schema and systems from the West, and runs them into African entities."[18]

Following this Mudimbean/Foucauldian reading of some of the original claims of *négritude*, let us now turn to the other aspect of Mudimbe's work that transforms Foucault's thought. As I have shown, Mudimbe's critique of *négritude* is intended to name the paradoxical presence of the Western *ratio* in it, so that it can be removed, circumvented, or surpassed by a more liberated discourse. It is here that Mudimbe stands Foucault on his head.

Foucault is well known for his criticism of the use of discourse merely to indicate a structure of language put into play in order to produce meaning. For him, discourse is not simply there to mediate between thought and speech or to legitimize original experiences through the constitution of subjects. Foucault calls for the resurgence of discourse without signification; for a world of discontinuity between the speaking subject and the discourse he or she produces; for a pure discourse criticism divorced from the type of sentence criticism that is enthralled by the analysis of latent meaning and propositional statements. He draws our attention to the exteriority of discourse by delineating the condition of possibility for its materiality.[19]

To obtain this pure discursive analysis, Foucault proposes to remove from discourse the regime of truth and to return to discourse its aleatory and subversive elements. In this effort, he debunks classical notions of creativity, unity, originality, and signification in discursive analysis, and he emphasizes in their stead the notion of reversibility, which reveals the negative side of subjugating discourse; the notion of discontinuity, which posits discursive statements as discontinuous practices that intersect each other, address each other, or exclude each other; and the notion of specificity, which conceives of discourse as a violence practiced upon other bodies. It is in these practices that contingencies and chance assume their regular recurrence and the notion of materiality comes to define the exterior "body" of discourse and its condition of possibility.[20]

If we suppose that Foucault is to Mudimbe what the French anthropologists were to Senghor—in the sense that the Africans have been empowered by the

17. Mudimbe, *L'odeur du père*, p. 44.
18. Ibid., p. 43.
19. See Diawara, "The Other('s) Archivist."
20. Mudimbe, *L'odeur du père*, p. 42.

Europeans to carry on a discourse about themselves—the next question raised by Mudimbe's *L'odeur du père* is how to get rid of the father's abusive smell. For Mudimbe, "really to escape the supremacy of Western thought presupposes an exact appreciation of what it means to rid ourselves of it. It presupposes a knowledge of how far the West, perhaps cunningly, has recreated itself in us. It presupposes also a knowledge of the Western in what has enabled us to denounce the West.[21]

The West cannot talk about Africa outside the Western text, just as Africans cannot form canons with texts that reflect European socio-cultural conditions. I have tried to show in this essay how Foucault's work influenced Mudimbe's critique of discursive formations in Africa. Moreover, when conceived in another manner, it is possible to argue that Mudimbe contradicts the French thinker. Foucault's thought properly belongs to a specific region in Western discourse which gives it its condition of possibility as a necessarily counter-hegemonic statement. In short, the Foucauldian system, too, under whatever ideological and methodological metamorphoses it appears, belongs to the history of Western culture. Even Foucault's call for a pure discourse criticism, for a discourse unconstrained by social appropriations, leaves unsaid the repression of non-Westerners by Western discourse. Additionally, I would like to suggest that what is feared most in the West is not the emergence of the discourses of Foucault, Marx, Freud, or Nietzsche, which are always already appropriated; what is feared is the emergence of (an)Other discourse, one that excludes the Western *ratio*. This means the breakdown of hierarchies between the West and the Other; the end of conquest and the removal of the self from the Other's space; the breakdown of the security and comfort to which one was accustomed when one was able to predict the Other's actions in one's discourse. In essence, the West fears the fear of the unknown. Accordingly, Foucault's call for the removal of the subject and the return of pure discourse criticism posits the condition of possibility for the deployment of a new Western *ratio* and the repression of other subjectivities. The pure discourse criticism, which is part of a particular culture, enables non-Westerners to denounce the domineering presence of the West in their texts, but paradoxically does not allow them to move forward and create a discourse outside the Foucauldian system.

Mudimbe, on the other hand, calls for a reformulation of discourse in Africa. He argues that "we Africans must invest in the sciences, beginning with the human and social sciences. We must reanalyze the claims of these sciences for our own benefit, evaluate the risks they contain, and their discursives spaces. We must reanalyze for our benefit the contingent supports and the areas of enunciation in order to know what new meaning and what road to propose for our quest so that our discourse can justify us as singular beings engaged in a history that is

21. Ibid., p. 44.

itself special."[22] For Mudimbe, Africans must rid themselves of the smell of an abusive father, of the presence of an order which belongs to a particular culture but which defines itself as a fundamental part of all discourse. In order to produce differently, they must practice a major discursive insurrection against the West.

For Mudimbe, the most radical break with the West can be obtained only through a linguistic revolution in which European languages are replaced by African languages. Just as the originators of Greek thought set into motion a reorganization of knowledge and life through their transformation of ancient Egypt's use of science and methodologies, the West dominates the rest of the world today because it has appropriated Greek thought in its languages. In like fashion, for Mudimbe, at least "a change in the linguistic apparatus of science and production would provoke an epistemological break and open the door for new scientific adventures in Africa."[23]

Mudimbe further argues that the other insurrectionist practice against the abusive father is obtained through the excommunication of Western *ratio* from African discursive practices that take place in European languages. In other words, Mudimbe calls for a reformulation of disciplines inherited from the West and a subtle discursive technique aimed at deconstructing Western control over the rules that govern scientific statements. While working within Western languages, the new practice nevertheless departs from the traditional duplications of the Western canon in Africa and moves toward the construction of an African regime of truth and socially appropriated sciences. The new and cannibalizing discourse swells, disfigures, and transforms the bodies of Western texts,[24] and establishes its order outside traditional binary oppositions such as primitive/civilized, (neo)colonized/colonizer, slave/master, receiver/donor. This uncovers the centrality of Althusserian notions of ideology in Mudimbe's work, which are beyond the scope of the present essay.

I will now turn to the novel *L'écart* in order to show Mudimbe's discursive practice of unmaking the Western *ratio* and of building the African regime of truth. *L'écart* is about Ahmed Nara, an African student in Paris working on a history dissertation on the Kouba people. Nara meets two Africans, Salim and Aminata, who are archivists at the Bibliothèque Nationale. Aminata and Nara become lovers. Other important characters in the story are Soum, an internationalist Marxist; Isabelle, Nara's French girlfriend; and Dr. Sano, a psychoanalyst.

The novel takes as its subject the questions of existence, history, and ideology. Its narrative strategy consists of describing African images in French

22. Ibid., p. 35.
23. Ibid., p. 47.
24. For more on the reorganization of Western texts by discourse in Africa, see Christopher Miller, "Trait d'union: Injunction and Dismemberment in Yambo Ouologuem's *Le devoir de violence*," *L'Esprit créateur* 23 (Winter 1983), pp. 62–73.

discourse as a projective construction in order to reveal the modes of existence of the "real" contours of Africa. Nara finds his individual freedom trapped by Sartre's influential definitions of *négritude* in *Orphée noire*, the famous introduction to Senghor's *Anthologie de la nouvelle poésie nègre et malgache de langue française* (1948). As Mudimbe argues in *L'odeur du père*, Sartre's intent to theorize *négritude*-for-*négritude*'s-sake was defeated by a master text: i.e., that of Existentialist Marxism. Sartre blots out the irreducible part of the *négritude* movement, manipulates its operational system, and contructs the black man as an androgynous character — that ambiguous figure already common in Western literature. For Mudimbe, Sartre "modified, in fact, the ascension of the first manifestations [in *négritude*], fixed the ways of interpreting the writings, named the rules and the modulations of the action, articulated, at last, the claims of the black race, and proposed a universalist strategy [identification with the proletariat] for its struggle."[25] *Orphée noire* has influenced in a fundamental manner not only the criticism of *négritude* but also the creative writing that followed it.

In *L'écart*, Nara tries to undo Sartre's recreation of androgyny in Africa and the limitation of his freedom as constrained by the Sartrean construction of the personae of *négritude*. Nara realizes that, for Isabelle, his French girlfriend, he is the one half of the androgynous figure — that is, the animal — while she herself is the other half — that is, the human. Their sexual encounter is therefore symbolic of the encounter between Europe and Africa, between the civilized and the primitive. As Nara puts it, "I was a phallus . . . could only be that . . . and the gasps that I was to hear, these cries that I had wanted never to have heard were supposed to have come from the junction of two reigns, the human and the animal."[26] Nara and Isabelle are incapable of reaching true love because of the barrier that Western literature constructs between the "rational European" and the "emotional African" — concepts which are thematized in Senghorian *négritude* and made to trap the lovers' freedom in their text. According to Nara, Isabelle sees him in every erotic poem she reads and tells him "you are my totem," to which he answers "I am not an animal."[27]

In the novel, Mudimbe also illustrates the manner in which universalist Marxism debunks the freedom of Africans by assimilating their struggle to that of the proletariat. Mudimbe, in *Entre les eaux* (1973), a novel that was awarded the Grand Prix Catholique Littéraire, had already exposed the violence inflicted by both Catholicism and classical Marxism on African spaces, which were outside the societies and class relations that produce these systems of thought. Likewise in *L'écart*, Soum, the socialist realist friend of Nara, believes that "to be a black, that is nothing exceptional in itself. To be a proletarian, yes."[28] Blotting out the

25. Mudimbe, *L'odeur du père*, p. 139.
26. V. Y. Mudimbe, *L'écart* (Paris: Presence Africaine, 1982), p. 34.
27. Ibid., p. 170.
28. Ibid., p. 45.

differences of culture and history and emphasizing class alone, Soum states that history begins the moment Africa joins the proletarians in the fight against the Euro-American capitalists and their puppets. Soum points out to Nara that to celebrate his African heritage is to indulge in false consciousness: "For thirty years [since independence] they have tried to divert us. They sing the richness and the complexity of our culture. . . . What a farce! When you think about the fact that the majority of our people do not have one full meal a day."[29]

Nara, however, is not satisfied with Soum's deterministic positivism and tabula rasa approach to African culture and history. He thinks to himself, "How could our people live all their desires if they could not have, in addition to the architects and the engineers, culturally impassioned people who could, if need be, look for and find the secret keepers of our traditions?"[30] Elsewhere he states, "How am I to tell Soum? When I tried to communicate my doubts to him on the universality of his practice, he quoted Marx to me: The relations of production form a whole; that does not imply at all that history is a totality, but that there are totalities in it."[31]

As a student of history, Nara is not convinced by Soum's "scientific" method, which pushes aside as insignificant the ambiguities, the contradictions, and the challenges that African societies present to Western discourse. Nara argues against the anthropologists and historians who project images of their own desires onto the surface of Africa and posits as an imperative for himself the need to be more sensitive to the specificity of local knowledge. For him, the question of archives is not limited only to "the particular expressions actualized by the brief history of Europe."[32] The new historian must also question the oral traditions, reformulate the symbols in local cultures, and avoid easy conclusions about rituals. Nara, who spends most of his time ruminating about the mode of existence of a discourse not held hostage by a Western regime of truth, states, "It is Aminata, boiling with a cold anger, who gave me last year a good lesson: 'Watch the dead, some things can make them move in the grave.' No other image could have been stronger for me. She forced me to be cautious, and I stopped entertaining Salim about the primitive aspects of Nyimi funerals. I found the itinerary of silence and sympathy. The contact with tradition and its rigorous practice subjected me to its norms, and *my speech bent faithfully before it*."[33]

Defining history from the perspective of oral tradition, Nara compares it to memory, to a thought understanding itself at the root of its own consciousness. He says, "Science was, in my mind, a memory. I could dig it up, read it in my own way; if need be, find it in error and discard it."[34] Clearly what Nara is doing at

29. Ibid., p. 44.
30. Ibid., p. 45.
31. Ibid., pp. 149–50.
32. Ibid., p. 67.
33. Ibid., p. 28.
34. Ibid., p. 68.

the Bibliothèque Nationale is appropriating the archives and constructing his own regime of truth. For him, the anthropologists have either dismissed the rigid norms of African tradition as primitive or aestheticized them beyond their socio-cultural limits. He therefore calls for a critical practice that will reveal the meaning of people's life to themselves instead of using them to form a metadiscourse on the West.

So far I have shown that Nara in *L'écart*, like Mudimbe in his books of criticism, creates a distance between himself and Western master texts by moving toward the construction of a discourse that can be socially and culturally appropriated by Africans. The comparison of the fiction to Mudimbe's theoretical works also helps us to understand *L'écart* within the social context that gave it theme and structure. When dealing with an elusive character such as Nara, an easy way out, inherited from traditional Western criticism of the novel, would be to label him as insane. I will call to the reader's attention here Foucault's criticism of the division of insanity discussed above as a means of controlling discursive deployments. The blurb on the back of *L'écart*, for example, describes Nara in the following terms: "Mudimbe is most certainly interested in a character who is a neurotic; he lives on the margins [*il vit l'écart*] of society. He is schizophrenic and it is killing him." Certainly the story of *L'écart* can be twisted to fit the classic case of a character who is mad. As a child, Nara was locked up in a rat-infested cellar for an entire night. The following morning he was told of his father's death. As a student in Europe, Nara's fear of rats and the dark became obsessive. And in Paris, Nara's women play simultaneously the ambivalent roles of lover and mother. It is convenient for a critic of thematology—the Geneva school of criticism for example—to find here a network of obsessive objects that are linked to a primal repression.

But such an interpretation only represses the revolutionary aspects of the text. Nara's power consists in being able to construct his text on the outer limits of Western discourse. He slips out of Soum's deterministic construct of history, Isabelle's image of the African as a totem, and the use of an Oedipus universalis to explain his desires. To put it in his own words, "I slipped out of bed, oozed out in the embrasure of the door, and took the first train to leave behind, forever, the torment of being loved."[35]

Nara's reformulation of discourse on Africa, like any form of essentialism, raises questions of discursive subjugation that Mudimbe addresses in *L'odeur du père*. As we have seen, however, Mudimbe's criticism of essentialism and identity does not mean a rejection of the concept. It is necessary for Africans, too, to construct temporary totalities and to be allowed to raise questions of individual freedom within these totalities. For example, such categories as African history and African literature, by assuming the cultural unity of Africans, leave unstated

35. Ibid., p. 50.

the diversity of traditions and, since the era of independence, the emerging nationalist discourse of the authors. Since the '60s, works of art and the lives of people have become reorganized according to new needs. They respond no longer to the need to struggle for independence or to the horrors committed by the white man. For Mudimbe, nowadays, "There is a clear diversification of themes, and, like all literatures, African literature too tends to occupy new spaces of enunciation. Each text is thus particularized according to the ideological and the literary inclination of its author. To a certain degree, the author's nationality also counts."[36]

The social context that provides the writer with the elements of his or her text is no longer the same from country to country; "the father to kill or to celebrate, when such is the case, is no longer the same from Senegal to the Congo."[37]

The unanimist tendency that one encounters in Nara and also in Mudimbe, although necessary, can therefore be posited only momentarily. It is necessary and convenient for signifying Europe's discursive violence against Africa, and the need for Africans to call for a discourse that can represent their history, their life, and their literature. But once Africans stand up and speak, a new discursive violence takes place, and this has to be constantly challenged.

In summary, I have tried to show Mudimbe's original contribution to African and contemporary discourse. His texts address the condition for the existence of literary canons in Africa and the issues of epistemological breaks both with the West and with traditional Africa. Mudimbe also raises questions concerning identity and difference in postcolonial discourse, and he thus reformulates the Foucauldian definition of discourse and transforms *négritude*.

36. Mudimbe, *L'odeur du père*, p. 143.
37. Ibid.

Which Idea of Africa?
Herskovits's Cultural Relativism

V. Y. MUDIMBE

Knowledge about Africa is now ordering itself in accordance with a new model. Despite the resiliency of primitivist and evolutionist myths, a new discourse, more exactly, a new type of relation to the African object is taking place. Anthropology, the most compromised of disciplines in the exploitation of Africa, began to rejuvenate itself first through functionalism (during the colonial period) and then, toward the end of the colonial era, in France, through structuralism. In so doing, anthropology, at least theoretically, revised its connection with its own object of study. In any case, in the mid-1950s it merged with other disciplines (economics, geography, history, literature, etc.) to constitute a new but rather vague body of knowledge about Africa or "Africanism." Bound together in the same epistemological space but radically divided in their aims and methods, these disciplines were caught between very concrete demands for the political liberation of Africa and the institutional demands to define their own scientificity, their own philosophical foundation. The figure of the African was taken both as an empirical fact and as the sign of absolute otherness. Michel Foucault remarks this point quite well in the following passage from *The Order of Things*:

> In this figure, which is at once empirical and yet foreign to (and in) all that we can experience, our consciousness no longer finds—as it did in the sixteenth century—the trace of another world; it no longer observes the wandering of a straying reason; it sees welling up that which is, perilously, nearest to us—as if, suddenly, the very hollowness of our existence is outlined in relief; the finitude upon the basis of which we are, and think, and know, is suddenly there before us; an existence at once real and impossible, thought that we cannot think, an object for our knowledge that always eludes us.[1]

1. Michel Foucault, *The Order of Things: An Archaeology of the Human Sciences* (New York: Vintage Books, 1973), p. 375.

From this quotation — a commentary on the figure of madness as the truth and the alterity of modern Western experience — I would like, paradoxically, to suggest that, in general, truth has been the aim of "Africanism." But is this really a paradox when one considers the way these "exotic" figures have, since the fifteenth century, served to testify to a conjunction of Africa with folly?[2] Yet, as strange as it may appear, methodical shifts, transformations, and conversions within the technical discourses of African anthropology and history have been guided by criteria designed to attain the truth about Africa and express it in true and "scientifically" credible discourses. It is this search which, for example, accounts for the existing tension in anthropology between evolutionism, functionalism, diffusionism, and structuralism.

It appears to me that the various methods of Africanism have also had to confront another major issue. This issue concerns the way empirical discourses must witness to the truth of theoretical discourses and vice versa. Indeed, this problem largely transgresses the modalities of Africanist methodological schools. In a paper on "The Search for Paradigms as a Hindrance to Understanding," Albert Hirschman notes that "a recent journal article argued forcefully against the collection of empirical materials as an end in itself and without sufficient theoretical analysis to determine appropriate criteria of selection." Immediately after this, Hirschman specifies his own project: to evaluate "the tendency toward compulsive and mindless theorizing — a disease at least as prevalent and debilitating . . . as the spread of mindless number work in social sciences."[3]

I would suggest that the real issue is not one of theory versus empirical observation and collection; it is, rather, the silent and a priori choice of the truth at which a given discourse aims. In this context, I understand truth as a derivative abstraction, as a sign and a tension. Simultaneously uniting and separating conflictual objectives of systems constituted on the basis of different axioms and paradigms, truth is neither pure idea nor purely objective.

"Whatever may be the case in respect to [a] wish for unity, it is at the beginning and at the end of truths. But as soon as the exigency for a single truth enters into history as a goal of civilization, it is immediately affected with a mark of violence. For one always wishes to tie the knot too early. The *realized* unity of the true is precisely the initial lie."[4] Thus, for example, the challenge of a Christianity linking its fate in 313 to that of the Roman Empire; the paradoxical power of a European expansion outside its borders which, almost exactly 500

2. See Dorothy Hammond and Alta Jablow, *The Myth of Africa* (New York: The Library of Social Science, 1977) and Bernard Mouralis, "L'Afrique comme figure de la folie," in *L'Exotisme*, ed. Alain Buisine, et al. (Paris: Didier-Erudition, 1988).
3. Albert Hirschman, "The Search for Paradigms as a Hindrance to Understanding," in *Interpretive Social Science: A Reader*, ed. Paul Rabinow and William M. Sullivan (Berkeley: University of California Press, 1979), p. 163.
4. Paul Ricoeur, *History and Truth*, trans. Charles A. Kelbley (Evanston: Northwestern University Press, 1965), p. 176.

years ago, invented and organized the world in which we are living today on the basis of the concept of natural law; finally, the lie that justified slavery and, apropos of all non-European territories, the idea of *"terra nullius"* thanks to which America, Australia, and South Africa are what they are today. The representations and signs that gave the hidden and violated memory of these countries its right and pertinence as a beginning seem now to have disappeared.

This type of "paradoxical" sign might be less interesting. It unveils too easily its own internal contradictions. But could I anchor this statement about truth as fault in a reflection dealing with the tasks of Africanists and, at the same time, found it?

Let me elaborate my hypothesis. I think that in the brief history of Africanism it has become obvious that beyond the dichotomy entertained by evolutionists—Lévy-Bruhl and his disciples, including Evans-Pritchard—between rudimentary and scientific knowledge, illusion and truth, there is a major problem concerning the very conditions of knowledge. Most of us would agree with Foucault that some distinctions should be made. On the one hand, there are necessary distinctions to be made about truth itself. One: there is *"a truth that is of the same order as the object—the truth that is gradually outlined, formed, stabilized, and expressed through the body* and the rudiments of perceptions"; two: there is *"the truth that appears as illusion"*; and three: concurrently *"there must also exist a truth that is of the order of discourse—a truth that makes it possible to employ, when dealing with the nature or history of knowledge, a language that will be true.[5] Such distinctions should have a universal application. On the other hand, there is an important question which concerns the status of a true discourse. As noted by Foucault, "either this true discourse finds its foundation and model in the empirical truth whose genesis in nature and in history it retraces, so that *one has an analysis of the positivist type* . . . or the true discourse anticipates the truth whose nature and history it defines . . . so that *one has a discourse of the eschatological type*."[6]

These methodological separations into types of truth, these attempts to define the conditions of possibility of a true discourse and the tension between positivist and eschatological discourses, make sense. Is there really a way of rigorously conceptualizing the reality of Africa without dealing with them? In order to clarify some theoretical consequences of the preceding remarks, I would like to focus seriously and at length on the notion of cultural relativism as expounded by Melville Herskovits, the founding father of African Studies in the United States.

*

5. Foucault, *Order of Things*, p. 320 (emphasis added).
6. Ibid. (emphasis added).

Let us begin with a simple inquiry. Herskovits's questions about ancient civilizations will speak to the most skeptical: how true is our knowledge about them?

> One may well ask, is not our knowledge of the civilizations of the palaeolithic at best too scanty? Do we know too little of the actual life of the people to judge it? In what sort of dwellings did these men live from the earliest times? What sort of language did they speak? What was their religion and their social organization? What clothing did they wear? What foods other than the meat of the animals whose bones we find in the refuse heaps did they eat? These and numerous other questions will occur to one; it is unfortunate that most of them cannot be answered with anything more than guesses, shrewd though these be.[7]

The predicament, as well as the real significance, of the so-called crisis of social sciences in general and African studies in particular might be located here. As Benoît Verhaegen saw it,[8] it resides in the tension between the claim and will to truth of empirical discourses (in which supposedly reality determines the credibility and objectivity of the discourse) and the claims of eschatological discourses (in which the value of a hope and a promise is supposed to actualize a truth in the process of fulfilling its being). Apropos this same tension, Foucault notes that Marxism comes in contact with phenomenology to posit the human being as a disturbing object of knowledge. More simply, one also discovers that Auguste Comte and Karl Marx witness to an epistemological configuration in which "eschatology (as the objective truth proceeding from man's discourse) and positivism (as the truth of discourse defined on the basis of the truth of the object) are indissociable."[9]

This awareness should have imposed itself as an epistemological demand. But in the 1960s, most African Marxist projects ignored the complexity of their epistemological roots and thus erased the paradoxes inherent in their own discourse and practice. On the other hand, non-Marxist works, by ignoring both the historical framework of their own discourses and the conflicting historicities of their "objects" of knowledge, tended to privilege allegorical models of closed, nonexistent societies reduced to mythical pasts; or, as in the case of John Mbiti, wrote and thought in a subjunctive mood accounted for by an uncritical leap out of history into Christian eschatology.[10] In all cases, it is the past — history, or

7. Melville Herskovits, "The Civilizations of Prehistory," in *Man and His World*, ed. B. Brownell (New York: Van Nostrand Co., 1929), p. 121.
8. See Benoît Verhaegen, *Introduction À l'Histoire Immédiate* (Gembloux: Duculot, 1974).
9. Foucault, *Order of Things*, pp. 320–21.
10. See John S. Mbiti, *New Testament Eschatology in an African Background* (London: Oxford University Press, 1971).

more exactly, histories of Africa—which was erased, thus reducing the idea of Africa to a potentiality in the future. Here we may recall Herskovits's advice:

> Make no mistake, cultural relativism is a "tough-minded" philosophy. It requires those who hold to it to alter responses that arise out of some of the strongest enculturative conditioning to which they have been exposed, the ethnocentrisms implicit in the particular value-systems of their society. In the case of anthropologists, this means following the implications of data which, when opposed to our enculturated system of values, sets up conflicts not always easy to resolve.[11]

I question Marxist lessons on Africa. Yet, they seem somehow right in insisting on the fact that there is a relation of necessity between the practice of social science and politics, and thus ethics. One might oppose the political deductions of the Marxists, but, about the idea of Africa, there is no way of ignoring their significance and the evidence they unveil. In terms of the future, the cost (or the price) of social mythologies (development, modernization, etc.) invented by functionalism, applied anthropology, and colonialism is such that a redefinition of the "Africanist" discourse and practice should be isomorphic with that of our political expectations. In terms of the past, the same holds true: what is the price to be paid in order to bring back to light what has been buried, blurred, or simply forgotten?

Perhaps it is now time to reread carefully Herskovits's *Economic Life of Primitive Peoples* (1940) and reanalyze its basic opposition between life before and after the machine, between the "foreign" and the "familiar."

<div align="center">*</div>

In his well-known volume on *Cultural Relativism* (1972), Herskovits stresses that cultural relativism—that is, an anti-ethnocentric approach to otherness—should be understood as a method, a philosophy, and a practice:

> As a method, relativism encompasses the principle of our science (i.e., anthropology) that in studying a culture, one seeks to attain as great a degree of objectivity as possible; that one does not judge the modes of behavior one is describing, or seek to change them. Rather, one seeks to understand the sanctions of behavior in terms of the established relationships within the culture itself, and refrains from making interpretations that arise from a preconceived frame of reference. Relativism as philosophy concerns the nature of cultural values and, beyond this, the implications of an epistemology that derives from a recogni-

11. Melville Herskovits, *Cultural Relativism*, ed. Frances Herskovits (New York: Random House, 1972), p. 37.

tion of the force of enculturative conditioning in shaping thought and behavior. Its practical aspects involve the application—the practice —of the philosophical principles derived from the method, to the wider, cross-cultural world scene.[12]

The project thus explicitly promotes the necessity of making statements which fall within the context of the actor's perceived and understood terms and experiences. Most clearly it denounces the partiality of prejudice. The exigency of such an orientation in Africanism actualizes a hermeneutical task, that of interrogating the reality of "temporal distance" and "otherness" with a rigor similar to that proposed by Hans-Georg Gadamer apropos of historical consciousness:

> We must raise to a conscious level the prejudices which govern under- standing and in this way realize the possibility that *"other* aims" emerge in their own right from tradition—which is nothing other than realizing the possibility that we can understand something in its *otherness.* . . . What demands our efforts at understanding is manifest before and in itself in its character of otherness . . . we must realize that every understanding begins with the fact that something *calls out* to us. And since we know the precise meaning of this affirmation, we claim *ipso facto* the bracketing of prejudices. Thus we arrive at our first conclusion: bracketing our judgments in general and, naturally first of all our own prejudices, will end by imposing upon us the demands of a radical reflection on the idea of questioning as such.[13]

The identity of tasks that I postulate by bringing Gadamer's meditation on the problem of historical consciousness to bear on Herskovits's relativism also reflects itself in the similarities that exist between history and anthropology. Claude Lévi-Strauss has argued that these two disciplines are actually two faces of the same Janus: "the fundamental difference between the two disciplines is not one of subject, of goal, or of method. They share the same subject, which is social life; the same goal which is a better understanding of man; and, in fact, the same method, in which only the proportion of research techniques varies. They differ, principally, in their choice of complementary perspectives: History organizes its data in relation to conscious expressions of social life, while anthropology pro- ceeds by examining its unconscious foundations."[14]

Herskovits's cultural relativism bears witness to *Einfülhung,* which strictly means "sympathy." This reminds me of a remarkable temptation faced by the

12. Ibid., pp. 38–39.
13. Hans-Georg Gadmer, "The Problem of Historical Consciousness," in *Interpretive Social Science: A Reader,* ed. Paul Rabinow and William M. Sullivan (Berkeley: University of California Press, 1979), pp. 156–57.
14. Claude Lévi-Strauss, *Structural Anthropology* (New York: Basic Books, 1963), p. 18.

Belgian missionary Placide Tempels in the 1940s — an era dominated in anthropology by reductionist models. The temptation was precisely to fuse, to identify with the other to the point of becoming the other, if only for a moment, in order to be able to speak sense about the other. Yet, such a project and its procedures of *Einfülhung*, undoubtedly legitimate, at least in principle, are fundamentally difficult to understand. They seem to presuppose at least two ambitious theses. The first concerns the possibility of a fusion of the I and the Other which would suggest that, transcending or negating its own indetermination and unpredictability, the I can really *know* the Other. Sartre has indicated, in a powerful and convincing text, some of the major and paradoxical difficulties of this thesis.[15]

The second problem stems from the questionable transparency of the object of anthropology. For Herskovits, the human as object of knowledge and science seems an obvious and unproblematic given, accounted for by the history and dynamics of a cultural space. Thus, for example, Schmidt's notion of "cultural invariants" from a comparative perspective, or Edel's theory of "indeterminacy" matter little to him, "since the difficulty would appear to be no more than a semantic one":

> The problem would rather seem to be analogous to that of ascertaining *the most adequate basis* for deriving general principles of human behavior, in terms of the relation between form and process. Here the issue is clear . . . with the particular experience of *each society giving historically unique formal expression to underlying processes*, which are operative in shaping the destiny of all human groups.[16]

In sum, Herskovits privileges the culture as a totality rather than the individual consciousness. As a consequence, a collective societal dynamic appears to stand, diachronically or synchronically, as a sort of consciousness of a society. Herskovits thus clearly confirms anthropology in its traditional configuration, that is, in its proximity to nineteenth-century biology and physiology. Yet, he insists that his "cross-cultural approach" studies "*Man in the large*, in the light of differences and similarities between societies, and in the ways by which different peoples must achieve these ends that all peoples must achieve if they are to survive and adjust to their natural and social environments."[17] A question remains: what is this "*Man in the large*"? How has he been conceived as a possible object for knowledge or for science, and from which epistemological and cultural space?

15. Jean-Paul Sartre, *Being and Nothingness*, trans. Hazel E. Barnes (New York: Washington Square Press, 1956), p. 353.
16. Herskovits, *Cultural Relativism*, pp. 56–57.
17. Ibid., p. 108.

Focusing on the various hypotheses regarding this *"Man in the large,"* Herskovits sees distortions in interpretations as dependent upon inappropriate attitudes and as exemplifying the paradox of the history of anthropology. "Early students of man," he notes, "stressed the concept of 'human nature,' but this was essentially to allow them to bring observed divergences under a single head. Later, more emphasis was laid on these differences, but again this was to show how diverse the manifestations of common human tendencies might be."[18] Or, as in the case of "Man" before and after the machine, he antagonizes and brings together cultures in terms of the type of their technologies.[19]

Herskovits's concept of *"Man in the large"* does not seem to rest on a clear distinction between the subject and the object of a culture, a language, a thought, on the one hand; and the subject and the object of the anthropological discourse on the other. In fact, I would say that the concept, mainly in Herskovits's earlier works, actualizes a truism of physical anthropology of the period: in order to know Man (with a capital m), it is imperative to know the varieties of men, their differences and similarities. A concrete illustration can be seen in his contribution to *Man and His World* (1929). In his essay entitled "The Civilizations of Prehistory," Herskovits ceaselessly makes statements such as: "we cannot say what *type of man* lived at the dawn of prehistory"; *"Man of [the] pre-Chellean epoch* had little in the way of civilization, yet it must have taken hundreds of generations to have brought him to this stage"; "That *paleolithic man* lived in Africa we are certain"; "the greatest contribution of *neolithic man* to human civilization was the fact that he learned how to tame plants and animals"; and so on.[20]

That Herskovits was aware of the problem (and of the complexity of the fundamental question that goes back to Kant's anthropology: what is man?) is obvious when one pays attention to the declension of the concepts of civilization and culture in their singular and plural forms: the singular generally postulates the unity of humankind, and the plural its diversity and cultural variation. One gets the clearest picture of Herskovits's art of double-talk in his brief 1961 critique of Henry E. Garret, a psychology professor who argued that racial differences and inequalities are empirical facts that were being opposed by a conspiracy of apostles of "the Equalitarian Dogma." Garret's arguments, published in an issue of *Perspectives in Biology and Medicine* (Autumn 1961), furnish an example of what Herskovits himself calls elsewhere "classical imperialism." Herskovits's criticism outlines two different and complementary orders of reflection. On the one hand, an explicit ethical argument contending in the name of "science" and "reason" that there is a historicity proper to each human group and even to each individual. This historicity can account for differences between

18. Ibid., p. 57.
19. Melville Herskovits, *The Economic Life of Primitive Peoples* (New York: Alfred A. Knopf, 1940), p. 22.
20. Herskovits, "Civilizations of Prehistory," pp. 108, 110, 127, 130 (emphasis added).

cultures and between individuals, but "no scientifically valid evidence has ever been produced to show that these differences, either in general intelligence or particular aptitudes, are related to race."[21] On the other hand, a more discreet order, strongly pressed, yet implicit, alludes to a major epistemological issue that I can illustrate by reference to one of Foucault's statements: "Western culture has contributed, under the name of man, a being who, by one and the same interplay of reasons, must be a positive domain of *knowledge* and cannot be an object of *science*."[22]

Fundamentally a relation to values, cultural relativism, whether diachronic or synchronic, is, as Herskovits aptly put it, "an approach to the question of the nature and role of values in culture."[23] As such, it defines itself as a vivid interrogation of ethnocentrism:

> The very core of cultural relativism is the social discipline that comes of respect for differences — of mutual respect. Emphasis on the worth of many ways of life, not one, is an affirmation of the values in each culture. Such emphasis seeks to understand and to harmonize goals, not to judge and destroy those that do not dovetail with our own. Cultural history teaches that, important as it is to discern and study the parallelisms in human civilizations, it is no less important to discern and study the different ways man has devised to fulfill his needs.[24]

Following Kluckhon, Herskovits believed that "the doctrine that science has nothing to do with values . . . is a pernicious heritage from Kant and other thinkers."[25] His *Human Factor in Changing Africa* (1967), particularly its two chapters on "Rediscovery and Integration," is probably the most concrete illustration of this belief.

<div align="center">*</div>

Let us now turn the discussion toward structuralism, the other major relativist trend in anthropology. In a careful reading of structuralism, after expounding the linguistic model and its transposition in Lévi-Strauss's *Structural Anthropology* (1963) and *The Savage Mind* (1966), Paul Ricoeur turns to the German theologian Gerhard Von Rad's *Theology of the Historical Traditions of Israel*, and notes:

21. Herskovits, *Cultural Relativism*, p. 115.
22. Foucault, *Order of Things*, pp. 366–67.
23. Herskovits, *Cultural Relativism*, p. 14.
24. Ibid., p. 33.
25. Ibid., 42.

Here we find ourselves confronting a theological conception exactly the inverse of that of totemism and which, because it is the inverse, suggests an inverse relationship between diachrony and synchrony and raises more urgently the problem of the relationship between structural comprehension and hermeneutic comprehension.[26]

This statement springs from both a methodological critique of structuralism and a philosophical thesis. The critique, says Paul Ricoeur, shows that "the consciousness of the validity of a method . . . is inseparable from the consciousness of its limits."[27] These limits would seem to be of two types: "on the one hand . . . the passage to *the* savage mind is made by favor of an example that is already too favorable, one which is perhaps an exception rather than an example. On the other hand, the passage from a structural science to a structuralist philosophy seems to me to be not very satisfying and not even very coherent."[28] If I understand correctly Ricoeur's critical reading of Lévi-Strauss's *Structural Anthropology* (1963) and *The Savage Mind* (1966), the example which permits the first passage is Lévi-Strauss's thesis about kinship as a form of language, or, symbolically, marriage rules as "words of the group."[29] As to the second passage, its fragility could be accounted for, according to Ricoeur, by the Lévi-Straussian concept of *bricolage*. Here is Ricoeur's question:

> Hasn't he [Lévi-Strauss] stacked the deck by relating the state of the savage mind to a cultural area — specifically, that of the "totemic illusion" — where the arrangements are more important than the contents, where thought is actually *bricolage*, working with a heterogeneous material, with odds and ends of meaning? Never in this book is the question raised concerning the unity of mythical thought. It is taken for granted that the generalization includes all savage thought. Now, I wonder whether the mythical base from which we [Westerners] branch — with its Semitic [Egyptian, Babylonian, Aramaic, Hebrew], proto-Hellenic, and Indo-European cores — lends itself so easily to the same operation; *or rather, and I insist on this point, it surely lends itself to the operation, but does it lend itself entirely?*[30]

The overall effect of this line of questioning is important, for it implies two main problems. First, the "unity" supposed by the concept of the "savage mind" is not proven. Thus Melville and Frances Herskovits's *Dahomean Narrative*, for

26. Paul Ricoeur, *The Conflict of Interpretations* (Evanston: Northwestern University Press, 1974), p. 45.
27. Ibid., p. 44.
28. Ibid., p. 45.
29. Lévi-Strauss, *Structural Anthropology*, p. 61; Ricoeur, *Conflict of Interpretations*, p. 36.
30. Ricoeur, *Conflict of Interpretations*, pp. 40–41 (emphasis added).

example, would simply witness to a well-localized *"bricolage."* Secondly, if the "savage mind" is only a hypothetical construct whose theoretical unity is challenged by a tension between actual, well-spatialized, and contradictory *"bricolages,"* how could it be used as a measure for comparison with the base from which sprang the Western tradition?

Let us pause one moment and reflect on the last phrase of my quotation from Ricoeur. Does the mythical base from which Westerners branch lend itself *entirely* to the same type of operation as does the mythical thinking of non-Western cultures? As hypothesis, we could retain Herskovits's understanding of myth, that is, a cultural narrative "deriving from human language skill, and man's fascination with symbolic continuities. But as a cultural fact, it also finds dynamic expression in the play between outer stimulus received by a people, and innovation from within."[31]

Well, I think Edmund Leach has demonstrated, in his brilliant and controversial studies, that biblical narratives can lend themselves to structuralist analysis.[32] Although George Dumézil rejected the concept of structuralism and explicitly stated that he was not a structuralist,[33] his works convincingly demonstrate that Indo-European historical and cultural experiences submit to typologizations, systems of transformations, and patterns similar to those produced by structural analysis in non-Western societies. And, Luc de Heusch's *The Drunken King* (1982), one of the foremost systematic structuralist analyses applied to Bantu myths, derives its methodology from both Lévi-Strauss's and Dumézil's lessons. These facts seem, at least partially, to lay to rest Ricoeur's suspicions.

But in the case of Israel's historical tradition, Ricoeur claims to find a conjunction of three historicities that does not seem to exist in totemic cultures and societies.[34] The first of these is that of a *hidden time* which expounds, in a mythical saga, Yahweh's action as Israel's history. The second, that of a *tradition,* founds itself on the authority of the hidden time; in successive readings and interpretations of this authority, it perceives its past and becoming, and reflects it as a *Heilgeschichte.* Finally, there is the historicity of hermeneutics, which Ricoeur refers to, using Von Rad's language, as *"Entfaltung,* 'unfolding' or 'development' to designate the task of a theology of the Old Testament which respects the threefold historical character of the *Heilige Geschichte* (the level of the founding events), the *Uberlieferungen* (the level of constituting traditions), and finally the identity of Israel (the level of a constituted tradition)."[35]

Of course, this makes sense. Yet how can one jump from the founding sagas of Abraham, Isaac, or Jacob to the concept of a *Heilgeschichte* unless one has

31. Herskovits, *Cultural Relativism,* p. 240.
32. See George Dumžil, *Camillus* (Berkeley: University of California Press, 1980).
33. Ibid., p. 11, n. 17.
34. Ricoeur, *Conflict of Interpretations,* pp. 45–56.
35. Ibid., p. 47.

already accepted that these founding events do indeed bear witness to it? It is *faith* in the confession, overextended by the narratives and subsequently by the power of commentaries and interpretations, which justifies and confirms a hidden time as sacred as it transmutes it first into signs of God's kerygma, then into both a history and an eschatology.

Here then is the paradox: Ricoeur's reading seems pertinent only insofar as it can be understood within the economy of the *tradition* that it documents and explains on the basis of the whole significance and role of a Christian thinking in the West. On the other hand, it is the very foundation of this tradition, and particularly the posited singularity and specificity of Israel's history, that gives meaning to Ricoeur's hermeneutics and its ambition. We are really facing something like a firmly closed circle which expands by exaggerating its own significance from the internal logic of a dialogue between its own different levels of meaning. In effect, from the margins of Christianity or, more exactly, from the margins of a Western history that institutionalized Christianity, how can one not think that what is going on here is a simple exegesis of a well-localized and tautologized tradition which seems incapable of imagining the very possibility of its exteriority, namely that, in its margins, other historical traditions can also be credible, meaningful, respectable and sustained by relatively well-delineated historicities?

It is in Herskovits's philosophical statements that I have found reasons to believe in truth as a goal. Other traditions situated outside the Western space — Christianity and its institutionalized procedures, and today's secularized philosophies — speak also about their own hidden times, and all of them, each in its manner, bear witness to their own historicities. Are these historicities two, three, or four? What really should matter is the challenge that this question implies. As Herskovits aptly put it: "there remains the challenge to take concepts and hypotheses into the laboratory of the cross-cultural field, and test their generalizing value, or arrive at new generalizations. Perhaps 'challenge' is too austere a word for our implicit meaning. In the tradition of humanistic scholarship, it is an invitation to discover for the world literature and thought vast resources which will inform and delight us."[36]

Precisely: taken seriously, this last invitation cannot but destroy classical Africanism, or, at any rate, conflict with its conceptual frames and boundaries.

36. Herskovits, *Cultural Relativism*, p. 241.

"Fireflies Caught in Molasses":
Questions of Cultural Translation

HOMI K. BHABHA

Postcolonial criticism bears witness to the unequal and uneven forces of cultural representation involved in the contest for political and social authority within the modern world order. Postcolonial perspectives emerge from the colonial or anticolonialist testimonies of Third World countries and from the testimony of minorities within the geopolitical division of East/West, North/ South. These perspectives intervene in the ideological discourses of modernity that have attempted to give a hegemonic "normality" to the uneven development and the differential, often disadvantaged, histories of nations, races, communities, and peoples. Their critical revisions are formulated around issues of cultural difference, social authority, and political discrimination in order to reveal the antagonistic and ambivalent moments within the "rationalizations" of modernity. To assimilate Habermas to our purposes, we could also argue that the postcolonial project, at its most general theoretical level, seeks to explore those social pathologies—"loss of meaning, conditions of anomie"—that no longer simply "cluster around class antagonism, [but] break up into widely scattered historical contingencies."[1]

These contingencies often provide the grounds of historical necessity for the elaboration of strategies of emancipation, for the staging of other social antagonisms. Reconstituting the discourse of cultural difference demands more than a simple change of cultural contents and symbols, for a replacement within the same representational time frame is never adequate. This reconstitution requires a radical revision of the social *temporality* in which emergent histories may be written: the rearticulation of the "sign" in which cultural identities may be inscribed. And contingency as the *signifying time* of counterhegemonic strategies is not a celebration of "lack" or "excess" or a self-perpetuating series of negative ontologies. Such "indeterminism" is the mark of the conflictual yet

* Short sections of this talk have been published elsewhere.
1. Jürgen Habermas, *The Philosophical Discourse of Modernity* (Cambridge: MIT Press, 1978), p. 348.

postcolonial perspective resists attempts to provide a holistic social explanation, forcing a recognition of the more complex cultural and political boundaries that exist on the cusp of these often opposed political spheres.

It is from this hybrid location of cultural value—the transnational *as* the translational—that the postcolonial intellectual attempts to elaborate a historical and literary project. It has been my growing conviction that the encounters and negotiations of differential meanings and values within the governmental discourses and cultural practices that make up "colonial" textuality have enacted, *avant la lettre,* many of the problematics of signification and judgment that have become current in contemporary theory: aporia, ambivalence, indeterminacy, the question of discursive closure, the threat to agency, the status of intentionality, the challenge to "totalizing" concepts, to name but a few.

To put it in general terms, there is a "colonial" countermodernity at work in the eighteenth- and nineteenth-century matrices of Western modernity that, if acknowledged, would question the historicism that, in a linear narrative, analogically links late capitalism to the fragmentary, simulacral, pastiche-like symptoms of postmodernity. This is done without taking into account the historical traditions of cultural contingency and textual indeterminacy that were generated in the attempt to produce an "enlightened" colonial subject—in both the foreign and native varieties—and that transformed, in the process, both antagonistic sites of cultural agency.

Postcolonial critical discourses require forms of dialectical thinking that do not disavow or sublate the otherness (alterity) that constitutes the symbolic domain of psychic and social identifications. The incommensurability of cultural values and priorities that the postcolonial critic represents cannot be accommodated within a relativism that assumes a public and symmetrical world. And the cultural potential of such differential histories has led Fredric Jameson to recognize the "internationalization of the national situations" in the postcolonial criticism of Roberto Retamar. Far from functioning as an absorption of the particular by the general, the very act of articulating cultural differences "calls us into question fully as much as it acknowledges the Other . . . neither reduc[ing] the Third World to some homogeneous Other of the West, nor . . . vacuously celebrat[ing] the astonishing pluralism of human cultures."[2]

The historical grounds of such an intellectual tradition are to be found in the revisionary impulse that informs many postcolonial thinkers. C. L. R. James once remarked that the postcolonial prerogative consisted in reinterpreting and rewriting the forms and effects of an "older" colonial consciousness from the later experience of the cultural displacement that marks the more recent, postwar histories of the Western metropolis. A similar process of cultural translation,

2. Roberto Fernandez, *Caliban and Other Essays,* trans. Edward Baker, foreword Fredric Jameson (Minneapolis: Minnesota University Press, 1989), pp. xi–xii.

Erratum

OCTOBER: The Second Decade, 1986–1996

edited by Rosalind Krauss, Annette Michelson, Yve-Alain Bois, Benjamin H. D. Buchloh, Hal Foster, Denis Hollier, and Silvia Kolbowski

The MIT Press

Cambridge, Massachusetts, and London, England

The page on the reverse of this page replaces page 212 in the text.

productive space in which the arbitrariness of the sign of cultural signification emerges within the regulated boundaries of social discourse.

It is in this salutary sense that various contemporary critical theories suggest that we learn our most enduring lessons for living and thinking from those who have suffered the sentence of history—subjugation, domination, diaspora, displacement. There is even a growing conviction that the affective experience of social marginality—as it emerges in noncanonical cultural forms—transforms our critical strategies. It forces us to confront the concept of culture outside *objets d'art* or beyond the canonization of the "Idea" of aesthetics, and thus to engage with culture as an uneven, incomplete production of meaning and value, often composed of incommensurable demands and practices, and produced in the act of social survival. Culture reaches out to create a symbolic textuality, to give the alienating everyday an "aura" of selfhood, a promise of pleasure. The transmission of "cultures of survival" does not occur in the ordered *musée ordinaire* of national cultures—with their claims to the continuity of an authentic past and a living present—regardless of whether this scale of value is preserved in the organicist national traditions of romanticism or within the more universal proportions of classicism.

Culture as a strategy of survival is both *transnational* and *translational*. It is transnational because contemporary postcolonial discourses are rooted in specific histories of cultural displacement: in the "middle passage" of slavery and indenture; in the "voyage out" of the colonialist civilizing mission; in the fraught accommodation of postwar "third world" migration to the West; or in the traffic of economic and political refugees within and outside the Third World. It is translational because such spatial histories of displacement—now accompanied by the territorial ambitions of global media technologies—make the question of *how* culture signifies, or what is signified by *culture,* rather complex issues. It becomes crucial to distinguish between the semblance and similitude of the *symbols* across diverse cultural experiences—literature, art, music, ritual, life, death—and the social specificity of each of these productions of meaning as it circulates *as a sign* within specific contextual locations and social systems of value. The transnational dimension of cultural transformation—migration, diaspora, displacement, relocations—turns the specifying or localizing process of cultural translation into a complex process of signification. For the natural(ized), unifying discourse of "nation," "peoples," "folk" tradition—these embedded myths of culture's particularity—cannot be readily referenced. The great, though unsettling, advantage of this position is that it makes one increasingly aware of the construction of culture, the invention of tradition, the retroactive nature of social affiliation and psychic identification.

The postcolonial perspective departs from the traditions of the sociology of underdevelopment or the "dependency" theory. As a mode of analysis it attempts to revise those nationalist or "nativist" pedagogies that set up the relation of Third and First Worlds in a binary structure of opposition. The

postcolonial perspective resists attempts to provide a holistic social explanation, forcing a recognition of the more complex cultural and political boundaries that exist on the cusp of these often opposed political spheres.

It is from this hybrid location of cultural value—the transnational *as* the translational—that the postcolonial intellectual attempts to elaborate a historical and literary project. It has been my growing conviction that the encounters and negotiations of differential meanings and values within the governmental discourses and cultural practices that make up "colonial" textuality have enacted, *avant la lettre,* many of the problematics of signification and judgment that have become current in contemporary theory: aporia, ambivalence, indeterminacy, the question of discursive closure, the threat to agency, the status of intentionality, the challenge to "totalizing" concepts, to name but a few.

To put it in general terms, there is a "colonial" countermodernity at work in the eighteenth- and nineteenth-century matrices of Western modernity that, if acknowledged, would question the historicism that, in a linear narrative, analogically links late capitalism to the fragmentary, simulacral, pastiche-like symptoms of postmodernity. This is done without taking into account the historical traditions of cultural contingency and textual indeterminacy that were generated in the attempt to produce an "enlightened" colonial subject—in both the foreign and native varieties—and that transformed, in the process, both antagonistic sites of cultural agency.

Postcolonial critical discourses require forms of dialectical thinking that do not disavow or sublate the otherness (alterity) that constitutes the symbolic domain of psychic and social identifications. The incommensurability of cultural values and priorities that the postcolonial critic represents cannot be accommodated within a relativism that assumes a public and symmetrical world. And the cultural potential of such differential histories has led Fredric Jameson to recognize the "internationalization of the national situations" in the postcolonial criticism of Roberto Retamar. Far from functioning as an absorption of the particular by the general, the very act of articulating cultural differences "calls us into question fully as much as it acknowledges the Other . . . neither reduc[ing] the Third World to some homogeneous Other of the West, nor . . . vacuously celebrat[ing] the astonishing pluralism of human cultures."[2]

The historical grounds of such an intellectual tradition are to be found in the revisionary impulse that informs many postcolonial thinkers. C. L. R. James once remarked that the postcolonial prerogative consisted in reinterpreting and rewriting the forms and effects of an "older" colonial consciousness from the later experience of the cultural displacement that marks the more recent, postwar histories of the Western metropolis. A similar process of cultural translation,

2. Roberto Fernandez, *Caliban and Other Essays,* trans. Edward Baker, foreword Fredric Jameson (Minneapolis: Minnesota University Press, 1989), pp. xi–xii.

and transvaluation, is evident in Edward Said's assessment of the response from disparate postcolonial regions as a "tremendously energetic attempt to engage with the metropolitan world in a common effort at reinscribing, reinterpreting, and expanding the sites of intensity and the terrain contested with Europe."[3]

How does the deconstruction of the sign, the emphasis on indeterminism in cultural and political judgment, transform our sense of the subject of culture and the historical agent of change? If we contest the grand, continuist narratives, then what alternative temporalities do we create to articulate the contrapuntal (Said) or interruptive (Spivak) formations of race, gender, class, and nation within a transnational world culture?

Such problematic questions are activated within the terms and traditions of postcolonial critique as it reinscribes the cultural relations between spheres of social antagonism. Current debates in postmodernism question the cunning of modernity—its historical ironies, its disjunctive temporalities, the paradoxical nature of progress. It would profoundly affect the values and judgments of such interrogations if they were open to the argument that metropolitan histories of *civitas* cannot be conceived without evoking the colonial antecedents of the ideals of civility. The postcolonial translation of modernity does not simply revalue the contents of a cultural tradition or transpose values across cultures through the transcendent spirit of a "common humanity."

*

Cultural translation transforms the value of culture-as-sign: as the time-signature of the historical "present" that is struggling to find its mode of narration. The sign of cultural difference does not celebrate the great continuities of a past tradition, the seamless narratives of progress, the vanity of humanist wishes. Culture-as-sign articulates that in-between moment when the rule of language as semiotic system—linguistic difference, the arbitrariness of the sign—turns into a struggle for the historical and ethical *right to signify*. The rule of language as signifying system—the possibility of speaking at all—becomes the misrule of discourse: the right for only some to speak diachronically and differentially and for "others"—women, migrants, Third World peoples, Jews, Palestinians, for instance—to speak only symptomatically or marginally. How do we transform the formal value of linguistic difference into an analytic of cultural difference? How do we turn the "arbitrariness" of the sign into the critical practices of social authority? In what sense is this an interruption within the discourses of modernity?

This is not simply a demand for a postcolonial semiology. From the

3. Edward Said, "Intellectuals and the Post-Colonial World," *Salmagundi* 70/71 (Spring/Summer 1986).

postcolonial perspective, it is an intervention in the way discourses of modernity structure their objects of knowledge. The right to signify—to make a name for oneself—emerges from the moment of undecidability—a claim made by Jacques Derrida in "Des Tours de Babel," his essay on "figurative translation." Let us not forget that he sees translation as the trope for the process of displacement through which language names its object. But even more suggestive, for our postcolonial purposes, is the Babel metaphor that Derrida uses to describe the cultural, communal process of "making a name for oneself": "The Semites want to bring the world to reason and this reason can signify simultaneously a colonial violence . . . and a peaceful transparency of the human condition."[4]

This is emphatically not, as Terry Eagleton has recently described it, "the trace or aporia or ineffable flicker of difference which eludes all formalization, that giddy moment of failure, slippage, or jouissance."[5] The undecidability of discourse is not to be read as the "excess" of the signifier, as an aestheticization of the formal arbitrariness of the sign. Rather, it represents, as Habermas suggests, the central ambivalence of the knowledge structure of modernity; "unconditionality" is the Janus-faced process at work in the modern moment of cultural judgment, where validity claims seek justification for their propositions in terms of the specificity of the "everyday." Undecidability or unconditionality "is built into the factual processes of mutual understanding. . . . Validity claimed for propositions and norms transcends spaces and times, but the claim must always be raised here and now, in specific contexts."[6]

Pace Eagleton, this is no giddy moment of failure; it is instead precisely the act of representation as a mode of regulating the limits or liminality of cultural knowledges. Habermas illuminates the undecidable or "unconditional" as the epistemological basis of cultural specificity, and thus, in the discourse of modernity, the claim to knowledge shifts from the "universal" to the domain of context-bound everyday practice. However, Habermas's notion of communicative reason presumes intersubjective understanding and reciprocal recognition. This renders his sense of cultural particularity essentially consensual and essentialist. What of those colonial cultures caught in the drama of the dialectic of the master and the enslaved or indentured?

This concept of the right to signify is, in the context of contemporary postcolonial poetry, nowhere more profoundly evoked than in Derek Walcott's poem on the colonization of the Caribbean through the possession of a space by means of the power of naming. In Walcott's "Names," ordinary language develops an auratic authority, an imperial persona; but in a specifically post-

4. Jacques Derrida, "Des Tours de Babel," in *Difference in Translation,* ed. Joseph F. Graham (Ithaca: Cornell University Press, 1985), p. 174.
5. Terry Eagleton, *The Ideology of the Aesthetics* (Oxford: Blackwell, 1990), p. 370.
6. Habermas, *The Philosophical Discourse of Modernity,* p. 323.

colonial performance of repetition, the focus shifts from the nominalism of linguistic imperialism to the emergence of another history of the sign. It is another destiny of culture as a site—one based not simply on subversion and transgression, but on the prefiguration of a kind of solidarity between ethnicities that meet in the tryst of colonial history. Walcott explores that space of cultural translation between the double meanings of culture: culture as the noun for naming the social imaginary, and culture as the act for grafting the voices of the indentured, the displaced, the nameless, onto an agency of utterance.

My race began as the sea began,
with no nouns, and with no horizon,
with pebbles under my tongue,
with a different fix on the stars. . . .

Have we melted into a mirror,
leaving our souls behind?
The goldsmith from Benares,
the stonecutter from Canton,
the bronzesmith from Benin.

A sea-eagle screams from the rock,
and my race began like the osprey
with that cry,
that terrible vowel,
that I!

. . . this stick
to trace our names on the sand
which the sea erased again, to our indifference.

And when they named these bays
bays,
was it nostalgia or irony? . . .

Where were the courts of Castile?
Versailles' colonnades
supplanted by cabbage palms
with Corinthian crests,
belittling diminutives,
then, little Versailles
meant plans for the pigsty,
names for the sour apples
and green grapes
of their exile. . . .

Being men, they could not live
except they first presumed
the right of everything to be a noun.
The African acquiesced,
repeated, and changed them.

Listen, my children, say:
moubain: the hogplum,
cerise: the wild cherry,
baie-la: the bay,
with the fresh green voices
they were once themselves
in the way the wind bends
our natural inflections.

These palms are greater than Versailles,
for no man made them,
their fallen columns greater than Castile,
no man unmade them
except the worm, who has no helmet,
but was always the emperor,

and children, look at these stars
over Valencia's forest!

Not Orion,
Not Betelgeuse,
tell me, what do they look like?
Answer you damned little Arabs!
Sir, fireflies caught in molasses.[7]

In this poem, there are two myths of history, each related to opposing versions of the place of language in the process of cultural knowledge. There is the pedagogical process of imperialist naming:

Being men, they could not live
except they first presumed
the right of everything to be a noun.

7. Derek Walcott, *Collected Poems 1948–1984* (New York: Noonday Press, 1990), pp. 305–8.

Opposed to this is the African acquiescence, which, in repeating the lessons of the masters, changes their inflections:

> *moubain:* the hogplum
> *cerise:* the wild cherry
> *baie-la:* the bay
> with the fresh green voices
> they were once themselves . . .

Walcott's purpose is not to oppose the pedagogy of the imperialist noun to the inflectional appropriation of the native voice; he proposes instead to go beyond such binaries of power in order to reorganize our sense of the process of language in the negotiations of cultural politics. He stages the slaves' right to signify not simply by denying the imperialist "right for everything to be a noun" but by questioning the masculinist, authoritative subjectivity produced in the colonizing process. What is "man" as an effect of, as subjected to, the sign— the noun—of a colonizing discourse? To this end, Walcott poses the problem of beginning outside the question of origins, beyond that perspectival field of vision which constitutes human consciousness in the "mirror of nature" (as Richard Rorty has famously described the project of positivism). According to this ideology, language is always a form of visual epistemology, the miming of a pre-given reality; knowing is implicated in the confrontational polarity of subject and object, Self and Other.

Within this mode of representation, naming (or nouning) the world is a mimetic act. It is founded on an idealism of the iconic sign, which assumes that repetition in language is the symptom of an inauthentic act, of nostalgia or mockery. In the context of imperialist naming, this can only lead to ethnocentric disdain or cultural despair:

> Where were the courts of Castile?
> Versailles' colonnades
> supplanted by cabbage palms
> with Corinthian crests,
> belittling diminutives . . .

Thus Walcott's history begins elsewhere: in that temporality of the negation of essences to which Fanon led us; in that moment of undecidability or uncondi- tionality that constitutes the ambivalence of modernity as it executes its critical judgments or seeks justification for its social facts. Against the possessive, coer- cive "right" of the Western noun, Walcott places a different mode of speech, a different historical time envisaged in the discourse of the enslaved or the indentured—the goldsmith from Benares, the stonecutter from Canton, the bronzesmith from Benin.

> My race began as the sea began,
> with no nouns, and with no horizon . . .

I began with no memory,
I began with no future . . .

I have never found that moment
When the mind was halved by a horizon . . .

And my race began like the osprey
with that cry,
that terrible vowel,
that I!

Is there a historical timelessness at the heart of slavery? By erasing the sovereign subject of the Western mind, of the mind "halved by the horizon," Walcott erases the mode of historicism that predicates the colonial civilizing mission on the question of the origin of races. "My race began . . . with no nouns." With this Walcott destroys the Eurocentric narrative of nouns, the attempt to objectify the New World, to enclose it in the teleology of the noun, in the fetish of naming. In destroying the teleology of the subject of naming, Walcott refuses to totalize differences, to make of culture a holistic, organic system. What is more, he emphatically stills that future-drive of the (imperialist) discourse of modernization or progress that conceals the disjunctive, fragmented moment of the colonial "present" by overlaying it with grand narratives and grandiose names or nouns: Castile, Versailles. Walcott reveals the space and time in which the struggle for the proper name of the postcolonial poet ensues.

Walcott's timeless moment, that undecidability from which he builds his narrative, opens up his poem to the historical present that Walter Benjamin, in his description of the historian, characterizes as a "present which is not a transition, but in which time stands still and has come to a stop. For this notion defines the present in which he himself is writing history."[8] Yet what is the history that is being rewritten in this present? Where does the postcolonial subject lie?

With "that terrible vowel, that I," Walcott opens up the disjunctive present of the poem's writing of its history. The "I" as vowel, as the arbitrariness of the signifier, is the sign of iteration or repetition; it is nothing in itself, only ever its difference. The "I" as pronomial, as the avowal of the enslaved colonial subject-position, is contested by the repetition of the "I" as vocal or vowel "sign," as the agency of history, tracing its name on the shifting sands, constituting a postcolonial, migrant community-in-difference: Hindu, Chinese, African. With this

8. Walter Benjamin, "Theses on the Philosophy of History," *Illuminations,* trans. Harry Zohn (New York: Schocken, 1969), p. 262.

disjunctive, double "I," Walcott writes a history of cultural difference that envisages the production of difference as the political and social definition of the historical present. Cultural differences must be understood as they constitute identities—contingently, indeterminately—between the repetition of the vowel *i* (which can always be reinscribed, relocated) and the restitution of the subject "I." Read like this, between the I-as-symbol and the I-as-sign, the articulations of difference—race, history, gender—are never singular, binary, or totalizable. These cultural differentials are most productively read as existing in-between each other. If they make claims to their radical singularity or separatism, they do so at the peril of their historical destiny to change, transform, solidarize. Claims to identity must never be nominative or normative. They are never nouns when they are productive; like the vowel, they must be capable of turning up in and as an other's difference and of turning the "right" to signify into an act of cultural translation.

*

The postcolonial revision of modernity I am arguing for has a political place in the writings of Raymond Williams. Williams makes an important distinction between emergent and residual practices of oppositionality, which require what he describes as a "non-metaphysical and non-subjectivist" historical position. He does not elaborate on this complex idea, but I hope that my description of agency as it emerges in the disjunctive temporality of the "present" in the postcolonial text may be one important instance of it. This concept has a contemporary relevance for those burgeoning forces of the left who are attempting to formulate a "politics of difference" that avoids both essentialism and cultural "nationalism"; Williams suggests that in certain historical moments—ours certainly among them—the profound deformation of the dominant culture will prevent it from recognizing "political practices and cultural meanings that are not reached for."[9]

Such a notion of the emergence of a cultural "minority" has a vivid realization in the work of many black American women writers—writers who emphasize, according to Houston Baker, "the processual quality of meaning . . . not material instantiation at any given moment but the efficacy of passage."[10] Such a passage of time-as-meaning emerges with a sudden ferocity in the work of the African-American poet Sonia Sanchez:

> life is obscene with crowds
> of black on white

9. Raymond Williams, *Problems in Materialism and Culture* (London: Verso, 1980), p. 43.
10. Houston Baker, "Our Lady: Sonia Sanchez and the Writing of a Black Renaissance," in *Reading Black, Reading Feminist*, ed. Henry Louis Gates (New York: Meridian, 1990).

death is my pulse.
what might have been
is not for him/or me
but what could have been
floods the womb until i drown.[11]

You can hear it in the ambiguity between "what might have been" and "what could have been"—again, in that undecidability through which Sanchez attempts to write her history of the present. You read it in that considerable shift in historical time between an obscene racist past—the "might have been" —and the emergence of a new birth that is visible in the writing itself—the "could have been." You see it suggested in the almost imperceptible displacement in tense and syntax—might, could—that makes all the difference between the pulse of death and the flooded womb of birth. And it is this repetition— the repetition of the could-in-the-might—that expresses the right to signify.

The postcolonial passage through modernity produces a form of retroaction: the past as projective. It is not a cyclical form of repetition that circulates around a lack. The time *lag* of postcolonial modernity moves *forward*, erasing that compliant past tethered to the myth of progress, ordered in the binarisms of its cultural logic: past/present, inside/outside. This forward is neither teleological nor is it an endless slippage. It is the function of the lag to slow down the linear, progressive time of modernity to reveal its gesture, its *tempi*—"the pauses and stresses of the whole performance." This can only be achieved—as Walter Benjamin remarked of Brecht's epic theater—by damming the stream of life, by bringing the flow to a standstill in a reflux of astonishment.

When the dialectic of modernity is brought to a standstill, then the temporal action of modernity—its progressive future drive—is *staged*, revealing "everything that is involved in the act of staging per se."[12] This slowing down, or lagging, impels the past, projects it, gives its "dead" symbols the circulatory life of the "sign" of the present, of passage, of the quickening of the quotidian. Where these temporalities touch contingently, their spatial boundaries overlap; at that moment their margins are sutured in the articulation of the "disjunctive" present. And this time-lag keeps alive the making and remaking of the past. As it negotiates the levels and liminalities of that spatial time that I have tried to unearth in the postcolonial archaeology of modernity, you might think that it "lacks" time or history. But don't be fooled!

11. Sonia Sanchez, quoted in Baker, "Our Lady: Sonia Sanchez," pp. 329–30.
12. Walter Benjamin, *Understanding Brecht,* trans. Stanley Mitchell (London: New Left Books, 1973), pp. 11–13. I have freely adapted some of Benjamin's phrases and interpolated the problem of modernity into the midst of his argument on Epic theater. I do not think that I have misrepresented his argument.

It appears "timeless" only in that sense in which, for Toni Morrison, African-American art is "astonished" by the belated figure of the ancestor . . . "the timelessness is there, this person who represented this ancestor."[13] And when the ancestor rises from the dead in the guise of the murdered slave daughter, Beloved, then we see the furious emergence of the projective past. Beloved is not the ancestor, the elder, whom Morrison describes as benevolent, instructive, and protective. Her presence, as *revenant,* is profoundly time-lagged and moves forward while continually encircling the moment of the "not there" that Morrison sees as the stressed, dislocatory absence that is crucial for the reconstruction of the narrative of slavery. Ella, a member of the chorus, standing at that very distance from the "event" from which modernity produces its historical sign, now describes the projective past:

> The future was sunset; the past something to leave behind. And if it didn't stay behind you might have to stomp it out. . . . As long as the ghost showed out from its ghostly place . . . Ella respected it. But if it took flesh and came in her world, well, the shoe was on the other foot. She didn't mind a little communication between the two worlds, but his was an invasion.[14]

The emergence of the "projective past" introduces into the narratives of identity and community a necessary split between the time of utterance and the space of memory. This "lagged" temporality is not some endless slippage; it is a mode of breaking the complicity of past and present in order to open up a space of revision and initiation. It is, in other words, the articulation between the pronominal "I" and verbal/vocal *i* that Walcott stages in the process of creating a postcolonial, Caribbean voice that is heard in the *interstitial* experience of diaspora and migration, somewhere between the "national" origins of the Benin bronzesmith, the Cantonese stonecutter, and the goldsmith from Benares.

The histories of slavery and colonialism that create the discursive conditions for the projective past and its split narratives are tragic and painful in the extreme, but it is their agony that makes them exemplary texts for our moment. They represent an idea of action and agency more complex than either the nihilism of despair or the utopia of progress. They speak of the reality of survival and negotiation that constitutes the lived moment of resistance, its sorrow and its salvation—the moment that is rarely spoken in the stories of heroism that are enshrined in the histories we choose to remember and recount.

13. Toni Morrison, "The Ancestor as Foundation," in *Black Women Writers,* ed. Mari Evans (London: Pluto Press, 1985), p. 343.
14. Toni Morrison, *Beloved* (New York: Plume, 1987), pp. 256–57.

Body Politics/Psychoanalysis

The Public Sphere and Experience: Selections*

OSKAR NEGT and ALEXANDER KLUGE

translated by PETER LABANYI

Foreword

Federal elections, Olympic ceremonies, the actions of a unit of sharp-shooters, a theater premiere — all count as public events. Other events of over-whelming public significance, such as child-rearing, factory work, and watching television within one's own four walls, are considered private. The real social experiences of human beings, produced in everyday life and work cut across such divisions.

We originally intended to write a book about the public sphere[1] and the mass media. This would have examined the most advanced structural changes within these two spheres, in particular the media cartel. The loss of publicity within the various sectors of the Left, together with the restricted access of workers in their existing organization to channels of communication, soon led us to ask if there can be any effective forms of counter-publicity against the bour-geois public sphere. This is how we arrived at the concept of proletarian public-ity, which embodies an experiential interest that is quite distinct. The dialectic of bourgeois and proletarian publicity is the subject of our book.

* The following selections are taken from *Öffentlichkeit und Erfahrung: Zur Organisationsanalyse von bür-gerlicher und proletarisher Öffentlichkeit.* © 1972 Suhrkamp Verlag, Frankfurt. The complete English translation was published as *Public Sphere and Experience: Toward an Analysis of the Bourgeois and Proletarian Public Sphere,* trans. Peter Labanyi, Jamie Owen Daniel, and Assenka Oksiloff. © 1993 University of Minnesota Press.

1. The key category — *Öffentlichkeit* — of Negt and Kluge's book is used by them in (at least) three senses: (1) as a spatial concept denoting the social sites or levels where meanings are manufac-tured, distributed, and exchanged; (2) as the ideational substance that is processed and produced within these sites; and (3) as "a general horizon of social experience" (see below). The difficulty in providing a translation is compounded by the fact that Negt and Kluge often use the term dialecti-cally, in more than one of these senses simultaneously. This, according to them, reflects real elisions and conflations in social practice. Whereas "public sphere," which has become the established translation of *Öffentlichkeit*, adequately, if inelegantly renders sense (1), it cannot grasp (2) and (3). For these latter senses of *Öffentlichkeit* not as a "sphere" but as substance and as criterion, I have taken the risk of trying to rehabilitate the term *publicity* in the hope that such an attempt to reconquer terrain colonized by capital interests is in the spirit of Negt and Kluge's project of producing not just analyses and critiques but "counter-publicity." Drawing attention to the etymological relation between *public sphere* and *publicity* only serves to highlight the gap between the latter concept's emancipatory promise and its reality as the tool of fundamentally private interests. — Tr.

Rifts in the movement of history—crises, war, capitulation, revolution, counterrevolution—denote concrete constellations of social forces within which proletarian publicity develops. Since the latter has no existence as a ruling public sphere, it has to be reconstructed from such rifts, marginal cases, isolated initiatives. **To study substantive attempts at proletarian publicity is, however, only one aim of our argument: the other is to examine the contradictions emerging within advanced capitalist societies for their potential for counter-publicity.** We are aware of the danger of concepts like "proletarian experience" and "proletarian publicity" being reduced to idealist platitudes. In this connection Jürgen Habermas speaks, far more cautiously, of a "variant of a plebian public sphere that has, as it were, been suppressed within the historical process."[2] During the past fifty years the concept "bourgeois" has been repeatedly devalued; but it is not possible to do away with it so long as the **facade of legitimation** created by the revolutionary bourgeoisie continues to determine the decaying postbourgeois forms of the public sphere. We use the word *bourgeois* as an invitation to the reader critically to reflect on the social origins of the ruling concept of the public sphere. Only in this way can the fetishistic character of the latter be grasped and a materialist concept developed.

We are starting from the assumption that the concept **proletarian** is no less ambiguous than **bourgeois**. Nonetheless, the former does refer to a strategic position that is substantively enmeshed within the history of the emancipation of the working class. The other reason we have chosen to retain this concept is because it is not at present susceptible to absorption into the ruling discourse; it

2. Jürgen Habermas, *Strukturwandel der Öffentlichkeit*, Neuwied and Berlin, 1969, p. 8. In favor of the concept of "plebian" publicity chosen by Habermas is the fact that throughout its history the proletariat never attempted to constitute a public sphere on its own, without bourgeois or lumpen-proletarian ingredients. It was the heterogeneous urban lower classes, who can be described as "plebian," who attempted during the French Revolution or the class struggles in nineteenth-century France to fashion a public sphere appropriate to them. Moreover, the imprecision of the concept, which makes it serviceable for historical analysis (it has to be able to embrace wholly heterogeneous individual historical moments), is indicated by the term *plebian* rather than by *proletarian*, which appears to have a more exact analytical significance. Despite this, we have opted for *proletarian* because in our view we are dealing not with a variant of the bourgeois public sphere but with an entirely distinct conception of the overall social context present in history but not grasped by the latter term. Thus a plant where there is a strike or an occupied factory is to be understood not as a variant of the plebian public sphere but as the nucleus of a *conception of publicity that is rooted in the production process*. Furthermore, the same difficulty would arise when one speaks of the people (a concept that Habermas places in quotation marks), since in the latter the nature of workers as engaged in production fails to find expression. For the method of analysis pursued here and in what follows, the dialectic between a historical and a systematic approach is of central significance. The systematic approach looks for precise concepts and terms that are analytically articulate and capable of distinguishing phenomena. The historical approach must, if it is to capture the real movement of history, again and again sublate the apparent precision of systematic concepts, in particular their tendency to exclude. For this reason, the adoption of the concept of a proletarian public sphere can be understood only in this dialectical context; it lays no claim to being more precise than, for instance, the term *plebian public sphere*, although our different choice of words indicates that our analysis is heading in a different direction.

resists categorization as part of the symbolic spectrum of the bourgeois public sphere which so readily accommodates the concept of "critical" publicity. There are objective reasons for this. Fifty years of counterrevolution and restoration have exhausted the labor movement's linguistic resources. The word *proletarian* has, in the Federal Republic, taken on an attenuated, indeed an anachronistic sense. Yet the real conditions it denotes belong to the present, and there is no other word for them. We believe it is wrong to allow words to become obsolete before there is a change in the objects they denote.[3]

Whereas it is self-evident that the bourgeois public sphere is not a reference point for bourgeois interests alone, it is not generally assumed that proletarian experience and its organization are equally a crystallizing factor —for a public sphere which represents the interests and experiences of the overwhelming majority of the population, insofar as these experiences and interests are real.[4] Proletarian life does not form a cohesive whole, but is

3. It is not our intention as individuals to replace historically evolved key concepts that denote unsublated real circumstances and do not have a purely definitional character. The fashioning of new concepts is a matter of collective effort. If historical situations really change, then new words come about too.

4. The concept of the proletarian public sphere is not our invention. It is used in various ways in the history of the labor movement, but in an often quite unspecific manner. So far as the period after the First World War is concerned, one feature, especially with reference to the communist parties, can be discerned that is significant for the way in which this concept is used. Proletarian publicity is not identical with the party. Someone who appeals to the proletarian public sphere also has the party in mind, but above all the masses. It is striking that the concept of public sphere employed in this context always depicts the mobilization of the masses or the party members for specific decisions that are either controversial or cannot be executed within the organizational apparatus. Thus there is talk of actions "that are calculated seriously to lower the estimation of party in the eyes of the proletarian public sphere" (Hermann Weber, *Die Stalinisierung der KPD in der Weimarer Republik*, documentary appendix, Rote Texte, Reihe Arbeiterbewegung, n.d., p. 416). There is an appeal to the proletarian public sphere when the aim is either to implement the decision and analysis of a specific sector within the party leadership or to criticize it as something that is irreconcilable with the interests of the proletariat as a whole. This instrumentalizing appeal to the masses and their acclamation corresponds, however, precisely to one of the principles of the bourgeois public sphere. Proletarian publicity does not operate in this way. The concept has here a sporadic, ad hoc quality, which is ascribed to the masses from outside. This situation is signalled by the fact that the party organization and the masses are no longer united in a common framework of experience. A still more graphic example of the way in which the concept of proletarian publicity is used is provided by the parallel action organized by Trotsky and his supporters alongside the official October demonstration during a phase in the development of Soviet society in which there was in practice only a small chance that Trotsky's Left Opposition could assert itself. Lenin, too, refers in various ways to appealing to the party so as to carry through certain decisions against the majority in the party leadership. In all these cases the proletariat is seen as a totality, as the material carrier of a specific publicity. With Marx, the concept proletarian incorporates a sense that is not contained in sociological and political-economic definitions of the working class, even though it is their material foundation. The practical negation of the existing world is subsumed within the proletariat, a negation that needs only to be conceptualized for it to become part of the history of the political emancipation of the ruling class. In his *Critique of Hegel's Philosophy of Right* Marx says that all the demands of the working class are forms of expression of the mode of existence of this class itself. "By proclaiming the *dissolution of the hitherto existing world order* the proletariat merely states the *secret of its own existence*, for it *is in fact* the dissolution of that world order. By demanding the *negation of private property*, the proletariat merely raises to the rank of

characterized by a blocking of any genuine coherence. That horizon of social experience which does *not* do away with, but rather reinforces this blocking, is the bourgeois public sphere.

What is striking about the prevailing interpretations of the concept of the public sphere is that they attempt to bring together a multitude of phenomena and yet exclude the two most important areas of life: **the entire industrial apparatus of businesses and family socialization. According to these interpretations, the public sphere derives its substance from an intermediate realm which does not specifically express any particular social life-context, even though this public sphere allegedly represents the totality of society.**

The characteristic weakness of virtually all forms of the bourgeois public sphere derives from this contradiction: namely that the bourgeois public sphere excludes substantial life-interests and nevertheless claims to represent society as a whole. To enable it to fulfill its own claims, it must be treated like the laurel tree in Brecht's *Stories from the Calendar*, about which Mr. K. says: it is trimmed to make it even more perfect and even more round until there is nothing left. Since the bourgeois public sphere is not sufficiently grounded in substantive life-interests, it is compelled to ally itself with the more tangible interests of capitalist production. For the bourgeois public sphere, proletarian life remains a "thing-in-itself": exerting an influence on the former, but without being understood.

Today the consciousness industry, advertising, the publicity campaigns of businesses, and administrative apparatuses—together with the advanced production process, itself a pseudo-public sphere—overlay, *as new production public spheres*, the classical bourgeois public sphere. Their roots are not public: they work the raw material of everyday life, which, in contrast to the traditional forms of publicity, derive their penetrative force directly from capitalist production. By circumventing the intermediate realm of the traditional public sphere (the seasonal public sphere of elections, public opinion), they seek direct access to the private sphere of the individual. It is essential that proletarian counter-publicity confront these public spheres permeated by the interests of capital, and does not merely regard itself as the antithesis of the classical bourgeois public sphere.

Practical political experience is the crux. The working class must know how to deal with the bourgeois public sphere, the threats the latter poses, without allowing its own experiences to be defined by the latter's narrow horizons. The bourgeois public sphere is of no use as a medium for the crystallization of the experience of the working class—it is not even the real enemy. Since it came into being, the labor movement's motive has been to express proletarian interests in its own forms. Parallel to this ran the attempt to contest the ruling class's

a *principle of society* what society has made the principle of the *proletariat*, what, without its own cooperation, is already incorporated in *it* as the negative result of society" (Karl Marx and Friedrich Engels, *Collected Works*, vol. 3, London, 1975, p. 187).

enlistment of the state. Marx recognizes this when he describes the theft of wood as analogous to the propertied class's theft of the public sphere by appropriating the executive power of the latter without paying for it, but rather by engaging thousands of gendarmes, foresters, and soldiers for its own interests. **If the masses try to fight a ruling class reinforced by the power of the public sphere, their fight is hopeless; they are always simultaneously fighting against themselves, for it is by them that the public sphere is constituted.**

It is so difficult to grasp this because the idea of the bourgeois public sphere—as the "bold fiction of a binding of all politically significant decision-making processes to the right guaranteed by law, of citizens to shape their own opinions"[5]—has, since its inception, been ambivalent. The revolutionary bourgeoisie attempted, via the emphatic concept of public opinion, to fuse the whole of society into a unity. This remained merely a goal. In reality, although this was not expressed in political terms, it was the value founded by commodity exchange and private property that forced society together. In this way, the idea of the bourgeois public sphere created, in the masses organized by it, an awareness of possible reforms and alternatives. This illusion repeats itself in every attempt at political stock-taking and mass mobilization that occurs within the categories of the bourgeois public sphere.

In the seventeenth and eighteenth centuries, after centuries of preparing public opinion, bourgeois society constituted the public sphere as a crystallization of its experiences and ideologies. The "dictatorship of the bourgeoisie" articulates itself in the compartmentalizations, the *forms* of this public sphere. Whereas the bourgeois revolution initially makes a thoroughgoing attempt to overcome the limits of the capitalist mode of production, the forms—for instance the separation of powers, the division between public and private, between politics and production, between everyday language and authentic social expression, between education, science, and art on the one hand and the interests and experiences of the masses on the other—prevent even the mention of social criticism, of counter-publicity, and of the emancipation of the majority of the population. There is no chance that the experiences and interests of the proletariat, in the broadest sense, will be able to organize themselves amid this splitting of all the interrelated qualitative elements of experience and social practice.

We do not claim to be able to say what the content of proletarian experience is. But our political motive in this book is to uncouple the investigation of the public sphere and the mass media from its naturalized context, where all it yields is a vast number of publications that merely execute variations on the compartmentalizations of the bourgeois public sphere. What we understand by "naturalized" is evidenced by the ambivalence—in almost every case

5. Jürgen Habermas, Introduction to *Theorie und Praxis*, Frankfurt, 1971, p. 32.

unrecognized—of the most important concepts associated with the key phrase *public sphere*: public opinion, public authority, freedom of information, the production of publicity, mass media, etc. All these concepts have specific historical origins and express specific interests. The contradictory development of society is sedimented in the contradictory nature of these concepts. The knowledge of whence they derive and who employs them tells us more about their content than can any excursions into philology or the history of ideas.

The bourgeois public sphere is anchored in the formal characteristics of communication; it can be described as a continuous historical progression, insofar as one focuses on the ideas that are concretized within it. **But if, by contrast, one takes its real substance as one's point of departure, it cannot be considered to be unified at all, but rather the aggregate of individual spheres that are only abstractly related.** Television, the press, interest groups and political parties, parliament, army, public education, public chairs in the universities, the legal system, the industry of churches are only apparently fused into a general concept of the public sphere. In reality, this general, overriding public sphere runs parallel to these fields as a mere idea, and is exploited by the interests contained within each sphere, especially by the organized interests of the productive sector. What are overriding are those spheres that derive from the productive sector, which is constituted as nonpublic, as well as the collective doubt—a by-product of the capitalist mode of production—about the capacity of the latter to legitimate itself. Both these tendencies come together and combine with the manifestations of the classical public sphere, as these are united in the state and in parliament. For this reason, the decaying classical public sphere is no mere specter, behind which one could come into direct contact with capitalist interests. This last notion is just as false as the contrary assumption that within this aggregated public sphere the politicians could take a decision that ran counter to the interests of capital.

To simplify our account, concrete examples have been restricted to two relatively recent mass media: the media cartel and television. We have not examined in detail other spheres such as the press, parliament, interest groups and political parties, trade unions, or science and research. Individual aspects of proletarian publicity are discussed in a series of commentaries.

Our political motive in this book is to provide a framework for discussion which will direct the analytical concepts of political economy downward, toward the real experiences of human beings. Such discussion cannot itself be conducted in the forms provided by the bourgeois or the traditional academic public sphere alone. One needs to have recourse to investigative work which brings together existing and newly acquired social experience. It is plausible that such investigative work would concern itself, above all, with the material bases of its own production, the structures of the public sphere and of the mass media.

The Public Sphere as the Organization
of Collective Experience

At the heart of our investigation lies the question of the use value of the public sphere. To what extent can the working class utilize the public sphere? Which interests do ruling classes pursue via the public sphere? Each of the latter's forms will be examined according to these interests. Because it is historically a concept of extraordinary fluidity, it is difficult to define the use value of the public sphere. "*Public* and *public sphere* reveal a diversity of competing meanings which derive from different historical phases and, when simultaneously applied to bourgeois society in the epoch of industrial advance and the welfare state, amount to an opaque combination."[6]

To begin with, underlying usage, there is a restriction: the concept "public sphere" is understood as the "epochally defining category" (Habermas) of the bourgeois public sphere. This sense is, however, derived from the **distributional context** of the public sphere. The latter thus appears as something invariable; its phenomenal forms conceal the actual **structure of production** and, above all, the genesis of its individual institutions.

Amid these restrictions, the category's frame of reference fluctuates confusingly. The public sphere denotes specific institutions and practices (e.g., public authority, the press, public opinion, the public, publicity work, streets, and public places); it is, however, also a general horizon of social experience, the summation of everything that is, in reality or allegedly, relevant for all members of society. In this sense publicity is, on the one hand, a matter for a handful of professionals (e.g., politicians, editors, officials), on the other, something that concerns everyone and realizes itself only in people's minds, a dimension of their consciousness.[7] In its fusion with the constellation of material interests in our "postbourgeois" society, the public sphere fluctuates between being a facade of legitimation capable of being deployed in diverse ways and being a mechanism for controlling the perception of what is relevant for society. In both its guises, the bourgeois public sphere shows itself to be illusory, but it cannot be equated with this illusion. **So long as the contradiction between the growing socialization of human beings and the attenuated forms of their private life persists, the public sphere is simultaneously a genuine articulation of a fundamental social need.** It is the only form of expression that links the members of society, who are

6. Habermas, *Strukturwandel*, p. 11. The reading of this book is prerequisite for the following, in particular with reference to the genesis of the bourgeois public sphere.
7. In social practice these two uses of the concept are repeatedly confused. Something that is purely private is regarded as public simply because it belongs within the ambit of a public institution or is provided with the stamp of public authority. Something that counts as private, such as the rearing of young children, is in reality of the greatest public interest.

merely "privately" aggregated via the production process, by combining their unfolded social characteristics with one another.[8]

This ambiguity cannot be eliminated by definitions alone. The latter would not result in the actual "utilization of the public sphere" by the masses organized within it. **The ambiguity has its roots in the structure and historical function of this public sphere.**[9] It is, however, possible to exclude at the outset *one* incorrect use of the concept: the shifting back and forth between an interpretation of the intellectual substance of and real need for public, social organization and the reality of the bourgeois public sphere. The decaying forms of the bourgeois public sphere can neither be redeemed nor interpreted by alluding to the emphatic concept of a public sphere as decided by the early bourgeoisie. The need of the masses to orient themselves within a public horizon of experience does nothing to ameliorate the fact that the public sphere acts as a mere system of norms whenever this need is not genuinely articulated within the latter. The alternation between an idealizing and a critical view of the public sphere leads not to a dialectical, but to an ambivalent outcome: at one moment the public sphere appears as something that can be utilized, at the next, as something that cannot. What needs to be done, rather, is to investigate the ideal history of the public sphere together with the history of its decay, so as to bring out their identical mechanisms.

8. In "On the Jewish Question," Marx analyzes the nineteenth-century state. According to Marx, the "political annulment of private property not only fails to abolish private property but even presupposes it" (*Collected Works*, p. 153). By the very fact that the state declares that distinctions of birth, class, and education are unpolitical, it does not sublate them as such but confirms them as materially existing elements on which it itself is based. The problem is not that it sublates these differences but that it takes up a negative stance toward them: this is the manner of its recognition. What takes place here is a kind of duplication of society into, as Marx says, "a heavenly and an earthly life: life in a political community in which he [man] considers himself a communal being, and life in civil society, in which he acts as a private individual. The relation of the political state to civil society is just as spiritual as the relation of heaven to earth" (*ibid.*, p. 154). For the nineteenth-century state, the public sphere corresponds to this celestial realm of ideas. This concept of the public sphere is ambivalent. On the one hand, it tends to hold fast to this parallelism of state and civil society, it draws its validity from state authority; on the other hand, it has the tendency to distinguish itself from the state as a kind of "control and conscience mechanism." In this capacity it is capable of assembling, at a synthetic level, people's socialized characteristics accumulated within the private sphere and within the alienated labor process. Publicity in this sense is distinct from both the socialized labor process as well as from private existence and from the state. The ambivalence of the concept makes it impossible objectively to define what is in reality of public interest; what we are dealing with is not a material but a constructed level.

9. Compare the more precise determination of the essential mechanisms of bourgeois publicity in later sections of this book: "The Repression and Occlusion of the Bourgeois Public Sphere by the Organized, Non-Public Production Public Spheres of Modern Big Industry" and "The Most Progressive Appearances of the Consciousness Industry." [Omitted here — Ed.]

The Concept of Experience and the Public Sphere

The public sphere possesses use value when social experience organizes itself within it.[10] In the practices of the bourgeois life and production, experience and organization stand in no specific relation to the totality of society. These concepts are primarily used *technically*. The most important decisions about forms of organization and the constitution of experience *antedate* the establishment of the bourgeois mode of production. "What we call private is so, only insofar as it is public. It has been public and must remain public precisely in order that it can be, whether for a moment or for several thousand years, private."[11] "In order to be able to isolate capital as something private, one must be able to control wealth as something public, since raw materials and tools, money and workers belong, in fact, to the public sphere. One can, as an individual, act in the market, buy it up, for example, precisely because it is a social phenomenon."[12]

The fact that whatever is private is dependent on the public sphere also applies to the way in which language, modes of social intercourse, and the public context itself come into being. Precisely because the important decisions about the horizon and organization of experience have been taken in advance, it is possible to exert control in a purely technical manner.[13] Added to this — so far as

10. This concept is here initially used in a generalized sense; it will be more precisely defined in due course. The organization of social experience can be employed either on behalf of a specific ruling interest or in an emancipatory fashion. For instance, scientists can be interested in the exchange and hence the organization, particularized and autonomous, of their scientific experience, whose object is the domination of nature on a world scale in the forms of the scientific public sphere; such experience, which is collective to only a restricted degree, will not as a rule tend to solidify into a political general will that embraces the whole of society. Another example is the interest of the ruling classes to bind the real social and collective experience of the majority of the population to the illusion of a public sphere and an alleged political general will and thereby to organize this experience as static. Whereas in the case of many industrial products such as chairs, bicycles, the use value elements are the same for almost every person, determining the use value of publicity is fundamentally dependent on class interest, on the specific relationship between particular interests that are bound up with a particular public sphere and with the whole of society.
11. Ferruccio Rossi-Landi, "Kapital und Privateigentum in der Sprache," *Ästhetik und Kommunikation*, no. 7 (1972), p. 44.
12. *Ibid.*
13. The real interplay between experience, its organization, and the horizon of publicity is, for bourgeois relations of production as well, dialectical and does *not* operate in a technical manner. This is not visible to everyday consciousness because the historical production of experience, organization, and publicity disappears into its product, the public sphere that defines the present. What can be perceived is the distributional apparatus of this public sphere, from which, again, experience is derived. This distributive public sphere is, however, as before, in reality defined by its *production structure* as the overdetermining factor; this structure is based not only on previous production, but repeatedly reproduces itself from out of the everyday experience of human beings who are subsumed under it. If one grasps the essential connections, then production is that which overdetermines the public sphere. The latter, however, appears not only to be separated from this context of production but also as something specific, as a realm of its own. In reality, however, the material nexus is that the production of publicity preceded commodity production, just as the production of the circulation and distribution sphere in the framework of commodity production is also the prerequisite of production, but the *production of this separation* is no longer visible in this separation.

bourgeois society's awareness of its own experience and its organization is concerned — is an almost constant analogy with the existing practice of universal commodity production.

The abstraction of value that underlies the latter and has the entire world in its grip — in other words, the separation of concrete and abstract labor — provides the model and can be recognized in the generalization of the activities of the state and the public sphere: in the law. Although the anarchy of commodity production is motivated by private interest, in other words, by the opposite of the collective will of society, it develops models of general relevance. **These models are mistaken for and interpreted as products of the collective will, as if the actual status quo, which has only been recognized retrospectively, rested on the latter.**

The structures of this bourgeois tradition also determine the way of life and production practices of the present, in which classes and individuals are themselves no longer citizens in the sense implied by that tradition. Today's middle classes, the sectors of the working class influenced by the bourgeois way of life, students, the technical intelligentsia are all successors of the narrow propertied and educated bourgeois stratum of the nineteenth century and recapitulate under late capitalist conditions individual components of its patterns of experience and organization. The purely technical application of the latter in the contexts of the domination of nature and of social function is, however, no more natural than it was in the bourgeois epoch itself. Perhaps the possibility of purely technical functioning rests on a high level of learning processes, of the socialization required by these learning processes, and of the social, public preconditions that are subjectively experienced as second nature. **The fact that all these preconditions are in fact dialectical emerges only if one goes back to this prehistory.**

In the classical theory of the bourgeoisie, this many-layered quality is reflected in the opposition between the concept of experience derived from the Humean tradition[14] and the critique of that tradition in the philosophy of Hegel.

14. The concepts of empirical experience, of receptivity, the recognition of that which is given, "merely contemplative materialism," attempt to bracket out the subject as a distorting factor. This concept of experience thereby appears to satisfy the requirement of increased objectivity. To be distinguished from this is a second level of the concept of experience within bourgeois philosophy that is grasped in terms of production. For Kant, only that which is the product of the subject is the object of experience; this subject itself produces the rules and laws of the structure of the phenomenal world. It experiences only that which it has itself previously produced. For only thereby is it possible to create a framework of experience that is distinct from mere imagination. This framework of experience is the functioning of the subject, which can, however, function only when it has a counterpart, a block (Adorno), a thing in itself against which it can work and which cannot be dissolved in this mechanism of experience produced by the subject. One can put it as follows: the material of the subject's experiential production can never be wholly appropriated. Everything that is real experience, which can also be verified and repeated by other reasoning subjects, is the expression of a process of production that is based not on isolated individuals but denotes the activity of a collective societal subject into which all the activities of engagement with external and internal nature

"This dialectical movement which consciousness performs on itself—both on its knowledge and on its object, insofar as the new true object emerges for consciousness from this movement itself—is, in fact, what is known as experience."[15] This describes the real workings of bourgeois society and any other society, whether or not the empirical subjects of this society are aware of the dialectic. In what follows, the concept of organized social experience derives from Hegel's definitions, which also underlie the work of Marx. This is not to deny that the concepts of experience and organized experience (the dialectical social mediation of experience) play only a subsidiary role in Marxist orthodoxy.

An individual worker—irrespective of which section of the working class he belongs to and of how far his concrete labor differs from that of other sections—makes "his experiences."[16] The horizon of these experiences is the unity of the proletarian life-context.[17] This context embraces both the various levels on which this worker's commodity and use value are produced (socialization, the psychic structure of the individual, school, the acquisition of professional knowledge, leisure, mass media) and—what is inseparable from the latter—his enlistment in the production process. It is via this unified context, which he "experiences" publicly and privately, that he absorbs "society as a whole," the totality of the context of mystification.[18] He would have to be a philosopher to understand how his experience—which is both preorganized and unorganized, which both molds and merely accompanies his empirical life—is produced. He is prevented from understanding what is taking place through him because the media through which experience is constituted, that is, language, psychic organization, the forms of social intercourse, and the public sphere, all participate in the mystificatory context of commodity fetishism. But even if he did understand, he would still have no experience. Not even philosophers could produce social experience on an individual basis. Before the worker registers this lack, he encounters a concept of experience derived from the natural sciences which has a real function and a suggestive power in that narrow sector of social practice whose object is the domination of nature. He will take this scientific body of experience, which is not socially but technically programmed, as the very form in which experience is secured. This will lead him to "understand" that there is

are drawn. Experience is in a strict sense simultaneously a production process and the reception of societal agreements about the manifestation or rule-boundedness of objects.

15. G. W. F. Hegel, Introduction to *Phänomenologie des Geistes*, vol. 2, Glockner, ed., Stuttgart-Bad Canstatt, 1964, p. 78. Further see Theodor W. Adorno, "Erfahrungsgehalt," in *Drei Studien zu Hegel. Gesammelte Schriften*, vol. 5, Frankfurt, 1971, pp. 295–325.

16. On the differentiation of industrial work see Horst Kern and Michael Schumann, *Industriearbeit und Arbeiterbewusstsein*, Part 1, Frankfurt, 1970, along with the bibliographical references given there.

17. Reimut Rieche, *Proletarischer Lebenszusammenhang*, typescript, Frankfurt, 1971, and *Die proletarische Familie*, Frankfurt, 1971.

18. On the concept of the context of mystification, see Adorno, *Drei Studien zu Hegel*.

nothing he can do with "experience," that he cannot alter his fate with its help. It is a matter for his superiors in the workplace and for specialists.

The Processing of Social Experience
by the New Production Public Spheres

The traditional public sphere, whose characteristic weakness rests on the mechanism of exclusion between public and private, is today overlaid by *industrialized production public spheres*, which tend to incorporate private realms, in particular the production process and the life-context.[19] These new forms *seem* to

19. On the concept of the industrialized production public sphere (one can employ the singular insofar as one is clear that this overdetermining "public sphere" is an accumulation of numerous individual public spheres, which are as diverse and as distinct from one another as the elements of the capitalist productions process itself):

(i) *The production public sphere has its nucleus in the sensual presence of publicity that takes as its point of departure the objective process of production—society as it exists.* This includes the organizational structure of production as a whole as well as "industry as the open book of human psychology" (Marx), in other words, both what has been internalized in human beings and the outside world: the spatial existence of bank and insurance company palaces, city centers, and industrial zones, along with the work, learning, and life-processes within and alongside factories. Because the overwhelming objectivity of this production nexus becomes its own ideology, the doubling of society into a "heavenly and earthly life," its division into a political community and the private, disappears: the earthly residue itself counts as a celestial realm of ideas. It is only within this public/nonpublic whole that the contradictions give rise to new doublings and mechanisms of exclusion.

(ii) *The consciousness industry, together with the nexus of consumption and advertising*, in other words, the production and distribution that are attached to the sphere of secondary exploitation, overlay and ally themselves with the primary production public sphere.

(iii) *The publicity work of firms and that of societal institutions* (interest groups, parties, the state) constitute an abstract form of the individual production public spheres and enter into the aggregate of the latter as an additional overlay.

In this *aggregate* of industrial production public spheres, traditional labor organizations or industrial relations law—even elements of the student movement—constitute from an emancipatory perspective an incorporated ornament, *even if from the perspective of nonemancipation they are real and effective partial forces.* One can get an idea of how the production public sphere overdetermines the political public sphere in the classical sense (seasonal elections, professional politics) if one bears in mind how natural it seems that the threat of the collapse of large economic units, Krupp or the Ruhr coal industry, which are after all private enterprises, becomes a public matter and compels intervention by the state. It would, for instance, be conceivable that a dismantling and building up of entire industrial regions, for instance in the wake of the European Economic Community (E.E.C.) development, could take place on account of real shifts in the production public sphere. Since there is an interplay between all elements of this organic whole, in atypical cases it can come about that political decisions too have a dominant impact; as a rule, however, this dominance is initiated here too by real infrastructural forces—for instance by the mass doubt that is a by-product of the production sphere (cf. the referendum vote against the E.E.C. entry in Norway).

The prototype of the production public sphere in early capitalism is the linking of housing and social amenities with the factory complex as in the case of Krupp. Nowadays there develops alongside the plants of individual concerns a plant in the wider sense which embraces the totality of social production. The social contract, which could only be counterfeited by the revolutionary bourgeoisie, is in the industrial production public spheres positively produced as an internalization of the objective impact of the social order. This totalization of the public sphere has two effects: the social totality is

people to be no less public than the traditional bourgeois public sphere. **Here, and in what follows, we understand that which is public as an aggregate of phenomena that have quite different characteristics and origins. What is public does not have a homogeneous substance at all.** It always consists of numerous elements, which give the impression of belonging together but are in reality only externally joined. In this light, the classical public sphere is originally rooted in the bourgeois life-context, yet separates itself from this context and from the production process. By contrast, the new production public spheres are **a direct expression of the domain of production.**

1. The classical public sphere of newspapers, chancellories, parliaments, clubs, parties, associations rests on a quasi-artisanal mode of production.[20] By comparison, the industrialized public sphere of a computer, the mass media, the media cartel, the combined public relations and legal departments of conglomerates and interest groups, and, finally, reality itself as a public sphere transformed by production, represent a superior and more highly organized level of production.[21]

2. The ideological output of the production public spheres, which permeates the classical public sphere and the social horizon of experience, embraces not only the unadulterated interests of capital — as articulated via the large interest groups of industry — but also the interests of the workers in the production process insofar as these are absorbed by the structure of capital. This represents a complex conjuncture of production interests, life interests, and legitimation needs. The production public sphere is — since it is not just an expression of overdetermining production apparatuses, but also the vehicle of life interests that have entered in it — no longer obliged then to resolve its contradictions as a mere reflex of the dictates of capital. **Instead of excluding the classical public sphere, the production public sphere — as it is intermeshed with the classical public sphere — oscillates between exclusion and intensified incorporation: actual situations that cannot be legitimated become the victims of deliberately manufactured nonpublicity; power relations in the production process that are not in themselves capable of legitimation are charged with legitimated interests of the whole and thereby presented in a context of legitimation. The differentiation between public and private is replaced by the contradiction between the pressure of production interests and the need for legitimation.** The structure

rendered public and, as a counter-tendency, extreme efforts are undertaken, in the interest of maintaining private property, to prevent this from occurring.
20. Kurt Tucholsky manages to capture this fundamental situation when he itemizes what is necessary to found a political party in the Weimar Republic: one chairman, one telephone, one typewriter.
21. The encounter between these different levels of public sphere, for example, takes the following form: a public prosecutor and a secretary will come up against thirty lawyers and sixty public relations specialists of a chemical firm if they try to bring to light an instance of environmental pollution.

of capital is as a result enriched, becomes capable of expansion; the spectrum of possible capitalist solutions to contradictions is, simultaneously, narrowed. The result is a type of transformation society, which is dominated by the capital relationship.[22] In relation to the classical public sphere, the production public sphere thus seems to possess no mechanism of exclusion that would dislodge it from its foundation of interests and weaken it. **In relation to the social horizon of experience, however, identical mechanisms are reiterated in the aggregated and intermeshed classical and production public spheres.**

3. If the demands of the classical public sphere collide with those of the production public sphere, the former, as a rule, give way. **The ideality of the bourgeois public sphere is here confronted with the compact materiality of the new production public spheres.** Even within the latter, those interests that regularly assert themselves are either those with the most direct connection to the profit interest or those that are capable of amassing more life-context [*Lebenszusammenhang*] within themselves. The intersections between the various production public spheres are characterized by fissures and a wealth of contradictions. These include the intersections between private consciousness industry and public service television; between mass media and the press, on the one hand, and the publicity work of conglomerates, on the other; between state publicity and monopolies of opinion; between the publicity of trade unions and that of employers' organizations, and so forth. Papering over these fissures is the task of a special branch of publicity work. This is necessary because there is no equilibrium among the production public spheres but, rather, a struggle to subsume one beneath the others.[23]

4. It is the function of this cumulative public sphere to bring about agreement, order, and legitimation. This public sphere is, however, subordinated to the primacy of the power relations that determine the domain of production. **For this reason, the work of legitimation within this public sphere can be carried**

22. The *culs de sac* [*Aporien*] that derive from this are in part new and in part extensions of those of the classical bourgeois public sphere at a higher level of organization. The claim of every public sphere to sovereignty resides in its capacity to legitimate itself: the legally established order. An authentic history of the bourgeois public sphere would, however, have to admit that its history is the history of force, just as this force continually reproduces itself within the production process. If the public sphere accumulates legitimation, it becomes stronger as a public sphere but must separate itself from production interests that cannot be legitimated—it becomes increasingly untenable as a production public sphere. If, on the other hand, it introduces more interests into its framework, it again becomes stronger, "obligatory" for the more powerful elements of society—but in doing so it renders its real existence, namely the contradictory structure of the production process, public and thereby tends to sublate its own foundation and endangers the validity of private property.

23. In this connection, the public service structure of a production public sphere such as television says nothing about its ability to assert itself. On the one hand, a higher degree of public service, "ideational," statutory elements will result in a separation from the characteristic profit interest that governs society. This separation weakens. On the other hand, public service television also indirectly binds profit interests of its suppliers and itself obeys a value abstraction of a special kind: it is making "legitimation profits."

out and overseen only distributively, and it can itself be changed only superficially, since its real history is taking place nonpublicly in the domain of production. As in the classical bourgeois public sphere, but for different reasons, the productive structure of publicity, and the nonpublic experience linked with it, separates itself from its mere manifestation in the apparatus of distribution — publicity as a finished product that is publicly experienced.

5. This is in no way altered by the fact that the state, as a summation of the classical public sphere, itself influences a significant part of the private sector by its interventions. On the contrary, the same rules apply to the state's contribution to the production public sphere.

6. Any change in this structure, any movement within the public sphere's system of legitimation, opens the possibility for a formal subsumption of sections of society under the control of other sections. The fact that this is how the public sphere operates in reality — its utilization by private interests, which have, of course, enriched themselves with the interests of those engaged in the domain of production and have thereby become incontestable — makes it difficult coherently to incorporate critical experience into the public sphere.

7. If the function of the public sphere were wholly transparent, if it corresponded to the early bourgeois ideal of publicity, then it could not continue to operate in this form. **This is why all the control stations of this public sphere are organized as arcane realms.** The key word *confidential* prevents the transfer of social experience from one domain to another. The mechanism of exclusion is admittedly more subtle than that of the classical bourgeoisie, but no less effective.

8. The bourgeois public sphere's network of norms is under occupation by massive production interests to such a degree that it becomes an arsenal that can be deployed by private elements.[24]

24. One can speak of a network of norms in the sense that norms are dislodged from their original historical context. In this substanceless formal shape they are taken up by the strongest capital interests and often turned precisely against demands that hold fast to the original historical content of these norms. Thus, for instance, the basic right of *press freedom*, which is intended to defend a press that is independent, critical, and rests on a diversity of opinions against the absolutist state, is interpreted by the Springer concern in such a way that it protects the latter's production interests, which destroy this very diversity of opinion. The exploitation of the historically evolved framework of public norms described here can already be found in the classical public sphere, but it is exacerbated in the era of the production public sphere. In both situations the system of publicly sanctioned norms appears to the profit interest as a second nature awaiting its exploitation. The norms cast off products for exploitation as trees do fruit. The more abstract the level, the more fruitful and opaque. At the level of the *global economy*, the norms of the world currency system are in the foreground. The most powerful capital interest, that of the United States, enjoys so-called special rights of withdrawal from the world currency fund, while the same norms are not accessible to the developing countries. Every ruling of the E.E.C. similarly contains norms that harmonize the structures of whole branches of industry in the interests of large production apparatuses. At a *national level*, safety, control, censorship, and quality regulations, originally intended to protect a general interest, are reinterpreted, however, in alliance with private interests into mechanisms to exclude competition. There-

9. Reiterated in the amalgamation of classical public sphere and the new production public sphere is **the rejection of the proletarian life-context as it stands.** Life-context is acknowledged insofar as it fits in with the realization of capital's interest in exploitation [*Verwertungsinteresse*]. In the process, capital's form of expression modifies itself; it accommodates itself to real needs, but must, however, simultaneously model all real needs so that it can slot them into its abstract system. To everyday experience this yields a confusing picture, wherein the life-context is simultaneously integrated into production and the public sphere, and yet is at the same time excluded because in its concrete totality it is not recognized as an autonomous whole.

10. Marx says that, for the nineteenth-century proletariat, the abstraction of everything human, even of the semblance of the human, has in practice been achieved. The old and new public spheres of bourgeois society can respond only with palliatives; **they provide, without any real change in the class situation, the semblance of humanity as a separate product.** This is the foundation of the culture industry's pauperism [*Pauperismus*], which destroys experience.[25] In the consciousness industry, but also in the public practice of aggrandizement and the ideological manufacture of the other production public spheres, **the consciousness of the worker** becomes the raw material and the site where these processes realize themselves. This does not alter the overall context of class struggles, but augments them with a higher, more opaque level. The position is

fore it was possible after 1975, for example, to drive Volkswagen competition from American markets with the aid of safety regulations for automobile production. The most consistent exploitation of public norms is the so-called syndicate structure, which during the Third Reich represented the typical form of economic organization. Within this system the structuring of branches of industry adequate to the interests of the concern is accomplished by setting up statutory semistate institutions via which redistributions of economic wealth and attenuations of production and distribution take place. Organized on a private basis, such syndicates would come up against the ban on cartels — in statutory form they are perfectly feasible. An example of this is provided by the first piece of Federal legislation in the field of media policy, the so-called Film Subvention Law. In this case the legislative division of competence between federal and provincial levels was exploited by particular interests in the commercial cinema in such a way that the medium, which comprises cultural and economic dimensions, was to be subsidized in an abstract economic fashion, since federal legislation has competence only for the economic side of film. The result of this is the so-called "schmaltz-cartel" [*Schnulzen-Kartell*], a law which favors only certain films financed by concerns while bracketing out independent productions as merely "cultural." In the Film Subvention Bureau set up in the wake of the Film Subvention Law, representatives of parliament, the churches, and television work together with certain sectors of the film industry so that there arises a mixture of public and private power that is completely inscrutable. What is characteristic of this is the confusion of areas of responsibility: Bundestag deputies become, as presidents of this bureau, representatives of economic interests, thereby being subject to the legal monitoring of ministries which they themselves, as parliamentary deputies, control. Such constitutional nonsense would not have been possible in the classical public sphere; in supranational organizations above all, it becomes the norm.
25. See Jürgen Habermas, "Die Dialektik der Rationalisierung. Vom Pauperismus in Produktion und Konsum," in *Merkur*, vol. VIII (1954), pp. 701ff. Reprinted in *Arbeit, Erkenntnis, Fortschritt*, Amsterdam, 1970, pp. 7ff.

thus altered insofar as those parts of the life-context that had not hitherto been directly valorized by the interests of capital are now likewise preorganized by society. So the proletarian life-context is split into two halves. One is reabsorbed into the new production public spheres and participates in the process of industrialization; the other is disqualified in accordance with the systems of production and the production public sphere by which society is determined. The proletarian life-context does not as such lose its experiential value; but the experience bound up in it is rendered "incomprehensible" in terms of social communication: it ultimately becomes private. As a result, those domains that relate to human activities that are not directly necessary for the production process and the substructure of legitimation are subjected to an organized impoverishment. At the same time, publicity work, the production of ideology, and the "management" of everyday life—the latter in particular via pluralistically balanced leisure and consciousness programs—appropriate as raw material human desires for a meaningful life and aspects of consciousness in order to erect an industrialized facade of legitimation. Real experience is torn into two parts that are, in class terms, opposed to one another.

The Workings of Fantasy as the Form
in which Authentic Experience Is Produced

In all previous history, living labor has, along with the surplus value extracted from it, produced something else—fantasy. The latter has many layers and develops as a necessary compensation for the experiences of the alienated labor process. The intolerability of his real situation creates in the worker a defense mechanism that protects the ego from the distresses an alienated reality imposes.[26] Since living, dialectical experience would not be able to tolerate this reality, the latter's oppressive dimension is taken up into fantasy, where the nightmare quality of reality is absented. To transform the experience bound up in fantasy into collective practical emancipation, it is not sufficient simply to use the fantasy product; rather one must theoretically grasp the relation of dependency between fantasy and the experience of an alienated reality. **In its unsublated form, as a merely libidinal counterweight to unbearable alienation, fantasy is itself merely an expression of the latter. Its content is therefore inverted consciousness. Yet by virtue of its mode of production, fantasy represents an unconscious practical criticism of alienation.**[27]

26. E.g. Anna Freud, *Das Ich und die Abwehrmechanismen*, Munich, 1971, p. 137: "The development of reactions serves as a safety device against the return of the repressed from within, fantasy conversely to deny distress from the outside world."
27. In this context one can interpret the following passage by Marx in a more literal sense than is customary (see letters from Marx to Ruge in the *Deutsch-Französische Jahrbücher*, vol. 1, pp. 345ff.).

In that case we do not confront the world in a doctrinaire way with a new principle:
Here is the truth, kneel down before it! We develop new principles for the world out of

Without a doubt these workings of fantasy, for which exploitation suppos-
edly has no use, have hitherto been suppressed on a vast scale: human beings are
expected to be realistic. But at the very sites of this suppression, it was not
possible for bourgeois society entirely to assimilate proletarian consciousness and
imagination or simply subsume them under the valorization interest [*Verwer-
tungsinteresse*]. The suppression of fantasy is the condition of its freer existence
in contemporary society. One can outlaw as unrealistic the spinning of a web
around reality, but if one does this it becomes difficult to influence the direction
and mode of fantasy production. The existence of the subliminal activity of
human consciousness—which, owing to its neglect hitherto by bourgeois inter-
ests and the public sphere, represents a partly autonomous mode of experience
by the working class—is today threatened because it is precisely the workings of
fantasy that constitute the raw material and the medium for the expansion of the
consciousness industry.

The capacity of fantasy to organize one's own experiences is concealed by
the structures of consciousness, attention spans, and stereotypes molded by the
culture industry, as well as by the apparent substantiality of everyday experience
in its bourgeois definition. The quantifying time of the production process—
composed of nothing but linear units of time, functionally linked with one
another—is generally hostile to fantasy. But it is precisely the former that is
helpless before the specific time scale, the "time-brand" (Freud) of fantasy.

The workings of fantasy are in an oblique relation to valorized time [*zur
verwerteten Zeit*]. The specific movement of fantasy, as described by Freud, fuses

the world's own principles. We do not say to the world: Cease your struggles, they are
foolish; we will give you the true slogan of struggle. We merely show the world what it is
really fighting for, and consciousness is something that it *has* to acquire, even if it does
not want to.

The reform of consciousness consists *only* in making the world aware of its own
consciousness, in awakening it out of its dream about itself, in *explaining* to it the
meaning of its own actions. Our whole object can only be—as is also the case in
Feuerbach's criticism of religion—to give religious and philosophical questions the
form corresponding to man who has become conscious of himself.

Hence, our motto must be: the reform of consciousness not through dogmas, but
by analyzing the mystical consciousness that is unintelligible to itself, whether it mani-
fests itself in a religious or a political form. It will then become evident that the world
has long dreamed of possessing something of which it has only to be conscious in order
to possess it in reality. It will become evident that it is not a question of drawing a great
mental dividing line between past and future, but of *realizing* the thoughts of the past.
Lastly, it will become evident that mankind is not beginning a *new* work, but is con-
sciously carrying into effect its old work.

This is by no means, as it were, a passage that has not yet been permeated by the materialist
method, and which employs *dream* only as an image. On the contrary, this represents a movement
that is materializing itself within individual consciousness but does not as yet have the *form* of
consciousness. This is expressed empirically not only in the stream of association that accompanies
the lifelong labor process but also in the historical sedimentations of this stream of consciousness in
the shape of cultural products and modes of life.

within each moment immediate present impressions, past wishes, and future wish-fulfillment.[28] Beneath the opposition between the pleasure principle and the reality principle, fantasy will display in all people the same mechanism, which attempts to associate present, past, and future. This mechanism is itself not class-specific. But, the fantasy material that is converted by means of these associations — and in particular the degree of distortion of the former under the pressure of the reality principle of society and the influence of the fragmentation of personal time — is entirely dependent on one's position within the production process. The same applies with respect to whether this fantasy material is expressed in a stunted or fully developed form.

It is important to recognize that fantasy relates to a concrete situation in a threefold sense: **to the situation within which a wish arose, to that of the immediate impression that has been processed, and to the imagined situation of the fulfillment of the wish.** Just such situations are, however, in the proletarian life-context, "damaged situations." In the real life cycle they appear disjoined, intermingled with other moments, transposed hither and thither without regard for the fantasy linked to them. The chaotic quality of fantasy is not an aspect of its true nature but of its manifestation in situations indifferent to its specific mode of production. The latter, moreover, remains reactive: it takes its cue from reality and therefore reproduces the distorted concreteness of this reality.

Whereas standard language and instrumental rationality do not cross the boundary between bourgeois and proletarian publicity, colloquial language and the workings of fantasy are exposed to the conflict between them (as attempts to express and grasp life). The junction between bourgeois and proletarian publicity, between the bourgeois and the proletarian articulation of the circumstances of everyday life, does not exist as a spatial, temporal, logical, or concrete threshold — which could, for instance, be crossed by vigorous translation work. Proletarian publicity negates bourgeois publicity because it either dissolves, destroys, or assimilates the latter's elements. For opposite reasons, the bourgeois public sphere does the same with every manifestation of proletarian publicity not supported by working-class power, and thus cannot repel attacks. Coexistence is impossible. It is true that centers for

28. Freud describes this by means of an example. It is, to be sure, no accident that he takes it from the labor process, even though the essay is about writers.

> Take the case of a poor orphan lad, to whom you gave the address of some employer where he may perhaps get work. On the way there he falls into a day-dream suitable to the situation from which it springs. The content of the fantasy will be somewhat as follows: He is taken on and pleases his new employer, makes himself indispensable in the business, is taken into the family of the employer, and marries the charming daughter of the house. Then he comes to conduct the business, first as a partner, and then as successor to his father-in-law (Sigmund Freud, "The Poet and Day-Dreaming," in *Collected Papers*, vol. IV, London, 1971, p. 178).

the articulation of proletarian interests can confront corresponding bourgeois centers in one and the same society; but when they come into contact, their interaction proves unreal. Fantasy that is drawn away from this point of conflict therefore takes on that travestied form that has hitherto made it impossible to conceive of science, education, and aesthetic production as organizing forms of the fantasy of the masses or, conversely, of incorporating fantasy, as it manifests itself among the masses, in emancipatory forms of consciousness appropriate to the level of industrial production. In this way, one of the raw materials of class consciousness, the imaginative faculty grasped as a medium of sensuality and fantasy, remains cut off from the overall social situation and frozen at a lower level of production—that of individuals or of only random cooperation. The higher levels of production in society excludes this raw material. At the same time, industry—in particular the consciousness industry—tries to develop techniques to reincorporate fantasy in domesticated form.

Insofar as fantasy follows its own mode of production, which is not structured by the process of exploitation, it is threatened by a specific danger. Fantasy has a tendency to distance itself from the alienated labor process and to translate itself into timeless and ahistorical modes of production "which do not and cannot exist." It would prevent the worker from representing his interests in reality. This danger is not, however, as great as may appear from the bolstered standpoint of the critical-rationalistic tradition of thought. As fantasies move further away from the reality of the production process, the goal that drives them on becomes less sensitive. Therefore, all escapist forms of fantasy production tend, once they have reached a certain distance from reality, to turn around and face up to real situations. They establish themselves at a level definitively separated from the production process only if they are deliberately organized and confined there by a valorization interest.[29]

Fantasy in the dissociated sense of modern usage is a product of the bourgeoisie. Accordingly, the word does not denote the underlying, unified intellectual productive force which represents a specific process with its own laws. **On the contrary, this productive force is from the outset schematized according to the alien principles of capitalist valorization. It is in this process that what is subsequently called fantasy is created by dissociation and confinement.**[30] That

29. This can be an interest in economic exploitation or in legitimation profits. The latter are the currency that enables subsumption under specific power relations. This can entail legitimation out of a desire for orthodoxy or also entertainment or new news values that are intended to justify subsumption under a news industry. The bourgeois novel, of which Lukács says that it does not have to be read but devoured, offers, at least in part, a comparable framework in which for long stretches fantasy moves alongside reality and not within it. It is absurd for Lukács to demand that precisely this quality of the "hermetic" work of art must be imported into socialism.

30. The *internment* of fantasy takes place in two respects: elements of it are absorbed as a cement to sustain alienated conditions of work, life, and culture. Ultimately, for instance, on the assembly line

which, from the standpoint of valorization, appears particularly difficult to control, the residue of unfulfilled wishes, ideas, of the brain's own laws of movement, which are both unprocessed and resist incorporation into the bourgeois scheme, is depicted as fantasy, as vagabond, as that component of the intellectual faculties which is unemployed. **In reality, fantasy is a specific means of production engaged in a process that is not visible to capital's interest in exploitation: the transformation of the relations between human beings and nature, along with the reappropriation of the dead labor of generations that is sedimented into history.**[31] Fantasy is thus not a particular substance — as when one says: "so-and-so has a lot of imagination" — but the organizer of mediation. It is the specific process whereby libidinal structure, consciousness, and the outside world are connected to one another. If this productive force of the brain is divided up to such a degree that it cannot obey the laws according to which it operates, the result is a significant obstacle for any emancipatory practice. This means that an important tool is lost for the self-emancipation of the workers, the precondition of which is an analysis in the social and historical sense, by analogy with the principle of the reappropriation of the repressed as developed by Freud for an *individual* life history.[32]

and in sweated labor, it consists almost solely of the internalized imagination of the consequences — real or imagined loss of love, punishment, isolation, etc. — if one were simply to escape from confinement. Here fantasy transforms itself into discipline, "realism," apathy. Other parts of this same energy, which appear to be floating around freely, roam through past, present, and future, but on account of their own libidinally directed laws of motion seek to avoid contact with alienated actuality, with the bourgeois reality principle. They were interned in the ghettos of the arts, reveries, beautiful feelings.

In the process of this partition the "realistic" and "unrealistic" elements of fantasy developed opposing need structures and capacities. Their opposition is not, by mere addition, capable of being reunited. Their combination into an effective intellectual productive force presupposes the reactualization of the entire prehistory of this partitioned fantasy activity.

31. By contrast with the bourgeois usage of the term *fantasy*, Freud therefore rightly speaks of dream-*work*, grief-*work*, the *work* of the imaginative faculty, etc. These are, however, only partial aspects of fantasy as a productive force which can develop itself as a whole only when its own laws of movement enter into the reality principle, against which it wears itself out, in the shape of a new reality principle.

32. What Freud is concerned with is the reappropriation of individual life history and its conflicts. The medium of analysis here is language. For the emancipation of social classes, the reappropriation of the dead labor bound up in the history of the human race, the medium of analysis is, by contrast, not verbal language but a language in the wider sense that embraces all mimetic, cultural, and social relationships as means of expression. The analysis of language is here only one aspect. The most important medium for a self-analysis of the masses would be work. It is, however, in part due to the partitioning of fantasy as a productive force, not understood as an agent of communication between past, present, and the desire for an autonomous identity in the future, but can operate only in the immediate context of the alienated labor process. If one sees the process of social revolution not in the form of public events, but as a specific process of labor and production, it becomes clear what political significance the productive force underlying fantasy possesses. Unless it is organized, the process of social transformation cannot be taken up by those who produce the wealth in society.

Proletarian Publicity as a Historical
Counter-Concept to Bourgeois Publicity

By contrast with the bourgeois class in which the interests of individuals are organized and implemented in private and public form alternately, the interests of workers can, since they are unrealized, be organized only if they enter into a life-context, in other words, into a proletarian public sphere. Only then do they have the chance to develop as interests, instead of remaining mere possibilities.

The fact that these interests can be realized as social labor power only through the needle's eye of their valorization as labor power for commodities makes them initially mere objects of other interests. If subsequently they are directly suppressed, in other words, if they are not socially valorized, they survive as living labor power, as raw material. In this capacity, as extraeconomic interests, they are — precisely in the forbidden zones of fantasy beneath the level of taboos — stereotypes of a proletarian life-context organized only in rudimentary form not susceptible to additional suppression. Therefore they cannot be assimilated either. **In this respect, they have two characteristics: by their defensive attitude toward society, their conservatism, and their subcultural character, they are once again mere objects; but they are, simultaneously, the block of real life that stands against the valorization interest.** As long as capital is dependent on living labor as a source of wealth, this element of the proletarian life-context cannot be extinguished by repression.

This state of affairs represents the initial phase of the constitution of proletarian publicity, and indeed at every stage of social development. Where attempts are made to fit this block into the interests of capital, for instance by the subsumption of the life-context under the program and consciousness industry or the new production public spheres, the accompanying oppression and exclusion produce the substance, appropriately differentiated, of a newly emergent block. On this block of proletarian life interests is based Lenin's belief that there is no situation without some solution. It is no contradiction that, initially, at the level of social mediation depicted, no concrete solutions present themselves. Capital cannot destroy this block, and the proletariat cannot take hold of society from within it.

In reality, this founding phase of proletarian publicity is only rarely encountered in this pure form. It is concealed by more highly organized levels of proletarian publicity.[33] For the history of the labor movement, it is above all two aspects of this higher level of organization that have been important. It is necessary to distinguish them, since all forms of proletarian publicity are the

33. As against this, it would not be concealed by the pure form of the bourgeois public sphere. It is precisely the result of exclusion and suppression, in other words, the very opposite of this bourgeois public sphere.

qualitative expression of the proletarian life-context and therefore tend — by contrast with the costumed character of the rapidly changing bourgeois public spheres — to exclude more developed forms.

Julia Margaret Cameron.
Cupid's Pencil of Light. *1870.*

Cupid's Pencil of Light:
Julia Margaret Cameron and the
Maternalization of Photography*

CAROL ARMSTRONG

Cupid's Pencil of Light, I

When one thinks of Victorian images of come-hither children, it is Lewis Carroll that one probably thinks of first, but in fact it is Julia Margaret Cameron, the good mother and grandmother, who has left us with the more obsessive, the more insistent, and I think the more perverse record of a fascination with the allure of childish bodies. (Just one example would be Cameron's *Infant Undine* of 1864, with that pseudononchalant, crossed-foot pose, that slightly sullen, almost sultry look, that sliding slip, and its revelation of plumped baby flesh, recalled in contemporary images, such as Sally Mann's snapshotty yet Hollywoodish photograph of her daughter, *Virginia at 3*, which verge on child pornography, so people felt at the time of their exhibition.)[1] In fact, the image of the child was central to Cameron's practice right from the beginning, when she took up her camera in 1864 at the matriarchal age of forty-nine and recorded a village girl, Annie Philpot, as her "first success in photography." Right from the start, the eroticized child was a mainstay—indeed, it is to 1864 that a good share of such pictures are dated (it is the year of *The Infant Undine*, *The Double Star*, and *The Infant Bridal*, for instance).

* A variant of this essay was given as a paper at Wellesley College, April 1995, in the symposium chaired by Anne Higgonet entitled "Imagined Children, Desired Images," which accompanied an exhibition of photographs from Julia Margaret Cameron's *Mia* album, and another smaller show of images of children by contemporary photographers.

1. Because Mann was accused of being a bad mother, *Virginia at 3* and the other photographs in *Immediate Family* necessitated the following denial from her: "I don't think of my children, and I don't think anyone else should think of them, with any sexual thoughts. I think childhood sexuality is an oxymoron" (quoted by Richard B. Woodward in "The Disturbing Photography of Sally Mann," *New York Times Magazine*, September 27, 1992, p. 52). That statement is interesting from the point of view of this essay, not only for its pointing to rather than excising sexuality from the scene of *Immediate Family*, but also for its collapsing of maternal "sexual thoughts" with "childhood sexuality." For an account of the relationship between Mann's and Cameron's (as well as Mann's and Lewis Carroll's, and Mann's and Edward Weston's) images, see Shannah Ehrhart, "Sally Mann's Looking-Glass House," in *Tracing Cultures* (New York: Whitney Museum of American Art, 1994).

The Infant Undine. *1864.*

In addition to the fact that she was a woman looking at children, and that most of those children were related to her, there is this difference between Cameron's less-known and Carroll's better-known images of sexy children: for Cameron, the naked child served as an allegorical figure of photography itself.[2] As the pictorialist Oskar Rejlander before her had done, Cameron depicted photography in the guise of a Cupid, in her case a Cupid wielding a "pencil of light," somewhat older than Rejlander's *Infant Photography*, more liminal, somewhere between a baby and an adolescent. And rather than "Infant Photography" handing his tool to (or receiving it from) Father Art, shown in the service and under the guidance of the Artist as patriarch—who, ruling unseen, stands both for the older art of Painting and for Artistry in general, including the artistry of the painterly photographer—rather than that, Cameron images photography *en abyme*, the child within the photograph, aligned with its frame, reproducing in miniature, with his "pencil of light" and on a photographic plate, the act of "natural drawing" that produced the larger image in which he sits enframed: the act of "natural drawing," in other words, that reproduced him reproducing it. And both the

2. See Carol Mavor, *Pleasures Taken: Performances of Sexuality and Loss in Victorian Photographs* (Durham, N.C.: Duke University Press, 1995), for a full-length account of sexuality and photography in the Victorian era. Mavor looks at Cameron, among others, in some ways that parallel my own concerns—but, among other things, she does not address the photographicness of photography, or the role of the child in figuring photography per se.

process and the product of that act of production-by-reproduction are imaged as
light itself, both as disembodied force and as embodied shape: amorphous light
above, which images the making of the photograph itself; blinding light within, on
the plate upon which Cupid draws, light embodied in the form of the child and
then disembodied in a play of glow and highlight at the edges and limits of his
form. *This* Cupid represents drawing under the aegis of Photography—in the
guise of light—rather than Photography under the aegis of the mastered arts of
drawing and painting; Photography in the image of its own process, its own mode
of production, rather than Photography ruled by the technical decrees of the
established arts; Photography under the sway of the Mother, rather than the law
of the Father.

For the light above Cupid is Mother Light, the Light of Cupid's Mother
Venus. At around the same time, Cameron also portrayed the Virgin Goddess
Diana, showing her in much the same amorphous guise as the light that presides
over Cupid the photographer, as seductress of her similarly posed, similarly
androgynous, similarly erotic Endymion child. Thus *Cupid's Pencil of Light,* together
with the series of similarly photographed children to which it belongs, is "Infant
Photography" both produced and seduced by Mother Photography, captured in
the self-reflexive embrace of incestuous Mother Photography, (re)produced by
her even as she reproduces herself, loved by her and her light even as she loves
herself.

None of Cameron's allegorical children are phallic children. (Even the

Venus Chiding Cupid and
Removing His Wings. *1873.*

The Young Endymion. *1870s.*

Cupid of *Cupid's Pencil of Light* has a slim little luminous pencil instead of a phallus, and in its reproductive capacity, under the aegis of the Mother, that pencil is hardly a symbolic phallus either, as "Infant Photography's" outsized paintbrush, which rightfully belongs to the Father, surely may be taken to be.) Neither are Cameron's Christ-infants, as we shall see, the phallic children of the Renaissance tradition: no genitals, and no genital-fondling here.[3] It is the androgyny of child-hood that abounds instead, although I'm not sure I would qualify it as sexlessness, quite. For Cameron's children play the roles of erotic boys—Cupid and Endymion, as well as Christ—and it is in the body of the mythological boy-child and the mystical boy-infant that her fascination with skin, with flesh and fleshliness, emerges.

As exemplified in *Cupid's Pencil of Light*, Cameron's photography is often self-reflexive, often as much about photography per se as it is about anything else. Indeed, it is fair to say that over and over again, Cameron sought to allegorize her own photographic practice and to define it alternatively by allegorical means—as something altogether different from technical mastery, pertaining, rather, to the domestic, the incestuously familial and the feminine; as something like hysteria—the hysteria of the mother—instead. Over and over again she used the body of the child to allegorize *that* notion of photography. And if photographs like *Cupid's Pencil of Light* propose that self-referentiality in photography *must* take the form of allegory,[4] they also suggest that at least for this Victorian photographer, eroticism could only circulate within the allegorical self-reflexivity of her photographs, within their repetitious oscillation between outward bodily reference and inward self-reference: which is to say, between the indexically traced photographic referent, the fleshly body (of the child), and the allegorized evidence of the materiality of the photographic process, i.e., streaks of light and chemistry and such.

Between Index and Icon: Praise and Prayer

It might well seem that Cameron's photographs belong to the same ideological universe as that of, say, Dante Gabriel Rossetti. For instance, in 1872 she portrayed Lewis Carroll's Alice—looking, at the age of twenty, not unlike Rossetti's *La Ghirlandata* of the following year. To take another instance, there are Cameron's several Pre-Raphaelite photographs of her great-niece Florence Fisher as a child,

3. See Leo Steinberg, *The Sexuality of Christ in Renaissance Art and Modern Oblivion* (New York: Pantheon, 1983).
4. Though this may be the case of medium self-referentiality (as distinguished from medium liter-alism) in general, it seems particularly the case of the photograph, where the inescapable referentiality of the photograph must always factor into its self-referentiality its referencing of its own materiality. This is the case even, as in some of Cameron's images, when we find the material traces of the workings of photography left visible on the plate and the print: insofar as they signify at all, those marks can never just be or refer to themselves; they must always enter into play with, and be read through, the photographic referent.

both as herself and as John the Baptist, which repeat the repeated poses of Rossetti's mature seductresses. In repeating the look of his *femmes morcelées,* they might also seem to repeat his repeated constructions of the "absoluteness of gender difference" and of the necessity of the status of woman as over and over again, as always already nothing but his erotic object, "'not as she is but as she fills his dream.'"[5] Despite their production by a woman, and their focus on children, women who have barely left childhood, and women together with children, Cameron's photographs might seem to illustrate Griselda Pollock's Lukacsian description of the operations of "photographic" "realism" in Rossetti's fetishistic typecasting of women just as well:

> Realism as *a mode of signification* . . . became increasingly dominant in bourgeois culture . . . with the establishment of photographic practices. . . . A sense of actuality—someone like this was here, once—combines with and plays against the freedom of fantasy, for the only actual presence, now, is the viewer's. Fantasy can be satisfied by realist means which secure the credibility of the imaginary scene, with details of costume, setting, accessories. The realist mode of signification disguises the fact of production beneath its veneer of appearance. It can work therefore just as powerfully in the satisfaction of fantasy by means of its management of specifically visual pleasures for a viewer who is protectively placed as privileged voyeur.[6]

But paradoxically, it is in the photographs, more than in the paintings contemporary with them, that the signs of production are often more evident. For Cameron's photographs tend to insist, self-reflexively and allegorically, on their own photographic process of production, and as they do so, they locate both the erotic *frisson* of the image and the belief in the "natural wonder" of photography *there,* in that evidence of process. So while repeating and supporting the repetitions and roles of a patriarchal, bourgeois gender system, Cameron's photographs exceed those roles and repetitions as well—and they do so in very specifically photographic terms. We will come to the photographic means of this exceeding the bounds of photographic realism in a moment. For now it is worth remarking one iconographic means of doing so as well—and that is Cameron's willingness to put the child in the place of the woman, to allow each to substitute erotically for the other.

No questions of censorship or pornography, or even of impropriety, ever seem to have been raised regarding Cameron's photographs. It was otherwise with the maker of *Infant Photography,* Cameron's pictorialist colleague Rejlander,

5. Christina Rossetti, *Poems,* ed. William M. Rossetti (London: Macmillan, 1895), p. 114, quoted in Griselda Pollock, *Vision and Difference: Femininity, Feminisms and the History of Art* (London: Routledge, 1988), p. 127.
6. Pollock, *Vision and Difference,* p. 124.

O. G. Rejlander. The Two Ways of Life. *1857.*

whom she probably met just before she took up photography herself, and from whom she may have received photographic advice. Like Cameron, Rejlander also moved between images of women, pictures of babies and children, and other painting-based scenes. Rejlander's most infamous and complicated confection was *The Two Ways of Life*, exhibited in 1857 to public acclaim and outcry at the Manchester Art Treasures Exhibition, as a demonstration of the powers of photography in artful British hands. Such was the faith in the "truth" of the photograph that this "real allegory," a kind of Hercules' choice between the paths of vice and virtue, based on Raphael's *School of Athens*, seamed together from some thirty negatives and from countless poses, props, and mirrorings, together with dodging, burning, piecing together, careful masking, gluing, and rephotographing, and in many ways probably more difficult to produce as a photograph than as a drawing or painting, was taken, alternately, as a marvel of photographic art (this was the view of Victoria and Albert, among others), and as a pornographic scandal. Said one critic, centering his attention on the back of the bacchante in the foreground, and the head-covered figure of Penitence, directly next to and behind the bacchante:

> When the Council of the Society [Scotland], some years ago, banished from the walls of its Exhibition a photograph entitled *The Two Ways of Life,* in which degraded females were exhibited in a state of nudity, with all the uncompromising truthfulness of photography, they did quite right, for there was neither art nor decency in such a photograph. . . . There is no impropriety in exhibiting such works as Etty's *Bathers*

Surprised by a Swan, or the *Judgement of Paris;* but there is impropriety in allowing the public to see photographs of nude prostitutes, in flesh-and-blood truthfulness and minuteness of detail.[7]

In this case it is evident that the "realism" of the photograph was disconcerting, perhaps especially because of its effort to create the semblance of a Renaissance painting. Some of the uneasiness lay, perhaps, in the awareness of the artifice of the image, felt to be incompatible with the "uncompromising truthfulness" of photography. But more than that, the problem was one of the sacrosanctity of Art, as it still is so often today. Rejlander's photograph laid claim, in every way, to the status of Art, and Art should not be contaminated with what appeared to be the inherently pornographic tendencies of photography. In fact, to a large extent, the appalled double takes in front of the "prostitutes" in the foreground of the combination print *ignored* the artificiality of its construction and concentrated, at least implicitly, on the innate indexicality of the photograph, speaking to some of the same feelings elicited over a century later, in confrontation with Sally Mann's just as clearly artificed photographs (or Mapplethorpe's or Sturges's, or other contemporary photographic work that is thought to skirt the boundary between art and pornography): these mythological, allegorical women were "real," *too* real for comfort; the boundary between image and life could not be trusted, could not even be seen. They *had* to be prostitutes—both because they were *really* nineteenth-century female models who one therefore knew to be fallen women, *and* because they were *really* allegorical whores, *really* a bacchante and *really* a penitential Mary-Magdalen sort. Their existence in a photograph, no matter how convoluted its achievement in the studio, confirmed their double existence in real and allegorical time, confirmed the double truth, both indexical and iconic,[8] of their "minute[ly] ... detail[ed]" "flesh-and-blood."

7. Thomas Sutton, "Photographic Society of Scotland," *Photo Journal* 8 (January 15, 1863), p. 203, quoted in Stephanie Spencer, *O. G. Rejlander: Photography as Art* (Ann Arbor: UMI Research Press, 1985), pp. 102–3.

8. See Charles S. Peirce, "Logic as Semiotic: The Theory of Signs," in *The Philosophy of Peirce, Selected Writings,* ed. Justus Buchler (New York: Harcourt, Brace & Co., 1950), pp. 98–119, for his division of signs into the "icon," the "index," and the "symbol": an "icon" is believed to resemble the object to which it refers, the "index" is physically caused by that object, and the "symbol" is agreed to stand for it, without either looking like it or being caused by it. See also Rosalind Krauss, "Notes on the Index," in *The Originality of the Avant-Garde and Other Modernist Myths* (Cambridge: MIT Press, 1985), pp. 196–219. The photograph, because it is a trace of the objects to which it refers, caused by a chemical reaction to light reflected off those objects, and because it also resembles those objects, is both an "icon" and an "index." In this essay the term "icon" is used in two ways, both in the broader sense of Peircian semiotics, and in the more limited sense of the religious icon, which is to be distinguished from the Renaissance and post-Renaissance concept of the picture, in that its relation to its referent is less one of resemblance per se and more that of a material equivalent for a nonvisible, spiritual entity. (Hence its model is less that of a transparent window onto the world than of a flat, opaque, materially worked sign for that world.)

And indeed, the convolutions of its production in the studio did not really negate the factuality of this photographic allegory—again, quite the contrary. About his photograph, Rejlander himself wrote the following published statement:

The rule of the proceeding here is . . . contrary to the art of drawing. I began with the foreground figures, and finished with those farthest off. After having fixed upon the size of the nearest figures, I proceeded with those in the second plane. With a pair of compasses I measured on the focussing glass the proportionate size according to the sketch; similarly with the third plane, and so on until I was as far off the smallest group as my operating-room would allow, and then I was not far enough off by yards: so I reversed the whole scene and took them from a looking-glass, thus increasing the distance. . . .

In printing, I commenced with the Old Hag, the negative of which was placed close to the long side of a printing-frame but half the size of the paper. . . . the velvet was made to cover the whole plate glass, except where the figure . . . of the Hag was; there the velvet was rucked in a heap, and thus brought to the light for printing; and when that figure was printed so deep as to be nearly invisible, I took that glass off and commenced with the Bacchante, having cut a piece of paper the shape of those parts of the Hag which joined the Bacchante, and then the Hag and all the rest of the paper was covered up, leaving the Bacchante exposed; then having measured off the distance, I printed the Bacchante, almost as dark. . . .

. . . Now comes the sun-painting. I cover up some part of the picture and use a few rays and *pencils of light* to just glaze over the gambling group; and using them a little more freely on the hinder figures, I . . . covered them up . . . "now please to paint me the background behind them." The rays do my bidding, and on it goes smoothly and evenly. . . . I then solicit the rays of the sun to do the same on the side of Industry, and many of the spots and marks from the printing of the separate figures are then evened by the same brush, and finally the whole top of the picture is exposed; but as such light as I choose works quickly, I must move as fast and guide it well, or there will be marks from his brush. *And thus the picture is produced.*[9]

Very evidently, part of the wonder of this photograph lay in its explanation, which was at once an explanation of its allegory and of the technical means by

9. Emphasis mine. Rejlander, "On Photographic Composition; with a Description of 'Two Ways of Life,'" *Journal of the Photographic Society* (April 21, 1858), pp. 191–94, quoted in *The Photography of O. G. Rejlander*, ed. Peter C. Bunnell (New York: Arno Press, 1979). The above-quoted explanation of Rejlander's "procedure" follows immediately on an exegesis of its allegory, which identifies each of the represented figures.

which it was achieved. The one did not seem to countermand the other, quite the contrary. Nor did the explanation of the artifice of the photograph's production countermand its status as a Nature-produced image, again quite the contrary: Rejlander's words indicate the shared authorship of the image, a partnership of Nature and himself, in which he simply guides the paintbrush of Nature—in the parlance of the day, Nature's "pencils" and "rays." Thus the artifice of the studio did not negate, undermine, or interrupt the Nature-made truth of the photograph, but simply partnered and directed it, in such a way that the light-trace was guided into forming a "picture," which, on all levels, is described as having been produced indexically: on the levels of posing and mirroring, the production of negatives, combination printing, dodging and burning, and even the hiding of the edges of individual photographic pieces. The truth-value of its studio-produced (and deeply patriarchal) allegory is everywhere confirmed by its indexicality, its realization by the "pencil of light."

Cameron's photographs share much with Rejlander's—beyond the fact that Cameron seemed obsessed with her own versions of the "two ways of life," portraying the allegorical poles of virtue and vice over and over again in the repeated form of storybook fallen women and virginal madonnas, she also partook of the positivist faith in the indexical production and confirmation of the studio-posed photograph. Her self-consciously domestic practice as a photographer also strayed from the positivist-pictorialist norm, however—it is her double participation in and divergence from that norm that I want to explore in what follows.

To begin with a photograph taken in 1865, a year after Cameron first began photographing. Its title, *Prayer and Praise,* is an allegorical one, naming a general, abstract concept rather than the particular, real people who posed for the photograph, already converting the photograph as indexical trace into the photograph as symbolic sign. It is also a devotional title, an injunction to the viewer to praise and to pray—to treat the photograph as one would a religious icon. And *Prayer and Praise* has the look of a religious icon as well, with its figures close up and filling the frame, showing themselves to be identified with, rather than naturalistically contained by, the photographic surface; and with its devotional presentation of the child's horizontal body so that it faces and is shown to the viewer, conforming to the conventional, iconic presentation of Christ's infant body and dead corpse. This photograph, then, is the devotional counterpart to Rejlander's more complicated constructions, meant to be viewed with the same attitude of belief, much intensified.

But in *Prayer and Praise* the devotional injunction, as well as Cameron's characteristic emphasis on the Christian family, is matched to the photographic effects of framing, and of the movement from indexical trace to iconic resemblance and back again. The photograph consists of its foregrounding of the child (at the bottom edge), the rare inclusion of the masculine unit of the adoring family (upper right-hand corner), and the curved-over, draped body of the mother

Prayer and Praise. *1865.*

at the upper left-hand corner. These three figures form a familial triad closely aligned with the frame of the photograph, so that family and framing are joined, as are framing and the action, theirs and ours, of adoring. Moreover, effects of photographic focus are very much at play in *Prayer and Praise*, and they help to mount a phenomenological proof of the truth of the enacted scene. It is in the flesh of the baby, pressed to the photograph's surface, that the range from out-of-focus to in-sharp-focus is most insistently displayed: note the hands and blurred upper line of the torso in contrast to the neck and underarm creases, the child's rounded facial features, somehow both blurred and distinct, and the *punctal* effect of the bit of hair.[10] Thus the child's body serves to embody the photographic action of bringing into being, as well as the optical properties of the lens—and thereby serves simultaneously to embody the incorporeal means of the photograph and its own fleshy, somatic corporeality, as well as the oscillation between

10. See Roland Barthes, *Camera Lucida* (New York: Hill and Wang, 1981), for his theory of the *punctum*. The *punctum* is defined in various ways, one of which is simply as a detail which fractures the unitary field of the photograph, which has no signifying function beyond calling up the referent to which the photograph is attached, and which therefore embodies the lawless indexicality of the photograph: the strands of hair, folds of flesh, and wrinkles in cloth that abound in Cameron's spiritist photographs do nothing else but that, and therefore I would qualify them as *punctal*. (Barthes also attaches the *punctum* to his distinction between the "erotic" and the "pornographic" photograph—the *punctum* applies in this sense as well to the peculiar eroticism of Cameron's images [pp. 41–42, 57–59].) For a further elaboration of the relevance of *Camera Lucida* to Cameron's practice, see n. 20.

the two. The qualities of focus also serve to enhance another property of the medium: that of light, and the contrast between light and dark. Again that contrast is condensed in the corporeality/incorporeality of the child's body, and in the meeting between mother and child: her dark drapery and light hand, and his light body.

There are, then, several differences worth noting between the photographic "realism" of Cameron and that of pictorialist photographers like Rejlander, not to mention Pre-Raphaelite painters like Rossetti. While Rejlander gave a written explanation of his method of photographic production, accounting for it technically and rationally, step by step, and while Rossetti (like Rejlander within *The Two Ways of Life* itself) expended every effort to hide his means of producing his painted fantasies and supplying them with their reality-effect, Cameron, by contrast, *displayed* how her photographs were made, and did so self-reflexively, automatically, and without reason, in and on the photographs themselves.

Never questioning the truth of the photograph, Cameron asserted the photograph's mode of production as indispensable to its truth. And rather than fantasy scenarios concentrating on the body of woman, hers "focused" on the body of the child, and on the physical contact between mother and child both as an internal figuration of the desired relationship of the external viewer to the photograph itself, and as an allegory of the photograph's engendering. And in Cameron's photographs, such as *Prayer and Praise*, it is the fantasy object, the infantile body displayed for (erotic) adoration, on which the evidence of the means of photographic production is most intensively displayed—this is not unlike the spiritual value of the materiality of gold and azure in a religious icon, except that in photographs like *Prayer and Praise* it is the evidence of the workings of light and the lens that count for spiritual (not to mention erotic) matter, and that are conferred on the figure most adored. It is thus, in that photographed childish body, (re)produced (and loved) by the mother, (re)produced (and loved) by light and the lens, that Cameron's photographs oscillate between the indexical and the iconic, between the trace and the resemblance, between the inwardly and the outwardly referential. It is thus, too, that they carve out their difference from the "bourgeois realism" both of pictorial photography and of photographic painting—and from the "bourgeois realism" that continues to preside over modern photographic fantasies, especially those that inhabit, or trespass into, the territory of pornography.

Home Theatricals: Vivien and the Pale Nun

In their time, Cameron's out-of-focus photographs, which she herself stated as having been the result of quasi deliberation—an acceptance and celebration of mistakes, such as the initial choice of a lens inappropriate to her camera—were taken as an indication of her "feminine"—read "hysterical"—lack of control of her technology. The signature of her photographic style, Cameron's fascination with

out-of-focus effects has continued, in twentieth-century monographs, to be aligned with a view of her as a kind of eccentric mistress of the house, her home management converted, at every turn and on every level, into wacky, slapdash, slovenly photographic practice. In its alignment with process and with such self-reflexive effects of the medium as framing and photographic chiaroscuro, and with an oscillation between and conflation of the qualities of corporeality and incorporeality, Cameron's out-of-focus manner clearly muddied the waters of nineteenth-century pictorialism, a pictorialism whose positivism was fairly obviously patriarchal in its simultaneous mastery (and masking) of technique, its controlled production and explanation of morality and meaning, and its fictive grasp of the body, particularly, of course, the female body.

From the beginning, Cameron's reputation was construed around her sex. Cameron's earliest twentieth-century monographer, Helmut Gernsheim, located his account of Cameron's practice within much-cherished anecdotes about her domestic eccentricities:

> The Cameron household had to adjust itself to the new pursuit of its mistress. The smell of collodion mingled with the scent of the sweetbriar hedge, copying-frames were spread out on the lawn, tubs of soaking prints stood about until the early hours of the morning. . . . Mrs. Cameron's penetrating voice could be heard giving orders to her maids posing in the glass house. . . .
>
> From now on photography had priority over household affairs. As the three parlor maids were occupied as models and darkroom assistants, the guests got used to answering the door and being kept waiting for lunch until Mrs. Cameron, quite oblivious of time, was satisfied with her picture. Then she would come triumphantly running into the dining room with the dripping plate, causing indelible stains on the table linen, so that she herself admitted, "I should have been banished from any less indulgent household!" Everyone was summoned to admire the latest creation: husband, children, and guests, the housemaids and the cook. Only after this procedure could luncheon be served.[11]

Like most writers of both the nineteenth and twentieth centuries, Gernsheim preferred Cameron's portraits to her allegorical pictures, and debated the degree of intentionality and technical control, or "art," that went into her pictures. But one thing is clear: he, like most others writing about her, was fascinated by

11. Helmut Gernsheim, *Julia Margaret Cameron: Her Life and Photographic Work* (New York: Aperture, 1975), p. 29. See Cameron, "Annals of My Glass House," *Photographic Journal* 51 (July 1927), pp. 296–301, reproduced in Mike Weaver, *Julia Margaret Cameron, 1815–1879* (Boston: Little, Brown, 1984), pp. 154–57, for her own account of the implication of her photographic practice within the running of her household.

her mad domesticity and treats her photography as housewifery run amok. In his account, the garden and the conservatory become the darkroom, the ordering of housemaids the posing of models; laundering is converted into the washing and printing of images, cooking into photographic alchemy, hostessing and presiding over meals into the exhibiting of pictures: all of the traditional provinces of the female head of the house are converted, through a kind of benign hysteria and magical mismanagement, into the processes of photography. Cameron the mad housewife is the same as Cameron the photographic witch, replete with beleaguered, indulgent husband who, muttering to himself, sequesters himself away from his crazy household and yet nevertheless presides patriarchally over it. The anecdotal picture of Cameron, then, and the judgments about her work, are strongly inflected by gender values. Whether negatively or positively, they feminize her photography and fit it to the feminine domain of the Victorian household, by making her photographic practice a kind of caricature and inversion of Victorian domestic practices.[12] And Cameron herself laid the groundwork for this myth of her practice (which I have no intention of overturning).

From beginning to end of her career, Cameron produced posed photographs featuring good and bad women (mostly the former) of Christian and other Victorian myths. The most obviously and consistently staged of these was the series taken in 1874, toward the end of Cameron's approximately ten-year photographic practice, and meant to illustrate Alfred Lord Tennyson's version of the Arthurian legend, *Idylls of the King*. In this series Cameron principally (and again unusually) attended to the figure of the fallen woman—ranging from the "lissome [witch] Vivien, of [Guinevere's] court / The wiliest and the worst,"[13] in Cameron's photograph, shown spellbinding Merlin, played by Cameron's elderly husband; to Queen Guinevere herself, "that wicked one, who broke / The vast design and purpose of the King . . . the wife / Whom he [knew] false . . . taken everywhere for pure, / . . . like a new disease, unknown to men, / . . . saps / The fealty of our friends, and stirs the pulse / With devil's leaps, and poisons half the young."[14] Cameron was as much a Victorian moralist as Tennyson himself—I make no claims for feminist subversion here—but nevertheless, one suspects a certain unconscious identification with the unruly woman in this series, particularly in the case of *Merlin and Vivien*, which looks so much like an allegorical figuration of Cameron herself as photographic sorceress, quite a bit younger than her husband, directing the bemused patriarch to hold his pose, commanding him to be still (and stop his giggling),

12. Weaver's work on Cameron is the most recent and most explicit example of that, even though he seeks to overturn some of Gernsheim's most obviously sexist pronouncements. (Weaver calls Cameron "a feminine rather than a feminist artist.") See Weaver, *Julia Margaret Cameron*, p. 14.
13. Alfred Lord Tennyson, *Idylls of the King*, ed. J. M. Gray (New Haven: Yale University Press, 1983): "Guinevere," ll. 27–29.
14. Ibid., ll. 663, 514–22.

Merlin and Vivien. *1874.*

and magically, indexically, enchanting him, transforming him into Merlin, all through the bewitching witchcraft of photography.[15]

All of Cameron's photographs are the results of home-produced theatricals: images like *Merlin and Vivien* are fairly direct statements to that effect. Moreover, Cameron's practice in general is full of the marks of homemaking—from her emphasis upon the album photograph, to her use of handwritten captions and excerpts, to her blithe acceptance of chemical stains, inappropriate lenses, and such. The *Idylls of the King* sequence is simply the series in which the evidence both of home-theatrical staging and of homemaking is most obtrusive—particularly in the creased and crumpled costume drapery and the wrinkled background drop cloths (most exaggerated in the scene featuring the Pale Nun sending Sir Galahad off on his quest for the Holy Grail). It is tempting to read this as some sort of self-conscious deconstruction of the Arthurian fiction—but I think it cannot be: it is too amateurishly solemn, too avocationally, lovingly serious for that. On the contrary, these are still in the believer's domain of the indexical truth of the

15. The model for Vivien was not actually Cameron—she was in her late fifties at this time; it was a so-called Miss Agnes, Lady Amateur. On "Miss Agnes'" account of the photographing session out of which this image emerged, in which Charles Cameron as Merlin apparently couldn't contain his laughter, made the "oak tree" prop against which he was leaning shake, and necessitated the taking of several negatives, see Joanne Lukitsh, *Cameron: Her Work and Career* (Rochester: International Museum of Photography at George Eastman House, 1986), pp. 16–17.

Sir Galahad and "The Pale Nun."
1874.

posed photograph—with the difference that here there is a kind of excess inscribed in the whole endeavor, a confirmation of the truth of the fiction that exceeds the simple reality-effect of the photograph, the consequent trust that this had to be some body's actual action, and that therefore the fiction was fact.

With few exceptions, these images are actionless, remarkably still, and their props are relatively few—only the aforementioned drapes and cloths—while the technology employed is without the complications of a Rejlander montage. Instead one is asked to attend to the simple facts of photographic detail, obviously dressed-up presence, and sheer absorption in role-playing—or better, role-*being*: the act of being and becoming someone else other than one's self.[16] So the confirmation here is not only that of the indexically derived fact of the fiction; it is also that of the lived, experiential quality of the fiction, all the truer for the traces of its homeyness. Where the usual confirming action of the photograph had to do with some specific body being *there* and doing *that*, the confirmational excess of these photographs goes in this direction: *I, Julia*, was there; *my* family—

16. See Nina Auerbach, *Private Theatricals: The Lives of the Victorians* (Cambridge: Harvard University Press, 1990), on Victorian attitudes toward theatricality, which included a lively fear of the artifice and shifting selfhood of masquerade, and a desire to use even the theater to promote a notion of character as unchanging internal essence, and as "nature": Tennyson's *Idylls of the King*, which Auerbach discusses here and there, and Cameron's photographs—in their stillness and in the belief evinced in them that as photographs they confirm the truth of what they show—both conform to this antitheatrical model of theatricality.

my intimates and my household—were there; *I* imagined them, and made them imagine themselves—as Vivien and Guinevere and the Pale Nun, as Madonna and Child, Venus and Cupid, and Christ—and *my* photographing confirms my household imaginings. The excess of this photographic positivism involves a double demonstration: that the photograph is the literalization of the photographer's imagination, and that the *tableau-vivant,* when photographed, is a first-person experience—the homemade stamp on Cameron's photographs and on the play-acting depicted in them is critical to both sides of this demonstration.

This, too, is different from the attitudes toward truth and theatricality found in a Rejlander. Between her occasionally overwrought attention to the particular (as in *Sir Galahad and "The Pale Nun"*)—which begins to suggest something like a hystericization of the detail—her insistence on visible process rather than masterfully hidden technique, and her declaration of home-staging, all serving the interests, ultimately, of demonstrating the personal quality of the truth of her fictions, Cameron's photographs not only pronounce how they are made, but also identify the locus and condition of their making as that of the female domain of the home. It is that domain that is identified as the locus and condition of their theatrical truth as well.

This feminization of the (mutually confirming) truth and theatricality of the photograph was not lost on Cameron's contemporaries; implicitly and explicitly it factored into the disparagement both of her photographic manner and of her choice of *tableau-vivant* subject matter. But Cameron's feminization of photographic production was not so much a refusal of, or rebellion against, the standards of technique, truth, and theatricality obeyed by Rejlander and other pictorialists of Cameron's day. Rather, it was in excess of those standards: a *more-than-usual* fascination with the indexical, chemical means of the magic of photography, an *over-*emphasis upon the photographic detail, *too much* belief in the verity—the presentness, once played and photographed—of the assumed role, the donned character, the enacted scene. And in particular, *too great* an identification with the roles assigned to women like Cameron, her daughters, granddaughters, nieces, and great-nieces, her maidservants and village girls—*too great* an identification with the roles of femininity, that is, and especially with that of the mother. It is this *too muchness* that lies at the heart of what we might call Cameron's hystericization of the photograph.

Mistress, Maid, and Madonna: Portrait of Mary Hillier

Cameron's cast of photographic actors most often consisted of friends, family, and neighboring villagers, but her favorite leading lady was a servant, her parlor maid Mary Hillier, prized for her Pre-Raphaelite profile, photographed over and over again in various, repetitive guises. Valued because of their association with a type derived from and referring to painting, Hillier's quite specific features, though sometimes interchangeable in presentation with those of other models

The Angel at the Sepulcher. *1869.*

and sometimes misidentified by modern historians, are used more than any others to illustrate, embody, and literalize different icons of femininity—now a dream; now the angel at the sepulcher; now an androgynous, girl-on-girl embrace, *The Kiss of Peace*, resembling the childish *Double Star* and *Infant Bridal;* now a line spoken by the doomed virgin Elaine in Tennyson's *Idylls of the King*—"I fain would follow love if that could be; / I needs must follow death, who calls for me; / Call and I follow, I follow; let me die." (It was Hillier, as well, who played the part of the Pale Nun in the photograph mentioned above, as well as that of the fallen Guinevere in the same series, having got herself to a nunnery for her betrayal of Arthur and his patriarchal court.)[17] In her assumption of different photographic roles, a certain mobility of photographic identity is involved—as well as a loose, open-ended relationship, typical of Cameron's photographs, between actual photographing session and final role- or caption assignment. But though Hillier becomes each of the figures she illustrates, her features also remain constant, and it is really quite impossible to decide whether that constancy is that of an individual or that of a

17. In Cameron's *Illustrations to Tennyson's Idylls of the King and Other Poems* (published in 1875), Hillier plays just two roles—the Pale Nun and Guinevere—and the two illustrations in which she plays those different roles are interrupted by one other, in which Guinevere is played by another model: so that, among other things, shifts in the assumed character of Hillier, and in the models used to play the same fictional part, can be charted across this series. *Call, I Follow*, in which Hillier plays Elaine, is an earlier photograph, and does not belong to this series.

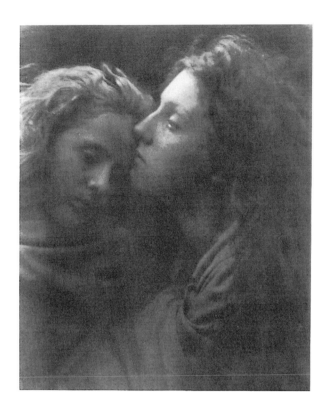

The Kiss of Peace. *1869.*

type: actually, I think it is both—that would seem to be the confirming point of the staged, homemade photograph.

One of the other things Hillier also becomes is a figure of allegorical repetition, and as such, of the repetitions of photography itself.[18] She has a certain erotic appeal—and it resides, self-reflexively, in the very repeatedness of her pose, in the variation of her allegorical disguises or "covers," and in the repeated meeting of white profile, dark, unbound hair, and shadowy drapery. Especially in the Tennysonian portrait, *Call, I Follow*, this meeting of dark and light emphasizes several things simultaneously: the black-and-whiteness of the photograph itself, the encounter between the body's covering and its uncovering, and the subtly erotic detail of Hillier's neck—the shadowy meeting of chin, ear, hair, throat, and neckline, the tense tendons and torsion of the neck. (In another Hillier photograph, *The Angel at the Tomb*, the disorder of hysteria is succinctly evoked in the detailed photographic rendering of the disorder of her hair, thus condensing in the figure of Hillier the hystericization of both the detail, and of the truth-value of the

18. See Joel Fineman, "The Structure of Allegorical Desire," in *Allegory and Representation*, ed. Stephen Greenblatt (Baltimore: Johns Hopkins University Press, 1981), pp. 26–60; and Angus Fletcher, *Allegory, the Theory of a Symbolic Mode* (Ithaca, N.Y.: Cornell University Press, 1964), for definitions of allegory which have been useful to me here: as involving disguises, coverings, repressions, and taboos, as polysemic and ambivalent, as having to do with repetition, and with structure rather more than with content or meaning, and as inherently thematic, self-thematizing and therefore self-reflexive; and for the structural links between allegory and desire.

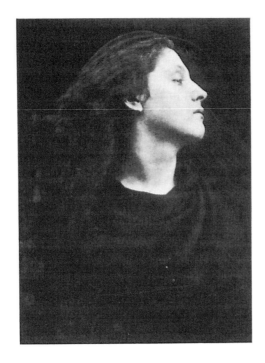

Call, I Follow, I Follow. Let Me Die.
Circa 1867.

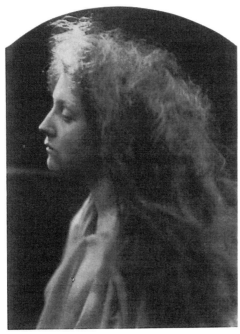

The Angel at the Tomb. *1869.*

repeatedly played photographic role.) Ultimately, it is the photographic self-reflexivity of Cameron's photographs that is eroticized in this repeated conflation of the ghostly dark-and-light incorporeality of the photograph with Hillier as a figure of photographic-allegorical repetition, and her drapery-framed corporeal details. At the same time, the self-confirming action of the photograph is eroticized as well—for those repeated black-and-white details do nothing if not confirm, simultaneously, the truth of Hillier's role-playing presence—the physical *thereness* of her pose—and the photographic nature of its presentation.

Cameron's repetitious photographing of Mary Hillier is undeniably reminiscent of Rossetti's repetitions. Both in her repeatedness and in her bodily fragmentation, Hillier is a figure of desire much like Elizabeth Siddal, similar even in the kinds of poses adopted at Cameron's command and in their iconography. Indeed, of all Cameron's photographs, those using Hillier's features come closest to Rossetti's painted performances of Woman. It would seem, then, that for Cameron the parlor maid was a kind of matriarchal substitute for the phenomenon of the mistress-model, a female, household version of the Other as the object of male desire—the object of desire, in this case, of the mistress of the house. True enough, but at the same time the self-reflexivity of Cameron's photographic desire makes a difference, as does the very fact of the choice of a household servant, and of the matriarchal orientation of that choice: as parlor maid, rather than paramour, Hillier's job, both in and out of the photographs taken of her, was not only to be ruled by Cameron, but also to *represent* Cameron herself, and Cameron's house.[19] Thus, in that she played the role both of the erotic object of Cameron's domestic-photographic gaze and of the erotic stand-in for Cameron as domestic-photographic subject, Hillier's eroticization, her figuring of Cameron's desire, was indistinguishable from a project of photographic autoeroticization.

One of the roles that Hillier played most repeatedly was that of Madonna, the holiest of mothers, in intimate contact with the somnolent body of the Child. It was in that role that she most clearly stood in for Cameron herself. Arranged and rearranged with different child models, in only slightly altered costuming, in various poses and allegorical titles (including, simply, *Madonna and Child*, but also

19. Something very similar happened, though only once, with the young Ellen Terry, whom Cameron photographed before she became a well-known stage actress—when she visited Freshwater with her older painter-husband, George Frederick Watts, on their honeymoon trip. In one of Cameron's most beautiful portraits, taken at the same time as an appropriately patriarchal likeness of the long-bearded Watts, Terry, caressed by light in a virginal white slip, luminously pinned against a light, flowered wall and twisting a necklace about her neck in a nervous, self-reflexive gesture (memorably described by Auerbach as "self-strangling"), is shown simultaneously as erotic object and as analogous to Cameron herself, equally the younger wife of a much older husband. See Auerbach, *Ellen Terry, Player in Her Time* (New York: W. W. Norton, 1987), p. 99. See also Virginia Woolf, *Freshwater, A Comedy,* ed. Lucio P. Ruotolo (New York: Harcourt Brace Jovanovich, 1976), for a fictionalized account involving both Terry and Hillier (the latter as a maid who married into the peerage, which she did in life as well), which also mimics the mode of the Victorian home-theatrical out of which Cameron's photographs emerged.

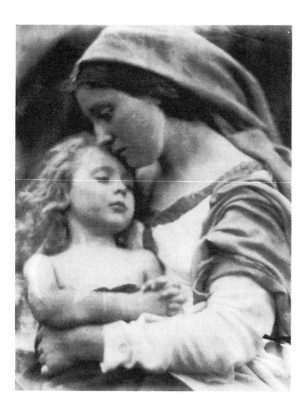

Grace through Love. *1865.*

Shadow of the Cross, Divine Love, Goodness, The Return after Three Days, Long Suffering, Grace through Love, and so on), Mary Hillier-as-Madonna features much the same subtly eroticized focus on the detail of the shadowy meeting of neck, jaw, and chin as seen before in her other roles. Each of these images, including *Grace through Love,* consists of at least one half-naked, angelic, androgynous child with an abundance of flowing hair, pressed close to the body of his "mother," so that there is an emphasis on skin touching skin—as in the contact between the "mother's" cheek and child's forehead—and skin touching fabric—as in the child's arms resting on his "mother's" sleeve, her hand resting on the heavy cloth around his waist, the contact between the drapery on her head and the back of her neck, between her chest and bodice, and between his chest and dark blanket covering. Over and over again, a young chest is half-naked or bared altogether, and contrasts markedly with the always-heavily-draped bust of Hillier, Mother of God, much as, in photographs like *Call, I Follow,* her own white neck contrasts with her own dark hair and costume drapery. And over and over again, the generative link between mother and child is tied, erotically, to the process of photographic generation: witnessed again and again in those in-focus/out-of-focus moments with which we started, of detailed contact between skin, hair, and cloth, and obsessively in the body of the child.

In one of these Mother-and-Child pictures, a variation on *Shadow of the Cross,* and beneath the ever re-present shadow of Hillier (as *my* maid she is a figure of *me*), beneath her, *that,* says Cameron, is "*my* grandchild!" (One does well to

My Grandchild. *1865.*

remember just how many children Cameron, proper childbearing Victorian that she was, had—six biological and three adopted—and how her grandchildren functioned as further children for her, with two of them joining her household: Cameron was evidently as identified with motherhood and grandmotherhood as she was with photography.) The diaristic emphasis of that statement helps to drive the point home: both a Madonna-and-Child and a portrait of a descendant, in which Hillier represents Cameron by proxy and acts out Cameron's photographic adoring of the childish body, as well as her hyperidentification with the role of the Mother, *My Grandchild* figures the link between photography, matriarchal generativity, and the domestic space of the household, the family and the matrilineal, that underwrites the rest of Cameron's practice. It makes it clear that Hillier *represents* Cameron's maternal-photographic gaze as much as she poses as its object. And it pronounces the body of the child as *the* object of Cameron's self-reflexively photographic desire.

Cupid's Pencil of Light, II: The Double Star

Not only is it in the body of the child that the eroticism of Cameron's photographic gaze is most thoroughly exposed; it is also the case that the erotic relationship most privileged in her work is that of the mother to the child. The eroticization of that relationship calls up the doctrinal and specifically genital "sexuality of Christ" as articulated by Leo Steinberg, but it diverges from it rather

The Double Star. *1864.*

dramatically as well. One side of the story of these photographs is that their privileging of the mother-child relationship, as well their simultaneous naturalization and spiritualization of the sexuality of that relationship, simply conforms to modern Christianity and the normative ideology of the nineteenth-century patriarchal family, its strict limitation and etherealization of female sexuality per se, and its confinement of the feminine to the domain of domesticity and the service of motherhood. But the other side of these photographs' story of sexuality is the sheer obsessive excess of their conformity to the ideology of the patriarchal family, an excess which converts the order of that family into a disorder that blurs the boundary between narcissism and object-love, that verges on the breaking of the incest taboo, and that leans so heavily on the female side of the family as to exclude memory of its masculine aspect and its heterosexual foundations. And the final, weight-shifting tilt in this drift of the "realism" of the photograph toward the realm of the hysterical, the maternal, and the incestuous lies in the repeated

emphasis—as found, among other photographs, in *The Infant Bridal* and *The Double Star*, and in their quasi-adult variant, *The Kiss of Peace*—on the androgynous or same-sex embrace, on childish or asexual union, on the conjugal bliss of the child, of the girlfriend, of the played-at, surrogate mother—where the difference between the love of sibling, friend, mother, and lover is constantly elided, and a sort of reverse pre-Oedipalism is strongly evoked.

These photographs might suggest a reevaluation of the relationship between the maternal and the sexual, from a matriarchal rather than a patriarchal point of view—from the vantage point of the mother and her retention of (or return to) some of the characteristics of infantile sexuality, rather than from that of the child and his/her development toward heterosexual maturity. That is, they might suggest the incest drive of the mother. But that is not where I want to end, really. Rather, I want to end with photography per se, rather than with matters of sexuality or a retelling of the story of children and their parents. Thus I wish to turn back to Mother Photography and her Child, and consider her difference from, rather than her similarity to, contemporary Art-photographies.

For Cameron's allegorized conception of photography represents, by in large, the road not taken. As much a true believer in the "real" of photography as any other practitioner of her time—or as any of us are today, even as the photograph begins to be replaced by its digitally manufactured look-alike, when we continue to take the photographic image for the "real thing," and confuse a piece of film or paper with its referent—Cameron's definitions of both the "real" and of photography's means of access to it were, and are, not the normative ones. In brief, hers was the photographic "real" of the generative process, rather than of technical exactitude, hers an alchemically rendered "real," rather than an optically perfect one, given over to the mistake, the trace, and in a certain way, the *punctum*, rather than the straight, the sharp, and the depth-of-field true. I'm tempted even to say that, despite its Victorian theatricality and pictorialism, and its emphasis upon Art and the "Operator," hers was a "realist" position on the photograph not unlike the Barthesian one, with Barthes's emphasis upon the chemistry over and above the optics of photography, the indexicality over and above the technological aspect of the medium, its magic and its poignance over and above its artfulness, its mastery, its intentionality—not to mention Barthes's linking of the photograph to the regime of the Mother.[20]

20. Barthes's *Camera Lucida* falls under the sign of the Mother in a variety of ways. The most obvious of these has to do with the search for the best picture of his dead mother, which would capture the truth of her as he felt it to be, conducted in *Camera Lucida*, and whose result—a snapshot of his mother as a young girl—he refuses to show to his readers, so private, incommunicable, and evanescent is the effect of that photograph. (That radical incommunicability is another, crucial aspect of the *punctum*, as is the poignance that accompanies the realization that this young mother from before Barthes's time, made present in the photograph, is a specter, dead and gone at the time of his looking at the image.) But Barthes speaks of the photograph as eliciting a desire for a return to the *heimlich* of the Mother's body (p. 40) as well, and throughout seems to suggest that the photograph occupies a prelinguistic

I began with *Cupid's Pencil of Light* and its sibling photographs: for those images state pretty clearly not only that Cameron's investment in her "Art" was surely erotic as well as photographic—Light incarnated as Mama Venus—not only that the erotics of the image was disembodied and etherealized in the form of light, and not only that the child's body was the focus of that erotics, but also that Cameron's conception of photography fell under the sign of the Mother. I end, now, with the child-bridal pictures, for their eroticism turns on the photographic too, and makes the case, perhaps better than any others, for the blinding of technique by process, and the photographic binding of eros to error. The best example of all of this is the *Double Star*, for its little conjugal souls, whose Siamese-twinning conjures up the repeating as much as the marrying of bodies, and with it the repetitions and reproductive reversals that make up the photographic process of generation, are embraced and marked by the traces of that process: a haloed streak of light above, vignetting and matching itself to the kissing-cousins curve of joined heads and Mary Hillieresque streaming hair beneath it; a hairline crack and chemical stain below, spreading across the fissuring and joining of little chests, the bit of cloth sandwiched between and the out-of-focus specter of a childish hand on an infantile breast.

The marring of the *Double Star*, whose very name allegorizes photography as a point of light that reproduces itself, is of the essence. For the mistakes of the *Double Star* are what make it "real"—that is, I think, why Cameron liked them so. They are indexical mistakes, physically caused by photographic actions—by light, by chemistry, by the handling of plates and lenses—and so they are the marks of

zone that is attached to the maternal, and that, with Cameron's photographs in mind, is reminiscent of the space of "maternal jouissance" described by Julia Kristeva in "Motherhood According to Bellini," in *Desire in Language: A Semiotic Approach to Literature and Art*, ed. Leon S. Roudiez, trans. Thomas Gora, Alice Jardine, and Leon S. Roudiez (New York: Columbia University Press, 1980), pp. 237–70.

I acknowledge the oddity of attaching Barthes's theory of photography to a practice like Cameron's—leaving aside her Christian sentimentality, surely nothing could have been greater anathema to him than Cameron's emphasis upon the Art of photography: *Camera Lucida* is written in celebration of the Spectator of the photograph, and in disparagement of both the Operator's managing of the anarchy of the photograph and of Art's domestication of it. On the other hand, the model of the Operator (a nineteenth-century usage) at work in *Camera Lucida* is that of the technician, and suggests an alliance to the technology of the camera that is at a far remove from a practice like Cameron's. *Camera Lucida* repeatedly states its allegiance to the chemical rather than the optical aspect of photography (as a sign, I think, of its attachment to the indexicality of the photograph—though that term is never once used—not to mention its fragile materiality) (pp. 10, 31, 49, 80). This brings it rather closer than one might first imagine to Cameron's conception of photography as a kind of alchemical sorcery (Barthes speaks of photography as "a magic, not an art" [p. 138]). And overall, the conception of photography as strange and wild and Nature-made that Barthes the "Realist" propounds in *Camera Lucida* is nineteenth-century in tone, closer to that century's sense of the photograph as "fairy picture" than to our normalized sense of it as ubiquitous camera-made image. (Joseph Nicéphore Niepce's *The Dinner Table*, which appears as one of *Camera Lucida*'s twenty-five illustrations, and which Barthes calls "the first photograph," stands as an emblem of Barthes's photographic atavism.)

the *Double Star*'s indexicality. They reinforce the indexical relationship of the photograph to its referents, but at the same time they render indexicality per se. They are *punctal* too, flaws in the iconic field of the photograph that, in resembling some of its details, like strands of hair and the seam between two bodies, punctuate them, so that the detail and the blemish are conjoined, each equally the result of the indexical workings of photography: each equally the child born of photographic generation, of Mother Photography's reflexive labor. With Father Art out of the picture, Cupid's pencil of light traces its way across a blinding plate, fractures it with its marks, and yields a Double Star. And over it all, the Mother presides, as she does over Barthes's *punctum*, his search for the maternal Real, and his journey through a mad Photography, a Photography that conforms neither to the *studium* of the sign nor to the rule of Art, nor to the law of the Father.

The Body's Shadow Realm

GERTRUD KOCH

translated by JAN-CHRISTOPHER HORAK and JOYCE RHEUBAN

On the History of Pornographic Films:
Cinema in Brothels, Brothels in Cinema,
Cinema in Place of Brothels

The history of film is also the history of its limitations, supervision, regimentation, judicial constraint, and examination of norms. Reviewing chronologies of film history, we see the extent of the censor's alarm system, which would monitor the flow of cinematographic production, classified and catalogued into acceptable and unacceptable areas:

> According to a police directive, censorship cards will be instituted and censorship jurisdiction will be transferred to the chief of police of each of Berlin's police precincts. (May 20, 1908)[1]

> All members of the Seventh District Court appeared at Berlin police headquarters for the screening of a film which has caused a public scandal. This is the first judicial review of a film in Germany. (December 12, 1909)

> In March, the Peoples Institute of New York and Dr. Charles Sprague Smith established the "National Board of Censorship" as a film review board. (1902)[2]

> In Sweden, film censorship is instituted at the request of the film industry. (1911)

> According to a German municipal ordinance, every film must be

1. Heinrich Fraenkel, *Unsterblicher Film. Die grosse Chronik von der Laterna Magica bis zum Tonfilm*, Munich, Kindler, 1956, p. 380.
2. *Ibid.*, p. 382.

submitted for certification to the appropriate precinct office twenty-four hours before public screening. (1911)[3]

Through the founding of the Hays organization's "Motion Picture Producers and Distributors of America," the American film industry sets up a form of voluntary self-regulation. (1922)[4]

Although these historians do not mention the rules then in effect for banning a film as offensive, we know from another source that the censorship authorities collected pornographic films:

For the most part, the supervising authorities, the police, know about this class of films, films fated to lead a humble and obscure life. We define pornographic films as the cinematic depiction in an obscene form of whatever concerns sexual life, and these include just about everything human fantasy can possibly invent in the area of sexuality. The films pass directly from the producer to the consumer, thus steering clear of the censor, and with good reason. Nevertheless, the police archives are filled with films such as chance and vigilance have brought their way.[5]

Even though the invention of cinema was soon followed by institutionalized censorship, pornographic films still had time to become widespread. Unencumbered by censorship, which wasn't established until 1908, film pornography was already in full bloom in Germany by 1904. Short pornographic films—of up to a minute in length—furthered the technical development already seen in photographic pornography in such apparatuses as the stereoscope and mutascope. By 1904, such films had grown to four acts and ran twenty minutes. Early pornographic movies thus kept pace with most of cinema's developments, which raises the questions: what kind of aesthetic development did this genre undergo? can we in fact even speak of a genre? and what would define its particular aesthetic?

To answer these questions we have to look to the few available sources describing early pornographic films and their modes of reception:

In most cases, these sotadic films were screened in private societies or in mens' clubs founded for this purpose. In Germany, the entry price ranged from ten to thirty marks. The distribution of tickets was handled by prostitutes, pimps, cafe waiters, barbers, and other persons in contact with the clientele, who knew they could earn a tidy profit by marking up the price. Since these vendors usually knew their clientele

3. *Ibid.*, p. 385.
4. *Ibid.*, p. 408.
5. Curt Moreck, *Sittengeschichte des Kinos*, Dresden, Paul Aretz, 1956, p. 173.

and their preferences, there was little danger of coming into conflict with the police.[6]

For the most part, pornographic films were bought and screened by brothels, which hoped to entice customers with filmic come-ons while also earning money by charging for the screenings. At first, the pleasure offered by pornographic films was expensive, reserved for the well-to-do customers who frequented such establishments in European metropolises from Paris to Moscow. Abroad, both Buenos Aires and Cairo offered international tourists the opportunity to visit pornographic cinemas. In *Die Schaubühne* Kurt Tucholsky describes an experience in a porn house in Berlin:

> Nobody spoke out loud, since everyone was a bit anxious; they only murmured. The screen turned white; a fragile, mottled silver-white light appeared, trembling. It began. But everyone laughed, myself included. We had expected something bizarre and extravagant. We saw a meow-kitty and a woof-doggy romping on the screen. Maybe the exporter had tacked the scene on to fool the police — who knows? The film ran without music, rattling monotonously; it was gloomy and not very pleasant. . . .
>
> Things remained *gemütlich* in the cinema. We didn't realize that even Tristan and Isolde would seem ridiculous in this setting, or that Romeo and Juliet, viewed impartially from another planet, would seem a comic and straight-laced affair.
>
> No, nothing of the sort among the patrons. The only reason they didn't play cards was because it was too dark. An atmosphere of healthy and hearty pleasure prevailed. You had to say to yourself — all this phony business — at least here you knew. . . . The ending was so obscure that when it was over everyone thought there was more to come — it just goes to show, that's how it is with sex. The men stood around feeling self-conscious and embarrassed, remarking on the lack of values here and in general. And then we pushed through narrow passageways into an adjoining establishment where the music was loud and shrill, and everyone was strangely quiet and excited. I heard later that the proprietor had ordered twenty call girls.[7]

The atmosphere of this occasion in Berlin — with the camaraderie of male bonding, uneasy and secret arousal, and forced jocularity — was apparently not unique. Norbert Jacques provides an illustration from Buenos Aires, one that enriches the steamy Berlin-beer flavor with sadomasochistically tinged exotic stereotypes:

6. *Ibid.*, p. 175. (The adjective *sotadic* derives from Sotades [323–247 B.C.] who wrote coarse satires and travesties of mythology in a peculiar meter which bears his name. — ed.)
7. *Ibid.*, pp. 178–180.

One night in Caracas, walking along the harbor wall where the long, low Platte River steamers slept, I reached a point beyond the criminal quarter. An odd but impressive scaffolding stopped me in my tracks. . . . While I was looking up into its towering height, I saw a boat under me with a light, tied to the harbor wall. A man on the boat called out something to me. This man and I were totally alone there. He rushed up to me and pointed across the harbor, saying: "Isla Maciel!" and blurted out in an international language, "Cinematografo. Nina, deitsch, frances, englishmen, amor, dirty cinematographico!" . . . A large arc lamp radiated harshly over a sinister-looking shack on the other side.

The man rowed me over there past the ships. . . . I came to a lonely trail, and one hundred meters up ahead of me was the glaring arc lamp. . . . On my left was a hedge; on the right, an impenetrable gloom of dirty shacks and dark corners; and on both sides, the breath of sudden, quick, raw, silent criminality. . . . I came to the house with the arc lamp. A large sign declared: "Cinematografo para hombres solo." The scene at its best! Before I went in, two local police at the door searched my pockets. It was like a scene out of a detective yarn.

The show was in progress. It was a large hall with a gallery running around the sides. A screen hung from the ceiling, on which the cinematographic theater played out its scenes. . . . While stupid pricks chased each other around up there, women roamed among the guests. They were mostly Germans. The dregs of the world's brothels. . . .

It was so stupid, so unbelievably dull and absurd, these idiotic, tired, and insolent wenches and the pretend vices on the screen overhead, which were supposed to enflame the customers' passions. It was all so insane, so nonsensically perverse. Here is this modern technical device, lighting up the faces of men staring up out of the darkness, acting as a pacesetter for a cat house, by speeding up the nervous, excited procession to the rooms. Men and hookers disappeared noisily and quickly up the dark steps.[8]

It seems that in viewing pornographic films one has to overcome a certain kind of shyness. Which has nothing to do with the legal or moral condemnation of pornography, nor with the obvious reason for pornographic films' being suited to the brothel. Even today, when pornographic films are shown in public theaters and no longer connected to the business of a brothel, a palpable sense of shame still attaches to the experience, which cannot be fully explained by the few remaining moral taboos. The same atmosphere of uneasiness and shame, excite-

8. *Ibid.*, pp. 180–182.

ment and repulsion is also revealed in historical documents encountered in more recent reports. Günter Kunert, for example, describes a visit to a porn house as follows:

> Kino Rondell. Silent men in darkness. No women. No throat-clearing. No coughing. Not even the proverbial pin drop could be heard. A gathering of the living dead, so it seems, sitting on folding chairs, always two at a table, whose greasy top has a list of drinks lit up from underneath, and a call bell. . . .
>
> A trailer for next week's feature is playing: a fat, aging "Herr Robert," whose voice lags behind the picture, snaps his fingers out of sync, followed by quick cuts of more or less (mostly more) naked girls parading across the screen in more or less (mostly less) seductive poses, displaying out-of-proportion bodies and faces radiating an aura of stupidity.
>
> Now a brandy! No one orders. No one smokes. No one breathes louder or heavier. In front of the rows of seats the celluloid nymphs twist and turn and seem more alive than the live audience, which, later, after the feature — a Danish production on the complexities and peculiarities of sex — leaves the Kino Rondell as silently as they had occupied it: without a laugh, without audible approval or disapproval.
>
> A kind of erotic phantom fades away quickly and quietly, condemned to take on corporeal existence once again, when the bell sounds for the next performance.[9]

If the porn cinema clientele is made up of human beings who act like zombies, voyeuristic pleasure in these cinemas clearly must have something in common with the secrecy of the peeping tom. The voyeur likes to look, but doesn't like to be seen. Displeasure in the porn house apparently results from the displeasure in being seen while looking. Where the connection between "cinema and brothel" still exists, and a "modern technical device" acts as a "pacesetter" for cat houses, then this displeasure and this shame in erotic relations will be channeled into "healthy and hearty pleasure." Pornographic films fulfill this function still, not only as a kind of G-rated masturbatory cinema, but also in brothels and prostitution. Along with this type, however, another type of pornographic film has developed which has no other intention, no other purpose than that of satisfying voyeuristic desire. In these films, the specialized sense of sight, regarded in the other type of pornographic cinema as fulfilling a subordinate function in foreplay, asserts its autonomy as isolated, unadulterated voyeuristic pleasure.

Only by assuming such a specialized mode of viewing can we explain the

9. Gunter Kunert, *Ortsangaben*, Berlin (East), 1970, pp. 123–124.

tremendous success of public pornographic movie houses, in spite of the displeasure they inflict on the zombielike voyeur. The language of our age of visual culture, in which the active subjugating eye wins out over the passive receptive sense organs, such as the ears, finds an apt metaphor in the recent divorce of cinema from brothel, pornography from prostitution. Since the workplace has long since demanded nothing more of the body than keeping a watchful eye on the control board, perhaps the private peep-show booth will soon offer the porn theater visitor a serviceable leisure-time retreat. It may be that over the history of pornographic cinema the films themselves have not changed so much as the organization of the senses. It may be that films' effects are more directly related to the social environments in which the films are presented than to the films' form and content. In other words, the audience's sexual orientation defines the way the product is consumed.

Although it is not certain whether pornographic films for heterosexuals are, aesthetically speaking, better or worse than those for homosexuals, they obviously encompass different modes of reception and consumption. Kurt Tucholsky described audience response in the days when the business of heterosexual pornography was still linked to prostitution: "Shouts, encouragements, grunts, applause, and rooting cheers rang out. Somebody compares his own private ecstasy. There was a lot of noise and yelling."[10]

Brendan Gill rediscovered a similar scene in a New York porn theater in the 1970s: "A large portion of the audience at both heterosexual and homosexual blue movies is Oriental. Unlike white males, Oriental males come into the theatre by two's and three's and talk and laugh freely throughout the course of the program."[11] Gill also describes a connection between gay porn theaters and erotic practice that is hardly ever encountered in public heterosexual porn houses:

> For the homosexual, it is the accepted thing that the theater is there to be cruised in; this is one of the advantages he has purchased with his expensive ticket of admission. . . . Far from sitting slumped motionless in one's chair, one moves about at will, sizing up possibilities. Often there will be found standing at the back of the theatre two or three young men, any of whom, for a fee, will accompany one to seats well down front and there practice upon one the same arts that are being practiced upon others on the screen.[12]

We also see that in the course of time, settings, stereotypes, and characters change even in pornographic cinema in order to conform to newer fashions, especially about what is considered sexy. Early pornography, for example,

10. Moreck, p. 179.
11. Brendan Gill, "Blue Notes," *Film Comment*, vol. 9, no. 1 (1973), p. 11.
12. *Ibid.*

attempted to please its well-to-do clientele by presenting erotic scenes involving servant girls and masters, thus capturing an everyday erotic fantasy, while in more recent pornographic films these roles give way to other trades. Newer films produced for public screening and sale also differ from older ones in that they follow the letter of the law more strictly; they avoid showing certain erotic activities that *were* shown earlier, since the early films were illegal anyway. According to Curt Moreck's description of pornographic films of the '20s and earlier, individual films could be distinguished according to country of origin and target audience:

> Pornographic films reveal something about different erotic prefer-
> ences in different countries. Thus French pornography presents ex-
> cretory acts with striking frequency and indulges in lengthy depictions
> of preparatory maneuvers, while the sex act itself often doesn't occur
> at all or is shifted behind the scenes. England, which produces such
> films mainly for South Africa and India, favors flagellation scenes and
> sadistic abuse of blacks. . . . Italy, whose southern location already
> overlaps into the zone of "Oriental" sexuality, cultivates the depiction
> of acts of sodomy as a specialty, while scenes of sexual union between
> humans and animals and scenes of animals mating are also popular. It
> has been said that Germans sin without grace. German pornographic
> films lend some credence to that assumption. Without exception they
> show well-executed, realistic scenes of coitus. On the other hand,
> erotic scenes with animals are totally absent. Now and again some-
> thing kinky is thrown in to broaden their appeal.[13]

Apparently, early pornographic films were also divided into those with quasi-realistic settings—thus bearing some relation to the customer's everyday life—and those set in a world of fantasy or using stock settings associated with forbidden sexuality or foreign exoticism. The "realistic" films depicted masters and servants in bourgeois surroundings—the home of an officer, for instance. The escapist ones were acted out in harems, cloisters, and so forth. This dichot-omy apparently still holds true: consider, on the one hand, the "Housewife Reports" (pornographic serials about housewife affairs with the postman, gas-man, etc.) and, on the other, racist excursions into exotic domains—Thailand in *Emanuelle*, for example.

The blue movie genre has meanwhile obviously become more professional, unintentional comic relief and unbelievable plots having given way to a routinely crafted product. Cinematography has become more skillful and the overall con-struction more sophisticated, with cutting for suspense and other formal proce-dures turning straightforward illustrations into cinematic images. Even if we

13. Moreck, p. 183.

assume that some ironic observations were employed by historical commentators as defense mechanisms against their own shame and excitement, we still come to the conclusion that early porn films were awkward and amateurish, made with little thought to achieving cinematic effect:

> Now came *Scenes in a Harem.* The wallpaper in the empty room, along with the carpet and curtains, suggested that the location was a red-light district, like Schlesisches Tor in Berlin. Fatima danced. The depraved girl took off her extravagant lingerie and danced—that is, she turned around casually by herself while everyone admired her. She danced in front of her sultan, who was lolling about listlessly in other harem girls' laps. He was a bon vivant. The women fanned him with large Japanese paper fans, and on a table in front of them stood a glass of *Weissbier.* . . .
>
> *Secrets of the Cloister* and *Anna's Sideline* came on next: Two "perverse beauties" rolled around on a carpet. One of them, I found out, was a certain Emmy Raschke, who laughed continuously, probably because she thought the whole thing a bit funny. Well, they were all there, cool and very businesslike, to act out (if the audience is any guide) the most exquisite things, while the cameraman yells directions at them. . . .
>
> *The Captain's Wife* was playing upstairs. It was pornography come to life. While the worthy officer cheated on his wife with the lieutenant's wife, the captain's wife made good use of the time with her husband's orderly. They are caught in the act, and it leads to blows. Say what you like, the film was true to life, even though the life of French soldiers does seem a little strange: things happen so fast. In any case, there were two or three moments where the actors played their roles to the hilt.[14]

Here, Tucholsky describes the kind of porn films that abstain from so-called perversions and limit themselves to that which Curt Moreck called typical for German blue movies: "well-executed, realistic scenes of coitus" and "sin without grace."[15]

Comic moments, described by Tucholsky as unintentional, occur often in the genre. We cannot assume that these comic aspects of old porn movies are merely an effect of historical distance. Even today, many sex films function as farce, dirty jokes, and witty commentary. So too, in popular older forms, comic moments played a significant role:

The comic element naturally plays an important role in pornographic

14. *Ibid.,* pp. 178–179.
15. *Ibid.,* p. 183.

films, since most people have a humorous attitude toward certain sexual practices rather than a serious or even pathetic one. Films make use of this fact by showing people in sticky situations, interrupted or embarrassed while tending to bodily needs, or getting caught in awkward positions through some droll mishap while having sexual relations.[16]

A "humorous attitude toward certain sexual practices" probably arises out of sexual repression and anxiety; laughter and nervous giggling are often indications that a taboo has been violated. It seems as if the persistence of comedy as a pornographic form has to do with the pleasure of looking, with voyeurism itself: we laugh at the secret exposure of others. This can also be seen in the fact that TV producers and viewers concur in considering as "comedy" shows, such as *Candid Camera*, that involve watching people with hidden cameras.

The Knowing Look and the Pleasure of Looking:
On the Autonomy of the Senses

What is new in pornographic cinema is obviously its existence as a voyeuristic amusement park. It promises nothing more or less than it advertises: the pleasure in looking, erotic activity without social contact. This new pornographic cinema is found not only in the large industrial metropolises but also in small towns and in the daily programs of staid resorts. Those who, with good and honorable intentions, reproach blue movies for deceiving the poor consumer — instead of delivering the genuine product, "real" sex, these films palm off on him a phony substitute — are missing the point. Such critics assume the primacy of genital pleasure over that which arises out of the "component instincts," one of which is voyeurism, visual sensuality, *Schaulust*.

The consumer who buys his ticket at the door doesn't expect and probably doesn't even want to experience sexual gratification with another person. Like Mr. Chance in Hal Ashby's film comedy *Being There* (1980), the porn movie patron is "just looking." Criticism of pornography thus misses the mark when it assumes that the customer has been cheated because he expects and pays for something he doesn't get. Customer fraud would hardly explain the success of pornographic movies. While having improved on their heavy-handed and awkward predecessors, the quality of today's porn films explains this success even less, since these films do not begin to come up to the formal standards of other genres. Recent attempts to have porn "taken seriously" by enhancing the genre with stars, festivals, and directors should probably be seen not so much as a gimmick to attract a wider audience as an effort by an association of craftsmen to

16. *Ibid.*

gain credibility. Meanwhile, even apart from the hype, the porn film trend keeps on growing. The bids for credibility may help overcome the last bastions of resistance to pornographic films, but they won't do much for box office.

In my view this trend toward pornographic movies involves a more far-reaching development in society's organization of our senses. Porn houses are not the motor but the chassis. An explanation for the growth of pornographic cinema can be found in its function within prevailing sexual organization. Walter Serner, overwhelmed by this new invention of cinema, already proposed such an idea in *Die Schaubühne* in 1913:

> All the likely reasons somehow don't add up to an explanation of the movies' unprecedented success everywhere one looks. The reason must lie deeper than we think. And if we look into those strange flickering eyes to find out why people spend their last penny to go to the movies, they take us way back into the history of humankind. There we find, writ large: *Schaulust.* It is not merely harmless fascination with moving images and color, but a terrifying lust, as powerful and violent as the deepest passions. It's the kind of rush that makes the blood boil and the head spin until that bafflingly potent excitement, common to every passion, races through the flesh. . . .
>
> This ghastly pleasure in seeing atrocities, violence, and death lies dormant in us all. It is this kind of pleasure which brings us, hurrying, to the morgue, to the scene of the crime, to every chase, to every street fight, and makes us pay good money for a glimpse of sodomy. And this is what draws the masses into the cinemas as if they were possessed. Cinema offers the masses the kind of pleasure which, day by day, is eroded by the advance of civilization. And neither the magic of the stage nor the tired thrills of a circus, music hall, or cabaret can attempt to replace it. In cinema, the masses reclaim, in all its former glory, the sensuousness of looking: *Schaulust.*[17]

Serner prophetically anticipates that cinema's appeal lies in a Nero-like diversion: being able to participate from the bleachers in the atrocities of an epoch. Acknowledgment of this aspect of the pairing within popular culture of "sex and violence," as the critics call it, has been suppressed. While societies have long permitted the depiction of brutal violence, hatred, war, crime, destruction, and death, this has not applied to the presentation of naked bodies and sexuality. It is no wonder that, with the relaxing of sexual taboos, cinema has now seized upon sexuality as a voyeuristic object. Up to now you could see just about every possible way of killing a person. Now we can also see 99, or 150, or "x" ways of making love. *Schaulust*, which Serner describes as a violent, volatile passion, and

17. Walter Serner, "Kino und Schaulust," *Die Schaubühne 9,* 1913. Quoted in Anton Kaes, ed., *Kino-Debatte*, Munich, Deutscher Taschenbuch, 1978, pp. 53–54.

to which he ascribes an ultimately corruptive influence, is itself neither outcome nor origin. Rather it arose and took shape on its own out of the processes involved in the establishment of a highly rationalized and thoroughly organized society. The success of the porn house in its present form is the expression of this cultural-historical development rather than of a primal passion:

> The eye is an organ constantly under stress, working, concentrating, always unequivocally interpreting. The ear, on the other hand, is more diffuse and passive. Unlike an eye, you don't have to open it first.[18]

> The eye has adapted to bourgeois rationality and ultimately to a highly industrialized order by accustoming itself to interpreting reality, a priori, as a world of objects, basically as a world of commodities; the ear has achieved nothing similar.[19]

> Such a division of labor between the various receptive faculties of human beings, a specialization of the senses, was necessary for a particular stage of capitalist production, the same stage of the production process that is singled out by "Taylorism."[20]

In the age of Taylorism, a dramatic rise in the dissemination of pornography was observed in Victorian England. It remains to be demonstrated that this sudden interest is strictly the result of the notoriously repressive Victorian society, that is, that it was conceived as an outlet for dammed-up passions. Rather, the dissemination of pornography is connected to specific social aspects of modernization, as well as to parallel changes in the perceptual apparatus and intrapsychic mechanisms. In a certain respect pornographic cinema is both the symptom of this development and its expression. Training the eye means adapting the sense of sight to strategies of rationalization and modernization. An expansion of voyeurism at the level of the organization of the drives corresponds to this social/perceptual development, thereby bringing sexuality in line with it.

The connection between power, control, and sexuality can only be made through changes in sexuality itself. Pornography may be one of those sieves through which power seeps into the inner regions of sexuality while sexuality flows out and becomes a part of this power. Michel Foucault analyzes the inter-

18. Theodor W. Adorno and Hanns Eisler, *Komposition für den Film*, Munich, Roger & Bernhard, 1969, p. 43.
19. *Ibid.*, p. 41.
20. Oskar Negt and Alexander Kluge, *Öffentlichkeit und Erfahrung. Zur Organisationsanalyse von bürgerlicher und proletarischer Öffentlichkeit*, Frankfurt am Main, Suhrkamp, 1972, p. 237. Frederick Winslow Taylor developed a system of rationalizing the work process, a conception which was widely adopted and applied to shape industrial design and management practices.

meshing of power and sex in the first volume of *The History of Sexuality*, without, however, viewing the matter in terms of a simple oppressor/victim relationship of repression:

> This implantation of multiple perversions is not a mockery of sexuality taking revenge on a power that has thrust on it an excessively repressive law. Neither are we dealing with paradoxical forms of pleasure that turn back on power and invest it in the form of a "pleasure to be endured." The implantation of perversions is an instrument-effect: it is through the isolation, intensification, and consolidation of peripheral sexualities that the relations of power to sex and pleasure branched out and multiplied, measured the body, and penetrated modes of conduct. And accompanying this encroachment of powers, scattered sexualities rigidified, became stuck to an age, a place, a type of practice. A proliferation of sexualities through the extension of power; an optimization of the power to which each of these local sexualities gave a surface of intervention: this concatenation, particularly since the nineteenth century, has been ensured and relayed by the countless economic interests which, with the help of medicine, psychiatry, prostitution, and pornography, have tapped into both this analytical multiplication of pleasure and this optimization of the power that controls it. Pleasure and power do not cancel or turn back against one another; they seek out, overlap, and reinforce one another. They are linked together by complex mechanisms and devices of excitation and incitement.[21]

The history of sexuality, according to Foucault, is inscribed in the "will to knowledge," meaning power. Pornography thus becomes nothing other than the "will to knowledge"—the night school for sex education—where, by means of voyeurism's cognitive urge, the discourse of power is begun. In fact, some studies of the social history of pornography offer evidence that these films were only too happy to be thought of as a contribution to research on sexuality and its various forms. Then came the recent wave of porn films whose opening credits declared their intention to offer practical advice for living, to be purveyors of knowledge. Examples of these are the Oswald Kolle series, or *Helga*. The classification of formal knowledge by category still attaches to an unending series of "Film Reports," often presenting sexual behavior according to various occupations. Even early porn films displayed a lexicographic tendency, as an eyewitness noticed:

21. Michel Foucault, *The History of Sexuality*, trans. Robert Hurley, New York, Vintage Books, 1980, p. 48.

A special flavor is given to obscene films through the scrupulously realistic presentation of every imaginable perversion. Although life itself very often offers the connoisseur a view of simple vice, the chance to enjoy real perversity as a spectator is much rarer; in this case, film tries to fill the void. There are some films in this genre which seem to have been staged directly from Krafft-Ebing's *Psychopathia Sexualis*, as a manual of abnormal sexual operations for civilized man.[22]

All the vices of man flickered by on the screen. Every one of the hundred and fifty ways from the old *Treatise on the Hundred and Fifty Ways of Loving* was demonstrated, with occasional interruptions for lesbian, pederast, and masturbation jokes. All that was harmless. Sadists and masochists waved their instruments, sodomy was practiced, coprophagous acts were on display. Nothing was held back, everything occurred in a banal reality, all the more infuriating for its technical crudity.[23]

The "will to knowledge" activates the eye, which in turn casts its gaze upon sexuality—*Schaulust* as an instrument of cognition, cognition as *Schaulust*: pornography discovers its social role. Psychoanalytic theory established the notion of a relationship between curiosity, cognitive activity, and voyeurism in the developmental history of the individual even before pornography revealed this connection by becoming a typical product of our society. The optical organization of reality implies control, from the vigilant eye of the hunter to "the great eye of the government" (Foucault). Jean-Paul Sartre notes in *Being and Nothingness*:

In addition the idea of discovery, of revelation, includes an idea of appropriative enjoyment. What is seen is possessed; to see is to *deflower*. . . . More than this, knowledge is a hunt. Bacon called it the hunt of Pan. The scientist is the hunter who surprises a white nudity and who violates by looking at it. Thus the totality of these images reveals something which we will call the *Actaeon-complex*. . . . : a person hunts for the sake of eating. Curiosity in an animal is always either sexual or alimentary. To know is to devour with the eyes.[24]

Let us assume the correctness of Foucault's thesis that the history of sexuality is based on a will to knowledge and concede that pornography is a conduit for

22. Moreck, p. 182.
23. *Ibid.*, p. 181.
24. Jean-Paul Sartre, *Being and Nothingness. An Essay on Phenomenological Ontology*, New York, Philosophical Library, 1956, p. 578.

this transmission of sex and power. If, in addition, we consider another point made by Sartre, we might be able to explain why pornographic cinema today is a medium for conveying knowledge (in Foucault's sense) rather than a medium for aesthetic experience. Sartre assumes a difference between art and cognition that is based on their different relationships to appropriation. Works of art resist appropriation: "The work of art is like a fixed emanation of the mind. The mind is continually creating it and yet it stands alone and indifferent in relation to that creation."[25] Cognition, on the other hand, is constituted as an act of appropriation, thus incorporating the object of cognition and assimilating it: "Knowledge is at one and the same time a *penetration* and a *superficial* caress, a digestion and the contemplation from afar of an object which will never lose its form."[26]

Sartre analyzes cognition as assimilation, whose end is reached when desire destroys its object, rather than preserving it through appropriation — you can't have your cake and eat it too! It seems to me that Sartre's analysis of cognition as penetration and as detached observation also characterizes the appropriation process in pornographic films. If the viewer allows himself to be carried away by the desire to possess — thus relinquishing the position of a detached observer — he must sacrifice his *Schaulust* in order to take in a specific moment or image; in the meantime, subsequent images and sensations have already appeared on the screen. Thus, the viewer is caught between two modes of appropriating: perception and cognition. It is like Buridan's hungry ass of old caught between two tasty piles of hay:

> When I look at a porn magazine, I don't care about the way the scene is visualized, even if the men and women are ugly or something else isn't quite right. In my fantasy they exist in a way that excites me. Besides, it's up to me which picture I choose to look at, and I can always turn the page or go back to a certain picture. . . . The viewer of a porn film always remains alienated from the situation he's observing, because he has to keep his clothes on and can't touch, even though the pictures arouse him. He becomes confused.[27]

This description of a user experience points to the key difference between the two pornographic mediums and raises the question: why, despite such a frustrating situation, have so many people developed a distinct preference for pornographic movies? Perhaps the reaction of the regular viewer of porn films is not one of confusion at all; maybe the person like Mr. Chance, who only wants to look, is quite common. It is possible that inside the porn theater desire actually becomes transformed into the fetishism of the aficionado, who only needs to

25. *Ibid.*, p. 578.
26. *Ibid.*, pp. 579–580.
27. Beate Klöckner, "Hörst du mein heimliches Rufen? Die 'gute' und die 'böse' Lust," *Strandgut*, no. 26 (March 1980), p. 17.

know what is available, then sits back down to watch — the ultimate triumph of
the eye over the body.

This theoretical notion seems to be supported by the evidence of amateur
pornographic films, like those that Robert van Ackern includes with other kinds
of home movies in his scathing compilation film *Germany in Private* (1980). The
films, though formally far inferior to commercial porn films, nevertheless draw
on them for their fantasies. Pornographic ideas and mise-en-scène are recorded
by a Super-8 camera in a totally naturalistic fashion; in fact, in contrast to more
polished professional porn, one has the distinct impression that the events are
taking place only for the sake of the camera. An agitated woman sprawls out on a
kidney-shaped coffee table in a living room; another models sexy underwear.
Pleasure in the actions themselves seems minimal; the liveliest thing about these
bodies is their lascivious gaze into the camera. The recording camera creates the
show. It's like Mr. Chance thinking he can turn off unpleasant reality with a flick
of his TV remote control. Once again the assimilation of filmed pornographic
fantasies becomes alienated from erotic practice. What is assimilated is not the
sexuality that is represented but the representation of sexuality. Pornographic
movies beget pornographic movies.

The Realm of the Pornographic Film:
Shadows, Shock, Scarcity, and Plenty

In the beginning of this essay I discussed the ways in which liberalization
through penal code reforms led, in most Western countries, to the emergence of
a varied system of pornographic cinemas. This development was understood as
the result of the permeation of sexuality by social power. It was also suggested
that in pornographic cinema instrumental reason tailors sensuality to its own
measure. The image of the human being in pornographic films is one of the body
as a mechanism for experiencing and maximizing pleasure, and of the person as
monad — as defined by bourgeois ideology in its strictest sense — as one whose
actions are guided by self-interest, specifically, in experiencing as much pleasure
as possible.

The perpetual motion of desire is choreographed for us in pornographic
cinema, and is constituted out of its arsenal. Everything becomes an instrument
for sensual pleasure: the body, a hair brush, a dildo, a banana. Every situation
leads to sex: a flat tire, the beach, the carwash, or an office party. Bodies are
linked with one another according to mathematical equations; orgies are con-
ducted like a game of dominos. What Horkheimer and Adorno have to say about
Sade also applies to porn movies.

What Kant grounded transcendentally, the affinity of knowledge and
planning, which impressed the stamp of inescapable expediency on
every aspect of a bourgeois existence that was wholly rationalized,

even in every breathing-space, Sade realized empirically more than a century before sport was conceived. The teams of modern sport whose interaction is so precisely regulated that no member has any doubt about his role, and which provide a reserve for every player, have their exact counterpart in the sexual teams of *Juliette*, which employ every moment usefully, neglect no human orifice, and carry out every function.[28]

In fact, newer pornographic films demonstrate significant advances, especially in the area of gymnastic-artistic formations. Technique has evolved from presentations of "perverse beauties rolling around on a carpet" to orgies of group sex that demonstrate athletic control of the body along with simultaneous sexual feats. The aesthetic of the pornographic film relies on an underlying metaphor of the body as a machine: editing makes it possible to replace tired bodies with fresh ones, or with those that have been replenished in the interim. Or else in a pinch, when nothing more can be exhorted from these sexual athletes, editing can be used to create movement artificially. The performers' interchangability and anonymity function as a material correlative to the ideology they express. There's no longer room for the old-fashioned clumsiness of a giggling Emmy Raschke. Now we have high performance professionals who, in the manner of Taylorization, contribute specialized physical skills to the completion of the final product. Meanwhile, maintenance crews with spare parts stand ready to take care of breakdowns. These production maneuvers are of no interest to the viewer, who pays as little notice to the rapid relay of aroused penises, wide-open mouths, spread thighs, and drawn labia as he or she does when the female performer changes wigs—from a blonde equestrienne to a red-headed lesbian.

The most sophisticated porn films are structured in such a way that the keyhole perspective of the voyeur is built right into the film. This device allows for several "numbers" at the same time, shown through parallel editing, and helps counteract the fatigue that invariably sets in when an entire coition is presented without interruption in a single take. The latter usually gives the impression of being hard work rather than pleasure. Pornographic cinema emerges at the end of a developmental process in a society of specialization and differentiation. Pornography itself contributes to this specialization by promoting the autonomy of *Schaulust*. The differentiation of pornography as a product parallels developments in society, as producers speculate on the consumer's current and projected needs and taboos. Male homosexuality doesn't turn up in a heterosexual porn house and vice versa, anal eroticism only takes place between men and women, and the only way a man comes close to another man is when a

28. Max Horkheimer and Theodore W. Adorno, *Dialectic of Enlightenment*, New York, Continuum, 1987, p. 88.

woman, who lies between them, is entered both vaginally and anally. Lesbian sex does not appear either; when women caress each other, it is only because they are waiting for a man or performing for a male voyeur.

But criticism of pornography is still clearly ill at ease with its newer forms, especially its filmic forms. Despite the routine way in which the socialization of sexuality is pursued, some quality still clings to pornographic cinema which places it into the category that Siegfried Kracauer called "phenomena overwhelming consciousness":

> Elemental catastrophes, the atrocities of war, acts of violence and terror, sexual debauchery, and death are events which tend to over-whelm consciousness. In any case they call forth excitements and agonies bound to thwart detached observation. No one witnessing such an event, let alone playing an active part in it, should therefore be expected accurately to account for what he has seen. Since these manifestations of crude nature, human or otherwise, fall into the area of physical reality, they comprise all the more cinematic subjects. Only the camera is able to represent them without distortion. . . .
>
> The cinema, then, aims at transforming the agitated witness into a conscious observer. Nothing could be more legitimate than its lack of inhibition in picturing spectacles which upset the mind. Thus it keeps us from shutting our eyes to the "blind drive of things."[29]

Kracauer suggests that only through the alienation of the image is it possible to imagine a reconciliation with objects and their recuperation from mere functionalism. The one-dimensionality of the optical appropriation of the world is mirrored in the flat screen of pornographic cinema, and somehow makes it even more scintillating and enticing than any ideological criticism — no matter how well-intentioned or well-founded — has been able to account for.

> One must learn to read between the lines of gaping flesh and labia, as if these constituted a code of prohibition and denial. . . . But the whole iconography of unlived life, of antieroticism in capitalist systems is only revealed to the person who remains sensitive to pornography's debasement, dirtiness, vulgarity, and brutality, who has seen its leering grin.[30]

Those who, like Peter Gorsen in the above quotation, learn to read pornographic films against the grain will find in it not only "a code of prohibition and denial" — in the sense that the cinema supplies what reality denies. They will also

29. Siegfried Kracauer, *Theory of Film*, London and New York, Oxford University Press, 1960, pp. 57–58.
30. Peter Gorsen, *Sexualästhetik. Zur bürgerlichen Rezeption von Obszönität und Pornographie*, Reinbek, Rowohlt, 1972, p. 104.

recognize the wounds that "the code of prohibition and denial" have inflicted on desire itself—wounds that are not external to but within the iconographic system, a system that expresses rather than represses. Even with the machinelike availability and interchangability of bodies in pornographic films, their crude naturalism harbors a wish for a realm beyond renunciation where milk and honey flow. In his study of sexuality and pornography in Victorian England, Steven Marcus traces the historical context of the era's imagery to its economy:

> The fantasies that are at work here have to do with economics; the body is regarded as a productive system with only a limited amount of material at its disposal. And the model on which this notion of semen is formed is clearly that of money. . . .
>
> Furthermore, the economy envisaged in this idea is based on scarcity and has as its aim the accumulation of its own product. And the fantasy of pornography, as we shall have ample opportunity to observe, is this idea's complement, for the world of pornography is a world of plenty. In it all men are limitlessly endowed with that universal fluid currency which can be spent without loss. Just as in the myth Zeus descends upon Danae in a shower of gold, so in pornography the world is bathed, floated, flooded, inundated in this magical produce of the body.[31]

The Victorian pornographic fantasy of abundance complemented real poverty in the external world. The wealth that pornographic cinema commands today had yet to be amassed. Thus, now, the endless flow of semen, the bodies of women doused in sperm, allude to one particular scarcity: that of the body itself. Pornographic fantasy invariably refers us back to the world of machines, of interlocking systems and cogs, in which everyone, ultimately, is caught up. But the fantasy alludes, above all, to the subjugation of the body, which suffers from want in the midst of material plenty.

Today pornographic film no longer refers to meanings lying outside its own subject matter; it refers primarily to itself by relying on what can be seen on the screen: bodies and their passions. Now we must reconsider the problem of voyeurism addressed above and pose the question: What is it that is seen? what aspects of sexuality can be visualized? I will attempt to answer this question in the next section, which deals with the iconography of the visible (the phallus) and the invisible (the vagina) in gender-specific pornographic imagery. But first I want to examine further that distance between observer and observed which, according to Kracauer, is created by the camera.

Kracauer believes distance is necessary to lessen the shock that would result from the spectator's direct confrontation with certain phenomena. Pornography

31. Steven Marcus, *The Other Victorians. A Study of Sexuality and Pornography in Mid-Nineteenth-Century England,* London, Corgi Books, 1964, p. 22.

obviously plays off a certain fear of crudity, coarseness, and undisguised, unsublimated sexuality. Only through the image can the observer confront that which would otherwise frighten him or her. The same process occurs within the individual in the dream-work. In the case of pornographic cinema, the camera becomes a device for creating distance and the medium of a harmless voyeurism:

> Like a camera, I observe but am not involved. In a narrow place in a dark cave I look through the camera and film a scene. I see a huge scorpion, while somebody outside tries to kill it. It's four or five feet long. The guy outside uses his hands and feet to throw sand into the cave, moving it fast, back and forth—so sexual. He hurls a cold, poisoned lobster's tail as bait, so the scorpion won't bite him. Jesus, what a dream! I filmed the battle between these two jokers. It's dangerous and disturbing.[32]

This dream, as related by a patient to his psychoanalyst, provides a good description of the discharge mechanism inherent in this camera-voyeurism. The dream is interpreted by the psychoanalyst as fear of sexuality. (The camera played a role not only in the dreams of this patient, but also in his actual sexual life. He made slides from photos that he took of his girlfriend during their sex games.) Parallels with the procedures of pornographic voyeurism can thus be found at the level of individual psychology. Such everyday examples demonstrate just how deeply embedded are these organizational forms of the perceptual apparatus. Thus the idea of a bad "influence" originating in the simple content of pornographic cinema—an idea often used by political conservatives as an argument for censorship—is not a viable one.[33]

Looking, as a form of sexual curiosity that probes an undiscovered sexuality, requires distance in order to mitigate the fear of the unknown—the Kracauerian shock. Some literary works employ shadow metaphors to create the necessary distance between observer and observed. The following example from literature demonstrates, from a different perspective, the same need for distance in sexual looking that we see in pornographic cinema:

> The shadow of the housekeeper's legs, as she lay with her back on the table, rose up with bent knees over the coachman's creeping shadow, and the shadow of the coachman, resting on his knees, rose above the shadow of the housekeeper's stomach. The shadow of the coachman's hands reached under the shadow of the housekeeper's skirts, the shadow of the skirt slipped down and the shadow of the coachman's abdomen burrowed into the shadow of the housekeeper's exposed thighs. The shadow of the coachman's arm dug into the shadow of his

32. Leon L. Altman, *Praxis der Traumdeutung*, Frankfurt am Main, Suhrkamp, 1981, p. 121.
33. In connection with these problems compare Volkmar Sigusch's summary of the *Pornography Report*, quoted in Gorsen, pp. 108–110.

crotch and pulled out a polelike shadow, which in its shape and position matched his tool; he thrust this protruding shadow into the big, well-rounded shadow of the housekeeper's belly after the shadow of the housekeeper's legs had raised themselves above the shadow of the coachman's shoulders.[34]

The schematic, the stereotypical, the elaboration of persons and identities through the movements of their bodies — thus does Peter Weiss capture the voyeuristic experience in a literary form in which the action dissolves into endless genitives. As a characteristic of pornographic film, the voyeuristic experience is presented at face value and is not problematized. The transformation of persons into patterns which comport themselves according to a preconceived design refers even in pornographic cinema to the longing for a sexual life that is not predicated on the identity of "mature personality" and "genital sex":

> One experiences a glimpse of sexual utopia when one doesn't have to be oneself, and when one doesn't merely love one's lover for herself: it is the negation of the ego principle. It undermines that invariable aspect of bourgeois society, in its broadest sense, which defines identity as integration. . . .
>
> The advancing social reinforcement of genitality brings about greater repression of the component instincts, as well as their representative forms in genital relations. What remains of those instincts is cultivated only in the socialized voyeurism of foreplay. Voyeurism exchanges union with one person for observation of all, and thus expresses sexuality's tendency to socialization, which is itself an aspect of sexuality's deadly integration.[35]

The constant change of locations encompassed in the domain of the porn movie, the make-up and costumes that are the trappings of anonymous passion, are perhaps the last traces of a search for nonidentity in sex. The appearance in a porn movie of a proletarian captain of a steamer on the Elb promises a two-fisted ingredient in *Firm Grip*. In *The Duchess of Porn* a black evening gown offers a touch of French decadence; and *Convent Girls* hints at sadomasochistic flagellation orgies in hair shirts. The component instincts conceal their desires in the secret code of the films' settings, desires obscured in the films themselves by the hearty gymnastic primacy of genital sex.

34. Peter Weiss, *Der Schatten des Körpers des Kutschers,* Frankfurt am Main, Suhrkamp, 1964, pp. 98–99.
35. Theodore W. Adorno, "Sexualtabus und Recht heute," in *Eingriffe. Neun kritische Modelle,* Frankfurt am Main, Suhrkamp, 1963, pp. 104–105.

*The Secret of the Missing Phallus
and Woman's Other Place*

Criticism of pornographic cinema, originally leveled by conservatives on moral grounds, is now exercised, after widespread easing of controls and liberalization, primarily in feminist political action and analysis. But the feminist critique of pornographic film is fundamentally distinguished from that of conservative moralists in its intent. Feminists see in pornographic cinema not the erosion of existing norms but rather their expression and confirmation. Pornographic cinema reduces sexuality to the measure of a male perspective, one grounded in patriarchal myths about female sexuality and the phallus. In short, pornographic cinema is sexist. Feminists argue that sexism prevents the emancipation of sexuality, an emancipation that would liberate women's sexual fantasies and prepare the way for a well-deserved end to phallocentric primacy in the prevailing sexual order. The intent of these arguments is, therefore, not a conservative preservation of existing values but revolutionary change. The arguments arise out of the strategies of the women's sexual and political liberation movement.

The disturbing state of sexuality today makes it difficult to object to the goals of feminist criticisms of pornographic film. One can, however, object to arguments that posit a direct connection between viewing pornographic films and engaging in certain sexual acts, the argument, for example, that whoever views sadistic porn movies sees in them a possible way of behaving and an invitation to rape and sadistically torture women; or that whoever sees phallic fantasies of omnipotence endorsed on the screen will hardly be prepared to act differently in reality. It has never been proven that filmed events have a direct effect on human behavior. It is my conviction that we can only conceive of such a connection in a broad, collective sense, not as a direct relationship as defined by behavioral psychology. In contrast to the above argument, I assume that pornography is less an expression of prevailing male sexual *practice* than an expression of its deficiency, the rehabilitation of damaged fantasies. Although legislative and executive regulation and prosecution is no longer widespread, the subculture of pornographic movies still maintains an aura of the secret and forbidden, the sensational and the never-before-seen; it is therefore promoted not as something ordinary or potentially ordinary, but as something "extraordinary." A porn house in London displayed the following notice in front of the theater: "WARNING: This cinema is showing pornographic films depicting close-ups of sexual intercourse, oral sex, and male and female masturbation and is not for the easily shocked."[36]

The shock, the sense of alarm used here as a promotion, recalls Kracauer's "phenomena overwhelming consciousness." This element of shock seems to be a

36. John Ellis, "On Pornography," *Screen*, vol. 21, no. 1 (Spring 1980), p. 103.

constituent of voyeuristic pleasure in pornographic cinema. But what is it that is so terrible to see? Are sex organs and copulating couples really terrifying? Where does this terror that leads to fascination come from? Feminist arguments overlap with psychoanalytical ones in answering this question, because both proceed from the assumption of the primacy of male sexuality in pornographic films.

According to Freud's analysis, there is a close connection between *Schaulust* and fear of castration: A male child who sees a woman's sex organ for the first time in his life is amazed that no penis is attached. Disturbed by the fact that an object so important for him is missing from the female organ, he imagines a number of equally anxiety-laden possibilities: a) the female organ is the result of castration, or b) the woman is hiding her penis. The second possibility, "b," is already a working through of the fears aroused by possibility of "a." It is this aspect of the castration complex that gives rise to the persistent voyeuristic mania to look at the female organ, constantly and as closely as possible, in order to uncover the secret of the missing penis. The adult viewer of pornographic films seeks a confirmation of his childhood sexual theory — the phallic myth about the female organ. Because this mania is the result of the castration complex, seeing lots of penises confirms their durability and intactness; castration anxiety is also reduced by inducing the feeling of phallic omnipotence. The restless search for something that can't be found — the woman's penis — is compensated by an appeasing display of erections and potency. The endless merry-go-round of sex orgies, the reduction of a person to his or her sex organs, the mechanical, compulsive repetition in the action of pornographic films thus arise out of the male sexual organization, rather than from a lack of imagination on the film-makers' part. A secret rite conjures up a naked body at any moment and around every corner. The fantasy world of the adult is like the magical, archaic world of the child, where time and space are freed from the constraints of physical reality. It is as if, with a magic word, an ordinary place becomes a secret site of sexuality. The world of pornographic films builds pyramids of gymnasts on an archaic foundation: on a childhood sexual theory.

John Ellis has shown that in the voyeuristic realm of pornographic films the invisible female phallus must be transformed into a visible fetish, so that pleasure can overcome the fear of castration:

> The fetish offered by these representations is no longer a fragment of clothing, or even the deceptively smooth body of the phallic woman, it is now the woman's sexual pleasure. The woman nevertheless has the phallus in sexual pleasure; the woman's lack of a phallus is disavowed in her orgasm. . . . In orgasm woman no longer is the phallus, she has the phallus. Films currently produced within the pornographic sector gain their impulsion from the repetition of instances of female sexual pleasure, and male pleasure is perfunctory in most cases. The films (and photographs) are concerned with the "mise-en-scène" of the

female organs; they constantly circle around it, trying to find it, to abolish the spectator's separation from it.[37]

The transformation of the empirical penis into a mythic, symbolic phallus, into a fetishistic image signifying the existence of female orgasm, also signifies the process of transformation whereby something invisible becomes visible in the fetish. It is true that many pornographic films give particular weight in their mise-en-scène to signifiers of female orgasm. But this raises another problem in the relationship of visible and invisible. For the place where the woman "possesses" a phallus and is supposed to have the orgasm is no more visible than the phantom phallus the man seeks to find in her.

Because of the expressive poverty of its naturalistic style, pornographic film necessarily reaches its limit literally *ante portas*, before achieving its goal of seeing the secret place where woman's pleasure resides. Dennis Giles outlines this problem in a psychoanalytic essay on pornographic films:

> The interior space she encloses (identified as the woman *in essence*) is an *invisible place* . . . it cannot be possessed by visual knowledge. In order to emphasize its separation from the *known* space of the pornographic film, I call this central interior the Other place.[38]

The invisible, other place, affirmed by pornographic films without showing it, can be made visible through pornographic language. Steven Marcus impressively affirms it in a description of the female body as a landscape, rendered in a Max Weberian construction of an ideal-typical "Pornotopia":

> Farther down, the scene narrows and changes in perspective. Off to the right and left just two smooth snowy ridges. Between them, at their point of juncture, is a dark wood—we are now at the middle of our journey. This dark wood—sometimes it is called a thicket—is triangular in shape. It is also like a cedar cover, and in its midst is a dark romantic chasm. In this chasm the wonders of nature abound. From its top there descends a large, pink stalactite, which changes in shape, size, and color in accord with the movement of the tides within. Within the chasm—which is roughly pearshaped—there are caverns measureless to man, grottoes, hermits' caves, underground streams— a whole internal and subterranean landscape. The climate is warm but wet. Thunderstorms are frequent in this region, as are tremors and quakings of the earth. The walls of the cavern often heave and con-

37. *Ibid.*, p. 103. Ellis's analysis takes its cue from Laura Mulvey's "Visual Pleasure and Narrative Cinema."
38. Dennis Giles, "Pornographic Space: The Other Place," "Film-Historical Theoretical Speculations," *The 1977 Film Studies Annual*, Pleasantville, New York, 1977, Part II.

tract in rhythmic violence, and when they do the salty streams that run through it double their flow. The whole place is dark yet visible. This is the center of the earth and the home of man.[39]

In film this literary utopian other place remains invisible. Woman's pleasure is not only signified, it is also simulated by external signs; only the penis is visible in pornographic films, and it must bear the burden of proof. We hardly ever see a coition that doesn't end with a penis ejaculating on a woman. The abundance of sperm once again becomes a sign of inadequacy, an inadequacy of representation. Still, the sight of an ejaculating penis seems to be pleasurable for the straight male viewer, because to him it is a sign of intactness, an assurance that the vagina, imagined as insatiable and dangerous, has once again yielded its victim, unscathed, to see the light of day. Another reason for the choice of a naturalistic style of depiction in pornographic films is that it confers perceptual certainty on the films' guarantee of "uncastratedness." This convention therefore sacrifices the woman's pleasure, since the actress has to simulate orgasm after the penis is no longer inside her.

The psychic codification of sexuality can thus be seen even in the naturalistic habits of pornographic films. Films are never transparent, pure images, they are always a symbolic structuring of that which is portrayed. Thus we can now extend the definition encountered above — pornographic cinema as an instrument of the "will to knowledge" — to the intrapsychic level: pornographic cinema is the night school of the sexual theories of children. Even though, ultimately, any such definitions remain inadequate, an analysis that measures pornographic films with the yardstick of psychopathology and concludes they involve infantile, perverse male sexual fantasies is, in a clinical diagnostic sense, entirely correct. This argument offers the feminist critique of pornographic film its strongest support.

Yet psychopathological analyses, based exclusively on a reconstruction of the male sexual perspective, cannot explain the fact that, "with disgusted and fascinated gaze,"[40] and in spite of well-founded moral and critical indignation, women are fellow travelers on the road to "Pornotopia."[41]

39. Marcus, pp. 274–275.
40. Marie-Françoise Hans and Gilles Lapouge, *Die Frauen — Pornographie und Erotik*, Neuwied, Luchterhand, 1979, p. 204.
41. If one strictly defines pornographic cinema as a medium oriented solely toward the depiction of male sexuality, then one still has to explain why women are not necessarily turned off by such depictions. They will hardly find an image of their own sexuality, unless we accept Freud's assumption of penis envy, which presupposes that the heterosexual, phallically oriented female identifies with the penis and its pleasure. The penis envy thesis, so vehemently opposed by feminist theoreticians, will not be discussed further here, although I'm inclined to accept its historical, if not its universal, anthropological validity. It might be helpful to look at Freud's assumption regarding a constitutional bisexuality, which characterizes not only men but also women. In his late works Freud

The pleasure of looking, as an exploration of a strange sex as well as one's own, is certainly a pleasure common to both sexes. Likewise, it is not only male desire that is expressed in the longing to return to the womb and in narcissistic fusion and exchange fantasies. The idea of promiscuous abundance, which saturates the images of pornographic films, is present not only at the level of symbolic abstraction — in the sense that all those visible, concrete penises and vulvas represent only a single symbolic phallus. Although always bound within a symbolic, social discourse, film images never quite free themselves from the resistance offered by the concrete world of objects, which those images transfer to the world of symbols.[42] If all these genitalia and individual bodies symbolize a single meaning, it may be because they are experienced through the abstract, generalizing mania of male perception — that is, only within the systematic context of the symbolic organization of a phallocentric world. Nevertheless, they still also exist as images of particular things whose substantiality is also real and empirical, as the naturalistic style of pornographic film never tires of reminding us. It may be that female perception is not actually integrated within a phallic discourse which can never be woman's own. It may be that women, through their own more concrete organization, can undo the fantasy in order to move about outside the inscribed symbolic discourse. Pornotopia would become a world of fragments, disclosing the gap between the sexes, something the phallus nervously denies. Pornotopia then becomes the empire of a phallic ruler, who is powerless against the woman's gaze at specific objects; it partitions his empire according to its own preferences. The woman's gaze at pornographic films, "disgusted and fascinated," doesn't have to search for and find a phallus behind every penis. The fact that women react ambivalently to pornographic films, torn between fascination and disappointment, may not always be because of a prudish upbringing, which forbids an open view and leads to repulsion and a defensive attitude toward sexuality. It may still be possible for women, in spite of their criticism, to take a utopian view of Pornotopia. This may come to pass if they are able to recognize

went so far as to state that biological bisexuality might contradict his penis envy theory. If we imagine that the strict schism between male/female, phallus/vulva is actually a relationship, whereby each sex incorporates repressed elements of the other, then we might have an explanation of why women can discover at least a portion of themselves in "Pornotopia." Viewing a penis would then also imply a degree of pleasure for women, and would thus not only mean subjugation by phallic power or identification with the oppressor. This would of course mean that we women would have to free ourselves from such constructs as "evil," "destructive," and "misogynist" perversions, while at the same time attempting to study the utopian and antiestablishment contents of these perversions before clinically disqualifying them.

42. Compare Kracauer, pp. 57–58. Kracauer's essentialist film theory, based as it is on phenomenology, is centrally concerned with the idea of film as a redemption of physical reality, as found in the "flow of life." Even if one doesn't agree with Kracauer's philosophical precepts, one can hardly disregard Kracauer's having defined one of the basic tenants of film aesthetics: the preservation of the physical representation of objects, which film captures as a physical image, not an imaginary image as, for example, painting might. According to Kracauer, film is — and this definition seems to me to hold true for pornography — "the shimmering sky reflected in a dirty puddle."

that utopian plentitude is not to be found in a phallocentric generalization, but rather in the details of a quivering world of objects; and if, with their gaze, they manage to create, out of the shadow world, bodies of flesh and blood. Concrete criticism and reception of pornographic cinema, as demonstrated in interviews conducted with women by Marie-Françoise Hans and Gilles Lapouge,[43] indicate something more than merely women's insufficient understanding of the objective content of pornographic movies; the concrete approach also turns up a different kind of appropriation, one which is reflected in fragments. Even when women smash pornographic cinema into pieces, they bring more to light in these fragments than the whole can possibly offer: an alternative sexuality, which is as much a part of the radical feminist negative critique of pornographic movies as it is of the "uncritical," appropriating gaze of its female patrons.

This article was initially published in Lust und Elend: Das erotische Kino *(Munich and Lucerne, C.J. Bucher, 1981), a collection of essays on erotic film. In the period between its writing and its English-language publication, the increasingly liberal attitudes toward pornography that the essay discusses have been reversed by the coming to power of conservatives in both Germany and the US. Moreover, the changes in pornography's production, distribution, and reception brought about by the advent of the home video market also occurred during this intervening period. — ed.*

43. See note 40. Compare Gertrud Koch, "Von der weiblichen Sinnlichkeit und ihrer Lust und Unlust am Kino. Mutmassungen über vergangene Freuden und neue Hoffnungen," in Gabriele Dietze, ed., *Die Überwindung der Sprachlosigkeit*, Neuwied, Luchterhand, 1979, pp. 116–138. (Koch's theoretical essays on women's responses to film have been published in English in *Jump Cut*. See "Why Women Go to the Movies" [no. 27] and "Female Sensuality: Past Joys and Future Hopes" [no. 30]).

Is the Rectum a Grave?

LEO BERSANI

to the memory of Robert Hagopian

*These people have sex twenty to thirty times
a night. . . . A man comes along and goes
from anus to anus and in a single night will
act as a mosquito transferring infected cells
on his penis. When this is practised for a
year, with a man having three thousand
sexual intercourses, one can readily under-
stand this massive epidemic that is currently
upon us.*

—Professor Opendra Narayan,
The Johns Hopkins Medical School

*I will leave you wondering, with me, why it
is that when a woman spreads her legs for a
camera, she is assumed to be exercising free
will.*

—Catherine A. MacKinnon

Le moi *est haïssable.* . . .

—Pascal

There is a big secret about sex: most people don't like it. I don't have any
statistics to back this up, and I doubt (although since Kinsey there has been no
shortage of polls on sexual behavior) that any poll has ever been taken in which
those polled were simply asked, "Do you like sex?" Nor am I suggesting the need
for any such poll, since people would probably answer the question as if they

were being asked, "Do you often feel the need to have sex?" and one of my aims will be to suggest why these are two wholly different questions. I am, however, interested in my rather irresponsibly announced findings of our nonexistent poll because they strike me as helping to make intelligible a broader spectrum of views about sex and sexuality than perhaps any other single hypothesis. In saying that most people don't like sex, I'm not arguing (nor, obviously, am I denying) that the most rigidly moralistic dicta about sex hide smoldering volcanoes of repressed sexual desire. When you make this argument, you divide people into two camps, and at the same time you let it be known to which camp you belong. There are, you intimate, those who can't face their sexual desires (or, correlatively, the relation between those desires and their views of sex), and those who know that such a relation exists and who are presumably unafraid of their own sexual impulses. Rather, I'm interested in something else, something both camps have in common, which may be a certain *aversion*, an aversion that is not the same thing as a repression and that can coexist quite comfortably with, say, the most enthusiastic endorsement of polysexuality with multiple sex partners.

The aversion I refer to comes in both benign and malignant forms. Malignant aversion has recently had an extraordinary opportunity both to express (and to expose) itself, and, tragically, to demonstrate its power. I'm thinking of course of responses to AIDS — more specifically, of how a public health crisis has been treated like an unprecedented sexual threat. The signs and sense of this extraordinary displacement are the subject of an excellent book just published by Simon Watney, aptly entitled *Policing Desire*.[1] Watney's premise is that "AIDS is not only a medical crisis on an unparalleled scale, it involves a crisis of representation itself, a crisis over the entire framing of knowledge about the human body and its capacities for sexual pleasure" (p. 9). *Policing Desire* is both a casebook of generally appalling examples of this crisis (taken largely from government policy concerning AIDS, as well as from press and television coverage, in England and America) and, most interestingly, an attempt to account for the mechanisms by which a spectacle of suffering and death has unleashed and even appeared to legitimize the impulse to murder.

There is, first of all, the by now familiar, more or less transparent, and ever-increasing evidence of the displacement that Watney studies. At the highest levels of officialdom, there have been the criminal delays in funding research and treatment, the obsession with testing instead of curing, the singularly unqualified members of Reagan's (belatedly constituted) AIDS commission,[2] and the general

1. Simon Watney, *Policing Desire: Pornography, AIDS, and the Media*, Minneapolis, University of Minnesota Press, 1987. The present essay began as a review of this book; page references for all quotations from it are given in parentheses.
2. Comparing the authority and efficiency of Reagan's AIDS commission to the presidential commission on the Space Shuttle accident, Philip M. Boffey wrote: "The staff and resources available to the AIDS commission are far smaller than that provided the Challenger commission. The Challenger panel had a staff of 49, including 15 investigators and several other professionals, operating

tendency to think of AIDS as an epidemic of the future rather than a catastrophe of the present. Furthermore, "hospital policies," according to a New York City doctor quoted by Watney, "have more to do with other patients' fears than a concern for the health of AIDS patients" (p. 38). Doctors have refused to operate on people known to be infected with the HIV virus, schools have forbidden children with AIDS to attend classes, and recently citizens of the idyllically named town of Arcadia, Florida, set fire to the house of a family with three hemophiliac children apparently infected with HIV. Television and the press continue to confuse AIDS with the HIV virus, to speak of AIDS as if it were a venereal disease, and consequently to suggest that one catches it by being promiscuous. The effectiveness of the media as an educating force in the fight against AIDS can be measured by the results of a poll cited by Watney in which 56.8 percent of *News of the World* readers came out "in favour of the idea that 'AIDS carriers' should be 'sterilised and given treatment to curb their sexual appetite', with a mere fifty-one percent in favour of the total recriminalisation of homosexuality" (p. 141). Anecdotally, there is, at a presumably high level of professional expertise, the description of gay male sex — which I quote as an epigraph to this essay — offered to viewers of a BBC *Horizon* program by one Opendra Narayan of the Johns Hopkins Medical School (background in veterinary medicine). A less colorfully expressed but equally lurid account of gay sex was given by Justice Richard Wallach of New York State Supreme Court in Manhattan when, in issuing the temporary restraining order that closed the New St. Marks Baths, he noted: "What a bathhouse like this sets up is the orgiastic behavior of multiple partners, one after the other, where in five minutes you can have five contacts."[3] Finally, the story that gave me the greatest morbid delight appeared in the London *Sun* under the headline "I'd Shoot My Son if He Had AIDS, Says Vicar!" accompanied by a photograph of a man holding a rifle at a boy at pointblank range. The son, apparently more attuned to his father's penchant for violence than the respectable reverend himself, candidly added, "Sometimes I think he would like to shoot me whether I had AIDS or not" (quoted pp. 94–95).

All of this is, as I say, familiar ground, and I mention these few disparate items more or less at random simply as a reminder of where our analytical inquiry starts, *and* to suggest that, given the nature of that starting point, analysis, while necessary, may also be an indefensible luxury. I share Watney's inter-

on a budget of about $3 million, exclusive of staff salaries. Moreover, the Challenger commission could virtually order NASA to perform tests and analyses at its bidding, thus vastly multiplying the resources at its disposal. In contrast, the AIDS commission currently has only six employees, although it may well appoint 10 to 15 in all, according to Dr. Mayberry, the former chairman. Its budget is projected at $950,000, exclusive of staff salaries. Although the AIDS commission has been promised cooperation by all Federal agencies, it is in no position to compel them to do its work" (*New York Times*, October 16, 1987, p. 10).

3. "Court Orders Bath House in Village to Stay Shut," *New York Times*, December 28, 1985, p. 11.

THE SUN, Monday.

I'D SHOOT MY SON IF HE HAD AIDS, SAYS VICAR!

Shotgun message . . . the Rev Robert Simpson demonstrates his point about AIDS with the help of son Chris

A VICAR vowed yesterday that he would take his teenage son to a mountain and shoot him if the boy had the deadly disease AIDS.

And to make his point, the Rev Robert Simpson climbed a hill behind his church and aimed a shotgun at his 18-year-old son Chris.

Mr Simpson, 61, said: "Chris would not get closer to me than six yards. He would be a dead man.

"Even though he is my own child I would pull the trigger.

"And that would go for the rest of my family as well as strangers.

Threat

"AIDS is so serious—there is no possible cure."

Bewildered Chris said: "I don't think I would like Dad to shoot me, but I know there is no chance with AIDS.

"Sometimes I think he would like to shoot me, whether I had AIDS or not."

Another red hot **Sun** exclusive

He would pull trigger on rest of his family

By JOHN LISNERS

But Mr Simpson, married with three other children, believes the disease is threatening Britain.

He said he would ban all practising homosexuals, who are most at risk from AIDS, from taking normal communion.

"I will not let anyone risk the health of my parishioners by allowing them to drink wine from the same chalice," he added at his home in Barnston, Humberside.

Mr Simpson said that in six years' time, more than a million people in Britain would have AIDS. He went on:

● If it continues, it will be like the Black Plague. It could wipe out Britain. Family will be against family.

"Nobody will trust anyone else and gun law will prevail."

But the fighting vicar says he has nothing against gays.

"My criticism is of the unnatural acts they engage in."

Mr Simpson calls on the Government to repeal the law on homosexuality between consenting adults and prostitution — and to punish promiscuity.

● A TODDLER with AIDS has been banned from a kindergarten in Sydney, Australia, after biting her best friend.

pretive interests, but it is also important to say that, morally, the only *necessary* response to all of this is rage. "AIDS," Watney writes, "is effectively being used as a pretext throughout the West to 'justify' calls for increasing legislation and regulation of those who are considered to be socially unacceptable" (p. 3). And the unacceptable ones in the AIDS crisis are, of course, male homosexuals and IV drug users (many of the latter, are, as we know, poor blacks and Hispanics). Is it unjust to suggest that *News of the World* readers and the gun-toting British vicar are representative examples of the "general public's" response to AIDS? Are there more decent heterosexuals around, heterosexuals who don't awaken a passionate yearning not to share the same planet with them? Of course there are, but — and this is particularly true of England and the United States — *power* is in the hands of those who give every sign of being able to sympathize more with the murderous "moral" fury of the good vicar than with the agony of a terminal KS patient. It was, after all, the Justice Department of the United States that issued a legal opinion stating that employers could fire employees with AIDS if they had so much as the suspicion that the virus could be spread to other workers, regardless of medical evidence. It was the American Secretary of Health and Human Services who recently urged Congress to defer action on a bill that would ban discrimination against people infected with HIV, and who also argued against the need for a federal law guaranteeing the confidentiality of HIV antibody test results.

To deliver such opinions and arguments is of course not the same thing as pointing a gun at your son's head, but since, as it has often been said, the failure to guarantee confidentiality will discourage people from taking the test and thereby make it more difficult to control the spread of the virus, the only conclusion we can draw is that Secretary Otis R. Bowen finds it more important to have the names of those who test positive than to slow the spread of AIDS into the sacrosanct "general public." To put this schematically: having the information necessary to lock up homosexuals in quarantine camps may be a higher priority in the family-oriented Reagan Administration than saving the heterosexual members of American families from AIDS. Such a priority suggests a far more serious and ambitious passion for violence than what are after all the rather banal, rather normal son-killing impulses of the Reverend Robert Simpson. At the very least, such things as the Justice Department's near recommendation that people with AIDS be thrown out of their jobs suggest that if Edwin Meese would not hold a gun to the head of a man with AIDS, he might not find the murder of a gay man with AIDS (or without AIDS?) intolerable or unbearable. And this is precisely what can be said of millions of fine Germans who never participated in the murder of Jews (and of homosexuals), but who *failed to find the idea of the holocaust unbearable*. That was the more than sufficient measure of their collaboration, the message they sent to their Führer even before the holocaust began but when the *idea* of it was around, was, as it were, being tested for acceptability during the '30s by less violent but nonetheless virulent manifestations of anti-Se-

mitism, just as our leaders, by relegating the protection of people infected with HIV to local authorities, are telling those authorities that anything goes, that the federal government does not find the idea of camps — or perhaps worse — intolerable.

We can of course count on the more liberal press to editorialize against Meese's opinions and Bowen's urgings. We can, however, also count on that same press to give front-page coverage to the story of a presumably straight health worker testing positive for the HIV virus and — at least until recently — almost no coverage at all to complaints about the elephantine pace at which various drugs are being tested and approved for use against the virus. Try keeping up with AIDS research through TV and the press, and you'll remain fairly ignorant. You will, however, learn a great deal from the tube and from your daily newspaper about heterosexual anxieties. Instead of giving us sharp investigative reporting — on, say, *60 Minutes* — on research inefficiently divided among various uncoordinated and frequently competing private and public centers and agencies, or on the interests of pharmaceutical companies in helping to make available (or helping to keep unavailable) new antiviral treatments and in furthering or delaying the development of a vaccine,[4] TV treats us to nauseating processions of yuppie women announcing to the world that they will no longer put out for their yuppie boyfriends unless these boyfriends agree to use a condom. Thus hundreds of thousands of gay men and IV drug users, who have reason to think that they may be infected with HIV, or who know that they are (and who therefore live in daily terror that one of the familiar symptoms will show up), or who are already suffering from an AIDS-related illness, or who are dying from one of these illnesses, are asked to sympathize with all those yuppettes agonizing over whether they're going to risk losing a good fuck by taking the "unfeminine" initiative of interrupting the invading male in order to insist that

4. On November 15, 1987 — a month after I wrote this — *60 Minutes* did, in fact, devote a twenty-minute segment to AIDS. The report centered on Randy Shilts's recently published tale of responses and nonresponses — both in the government and in the gay community — to the AIDS crisis (*And the Band Played On*, New York, St. Martin's Press, 1987). The report presented a sympathetic view of Shilts's chronicle of the delayed and half-hearted efforts to deal with the epidemic, and also informed viewers that not a single official of the Reagan Administration would agree — or was authorized — to talk on *60 Minutes* on the politics of AIDS. However, nearly half of the segment — the first half — was devoted to the murderously naughty sexual habits of Gaetan Dugas, or "Patient Zero," the French-Canadian airline steward who, Shilts claims, was responsible for 40 of the first 200 cases of AIDS reported in the US. Thus the report was sensationalized from the very start with the most repugnant image of homosexuality imaginable: that of the irresponsible male tart who willfully spread the virus after he was diagnosed and warned of the dangers to others of his promiscuity. I won't go into — as of course *60 Minutes* (which provides the *best* political reporting on American network television) didn't go into — the phenomenon of Shilts himself as an overnight media star, and the relation between his stardom and his irreproachably respectable image, his longstanding willingness, indeed eagerness, to join the straights in being morally repelled by gay promiscuity. A good deal of his much admired "objectivity" as a reporter consists in his being as venomous toward those at an exceptionally high risk of becoming afflicted with AIDS (gay men) as toward the government officials who seem content to let them die.

he practice safe sex. In the face of all that, the shrillness of a Larry Kramer can seem like the simplest good sense. The danger of not exaggerating the hostility to homosexuality "legitimized" by AIDS is that, being "sensible," we may soon find ourselves in situations where exaggeration will be difficult, if not impossible. Kramer has recently said that "if AIDS does not spread out widely into the white non-drug-using heterosexual population, as it may or may not do, then the white non-drug-using population is going to hate us even more—for scaring them, for costing them a fucking fortune, for our 'lifestyle,' which they say caused this."[5] What a morbid, even horrendous, yet perl aps sensible suggestion: only when the "general public" is threatened can whatever the opposite of a general public is hope to get adequate attention and treatment.

Almost all the media coverage of AIDS has been aimed at the heterosexual groups now minimally at risk, as if the high-risk groups were not part of the audience. And in a sense, as Watney suggests, they're not. The media targets "an imaginary national family unit which is both white and heterosexual" (p. 43). This doesn't mean that most TV viewers in Europe and America are *not* white and heterosexual and part of a family. It does, however, mean, as Stuart Hall argues, that representation is very different from reflection: "It implies the active work of selecting and presenting, of structuring and shaping: not merely the transmitting of already-existing meaning, but the more active labour of *making things mean*" (quoted p. 124). TV doesn't make the family, but it makes the family *mean* in a certain way. That is, it makes an exceptionally sharp distinction between the family as a biological unit and as a cultural identity, and it does this by teaching us the attributes and attitudes by which people who thought they were already in a family actually only *begin to qualify* as belonging to a family. The great power of the media, and especially of television, is, as Watney writes, "its capacity to manufacture subjectivity itself" (p. 125), and in so doing to dictate the shape of an identity. The "general public" is at once an ideological construct and a moral prescription. Furthermore, the definition of the family *as an identity* is, inherently, an exclusionary process, and the cultural product has no obligation whatsoever to coincide exactly with its natural referent. Thus the family identity produced on American television is much more likely to include your dog than your homosexual brother or sister.

*

The peculiar exclusion of the principal sufferers in the AIDS crisis from the discourse about it has perhaps been felt most acutely by those gay men who, until recently, were able to feel that they could both be relatively open about their

5. Quoted from a speech at a rally in Boston preceding a gay pride celebration; reprinted in, among other publications, the San Francisco lesbian and gay newspaper *Coming Up!*, vol. 8, no. 11 (August 1987), p. 8.

sexuality and still be thought of as belonging to the "general public," to the mainstream of American life. Until the late '60s and '70s, it was of course difficult to manage both these things at the same time. There is, I believe, something salutary in our having to discover the illusory nature of that harmonious adjustment. We now know, or should know, that "gay men," as Watney writes, "are officially regarded, in our entirety, as a disposable constituency" (p. 137). "In our entirety" is crucial. While it would of course be obscene to claim that the comfortable life of a successful gay white businessman or doctor is as oppressed as that of a poverty-stricken black mother in one of our ghettoes, it is also true that the power of blacks *as a group* in the United States is much greater than that of homosexuals. Paradoxically, as we have recently seen in the vote of conservative Democratic senators from the South against the Bork nomination to the Supreme Court, blacks, by their sheer number and their increasing participation in the vote, are no longer a disposable constituency in those very states that have the most illustrious record of racial discrimination. This obviously doesn't mean that blacks have made it in white America. In fact, some political attention to black interests has a certain tactical utility: it softens the blow and obscures the perception of a persistent indifference to the always flourishing economic oppression of blacks. Nowhere is that oppression more visible, less disguised, than in such great American cities as New York, Philadelphia, Boston, and Chicago, although it is typical of the American genius for politically displaced thought that when white liberal New Yorkers (and white liberal columnists such as Anthony Lewis) think of racial oppression, they probably always have images of South Africa in mind.[6] Yet, some blacks are needed in positions of prominence or power, which is not at all true for gay people. Straights can very easily portray gays on TV, while whites generally can't get away with passing for black and are much less effective than blacks as models in TV ads for fast-food chains targeted at the millions of blacks who don't have the money to eat anywhere else. The more greasy the product, the more likely some black models will be allowed to make money promoting it. Also, the country obviously needs a Civil Rights Commission, and it just as obviously has to have blacks on that commission, while there is clearly no immediate prospect for a federal commission to protect and promote gay ways of life. There is no longer a rationale for the oppression of blacks in America, while AIDS has made the oppression of gay men seem like a moral imperative.

In short, a few blacks will always be saved from the appalling fate of most blacks in America, whereas there is no political need to save or protect any homosexuals at all. The country's discovery that Rock Hudson was gay changed

6. The black brothers and sisters on behalf of whom Berkeley students demonstrate in Sproul Plaza are always from Johannesburg, never from East Oakland, although signs posted on Oakland telephone poles and walls, which these same students have probably never seen, now announce — dare we have the optimism to say "ominously"? — "Oakland is South Africa."

nothing: nobody needs actors' votes (or even actors, for that matter) in the same way Southern senators need black votes to stay in power. In those very cities where white gay men could, at least for a few years, think of themselves as decidedly more white than black when it came to the distribution of privileges in America, cities where the increasingly effective ghettoization of blacks progresses unopposed, the gay men who have had as little trouble as their straight counterparts in accepting this demographic and economic segregation must now accept the fact that, unlike the underprivileged blacks all around them whom, like most other whites, they have developed a technique for not seeing, they—the gays—have no claims to power at all. Frequently on the side of power, but powerless; frequently affluent, but politically destitute; frequently articulate, but with *nothing but a moral argument*—not even recognized as a moral argument—to keep themselves in the protected white enclaves and out of the quarantine camps.

On the whole, gay men are no less socially ambitious, and, more often than we like to think, no less reactionary and racist than heterosexuals. To want sex with another man is not exactly a credential for political radicalism—a fact both recognized and denied by the gay liberation movement of the late '60s and early '70s. Recognized to the extent that gay liberation, as Jeffrey Weeks has put it, proposed "a radical separation . . . between homosexuality, which was about sexual preference, and 'gayness,' which was about a subversively political way of life."[7] And denied in that this very separation was proposed by homosexuals, who were thereby at least implicitly arguing for homosexuality itself as a privileged locus or point of departure for a political-sexual identity not "fixed" by, or in some way traceable to, a specific sexual orientation.[8] It is no secret that many homosexuals resisted, or were simply indifferent to, participation in "a subversively political way of life," to being, as it were, de-homosexualized in order to join what Watney describes as "a social identity defined not by notions of sexual 'essence', but in oppositional relation to the institutions and discourses of medicine, the law, education, housing and welfare policy, and so on" (p. 18). More precisely—and more to the point of an assumption that radical sex means or leads to radical politics—many gay men could, in the late '60s and early '70's, begin to feel comfortable about having "unusual" or radical ideas about what's OK in sex without modifying one bit their proud middle-class consciousness or even their racism. Men whose behavior at night at the San Francisco Cauldron or

7. Jeffrey Weeks, *Sexuality and Its Discontents: Meanings, Myths and Modern Sexualities*, London, Boston, and Henley, Routledge & Kegan Paul, 1985, p. 198.
8. Weeks has a good summary of that "neat ruse of history" by which the "intent of the early gay liberation movement . . . to disrupt fixed expectations that homosexuality was a peculiar condition or minority experience" was transformed, by less radical elements in the movement, into a fight for the legitimate claims of a newly recognized minority, "of what was now an almost 'ethnic' identity." Thus "the breakdown of roles, identities, and fixed expectations" was replaced by "the acceptance of homosexuality as a minority experience," an acceptance that "deliberately emphasizes the ghettoization of homosexual experience and by implication fails to interrogate the inevitability of heterosexuality" (*ibid.*, pp. 198–199).

the New York Mineshaft could win five-star approval from the (mostly straight) theoreticians of polysexuality had no problem being gay slumlords during the day and, in San Francisco for example, evicting from the Western Addition black families unable to pay the rents necessary to gentrify that neighborhood.

I don't mean that they *should* have had a problem about such combinations in their lives (although I obviously don't mean that they should have felt comfortable about being slumlords), but I do mean that there has been a lot of confusion about the real or potential political implications of homosexuality. Gay activists have tended to deduce those implications from the status of homosexuals as an oppressed minority rather than from what I think are (except perhaps in societies more physically repressive than ours has been) the more crucially operative continuities between political sympathies on the one hand and, on the other, fantasies connected with sexual pleasure. Thanks to a system of gliding emphases, gay activist rhetoric has even managed at times to suggest that a lust for other men's bodies is a by-product or a decision consequent upon political radicalism rather than a given point of departure for a whole range of political sympathies. While it is indisputably true that sexuality is always being politicized, the ways in which *having sex* politicizes are highly problematical. Right-wing politics can, for example, emerge quite easily from a sentimentalizing of the armed forces or of blue-collar workers, a sentimentalizing which can itself prolong and sublimate a marked sexual preference for sailors and telephone linemen.

In short, to put the matter polemically and even rather brutally, we have been telling a few lies — lies whose strategic value I fully understand, but which the AIDS crisis has rendered obsolescent. I do not, for example, find it helpful to suggest, as Dennis Altman has suggested, that gay baths created "a sort of Whitmanesque democracy, a desire to know and trust other men in a type of brotherhood far removed from the male bondage of rank, hierarchy, and competition that characterise much of the outside world."[9] Anyone who has ever spent one night in a gay bathhouse knows that it is (or was) one of the most ruthlessly ranked, hierarchized, and competitive environments imaginable. Your looks, muscles, hair distribution, size of cock, and shape of ass determined exactly how happy you were going to be during those few hours, and rejection, generally accompanied by two or three words at most, could be swift and brutal, with none of the civilizing hypocrisies with which we get rid of undesirables in the outside world. It has frequently been suggested in recent years that such things as the gay-macho style, the butch-fem lesbian couple, and gay and lesbian sado-masochism, far from expressing unqualified and uncontrollable complicities with a brutal and misogynous ideal of masculinity, or with the heterosexual couple permanently locked into a power structure of male sexual and social mastery

9. Dennis Altman, *The Homosexualization of America, The Americanization of the Homosexual*, New York, St. Martins Press, 1982, pp. 79–80.

over female sexual and social passivity, or, finally, with fascism, are in fact subversive parodies of the very formations and behaviors they appear to ape. Such claims, which have been the subject of lively and often intelligent debate, are, it seems to me, totally aberrant, even though, in terms probably unacceptable to their defenders, they can also—indeed, must also—be supported.

First of all, a distinction has to be made between the possible effects of these styles on the heterosexual world that provides the models on which they are based, and their significance for the lesbians and gay men who perform them. A sloganesque approach won't help us here. Even Weeks, whose work I admire, speaks of "the rise of the macho-style amongst gay men in the 1970s . . . as another episode in the ongoing 'semiotic guerilla warfare' waged by sexual outsiders against the dominant order," and he approvingly quotes Richard Dyer's suggestion that "by taking the signs of masculinity and eroticizing them in a blatantly homosexual context, much mischief is done to the security with which 'men' are defined in society, and by which their power is secured."[10] These remarks deny what I take to be wholly nonsubversive intentions by conflating them with problematically subversive effects. It is difficult to know how "much mischief" can be done by a style that straight men see—if indeed they see it at all—from a car window as they drive down Folsom Street. Their security as males with power may very well not be threatened at all by that scarcely traumatic sight, because nothing forces them to see any relation between the gay-macho style and their image of their own masculinity (indeed, the very exaggerations of that style make such denials seem plausible). It may, however, be true that to the extent that the heterosexual male more or less secretly admires or identifies with motorcycle masculinity, its adoption by faggots creates, as Weeks and Dyer suggest, a painful (if passing) crisis of representation. The gay-macho style simultaneously invents the oxymoronic expression "leather queen" and denies its oxymoronic status; for the macho straight man, leather queen is intelligible, indeed tolerable, only *as* an oxymoron—which is of course to say that it must remain unintelligible. Leather and muscles are defiled by a sexually feminized body, although—and this is where I have trouble with Weeks's contention that the gay-macho style "gnaws at the roots of a male heterosexual identity"[11]—the macho male's rejection of his representation by the leather queen can also be accompanied by the secret satisfaction of knowing that the leather queen, for all his despicable blasphemy, at least *intends* to pay worshipful tribute to the style and behavior he defiles. The very real potential for subversive confusion in the joining of female sexuality (I'll return to this in a moment) and the signifiers of machismo is dissipated once the heterosexual recognizes in the gay-macho style a *yearning* toward machismo, a yearning that, very conveniently

10. Weeks, p. 191.
11. *Ibid.*

for the heterosexual, makes of the leather queen's forbidding armor and warlike manners a *per*version rather than a *sub*version of real maleness.

Indeed, if we now turn to the significance of the macho-style for gay men, it would, I think, be accurate to say that this style gives rise to two reactions, both of which indicate a profound respect for machismo itself. One is the classic put-down: the butch number swaggering into a bar in a leather get-up opens his mouth and sounds like a pansy, takes you home, where the first thing you notice is the complete works of Jane Austen, gets you into bed, and—well, you know the rest. In short, the mockery of gay machismo is almost exclusively an internal affair, and it is based on the dark suspicion that you may not be getting the real article. The other reaction is, quite simply, sexual excitement. And this brings us back to the question not of the reflection or expression of politics in sex, but rather of the extremely obscure process by which sexual pleasure *generates* politics.

If licking someone's leather boots turns you (and him) on, neither of you is making a statement subversive of macho masculinity. Parody is an erotic turn-off, and all gay men know this. Much campy talk is parodistic, and while that may be fun at a dinner party, if you're out to make someone you turn off the camp. Male gay camp is, however, largely a parody of women, which, obviously, raises some other questions. The gay male parody of a certain femininity, which, as others have argued, may itself be an elaborate social construct, is both a way of giving vent to the hostility toward women that probably afflicts every male (and which male heterosexuals have of course expressed in infinitely nastier and more effective ways) *and* could also paradoxically be thought of as helping to deconstruct that image for women themselves. A certain type of homosexual camp speaks the truth of that femininity as mindless, asexual, and hysterically bitchy, thereby provoking, it would seem to me, a violently antimimetic reaction in any female spectator. The gay male bitch desublimates and desexualizes a type of femininity glamorized by movie stars, whom he thus lovingly assassinates with his style, even though the campy parodist may himself be quite stimulated by the hateful impulses inevitably included in his performance. The gay-macho style, on the other hand, is intended to excite others sexually, and the only reason that it continues to be adopted is that it frequently succeeds in doing so. (If, especially in its more extreme leather forms, it is so often taken up by older men, it is precisely because they count on it to supplement their diminished sexual appeal.)

The dead seriousness of the gay commitment to machismo (by which I of course don't mean that all gays share, or share unambivalently, this commitment) means that gay men run the risk of idealizing and feeling inferior to certain representations of masculinity on the basis of which they are in fact judged and condemned. The logic of homosexual desire includes the potential for a loving identification with the gay man's enemies. And that is a fantasy-luxury that is at once inevitable and no longer permissible. Inevitable because a sexual desire for men can't be merely a kind of culturally neutral attraction to a Platonic Idea of

the male body; the object of that desire necessarily includes a socially determined and socially pervasive definition of what it means to be a man. Arguments for the social construction of gender are by now familiar. But such arguments almost invariably have, for good political reasons, quite a different slant; they are didactically intended as demonstrations that the male and female identities proposed by a patriarchal and sexist culture are not to be taken for what they are proposed to be: ahistorical, essential, biologically determined identities. Without disagreeing with this argument, I want to make a different point, a point understandably less popular with those impatient to be freed of oppressive and degrading self-definitions. What I'm saying is that a gay man doesn't run the risk of loving his oppressor *only* in the ways in which blacks or Jews might more or less secretly collaborate with their oppressors — that is, as a consequence of the oppression, of that subtle corruption by which a slave can come to idolize power, to agree that he should be enslaved because he is enslaved, that he should be denied power because he doesn't have any. But blacks and Jews don't *become* blacks and Jews as a result of that internalization of an oppressive mentality, whereas that internalization is in part constitutive of male homosexual desire, which, like all sexual desire, combines and confuses impulses to appropriate and to identify with the object of desire. An authentic gay male political identity therefore implies a struggle not only against definitions of maleness and of homosexuality as they are reiterated and imposed in a heterosexist social discourse, but also against those very same definitions so seductively and so faithfully reflected by those (in large part culturally invented and elaborated) male bodies that we carry within us as permanently renewable sources of excitement.

*

There is, however, perhaps a way to explode this ideological body. I want to propose, instead of a denial of what I take to be important (if politically unpleasant) truths about male homosexual desire, an arduous representational discipline. The sexist power that defines maleness in most human cultures can easily survive social revolutions; what it perhaps cannot survive is a certain way of assuming, or taking on, that power. If, as Weeks puts it, gay men "gnaw at the roots of a male heterosexual identity," it is not because of the parodistic distance that they take from that identity, but rather because, from within their nearly mad identification with it, *they never cease to feel the appeal of its being violated.*

To understand this, it is perhaps necessary to accept the pain of embracing, at least provisionally, a homophobic representation of homosexuality. Let's return for a moment to the disturbed harmonies of Arcadia, Florida, and try to imagine what its citizens — especially those who set fire to the Rays' home — actually saw when they thought about or looked at the Rays' three boys. The persecuting of children or of heterosexuals with AIDS (or who have tested positive for HIV) is particularly striking in view of the popular description of

such people as "innocent victims." It is as if gay men's "guilt" were the real agent of infection. And what is it, exactly, that they are guilty of? Everyone agrees that the crime is sexual, and Watney, along with others, defines it as the imagined or real promiscuity for which gay men are so famous. He analyzes a story about AIDS by the science correspondent of the *Observer* in which the "major argument, supported by 'AIDS experts in America,' [is] against 'casual sexual encounters.'" A London doctor does, in the course of the article, urge the use of condoms in such encounters, but "the main problem . . . is evidently 'promiscuity', with issues about the kinds of sex one has pushed firmly into the backgound" (p. 35). But the kinds of sex involved, in quite a different sense, may in fact be crucial to the argument. Since the promiscuity here is homosexual promiscuity, we may, I think, legitimately wonder if what is being done is not as important as how many times it is being done. Or, more exactly, the act being represented may itself be associated with insatiable desire, with unstoppable sex.

Before being more explicit about this, I should acknowledge that the argument I wish to make is a highly speculative one, based primarily on the exclusion of the evidence that supports it. An important lesson to be learned from a study of the representation of AIDS is that the messages most likely to reach their destination are messages already there. Or, to put this in other terms, representations of AIDS have to be X-rayed for their fantasmatic logic; they document the comparative irrelevance of information in communication. Thus the expert medical opinions about how the virus cannot be transmitted (information that the college-educated mayor of Arcadia and his college-educated wife have heard and refer to) is at once rationally discussed and occulted. SueEllen Smith, the Arcadia mayor's wife, makes the unobjectionable comment that "there are too many unanswered questions about this disease," only to conclude that "if you are intelligent and listen and read about AIDS you get scared when it involves your own children, because you realize all the assurances are not based on solid evidence." In strictly rational terms, this can of course be easily answered: there are indeed "many unanswered questions" about AIDS, but the assurances given by medical authorities that there is no risk of the HIV virus being transmitted through casual contact among schoolchildren is in fact based on "solid evidence." But what interests me most about the *New York Times* interview with the Smiths from which I am quoting (they are a genial, even disarming couple: "I know I must sound like a country jerk saying this," remarks Mr. Smith, who really never does sound like a country bumpkin) is the evidence that they have in fact received and thoroughly assimilated quite different messages about AIDS. The mayor said that "a lot of local people, including himself, believed that powerful interests, principally the national gay leaders, had pressured the Government into refraining from taking legitimate steps to help contain the spread of AIDS."[12] Let's ignore the charming illusion that "national gay leaders" are

12. Jon Nordheimer, "To Neighbors of Shunned Family AIDS Fear Outweighs Sympathy," *New*

powerful enough to pressure the federal government into doing anything at all, and focus on the really extraordinary assumption that those belonging to the group hit most heavily by AIDS want nothing more intensely than to see it spread unchecked. In other words, those being killed are killers. Watney cites other versions of this idea of gay men as killers (their behavior is seen as the cause and source of AIDS), and he speaks of "a displaced desire to kill them all—the teeming deviant millions" (p. 82). Perhaps; but the presumed original desire to kill gays may itself be understandable only in terms of the fantasy for which it is offered as an explanation: homosexuals are killers. But what is it, exactly, that makes them killers?

The public discourse about homosexuals since the AIDS crisis began has a startling resemblance (which Watney notes in passing) to the representation of female prostitutes in the nineteenth century "as contaminated vessels, conveyancing 'female' venereal diseases to 'innocent' men" (pp. 33–34).[13] Some more light is retroactively thrown on those representations by the association of gay men's murderousness with what might be called the specific sexual heroics of their promiscuity. The accounts of Professor Narayan and Judge Wallach of gay men having sex twenty to thirty times a night, or once a minute, are much less descriptive of even the most promiscuous male sexuality than they are reminiscent of male fantasies about women's multiple orgasms. The Victorian representation of prostitutes may explicitly criminalize what is merely a consequence of a more profound or original guilt. Promiscuity is the social correlative of a sexuality physiologically grounded in the menacing phenomenon of the nonclimactic climax. Prostitutes publicize (indeed, sell) the inherent aptitude of women for uninterrupted sex. Conversely, the similarities between representations of female prostitutes and male homosexuals should help us to specify the exact form of sexual behavior being targeted, in representations of AIDS, as the criminal, fatal, and irresistibly repeated act. This is of course anal sex (with the potential for multiple orgasms having spread from the insertee to the insertor, who, in any case, may always switch roles and be the insertee for ten or fifteen of those thirty nightly encounters), and we must of course take into account the widespread confusion in heterosexual *and* homosexual men between fantasies of anal and vaginal sex. The realities of syphilis in the nineteenth century and of AIDS today "legitimate" a fantasy of female sexuality as intrinsically diseased; and promiscuity in this fantasy, far from merely increasing the risk of infection, is the *sign of infection*. Women and gay men spread their legs with an unquenchable appetite for destruction.[14] This is an image with extraordinary power; and if the good

York Times, August 31, 1987, p. A1.
13. Charles Bernheimer's excellent study of the representation of prostitution in nineteenth-century France will be published by Harvard University Press in 1988.
14. The fact that the rectum and the vagina, as far as the sexual transmission of the HIV virus is concerned, are privileged loci of infection is of course a major factor in this legitimizing process, but it hardly explains the fantasmatic force of the representations I have been discussing.

citizens of Arcadia, Florida, could chase from their midst an average, law-abiding family, it is, I would suggest, because in looking at three hemophiliac children they may have seen—that is, unconsciously represented—the infinitely more seductive and intolerable image of a grown man, legs high in the air, unable to refuse the suicidal ecstasy of being a woman.

But why "suicidal"? Recent studies have emphasized that even in societies in which, as John Boswell writes, "standards of beauty are often predicated on male archetypes" (he cites ancient Greece and the Muslim world) and, even more strikingly, in cultures that do not regard sexual relations between men as unnatural or sinful, the line is drawn at "passive" anal sex. In medieval Islam, for all its emphasis on homosexual eroticism, "the position of the 'insertee' is regarded as bizarre or even pathological," and while for the ancient Romans, "the distinction between roles approved for male citizens and others appears to center on the giving of seed (as opposed to the receiving of it) rather than on the more familiar modern active-passive division," to be anally penetrated was no less judged to be an "indecorous role for citizen males."[15] And in Volume II of *The History of Sexuality*, Michel Foucault has amply documented the acceptance (even glorification) *and* profound suspicion of homosexuality in ancient Greece. A general ethical polarity in Greek thought of self-domination and a helpless indulgence of appetites has, as one of its results, a structuring of sexual behavior in terms of activity and passivity, with a correlative rejection of the so-called passive role in sex. What the Athenians find hard to accept, Foucault writes, is the authority of a leader who as an adolescent was an "object of pleasure" for other men; there is a legal and moral incompatibility between sexual passivity and civic authority. The only "honorable" sexual behavior "consists in being active, in dominating, in penetrating, and in thereby exercising one's authority."[16]

In other words, the moral taboo on "passive" anal sex in ancient Athens is primarily formulated as a kind of hygienics of social power. *To be penetrated is to abdicate power.* I find it interesting that an almost identical argument—from, to be sure, a wholly different moral perspective—is being made today by certain feminists. In an interview published a few years ago in *Salmagundi*, Foucault said, "Men think that women can only experience pleasure in recognizing men as masters"[17]—a sentence one could easily take as coming from the pens of Catherine MacKinnon and Andrea Dworkin. These are unlikely bedfellows. In the same interview from which I have just quoted, Foucault more or less openly praises sado-masochistic practices for helping homosexual men (many of whom

15. John Boswell, "Revolutions, Universals and Sexual Categories," *Salmagundi*, nos. 58–59 (Fall 1982–Winter 1983), pp. 107, 102, and 110. See also Boswell's *Christianity, Social Tolerance and Homosexuality*, Chicago, University of Chicago Press, 1980.
16. Michel Foucault, *The Use of Pleasure*, trans. Robert Hurley, New York, Pantheon, 1985. This argument is made in chapter 4.
17. "Sexual Choice, Sexual Act: An Interview with Michel Foucault," *Salmagundi*, nos. 58–59 (Fall 1982–Winter 1983), p. 21.

share heterosexual men's fear of losing their authority by "being under another man in the act of love") to "alleviate" the "problem" of feeling "that the passive role is in some way demeaning."[18] MacKinnon and Dworkin, on the other hand, are of course not interested in making women feel comfortable about lying under men, but in changing the distribution of power both signified and constituted by men's insistence on being on top. They have had quite a bit of bad press, but I think that they make some very important points, points that—rather unexpectedly—can help us to understand the homophobic rage unleashed by AIDS. MacKinnon, for example, argues convincingly against the liberal distinction between violence and sex in rape and pornography, a distinction that, in addition to denying what should be the obvious fact that violence *is* sex for the rapist, has helped to make pornography sound merely sexy, and therefore to protect it. If she and Dworkin use the word *violence* to describe pornography that would normally be classified as nonviolent (for example, porno films with no explicit sado-masochism or scenes of rape), it is because they define as violent the power relation that they see inscribed in the sex acts pornography represents. Pornography, MacKinnon writes, "eroticizes hierarchy"; it "makes inequality into sex, which makes it enjoyable, and into gender, which makes it seem natural." Not too differently from Foucault (except, of course, for the rhetorical escalation), MacKinnon speaks of "the male supremacist definition of female sexuality as lust for self-annihilation." Pornography "institutionalizes the sexuality of male supremacy, fusing the eroticization of dominance and submission with the social construction of male and female."[19] It has been argued that even if such descriptions of pornography are accurate, they exaggerate its importance: MacKinnon and Dworkin see pornography as playing a major role in constructing a social reality of which it is really only a marginal reflection. In a sense—and especially if we consider the size of the steady audience for hard-core pornography—this is true. But the objection is also something of a cop-out, because if it is agreed that pornography eroticizes—and thereby celebrates—the violence of inequality itself (and the inequality doesn't have to be enforced with whips to be violent: the denial to blacks of equal seating privileges on public busses was rightly seen as a form of racial violence), then legal pornography is legalized violence.

Not only that: MacKinnon and Dworkin are really making a claim for the realism of pornography. That is, whether or not we think of it as constitutive (rather than merely reflective) of an eroticizing of the violence of inequality, pornography would be the most accurate description and the most effective promotion of that inequality. Pornography can't be dismissed as less significant socially than other more pervasive expressions of gender inequality (such as the

18. *Ibid.*
19. Catherine A. MacKinnon, *Feminism Unmodified: Discourses on Life and Law*, Cambridge, Massachusetts, and London, England, Harvard University Press, 1987, pp. 3 and 172.

abominable and innumerable TV ads in which, as part of a sales pitch for cough medicine and bran cereals, women are portrayed as slaves to the normal functioning of their men's bronchial tubes and large intestines), because only pornography tells us why the bran ad is effective: the slavishness of women is erotically thrilling. The ultimate logic of MacKinnon's and Dworkin's critique of pornography — and, however parodistic this may sound, I really don't mean it as a parody of their views — would be *the criminalization of sex itself until it has been reinvented.* For their most radical claim is not that pornography has a pernicious effect on otherwise nonpernicious sexual relations, but rather that so-called normal sexuality is already pornographic. "When violence against women is eroticized as it is in this culture," MacKinnon writes, "it is very difficult to say that there is a major distinction in the level of sex involved between being assaulted by a penis and being assaulted by a fist, especially when the perpetrator is a man."[20] Dworkin has taken this position to its logical extreme: the rejection of intercourse itself. If, as she argues, "there is a relationship between intercourse per se and the low-status of women," and if intercourse itself "is immune to reform," then there must be no more penetration. Dworkin announces: "In a world of male power — penile power — fucking is the essential sexual experience of power and potency and possession; fucking by mortal men, regular guys."[21] Almost everybody reading such sentences will find them crazy, although in a sense they merely develop the implicit *moral* logic of Foucault's more detached and therefore more respectable formulation: "Men think that women can only experience pleasure in recognizing men as masters." MacKinnon, Dworkin, and Foucault are all saying that a man lying on top of a woman assumes that what excites her is the idea of her body being invaded by a phallic master.

The argument against pornography remains, we could say, a liberal argument as long as it is assumed that pornography violates the natural conjunction of sex with tenderness and love. It becomes a much more disturbingly radical argument when the indictment against pornography is identified with an indictment against sex itself. This step is usually avoided by the positing of pornography's violence as either a sign of certain fantasies only marginally connected with an otherwise essentially healthy (caring, loving) form of human behavior, or the symptomatic by-product of social inequalities (more specifically, of the violence intrinsic to a phallocentric culture). In the first case, pornography can be defended as a therapeutic or at least cathartic outlet for those perhaps inescapable but happily marginal fantasies, and in the second case pornography becomes more or less irrelevant to a political struggle against more pervasive social structures of inequality (for once the latter are dismantled, their pornographic derivatives will have lost their raison d'être). MacKinnon and Dworkin, on the other hand, rightly assume the immense power of sexual images to orient our

20. *Ibid.*, p. 92.
21. Andrea Dworkin, *Intercourse*, New York, The Free Press, 1987, pp. 124, 137, 79.

imagination of how political power can and should be distributed and enjoyed, and, it seems to me, they just as rightly mistrust a certain intellectual sloppiness in the catharsis argument, a sloppiness that consists in avoiding the question of how a center of presumably wholesome sexuality ever produced those unsavory margins in the first place. Given the public discourse around the center of sexuality (a discourse obviously not unmotivated by a prescriptive ideology about sex), the margins may be the only place where the center becomes visible.

Furthermore, although their strategies and practical recommendations are unique, MacKinnon's and Dworkin's work could be inscribed within a more general enterprise, one which I will call the *redemptive reinvention of sex*. This enterprise cuts across the usual lines on the battlefield of sexual politics, and it includes not only the panicky denial of childhood sexuality, which is being "dignified" these days as a nearly psychotic anxiety about child abuse, but also the activities of such prominent lesbian proponents of S & M sex as Gayle Rubin and Pat Califia, neither of whom, to put it mildly, share the political agenda of MacKinnon and Dworkin. The immense body of contemporary discourse that argues for a radically revised imagination of the body's capacity for pleasure — a discursive project to which Foucault, Weeks, and Watney belong — has as its very condition of possibility a certain refusal of sex as we know it, and a frequently hidden agreement about sexuality as being, in its essence, less disturbing, less socially abrasive, less violent, more respectful of "personhood" than it has been in a male-dominated, phallocentric culture. The mystifications in gay activist discourse on gay male machismo belong to this enterprise; I will return to other signs of the gay participation in the redemptive sex project. For the moment, I want to argue, first of all, that MacKinnon and Dworkin have at least had the courage to be explicit about the profound *moral revulsion* with sex that inspires the entire project, whether its specific program be antipornography laws, a return to the arcadian mobilities of childhood polysexuality, the S & M battering of the body in order to multiply or redistribute its loci of pleasure, or, as we shall see, the comparatively anodine agenda (sponsored by Weeks and Watney) of sexual pluralism. Most of these programs have the slightly questionable virtue of being indubitably saner than Dworkin's lyrical tribute to the militant pastoralism of Joan of Arc's virginity, but the pastoral impulse lies behind them all. What bothers me about MacKinnon and Dworkin is not their analysis of sexuality, but rather the pastoralizing, redemptive intentions that support the analysis. That is — and this is the second, major point I wish to argue — they have given us the reasons why pornography must be multiplied and not abandoned, and, more profoundly, the reasons for defending, for cherishing the very sex they find so hateful. Their indictment of sex — their refusal to prettify it, to romanticize it, to maintain that fucking has anything to do with community or love — has had the immensely desirable effect of publicizing, of lucidly laying out for us, the inestimable value of sex as — at least in certain of its ineradicable aspects — anticommunal, antiegalitarian, antinurturing, antiloving.

Let's begin with some anatomical considerations. Human bodies are constructed in such a way that it is, or at least has been, almost impossible not to associate mastery and subordination with the experience of our most intense pleasures. This is first of all a question of positioning. If the penetration necessary (until recently . . .) for the reproduction of the species has most generally been accomplished by the man's getting on top of the woman, it is also true that being on top can never be just a question of a physical position — either for the person on top or for the one on the bottom. (And for the woman to get on top is just a way of letting her play the game of power for awhile, although — as the images of porn movies illustrate quite effectively — even on the bottom, the man can still concentrate his deceptively renounced aggressiveness in the thrusting movement of his penis.)[22] And, as this suggests, there is also, alas, the question of the penis. Unfortunately, the dismissal of penis envy as a male fantasy rather than a psychological truth about women doesn't really do anything to change the assumptions behind that fantasy. For the idea of penis envy describes how men feel about having one, and, as long as there are sexual relations between men and women, this can't help but be an important fact *for women*. In short, the social structures from which it is often said that the eroticizing of mastery and subordination derive are perhaps themselves derivations (and sublimations) of the indissociable nature of sexual pleasure and the exercise or loss of power. To say this is not to propose an "essentialist" view of sexuality. A reflection on the fantasmatic potential of the human body — the fantasies engendered by its sexual anatomy and the specific moves it makes in taking sexual pleasure — is not the same thing as an a priori, ideologically motivated, and prescriptive description of the essence of sexuality. Rather, I am saying that those effects of power which, as Foucault has argued, are inherent in the relational itself (they are immediately produced by "the divisions, inequalities and disequilibriums" inescapably present "in every relation from one point to another")[23] can perhaps most easily be exacerbated, and polarized into relations of mastery and subordination, in sex, and that this potential may be grounded in the shifting experience that every human being has of his or her body's capacity, or failure, to control and to manipulate the world beyond the self.

Needless to say, the ideological exploitations of this fantasmatic potential have a long and inglorious history. It is mainly a history of male power, and by now it has been richly documented by others. I want to approach this subject from a quite different angle, and to argue that a gravely dysfunctional aspect of what is, after all, the healthy pleasure we take in the operation of a coordinated

22. The idea of intercourse without thrusting was proposed by Shere Hite in *The Hite Report*, New York, Macmillan, 1976. Hite envisaged "a mutual lying together in pleasure, penis-in-vagina, vagina-covering-penis, with female orgasm providing much of the stimulation necessary for male orgasm" (p. 141).
23. Michel Foucault, *The History of Sexuality, vol. 1, An Introduction*, trans. Robert Hurley, New York, Vintage Books, 1980, pp. 93–94.

and strong physical organism is the temptation to deny the perhaps equally strong appeal of powerlessness, of the loss of control. Phallocentrism is exactly that: not primarily the denial of power to women (although it has obviously also led to that, everywhere and at all times), but above all the denial of the *value* of powerlessness in both men and women. I don't mean the value of gentleness, or nonaggressiveness, or even of passivity, but rather of a more radical disintegration and humiliation of the self. For there is finally, beyond the fantasies of bodily power and subordination that I have just discussed, a transgressing of that very polarity which, as Georges Bataille has proposed, may be the profound sense of both certain mystical experiences and of human sexuality. In making this suggestion I'm also thinking of Freud's somewhat reluctant speculation, especially in the *Three Essays on the Theory of Sexuality*, that sexual pleasure occurs whenever a certain threshold of intensity is reached, when the organization of the self is momentarily disturbed by sensations or affective processes somehow "beyond" those connected with psychic organization. Reluctant because, as I have argued elsewhere, this definition removes the sexual from the intersubjective, thereby depriving the teleological argument of the *Three Essays* of much of its weight. For on the one hand Freud outlines a normative sexual development that finds its natural goal in the post-Oedipal, genitally centered desire for someone of the opposite sex, while on the other hand he suggests not only the irrelevance of the object in sexuality but also, and even more radically, a shattering of the psychic structures themselves that are the precondition for the very establishment of a relation to others. In that curiously insistent, if intermittent, attempt to get at the "essence" of sexual pleasure—an attempt that punctuates and interrupts the more secure narrative outline of the history of desire in the *Three Essays*—Freud keeps returning to a line of speculation in which the opposition between pleasure and pain becomes irrelevant, in which the sexual emerges as the *jouissance* of exploded limits, as the ecstatic suffering into which the human organism momentarily plunges when it is "pressed" beyond a certain threshold of endurance. Sexuality, at least in the mode in which it is constituted, may be a tautology for masochism. In *The Freudian Body*, I proposed that this sexually constitutive masochism could even be thought of as an evolutionary conquest in the sense that it allows the infant to survive, indeed to find pleasure in, the painful and characteristically human period during which infants are shattered with stimuli for which they have not yet developed defensive or integrative ego structures. Masochism would be the psychical strategy that partially defeats a biologically dysfunctional process of maturation.[24] From this Freudian perspective, we might say that Bataille reformulates this self-shattering into the sexual as a kind of nonanecdotal self-debasement, as a masochism to which the melancholy of the

24. See Leo Bersani, *The Freudian Body: Psychoanalysis and Art*, New York, Columbia University Press, 1986, chapter II, especially pp. 38–39.

post-Oedipal superego's moral masochism is wholly alien, and in which, so to speak, the self is exuberantly discarded.[25]

The relevance of these speculations to the present discussion should be clear: the self which the sexual shatters provides the basis on which sexuality is associated with power. It is possible to think of the sexual as, precisely, moving between a hyperbolic sense of self and a loss of all consciousness of self. But sex as self-hyperbole is perhaps a repression of sex as self-abolition. It inaccurately replicates self-shattering as self-swelling, as psychic tumescence. If, as these words suggest, men are especially apt to "choose" this version of sexual pleasure, because their sexual equipment appears to invite by analogy, or at least to facilitate, the phallicizing of the ego, neither sex has exclusive rights to the practice of sex as self-hyperbole. For it is perhaps primarily *the degeneration of the sexual into a relationship that condemns sexuality to becoming a struggle for power.* As soon as persons are posited, the war begins. It is the self that swells with excitement at the idea of being on top, the self that makes of the inevitable play of thrusts and relinquishments in sex an argument for the natural authority of one sex over the other.

*

Far from apologizing for their promiscuity as a failure to maintain a loving relationship, far from welcoming the return to monogamy as a beneficent consequence of the horror of AIDS,[26] gay men should ceaselessly lament the practical necessity, now, of such relationships, should resist being drawn into mimicking the unrelenting warfare between men and women, which nothing has ever changed. Even among the most critical historians of sexuality and the most angry activists, there has been a good deal of defensiveness about what it means to be gay. Thus for Jeffrey Weeks the most distinctive aspect of gay life is its "radical pluralism."[27] Gayle Rubin echoes and extends this idea by arguing for a "theoretical as well as a sexual pluralism."[28] Watney repeats this theme with, it is true, some important nuances. He sees that the "new gay identity was constructed

25. Bataille called this experience "communication," in the sense that it breaks down the barriers that define individual organisms and keep them separate from one another. At the same time, however, like Freud he seems to be describing an experience in which the very terms of a communication are abolished. The term thus lends itself to a dangerous confusion if we allow it to keep any of its ordinary connotations.
26. It might be pointed out that, unless you met your lover many, many years ago and neither you nor he has had sex with anyone else since then, monogamy is not that safe anyway. Unsafe sex a few times a week with someone carrying the HIV virus is undoubtedly like having unsafe sex with several HIV positive strangers over the same period of time.
27. Weeks, p. 218.
28. Gayle Rubin, "Thinking Sex: Notes for a Radical Theory of the Politics of Sexuality," in Carole Vance, ed., *Pleasure and Danger: Exploring Female Sexuality*, Boston, London, Melbourne, and Henley, Routledge & Kegan Paul, 1984, p. 309.

through multiple encounters, shifts of sexual identification, actings out, cultural reinforcements, and a plurality of opportunity (at least in large urban areas) for desublimating the inherited sexual guilt of a grotesquely homophobic society," and therefore laments the "wholesale de-sexualisation of gay culture and experience" encouraged by the AIDS crisis (p. 18). He nonetheless dilutes what I take to be the specific menace of gay sex for that "grotesquely homophobic society" by insisting on the assertion of "the diversity of human sexuality in *all* its variant forms" as "perhaps the most radical aspect of gay culture" (p. 25). *Diversity* is the key word in his discussions of homosexuality, which he defines as "a fluctuating field of sexual desires and behaviour" (p. 103); it maximizes "the mutual erotic possibilities of the body, and that is why it is taboo" (p. 127).[29]

Much of this derives of course from the rhetoric of sexual liberation in the '60s and '70s, a rhetoric that received its most prestigious intellectual justification from Foucault's call — especially in the first volume of his *History of Sexuality* — for a reinventing of the body as a surface of multiple sources of pleasure. Such calls, for all their redemptive appeal, are, however, unnecessarily and even dangerously tame. The argument for diversity has the strategic advantage of making gays seem like passionate defenders of one of the primary values of mainstream liberal culture, but to make that argument is, it seems to me, to be disingenuous about the relation between homosexual behavior and the revulsion it inspires. The revulsion, it turns out, is all a big mistake: what we're really up to is pluralism and diversity, and getting buggered is just one moment in the practice of those laudable humanistic virtues. Foucault could be especially perverse about all this: challenging, provoking, and yet, in spite of his radical intentions, somewhat appeasing in his emphases. Thus in the *Salmagundi* interview to which I have already referred, after announcing that he will not "make use of a position of authority while [he is] being interviewed to traffic in opinions," he delivers himself of the highly idiosyncratic opinions, first of all, that "for a homosexual, the best moment of love is likely to be when the lover leaves in the taxi" ("the homosexual imagination is for the most part concerned with reminiscing about the act rather than anticipating [or, presumably, enjoying] it") and, secondly, that the rituals of gay S & M are "the counterpart of the medieval courts where strict rules of proprietary courtship were defined."[30] The first opinion is somewhat embarrassing; the second has a certain campy appeal. Both turn our attention away from the body — from the acts in which it engages, from

29. A frequently referred to study of gay men and women by the Institute for Sex Research founded by Alfred C. Kinsey concluded that "homosexual adults are a remarkably diverse group." See Alan P. Bell and Martin S. Weinberg, *Homosexualities: A Study of Diversity among Men and Women*, New York, Simon and Schuster, 1978, p. 217. One can hardly be unhappy with that conclusion in an "official" sociological study, but, needless to say, it tells us very little — and the tables about gay sexual preferences in the same study aren't much help here either — concerning fantasies of and about homosexuals.

30. "Sexual Choice, Sexual Act," pp. 11, 20.

the pain it inflicts and begs for—and directs our attention to the romances of memory and the idealizations of the presexual, the courting imagination. That turning away from sex is then projected onto heterosexuals as an explanation for their hostility. "I think that what most bothers those who are not gay about gayness is the gay life-style, not sex acts themselves," and, "It is the prospect that gays will create as yet unforseen kinds of relationships that many people cannot tolerate."[31] But what is "*the* gay life-style"? Is there one? Was Foucault's life-style the same as Rock Hudson's? More importantly, can a nonrepresentable form of relationship really be more threatening than the representation of a particular sexual act—especially when the sexual act is associated with women but performed by men and, as I have suggested, has the terrifying appeal of a loss of the ego, of a self-debasement?

We have been studying examples of what might be called a frenzied epic of displacements in the discourse on sexuality and on AIDS. The government talks more about testing than it does about research and treatment; it is more interested in those who may eventually be threatened by AIDS than in those already stricken with it. There are hospitals in which concern for the safety of those patients who have not been exposed to HIV takes precedence over caring for those suffering from an AIDS-related disease. Attention is turned away from the kinds of sex people practice to a moralistic discourse about promiscuity. The impulse to kill gays comes out as a rage against gay killers deliberately spreading a deadly virus among the "general public." The temptation of incest has become a national obsession with child abuse by day-care workers and teachers. Among intellectuals, the penis has been sanitized and sublimated into the phallus as the originary signifier; the body is to be read as a language. (Such distancing techniques, for which intellectuals have a natural aptitude, are of course not only sexual: the national disgrace of economic discrimination against blacks is buried in the self-righteous call for sanctions against Pretoria.) The wild excitement of fascistic S & M becomes a parody of fascism; gay males' idolatry of the cock is "raised" to the political dignity of "semiotic guerrilla warfare." The phallocentrism of gay cruising becomes diversity and pluralism; representation is displaced from the concrete practice of fellatio and sodomy to the melancholy charms of erotic memories and the cerebral tensions of courtship. There has even been the displacement of displacement itself. While it is undeniably right to speak—as, among others, Foucault, Weeks, and MacKinnon have spoken—of the ideologically organizing force of sexuality, it is quite another thing to suggest—as these writers also suggest—that sexual inequalities are predominantly, perhaps exclusively, displaced social inequalities. Weeks, for example, speaks of erotic tensions as a displacement of politically enforced positions of power and subordination,[32]

31. *Ibid.*, p. 22.
32. See Weeks, p. 44.

as if the sexual—involving as it does the source and locus of every individual's original experience of power (and of powerlessness) in the world: the human body—could somehow be conceived of apart from all relations of power, were, so to speak, belatedly contaminated by power from elsewhere.

Displacement is endemic to sexuality. I have written, especially in *Baudelaire and Freud*, about the mobility of desire, arguing that sexual desire initiates, indeed can be recognized by, an agitated fantasmatic activity in which original (but, from the start, unlocatable) objects of desire get lost in the images they generate. Desire, by its very nature, turns us away from its objects. If I refer critically to what I take to be a certain refusal to speak frankly about gay sex, it is not because I believe either that gay sex is reducible to one form of sexual activity or that the sexual itself is a stable, easily observable, or easily definable function. Rather, I have been trying to account for the murderous representations of homosexuals unleashed and "legitimized" by AIDS, and in so doing I have been struck by what might be called the aversion-displacements characteristic of both those representations and the gay responses to them. Watney is acutely aware of the displacements operative in "cases of extreme verbal or physical violence towards lesbians and gay men and, by extension, the whole topic of AIDS"; he speaks, for example, of "displaced misogyny," of "a hatred of what is projected as 'passive' and therefore female, sanctioned by the subject's heterosexual drives" (p. 50). But, as I argued earlier, implicit in both the violence toward gay men (and toward women, both gay and straight) *and* the rethinking among gays (and among women) of what being gay (and what being a woman) means is a certain agreement about what sex should be. The pastoralizing project could be thought of as informing even the most oppressive demonstrations of power. If, for example, we assume that the oppression of women disguises a fearful male response to the seductiveness of an image of sexual powerlessness, then the most brutal machismo is really part of a domesticating, even sanitizing project. The ambition of performing sex as *only* power is a salvational project, one designed to preserve us from a nightmare of ontological obscenity, from the prospect of a breakdown of the human itself in sexual intensities, from a kind of selfless communication with "lower" orders of being. The panic about child abuse is the most transparent case of this compulsion to rewrite sex. Adult sexuality is split in two: at once redeemed by its retroactive metamorphosis into the purity of an asexual childhood, and yet preserved in its most sinister forms by being projected onto the image of the criminal seducer of children. "Purity" is crucial here: behind the brutalities against gays, against women, and, in the denial of their very nature and autonomy, against children lies the pastoralizing, the idealizing, the redemptive project I have been speaking of. More exactly, the brutality is identical to the idealization.

The participation of the powerless themselves in this project is particularly disheartening. Gays and women must of course fight the violence directed against them, and I am certainly not arguing for a complicity with misogynist and

homophobic fantasies. I am, however, arguing against that form of complicity that consists in accepting, even finding new ways to defend, our culture's lies about sexuality. As if in secret agreement with the values that support misogynist images of female sexuality, women call for a permanent closing of the thighs in the name of chimerically nonviolent ideals of tenderness and nurturing; gays suddenly rediscover their lost bathhouses as laboratories of ethical liberalism, places where a culture's ill-practiced ideals of community and diversity are authentically put into practice. But what if we said, for example, not that it is wrong to think of so-called passive sex as "demeaning," but rather that *the value of sexuality itself is to demean the seriousness of efforts to redeem it?* "AIDS," Watney writes, "offers a new sign for the symbolic machinery of repression, making the rectum a grave" (p. 126). But if the rectum is the grave in which the masculine ideal (an ideal shared — differently — by men *and* women) of proud subjectivity is buried, then it should be celebrated for its very potential for death. Tragically, AIDS has literalized that potential as the certainty of biological death, and has therefore reinforced the heterosexual association of anal sex with a self-annihilation originally and primarily identified with the fantasmatic mystery of an insatiable, unstoppable female sexuality. It may, finally, be in the gay man's rectum that he demolishes his own perhaps otherwise uncontrollable identification with a murderous judgment against him.

That judgment, as I have been suggesting, is grounded in the sacrosanct value of selfhood, a value that accounts for human beings' extraordinary willingness to kill in order to protect the seriousness of their statements. The self is a practical convenience; promoted to the status of an ethical ideal, it is a sanction for violence.[33] If sexuality is socially dysfunctional in that it brings people together only to plunge them into a self-shattering and solipsistic *jouissance* that drives them apart, it could also be thought of as our primary hygienic practice of nonviolence. Gay men's "obsession" with sex, far from being denied, should be celebrated — not because of its communal virtues, not because of its subversive potential for parodies of machismo, not because it offers a model of genuine pluralism to a society that at once celebrates and punishes pluralism, but rather because it never stops re-presenting the internalized phallic male as an infinitely loved object of sacrifice. Male homosexuality advertises the risk of the sexual itself as the risk of self-dismissal, of *losing sight* of the self, and in so doing it proposes and dangerously represents *jouissance* as a mode of ascesis.

33. This sentence could be rephrased, and elaborated, in Freudian terms, as the difference between the ego's function of "reality-testing" and the superego's moral violence (against the ego).

The Freudian Subject:
From Politics to Ethics*

MIKKEL BORCH-JACOBSEN

translated by RICHARD MILLER and X. P. CALLAHAN

> *I have no conscience. The* Führer *is my conscience.*
>
> —Hermann Goering

> *When one has a sense of guilt after having committed a misdeed, and because of it, the feeling should more properly be called* remorse. *It relates only to a deed that has been done, and of course it presupposes that a* conscience—*the readiness to feel guilty—was already in existence before the deed took place. . . . But if the human sense of guilt goes back to the killing of the primal father, that was after all a case of "remorse." Are we to assume that at that time a sense of guilt was not, as we have presupposed, in existence before the deed? If not, where, in this case, did the remorse come from?*
>
> —Sigmund Freud

It may seem strange that I should approach the notion of "the subject in psychoanalysis" from the angle of politics and Freudian ethics. After all, isn't the main subject with which and with whom psychoanalysis deals the individual, in all his remarkable resistance to the ethical and political prescriptions of society? Why, then, should we consider this implacably singular subjectivity from the perspective of what—as political power or moral taboo—most often oppresses it, shackles it, or censures it? And isn't the most intractable feature of the desiring subject precisely its tendency to balk at being reduced to what Freud called the social "ego," the political

* This text was originally delivered as a lecture in June 1986 at the Psychoanalytic Institute in Paris, as part of a seminar on "The Subject in Psychoanalysis" conducted by Dr. Paulette Wilgowicz and Dr. Jean Gillibert. The Freud epigraph is from *Civilization and Its Discontents, SE* 21: 131–32.

"ego ideal," the moral "superego"? Perhaps. But we may still wonder why Freud himself, after having set up this great antagonism between desiring subjectivity and the various "egoic" forms of repression, kept on trying to reduce it by rooting the ego in the id, by analyzing the libidinal structure of political submission's link to the Ego Ideal–Father–Leader, and even by uncovering the Oedipal origin of the moral superego. The question remains, in other words, of whether what we stubbornly persist in calling the *subject* of desire or the *subject* of the unconscious is really so easy to distinguish from what we no less stubbornly persist in thinking of as its *Other*—that is, in no particular order, the symbolic Father, Law, prohibition, society, power. . . .

We might as well start by saying that nothing seems more fragile than this distinction. Indeed, everything in the Freudian text combines to suggest the identity—the identification—between the desiring subject and this "Other" that, at first glance, seems to be opposed to it and to alienate it, divide it, or separate it from itself. In short, and at the risk of encroaching on what will be my conclusion, I would say that the Freudian subject *is* the other, is *the same as* the other. This equation is obviously ambiguous, and so we must understand it carefully, literally, and in all its senses. It involves two very different notions or "versions" of the subject, according to the emphasis we put on it. Thus, either we understand that the Other is *the same as the subject*, in which case the subject, always identical to itself, triumphantly assimilates or absorbs that otherness into itself—this is the dialectical (and, in Freud, the *political*) version of this equation—or we understand the subject to be *the same as the Other*, and at once the equation becomes more difficult to understand, at once we no longer know who or what this subject is that a moment ago seemed so obvious, nor do we know whether we are still dealing with a subject at all. Strictly speaking, I am not sure that we should even contrast this second "version" with the first. To do so would be to force it into the dialectical mode, whereas here it is only a question of a different emphasis on the *same* notion. But that notion does exist in Freud, where it indicates what I will call, for lack of a better term, an *ethical* "beyond" of the subject. That, at least, is what I would like to demonstrate, convinced as I am that here, in this infinitesimal, imperceptible difference of emphasis, is where Freud's notion of the subject is ultimately played out. This is also an opportunity for me to extend and reinflect certain of my own previously published analyses of the "Freudian subject."[1]

But even before we turn to the Freudian wavering between a "politics" and an "ethics" of the subject, we surely ought to reach some agreement on the significance and implications of that little word *subject*, apparently so obvious and so transparent. Nowadays we speak easily—and I've just been doing so myself—about the "subject of desire," the "subject of the unconscious," the "subject of fantasy." But are we really sure that we always know what we are talking about? For example, do we know the history, the origin, the genealogy of this term? In this connection, it may be useful to recall that the word *subject* appears only rarely in Freud, who preferred to speak of the "ego," the "id," the "superego," or of the "conscious" and the "uncon-

1. Mikkel Borch-Jacobsen, *The Freudian Subject*, trans. Catherine Porter (Stanford: Stanford University Press, 1988).

scious." That is why it is best to recognize right away that the "subject" comes to us not from Freud himself but from a particular interpretation of his work: it is from Lacan and his "return to Freud," begun in the early 1950s, that we must date the intemperate use of the word *subject* by French psychoanalysts.

This word, as Jacques Lacan well knew, comes from philosophy. We could even say that it is the key term of Western metaphysics. The subject is not first of all the individual, much less the psychological ego to which we so often find it reduced today. Above all, the word *subject* designates the *hypokeimenon*, the "underlying" or "subjacent" goal of basic, founding philosophical inquiry, the quest for which is posed, supposed, and presupposed in Book VII of Aristotle's *Metaphysics*: τί τὸ ὄν, "What is being as being?" And, as Heidegger has shown, it is only to the extent that the ego, in the form of the Cartesian *cogito*, is heir to this ultimate basic position, the *ultimum subjectum*, that it becomes a "subject" in the strictly modern sense of the word. This should not be understood in the sense of an "egoist" or "subjectivist" determination of being, but rather in the sense that the whole of being is henceforth to be conceived on the initially Cartesian model of the autofoundation or autopositioning of a subject presenting itself to itself as consciousness, in representation or in the will, in labor or in desire, in the State or in the work of art.

Thus it was this modern (even strictly Cartesian, as we could show in some detail) concept of the subject that Lacan imported into psychoanalysis, with well-known success. Since others have already done so, I will not dwell here on the theoretical and institutional stakes of that operation, or on the complex conceptual "corruptions"[2] to which it has given rise. I would merely like to call attention, in a very preliminary way, to this operation's fundamentally equivocal character. No doubt this appeal to the philosopheme of the subject (as well as to several others: of "truth," "desire," "intersubjectivity," "dialectics," "alienation," and so on) permitted the restoration of the Freudian text's trenchant quality by ridding it from the outset of all psychologism and biologism. But why, finally, keep the word—and hence also the concept—*subject*, particularly when it was simultaneously being invested with all the Heideggerian de(con)struction of the "metaphysics of subjectivity"? Wasn't what was at stake, as Lacan indicated in "The Mirror Stage as Formative of the Function of the I," the removal of the psychoanalytic experience of the I from "any philosophy directly issuing from the *Cogito*"[3]? In fact, would Freud have deserved even a moment's philosophical attention if he had not contributed, and more than anyone else, to a challenging of the notion of subject *qua* ego present to itself in consciousness, in representation, or in the will?

Nor is this a matter of overlooking the fact that the Lacanian subject is the originally divided, split subject of desire, the profoundly subjected subject of the signifier and of language—and therefore nothing like the transcendental and absolute subject of the philosophers, nothing like the strong, autonomous ego of the ego psychologists, its pale successor. Nevertheless, this infinitely decentered subject,

2. Philippe Lacoue-Labarthe and Jean-Luc Nancy, *Le Titre de la lettre* (Paris: Galilée, 1973).
3. Jacques Lacan, *Ecrits: A Selection*, trans. Alan Sheridan (New York: Norton, 1977), p. 1.

reduced to the desire for that portion of itself that language simultaneously arouses and forbids it to rejoin, is still a subject. Lacan, in a very enigmatic way, retains the *word*—at least, that is, the pure position—of the subject. That this position, from the very fact of its being linguistic, is equivalent to a de-position or a disappearance makes little difference—and that much less difference if the subject's *fading* or *aphanisis* occurs through what we persist in describing as an autoenunciation. Emptied of substance, virtually null, the subject subsists in the *representation* of its lack, in the closed combinative of signifiers in which it stubbornly continues to represent itself, to present itself in front of itself, always disappearing but always reborn upon its disappearance.

It is not my intention here, however, to analyze this powerful ontology of the subject in any detail, this ontology that is all the more powerful for being presented in the guise of a kind of negative ego-logy eager to ambush the "imaginary ego" and the "subject supposed to know." If, getting ahead of analyses still to come, I have nevertheless referred briefly to this ontology, it is because it constitutes both the outer limit and the condition of possibility of any investigation into the "subject in psychoanalysis" today. Above all, I have referred to it because it seems to me that it functions as a veritable *symptom.* How, when we really think about it, are we to interpret this surprising resurfacing of the subject, right in the middle of a discourse devoted to a critique of the authority of consciousness and the illusions of the ego? Once Lacan's many conceptual "corruptions" of Freud's text had been taken into account, shouldn't we have asked what, even in Freud himself, had brought about this surreptitious restoration of the subject? Shouldn't we have suspected the radicality and depth of the break that Freud had made in the name of the unconscious? In short, shouldn't we indeed have returned to Freud, but to Freud's philosophical underpinnings, which alone hold the key to the confused fate of psychoanalysis in France?

That, it would be useless to deny, is what I attempted to do in *The Freudian Subject.* I thought that it might be timely, even urgent, to question whether, behind the apparently radical critique of consciousness and ego, the schema of the subject might not be silently continuing to govern the theory and the practice—which is also to say the politics—of psychoanalysis. In short, I wanted to know the extent to which the "fundamental concepts" of psychoanalysis might still be prisoners of, or might have escaped, the summons of their foundation—for that, in fact, is always what is involved in questions of "the subject."

And, indeed, once the question has been couched in these terms, isn't it obvious that by providing himself with an unconscious made up of "representations," "thoughts," "fantasies," "memory traces," Freud at the same time provided himself with a *subject* of representation, of imagination, of memory—in short, with the material for a new *cogito,* one simply conceived as more basic and more subjectival than the conscious ego? Let us not forget that the subject of the Moderns is first and foremost the subject of representation—we could even go so far as to say: subject *as* representation and representation *as* subject. Let us also remember that by

representing itself, posing itself in the mode of the *cogito me cogitare,* "with" all the representations it sets before itself, the Cartesian ego establishes itself as the basis of all possible truth, that is, as *subjectum* of the whole of being. Therefore, we must take care not to reduce the subject to the ego. In reality, the ego is nothing outside the *cogitatio* wherein it consciously presents itself to itself; and so it is the structure of representation as autorepresentation, rather than the ego, that actually should be called the true and ultimate subject.

In this sense, Freud, attempting to qualify this radical nonpresence to the self that he called "the unconscious," could hardly have chosen a more unfortunate term than *representation* (*Vorstellung*).[4] To speak of unconscious "representations" was obviously to signal the existence of something beyond the subject, since I—I the ego—was thus supposed to have thoughts (*Gedanken*) that could think without me. But, through an inevitable countercoup, this was also to reinstate another ego (still the same one, of course) in that beyond, since there must be a spectator of that "other scene"—since such representations require a subject that represents them to *itself* and thus represents *itself* in them. It is this powerful constraint that caused Lacan, with respect to the "other scene" of language, to write that "the signifier is what represents *the subject* for another signifier."[5] It is also what obliged Freud to *substantize*—that is, to subjectivize—the unconsciousness with which he was dealing into an "unconscious," or into an "id." The various topographies erected since the "Project for a Scientific Psychology" are testimony to this constant substratification of the psychoanalytic subject, ever more fragmented and shattered, yet ever more deeply driven back down to its own primordiality. In this sense, the multiplication of topographic agencies and "characters" does much more to presume than to contradict the unity and identity of the subject: the subject can be divided only because it is first of all *one* subject. Finally, neither the theme of a "primal repression" nor even that of an *après-coup* (*Nachträglichkeit*) would have been enough to make Freud question the stubbornly maintained notion of an already given subject, already present to (already subjacent to, underlying) its representations. In this respect, we can guess that the idea so dear to Emmanuel Lévinas—that of a "trauma" predating and seizing subjectivity before any representation or any memory, and therefore also before any repression—would have seemed completely nonsensical to Freud. The unconscious, for Freud, *is* memory, a storehouse of traces, inscriptions, remembrances, fantasies. And this memory, traumatic and fractural though it may be, must be underlaid, re-membered, by a subject to whom and in whom it represents itself.

Does it change anything to call this eternal subject of representation "desire"? Probably not. Desire, whether understood as libido, drive, or fantasmatic wish, is always a subject's desire, at least to the extent that it is characterized as desire for an object. And although such an object may be defined as a fantasmatic or even "fundamentally lost" object, nothing can prevent its being presented, prosaically, as

4. Michel Henry makes this point in his admirable and highly important *The Genealogy of Psychoanalysis*, trans. Douglas Brick (Stanford: Stanford University Press, 1993).
5. Jacques Lacan, "Radiophonie," *Scilicet* 2/3 (Paris: Le Seuil, 1970), p. 65.

an object for a subject, before a subject. The object, for us Moderns, is always the object of a representing (that is, as the German language so aptly puts it, the object of a "setting-before," of a *Vorstellen*), and this notion is in no way challenged by our understanding the object as the object of a desire, a libido, or a drive. We need only wonder why, in Freud, the drive is inaccessible except through its objects: it is because Freud conceived of the drive only as *represented* to or before the psyche—that is, to or before the subject. The subject is necessarily presumed to underlie the object in which it presents its own pleasure or enjoyment before itself, and in which it simultaneously presents *itself* before itself. From this perspective, by conceiving of the object of desire as that "part" that language and representation deduct from the subject, Lacan merely confirmed the fundamentally autorepresentational structure of desire. The so-called object *a* eludes the subject so thoroughly only because the subject represented itself in it to begin with: thus the object subsists—breast or feces, gaze or voice—in the representation of its absence, of its lack-of-being-itself.

Therefore, this objectival conception of desire in Freud is not, I believe, where we should go looking for material to elaborate an in-depth critique of the schema of the subject. But that is not quite true for another, much more problematic aspect of Freud's theory of desire: the aspect that deals with the desire of the ego—and here we should take this possessive phrase in both its senses, the subjective and the objective. Indeed, we know that very early on Freud felt constrained to make room, alongside the desire for the object (the desire that he discerned in sexuality), for an "egoist" type of desire, a desire-to-be-oneself or desire-to-be-an-ego, which at first he called "egoistic" and later called "narcissistic," finally fusing it with the process of identification. Without retracing the various steps of Freud's discovery, through the themes of the "egoism" of dreams and fantasies, homosexuality, paranoia, or passionate love, I must stress this discovery's importance, for the implications of this shift in Freud's interest are often not fully appreciated. Indeed, to emphasize the violent passion that the ego devotes to itself (or that devotes the ego to itself) was not merely to overturn the initially objectival definition of desire by forever tilting all subsequent investigations toward the repressing "ego"—the ego that, as Freud admitted in a letter to Jung,[6] he had not studied enough. It was also—obscurely, problematically—to challenge the notion of the subject of desire, the same subject of desiring representation that had been so tenaciously presumed until then.

What is it all about, this desire that Freud called "egoist" or "narcissistic"? First of all, it is about being an "I," a "self"—that is, a subject: closed upon itself, free of all bonds, absolute in this sense. But if I *desire* to be (an) I, if I *desire* myself, then according to the most elementary logic, it must be because that is not what I am. Thus this singular desire is not, on the whole, the desire of any subject. When Freud wrote, for example, that the ideal of the narcissistic ego is "what we would like to be,"[7] or, with respect to identification, that it is an "emotional tie with another person"

6. Sigmund Freud and C. G. Jung, *The Freud/Jung Letters*, ed. William McGuire, trans. Ralph Manheim (Princeton, N.J.: Princeton University Press, 1974), p. 278.
7. *On Narcissism: An Introduction, SE* 14: 90.

one desires *to be* (by contrast with the object one desires *to have*),[8] he was clearly emphasizing the abyssal nature of narcissistic passion. This ego-being (or ego-ness, as we could also call it, the essence and foundation of its *ego* identity) is not in me: it is elsewhere, in that other—always that *alter ego*—that fascinates me, in which I love myself, in which I kill myself. *Ergo,* I am that other: *ego sum alterum.* Or, better yet, a more Freudian version of this other and very different *cogito*: "I am the breast."[9]

By the strangest yet most logical of paradoxes, Freud's attention to the ego's narcissism led to the question of the other, of others. The question was to haunt him from that point on, all the more so in that this "other"—model or rival, homosexual figure or persecutor—seemed to be ever more identical to the ego, to the point where their opposition itself might disappear. That is probably why the major texts of the second topography inextricably blended "analysis of the ego" with analysis of culture and the social tie: when the other is no longer an object, an *Objekt*, there is a need to attend to nonerotic, "social," relationships with others; and, inversely, when the ego is no longer a subject, there is a need to inscribe this "sociality" into the ego itself, in the form of identification, superego, and so on. Thus, whether the ego was originally identified with others or others were first assimilated to the ego, everything converged, in many ways, to undermine the mutual posing of subject and object, which is also to say the posing of the subject of representation. And that is certainly the ultimate implication of the whole discourse on narcissism, on primary identification, and on primary incorporation: if I am the other, then *I no longer represent him to myself* since the exteriority where he might have proposed himself to me, as model or object, as *Vor-bild* or *Ob-jekt*, has vanished into thin air. And, at the same time, I have become unable to *represent myself,* to present myself to myself in front of myself: the other that I am no longer exists, has never been in front of me, since I identified myself with him from the start, since I assimilated, consumed, incorporated him from the very beginning.

This—which is nothing other than what was formerly the "subject of desire"—is difficult to imagine, of course, and in any case is impossible to *represent.* But wasn't Freud moving in that direction, toward that unrepresentable "point of otherness," when he stated, for example, that the ego emerges through "primary identification," adding that this primitive relationship to the object is immediately equivalent to the incorporation that destroys it? Or when, using such various terms as "primary narcissism," "animism," "omnipotence of thought," and "magic," he attempted to describe a type of mental functioning that knows no distinction between ego and other, subject and object, desire and its fulfillment? And isn't it mainly here, in this fundamentally unrepresentable thought, this thought of no subject, that we ought to be seeking the ever-elusive "unconscious"?

But, as I have just said, this is difficult to imagine, and I must immediately add that Freud himself had great trouble confronting this difficulty. Freud most often interpreted this narcissism, this desire-to-be-oneself that so radically upset

8. *Group Psychology, SE* 18: 105.
9. "Findings, Ideas, Problems," *SE* 23: 299.

any idea of a "self," as a desire of oneself *by oneself*—in short, as a subject's autoaffirmation, autopositioning, or circular autoconception. We need only recall the fascinating figures, entirely closed in on themselves, of the narcissistic Child and Woman in *On Narcissism: An Introduction*, or the theory of primary narcissism's secondary "granting" to and "withdrawal" from objects: everything originates from and returns to Narcissus, who loses himself in objects only to rediscover and represent himself in them as in a mirror, specularly, speculatively. It is this rediscovery of the narcissistic ego in the specular other that Lacan described with the term "imaginary," doing so, of course, in order to expose, virulently, the trap and the illusion. But by keeping the *image* of the ego, if not the ego itself, he too, with all the appearance of a reversal, allowed himself to be caught by the autorepresentative structure of narcissistic desire. Let the ego imagine itself outside itself, or image itself before itself in the mirror that the other holds up: in no way does this infringe on its autopositioning, since the domain of that auto-*ob*-positioning is precisely here. . . . As for branding the "alienation" of the narcissistic ego in the imaginary "small other," that merely helps confirm the deeply dialectical character of the process described in this way. The ego, in the Lacan of "The Mirror Stage" as in the Freud of *On Narcissism*, continues to *represent* itself—and therefore, inevitably, to represent *itself*—in the specular reflection wherein it loves and desires itself.

Therefore, I believe that these Freudian or Lacanian interpretations of narcissism must themselves be interpreted. They interpret narcissistic desire along the same lines as desire; they subscribe to a certain autointerpretation of desire, whereas desire is precisely a *desire to be a subject*, a desire to be oneself for oneself within an unalienated identity and an unalienated autonomy. In this sense, the proposition of narcissism does more than display, sometimes crudely and sometimes more subtly, the fascinated submission of psychoanalysts where the paradigm of the subject is concerned. It bears equal witness, as if reciprocally, to this paradigm's narcissistic character. Therefore, it is one and the same thing to say, as I have on various occasions, that psychoanalysis in its essence is deeply narcissistic and that it reinstates, sometimes in the form of a caricature, the old but always new question of the subject.

*

This reinstatement is probably most flagrant, most "massive," in Freud's so-called political or sociological texts. Moreover, this is all the more striking in that Freud's investigation into culture and the social tie corresponded at first, as I have said, to the constraining movement that tilted the question of the narcissistic ego toward the question of the other who inwardly haunts and obsesses it. In fact, the great 1921 "political" text *Group Psychology and the Analysis of the Ego* first appeared under the rubric of the *Andere* (the *Other*):

> In the individual's mental life, the other is invariabley involved as a model,
> . . . as a helper, as an opponent; and from the very first, individual
> psychology . . . is at the same time social psychology as well.[10]

This admirable statement, by inscribing the other into the ego in this way, actually seems to contain, in embryo, a whole nonsubjectival theory of the "subject" and of the "social relationship." Nevertheless, a reading of *Group Psychology* suffices to show that the theory remains in embryonic form, stifled as it is by the whole question of the political Subject.

Space does not permit a detailed description of the extraordinarily complex route traced by that essay, but we can say that Freud, in his attempt to take account of the social relationship, ultimately never stopped assuming a *subject* of the relationship, whether an "individual" subject or a supra-individual, political subjectivity. Indeed, on the one hand, his analysis took desire as its point of departure, love or the libido of individuals, and these individuals were consequently assumed to preexist the different erotico-objectival relationships that link them to one another. And, on the other hand, once Freud recognized the fundamental fact that all subjectivity and all individual desire vanish in crowds, his analysis ended up with a sort of political super-Subject, in the dual form of the narcissistic Chief and the Mass bonded by love for this Chief. Society, Freud said, is a unanimous "mass" whose members have all put the same "object" (the "leader," the *Führer*) in the place of the ego ideal and who identify with one another as a result.

To say this is first of all to say that society—any society—is essentially political, since it is wholly dependent on the figure of a Chief, of a sovereign head in which it represents itself and without which it would simply fall apart. But we must then go on to say that society, any society, is fundamentally *totalitarian*—not, I hasten to add, because state coercion or tyrannical violence are somehow essential to this conception; these traits are in no way exclusive to totalitarian societies, and Freud clearly said that the reign of the *Führer* rests above all on the fiction of his love. Rather, if society for Freud is totalitarian in the strictest sense, it is because it presents itself as an integrally political totality, as a *totale Staat*, knowing no divisions except the one—minimal, and solely intended to relate the social body to itself—between the beloved Chief and his loving subjects. This is further borne out by the speculative biology underlying the description in *Group Psychology* because, on the grounds of "union" and erotic *Bindung*, it tends to turn society into an actual organism, a real body politic. And, as Claude Lefort has shown, expanding on work by Ernst Kantorowicz,[11] this is the totalitarian fantasy par excellence. It is the profoundly narcissistic fantasy of a single, homogeneous body that knows no exteriority or alterity other than that of its own relationship to itself. It is therefore the fantasy, the autorepresentation, of a subject: society, for Freud, is a compact mass, and this mass forms a complete *body* with the Chief-Subject that *incarnates* it.

10. *Group Psychology*, *SE* 18: 69.
11. Claude Lefort, "L'Image du corps et le totalitarisme," in *L'Invention démocratique* (Paris: Fayard, 1981).

There is certainly no point in saying that this description is false. History has confirmed it with too many examples for us to doubt its accuracy. Moreover, from this standpoint, I am completely prepared to recognize, with Serge Moscovici,[12] the exceptional importance of Freudian "group psychology" for any understanding of the political and social events of our time—but only if we also recognize that Freud did not so much analyze this totalitarian fantasy as subscribe to it. Contrary to what he is sometimes reported to have said (as in the thesis, or myth, of Lacan,[13] among others), Freud never *criticized* "group psychology" at all, convinced as he was that here was to be found the very essence of society. Nor did he ever question the primacy of the Chief, and he went so far as to write the following dreadful passage to Einstein:

> One instance of the innate and ineradicable inequality of men is their tendency to fall into the two classes of leaders [*Führer*] and followers. The latter constitute the vast majority; they stand in need of an authority which will make decisions for them and to which they for the most part offer an unqualified submission.[14]

We must carefully examine what this exacerbation of the role of the mass's "leader" corresponds to, historically and theoretically. It corresponds—in Freud as in Gustave Le Bon or Gabriel Tarde, in the fascist ideologues as in the Georges Bataille

12. Serge Moscovici, *L'Age des foules* (Paris: Fayard, 1981).
13. Jacques Lacan, *Ecrits* (Paris: Le Seuil, 1966), pp. 474–75: "For our purposes, we must begin with the remark—never made, to our knowledge—that Freud started the I[nternational] A[ssociation of] P[sy-choanalysis] on its path ten years before he became interested, in *Group Psychology and the Analysis of the Ego*, in the church and the army, in the mechanisms through which an organic group participates in the crowd, an exploration whose clear partiality can be justified by the basic discovery of the identification of each individual's ego with a shared ideal image, whose mirage is supported by the personality of the chief. This was a sensational discovery, made before the fascist organizations rendered it patently obvious. *Had he been made aware earlier of its effects* [emphasis added], Freud probably would have wondered about the field left open to dominance by the function of the boss or caïd in any organization," etc. This remark gives rise in turn to several others: (1) Freud's "basic discovery" in *Group Psychology* is not at all that egos are united in the same *identification* with the ego's Ideal-Chief, because he states, on the contrary, that they mutually identify because of their shared *love* for the "Object" that is set up "in place of" the Ego ideal. In fact, Lacan's "remark" supposes a reinterpretation of Freud's thesis, a reinterpretation probably dictated by implicit reflection on the fascist phenomenon. (2) Freud's "sensational discovery" "anticipates" the fas-cist mass organizations (as Georges Bataille was to note as early as 1933; cf. his *Oeuvres complètes* I [Paris: Gallimard, 1970,] p. 356) only because it broadly confirms a description of "crowd psychology," such as Gustave Le Bon's, that fascist ideologues, led by Hitler and Mussolini, were to exploit deliberately (cf. R. A. Nye, *The Origins of Crowd Psychology: Gustave Le Bon and the Crisis of Mass Democracy in the Third Republic* [London: Sage. 1975], pp. 178–79; see also Moscovici, *L'Age*, pp. 92–95). (3) "Made aware of its effects" in 1921, Freud felt absolutely no need to reorganize the analytical community on another model—and for good reason: as Lacan himself noted in the earlier version of his text (published as an appendix to *Ecrits*, p. 487), Freud stressed his own function as Chief-Father all the more for never once doubting the basic "inadequacies" of his "band" of disciples. The masses need a leader—isn't that what all the great "leaders" of this century have contended, publicly or privately, from Lenin to Mao by way of Mussolini or Tito? And isn't this what Lacan himself is also saying, in his own way, when he heaps contempt on those attending his seminar, or when he signs contributions to *Scilicet* with his name alone? In fact, neither Freud nor Lacan did anything at all to deal with what Lacan called "the obscenity of the social tie" or to substitute another one for it, one "cleansed of any group needs" ("L'Etourdit," in *Scilicet* 4 [1973], p. 31).
14. "Why War?" *SE* 22: 212.

of the 1930s—to the following observation, variously appreciated and exploited by these authors, but in the end always the same: modern man, the self-styled *Homo democraticus,* is in reality the man in the street, communal mass man, the man of the melting pot. And this anonymous man, brutally revealed by the retreat of the great transcendent political and religious systems, is no longer a subject: he is the "man without qualities," without his own identity, the deeply panicked, deindividualized, suggestible, hypnotizable (or "media-tized," as we might say today) being of the lonely crowd. From now on, only an absolute Chief—"prestigious" and "charismatic" for Le Bon and Max Weber, "*sovereign*" and "*heterogeneous*" for Bataille—can reembody, give substantial consistency and subjective unity to, this magma of unanchored identifications or imitations. Thus the figure of the Chief-Subject, in theoretical texts as in the historical reality that they inspire, looms all the more brutally for its warding off of what is perceived as a radical desubjectification and alienation.

On this score, it is probably not enough to say, as we so readily do nowadays, that the totalitarianisms of the twentieth century have fulfilled the modern logic of the Subject in a political sense, filling in the outline of its total ab-solution and immanence. We must add that our century's totalitarianisms have fulfilled this logic all the more successfully for having lucidly and cynically confronted the de-liaison and dissolution of subjects that this outline implied all along. In short, the totalitarian Chief can impose the fiction or the figure of his absolute subjectivity all the more easily because he knows very well that it is a myth, and that before him is only a mass of non-subjects. In this connection, it is no accident that these totalitarianisms have seen the flourishing of so many "new mythologies" and "personality cults," or that Bataille and his friends dreamed, lucidly and naïvely, of opposing fascism with an *other,* "heterogeneous" and "headless," mythology. Once the masses have no identity of their own, only a myth can provide them with one, by offering them a fiction in which they can once again depict their unity—in which they can depict and present themselves as Subject. And *the Subject,* from now on, *is a myth* because we know very well that we are dealing with a fiction (with a deus ex machina), but also because in this fiction the subject is once again depicted and reinstated—"massively."

We find the same totalitarian myth of the Subject in *Group Psychology,* here again at the far reaches of an investigation into the nonpresence to oneself implied by being-in-society. Where social identifications are concerned, Freud, in the same way that he emphasized the radical alteration of so-called subjects assembled into crowds and stressed the primitive character of this "group psychology," also restored, reinstated in spite of everything, the primacy and principality of an absolute Subject. Recall that the investigation of *Group Psychology* concludes with an allusion to the "absolutely narcissistic" Father-Chief-Hypnotist. This theme of the Father's "narcissism" and jealous "egoism"[15] is decisive here, too, since it is very clear that

15. *Group Psychology, SE* 18: 123: "He, at the very beginning of the history of mankind, was the 'superman' whom Nietzsche only expected from the future. Even today the members of a group stand in need of the illusion that they are equally and justly loved by their leader (Führer), but the leader himself need love no one else; he may be of a masterful nature, absolutely narcissistic, self-confident and independent."

only because the Chief allies himself with no one (with no "object," as Freud said) can he offer himself as the sole object of the admiring, terrified love of the tribe—in short, establish community where before there was only a chaos of reciprocal identifications and suggestions. In other words, everything becomes invested in this fascinating figure of a Narcissus or an Egocrat sprung up from nowhere—and hence the difficult question of a social relationship or tie that predates the ego is freshly disposed of, in favor of a "scientific myth" that is simultaneously the myth of the Subject's origin and the myth of the founding of the Political. The Subject thereby proclaims itself Chief, and the Chief is self-engendered as Subject.

*

It goes without saying that we must still examine this myth, as much for its enigmatic resemblance to the totalitarian myth as for its strange reinstatement of the figure of the Subject. Does it suffice, however, to say that we are dealing here with a *myth*? I think not, and I want especially to emphasize this point because it was just such an exposure of the myth that preoccupied me in *The Freudian Subject.* The very crudeness, it seemed to me then, with which Freud proposed a Subject at the origin of the Political signaled the failure of his attempt to establish a foundation, an *instauratio.* And, in a way, I enjoyed showing how he had failed: I was satisfied simply to draw attention to Freud's inability to establish the social tie—the relationship with others—except by assuming, in mythic form, a Subject founded in and by itself. In short, I was satisfied merely to bring up the unfounded, abyssal nature itself of this constant, circular assumption of a Subject-Foundation. But how, in that very abyss—the abyss of relationship—could one find the means for a non-"subjective" notion of the Political, a non-"political" notion of the Subject? Weren't we, in the deeply ambiguous gesture of our modernity, condemned to go sifting through lack-of-foundation, obliteration-of-subject, loss-of-origin, collapse-of-principle? And as for this "an-archy" of the masses that the myth of the Chief-Subject, as a last resort, was warding off, would it allow us a different, more essential understanding of "archy," of the beginnings, the commandment?

That, ultimately, is the formidable problem raised by the Freudian—and, more generally, the totalitarian—myth of the Chief-Subject. Once its mythic character has been noted, the source of its incredible *authority* remains to be understood. Like it or not, the myth works: everywhere, the masses gather around a Chief or a Party supposed to represent them, everywhere they convulsively sacrifice themselves at the altar of the Chief's or the Party's myth. And, as we have seen, this myth works all the better for assuming the radical absence of the same political subjectivity that it sets up. Where, then, does the myth get its terrible founding power? On what grounds does it authorize itself, since its authority does not come from a subject, since—and here, precisely, is totalitarianism's cynical lesson—the subject is a myth? Today, we can no longer avoid this question, especially because it is only through this question that we will be able—perhaps—to find the means of resisting what

from now on will be the global domination of the "politics of the subject." Finally, *in the name of what* should we reject totalitarianism? In the name of what notion of the "subject" or of the "political," if it is now definitely impossible to speak either of the Individual arisen against the State or of the Rights of Man the Subject?

Perhaps, in spite of everything, we can find the beginnings of an answer to this question in the Freudian myth. But we cannot rely, as I have been doing up to this point, on the version of it that *Group Psychology* presents. That political version of the myth is already reinterpreting and reelaborating an older version, a more strictly *ethical* one, to which we must now return. We are familiar with this basic form of the myth: it is the fable of the primitive Father's murder, as set forth in *Totem and Taboo*. This fable, examined more closely, pictures a wholly different genesis of authority from the one found in *Group Psychology* (I use the term "authority" here so as not to have to say "power"). In *Totem and Taboo*, the primal authority is not the Father-Chief-Hypnotist, that "Superman" that Freud, following Nietzsche, alluded to before calling him, in *Moses and Monotheism*, the "great man." It is the *guilt-creating* Father, the Father able to create guilt because he is the *dead* Father. This is already tantamount to saying—but here lies the enigma—that this authority is the authority of no one, or anyway of no man, much less of an absolute Narcissus.

It is true that Freud was still speaking of the murder of a primitive *Father* and that in this he certainly seemed once again to be speaking the language of myth. That is what our whole disenchanted modern age, from Claude Lévi-Strauss to René Girard, has reproached him for: *Totem and Taboo*, by presupposing the Father's authority rather than deducing it, offers us nothing but another myth of origins, a myth of foundation. It happens, however, that this myth—which definitely is one, even in its autorepresentation *as* myth—is at the same time the myth of the origin of the myth of the Father (we would even have to say: the myth of the origin *of myth*). Freud was well aware that the dominating, jealous male of the Darwinian tribe is no Father, which is the whole reason why Freud in his narrative felt the need to have him finished off by his fellows: since his power resides in strength alone, he still holds no real paternal authority, and so sooner or later, in this logic of the natural state, he must be forcibly overthrown. Thus it is only *after* the murder, *after* having killed and devoured their tyrant, that his murderers submit to him, by virtue of a guilt and an obedience enigmatically described as "retrospective" (*nachträglich*). The "Father," in other words, appears only after the fact, in the remorse of those who for the first time in history become "brothers," and become "brothers" because they are guilty "sons." The "Father," then, in this strange Freudian myth, emerges only as myth—the myth of his own power, and the power of his own myth: "The dead," Freud wrote, "became stronger than the living had been."[16]

From our present perspective, this genesis of authority is extraordinarily interesting in that it defines the primal authority as "ethical," "moral" authority and not as political authority. What the members of the tribe submit to—and through which

16. *Totem and Taboo, SE* 13: 143. Translation slightly modified.

they form a community, ultimately a fraternal and human community—is in fact no power, since the holder of this power is now dead, perfectly impotent. Freud strongly emphasized that only in the feeling of guilt—in the feeling of a *moral* lapse—does there arise the terrifying figure of the one who will become the omnipotent Father and, later, God or the Chief. The feeling of guilt, as Freud said in *Civilization and Its Discontents*, is not social anxiety (*soziale Angst*), the ordinary fear of being punished by an external power or censor. It is moral anxiety (or anxiety of conscience, *Gewissenangst*) before an "internal" authority, as "imperative" as it is "categorical." This strange moral authority—all the stranger because the subject submits to it of his own accord, autonomously—is what Freud had described earlier as the "voice of conscience" (*Stimme des Gewissens*) and is what, from *Totem and Taboo* on, he called the "superego" or the "ego ideal." "In place of" that ego ideal he set up the *Führer* of *Group Psychology*, which finally amounted to saying that the essence of the community is ethical before it is political. What establishes the community is not principally the fusional, amorous partaking in a collective Super-Subject or "Superman" but rather the always singular summons of a *Super*ego that, strictly speaking, is no one.

This bears repeating: primal authority—ethical authority—belongs to no one, and especially not to the Father-Chief-Narcissus, whose myth appears only after the fact. That the murderers may have felt guilty with respect to a previously known and established law (which would bring us back to a situation of *soziale Angst*) is far from being the case; rather, it was in the feeling of guilt (in *Gewissenangst*) that they first came to know—inexplicably, terribly—the law of the Father: "They thus created," Freud wrote, careful to emphasize the paradox, "*out of their filial sense of guilt* the two fundamental taboos of totemism."[17] Freud did not say, then, that the murderers were anxious about having trangressed the taboos laid down by the Father. He said something much stranger: that the Father's taboos, and therefore human society, arise from anxiety—about what? About nothing, about no one. It is when the powerful male is dead and no longer there to prohibit anything at all that, in a perfectly disconcerting way, there emerge the alterity of duty and the debt of guilt, both of them all the more unbearable. The Father emerges from his own death, the law emerges from its own absence—quite literally ex nihilo. And that is why the Freudian myth, in spite of how it looks, is not a "myth of the twentieth century," a new myth nostalgically reinstating the lost transcendence of myth (the myth of the Father, of God, of the Chief). Freud did not lament the death of the Father, any more than he attempted to cure the resulting "discontents of civilization." On the contrary: rooting civilization in the "discontents" of an a priori guilt that precedes all Law and any Name of the Father, he offered us the myth of the *death* of myth— which is also to say the myth of its inexhaustible resurrection. After all, if the Father is dead (if his authority is purely mythic), then how is it that his murderers submit to him? And how does it happen that, if God is dead, we (for this is about ourselves, the "murderers of God") are so eager to reinstate Him at the center and base of our

17. Ibid.

societies—socialist humanity prostrate before "Father" Stalin, the *Volk* or race fasci-
ated behind its *Führer*?

It is because we feel guilty for having killed Him—that is Freud's answer, still
a mythic one. But the question only rebounds: Why do we feel guilty, if there is no
longer any Father—if there has never been one—to punish us? There lies the
enigma of the myth—of the Freudian myth and of the mythic power that it de-
scribes. To solve the enigma, is it enough to mention love for the Father again?
Freud wrote, in fact, that the murderers

> hated their father, who presented such a formidable obstacle to their crav-
> ing for power [*Machtbedürfnis*] and their sexual drives; but they loved and ad-
> mired him too. After they had got rid of him, had satisfied their hatred and
> had put into effect their wish to identify themselves with him, the affection
> which had all this time been pushed under was bound to make itself felt.[18]

But this "love" for the Father is itself all too clearly part of the myth. It is only
after having eliminated the hated rival, and under the influence of remorse, that the
murderers began to love him as a Father and to be united in that love. To love him,
then, they had to begin by killing him. Society, a community of love, rests on a crime
and on remorse for that crime.

Thus it is not so much in "love" per se that we should be looking for the key to
the son-brothers' "retrospective obedience" as in that love's ambivalent character,
hateful and devouring from the very beginning. The members of the tribe, as the
myth specifies, killed and *devoured* the jealous male. Why would they have done so,
if this had been only a question of eliminating the monopolizer of the group's
women? The myth spells it out: because his murderers "loved and *admired him.*" This
peculiar "love" was an admiring, identifying, envious love, and so it necessarily led
to the cannibalistic incorporation of the model. As the narrative has it:

> The violent primal father had doubtless been the feared and envied
> model of each one of the company of brothers: and in the act of devour-
> ing him they accomplished their identification with him, and each one
> of them acquired a portion of his strength.[19]

"Model," "identification," "devouring," "appropriation"—this is quite clear.
The myth is not telling us here about the love for an object but rather about an in-
dissolubly narcissistic passion of identification: it is in order *to be* the Father—*to be*

18. Ibid.; cf. also *Civilization and Its Discontents, SE* 21: 132: "This remorse was the result of the pri-
mordial ambivalence of feeling toward the father. His sons hated him, but they loved him, too. After their
hatred had been satisfied by their act of aggression, their love came to the fore in their remorse for the
deed. . . . Now, I think we can at last grasp two things perfectly clearly: the part played by love in the ori-
gin of conscience and the fatal inevitability of the sense of guilt."
19. *Totem and Taboo, SE* 13: 142. See also *Moses and Monotheism, SE* 23: 82: "They not only feared and
hated their father but also honoured him as a model, and . . . each of them wished to take his place in re-
ality. We can . . . understand the cannibalistic act as an attempt to ensure identification with him by in-
corporating a piece of him."

(the) Subject—that the members of the tribe kill and devour him and not at all (or only incidentally) in order to *have* the women of the group. Freud, speaking of the "need for power" and the "desire to identify with the Father," put it aptly: the stakes of the murder are not the possession of an object of love or of pleasure but rather the acquisition of an identity. The murder of the Father, in this case, is much less a brutish struggle than a Freudian version of Hegel's "struggle for pure prestige." If desire ends in murder and devouring, it is because it is the desire to appropriate the being of the other, the desire to assimilate his power (*Macht*), his potency (*Stärke*)—in a word, his mastery: his narcissistic autonomy. My being is in the other, and that is why I cannot become "myself," an ego, unless I devour him—here, in short, is what the Freudian myth is telling us, a myth ultimately much less mythic than it appears. What it deals with is the primitive relationship to others, taking it all the way back to the mythic origins of human community—"primitive" because it is the relationship of no ego to no other, of no subject to no object. Thus it is also a connection with no connection to others, an unbinding tie. I the ego am born by assimilating the other, by devouring him, incorporating him. Everything in so-called individual history, then, as in the history of society, begins with murderous, blind identification, all the blinder because there is still no ego to see anything or represent anything to itself at all, and because the "envied model" that it assimilates is immediately annihilated, eaten, engulfed: "I am the breast," "I am the Father"—that is, *no one.* In other words, everything begins with a subjectless identification—by which the Freudian myth corresponds exactly to the situation of the panicked, anarchic, headless masses without a Chief. The Father (who was actually not a Father, not even a brother, but only a counterpart) has been killed, and so there is no subject at the basis of the social tie, whether we mean loving subjects or a beloved Subject.

His myth arises at this very moment, however. The ghost of the Father-Subject assails the guilty conscience of the sons, who then attempt to redeem their sin through their love and submission. But where can this ghost be getting such vain, empty power? From the *failure* of this devouring identification. In a footnote, Freud gave what turned out to be his only explanation of the sons' "retrospective obedience":

> This fresh emotional attitude must also have been assisted by the fact that the deed cannot have given complete satisfaction to those who did it. From one point of view it had been done in vain. Not one of the sons had in fact been able to put his original wish—of taking his father's place—into effect. And, as we know, failure is far more propitious for a moral reaction than satisfaction.[20]

As a result, none of the sons is able to become Subject and Chief by appropriating the identity and the glorious being of the Other. What, ultimately, is the irreducible alterity that causes the failure of this violent act of identification, this

20. *Totem and Taboo, SE* 13: 143.

dialectical assimilation of the other? It can only be (to return to and reverse Hegel's term) the "absolute Master," death—death or *the dead one: der Tote,* for Freud.

Empirically, there would be nothing to prevent one of the tribe's members from eliminating his rivals and taking the dominant male's place (in fact, Freud did conceive of this solution in other versions of the myth).[21] Therefore, we must be dealing here with something else entirely, something not at all empirical: the unoccupiable place of the dead one, since death sets the absolute limit on identification. The myth does not say this so clearly, of course, but there is no other way to understand the retrospective power of the dead one. *Der Tote,* who is resurrected and lives on eternally in the guilty memory of the sons, *represents* death, *represents* their own unrepresentable death to them. Indeed, at the myth's extreme, we must imagine that the murderers, having devoured the other in order to appropriate his being, suddenly found themselves once again facing "themselves"—that is, facing no one. The other was dead, *and so they themselves were dead.* The identifying act of incorporation confronted them—brutally, dizzyingly—with what is preeminently unassimilable: their own death, their own being-dead, the very thing that eludes all appropriation. That is why "the dead became stronger than the living had been" and also why the "sense of guilt" is born of the anxious apprehension of death "beside the dead body of the loved one," as Freud said in "Thoughts for the Times on War and Death."[22] "This dead man," his stupefied murderers must have said to themselves, "is myself—and yet he is infinitely other, since I cannot picture myself dead.[23] Being myself, he is all the more other. And this All-Other this All-Mighty who has eluded my power—how will I now be able to appease His wrath?"

Attempting, like Freud, to represent the unrepresentable, attempting to represent to *myself* this other that I am, by once more setting that other in front of me,

21. First of all in *Totem and Taboo,* where Freud, as if alarmed by his own paradox, had the father's murder followed by a fratricidal struggle—which brought Freud back to his point of departure and thus constrained him to fall back on the hypothesis (a far more classical one, which the hypothesis of "retrospective obedience" was intended to avoid) of a "social contract" among the rival brothers. See also *Group Psychology, SE* 18: 135: "None of the group of victors could take his place, or, if one of them did, the battles began afresh, until they understood that they must all renounce their father's heritage"; and *Moses and Monotheism, SE* 23: 82: "It must be supposed that after the patricide a considerable time elapsed during which the brothers disputed with one another for their father's heritage, which each of them wanted for himself alone."

22. "Thoughts for the Times on War and Death," *SE* 14: 295: "What came into existence beside the dead body of the loved one was not only the doctrine of the soul, the belief in immortality and a powerful source of man's sense of guilt, but also the earliest ethical commandments. The first and most important prohibition made by the awakening conscience was 'Thou shalt not kill.' It was acquired in relation to dead people who were loved, as a reaction against the satisfaction of the hatred hidden behind the grief for them." Therefore, the important thing in arousing the moral conscience is not that the corpse be that of a father or even that it actually have been murdered. The only important thing is that "primaeval man" be confronted with a *dead person with whom he identifies* in the ambivalent mode of devouring "love," for "then, in his pain, he [is] forced to learn that one can die, too, oneself, and his whole being revolt[s] against the admission; for each of these loved ones was, after all, *a part of his own beloved self*" (ibid., p. 293; emphasis added).

23. Ibid., p. 294: "Man could no longer keep death at a distance because he had tasted it in his pain about the dead; but he was nevertheless unwilling to acknowledge it, for he could not conceive himself as dead."

I have just been speaking the language of myth. It is a myth, of course, but the myth is unavoidable. That is precisely the power of myth: we cannot (but) represent the unrepresentable to ourselves, we cannot (but) present the unpresentable. That is why Freud, seeking to represent this abyssal withdrawal of the subject, could only write a new myth—powerful, like every other myth, and one that also founded a community. But this myth—the myth of the death of myth, the myth of the un-avoidable power of myth—is no longer wholly a myth. Being the myth of the mythic emergence of the Subject, it is no longer wholly the myth of the Subject which is why, lucidly confronting the vast power of the totalitarian myth, it allows us—perhaps—to elude it.

In the end, what does it tell us? In the first place, that we are submitting to nothing but ourselves—and here, of course, it merely repeats the totalitarian myth of the Subject: the State, the Law, the Chief, the *Führer*, the Other in general are all Me, always Me, always "His Majesty the Ego." And it is also quite true that Freud him-self, in large part, believed in this myth and succumbed to its power. But by adding that this all-powerful Ego is "death," *our* death, he also told us something completely different, which can scarcely be uttered, and which he therefore put in mythic terms: "I am death and the dead one." "I am (the) other." In short: "I am not myself, I am not (a) subject." What the members of the murdering tribe submit *to*, what they gather to form a community around, is *nothing*—no Subject, no Father, no Chief but their own mortality, their own finitude, their own inability to be Absolute Subjects, "absolute Narcissi."

And that, finally, is why Freud's enigmatic "retrospective obedience" is ethical respect before it is political submission, my respect for others before it is submis-sion to myself. It is obedience to what, within the subject, transcends the subject, to what in me is above me, to the ego's superego. Or, to return to the Freudian myth and add *nothing* to it, "retrospective obedience" is obedience to what withdraws from the social body through its very incorporation, in this way—but only in this way— giving rise to the "body politic," to the "mystical body." "Here is my body. Behold here my death. Here behold your own."

Richard Avedon. Andy Warhol, Artist,
New York City, 8/20/69. *1969.*

HAL FOSTER

> *The human organism is an atrocity exhibition*
> *at which he is an unwilling spectator.*
>
> —J. G. Ballard, *The Atrocity Exhibition*

In *The Philosophy of Andy Warhol* (1975) the great idiot savant of our time chats about many big subjects—love, beauty, fame, work—but when it comes to death this is all he has to say: "I don't believe in it because you're not around to know that it's happened. I can't say anything about it because I'm not prepared for it."[1] On first hearing there is not much in this stony demurral (which has little of the light wit of the rest of the book); yet listen again to these phrases: "not around to know . . . can't say anything . . . not prepared." There is a break in subjectivity here, a disorientation of time and space. To me it suggests an experience of shock or trauma, an encounter where one misses the real, where one is too early or too late (precisely "not around," "not prepared"), but where one is somehow marked by this very missed encounter.

I fix on this idiosyncratic passage because I think it encrypts a relation to the real that suggests a new way into Warhol, especially into the "Death in America" images from the early 1960s, one that may get us beyond the old opposition that constrains so many approaches to the work: that the images are attached to referents, to iconographic themes or to real things in the world, or, alternatively, that the world is nothing but image, that all Pop images in particular represent are other images.[2] Most readings not only of Warhol but of postwar art based in

1. Andy Warhol, *The Philosophy of Andy Warhol* (New York: Harcourt Brace Jovanovich, 1975), p. 123. This text began as a talk at a conference convened at the Andy Warhol Museum by Colin MacCabe, Mark Francis, and Peter Wollen in April 1995. I also thank participants in the Visual Culture Colloquium at Cornell University, in particular Susan Buck-Morss, Geoff Waite, and especially Mark Seltzer. Finally, I dedicate the text to the memory of Bill Readings, a true critical theorist who possessed a terrific *joie de vivre*.
2. "Death in America" was the title of a projected show in Paris of "the electric-chair pictures and the dogs in Birmingham and car wrecks and some suicide pictures" (Gene Swenson, "What Is Pop Art? Answers from 8 Painters, Part I," *Art News* 62 [November 1963], p. 26).

photography divide somewhere along this line: the image as referential *or* as simulacral. This is a reductive either/or that a notion of traumatic realism may open up productively.[3]

Traumatic Realism

It is no surprise that the *simulacral* reading of Warholian Pop is advanced by critics associated with poststructuralism, for whom Warhol is Pop and, more importantly, for whom the theory of the simulacrum, crucial as it is to the poststructuralist critique of representation, sometimes seems to depend on the example of Warhol as Pop. "What Pop art wants," Roland Barthes writes in "That Old Thing, Art" (1980), "is to desymbolize the object," that is, to release the image from deep meaning (metaphoric association or metonymic connection) into simulacral surface.[4] In the process the author is also released: "The Pop artist does not stand *behind* his work," Barthes continues, "and he himself has no depth: he is merely the surface of his pictures, no signified, no intention, anywhere."[5] With variations this reading of Warholian Pop is performed by Michel Foucault, Gilles Deleuze, and Jean Baudrillard, for whom referential depth and subjective interiority are also victims of the sheer superficiality of Pop. In "Pop—An Art of Consumption?" (1970), Baudrillard agrees that the object in Pop "loses its symbolic meaning, its age-old anthropomorphic status."[6] But where Barthes and company see an avant-gardist disruption of representation, Baudrillard sees an "end of subversion," a "total integration" of the art work into the political economy of the commodity-sign.[7]

The *referential* view of Warholian Pop is advanced by critics and historians who tie the work to different themes: the worlds of fashion, celebrity, gay subculture, the Warhol Factory, and so on. Its most intelligent version is presented by Thomas Crow, who, in "Saturday Disasters: Trace and Reference in Early Warhol" (1987), disputes the simulacral account of Warhol that the images are indiscriminate and the artist impassive. Underneath the glamorous surface of commodity fetishes and media stars Crow finds "the reality of suffering and death"; the tragedies of Marilyn, Liz, and Jackie in particular are said to prompt "straightforward

3. My way to this notion has come through the art work of Sarah Pierce. I think it opens onto other realisms not only after the war (photorealist and appropriation art in particular) but before as well (Surrealism in particular)—a genealogy that I sketch in "Reality Bites," in *Hidden in Plain Sight: Illusion and the Real in Recent Art*, ed. Virginia Rutledge (Los Angeles: Los Angeles County Museum of Art, forthcoming, 1996). I am also interested in this notion as one way to think beyond the stalemated oppositions of new art history—semiotic versus social-historical, text versus context—as well as of cultural criticism—signifier versus referent, constructivist subject versus naturalist body.

4. Roland Barthes, "That Old Thing, Art," in *Post-Pop*, ed. Paul Taylor (Cambridge: MIT Press, 1989), p. 25.

5. Ibid., p. 26.

6. Jean Baudrillard, "Pop—An Art of Consumption?" in *Post-Pop*, p. 33. (This text is extracted from *La société de consommation: ses mythes, ses structures* [Paris: Gallimard, 1970], pp. 174–85.)

7. Ibid., p. 35. Neither position is wrong, I will argue throughout this text; rather, the two must be thought somehow together.

expressions of feeling."[8] Here Crow finds not only a referential object *for* Warhol but an empathetic subject *in* Warhol, and here he locates the criticality *of* Warhol—not in an attack on "that old thing, art" (as Barthes would have it) through an embrace of the simulacral commodity-sign (as Baudrillard would have it), but rather in an exposé of "complacent consumption" through "the brutal fact" of accident and mortality.[9] In this way Crow pushes Warhol beyond humanist sentiment to political engagement. "He was attracted to the open sores in American political life," Crow writes in a reading of the electric-chair images as agit-prop against the death penalty and of the race-riot images as a testimonial for civil rights. "Far from a pure play of the signifier liberated from reference," Warhol belongs to the popular American tradition of "truth-telling."[10]

This reading of Warhol as empathetic, even *engagé*, is a projection (an essay could be written on the desire of left critics to make Warhol over into a contemporary Brecht). But it is no more a projection than the superficial, impassive Warhol, even though this projection was his own: "If you want to know all about Andy Warhol, just look at the surface of my paintings and films and me, and there I am. There's nothing behind it."[11] Both camps make the Warhol they need, or get the Warhol they deserve; no doubt we all do. (What is it, by the way, that renders Warhol such a site for projection? He posed as a blank screen, to be sure, but Warhol was very aware of these projections, indeed very aware of identification *as* projection; it is one of his great subjects.)[12] In any case neither projection is wrong; but they cannot both be right . . . or can they? Can we read the "Death in America" images as referential *and* simulacral, connected *and* disconnected, affective *and* affectless, critical *and* complacent? I think we must, and I think we can if we read them in a third way, in terms of traumatic realism.

One way to develop this notion is through the famous motto of the Warholian persona: "I want to be a machine."[13] Usually this statement is taken to confirm the blankness of artist and art alike, but it may point less to a blank subject than to a shocked one, who takes on the nature of what shocks him as a mimetic

8. Thomas Crow, "Saturday Disasters: Trace and Reference in Early Warhol," in *Reconstructing Modernism*, ed. Serge Guilbaut (Cambridge: MIT Press, 1990), pp. 313, 317. This is the second version; the first appeared in *Art in America* (May 1987).
9. Ibid., p. 322.
10. Ibid., p. 324. Again, his "attraction" to these subjects may not be "complacent," but it is not necessarily critical.
11. Gretchen Berg, "Andy: My True Story," *Los Angeles Free Press* (March 17, 1963), p. 3. Warhol continues: "I see everything that way, the surface of things, a kind of mental Braille, I just pass my hands over the surface of things. . . . There was no profound reason for doing a death series, no victims of their time; there was no reason for doing it at all, just a surface reason." Of course, this very insistence could be read as a denial, that is, as a signal that there may be a "profound reason." This shuttling between surface and depth may be unstoppable in Pop; indeed, it may be characteristic of (its) traumatic realism.
12. This is not say that there are no qualitative differences between projections, or between fascinated projections and motivated interpretations.
13. Swenson, "What Is Pop Art?" p. 26.

Sixteen Jackies. *1964.*

Tunafish Disaster. *1963.*

defense against this shock: I am a machine too, I make (or consume) serial product-images too, I give as good (or as bad) as I get. "Someone said my life has dominated me," Warhol told Gene Swenson in the celebrated interview of 1963. "I liked that idea."[14] Here Warhol has just confessed to the same lunch every day for the past twenty years (what else but Campbell's soup?). In context, then, the two statements read as a preemptive embrace of the compulsion to repeat put into play by a society of serial production and consumption.[15] If you can't beat it, Warhol suggests, join it. More, if you enter it totally, you might expose it; that is, you might reveal its automatism, even its autism, through your own excessive example. Used strategically in Dada, this capitalist nihilism was performed ambiguously by Warhol, and many artists have played it out since.[16] (This is a performance, of course: there is a subject "behind" this figure of nonsubjectivity who presents it *as* a figure. Otherwise the shocked subject is an oxymoron, for, strictly speaking, there is no subject in shock, let alone in trauma. And yet the fascination of Warhol is that one is never certain about this subject "behind": is anybody home, inside the automaton?)

These notions of shocked subjectivity and compulsive repetition reposition the role of *repetition* in the Warhol persona and images. "I like boring things" is another famous motto of this quasi-autistic persona. "I like things to be exactly the same over and over again."[17] In *POPism* (1980) Warhol glossed this embrace of boredom, repetition, domination: "I don't want it to be essentially the same—I want it to be *exactly* the same. Because the more you look at the same exact thing, the more the meaning goes away, and the better and emptier you feel."[18] Here repetition is both a draining of significance and a defending against affect, and this strategy guided Warhol as early as the 1963 interview: "When you see a gruesome picture over and over again, it doesn't really have any effect."[19] Clearly

14. Ibid.
15. I hesitate between "product" and "image" and "make" and "consume" because, historically, Warhol seems to occupy a liminal position between the orders of production and consumption; at least the two operations appear blurred in his work. This liminal position might also bear on my hesitation between "shock," a discourse that develops around accidents in industrial production, and "trauma," a discourse in which shock is rethought in the register not only of psychic causality but also of imaginary fantasy—and so, perhaps, a discourse that is more pertinent to a consumerist subject.
16. Indeed, artists like Jeff Koons have run it right into the ground. For this capitalist nihilism in Dada see my "Armor Fou," *October* 56 (Spring 1991); and in Warhol see Benjamin Buchloh, "The Andy Warhol Line," in *The Work of Andy Warhol,* ed. Gary Garrels (Seattle: Bay Press, 1989). In Dada, in much reactionary representation of the 1920s, and again in contemporary art, this nihilism assumes an infantilist aspect, as if "acting out" were the same as "performing."
17. Undated statement by Warhol, as read by Nicholas Love at the Memorial Mass for Andy Warhol, St. Patrick's Cathedral, New York, April 1, 1987, and as cited in *Andy Warhol: A Retrospective,* ed. Kynaston McShine (New York: Museum of Modern Art, 1989), p. 457.
18. Andy Warhol and Pat Hackett, *POPism: The Warhol '60s* (New York: Harcourt Brace Jovanovich, 1980), p. 50.
19. Swenson, "What Is Pop Art?" p. 60. That is, it still has an effect, but not *really.* I mean my use of "affect" not to reinstate a referential experience but, on the contrary, to suggest an experience that cannot be located precisely.

this is one function of repetition: to repeat a traumatic event (in actions, in dreams, in images) in order to integrate it into a psychic economy, a symbolic order. But the Warhol repetitions are not restorative in this way; they are not about a mastery of trauma.[20] More than a patient release from the object in mourning, they suggest an obsessive fixation on the object in melancholy. Think of all the *Marilyns* alone, of all the cropping, coloring, and crimping of these images: as Warhol works over this image of love, the "hallucinatory wish-psychosis" of a melancholic seems to be in play.[21] But this analysis is not right either. For one thing the repetitions not only *re*produce traumatic effects; they *produce* them as well (at least they do in me). Somehow in these repetitions, then, several contradictory things occur at the same time: a warding away of traumatic significance *and* an opening out to it, a defending against traumatic affect *and* a producing of it.

Here I should make explicit the theoretical model I have implicated so far. In the early 1960s Jacques Lacan was concerned to define the real in terms of trauma. Titled "The Unconscious and Repetition," this seminar was roughly contemporaneous with the "Death in America" images (it ran in early 1964).[22] But unlike the theory of simulacra in Baudrillard and company, the theory of trauma in Lacan was not influenced by Pop. It was, however, informed by Surrealism, which has its deferred effect on Lacan here, an early associate of the Surrealists; and Pop is related to Surrealism as a traumatic realism (certainly my reading of Warhol is a Surrealist one). It is in this seminar that Lacan defines the traumatic as a missed encounter with the real. As missed, the real cannot be represented; it can only be repeated, indeed it *must* be repeated. "*Wiederholen*," Lacan writes in etymological reference to Freud on repetition, "is not *Reproduzieren*"; repetition is not reproduction.[23] This can stand as an epitome of my argument too: repetition in Warhol is not reproduction in the sense of representation (of a referent) or simulation (of a pure image, a detached signifier). Rather, repetition serves to *screen* the real understood as traumatic. But this very need *points* to the real, and it is at this point that the real *ruptures* the screen of repetition. It is a rupture not in the world but in the subject; or rather it is a rupture between perception and consciousness of a subject *touched* by an image. In an allusion to Aristotle on accidental causality, Lacan calls this traumatic point the *tuché*; in *Camera Lucida* (1980) Barthes calls it

20. But this is the role of art history in relation to Warhol (among many others): to find a referent, to develop an iconography, in order to integrate the work. In some ways Warhol defies this process, as did Rauschenberg before him; in other ways they both play right into it.

21. Sigmund Freud, "Mourning and Melancholia" (1917), in *General Psychological Theory*, ed. Philip Rieff (New York: Collier Books, 1963), p. 166. Crow is especially good on the Warhol memorial to Marilyn, but he reads it in terms of mourning more than of melancholia.

22. See Jacques Lacan, *The Four Fundamental Concepts of Psychoanalysis*, trans. Alan Sheridan (New York: W. W. Norton, 1978), pp. 17–64. The seminar that follows, "Of the Gaze as *Objet Petit a*," has received more attention, but this seminar has as much relevance to contemporary art (in any case the two must be read together). For a provocative application of the seminar on the real to contemporary writing (including Ballard), see Susan Stewart, "Coda: Reverse Trompe L'Oeil\The Eruption of the Real," in *Crimes of Writing* (New York: Oxford University Press, 1991), pp. 273–90.

23. Lacan, *Four Fundamental Concepts*, p. 50.

the *punctum*.[24] "It is this element which rises from the scene, shoots out of it like an arrow, and pierces me," Barthes writes. "It is what I add to the photograph and what is nonetheless already there." "It is acute yet muffled, it cries out in silence. Odd contradiction: a floating flash."[25] (This confusion about the location of the rupture, *tuché*, or *punctum* is a confusion between subject and world, inside and outside. It is an aspect of trauma; indeed, it may be this confusion that *is* traumatic. "Where Is Your Rupture?" Warhol asks in a 1960 painting of a newspaper advertisement of a nude female torso.)

In *Camera Lucida* Barthes is concerned with straight photographs, so he relates the *punctum* to details of content. This is rarely the case in Warhol. And yet there is a *punctum* for me (Barthes stipulates that it is a personal effect) in the indifference of the passerby in *White Burning Car III* (1963). This indifference to the crash victim impaled on the telephone pole is bad enough, but its repetition is *galling*, and this points to the general operation of the *punctum* in Warhol. It works less through content than through technique, especially through the "floating flashes" of the silk-screen process, the slipping and streaking, blanching and blanking, repeating and coloring of the images. To take another instance, a *punctum* arises for me less from the slumped woman in the top image in *Ambulance Disaster* (1963) than from the obscene tear that effaces her head in the bottom image. Just as the *punctum* in Gerhard Richter lies less in details than in the pervasive blurring of the image, so the *punctum* in Warhol lies less in details than in this repetitive "popping" of the image.[26]

These pops, such as the slipping of the register of the image and the washing of the whole in color, serve as visual equivalents of our missed encounters with the real. "What is repeated," Lacan writes, "is always something that occurs . . . *as if by chance*."[27] And so it is with these pops: they seem accidental, but they also appear repetitive, automatic, even technological (the relation between accident and technology, crucial to the discourse of shock, is another great subject of Warhol).[28] In

24. "I am trying here to grasp how the *tuché* is represented in visual apprehension," Lacan states. "I shall show that it is at the level that I call the stain that the tychic point in the scopic function is found" (ibid., p. 77). This tychic point, then, is not in the world but in the subject, but in the subject as an effect, a shadow or a "stain" cast by the gaze of the world. Lacan argued that this gaze "qua *objet a* may come to symbolize this central lack expressed in the phenomenon of castration" (ibid., p. 77). In other words, the gaze queries us about our rupture.
25. Roland Barthes, *Camera Lucida*, trans. Richard Howard (New York: Hill and Wang, 1981), pp. 26, 55, 53. For an account of this connection between Barthes and Lacan, see Margaret Iversen, "What Is a Photograph?" *Art History*, vol. 17, no. 3 (September 1994), pp. 450–64.
26. Yet another instance of this popping is the blanking of the image (which often occurs in the diptychs, for example in the black panel opposite the panel of the crashes in *Five Deaths Seventeen Times in Black and White* [1963]). This blanking works as a kind of correlative of a black-out or a blank-down in shock. (For the point about the blur in Richter I am indebted to the art and music critic Julian Meyers.)
27. Lacan, *Four Fundamental Concepts*, p. 54.
28. For that matter, it is a great subject of modernism from Baudelaire to Surrealism and beyond. See, of course, Walter Benjamin, "On Some Motifs in Baudelaire" (1939), in *Illuminations*, trans. Harry Zohn (New York: Schocken Books, 1969). Also see Wolfgang Schivelbusch, *The Railway Journey* (Berkeley: University of California Press, 1986).

White Burning Car III. *1963.*

Ambulance Disaster. *1963*.

Compare with Deller ↗ *repeats the action* ↓ (handwritten marginal note)

this way Warhol elaborates on our optical unconscious, a term introduced by Walter Benjamin to describe the subliminal effects of modern technologies of the image. Benjamin developed this notion in the early 1930s, in response to photography and film; Warhol updates it thirty years later, in response to the postwar society of the spectacle, of mass media and commodity-signs.[29] In these early images we see what it looks like to dream in the age of television, *Life*, and *Time*; or rather, what it looks like to nightmare as shock victims who prepare for disasters that have already come, for Warhol selects moments when this spectacle cracks (the JFK assassination, the Monroe suicide, racist attacks, car wrecks), but cracks only to expand.[30]

Content in Warhol is thus not trivial (Crow is absolutely right here). A white woman slumped from a wrecked ambulance, or a black man attacked by a police

29. In fact the notion is not much developed by Benjamin. See the passing references in "A Short History of Photography" (1931), in *Classic Essays on Photography*, ed. Alan Trachtenberg (New Haven: Leete's Island Books, 1980), and "The Work of Art in the Age of Mechanical Reproduction" (1936), in *Illuminations*.

30. These *shocks* may exist in the world, but they occur in the subject. Certainly they develop as *traumas* only in the subject. And to develop in this way, to be registered as a trauma, requires that the first event, the shock, be recoded by a later event (this is what Freud meant by the deferred [*nachträglich*] action at work in trauma: it takes two traumas to make a trauma). This distinction is important for my reading of Warhol especially in the next section, for what is first a calamity, like the JFK assassination, or a disaster, like the Challenger explosion, only becomes a trauma later, *après-coup*; and the mass subjectivities effected by shock and trauma are different.

dog, is a shock. But, again, it is this first order of shock that the repetition of the image serves to screen, even if in doing so the repetition produces a second order of trauma, here at the level of technique where the *punctum* breaks through the screen and allows the real to poke through. The real, Lacan puns, is *trou*matic, and again the tear in *Ambulance Disaster* is such a hole for me, though what loss is figured there I cannot say. Through these pokes or pops we seem almost to touch the real, which the repetition of the image at once distances and rushes toward us. Sometimes the coloring of the images has this strange double effect as well.[31]

In this way different kinds of repetition are put into play by Warhol: repetitions that fix on the traumatic real, that screen it, that produce it. And this multiplicity makes for the Warholian paradox not only of images that are both affective and affectless, but also of viewers that are neither integrated (which is the ideal of most modern aesthetics: the subject composed in contemplation) nor dissolved (which is the effect of much popular culture: the subject given over to the schizo intensities of the commodity-sign). "I never fall apart," Warhol remarks in *The Philosophy of Andy Warhol*, "because I never fall together."[32] Such is the subject-effect of his work too, and it resonates in some art after Pop as well: some photorealism, some appropriation art, some object art today. In other words, there is a genealogy of traumatic realism, and it has surfaced strongly in the present.[33]

Mass Witnessing

Barthes was wrong to suggest that the *punctum* is only a private affair; it can have a public dimension as well. The breakdown of the distinction between private and public is traumatic too; again, understood as a breakdown of inside and outside, it is one way to understand trauma as such.[34] But this understanding is

31. In "Information, Crisis, Catastrophe" Mary Anne Doane argues that television coverage serves to block the shock of catastrophic events, only to produce this effect when its coverage fails (in *Logics of Television*, ed. Patricia Mellencamp [Bloomington: Indiana University Press, 1990]). As suggested, the Warhol washing of the image in color often screens *and* reveals the traumatic real in a similar way. These washes might then recall the hysterical red that Marnie sees in the eponymous film by Hitchcock (1964). But this red is too coded, almost safely symbolic, even iconographic. The Warhol colors are more acrid, arbitrary, *effective*.

32. Warhol, *The Philosophy of Andy Warhol*, p. 81. In "Andy Warhol's One-Dimensional Art: 1956–1966," Benjamin Buchloh argues that "consumers . . . can celebrate in Warhol's work their proper status of having been erased as subjects" (*Andy Warhol: A Retrospective*, p. 57). This is the other extreme of the position argued by Crow that Warhol exposes "complacent consumption." Again, rather than choose between the two, they must be thought somehow together.

33. I discuss this genealogy in *The Return of the Real* (Cambridge: MIT Press, forthcoming 1996).

34. I repeat this point because with artists like Warhol and Richter the *punctum* is not strictly private or public. This is especially the case with the Richter suite of paintings titled "October 18, 1977" (1988) concerning the deaths in the Baader-Meinhof group. The painting of the little record player kept by Andreas Baader holds a special charge for me. This is not a private affair, and yet I cannot explain it through any public *studium*—its use in prison, its status as an outmoded leisure-commodity, whatever. I am aware of the psychologistic tendency of this section of my text, in particular the slippage of trauma from a psychoanalytic definition to a sociological application, but I think my subject requires it.

Crowd. *1963.*

historical, which is to say that this traumatic breakdown is historical, and no one evokes its effects quite like Warhol. "It's just like taking the outside and putting it on the inside," he once said of Pop in general, "or taking the inside and putting it on the outside."[35] This is cryptic, but it does suggest a new relay between private fantasy and public reality as both an object and an operation in Pop. "In the past we have always assumed that the external world around us has represented reality," J. G. Ballard, the best complement of Warhol in fiction, writes in an introduction to his great Pop novel *Crash* (1973),

> and that the inner worlds of our minds, its dreams, hopes, ambitions, represented the realm of fantasy and the imagination. These roles, it seems to me, have been reversed. . . . Freud's classic distinction between the latent and manifest content of the dream, between the apparent and the real, now needs to be applied to the external world of so-called reality.[36]

The result of this confusion is a pathological public sphere, a strange new mass subjectivity, and it fascinated Warhol as it does Ballard.[37] I want to turn to this fascination because it does much to illuminate not only "Death in America" but Politics in America as well. To do so, however, a quick detour through political theory is necessary.

In his classic study *The King's Two Bodies* (1957) the historian Ernst Kantorowicz provides an anatomy of the body politic in the feudal order. On the one hand the king represents this body politic (as in the synecdoche "I am England"), on the other hand he serves as its head; and in this corporal metaphor lies a measure of social hierarchy and political control. (A late imaging of this body politic appears as the famous frontispiece of the *Leviathan* of Hobbes [1651].) However, with the bourgeois revolution, this image, this social imaginary, is threatened. As democracy decapitates the king, it "disincorporates" the body politic as well, and the result is a crisis in political representation. How can this new inchoate mass be represented?[38] For the political theorist Claude Lefort totalitarianism is a

35. Berg, "Andy: My True Story," p. 3.
36. This introduction appears in the French translation of *Crash* (Paris: Calmann-Levy, 1974); it was published in the original English in *Foundation* 9 (November 1975) and in *Re/Search* 8/9 (1984; J. G. Ballard issue), p. 98. In this regard Warhol and Ballard point to an important concern in recent psychoanalytical art and criticism (e.g., the work of Slavoj Žižek): the role of fantasy in the social imaginary and the body politic.
37. Mark Seltzer develops the notion of a pathological public sphere in "Serial Killers II," *Critical Inquiry* (Fall 1995).
38. This is a primary question for many modernists, mainly socialists, across a range of practices (e.g., Sergei Eisenstein, El Lissitzky, John Heartfield, Diego Rivera), but Warhol addresses it too, from his own perspective. In *Crowd* (1963), for example, the mass appears as a truncated blur of a newspaper photo or a television image barely seen or remembered. In crowd theory of the nineteenth century, most of which is quite reactionary (e.g., Gustave Le Bon), the problem is posed explicitly in terms of control: how to *restrain* the mass in representation. (I am grateful to Susan Buck-Morss for her attention to this neglected part of the modernist project.)

Frontispiece of Hobbes's
Leviathan. *1651.*

Xanti. Mussolini. *1934.*

belated response to this crisis: the figure of the supreme leader returns as an "Egocrat" to reembody "the People-as-One."[39] But this return of the sovereign figure has a correlative in spectacular societies of the West: the politician as celebrity, the celebrity as politician, who rules through a politics of identification-as-projection—a return that Jürgen Habermas has called a "refeudalizing" of the public sphere.[40] In a gloss both on Habermas on the public sphere and on Lefort on democratic disincorporation, the critic Michael Warner describes this reembodiment in these terms: "Where printed public discourse formerly relied on a rhetoric of abstract disembodiment, visual media—including print—now display bodies for a range of purposes: admiration, identification, appropriation, scandal, and so forth. To be public in the West means to have an iconicity, and this is true equally of Muammar Qaddafi and Karen Carpenter."[41]

Again, Warhol was fascinated by this mass subject. "I want everybody to think alike," he said in 1963. "Russia is doing it under government. It's happening here all by itself."[42] Warhol was no situationist, but in his own blankly affirmative way he does register here a convergence between the "concentrated" spectacle of the Soviet Union and the "diffuse" spectacle of the United States, one that Debord foresaw in *The Society of the Spectacle* (1967) and confirmed in *Comments on the Society of the Spectacle* (1988). And with his *Maos*, made in 1972 at the point of the Nixon opening to China, Warhol does suggest a related convergence of spectacular orders.[43] In any case he was concerned to address the mass subject. "I don't think art should be only for the select few," Warhol commented in 1967. "I think it should be for the mass of American people."[44] But how does one go about such a representation in a society of consumer capitalism?

One way at least to evoke the mass subject is through its proxies, that is, through its objects of taste (thus the wallpaper kitsch of the flowers in 1964 and the folk logo of the cows in 1966) and/or its objects of consumption (thus the serial presentation of the Campbells and the Cokes, the Heinzes and the Brillos, from 1962 on).[45] But can one *figure* this subject? Does it have a body to figure? Or is it

39. Claude Lefort, "The Image of the Body and Totalitarianism," in *The Political Forms of Modern Society*, ed. John B. Thompson (Cambridge: MIT Press, 1986), pp. 298–99. For the image of the body in Italian fascism see Jeffrey Schnapp, *Staging Fascism* (Palo Alto: Stanford University Press, 1995).
40. Jürgen Habermas, *The Structural Transformation of the Public Sphere*, trans. Thomas Burger (Cambridge: MIT Press, 1989), p. 201. First published in 1964, this landmark text is also roughly contemporaneous with the "Death in America" images.
41. Michael Warner, "The Mass Public and the Mass Subject," in *The Phantom Public Sphere*, ed. Bruce Robbins (Minneapolis: University of Minnesota Press, 1993), p. 242. My line of argument here is indebted to Warner, who also discusses Ballard.
42. Swenson, "What Is Pop Art?" p. 26.
43. For an extraordinary meditation on different mass subjectivities from Chairman Mao to Doctor Moon, from the novel to terrorism in the news, see Don DeLillo, *Mao II* (New York: Viking, 1991).
44. Berg, "Andy: My True Story," p. 3. He also preferred the term "commonist" to "Pop."
45. *The Philosophy of Andy Warhol* includes an ode to Coke that celebrates the absurd democracy of consumerism at issue here: "What's great about this country is that America started the tradition where the richest consumers buy essentially the same things as the poorest. You can be watching TV and see Coca-Cola, and you can know that the President drinks Coke, Liz Taylor drinks Coke, and just

displaced in the fetishism of the commodity-sign, dissolved in the society of the spectacle? "The mass subject cannot have a body," Warner asserts, "except the body it witnesses."[46] If we grant this principle provisionally, it may suggest why Warhol evokes the mass subject through its figural projections—from celebrities and politicians like Marilyn and Mao to all the lurid cover-people of *Interview* magazine. It may also suggest why the world of Warhol was overrun by voyeurs and exhibitionists. For Warhol not only evoked the mass subject; he also incarnated it, and he incarnated it precisely in its guise as "witness." This witnessing is not neutral or impassive; it is an erotics that is both voyeuristic and exhibitionist, both sadistic and masochistic, and it is especially active in two areas, the Factory filmmaking and the Warholian cult of celebrity. Here again Ballard is the best complement of Warhol, for while Ballard tends to explore the sadistic side of mass witnessing (his "Plan for the Assassination of Jacqueline Kennedy" [1966] and "Why I Want to Fuck Ronald Reagan" [1967] are classics of the genre), Warhol tends to slip into its masochistic side (as in his servility before the likes of Imelda Marcos and Nancy Reagan).[47]

However, Warhol did more than evoke the mass subject through its kitsch, commodities, and celebrities. He also represented it in its very unrepresentability, that is, in its absence and anonymity, its disaster and death. Eventually this led him to the *Skulls* (1976), the most economical image of the mass subject, for, as his assistant Ronnie Cutrone once remarked, to paint a skull is to do "the portrait of everybody in the world."[48] Yet Warhol was drawn to death, the democratic leveler of famous mass object and anonymous mass subject alike, long before. Here is one more statement from the 1963 interview:

> I guess it was the big crash picture, the front page of a newspaper:
> 129 DIE. I was also painting the *Marilyns*. I realized that everything I

think, you can drink Coke, too. A Coke is a Coke and no amount of money can get you a better Coke than the one the bum on the corner is drinking. All the Cokes are the same and all the Cokes are good. Liz Taylor knows it, the President knows it, the bum knows it, and you know it" (pp. 100–101). In this ad for democracy there is only one Real Thing, and We are indeed the World.
46. Warner, "The Mass Public," p. 250.
47. This is where the principle "the mass subject cannot have a body except the body it witnesses" might be qualified. For the mass does "have" a body (as with the phallus, having and being a body are not the same): it has a body in the sense that it may be convoked not only through a body (e.g., a celebrity) but as a body (e.g., a collective shocked or traumatized by the same event). It also retains its bodies in the usual sense (mass subjects as "organisms" rather than as "spectators" in the terms of my Ballard epigraph). These individual bodies of desires, fears, and fantasies allow mass subjects to customize mass objects in personal and/or group ways (e.g., gay, Catholic, working-class); in the case of Warhol to camp or to clone images of Elvis, Troy, Warren, Marlon, and other most wanted men in terms of gay desire (on this point see Richard Meyer, "Warhol's Clones," *The Yale Journal of Criticism*, vol. 7, no. 1 [1994]). To use a notion like "mass subject," then, is not necessarily to massify the subject, to disallow personal and/or group appropriations. In fact the Factory was a virtual factory of such reinventions. For another analysis of some of these problems, see Christopher Phillips, "Desiring Machines," in *Public Information: Desire, Disaster, Document*, ed. Gary Garrels (San Francisco: MOMA, 1995). (The two Ballard texts are collected in *The Atrocity Exhibition* [London: Jonathan Cape, 1969].)
48. Ronnie Cutrone quoted in Trevor Fairbrother, "Skulls," in *The Work of Andy Warhol*, ed. Gary Garrels (Seattle: Bay Press, 1989), p. 96. This is the best text I know on the theme of death in Warhol.

Mao. *1972.*

Skull. *1976.*

was doing must have been Death. It was Christmas or Labor Day—a holiday—and every time you turned on the radio they said something like, "4 million are going to die." That started it.[49]

But started what exactly? Nine years later Warhol returned to this question:

> Actually you know it wasn't the idea of accidents and things like that. . . . I thought of all the people who worked on the pyramids and . . . I just always sort of wondered what happened to them . . . well it would be easier to do a painting of people who died in car crashes because sometimes you know, you never know who they are.[50]

This implies that his primary concern was not disaster and death but the mass subject, here in the guise of the anonymous victims of history, from the drones of the pyramids to the statistical DOAs at the hospitals.[51] Yet disaster and death were necessary to evoke this subject, for in a spectacular society the mass subject often appears as an *effect* of the mass media (the newspaper, the radio), or of a catastrophic failure of technology (the plane crash), or, more precisely, of both (the *news* of such a catastrophic failure). Along with icons of celebrity like the *Marilyns* or the *Maos,* reports of disastrous death like "129 Die" is a primary way that mass subjectivity is made.[52]

Now even as the mass subject may worship an idol only to gloat over his or her fall, so too it may mourn the dead in a disaster only to be warmed by the bonfire of these bodies. In "The Storyteller" (1936) Benjamin suggests that this is one service performed by the novel—to stir anonymous readers with a singular death—and I want, through Warhol, to suggest that media news offers a contemporary version of this mass warming.[53] Here, again, in its guise as witness the mass subject reveals its sadomasochistic aspect, for this subject is often split in relation to a disaster: even as he or she may mourn the victims, even identify with them masochistically, he or she

49. Swenson, "What Is Pop Art?" p. 60. It is at this point that Warhol remarks, "But when you see a gruesome picture over and over again, it doesn't really have any effect." And yet this particular image from 1962 is not repeated, and with the blackened wing become a deathly scythe Warhol heightens its grim fatality.
50. David Bailey, *Andy Warhol: Transcript* (London, 1972), quoted by Buchloh in "Andy Warhol's One-Dimensional Art," p. 53. Here, perhaps, there is a point of contact, however inadvertent, with Brecht; see, for example, his poem "The Worker Reads History."
51. Warhol captures the catastrophic version of contemporary death, in which "death is no longer the culminating experience of a life rich in continuity and meaning but, instead, pure discontinuity, disruption—pure chance or accident—the result of being in the wrong place at the wrong time" (Doane, "Information, Crisis, Catastrophe," p. 233).
52. "Disaster is popular, as it were," Warner writes, "because it is a way of making mass subjectivity available, and it tells us something about the desirability of that mass subject" ("The Mass Public," p. 248). What are the different effects of the different mediations (newspaper, radio, network television, satellite and cable news, Internet) of modern disaster? For example, what is the difference in subject-effect between readings of the *Titanic* sinking and viewings of the *Challenger* exploding? Is the first as given over to compulsive repetitions, to the *jouissance* of the death drive, as the second?
53. "What draws the reader to the novel," Benjamin writes, "is the hope of warming his shivering life with a death he reads about" (*Illuminations*, p. 101).

129 Die in Jet (Plane Crash). *1962.*

may also be thrilled, sadistically, that there *are* victims of whom he or she is *not* one. (There is a triumphalism of the survivor that the trauma of the witness does not cancel out.)[54] Paradoxically, perhaps, this sadomasochistic aspect helps the mass subject cohere as a collectivity. For the death of the old body politic did not only issue in the return of the total leader or the rise of the spectacular star; it also led to the birth of *the psychic nation*, that is, to a mass-mediated polis that is not only convoked around calamitous events (like the Rodney King beating or the Oklahoma City bombing) but also addressed, polled, and reported as a traumatic subject (the generations that share the JFK assassination, the Vietnam War, and so on).[55] Warhol was interested in this strange avatar of the mass subject; it is a shame he did not live to see the golden age of hysterical talk shows and lurid murder trials.

For the most part Warhol evoked the mass subject in two opposite ways: through iconic celebrity and abstract anonymity.[56] But he came closest to this subject through a compromise-representation somewhere between celebrity and anonymity, that is, through the figure of *notoriety*, the fame of fifteen minutes. For me his best representation of the mass subject is an implicit double-portrait: the

54. This point may bear on the guilty implication that a mass subject may feel in relation to a disaster—that he or she has somehow participated in it, even indirectly caused it, as a spectator. Sometimes a disaster prompts a confusion of cause and effect, let alone of public and private, that is difficult to register *except as a reversal*, in which the subject—paranoically and pathetically—feels that he or she has dictated the event, or at least colluded in its fixing. Consider the superstitions of sports fans, who gyrate in front of televisions so that a catch be made, a putt sunk, or who turn off the game lest the hero fail, the team lose. (I am indebted to Christopher Pye for this example of reversal.)

55. Again, the difference is this: a shock may be instantaneous; a trauma takes time to produce (see note 30). This convoking of a mass subject through shock may be easier to register at the level of the city. To be a witness in New York in the 1980s, for example, was to lurch from one fatal event to another (from Lisa Steinberg to Jennifer Levin, say, from Howard Beach to Bensonhurst), events usually marked by extreme violations of difference—generational, sexual, and/or ethnic. These events wired New Yorkers, shocked them into a collectivity of (dis)identification, which is a role that New York long played for the rest of the psychic nation. This part has now passed in part to Los Angeles, the city that, outside of Hollywood Babylon, was long imagined to be free of such events.

The term "psychic nation" may be too slippery to define, let alone to locate. The "psychification" of the nation is an old tendency in cultural criticism, from the "nervous" 1880s to the "narcissistic" 1970s and the "schizophrenic" 1980s. I do not intend an analogy, much less an equivalence, between psyche and nation. Rather I see the presumed commutability of the two as another symptom of a breakdown between private and public (which is also difficult to define, let alone to locate). There is also the question of the technological mediation of the psychic nation: again, how does this kind of collectivity change with different media? And when does it exceed the national as a matter of course? This question may point to a difference between the early 1960s and the middle 1990s. In an almost sociological way Warhol could use certain images to represent "death in America" for a show in Paris, with the assumption that these images would not be known there, and that American types of death were somehow distinctive. Today images of the carnage of the Oklahoma City bombing (or, for that matter, of the Sarajevo shelling) are broadcast internationally: the nation is hardly a boundary of the psychic collectivity effected by disaster and death. Indeed, not long after the early 1960s "death in America" might just as well signal death in Vietnam. Perhaps it was then, with the television reportage of the war, that the national boundary was definitively transgressed. In any case it is significant that Warhol tended to steer clear of these war images and indeed of television images.

56. These are opposite but not opposed, for most celebrities are so constructed in the social as to appear characterless if not anonymous.

most wanted man and the empty electric chair, the first a kind of modern icon, the second a kind of modern crucifix.[57] What more exact representation of the pathological public sphere than this twinning of iconic mass murderer and abstract state execution? That is, what more difficult image? When Warhol made his *Thirteen Most Wanted Men* for the 1964 World's Fair in New York, power—men like Robert Moses and Philip Johnson, who not only designed the society of the spectacle but also represented it as the fulfillment of the American dream of success and self-rule—could not tolerate it.[58] As is well known, Warhol was ordered to cover up the image (which he did with his signature silver paint), and Moses was not amused when Warhol offered to substitute a portrait of Moses.

In a sense the notoriety of the most wanted man is not so different from the notoriety of Warhol. For, again, he not only incarnated the mass subject as witness; he also instantiated the mass object as icon. This double status allowed Warhol to mediate between the two as well as he did; but it also suspended him between the iconicity of celebrity and the abstraction of anonymity. Perhaps it was this in-between position that made for his strange presence, at once very marked, even targeted (he was an easy celebrity to spot, a trait that advertisers came to exploit), and very white, even spectral (he was never *quite* there when he was *just* there on the street). Warhol emanated a flat uncanniness—as if he were his own double, his own stand-in.[59] As both witness and icon, voyeur and exhibitionist, he often seemed caught in a cross fire of gazes, which is to say that he too became an object of the sadomasochism of the mass subject. "In the figures of Elvis, Liz, Michael, Oprah, Geraldo, Brando, and the like," Warner writes, "we witness and transact the bloating, slimming, wounding, and general humiliation of the public body. The bodies of these public figures are prostheses for our own mutant desirability."[60] Even as he represented these figures, Warhol became one of them—a status that he both wanted desperately and refused quasi-autistically (no prosthesis of desirability he).

Perhaps, finally, it was this status as a star that set him up to be shot. For stars are products of our own light projected above us, and often we come to feel that they influence us (etymologically: flow into us) too much. As Warhol must have

57. Traces of churchly art are everywhere in Warhol: the gold relics of the shoe ads, the shrines to Marilyn and others, the Vanitas skulls, the patron portraits, and so on. (I am indebted to Peter Wollen for the association of electric chair and crucifix.)
58. Even though these criminals fulfill this dream too, equal (if opposite) to any other top ten (or thirteen) list: the richest, the best dressed, and so on. On this point see Sidra Stich, "The American Dream/The American Dilemma," in *Made in USA: An Americanization in Modern Art, the '50s and '60s* (Berkeley: University of California Press, 1987), p. 177.
59. Barthes: "Pop art rediscovers the theme of the Double . . . but [it] is harmless—has lost all maleficent or moral power . . . the Double is a Copy, not a Shadow: *beside*, not *behind*: a flat, insignificant, hence irreligious Double" ("That Old Thing, Art," p. 24). Perhaps any encounter with a celebrity produces a degree of this flat uncanniness.
60. Warner, "The Mass Public," p. 250.

Thirteen Most Wanted Men No. 11,
John Joseph H. *1964.*

Silver Disaster. *1963.*

sensed, this star-production can pass beyond the sadomasochistic to the paranoid: the relation to the star becomes a problem of distance (the star is too far from us, or too close) that is a problem of control (the star has too little, or too much, over us). Sometimes this conflict is only ended with the fall of the star; once in a while the mass subject is driven to shoot the star down—to eject this ideal double from the blinded self. Such, it seems, was the case with Mark David Chapman vis-à-vis John Lennon in December 1980. Perhaps a similar imperative drove Valerie Solanis, a frustrated hanger-on of the Factory, to shoot Warhol in June 1968.

In lieu of a conclusion I will end where I began, with the *The Philosophy of Andy Warhol*. This final monologue touches on most of my concerns here: a traumatic notion of the real, a contemporary version of the optical unconscious, a historical confusion between private fantasy and public reality, a hysterical relay between mass subject and mass object, a forging of a psychic nation through mass-mediated disaster and death:[61]

> Before I was shot, I always thought that I was more half-there than all-there—I always suspected that I was watching TV instead of living life. People sometimes say the way things happen in movies is unreal, but actually it's the way things happen to you in life that's unreal. The movies make emotions look so strong and real, whereas when things really do happen to you, it's like watching television—you don't feel anything.
>
> Right when I was being shot and ever since, I knew that I was watching television. The channels switch, but it's all television. When you're really involved with something, you're usually thinking about something else. When something's happening, you fantasize about other things. When I woke up somewhere—I didn't know it was at the hospital and that Bobby Kennedy had been shot the day after I was—I heard fantasy words about thousands of people being in St. Patrick's Cathedral praying and carrying on, and then I heard the word "Kennedy" and that brought me back to the television world again because then I realized, well, here I was, in pain.

61. This statement appears on p. 91 of *The Philosophy*. It also touches on a few related concerns that I have not much developed here: the dialectic of media and technology as both shock and shield for the subject, the complication in trauma of causality and temporality, the irreducibility of the body in pain. As for the first point, also see this statement in *The Philosophy*: "The acquisition of my tape recorder really finished whatever emotional life I might have had, but I was glad to see it go. . . . During the '60s, I think, people forgot what emotions were supposed to be. And I don't think they've ever remembered. I think that once you see emotions from a certain angle you can never think of them as real again. That's what more or less has happened to me" (pp. 26–27).

Richard Misrach. Playboy #38
(Warhol). *1990.*

Spectacle/Institutional Critique

Aesthetics and Anaesthetics:
Walter Benjamin's Artwork
Essay Reconsidered*

SUSAN BUCK-MORSS

I

Walter Benjamin's essay "The Work of Art in the Age of Mechanical Reproduction"[1] is generally taken to be an affirmation of mass culture and of the new technologies through which it is disseminated. And rightly so. Benjamin praises the cognitive, hence political, potential of technologically mediated cultural experience (film is particularly privileged).[2] Yet the closing section of this 1936 essay reverses the optimistic tone. It sounds a warning. Fascism is a "violation of the technical apparatus" that parallels fascism's violent "attempt to organize the newly proletarianized masses"—not by giving them their due, but by "allowing them to express themselves."[3] "The logical result of Fascism is the introduction of aesthetics into political life."[4]

Benjamin seldom makes sweeping condemnations, but here he states categorically: "All efforts to render politics aesthetic culminate in one thing: war."[5] He is writing during the early period of fascist military adventurism—Italy's colonial war in Ethiopia, Germany's intervention in the Spanish Civil War. Yet Benjamin recognizes that the aesthetic justification of this policy was already in place at the century's start. It was the Futurists who, just before World War I,

* I am grateful to Joan Sage for her help with the photographs for this piece.
1. This is the now-conventional English translation (see Harry Zohn, trans., *Illuminations*, ed. Hannah Arendt [New York: Schocken Books, 1969]). The literal translation of the German title is significantly different: "The Artwork in the Age of its Technological Reproducibility (*technischen Reproduzierbarkeit*)." I have sidestepped the problem by using a shortened form: Artwork essay.
2. The best reading of Benjamin's Artwork essay remains Miriam Hansen's essay, "Benjamin, Cinema and Experience: 'The Blue Flower in the Land of Technology,'" *New German Critique* 40 (Winter 1987).
3. "The masses have the right to a change in property relations; Fascism seeks to give them a form of expression in the preservation of these relations" (Benjamin, *Illuminations*, p. 241, trans. modified).
4. Ibid.
5. Ibid.

first articulated the cult of warfare as a form of aesthetics. Benjamin cites their manifesto:

> War is beautiful because it establishes human domination over the subjugated machinery, thanks to the gas masks, the terror-producing megaphones, the flame-throwers, the small tanks. War is beautiful because it initiates the dreamt of metalization of the human body. War is beautiful because it enriches a flowering meadow with the fiery orchids of machine guns. War is beautiful because it fuses gunfire, cannonades, cease-fires, the scents and stench of putrefaction into a symphony. War is beautiful because it creates the new architectural form of big tanks, geometrical flight formations, smoke spirals from burning villages . . .[6]

Benjamin concludes:

> *Fiat ars—pereat mundus"* [create art—destroy the world],[7] says Fascism, and expects war to supply, just as Marinetti confesses that it does, the artistic gratification of a sense perception that has been altered by technology. This is the obvious perfection of *l'art pour l'art.* Humanity that, according to Homer, was once an object of spectacle [*Schauobjekt*] for the Olympian gods, now is one for itself. Its self-alienation has reached such a degree that it is capable of experiencing [*erleben*] its own destruction as an aesthetic enjoyment [*Genuss*] of the highest order. So it is with the aestheticization of politics, which is being managed by fascism. Communism responds with the politicization of art.[8]

This paragraph has haunted me for the twenty-odd years I have been reading the Artwork essay—a period when politics as spectacle (including the aestheticized spectacle of war) has become a commonplace in our televisual world. Benjamin is saying that sensory alienation lies at the source of the aestheticization of politics, which fascism does not create, but merely "manages" (*betreibt*). We are to assume that both alienation and aestheticized politics as the sensual conditions of modernity outlive fascism—and thus so does the enjoyment taken in viewing our own destruction.

The Communist response to this crisis is to "politicize art," implying—what? Surely Benjamin must mean more than merely to make culture a vehicle

6. Ibid., p. 242 (trans. modified).
7. A distortion of the Baroque original: "Create justice, transform the world," the electoral promise of Emperor Ferdinand I (1563). See Walter Benjamin, *Gesammelte Schriften* I:3, ed. Rolf Tiedemann and Hermann Schweppenhaeuser (Frankfurt a.M.: Suhrkamp Verlag, 1974), p. 1055.
8. Benjamin, *Illuminations*, p. 242 (trans. modified).

for Communist propaganda.[9] He is demanding of art a task far more difficult —that is, to *undo* the alienation of the corporeal sensorium, to *restore the instinctual power of the human bodily senses for the sake of humanity's self-preservation,* and to do this, not by avoiding the new technologies, but by *passing through* them.

The problem of interpreting the closing section of Benjamin's text lies in the fact that, halfway through this final thought (aestheticized politics, politicized art), Benjamin changes the constellation in which his conceptual terms (politics, art, aesthetics) are deployed, and hence their meaning. If we were really to "politicize art" in the radical way he is suggesting, art would cease to *be* art as we know it. Moreover, the key term "aesthetics" would shift its meaning one hundred and eighty degrees. "Aesthetics" would be transformed, indeed, redeemed, so that, ironically (or dialectically), *it* would describe the field in which the antidote to fascism is deployed as a political response.

This point may seem trivial, or unnecessarily sophistic. But if it is allowed to develop, it changes the entire conceptual order of modernity. That is my claim. Benjamin's critical understanding of mass society disrupts the tradition of modernism (far more radically, incidentally, than does his contemporary, Martin Heidegger) by exploding the constellation of art, politics, and aesthetics into which, by the twentieth century, this tradition has congealed.

II

What I will *not* try to do is to take you through the whole history of Western metaphysics in order to demonstrate the permutations of this constellation in terms of the inner-historical development of philosophy, a decontextualized "life of the mind." Others have done this with sufficient brilliance to make clear the unfruitfulness of this approach for the problem with which we are dealing, because it presumes just that continuity in cultural tradition which Benjamin wanted to explode.[10]

9. Otherwise, the two conditions, crisis and response, would turn out to be the same. Once art is drawn into politics (Communist politics no less than Fascist politics), how could it help but put itself into its service, thus to render up to politics its own artistic powers, i.e., "aestheticize politics"?
10. Heidegger has been particularly concerned with the philosophical wanderings of the key term "aesthetics" in Western philosophy (see, e.g., his lectures from 1936/37—contemporaneous with Benjamin's essay—*Nietzsche: Der Wille zur Macht als Kunst,* vol. 43 of Martin Heidegger, *Gesammtausgabe II: Abteilung: Vorlesungen, 1923–76* [Frankfurt a.M.: Vittorio Klostermann, 1985). For a provocatively critical, contextualized account of the discourse of "aesthetics" within the modern era of European culture, see Terry Eagleton, *The Ideology of the Aesthetic* (London: Basil Blackwell, 1990). For an excellent intellectual history of the connection between aesthetics and politics in German thought that stresses the importance of Hellenism in general and of Winckelmann in particular (omitted from Eagleton's account), the idea of the Greeks as an "aesthetic" and "cultural" people in contrast to material and imperial Rome, see Josef Chytry, *The Aesthetic State: A Quest in Modern German Thought* (Berkeley: University of California Press, 1989).

But it *will* be helpful to recall the original etymological meaning of the word "aesthetics," because it is precisely to this origin that, via Benjamin's revolution, we find ourselves returned. *Aisthitikos* is the ancient Greek word for that which is "perceptive by feeling." *Aisthisis* is the sensory experience of perception. The original field of aesthetics is not art but reality—corporeal, material nature. As Terry Eagleton writes: "Aesthetics is born as a discourse of the body."[11] It is a form of cognition, achieved through taste, touch, hearing, seeing, smell—the whole corporeal sensorium. The terminae of all of these—nose, eyes, ears, mouth, some of the most sensitive areas of skin—are located at the surface of the body, the mediating boundary between inner and outer. This physical-cognitive apparatus with its qualitatively autonomous, nonfungible sensors (the ears cannot smell, the mouth cannot see) is "out front" of the mind, encountering the world prelinguistically,[12] hence prior not only to logic but to meaning as well. Of course all of the senses can be acculturated—that is the whole point of philosophical interest in "aesthetics" in the modern era.[13] But however strictly the senses are trained (as moral sensibility, refinement of "taste," sensitivity to cultural norms of beauty), all of this is *a posteriori*. The senses maintain an uncivilized and uncivilizable trace, a core of resistance to cultural domestication.[14] This is because their immediate purpose is to serve instinctual needs—for warmth, nourishment, safety, sociability[15]—in short, they remain a part of the biological apparatus, indispensable to the self-preservation of both the individual and the social group.

III

So little does aesthetics have to do intrinsically with the philosophical trinity of Art, Beauty, and Truth that one might rather place it within the field of

11. Eagleton, *Ideology of the Aesthetic*, p. 13. Eagleton is dealing with the historical birth of aesthetics as a modern discourse (specifically, in the work of the mid-eighteenth-century German philosopher Alexander Baumgarten), and describes the political implications of this anti-Cartesian focus on the "dense, swarming territory" outside of the mind that comprises "nothing less than the whole of our sensate life together," as the "first stirrings of a primitive materialism—of the body's long inarticulate rebellion against the tyranny of the theoretical" (p. 13).

12. This was its meaning for Baumgarten, who first developed the "aesthetic" as an autonomous thematic in philosophy. Yet Eagleton is correct to note that the affirmation of sense experience is short-lived in Baumgarten's theory: "If his *Aesthetica* (1750) opens up in an innovative gesture the whole terrain of sensation, what it opens it up to is in effect the colonization of reason" (Eagleton, *Ideology of the Aesthetic*, p. 15).

13. See, e.g., Rousseau's discussion of the education of the senses in *Emile*.

14. Baumgarten distinguishes between *aesthetica artificialis* (to which he devotes the majority of his text) and *aesthetica naturalis*, as it is observed in children's play.

15. Sociability is not only a historico-cultural category, but a part of our "nature." That much must be granted to sociobiology (and to Aristotle and Marx, for that matter). The mistake is to presume that today's societies are accurate expressions of this biological instinct. It could be argued, for example, that precisely in its most biological aspect (reproduction of the species), the privatized family is unsocial.

animal instincts.[16] This is, of course, just what made philosophers suspicious of "the aesthetic." Even as Alexander Baumgarten articulated "aesthetics" for the first time as an autonomous field of inquiry, he was aware that "one could accuse him of concerning himself with things unworthy of a philosopher."[17]

Just how it happened that, within the course of the modern era, the term "aesthetics" underwent a reversal of meaning so that in Benjamin's time it was applied first and foremost to art—to cultural forms rather than sensible experience, to the imaginary rather than the empirical, to the illusory rather than the real—is not self-evident. It demands a critical, exoteric explanation of the socioeconomic and political context in which the discourse of the aesthetic was deployed, as Terry Eagleton has recently demonstrated in *The Ideology of the Aesthetic*. Eagleton traces the ideological implications of this concept during its checkered career in the modern era—how it bounces like a ball among philosophical positions, from its critical-materialist connotations in Baumgarten's original articulation, to its class-based meaning in the work of Shaftesbury and Burke as an aesthetics of "sensibility," an aristocratic moral style, and thence to Germany. There, throughout the tradition of German idealism, it was recognized with varying degrees of caution as a legitimate cognitive mode, yet evermore fatally connected with the sensuous, the heteronomous, the fictitious, only to end up in the neo-Kantian schemata of Habermas as (to cite Fredric Jameson) "a kind of sandbox to which one consigns all those vague things . . . under the heading of the irrational . . . [where] they can be monitored and, in case of need, controlled (the aesthetic is in any case conceived as a kind of safety valve for irrational impulses)."[18]

The story is quite incredible, really, particularly when one considers the leitmotif that runs through all of these alterations, the ground from which the "aesthetic" pushes forth in its various forms. It is the motif of autogenesis, surely one of the most persistent myths in the whole history of modernity (and of Western *political* thought before then, one might add).[19] Doing one better

16. Again, the relation is dialectical: if neither the individual nor the social ever exists as "nature," but always only as "second nature" (hence, culturally constructed), it is equally true that neither the "individual" nor the "social" enters into the culturally constructed world without leaving a remainder, a biological substrate that can provide the basis for resistance.

17. Benedetto Croce, cited in Hans Rudolf Schweizer, *Aesthetik als Philosophie der Sinnlichen Erkenntnis* (Basil: Schwabe and Co., 1973), p. 33. Schweizer claims, against Croce, that Baumgarten was not overly concerned or apologetic, and that the real bias against the aesthetic is a later development.

18. Fredric Jameson, *Late Marxism: Adorno, or, the Persistence of the Dialectic* (New York: Verso, 1990), p. 232.

19. The "birth" of the Greek polis is attributed precisely to the wondrous idea that man can produce himself *ex nihilo*. The polis becomes the artifact of "man," in which he can bring forth, as a material reality, his own higher essence. Similarly, Machiavelli wrote in praise of the Prince who self-creatively founds a new principality, and connects this autogenetic act with the height of manliness.

than Virgin birth, modern man, *homo autotelus,* literally produces himself, generating himself, to cite Eagleton, "miraculously out of [his] own substance."[20]

What seems to fascinate modern "man" about this myth is the narcissistic illusion of total control. The fact that one can *imagine* something that *is* not, is extrapolated in the fantasy that one can (re)create the world according to plan (a degree of control impossible, for example, in the creation of a living, breathing child). It is the fairy-tale promise that wishes are granted—without the fairy tale's wisdom that the consequences can be disastrous. It must be admitted that this myth of creative imagination has had salutary effects, as it is intimately entwined with the idea of freedom in Western history. For that reason (an excellent reason), it has been staunchly defended and highly praised.[21]

Yet present feminist consciousness in scholarship has revealed how fearful of the biological power of women this mythic construct can be.[22] The truly autogenetic being is entirely self-contained. If it has any body at all, it must be one impervious to the senses, hence safe from external control. Its potency is in its lack of corporeal response. In abandoning its senses, it, of course, gives up sex. Curiously, it is precisely in this castrated form that the being is gendered male—as if, having nothing so embarrassingly unpredictable or rationally uncontrollable as the sense-sensitive penis, it can then confidently claim to *be* the phallus. Such an asensual, *an*aesthetic protruberance is this artifact: modern man.

Consider Kant on the sublime. He writes that, faced with a threatening and menacing nature—towering cliffs, a fiery volcano, a raging sea—our first impulse, connected (not unreasonably) to self-preservation,[23] is to be afraid. Our *senses* tell us that, faced with nature's might, "our ability to resist becomes an insignificant trifle."[24] But, says Kant, there is a different, more "sensible" (!) standard, which we acquire when viewing these awesome forces from a "safe" place, by which nature is small and our superiority immense:

> Though the irresistibility of nature's might makes us, considered as natural beings, recognize our physical impotence, it reveals in us at the same time an ability to judge ourselves independent of nature,

20. Eagleton, *Ideology of the Aesthetic,* p. 64.
21. See Carlos Castoriades, *The Imaginary Institution of Society,* trans. Kathleen Blamey (Cambridge: MIT Press, 1987).
22. See, for example, the work of Luce Irigaray. For an excellent discussion of the parameters of the feminist debate, see articles by Seyla Benhabib, Judith Butler, and Nancy Frazer in *Praxis International* 2 (July 1991), pp. 137–77.
23. This "first impulse" might, in fact, be considered superior. But Kant writes condescendingly of the Savoyard peasant who, unlike the enraptured bourgeois tourist, "did not hesitate to call anyone a fool who fancies glaciered mountains" (Immanuel Kant, *Critique of Judgement,* trans. Werner S. Pluhar [Indianapolis: Hackett, 1987], p. 124).
24. Kant, *Critique of Judgement,* pp. 120–21. Again, from an ecological perspective, this is not a foolish response.

and reveals in us a superiority over nature that is the basis of a self-preservation quite different in kind. . . .[25]

It is at this point in the text that the modern constellation of aesthetics, politics, and war congeals, linking the fate of those three elements. Kant's example of the man most worthy of respect is the warrior, impervious to all his sense-giving information of danger. "Hence, no matter how much people may dispute, when they compare the statesman with the general, as to which one deserves the superior respect, an aesthetic [*sic*] judgment decides in favor of the general."[26] *Both* statesman and general are held by Kant in higher "aesthetic" esteem than the artist, as both, in shaping *reality* rather than its representations, are mimicking the autogenetic prototype, the nature- and self-producing Judeo-Christian God.

If in the Third Critique the "aesthetic" in judgments is robbed of its senses, in the Second Critique the senses play no role at all. The moral being is sense-dead from the start. Again, Kant's ideal is autogenesis. The moral will, cleansed of any contamination by the senses (which, in the First Critique, are the source of all cognition), sets up its own rule as a universal norm. Reason produces itself in Kant's morality—the most "sublimely" when one's own life is sacrificed to the idea.

"The further Kant goes," Ernst Cassirer writes, "the more he rids himself . . . of the prevailing sentimentality" of the "Age of Sensibility."[27] To be historically accurate, it should be acknowledged that this sensibility, influenced enormously by Johann Winckelmann's conception of Hellenism, was homophilic. It affirmed the aesthetic beauty, first and foremost, of the *male* body. Indeed, homoerotic sensuality may have been even more threatening to the emerging modernist psyche than the reproductive sexuality of women.[28] Kant's transcendental subject purges himself of the senses which endanger autonomy not only because they unavoidably entangle him in the world, but, specifically, because they make him passive ("languid" [*schmelzend*] is Kant's word) instead of active ("vigorous" [*wacker*]),[29] susceptible, like "Oriental voluptuaries,"[30] to sympathy and tears. Cassirer writes that this was

the reaction of Kant's completely virile way of thinking to the effeminacy and over-softness that he saw in control of all around him. It

25. Ibid.
26. Ibid., pp. 121–22.
27. Ernst Cassirer, *Kant's Life and Thought*, trans. James Haden, intro. Stephan Körner (New Haven: Yale University Press, 1981), p. 269.
28. Was it merely a coincidence that Kant praised as sublime precisely those Swiss alps, the size and precipitous appearance of which so appalled Winckelman that, upon coming within sight of them in 1768, he abandoned his planned return to Germany and turned back to Italy?
29. Kant, *Critique of Judgement*, p. 133.
30. Ibid., p. 134.

is in this sense, in fact, that he came to be understood. . . . Not only Schiller, who explicitly lamented in a letter to Kant that he had momentarily taken on the "aspect of an opponent," but Wilhelm von Humbolt, Goethe, and Hölderlin also concur in this judgment. Goethe extols as Kant's "immortal service" that he released morality from the feeble and servile estate into which it had fallen, through the crude calculus of happiness, and thus "brought us all back from the effeminacy [*Weichlichkeit*] in which we were wallowing."[31]

The theme of the autonomous, autotelic subject as sense-dead, and for this reason a *manly* creator, a self-starter, sublimely self-contained,[32] appears throughout the nineteenth century—as does the association of the "aesthetics" of this creator with the warrior, and hence with war. At the end of the century, with Nietzsche, there is a new affirmation of the body, but it remains self-contained, taking the highest pleasure in its own biophysical emanations. Nietzsche's ideal of the artist-philosopher, the embodiment of the Will to Power, manifests the elitist values of the warrior,[33] perhaps "so far distant from other men that he can form them."[34] This combination of autoerotic sexuality and wielding power over others is what Heidegger calls Nietzsche's "*Mannesaesthetik*."[35] It is to replace what Nietzsche himself calls "*Weibesaesthetik*"[36]—"female aesthetics" of receptivity to sensations from the outside.

One could go on documenting this solopsistic—and often truly silly—fantasy of the phallus, this tale of all-male reproduction, the magic art of *creation ex nihilo*. But, although the theme will return below, I want to argue for the philosophical fruitfulness of a different approach, one more in line with Benjamin's own method in the Artwork essay. And that is to trace the development, not of the meaning of terms, but of the human sensorium itself.

31. Cassirer, *Kant's Life and Thought,* p. 270. Cassirer is citing Goethe's comment to Chancellor von Muller, April 1818. (The translation in Cassirer's book is more strongly gendered than Goethe's text. Thanks to Alexandra Cook for pointing this out.) Goethe's famous study of Winckelmann (1805) praises him for living a life close to the ancient Hellenic ideal. This included, explicitly, his sensual relationships with beautiful young men. It was Kant's *Critique of Judgement* that "captivated" Goethe (Cassirer, p. 273).
32. "To be sufficient to oneself and hence have no need of society, yet without being unsociable, i.e., without shunning society, is something approaching the sublime, as is any case of setting aside our needs" (*Critique of Judgement,* p. 136).
33. The work of warriors "is an instinctive creation and imposition of forms . . . they do not know what guilt, responsibility or consideration are . . . they exemplify that terrible artists' egoism that . . . knows itself justified to all eternity in its 'work,' like a mother in her child" (Nietzsche, cited in Eagleton, p. 237).
34. Friedrich Nietzsche, *The Will to Power,* trans. Walter Kaufmann and R. J. Hollingdale (New York: Random House, 1967), p. 419.
35. Heidegger, *Nietzsche,* pp. 91–92. The dichotomy of terms does not appear in Nietzsche's text.
36. Nietzsche, *Will to Power,* p. 429.

Brain of Sonja Kovalevskaya, Russian mathematician (1840–1901).

IV

The senses are effects of the nervous system, composed of hundreds of billions of neurons extending from the body surfaces through the spinal cord, to the brain. The brain, it must be said, yields to philosophical reflection a sense of the uncanny. In our most empiricist moments, we would like to take the matter of the brain itself for the mind. (What could be more appropriate than the brain studying the brain?) But there seems to be such an abyss between us, alive, as we look out on the world, and that gray-white gelatinous mass with its cauliflower-like convolutions that *is* the brain (the biochemistry of which does not differ qualitatively from that of a sea slug) that, intuitively, we resist naming them as identical. If this "I" who examines the brain were nothing *but* the brain, how is it that I feel so uncomprehendingly alien in its presence?[37]

Hegel thus has intuition on his side in his attacks against the brain-watchers. If you want to understand human thought, he argues in *The Phenomenology of Mind,* don't place the brain on a dissecting table, or feel the bumps on the head for phrenological information. If you want to know what the mind is, examine what it *does*—thus turning philosophy away from natural science to

37. Modern philosophers have quite persistently refused to conflate the brain with the "mind" (alias ego, *ame, Seele,* soul, subject, *Geist*). Descartes gave the soul protection from the "body machine" of the brain-nerves-muscles by locating it in "a certain extremely small gland" suspended in the middle of the brain (see *The Passions of the Soul*). Kant's transcendental consciousness of the self manages to bypass the brain from the start.

Vincent Van Gogh. Pollard Birches. *1885.*

the study of human culture and human history. The two discourses henceforth went separate ways: philosophy of the mind and physiology of the brain remained, for the most part, as blind to the activities of one another as the two hemispheres of a "split-brain" patient are oblivious to the operations of each other—arguably, to the detriment of both.[38]

The nervous system is not contained within the body's limits. The circuit from sense-perception to motor response begins and ends in the world. The brain is thus not an isolable anatomical body, but part of a system that passes through the person and her or his (culturally specific, historically transient) environment. As the source of stimuli and the arena for motor response, the external world must be included to complete the sensory circuit. (Sensory deprivation causes the system's internal components to degenerate.) The field of the sensory circuit thus corresponds to that of "experience," in the classical philosophical sense of a mediation of subject and object, and yet its very composition makes the so-called split between subject and object (which was the

38. Contemporary brain research, while impressive in its application of new technologies that allow us to "see" the brain in ever-greater detail, has suffered from too little philosophical and theoretical radicalism, while philosophy risks speaking in a language so archaic, given the new empirical discoveries of neuro-science, that it relegates itself to scholastic irrelevance—or simply to myth.
 Recently, there has been an interest in reconnecting the discourses. See, e.g., Patricia Smith Churchland, *Neurophilosophy: Toward a Unified Science of the Mind-Brain* (Cambridge: MIT Press, 1986), J. Z. Young, *Philosophy and the Brain* (New York: Oxford University Press, 1987), and the many books by the prolific author R. M. Young.

Illustration of cells described by Vladimir Betz.

constant plague of classical philosophy) simply irrelevant. In order to differentiate our description from the more limited, traditional conception of the human nervous system which artificially isolates human biology from its environment, we will call this aesthetic system of sense-consciousness, decentered from the classical subject, wherein external sense-perceptions come together with the internal images of memory and anticipation, the "synaesthetic system."[39]

This synaesthetic system is "open" in the extreme sense. Not only is it open to the world through the sensory organs, but the nerve cells within the body form a network that is in itself discontinuous. They reach out toward other nerve cells at points called synapses, where electrical charges pass through the space between them. Whereas in blood vessels a leak is lamentable, in the networks between nerve bundles everything "leaks." Any cross section of the brain levels show this architectonic discontinuity, and the dendrite-like morphology of their extensions. The giant, pyramid-like layer of cells in the brain cortex was first described in 1874 by the Ukrainian anatomist Vladimir Betz.[40] A decade later, coincidentally, Vincent van Gogh, while a mental patient at St. Remy, found this form replicated in the external world.

39. If the "center" of this system is not in the brain, but on the body's surface, then subjectivity, far from bounded within the biological body, plays the role of mediator between inner and outer sensations, the images of perception and those of memory. For this reason, Freud situated consciousness on the surface of the body, decentered from the brain (which he was willing to view as nothing more than large and evolved nerve ganglia).
40. Betz left no illustration of the cells he described and that were named after him.

V

Let us resist for a moment Hegel's abandonment of physiology and follow the neurological inquiry of one of his contemporaries, the Scottish anatomist Sir Charles Bell. Trained in painting as well as surgical medicine, Bell, with great excitement, studied the fifth nerve, the "grand nerve of expression," in the belief that "the countenance is the index of the mind."[41]

The expressive face is, indeed, a wonder of synthesis, as individual as a fingerprint, yet collectively legible by common sense. On it the three aspects of the synaesthetic system—physical sensation, motor reaction, and psychical meaning—converge in signs and gestures comprising a mimetic language. What this language speaks is anything but the concept. Written on the body's surface

41. Cited in Sir Gordon Gordon-Taylor and E. W. Walls, *Sir Charles Bell: His Life and Times* (London: E. & S. Livingstone, 1958), p. 116. In his enthusiasm for the philosophical implications of his discovery, Bell was careless about the physiological ones, with the result that a French colleague preempted him in scientific publication. It led to an unpleasant struggle between them as to who made the discovery first. See Paul F. Cranefield, *The Way In and the Way Out: François Magendie, Charles Bell, and the Roots of the Spinal Nerves* (Mt. Kisco, New York: Futura Publishing, 1974).

The Fifth Nerve. *From Sir Charles Bell,* On the Nerves, *1821*.

as a convergence between the impress of the external world and the express of subjective feeling, the language of this system threatens to betray the language of reason, undermining its philosophical sovereignty.

Hegel, writing *The Phenomenology of Mind* in his Jena study in 1806, interpreted the advancing army of Napoleon (whose cannons he could hear roaring in the distance) as the unwitting realization of Reason. Sir Charles Bell, who, as a field doctor performing limb amputations, was physically present a decade later at the Battle of Waterloo, had a very different interpretation:

> It is a misfortune to have our sentiments at variance with the universal sentiment. But there must ever be associated with the honours of Waterloo, in my eyes, the shocking signs of woe: to my ears, accents of intensity, outcry from the manly breast, interrupted, forcible expressions from the dying—and noisome smells. I must show you my note book [with sketches of those wounded], for . . . it may convey an excuse for this excess of sentiment.[42]

Bell's "excess" of sentiment did not mean emotionalism. He found his "mind calm amidst such a variety of suffering."[43] And it would be grotesque to interpret "sentiment" in this context as having anything to do with "taste." The excess was one of perceptual acuity, material awareness that ran out of the control of conscious will or intellection. It was not a psychological category of sympathy or compassion, of understanding the other's point of view from the perspective of intentional meaning, but, rather, physiological—a sensory mimesis, a response of the nervous system to external stimuli which was "excessive" because what he apprehended was *un*intentional, in the sense that it resisted intellectual comprehension. It could not be given meaning. The category of rationality could be applied to these physiological perceptions only in the sense of rationalization.[44]

42. Sir Charles Bell, cited in Leo M. Zimmerman and Ilza Veith, *Great Ideas in the History of Surgery*, 2nd ed., rev. (New York: Dover, 1967), p. 415.
43. "It was a strange thing to feel my clothes stiff with blood, and my arms powerless with the exertion of using the knife; and more extraordinary still, to find my mind calm amidst such a variety of suffering. But to give one of these objects access to your feelings was to allow yourself to be unmanned [*sic*] for the performance of a duty. It was less painful to look upon the whole, than to contemplate one" (cited in Zimmerman and Veith, p. 414).
44. Later in his life Bell was to endow this resistance with at least a weak theological meaning, as he described his aversion to animal vivisection, even when he acknowledged its great value to the progress of the art of medicine and practice of surgery: "I should be writing a third paper on the Nerves, but I cannot proceed without making some experiments, which are so unpleasant to make that I defer them. You may think me silly, but I cannot perfectly convince myself that I am authorized in nature, or religion, to do these cruelties—for what?—for anything else than a little egotism or self-aggrandizement; and yet, what are my experiments in comparison with those which are daily done? and are done daily for nothing" (Gordon-Taylor and Walls, *Sir Charles Bell*, p. 111). Note that this comment was made only after he had already dissected, e.g., the nerves of the face of a live ass.

VI

Walter Benjamin's understanding of modern experience is neurological. It centers on shock. Here, as seldom elsewhere, Benjamin relies on a specific Freudian insight, the idea that consciousness is a shield protecting the organism against stimuli—"excessive energies"[45]—from without, by preventing their retention, their impress as memory. Benjamin writes: "The threat from these energies is one of shocks. The more readily consciousness registers these shocks, the less likely they are to have a traumatic effect."[46] Under extreme stress, the ego employs consciousness as a buffer, blocking the openness of the synaesthetic system,[47] thereby isolating present consciousness from past memory. Without the depth of memory, experience is impoverished.[48] The problem is that under conditions of modern shock—the daily shocks of the modern world—response to stimuli *without* thinking has become necessary for survival.

Benjamin wanted to investigate the "fruitfulness" of Freud's hypothesis, that consciousness parries shock by preventing it from penetrating deep enough to leave a permanent trace on memory, by applying it to "situations far removed from those which Freud had in mind."[49] Freud was concerned with war-neurosis, the trauma of "shell shock" and catastrophic accident that plagued soldiers in World War I. Benjamin claimed this battlefield experience of shock "has become the norm" in modern life.[50] Perceptions that once occasioned conscious reflection are now the source of shock-impulses that consciousness must parry. In industrial production no less than modern warfare, in street crowds and erotic encounters, in amusement parks and gambling casinos, shock is the very essence of modern experience. The technologically altered environment exposes the human sensorium to physical shocks that have their correspondence in

45. Benjamin cites Freud: "For a living organism, protection against stimuli is an almost more important function than the reception of stimuli; the protective shield is equipped with its own store of energy . . . [operating] against the effects of the excessive energies at work in the external world . . ." (*Charles Baudelaire*, trans. Harry Zohn [London: Verso, 1983], p. 115). The text by Freud is *Beyond the Pleasure Principle* (1921), which returns to one of Freud's earliest schemata of the psyche, the 1895 project which he described as a "Psychology for Neurologists," and which was published posthumously as "Entwurf einer Psychologie." The 1921 essay is the only text of Freud that Benjamin considers here.
46. Benjamin, *Baudelaire*, p. 115.
47. The conception of the "synaesthetic system" is compatible with Freud's understanding of the ego as "ultimately derived from bodily sensations, chiefly from those springing from the surface of the body," the place from which "both external and internal perceptions may spring"; the ego "may be thus regarded as a mental projection of the surface of the body" (Freud, *The Ego and the Id* [1923], trans. Joan Rivere [New York: W. W. Norton, 1960], pp. 15 and 16n).
48. "Recollection is . . . an elemental phenomenon which aims at giving us the time for organizing the reception of stimuli which we initially lacked" (Paul Valery, cited in Benjamin, *Baudelaire*, p. 116).
49. Benjamin, *Baudelaire*, p. 114.
50. Ibid., p. 116.

psychic shock, as Baudelaire's poetry bears witness. To record the "breakdown" of experience was the "mission" of Baudelaire's poetry: he "placed the shock experience at the very center of his artistic work."[51]

The motor responses of switching, snapping, the jolt in movement of a machine have their psychic counterpart in the "sectioning of time"[52] into a sequence of repetitive moments without development. The effect on the synaesthetic system[53] is brutalizing. Mimetic capacities, rather than incorporating the outside world as a form of empowerment, or "innervation,"[54] are used as a deflection against it. The smile that appears automatically on passersby wards off contact, a reflex that "functions as a mimetic shock absorber."[55]

Nowhere is mimesis as a defensive reflex more apparent than in the factory, where (Benjamin cites Marx) "workers learn to coordinate their own 'movements to the uniform and unceasing motion of an automaton.'"[56] "Independently of the worker's volition, the article being worked on comes within his range of action and moves away from him just as arbitrarily."[57] Exploitation is here to be understood as a cognitive category, not an economic one: The factory system, injuring every one of the human senses, paralyzes the imagination of the worker.[58] His or her work is "sealed off from experience"; memory is replaced by conditioned response, learning by "drill," skill by repetition: "practice counts for nothing."[59]

Perception becomes experience only when it connects with sense-memories of the past; but for the "protective eye" that wards off impressions, "there is no

51. Ibid., pp. 139, 116–17. "Baudelaire speaks of a man who plunges into the crowd as into a reservoir of electric energy. Circumscribing the experience of shock, he calls this a '*kaleidoscope* equipped with consciousness'" (p. 132).
52. Ibid., p. 139.
53. Benjamin uses the term "synaesthesia" here in connection with the theory of correspondences (ibid., p. 139). He may have been aware that the term is used in physiology to describe a sensation in one part of the body when another part is stimulated; and, in psychology, to describe when a sense stimulus (e.g., color) evokes another sense (e.g., smell). My use of "synaesthetic" is close to these: it identifies the mimetic synchrony between outer stimulus (perception) and inner stimulus (bodily sensations, including sense-memories) as the crucial element of aesthetic cognition.
54. "Innervation" is Benjamin's term for a mimetic reception of the external world, one that is empowering, in contrast to a defensive mimetic adaptation that protects at the price of paralyzing the organism, robbing it of its capacity of imagination, and therefore of active response.
55. Benjamin, *Baudelaire*, p. 133.
56. Ibid. Benjamin continues (quoting *Capital*): "'Every kind of capitalist production . . . has this in common [. . .] that it is not the workman that employs the instruments of labor, but the instruments of labor that employ the workman. But it is only in the factory system that this inversion for the first time acquires technical and palpable reality'" (p. 132).
57. Ibid., p. 133.
58. In the 1844 manuscripts, Marx notes: "The *forming* of the five senses is a labor of the entire history of the world down to the present." For Marx sensory life is "real"; man is to be "affirmed in the active world not only in the act of thinking, but with all his senses." In equating reality with sensory life, it is the materialist, Marx, who "aestheticizes" politics, in the authentic meaning of the term. Benjamin is close to Marx here.
59. Benjamin, *Baudelaire*, p. 133.

daydreaming surrender to faraway things."[60] Being "cheated out of experience" has become the general state,[61] as the synaesthetic system is marshaled to parry technological stimuli in order to protect both the body from the trauma of accident and the psyche from the trauma of perceptual shock. As a result, the system reverses its role. Its goal is to *numb* the organism, to deaden the senses, to repress memory: the cognitive system of synaesthetics has become, rather, one of *an*aesthetics. In this situation of "crisis in perception," it is no longer a question of educating the crude ear to hear music, but of giving it back hearing. It is no longer a question of training the eye to see beauty, but of restoring "perceptibility."[62]

The technical apparatus of the camera, incapable of "returning our gaze," catches the deadness of the eyes that confront the machine—eyes that "have lost their ability to look."[63] Of course, the eyes still see. Bombarded with fragmentary impressions they see too much—and register nothing. Thus the simultaneity of overstimulation and numbness is characteristic of the new synaesthetic organization as *an*aesthetics. The dialectical reversal, whereby aesthetics changes from a cognitive mode of being "in touch" with reality to a way of blocking out reality, destroys the human organism's power to respond politically even when self-preservation is at stake: Someone who is "past experiencing" is "no longer capable of telling . . . proven friend . . . from mortal enemy."[64]

VII

Anaesthetics became an elaborate technics in the latter part of the nineteenth century. Whereas the body's self-anaesthetizing defenses are largely involuntary, these methods involved conscious, intentional manipulation of the synaesthetic system. To the already-existing Enlightenment narcotic forms of coffee, tobacco, tea, and spirits, there was added a vast arsenal of drugs and therapeutic practices, from opium, ether, and cocaine to hypnosis, hydrotherapy, and electric shock.

Anaesthetic techniques were prescribed by doctors against the disease of

60. Ibid., p. 151. Benjamin's observation is in total accord with neurological research. The neurologist Frederick Mettler reports "a contradiction" between the reflective calm necessary to be creative (and to *invent* machines) and the destruction of this calm milieu "by the very machines and increased productivity which the reflective mind creates." He notes that you have merely to be *present* to drive a car, whereas creative reflection is "absent-minded" (*Culture and the Structural Evolution of the Neural System* [New York: The American Museum of Natural History, 1956], p. 51).
61. Benjamin, *Baudelaire*, p. 137.
62. Ibid., pp. 147–48. In this context, film reconstitutes experience, establishing "perception in the form of shocks" as its "formal principle" (p. 132). *How* a film is constructed, whether it breaks through the numbing shield of consciousness or merely provides a "drill" for the strength of its defenses, becomes a matter of central political significance.
63. Ibid., pp. 147–49.
64. Ibid., p. 143.

"neurasthenia," identified in 1869 as a pathological construct.[65] Striking in nineteenth-century descriptions of the effects of neurasthenia is the disintegration of the capacity for experience—precisely as in Benjamin's account of shock. The dominant metaphors for the disease reflect this: "shattered" nerves, nervous "breakdown," "going to pieces," "fragmentation" of the psyche. The disorder was caused by "excess of stimulation" (*sthenia*), and the "incapacity to react to same" (*asthenia*). Neurasthenia could be brought about by "overwork," the "wear and tear" of modern life, the physical trauma of a railroad acccident, modern civilization's "ever-growing tax upon the brain and its tributaries," the "morbid ill effects attributed . . . to the prevalence of the factory system."[66]

Remedies for neuraesthenia might include hot baths or a trip to the seashore, but the most common treatment was drugs. The "chief" of all drugs used for "nervous exhaustion" was opium, because of its twofold impact: "it excites and stimulates for a short time the brain-cells, and then leaves them in a state of tranquility, which is best adapted to their nutrition and repair."[67] Opiates were "the leading children's drug throughout the nineteenth century."[68] Mothers working in factories drugged their children as a form of day-care. Anaesthetics were prescribed as sleeping aids for insomnia and tranquilizers for the insane.[69] Procurement of opiates was unregulated: patent medicines (nerve tonics and painkillers of every sort) were money-making, transnational commodities, traded and sold free of governmental control.[70] Cocaine, first extracted from Peruvian coca in 1859 by the European Albert Niemann, became widely used by the end of the century.[71] Hypodermic syringes were available for subcutaneous injections beginning in the 1860s.[72]

The use of anaesthetics in medical surgery dates, not accidentally,[73] from

65. The term "neurasthenia" was publicized by the New York doctor George Miller Beard. By the 1880s it had taken a prominent place in European discussions. Beard himself suffered from nervous debilitation, and gave himself electrotherapy (shocks) "to replenish exhausted supplies of nerve force" (Janet Oppenheim, *Shattered Nerves: Doctors, Patients and Depression in Victorian England* [New York: Oxford University Press, 1991], p. 120).
66. Cited in Oppenheim, *Shattered Nerves*, pp. 44, 87, 95, 96, 101, 105.
67. Thomas Dowse (1880s), cited in Oppenheim, pp. 114–15.
68. Oppenheim, *Shattered Nerves*, p. 113.
69. Martin S. Pernick, *A Calculus of Suffering: Pain, Professionalism, and Anaesthesia in Nineteenth-Century America* (New York: Columbia University Press, 1985) p. 83.
70. Controls (e.g., England's Pharmacy and Poison Act of 1908) were not passed until the twentieth century.
71. Owen H. Wangensteen and Sarah D. Wangensteen, *The Rise of Surgery: From Empiric Craft to Scientific Discipline* (Minneapolis: University of Minnesota Press, 1978).
72. Oppenheim, *Shattered Nerves*, p. 114.
73. I have not found reference to Charles Bell's practice during surgery, but his French counterpart, Larry, surgeon for Napoleon's army, froze the limbs to be amputated with ice, or knocked the patient unconscious. Larry was willing to experiment with nitrous oxide, which was known in his time, but the suggestion was considered by the majority of the French Royal Academy to border on the criminal (Frederick Prescott, *The Control of Pain* [London: The English Universities Press, 1964], pp. 18–28).

Late-nineteenth-century advertisement for patent medicine.

Caricature of nitrous oxide (ether) frolics. 1808.

this same period of manipulative experimentation with the elements of the synaesthetic system. "Ether frolics," the nineteenth-century version of glue-sniffing, was a party game, in which "laughing gas" (nitrous oxide) was inhaled, producing "voluptuous sensations," "dazzling visible impressions," "a sense of tangible extension highly pleasurable in every limb," "entrancing visions," "a world of new sensations," a new "universe composed of impressions, ideas, pleasures, and pain."[74] It was not until mid-century that the practical implications for surgery were developed. It happened in the United States when, independently, medical students in Georgia and Massachusetts participated in these "frolics." A Georgia surgeon, Crawford W. Long, noted that those bruised during the celebrations felt no pain. At a party in Massachusetts, medical students gave ether to rats in high enough doses to make them immobile, producing total insensibility. Crawford Long used anaesthetics successfully in operations in 1842. In 1844 a Hartford, Connecticut, dentist performed tooth extractions with nitrous oxide. In 1846—in a much more sober, legitimating atmosphere than the "ether frolics"—the first public demonstration of general anaesthesia was given at Massachusetts General Hospital,[75] whence this "wonderful discovery"[76] spread rapidly to Europe.

VIII

It was not uncommon in the nineteenth century for surgeons to become drug addicts.[77] Freud's self-experimentation with cocaine is well known. Elizabeth Barrett Browning was a morphinist from late youth. Samuel Coleridge began his life-long addiction at the age of twenty-four. Charles Baudelaire used opium. By mid-nineteenth century habitual drug-taking was "rampant among the poor," and "spreading" among the "affluent, even among royalty."[78]

Drug addiction is characteristic of modernity. It is the correlate and counterpart of shock. The social problem of drug addiction, however, is not the same as the (neuro)psychological problem, for a drug-free, unbuffered adaptation to shock can prove fatal.[79] But the cognitive (hence, political) problem

74. Effects of nitrous oxide reported in Prescott, p. 19.

75. See Wangensteen and Wangensteen, pp. 277–79.

76. Prescott, p. 28. Acceptance of anesthetics was not without resistance. Cultural encoding of the meaning of pain included a strong tradition that held pain was "natural" or God-intended (especially in childbirth), and beneficial to healing. Resistance to the insensibility of general anaesthetics was also political: Elizabeth Cady Stanton "objected to a woman's surrendering her consciousness and body to a male doctor" (Pernick, pp. 16–61). "Long after 1846, alcoholic stupor remained an acceptable surgical anodyne" (ibid., p. 178).

77. Wangensteen and Wangensteen, *The Rise of Surgery,* p. 293.

78. Oppenheim, *Shattered Nerves,* p. 113.

79. See Hans Selye, *The Stress of Life,* 2nd ed., rev. (New York: McGraw-Hill, 1976), p. 307. In an article published the same year as Benjamin's Artwork essay (1936), Selye first defined "Stress Syndrome" as a "Disease of Adaptation," that is, an inability of the organism to meet a (nonspecific)

lies still elsewhere. The experience of intoxication is not limited to drug-induced, biochemical transformations. Beginning in the nineteenth century, a narcotic was made out of reality itself.

The key word for this development is phantasmagoria. The term originated in England in 1802, as the name of an exhibition of optical illusions produced by magic lanterns. It describes an appearance of reality that tricks the senses through technical manipulation. And as new technologies multiplied in the nineteenth century, so did the potential for phantasmagoric effects.[80]

In the bourgeois interiors of the nineteenth century, furnishings provided a phantasmagoria of textures, tones, and sensual pleasure that immersed the home-dweller in a total environment, a privatized fantasy world that functioned as a protective shield for the senses and sensibilities of this new ruling class. In the *Passagen-Werk*, Benjamin documents the spread of phantasmagoric forms to public space: the Paris shopping arcades, where the rows of shop windows created a phantasmagoria of commodities on display; panoramas and dioramas that engulfed the viewer in a simulated total environment-in-miniature, and the World Fairs, which expanded this phantasmagoric principle to areas the size of small cities. These nineteenth-century forms are the precursors of today's shopping malls, theme parks, and video arcades, as well as the totally controlled environments of airplanes (where one sits plugged in to sight and sound and food service), the phenomenon of the "tourist bubble" (where the traveler's "experiences" are all monitored and controlled in advance), the individualized audiosensory environment of a "walkman," the visual phantasmagoria of advertising, the tactile sensorium of a gymnasium full of Nautilus equipment.

Phantasmagorias are a technoaesthetics. The perceptions they provide are "real" enough—their impact upon the senses and nerves is still "natural" from a neurophysical point of view. But their social function is in each case compensatory. The goal is manipulation of the synaesthetic system by control of environmental stimuli. It has the effect of anaesthetizing the organism, not through numbing, but through flooding the senses. These simulated sensoria alter consciousness, much like a drug, but they do so through sensory distraction rather

demand made on it with adequate adaptive reactions. Stress was "the common denominator of all adaptative reactions in the body." It went through three phases if the external demand continued unabated: alarm reaction (general resistance to the demand), adaptation (an attempt, successful in the short-run, to coexist), and finally, exhaustion, resulting in passivity (lack of resistance, and possibly death).

80. Technology thus develops with a double function. On the one hand, it extends the human senses, increasing the acuity of perception, and forces the universe to open itself up to penetration by the human sensory apparatus. On the other hand, precisely because this technological extension leaves the senses open to exposure, technology doubles back on the senses as protection in the form of illusion, taking over the role of the ego in order to provide defensive insulation. The development of the machine as tool has its correlation in the development of the machine as armor (see below). It follows that the synaesthetic system is not a constant in history. It extends its scope, and it is through technology that this extension occurs.

Franz Skarbina. View of the Seine and Paris at Night. *1901.*

than chemical alteration, and—most significantly—their effects are experienced collectively rather than individually. Everyone sees the same altered world, experiences the same total environment. As a result, unlike with drugs, the phantasmagoria assumes the position of objective fact. Whereas drug addicts confront a society that challenges the reality of their altered perception, the intoxication of phantasmagoria itself becomes the social norm. Sensory addiction to a compensatory reality becomes a means of social control.

The role of "art" in this development is ambivalent because, under these conditions, the definition of "art" as a sensual experience that distinguishes itself precisely by its separation from "reality" becomes difficult to sustain. Much of "art" enters into the phantasmagoric field as entertainment, as part of the commodity world. The effects of phantasmagoria exist on multiple levels, as is visible in a turn-of-the-century painting by Franz Skarbina.[81] The view is of the World Fair in Paris in 1901, depicted in the doubly illusory form provided by lighting at night. The painting is a *Stimmungsbild,* a "mood-painting," a genre,

81. See John Czaplicka's discussion of this painting in "Pictures of a City at Work, Berlin, circa 1890–1930: Visual Reflections on Social Structures and Technology in the Modern Urban Construct," *Berlin: Culture and Metropolis,* eds. Charles W. Haxthausen and Heidrun Suhr (Minneapolis: University of Minnesota Press, 1990), pp. 12–16. I am grateful to the author for pointing out the relevance of the *Stimmungsbild* for the discussion at hand.

then in fashion, that aimed at depicting an atmosphere or "mood" more than a subject. Despite the depth of the view, visual pleasure is provided by the luminous surface of the painting that shimmers over the scene like a veil. John Czaplicka writes: The city is "reduced to a mood of the beholder. . . . The experience of place . . . is more emotional than rational. . . . There is subtle denial of the city as artifice . . . and a subtle relinquishing of humanity's responsibility for having made this environment."[82]

Benjamin describes the flaneur as self-trained in this capacity of distancing oneself by turning reality into a phantasmagoria: rather than being caught up in the crowd, he slows his pace and observes it, making a pattern out of its surface. He sees the crowd as a reflection of his dream mood, an "intoxication" for his senses.

The sense of sight was privileged in this phantasmagoric sensorium of modernity. But sight was not exclusively affected. Perfumeries burgeoned in the nineteenth century, their products overpowering the olfactory sense of a population already besieged by the smells of the city.[83] Zola's novel *Le Bonheur des Dames* describes the phantasmagoria of the department store as an orgy of tactile eroticism, where women felt their way by touch through the rows of counters heaped with textiles and clothing. In regard to taste, Parisian gustatory refinements had already reached an exquisite level in post-Revolutionary France, as former cooks for the nobility sought restaurant employment. It is significant for the anaesthetic effects of these experiences that the singling out of any one sense for intense stimulus has the effect of numbing the rest.[84]

The most monumental artistic attempt to create a total environment was Richard Wagner's design for music drama as a *Gesammtkunstwerk* (total artwork), in which poetry, music, and theater were combined in order to create, as Adorno writes, an "intoxicating brew" (surmounting the uneven development of the senses and reuniting them).[85] Wagnerian music drama floods the senses and fuses them as a "consoling phantasmagoria," in a "permanent invitation to intoxication, as a form of oceanic regression."[86] It is the "perfection of the illusion that the work of art is reality sui generis":[87] "Like Nietzsche and subsequently Art Nouveau, which he anticipates in many respects, [Wagner] would like single-handed to will an aesthetic totality into being, casting a magic spell

82. Ibid., p. 15.
83. See Benjamin: "The recognition of a scent . . . deeply drugs the sense of time" (*Baudelaire*, p. 143).
84. See Marshall McLuhan, *Understanding Media: The Extensions of Man* (New York: McGraw-Hill, 1964), p. 53. This specialization of sense stimulation causes an uneven development of the senses; they are transformed within industrial societies at different rates.
85. Theodor Adorno, *In Search of Wagner,* trans. Rodney Livingstone (London: NLB, 1981), p. 100. Adorno makes the point that "in advanced bourgeois civilization every organ of sense apprehends . . . a different world" (p. 104).
86. Ibid., pp. 87, 100.
87. Ibid., p. 85.

and with defiant unconcern about the absence of the social conditions necessary for its survival."[88] It is this pseudo-totalization that, for Adorno, makes Wagnerian opera a phantasmagoria. Its unity is superimposed. Whereas, "under conditions of modernity," in the "contingent experience of the individual" outside the opera house, "the separate senses do not unite" into a unified perception, here "disparate procedures are simply aggregated in such a way as to make them appear collectively binding."[89] In lieu of internal musical logic, the Wagnerian opera evokes a surface "unity of style," one that overwhelms by not pausing for breath.[90] Unity is mere duplication, which "substitutes for protest";[91] "the music repeats what the words have already said"; the musical motifs recur like an advertising theme; intoxication, the ecstasy that might have affirmed sensuality, is reduced to surface sensation, while the content of the dramas is life's negation: "the action culminates in the decision to die."[92]

Wagner's *Gesammtkunstwerk,* "intimately related to the disenchantment of the world,"[93] is an attempt to produce a totalizing metaphysics instrumentally, by means of every technological means at its disposal. This is true of dramatic representation as well as musical style. At Bayreuth the orchestra—the means of production of the musical effects—is hidden from the public by constructing the pit below the audience's line of vision. Supposedly "integrating the individual arts," the performance of Wagner's operas "ends up by achieving a division of labor unprecedented in the history of music."[94]

Marx made the term phantasmagoria famous, using it to describe the world of commodities that, in their mere visible presence, conceal every trace of the labor that produced them. They veil the production process, and—like mood pictures—encourage their beholders to identify them with subjective fantasies and dreams. Adorno comments on Marx's theory of commodities that their phantasmagoria "mirrors subjectivity by confronting the subject with the product of its own labor, but in such a way that the labor that has gone into it is no longer identifiable"; rather, "the dreamer encounters his [her] own image impotently."[95] Adorno argues that the deceptive illusion of Wagner's art is

88. Ibid., p. 101. "The basic idea is one of totality: the *Ring* attempts, without much ado, nothing less than the encapsulation of the world process as a whole" (ibid.).
89. Ibid. p. 102.
90. Ibid. "The style becomes the sum of all the stimuli registered by the totality of the senses."
91. Ibid., p. 112. "The aesthetics of duplication is substituted for protest, a mere amplification of subjective expression that is nullified by its very vehemence."
92. Ibid., pp. 102–103.
93. Ibid., p. 107.
94. Ibid., p. 109. Adorno cites "evidence from Wagner's immediate circle": "On 23 March 1890, that is to say, long before the invention of the cinema, Chamberlain wrote to Cosima about Liszt's *Dante* symphony, which can stand here for the whole tendency. 'Perform this symphony in a darkened room with a sunken orchestra and show pictures moving past in the background—and you will see how all the Levis and all the cold neighbors of today, whose unfeeling natures give such pain to a poor heart, will all fall into ecstasy' " (p. 107).
95. Ibid., p. 91.

The swimming machines in action

... as seen by the audience

Swimming machines for Das Rheingold.

analogous.[96] The task of his music is to hide the alienation and fragmentation, the loneliness and the sensual impoverishment of modern existence that was the material out of which it is composed: "the task of [Wagner's] music is to warm up the alienated and reified relations of man and make them sound as if they were still human."[97] Wagner himself speaks of "healing up the wounds with which the anatomical scalpel has gashed the body of speech."[98]

96. Wagner's oeuvre resembled "the consumer goods of the nineteenth century which knew no greater ambition than to conceal every sign of the work that went into them, perhaps because any such traces reminded people too vehemently of the appropriation of the labor of others, of an injustice that could still be felt" (ibid., p. 83).
97. Ibid., p. 100.
98. Cited in ibid., p. 89. In this context we can understand Benjamin's praise of Baudelaire (a

IX

The factory was the work-world counterpart of the opera house—a kind of counter-phantasmagoria that was based on the principle of fragmentation rather than the illusion of wholeness. Marx's *Capital* (written in the 1860s and thus a part of the same era as Wagner's operas) describes the factory as a total environment:

> Every organ of sense is injured in an equal degree by artificial elevation of temperature, by the dust-laden atmosphere, by the deafening noise, not to mention danger to life and limb among the thickly crowded machinery, which, with the regularity of the seasons, issues its list of the killed and the wounded in the industrial battle.[99]

We have learned from recent writing on social history that doctors were "uniformly horrified by the grisly body count of the industrial revolution."[100] The rates of injuries due to factory and railroad accidents in the nineteenth century made surgical wards look like field hospitals. At Massachusetts General Hospital in mid-century (after introduction of general anaesthetics), nearly seven percent of all patients admitted received amputations.[101] As most hospital patients were charity cases, this group was largely from the lower class.[102] Threatened bodies, shattered limbs, physical catastrophe—these realities of modernity were the underside of the technical aesthetics of phantasmagorias as total environments of bodily comfort. The surgeon whose task it was, literally, to piece together the casualties of industrialism achieved a new social prominence. The medical practice was professionalized in the mid-nineteenth century,[103] and doctors became prototypical of a new elite of technical experts.

Anaesthesia was central to this development. For it was not only the patient who was relieved from pain by anaesthesia. The effect was as profound upon the surgeon. A deliberate effort to desensitize oneself from the experience of

contemporary of both Wagner and Marx), for confronting modern shock head-on, and for being able to record in his poetry precisely the fragmented and jarring, even painful sensuality of modern experience in a way that pierces through the phantasmagoric veil. He writes that "the possible establishment of proof that [Baudelaire's] poetry transcribes reveries experienced under hashish in no way invalidates this interpretation" (*Das PassagenWerk*, vol. 5, *Gesammelte Schriften*, ed. Rolf Tiedemann [Frankfurt a.M.: Suhrkamp Verlag, 1992], p. 71). (For Benjamin's own experiments with hashish, see *Gesammelte Schriften*, vol. 6.) Indeed, in an era of sensory numbing as a cognitive defense, Benjamin claimed that insight into the truth of modern experience was "seldom to be had in a sober state."

99. Marx, *Capital*, vol. 1, ch. 15, section 4.
100. Pernick, *A Calculus of Suffering*, p. 218.
101. Ibid., p. 211.
102. Until the discovery of the importance of antiseptics, upper-class operations were performed at home, anaesthesia being administered with a "bottle and a rag" (ibid., p. 223).
103. The American Medical Association was established in mid-century. Prior to this, there was no regulation as to who was authorized to perform surgery.

the pain of another was no longer necessary. Whereas surgeons earlier had to train themselves to repress empathic identification with the suffering patient, now they had only to confront an inert, insensate mass that they could tinker with without emotional involvement.

These developments entailed a cultural transformation of medicine—and of the discourse of the body generally—as is exemplified clearly in the case of limb amputations. In 1639, the British naval surgeon John Woodall advised prayer before the "lamentable" surgery of amputation: "For it is no small presumption to Dismember the Image of God."[104] In 1806 (the era of Charles Bell), the surgeon's attitude evoked Enlightenment themes of Stoicism, the glorification of reason, and the sanctity of individual life. But with the introduction of general anaesthesia, the *American Journal of Medical Sciences* could report in 1852 that it was "very gratifying to the operator and to the spectators that the patient lies a tranquil, passive subject, instead of struggling and perhaps uttering piteous cries and moans, while the knife is at work."[105] The control provided to the surgeon by a "tranquilly pliant" patient allowed the operation to proceed with unprecedented technical thoroughness and "all convenient deliberation."[106] Of course, the point is in no way to criticize surgical advances. Rather, it is to document a transformation in perception, the implications of which far surpassed the scene of the surgical operation.

Phenomenology uses the term *hyle*, undifferentiated, "brute" matter—to describe that which is perceived but not "intended." Husserl's example is Dürer's engraving on wood of the knight on horseback. Although the wood is perceived along with the knight's image, it is not the *meaning* of the perception. If you are asked, what do you see? you will say, a knight (i.e., the surface image), not a piece of wood. The material stuff disappears behind the intent, or meaning of the image.[107] Husserl, the founder of modern phenomenology, was writing at the turn of the century, the era when professionalization, technical expertise, division of labor, and the rationalization of procedures were transforming social practices. Urban-industrial populations began to be perceived as themselves a "mass"—undifferentiated, potentially dangerous, a collective body that needed to be controlled and shaped into a meaningful form. In one sense, this was a continuation of the autotelic myth of creation *ex nihilo*, wherein "man" transforms material nature by shaping it to his will. New were the theme of the social collectivity, and the division of labor to which the creative process now submitted.

For Kant the domination of nature was internalized: the subjective will,

104. Cited in Wangensteen and Wangensteen, *The Rise of Surgery,* p. 181.
105. Cited in Pernick, *A Calculus of Suffering,* p. 83.
106. Cited in ibid., p. 83.
107. I discuss the connection between Husserl's conception and early cinema in Anthony Vidler, ed., *Territorial Myths* (Princeton: Princeton University Press, 1992).

Frontispiece from Sir Charles Bell, The Principles of Surgery, *1806:*
"Who would lose for fear of pain this intellectual being?"

the disciplined, material body, and the autonomous self that was produced as a result, were all *within* the (same) individual. In early-modern autogenesis the autonomous subject produced *himself.* But by the end of the nineteenth century, these functions were divided: the "self-made man" was entrepreneur of a large corporation; the "warrior" was general of a technologically sophisticated war machine; the ruling prince was head of an expanding bureaucracy; even the social revolutionary had become the leader and shaper of a disciplined, mass-party organization.

Technology affected the social imaginary. The new theories of Herbert Spencer and Emile Durkheim perceived society as an organism, literally a "body" politic, in which the social practices of institutions (rather than, as in premodern Europe, the social ranks of individuals) performed the various organ func-

tions.[108] Labor specialization, rationalization and integration of social functions, created a techno-body of society, and it was imagined to be as insensate to pain as the individual body under general anaesthetics, so that any number of operations could be performed upon the social body without needing to concern oneself lest the patient—society itself—"utter piteous cries and moans." What happened to perception under these circumstances was a tripartite splitting of experience into agency (the operating surgeon), the object as hyle (the docile body of the patient), and the observer (who perceives and acknowledges the accomplished result). These were positional differences, not ontological ones, and they changed the nature of social representation. Listen to Husserl's description of experience, in which this tripartite division is evident even in one individual, the philosopher himself. Husserl writes in *Ideen II:*

> If I cut my finger with a knife, then a physical body is split by the driving into it of a wedge, the fluid contained in it trickles out, etc. Likewise, the physical thing, "my Body," is heated or cooled through

108. Spencer wrote in 1851: "We commonly enough compare a nation to a living organism. We speak of the 'body politic,' of the function of its several parts, of its growth, and of its diseases, as though it were a creature. But we usually employ these expressions as metaphors, little suspecting how close is the analogy, and how far it will bear carrying out. So completely, however, is a society organized upon the same system as an individual being, that we may almost say there is something more than analogy between them" (cited in Robert M. Young, *Mind, Brain and Adaptation in the Nineteenth Century,* 2nd ed. [New York: Oxford University Press, 1990], p. 160).

William T. Morton administering anesthesia at the Massachusetts General Hospital, October 16, 1846.

contact with hot or cold bodies; it can become electrically charged through contact with an electric current; it assumes different colors under changing illumination: and one can elicit noises from it by striking it.[109]

This separation of the elements of synaesthetic experience would have been inconceivable in a text by Kant. Husserl's description is a technical observation, in which the bodily experience is split from the cognitive one, and the experience of agency is, again, split from both of these. An uncanny sense of self-alienation results from such perceptual splitting. Something similar happened at this time in the operating room.

The Enlightenment practice of performing surgical procedures in an amphitheater (whose grandeur rivaled the Wagnerian stage) went through a radical alteration with the introduction of general anaesthetics. The initial impact was to heighten the theatrical effect, as (we have already noted) neither surgeon nor audience had to bother with the feelings of the insensate patient. Here is a description of an early amputation under general anaesthesia:

> The Catlin, glittering for a moment above the head of the operator, was plunged through the limb and with one artistic sweep made the

109. Edmund Husserl, *Ideas Pertaining to a Pure Phenomenology and to a Phenomenological Philosophy*, vol. 1, trans. R. Rojcewicz and A. Schuwer (Boston: Kluwer Academic Publishers, 1989), p. 168.

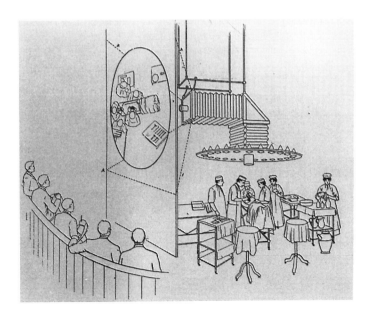

Diagram of an operating theater. c. 1890.

flaps or completed a circular amputation. After several aerial gyra-
tions the saw severed the bone as if driven by electricity. The fall of
the amputated part was greeted with tumultuous applause by the
excited students. The operator acknowledged the compliment with a
formal bow.[110]

A radical alteration occurred at the end of the century, when discoveries in
germ theory and antiseptics transformed the operating room from theatrical
stage into a tile-and-marble, scrubbed-down, sterilized environment. At the
Tenth International Medical Congress in 1890, J. Baladin of St. Petersburg
described the first use of a glass partition to separate students and visitors from
the operating arena.[111] The glass window became a projection screen: a series
of mirrors provided an informative image of the procedure. Here the tripartite
division of perceptual perspective—agent, matter, and observer—paralleled the
brand new, contemporary experience of the cinema. In the Artwork essay,
Walter Benjamin discusses the surgeon and cameraman (as opposed to the
magician and painter). The operations of both surgeon and cameraman are
nonauratic; they "penetrate" the human being; in contrast, the magician and
painter confront the other person intersubjectively, as Benjamin writes, "man
to man."[112]

X

The German writer Ernst Jünger, several times wounded in World War I,
wrote afterwards that "sacrifices" to technological destruction—not only war
casualties but industrial and traffic accidents as well—now occurred with statis-
tical predictability.[113] They had become accepted as a self-understood feature
of existence, thereby causing the "Worker," as the new modern "type," to
develop a "Second Consciousness": "This Second and colder Consciousness is
indicated in the ever-more sharply developed capacity to see oneself as an
object."[114] Whereas the "self-reflection" characteristic of psychology of the "old
style" took as its subject matter "the sensitive human being," this Second Con-

110. Cited in Wangensteen and Wangensteen, *The Rise of Surgery,* p. 462.
111. Ibid., p. 466.
112. Benjamin, *Illuminations,* p. 233.
113. As part of the "professionalization" of medicine and of the depersonalization of the patient,
statistics set up norms of surgical practice and, by the end of the nineteenth century, due to such
statistical knowledge, health insurance companies became a historical possibility. They allowed
human suffering to be calculated: "Whoever dies is unimportant; it is a question of ratio between
accidents and the company's liabilities" (Theodor W. Adorno and Max Horkheimer, *Dialectic of
Enlightenment,* trans. John Cumming (London: Verso, 1979), p. 84.
114. Ernst Jünger, "Über den Schmerz" (1932), *Samtliche Werke,* vol. 7: *Essays I: Betrachtungen zur
Zeit* (Stuttgart: Klett-Cotta, 1980), p. 181. Partial translation in Christopher Philips, ed., *Photography
in the Modern Era* (New York: The Metropolitan Museum of Art, 1989).

sciousness "is directed at a being who stands outside the zone of pain."[115] Jünger connects this changed perspective with photography, that "artificial eye" which "arrests the bullet in flight just as it does the human being at the instant of being torn to pieces by an explosion."[116] The powerfully prosthetic sense organs of technology are the new "ego" of a transformed synaesthetic system. Now *they* provide the porous surface between inner and outer, both perceptual organ and mechanism of defense. Technology as a tool and a weapon extends human power—at the same time intensifying the vulnerability of what Benjamin called "the tiny, fragile human body"[117]—and thereby produces a counter-need, to use technology as a protective shield against the "colder order" that it creates. Jünger writes that military uniforms have always had a protective "character of defense"; but now, *"Technology is our uniform"*:

> It is the technological order itself, that great mirror in which the growing objectifications of our life appear most clearly, and which is sealed against the clutch of pain in a special way. . . . We, however, stand far too deeply in the process to view this. . . . This is all the more the case, as the comfort-character [read phantasmagoric function] of our technology merges ever more unequivocally with its characteristic of instrumental power.[118]

In the "great mirror" of technology, the image that returns is displaced, reflected onto a different plane, where one sees oneself as a physical body divorced from sensory vulnerability—a statistical body, the behavior of which can be calculated; a performing body, actions of which can be measured up against the "norm"; a virtual body, one that can endure the shocks of modernity without pain. As Jünger writes: "It almost seems as if the human being possessed a striving to create a space in which pain . . . can be regarded as an illusion."[119]

We have seen that Adorno identified Art Nouveau as a continuation of Wagner's commodity-like phantasmagoria. Again, surface unity provided the phantasmagoric effect. Just before the war, this movement denied the experience of fragmentation by representing the body as an ornamental surface, as if reflected off the inside of technology's protective shield. The outbreak of war made such denial no longer possible. The Berlin Dada Manifesto of 1918

115. Ibid.
116. Ibid., p. 182.
117. He writes in "The Storyteller" about the impoverishment of experience due to the First World War: "A generation that had gone to school on a horse-drawn streetcar now stood under the open sky in a countryside in which nothing remained unchanged but the clouds, and beneath these clouds, in a field of force of destructive torrents and explosions, was the tiny, fragile human body" (Benjamin, *Illuminations,* p. 84).
118. Ibid., p. 174.
119. Jünger, p. 184.

DAS GESICHT DER ERDE *Stadt*

From Ernst Jünger, The Transformed World, *1933: "The face of the earth: city, country."*

announced: "The highest art will be the one which in its conscious content presents the thousand-fold problems of the day, the art which has been visibly shattered by the explosions of last week, which is forever trying to collect its limbs after yesterday's crash."[120] It is possible to read the portraits of Expressionist artists as bearing on the surface of the face, unarmored and exposed, the material impress of this technological shattering. (This is totally opposed to the fascist interpretation of Expressionism as degenerate art, which ontologizes the surface appearance, and reduces history to biology.) The vigorous, postwar movement of photomontage also made the fragmented body its stuff and substance.[121] But the effect was to piece the fragments together again in images that appear impervious to pain. For example, in Hannah Höch's 1926 montage *Monument II: Vanity,* the image is unified with precision, creating a coherent (if disturbing) surface—yet without the superimposed unity of the phantasmagoric.

120. Cited in Robert Hughes, *The Shock of the New,* rev. ed. (New York: Alfred A. Knopf, 1991), p. 68.
121. Benjamin speaks positively in the Baudelaire essay of cinematic montage as turning fragmentation into a constructive principle.

At the same time, surface pattern, as an abstract representation of reason, coherence, and order, became the dominant form of depicting the *social* body that technology had created—and that in fact could not be perceived otherwise. In 1933 Junger wrote the introduction to a book of photographs, in which German cities and fields form a surface design of abstract orderliness that is the hallmark of instrumental technology. The same aesthetics is visible in the Soviet "plan"; its organization chart of 1924 shows the entire society from the perspective of centralized power in terms of its productive units—from steel to matchsticks.

The aesthetics of the surface in these images gives back to the observer a reassuring perception of the rationality of the whole of the social body, which when viewed from his or her own particular body is perceived as a threat to wholeness. And yet, if the individual does find a point of view from which it can see itself as whole, the social techno-body disappears from view. In fascism (and this is key to fascist aesthetics), this dilemma of perception is surmounted by a phantasmagoria of the individual as part of a crowd that itself forms an integral whole—a "mass ornament," to use Siegfried Kracauer's term, that pleases as an aesthetics of the surface, a deindividualized, formal, and regular pattern—much like the Soviet plan. The Urform of this aesthetics is already present in Wagner's operas in the staging of the chorus, which anticipates the crowd's salute to Hitler. But lest we forget that fascism is not itself responsible for the transformed perception, musical productions of the 1930s used this same design motif (Hitler was an aficionado of American musicals).

Fig. 5.2 General scheme of organization of the Supreme Council of National Economy (from *The Russian Economist*, January 1921, vol. 1, no. 2, facing p. 332)

Soviet organization plan. 1921.

Performance of Wagner in Bayreuth in 1930.

Hitler in the Reichstag.

XI

We are—by a long detour—back to Benjamin's concerns at the end of the Artwork essay: the crisis in cognitive experience caused by the alienation of the senses that makes it possible for humanity to view its own destruction with enjoyment. Recall that this essay was first published in 1936. That same year Jacques Lacan traveled to Marienbad to deliver a paper to the International Psychoanalytic Association that first formulated his theory of the "mirror stage."[122] It described the moment when the infant of six to eighteen months triumphantly recognizes its mirror image, and identifies with it as an imaginary bodily unity. This narcissistic experience of the self as a specular "reflection" is one of *mis*(re)cognition. The subject identifies with the image as the "form" (*Gestalt*) of the ego, in a way that conceals its own lack. It leads, retroactively, to a fantasy of the "body-in-pieces" (*corps morcele*). Hal Foster has situated this theory in the historical context of early fascism, and pointed out the personal connections between Lacan and Surrealist artists who made the fragmented body their theme.[123] I believe one can push the significance of this contextualization very far, so that the mirror stage can be read as a theory of fascism.

The experience Lacan describes may (or may not) be a universal stage in developmental psychology, but its importance psychoanalytically comes only after-the-fact, as deferred action (*Nachträglichkeit*), when the recollection of this infant fantasy is triggered in the memory of the adult by something in his or her present situation. Thus the significance of Lacan's theory emerges only in the historical context of modernity as precisely the experience of the fragile body and the dangers to it of fragmentation that replicates the trauma of the original infantile event (the fantasy of the *corps morcelê*). Lacan himself recognized the historical specificity of narcissistic disorders, commenting that Freud's major paper on narcissism, not accidentally, "dates from the beginning of the 1914 war, and it is quite moving to think that it was at that time that Freud was developing such a construction."[124]

The day after Lacan delivered his paper in Marienbad he deserted the Congress and took the train to Berlin, in order to watch the Olympic Games being held there.[125] In a note to the Artwork essay, Benjamin commented on these modern Olympics, which, he said, differed from their ancient prototypes inasmuch as they were less a contest than a proceeding of exact, technological

122. In fact this paper was never published. A different version, reported here, appeared in 1949.
123. See Foster, "Armor Fou," *October* 57 (Spring 1991). This section is strongly indebted to Foster's insights.
124. *The Seminars of Jacques Lacan, Book I: Freud's Papers on Technique, 1953–54,* ed. Jacques-Alain Miller and trans. John Forrester (New York: W. W. Norton & Company, 1988), p. 118.
125. See David Macey, *Lacan in Contexts* (New York: Verso, 1988) for an account of Lacan's Marienbad/Berlin trip.

measurement, a form of test rather than competition.[126] Drawing on Jünger, Foster points out that fascism displayed the physical body as a kind of armor against fragmentation, and also against pain. The armored, mechanized body with its galvanized surface and metallic, sharp-angled face provides the illusion of invulnerability. It is the body viewed from the point of view of the "second consciousness" described by Jünger as "numbed" against feeling. (The word narcissism comes from the same root as narcotic!) But if fascism thrived on the representation of the body-as-armor, it was not its only aesthetic form relevant to this problematic.

XII

There are two self-definitions of fascism that, in closing, I would like to consider. The first is a description by Joseph Goebbels in a letter of 1933: "We who shape modern German politics feel ourselves to be artistic people, entrusted with the great responsibility of forming out of the raw material of the masses a solid, well-wrought structure of a *Volk*."[127] This is the technologized version of the myth of autogenesis, with its division between the agent (here, the fascist leaders) and the mass (the undifferentiated hyle, acted *upon*). We will remember that this division is tripartite. There is as well the observer, who "knows" through observation. It was the genius of fascist propaganda to give to the masses a double role, to be observer as well as the inert mass being formed and shaped. And yet, due to a displacement of the place of pain, due to a consequent mis(re)cognition, the mass-as-audience remains somehow undisturbed by the spectacle of its own manipulation—much like Husserl cutting open his finger. In Leni Riefenstahl's 1935 film, *Triumph of the Will* (of which Benjamin, writing the Artwork essay, was surely aware), the mobilized masses fill the grounds of the Nuremberg stadium and the cinema screen, so that the surface patterns provide a pleasing design of the whole, letting the viewer forget the purpose of the display, the militarization of society for the teleology of making war. The aesthetics allows an *an*aesthetization of reception, a viewing of the "scene" with disinterested pleasure, even when that scene is the preparation through ritual of a whole society for unquestioning sacrifice and ultimately, destruction, murder, and death.

In *Triumph of the Will* Rudolf Hess shouts out to the crowd in the arena: "Germany is Hitler and Hitler is Germany!" And so we come to the second self-definition of fascism. The intentional meaning is that Hitler embodies the entire power of the German nation. But if we turn the camera on Hitler in a nonauratic

126. Benjamin, *Gesammelte Schriften* I, p. 1039.
127. Cited in Rainer Stollman, "Fascist Politics as a Total Work of Art," *New German Critique* 14 (Spring 1978), p. 47.

manner, that is, if we use this technological apparatus as an aid to sensory comprehension of the external world, rather than as a phantasmagoric, or narcissistic, escape *from* it, we see something very different.

We know that in 1932 (under the direction of the opera singer Paul Devrient) Hitler practiced his facial expressions in front of a mirror,[128] in order to have what he believed was the proper effect. There is reason to believe that this effect was not expressive, but reflective, giving back to the man-in-the-crowd his own image—the narcissistic image of the intact ego, constructed against the fear of the body-in-pieces.[129]

In 1872, Charles Darwin published *The Expression of the Emotions in Man and Animals,* expressing his own indebtedness to the work of Charles Bell. Darwin's book was the first of its kind to make use of photographs rather than drawings, which allowed a greater precision of analysis of the facial expressions of human emotions. If one compares photographs of Hitler's facial expressions as he practiced in front of a mirror with the photographs in Darwin's book, one might expect to find that his expressions connote aggressive emotions—anger and rage. Or, one might presume that Hitler should have tried to project the impervious, "armored" face that Jünger describes, and that was so typical of Nazi art. But in fact the two emotions described by Darwin that match Hitler's photographs are quite different from both of these.

The first emotion is fear. Listen to Darwin's description:

> As fear increases into an agony of terror . . . the wings of the nostrils are wildly dilated . . . there is a gasping and convulsive motion of the lips, a tremor on the hollow cheek . . . eyeballs are fixed on the object of terror . . . the muscles of the body may become rigid . . . hands are alternately clenched and opened . . . [t]he arms may be protruded, as if to avert some dreadful danger, or may be thrown wildly over the head.[130]

There is a second emotion identifiable in Hitler's gestures. It is what Darwin calls "suffering of the body and mind: weeping," and the relevant photographs are, specifically, the faces of screaming and weeping infants. Darwin writes:

128. Hitler had so strained his voice organs by 1932 that a doctor advised him to train his voice with Devrient (born Paul Stieber-Walter), which Hitler did between April and November of that year, during his election touring. (See Werner Maser, *Adolf Hitler: Legende Mythos Wirklichkeit* [Munich: Bechtle Verlag, 1976], p. 294n.)
129. Max Picard speaks from direct experience of the absolute "nullity" that was Hitler's face, "a face not like one who leads, but like one who needs leading" (Picard, *Hitler in Ourselves,* trans. Heinrich Hauser [Hinsdale, Ill.: Henry Regnery Company, 1947], p. 78).
130. Charles Darwin, *The Expression of the Emotions in Man and Animals,* preface Konrad Lorenz (Chicago: University of Chicago Press, 1965), p. 291.

FIG. 20.—Terror, from a photograph by Dr. Duchenne.

Above and below: From Charles Darwin, The Expression of the Emotions in Man and Animals, *1872.*

Above and below: Heinrich Hoffman. Hitler Oratorical Pose. *1932.*

The raising of the upper lip draws upward the flesh of the upper parts of the cheeks, and produces a strongly-marked fold on each cheek—the naso-labial fold—which runs from near the wings of the nostrils to the corners of the mouth and below them. This fold or furrow may be seen in all the photographs, and it is very characteristic of the expression of a crying child. . . . [131]

The camera can aid us in knowledge of fascism, because it provides an "aesthetic" experience that is nonauratic, critically "testing,"[132] capturing with its "unconscious optics"[133] precisely the dynamics of narcissism on which the politics of fascism depends, but which its own auratic aesthetics conceals. Such knowledge is not historicist. The juxtaposition of photographs of Hitler's face and Darwin's illustrations will not answer the complexities of von Ranke's question of "how it actually was" in Germany, or what determined the uniqueness of its history. Rather, the juxtaposition creates a synthetic experience that resonates with our own time, providing us, today, with a double recognition—first, of our own infancy, in which, for so many of us, the face of Hitler appeared as evil incarnate, the bogeyman of our own childhood fears. Second, it shocks us into awareness that the narcissism that we have developed as adults, that functions as an anaesthetizing tactic against the shock of modern experience—and that is appealed to daily by the image-phantasmagoria of mass culture—is the ground from which fascism can again push forth. To cite Benjamin: "In shutting out the experience [of the inhospitable, blinding age of big-scale industrialism], the eye perceives an experience of a complementary nature, in the form of its spontaneous after-image."[134] Fascism is that afterimage. In its reflecting mirror we recognize ourselves.

131. Ibid., p. 149.
132. Benjamin, *Illuminations,* p. 229.
133. Ibid., p. 237.
134. Benjamin, *Baudelaire,* p. 111.

JONATHAN CRARY

Whether or not the term *spectacle* was originally taken from Henri
Lefebvre's *Critique de la vie quotidienne*, its currency emerged from the activities
in the late 1950s and early 1960s of the various configurations now designated as
presituationist or situationist.[1] The product of a radical critique of modernist art
practice, a politics of everyday life, and an analysis of contemporary capitalism, its
influence was obviously intensified with the publication of Guy Debord's *Society of
the Spectacle* in 1967.[2] And twenty-two years later, the word *spectacle* not only
persists but has become a stock phrase in a wide range of critical and not-so-criti-
cal discourses. But, assuming it has not become completely devalued or ex-
hausted as an explanation of the contemporary operation of power, does it still
mean today what it did in the early '60s? What constellation of forces and
institutions does it designate? And if these have mutated, what kind of practices
are required now to resist their effects?

One can still well ask if the notion of spectacle is the imposition of an
illusory unity onto a more heterogenous field. Is it a totalizing and monolithic
concept that inadequately represents a plurality of incommensurable institutions
and events? For some, a troubling aspect about the term *spectacle* is the almost
ubiquitous presence of the definite article in front of it, suggesting a single and
seamless global system of relations. For others, it is a mystification of the func-
tioning of power, a new opiate-of-the-masses type of explanation, a vague cul-
tural-institutional formation with a suspicious structural autonomy. Or is a con-
cept such as spectacle a necessary tool for the figuration of a radical systemic shift
in the way power functions noncoercively within twentieth-century modernity? Is
it an indispensable means of revealing as related what would otherwise appear as
disparate and unconnected phenomena? Does it not show that a patchwork or
mosaic of techniques can still constitute a homogenous effect of power?

1. This paper was originally presented at the Sixth International Colloquium on Twentieth
Century French Studies, "Revolutions 1889–1989," at Columbia University, March 30–April 1,
1989.
2. Guy Debord, *Society of the Spectacle*, Detroit, Red and Black, 1977.

Fritz Lang. Dr. Mabuse the Gambler. *1922.*

A striking feature of Debord's book was the absence of any kind of histori-
cal genealogy of the spectacle, and that absence may have contributed to the
sense of the spectacle as having appeared full-blown out of the blue. The ques-
tion that concerns me is, then: assuming the spectacle does in fact designate a
certain set of objective conditions, what are its origins? When might we say it was
first effective or operative? And I don't ask this simply as an academic exercise.
For the term to have any critical or practical efficacy depends, in part, on how
one periodizes it—that is, the spectacle will assume quite different meanings
depending on how it is situated historically. Is it more than just a synonym for
late capitalism? for the rise of mass media and communication technology? more
than an updated account of the culture or consciousness industry and thus
chronologically distinct from these?

The "early" work of Jean Baudrillard provides some general parameters
for what we might call the prehistory of the spectacle (which Baudrillard sees as
having disappeared by the mid-1970s). For Baudrillard, writing in the late '60s,
one of the crucial consequences of the bourgeois political revolutions was the
ideological force that animated the myths of the Rights of Man: the right to
equality and the right to happiness. What he sees happening in the nineteenth
century, for the first time, is that observable proof became necessary to demon-
strate that happiness had in fact been obtained. Happiness, he says "had to be
measurable in terms of signs and objects," signs that would be evident to the eye
in terms of "*visible* criteria."[3] Several decades earlier, Walter Benjamin had also
written about "the phantasmagoria of equality" in the nineteenth century in
terms of the transformation of the citizen into consumer. Baudrillard's account
of modernity is one of an increasing destabilization and mobility of signs begin-
ning in the Renaissance, signs which previously had been firmly rooted to rela-
tively secure positions within fixed social hierarchies.[4] Thus, for Baudrillard,
modernity is bound up in the struggle of newly empowered classes to overcome
this "exclusiveness of signs" and to initiate a "proliferation of signs on demand."
Imitations, copies, and counterfeits are all challenges to that exclusivity. The
problem of mimesis, then, is not one of aesthetics but one of social power, and
the emergence of the Italian theater and perspective painting are at the start of
this ever-increasing capacity to produce equivalences. But obviously, for
Baudrillard and many others, it is in the nineteenth century, alongside new
industrial techniques and forms of circulation, that a new kind of sign emerges:

3. Jean Baudrillard, *La société de consommation: ses mythes, ses structures*, Paris, Gallimard, 1970,
p. 60. Emphasis in original.
4. A well-known passage from the "later" Baudrillard amplifies this: "There is no such thing as
fashion in a society of caste and rank since one is assigned a place irrevocably. Thus class-mobility is
non-existent. A prohibition protects the signs and assures them a total clarity; each sign refers
unequivocally to a status. . . . In caste societies, feudal or archaic, the signs are limited in number
and are not widely diffused. . . . Each is a reciprocal obligation between castes, clans, or persons"
(*Simulations*, trans. Paul Foss, New York, Semiotexte, 1983, p. 84).

"potentially identical objects produced in indefinite series." For Baudrillard "the relation of objects in such a series is equivalence and indifference . . . and it is on the level of reproduction, of fashion, media, advertising, information and communication (what Marx called the unessential sectors of capitalism) . . . that the global process of capital is held together." The spectacle then would coincide with the moment when sign-value takes precedence over use-value. But the question of the location of this moment in the history of the commodity remains unanswered.

T. J. Clark offers a much more specific periodization in the introduction to his book *The Painting of Modern Life*. If one agrees with Clark, not only do the origins of modernism and the spectacle coincide, but the two are inextricably related. Writing about the 1860s and '70s, Clark uses the spectacle to explain the embeddedness of Manet's art within a newly emerging social and economic configuration. This society of the spectacle, he writes, is bound up in "a massive internal extension of the capitalist market—the invasion and restructuring of whole areas of free time, private life, leisure and personal expression. . . . It indicates a new phase of commodity production—the marketing, the making-into-commodities of whole areas of social practice which had once been referred to casually as everyday life."[5] In Clark's chronology, then, the spectacle coincides with the early phase of modern Western imperialism, with two parallel expansions of a global marketplace, one internal, one external.

Although he calls "neat temporality" impossible, he does place the onset of the spectacle in the late 1860s and '70s, citing the emergence of commercialized aspects of life and leisure that are themselves due to a shift from one kind of capitalist production to another. This shift, he says, was "not a matter of mere cultural and ideological refurbishing but of all-embracing economic change." But what are Clark's examples of this sweeping change? "A move to the world of *grands boulevards* and *grands magasins* and their accompanying industries of tourism, recreation, fashion, and display." Surprisingly, Clark then reminds his readers that the spectacle was designed "first and foremost as a weapon of combat" in the 1960s.[6] Does he mean to suggest that the political and economic structure of this world of boulevards and department stores is essentially *continuous* with what Debord described as the contested terrain in 1967? And that the cultural politics of the 1960s occurred within a set of conditions isomorphic with those of the 1870s? This implication of a single spectacle common to both the Paris of Manet and of Debord is problematic to say the least.

Working with one of the most familiar examples of modernization in the nineteenth century, Haussmann's rebuilding of Paris, Clark presents it as part of a transformation from small entrepreneurial capitalism to increasingly monopo-

5. T. J. Clark, *The Painting of Modern Life: Paris in the Art of Manet and His Followers*, Princeton, Princeton University Press, 1984, p. 9.
6. *Ibid.*, p. 10.

listic forms. And the new post-Haussmann Paris becomes for him the visible expression of a new alignment of class relations. But this way of deploying the spectacle posits it as a form of domination imposed onto a population or individual from without. The kind of change he delineates remains essentially exterior to the make-up of an individual subject, preserving for the latter a detached position from which the spectacle could be, however imperfectly, recorded and represented. By periodizing the spectacle in this way, Clark disregards the possibility that spectacle may be equally about a fundamental reorganization of the subject, about the construction of an observer who was a precondition for the transformation of everyday life that began then. Making the society of the spectacle more or less an equivalent for consumer society, Clark dilutes its historical specificity and overlooks some features of the spectacle that were crucial to the political practice of situationism in the 1960s: the spectacle as a new kind of power of recuperation and absorption, a capacity to neutralize and assimilate acts of resistance by converting them into objects or images of consumption.

Guy Debord himself has very recently given a surprisingly precise date for the beginning of the society of the spectacle. In a text published in 1988 Debord writes that in 1967, the date of his original book, the spectacle was barely forty years old.[7] Not a more approximate kind of number like fifty, but forty. Thus, 1927, or roughly the late 1920s. Unfortunately he doesn't provide an indication as to why he singles out this moment. It made me curious about what he might have meant by designating the late '20s as a historical threshold, thus placing the origin of the spectacle some half-century later than did Clark. I offer, then, some fragmentary speculations on some very dissimilar events that could possibly have been implicit in Debord's remark.

*

1. The first is both symbolic and substantive. The year 1927 saw the technological perfection of television. Vladimir Zworikin, the Russian-born, American-trained engineer and physicist, patented his iconoscope — the first electronic system of a tube containing an electron gun and a screen made out of a mosaic of photoemissive cells, each of which produced a charge proportional to the varying light intensity of the image focused on the screen. Right at the moment when an awareness arose of the age of mechanical reproduction, a new model of circulation and transmission appeared that was to exceed that age, one that had no need of silver salts or permanent physical support.[8] The spectacle was to become

7. Guy Debord, *Commentaires sur la société du spectacle*, Paris, Editions Gérard Lebovici, 1988, p. 13.
8. The historian of science François Dagognet cites the revolutionary nature of this development in his *Philosophie de l'image*, Paris, J. Vrin, 1986, pp. 57–58.

*Television transmitter sending a picture of the woman
seated directly in front of the apparatus, c. 1929.*

inseparable from this new kind of image and its speed, ubiquity, and simultaneity.

But equally important was that by the late 1920s, when the first experimental broadcasts occurred, the vast interlocking of corporate, military, and state control of television was being settled. Never before had the institutional regulation of a new technique been planned and divided up so far in advance. So, in a sense, much of the territory of spectacle, the intangible domain of the spectrum, had already been diagrammed and standardized before 1930.

*

2. Perhaps more immediately significant, the movie *The Jazz Singer* premiered in 1927, signaling the arrival of the sound film, and specifically *synchronized* sound. This was not only a transformation in the nature of subjective experience; it was also an event that brought on the complete vertical integration

of production, distribution, and exhibition within the film industry and its amal-gamation with the corporate conglomerates that owned the sound patents and provided the capital for the costly move to the new technology.[9] Again, as with television, the nascent institutional and economic infrastructure of the spectacle was set in place.

Specifying sound here obviously suggests that spectacular power cannot be reduced to an optical model but is inseparable from a larger organization of perceptual consumption. Sound had of course been part of cinema in various additive forms from the beginning, but the introduction of sync sound trans-formed the nature of *attention* that was demanded of a viewer. Possibly it is a break that makes previous forms of cinema actually closer to the optical devices of the late nineteenth century. The full coincidence of sound with image, of voice with figure, not only was a crucial new way of organizing space, time, and narrative, but it instituted a more commanding authority over the observer, enforcing a new kind of attention. A vivid sign of this shift can be seen in Fritz Lang's two Mabuse films. In *Dr. Mabuse the Gambler*, a 1922 silent film, the proto-fascist Mabuse exercises control through his gaze, with a hypnotic optical power; while in *The Testament of Dr. Mabuse* (1932) an incarnation of the same character dominates his underlings only through his voice, emanating from behind a curtain (which, it turns out, conceals not a person, but recording technology and a loudspeaker).

And from the 1890s well into the 1930s one of the central problems in mainstream psychology had been the nature of attention: the relation between stimulus and attention, problems of concentration, focalization, and distraction. How many sources of stimulation could one attend to simultaneously? How could novelty, familiarity, and repetition in attention be assessed? It was a problem whose position in the forefront of psychological discourse was directly related to the emergence of a social field increasingly saturated with sensory input. Some of this was the work of James McKeen Cattell, whose experiments on students at Columbia University provided the classical data for the notion of range of attention. Initially much of this research was bound up in the need for informa-tion on attention in the context of rationalizing production, but even as early as 1910 hundreds of experimental laboratory studies had been done specifically on the range of attention in advertising (including titles such as "The Attention Value of Periodical Advertisements," "Attention and the Effects of Size in Street Car Advertisements," "Advertising and the Laws of Mental Attention," "Mea-suring the Attention Value of Color in Advertising," the last a 1913 Columbia dissertation).

9. See Steven Neale, *Cinema and Technology: Image, Sound, Colour*, Bloomington, Indiana, 1985, pp. 62–102; and Douglas Gomery, "Toward an Economic History of the Cinema: The Coming of Sound to Hollywood," in Teresa de Lauretis and Stephen Heath, eds., *The Cinematic Apparatus*, London, Macmillan, 1980, pp. 38–46.

The year 1927 was also when Walter Benjamin began his Arcades Project, a work in which he would eventually point to "a crisis in perception itself," a crisis that is the result of a sweeping remaking of the observer by a calculated technology of the individual, derived from new knowledge of the body. In the course of writing the Arcades Project, Benjamin himself became preoccupied with the question of attention and the related issues of distraction and shock, and he turned to Henri Bergson's *Matter and Memory* for a way out of what he saw as the "standardized and denatured" perception of the masses. Bergson had fought to recover perception from its status as sheer physiological event; for him attention was a question of an engagement of the body, an inhibition of movement, a state of consciousness arrested in the present. But attention could become transformed into something productive only when it was linked to the deeper activity of memory:

> Memory thus creates anew present perception . . . strengthening and enriching [it]. . . . If after having gazed on any object, we turn our eyes abruptly away, we obtain an "after-image" [*image consécutive*] of it. It is true we are dealing here with images photographed on the object itself, and with memories following immediately upon the perception of which they are but the echo. But behind these images which are identical with the object, there are others, stored in memory which only resemble it. . . . [10]

What Bergson sought to describe was the vitality of the moment when a conscious rift occurred between memory and perception, a moment in which memory had the capacity to rebuild the object of perception. Deleuze and Guattari have described similar effects of the entry of memory into perception, for example in the perception of a face: one can see a face in terms of a vast set of micromemories and a rich proliferation of semiotic systems, or, what is far more common, in terms of bleak redundancies of representations, which, they say, is where connections can always be effected with the hierarchies of power formations.[11] That kind of redundancy of representation, with its accompanying inhibition and impoverishment of memory, was what Benjamin saw as the standardization of perception, or what we might call an effect of spectacle.

Although Benjamin called *Matter and Memory* a "towering and monumental work," he reproached Bergson for circumscribing memory within the isolated frame of an individual consciousness; the kind of afterimages that interested Benjamin were those of collective historical memory, haunting images of

10. Henri Bergson, *Matter and Memory*, trans. N. M. Paul and W. S. Palmer, New York, Zone Books, 1988, pp. 101–103.
11. See, for example, Felix Guattari, "Les machines concrètes," in his *La révolution moléculaire*, Paris, Encres, 1977, pp. 364–376.

the out-of-date which had the capacity for a social reawakening.[12] And thus Benjamin's apprehension of a present-day crisis in perception is filtered through a richly elaborated afterimage of the mid-nineteenth century.

*

3. Given the content of Debord's work, we can also assume another crucial development in the late 1920s: the rise of fascism and, soon after, Stalinism, and the way in which they incarnated models of the spectacle. Important, for example, was Goebbels's innovative and synergetic use of every available medium, especially the development of sound/image propaganda, and his devaluation of the written word, because reading implied time for reflection and thought. In one election campaign in 1930, Goebbels mailed 50,000 phonograph records of one of his own speeches to specially targeted voters. Goebbels also introduced the airplane into politics, making Hitler the first political candidate to fly to several different cities on the same day. Air travel thus functioned as a conveyor of the image of the leader, providing a new sense of ubiquity.

As part of this mixed technology of attention, television was to have played a crucial role. And as recent scholarship has shown, the development of television in Germany was in advance of that of any other country.[13] German TV broadcasting on a regular basis began in 1935, four years ahead of the United States. Clearly, as an instrument of social control, its effectiveness was never realized by the Nazis, but its early history in Germany is instructive for the competing models of spectacular organization that were proposed in the 1930s. A major split emerged early on between the monopolistic corporate forces and the Nazi Party with regard to the development of television in Germany. The Party sought to have television centralized and accessible in public screening halls, unlike the decentralized use of radio in private homes. Goebbels and Hitler had a notion of group reception, believing that this was the most effective form of reception. Public television halls, seating from 40 to 400, were designated, not unlike the subsequent early development of television in the USSR, where a mass viewing environment was also favored. According to the Nazi director of broadcasting, writing in 1935, the "sacred mission" of television was "to plant indelibly the image of the Führer in the hearts of the German people."[14] Corporate

12. "On the contrary he [Bergson] rejects any historical determination of memory. He thus manages above all to stay clear of that experience from which his own philosophy evolved or, rather, in reaction to which it arose. It was the inhospitable, blinding age of big-scale industrialism" (Walter Benjamin, *Illuminations*, trans. Harry Zohn, New York, Schocken, 1969, pp. 156–157).
13. I have relied on the valuable research in William Uricchio, "Rituals of Reception, Patterns of Neglect: Nazi Television and its Postwar Representation," *Wide Angle*, vol. 10, no. 4, pp. 48–66. See also Robert Edwin Herzstein, *The War That Hitler Won: Goebbels and the Nazi Media Campaign*, New York, Paragon, 1978.
14. Quoted in Uricchio, p. 51.

power, on the other hand, sought home viewing, for maximization of profit. One model sought to position television as technique within the demands of fascism in general: a means of mobilizing and inciting the masses, whereas the agents of capitalism sought to privatize, to divide and molecularize, to impose a model of cellularity.

It is easy to forget that in *Society of the Spectacle* Debord outlined two different models of the spectacle; one he called "concentrated" and the other "diffused," preventing the word *spectacle* from simply being synonymous with consumer or late capitalism. Concentrated spectacle was what characterized Nazi Germany, Stalinist Russia, and Maoist China; the preeminent model of diffused spectacle was the United States: "Wherever the concentrated spectacle rules so does the police . . . it is accompanied by permanent violence. The imposed image of the good envelops in its spectacle the totality of what officially exists and is usually concentrated in one man who is the guarantee of totalitarian cohesion. Everyone must magically identify with this absolute celebrity — or disappear."[15] The diffuse spectacle, on the other hand, accompanies the abundance of commodities. And certainly it is this model to which Debord gives most of his attention in his 1967 book.

I will note in passing Michel Foucault's famous dismissal of the spectacle in *Discipline and Punish:* "Our society is not one of spectacle, but of surveillance; under the surface of images one invests bodies in depth."[16] But the spectacle is also a set of techniques for the management of bodies, the management of attention (I am paraphrasing Foucault) "for assuring the ordering of human multiplicities," "its object is to fix, it is an anti-nomadic technique," "it uses procedures of partitioning and cellularity . . . in which the individual is reduced as a political force."[17] I suspect that Foucault did not spend much time watching television or thinking about it, because it would not be difficult to make a case that television is a further perfecting of panoptic technology. In it *surveillance* and *spectacle* are not opposed terms, as he insists, but collapsed onto one another in a more effective disciplinary apparatus. Recent developments have confirmed literally this overlapping model: television sets that contain advanced image recognition technology in order to monitor and quantify the behavior, attentiveness, and eye movement of a spectator.[18]

But in 1988 Debord sees his two original models of diffused and concentrated spectacle becoming indistinct, converging into what he calls "the integrated society of the spectacle."[19] In this deeply pessimistic book, he describes a

15. Debord, *Society of the Spectacle*, sec. 64.
16. Michel Foucault, *Discipline and Punish*, trans. Alan Sheridan, New York, Pantheon, 1976, p. 217.
17. *Ibid.*, pp. 218–219.
18. See, for example, Bill Carter, "TV Viewers, Beware: Nielsen May Be Looking," *The New York Times*, June 1, 1989, p. A1.
19. Debord, *Commentaires*, pp. 17–19.

more sophisticated deployment of elements from those earlier models, a flexible arrangement of global power adaptable to local needs and circumstances. In 1967 there were still marginalities and peripheries that escaped its reign: today, he insists, the spectacle has irradiated into everything and has absolute control over production, over perception, and especially over the shape of the future and the past.

As much as any single feature, Debord sees the core of the spectacle as the annihilation of historical knowledge — in particular the destruction of the recent past. In its place there is the reign of a perpetual present. History, he writes, had always been the measure by which novelty was assessed, but whoever is in the business of selling novelty has an interest in destroying the means by which it could be judged. Thus there is a ceaseless appearance of the important, and almost immediately its annihilation and replacement: "That which the spectacle ceases to speak of for three days no longer exists."[20]

In conclusion I want to note briefly two different responses to the new texture of modernity taking shape in the 1920s. The painter Fernand Léger writes, in a 1924 essay titled "The Spectacle," published soon after the making of his film *Ballet Mécanique*,

> The rhythm of modern life is so dynamic that a slice of life seen from a café terrace is a spectacle. The most diverse elements collide and jostle one another there. The interplay of contrasts is so violent that there is always exaggeration in the effect that one glimpses. On the boulevard two men are carrying some immense gilded letters in a hand cart: the effect is so unexpected that everyone stops and looks. There is the origin of the modern spectacle . . . in the shock of the surprise effect.[21]

But then Léger goes on to detail how advertising and commercial forces have taken the lead in the making of modern spectacle, and he cites the department store, the world of fashion, and the rhythms of industrial production as forms that have conquered the attention of the public. Léger's goal is the same: wanting to win over that public. Of course, he is writing at a point of uncertainty about the direction of his own art, facing the dilemma of what a public art might mean, but the confused program he comes up with in this text is an early instance of the ploys of all those — from Warhol to today's so-called simulationists — who believe, or at least claim, they are outwitting the spectacle at its own game. Léger summarizes this kind of ambition: "Let's push the system to the extreme," he states, and offers vague suggestions for polychroming the exterior of factories and apartment buildings, for using new materials and setting them in

20. *Ibid.*, p. 29.
21. Fernand Léger, *Functions of Painting*, trans. Alexandra Anderson, New York, Viking, 1973, p. 35.

motion. But this ineffectual inclination to outdo the allure of the spectacle becomes complicit with its annihilation of the past and fetishization of the new.

But the same year, 1924, the first Surrealist Manifesto suggests a very different aesthetic strategy for confronting the spectacular organization of the modern city. I am referring to what Walter Benjamin called the "anthropological" dimension of surrealism.[22] It was a strategy of turning the spectacle of the city inside out through counter-memory and counter-itineraries. These would reveal the potency of outmoded objects excluded from its slick surfaces, and of derelict spaces off its main routes of circulation. The strategy incarnated a refusal of the imposed present, and in reclaiming fragments of a demolished past it was implicitly figuring an alternative future. And despite the equivocal nature of many of these surrealist gestures, it is no accident that they were to reappear in new forms in the tactics of situationism in the 1960s, in the notion of the *dérive* or drift, of *détournement,* of psychogeography, the exemplary act, and the constructed situation.[23] Whether these practices have any vitality or even relevance today depends in large measure on what an archaeology of the present tells us. Are we still in the midst of a society that is organized as appearance? Or have we entered a nonspectacular global system arranged primarily around the control and flow of information, a system whose management and regulation of attention would demand wholly new forms of resistance and memory?[24]

22. Walter Benjamin, *One Way Street,* trans. Edmund Jephcott and Kingsley Shorter, London, New Left Books, 1979, p. 239. Christopher Phillips suggested to me that the late 1920s would also likely be crucial for Debord as the moment when surrealism became coopted, that is, when its original revolutionary potential was nullified in an early instance of spectacular recuperation and absorption.
23. On these strategies, see the documents in Ken Knabb, ed., *Situationist International Anthology,* Berkeley, Bureau of Public Secrets, 1981.
24. See my "Eclipse of the Spectacle," in Brian Wallis, ed., *Art After Modernism,* Boston, David Godine, 1984, pp. 283–294.

The Cultural Logic of the Late Capitalist Museum*

ROSALIND KRAUSS

May 1, 1983: I remember the drizzle and cold of that spring morning, as the feminist section of the May Day parade formed up at République. Once we started moving out, carrying our banners for the march towards the Place de la Bastille, we began our chant. "Qui paie ses dettes s'enrichit," it went, "qui paie ses dettes s'enrichit," in a reminder to Mitterand's newly appointed Minister of Women's Affairs that the Socialists' campaign promises were still deeply in arrears. Looking back at that cry now, from a perspective firmly situated at the end of the '80s, sometimes referred to as "the roaring '80s," the idea that paying your debts makes you rich seems pathetically naive. What make you rich, we have been taught by a decade of casino capitalism, is precisely the opposite. What makes you rich, fabulously rich, beyond your wildest dreams, is leveraging.

July 17, 1990: Coolly insulated from the heat wave outside, Suzanne Pagé and I are walking through her exhibition of works from the Panza Collection, an installation that, except for three or four small galleries, entirely fills the Musée d'Art Moderne de la Ville de Paris. At first I am extremely happy to encounter these objects — many of them old friends I have not seen since their early days of exhibition in the 1960s — as they triumphantly fill vast suites of galleries, having muscled everything else off the walls to create that experience of articulated spatial presence specific to Minimalism. The importance of this space as a vehicle for the works is something Suzanne Pagé is conscious of as she describes the desperate effort of remodeling vast tracts of the museum to give it the burnished neutrality necessary to function as background to these Flavins and Andres and Morrises. Indeed, it is her focus on the space — as a kind of reified and abstracted entity — that I finally find most arresting. This climaxes at the point when she

* This text, written as a lecture for the September 10, 1990 meeting of the International Association of Museums of Modern Art (CIMAM) in Los Angeles, is being published here considerably before I have been able to deliver, as fully as I would have liked, on the promise of its title. The timeliness of the issues, however, suggested that it was more important to open them to immediate discussion than to wait to refine either the theoretical level of the argument or the rhetoric within which it is framed.

positions me at the spot within the exhibition that she describes as being, for her, somehow the most riveting. It is in one of the newly stripped and smoothed and neutralized galleries, made whitely luminous by the serial progression of a recent work by Flavin. But we are not actually looking at the Flavin. At her direction we are scanning the two ends of the gallery through the large doorways of which we can see the disembodied glow produced by two other Flavins, each in an adjoining room: one of these an intense apple green light; the other an unearthly, chalky blue radiance. Both announce a kind of space-beyond which we are not yet in, but for which the light functions as the intelligible sign. And from our point of view both these aureoles can be seen to frame — like strangely industrialized haloes — the way the gallery's own starkly cylindrical, International Style columns enter our point of view. We are having this experience, then, not in front of what could be called the art, but in the midst of an oddly emptied yet grandiloquent space of which the museum itself — as a building — is somehow the object.

Within this experience, it is the museum that emerges as powerful presence and yet as properly empty, the museum as a space from which the collection has withdrawn. For indeed, the effect of this experience is to render it impossible to look at the paintings hanging in those few galleries still displaying the permanent collection. Compared to the scale of the Minimalist works, the earlier paintings and sculpture look impossibly tiny and inconsequential, like postcards, and the galleries take on a fussy, crowded, culturally irrelevant look, like so many curio shops.

*

These are two scenes that nag at me as I think about the "cultural logic of the late capitalist museum," because somehow it seems to me that if I can close the gap between their seeming disparateness, I can demonstrate the logic of what we see happening, now, in museums of modern art.[1] Here are two possible bridges, flimsy perhaps, because fortuitous, but nonetheless suggestive.

1. In the July 1990 *Art in America* there occurs the unanalyzed but telling juxtaposition of two articles. One is the essay called "Selling the Collection," which describes the massive change in attitude now in place according to which the objects in a museum's keeping can now be coolly referred to, by its director as well as its trustees, as "assets."[2] This bizarre Gestalt-switch from regarding the collection as a form of cultural patrimony or as specific and irreplaceable embodiments of cultural knowledge to one of eying the collection's contents as so much capital — as stocks or assets whose value is one of pure exchange and thus only

1. Throughout, my debt to Fredric Jameson's "Postmodernism, or The Cultural Logic of Late Capitalism," (*New Left Review*, no. 146 [July-August 1984], pp. 53–93) will be obvious.
2. Philip Weiss, "Selling the Collection," *Art in America*, vol. 78 (July 1990), pp. 124–131.

truly realized when they are put in circulation—seems to be the invention not merely of dire financial necessity: a result, that is, of the American tax law of 1986 eliminating the deductibility of the market value of donated art objects. Rather, it appears the function of a more profound shift in the very context in which the museum operates—a context whose corporate nature is made specific not only by the major sources of funding for museum activities but also, closer to home, by the makeup of its boards of trustees. Thus the writer of "Selling the Collection" can say: "To a great extent the museum community's crisis results from the free-market spirit of the 1980s. The notion of the museum as a guardian of the public patrimony has given way to the notion of a museum as a corporate entity with a highly marketable inventory and the desire for growth."

Over most of the course of the article, the market understood to be putting pressure on the museum is the art market. This is, for example, what Evan Maurer of the Minneapolis Institute of Art seems to be referring to when he says that in recent years museums have had to deal with a "market-driven operation" or what George Goldner of the Getty means when he says that "there will be some people who will want to turn the museum into a dealership." It is only at the end of the essay, when dealing with the Guggenheim Museum's recent sales, that some larger context than the art market's buying and selling is broached as the field within which deaccessioning might be discussed, although the writer does not really enter this context.

But "Selling the Collection" comes back-to-back with quite another article, which, called "Remaking Art History," raises the problems that have been spawned within the art market itself by one particular art movement, namely Minimalism.[3] For Minimalism almost from the very beginning located itself, as one of its radical acts, within the technology of industrial production. That objects were fabricated from plans meant that these plans came to have a conceptual status within Minimalism allowing for the possibility of replication of a given work that could cross the boundaries of what had always been considered the unreproducibility of the aesthetic original. In some cases these plans were sold to collectors along with or even in place of an original object, and from these plans the collector did indeed have certain pieces refabricated. In other cases it has been the artist himself or herself who has done the refabrication, either issuing various versions of a given object—multiple originals, so to speak—as is the case with the many Morris glass cubes, or replacing a deteriorated original with a contemporary remake as in the case of Alan Saret. This break with the aesthetic of the original is, the writer of this essay argues, part and parcel with Minimalism itself, and so she writes: "If, as viewers of contemporary art, we are unwilling to relinquish the conception of the unique original art object, if we insist that all refabrications are fraudulent, then we misunderstand the nature of

3. Susan Hapgood, "Remaking Art History," *Art in America*, vol. 78 (July 1990), pp. 114–123.

many of the key works of the '60s and '70s. . . . If the original object can be replaced without compromising the original meaning, refabrication should raise no controversy."

However, as we know, it is not exactly viewers who are raising controversy in this matter, but artists themselves, as Donald Judd and Carl Andre have protested Count Panza's various decisions to act on the basis of the certificates they sold him and make duplicate versions of their works.[4] And indeed the fact that the group countenancing these refabrications is made up of the works' owners (both private collectors and museums)—that is, the group normally thought to have most interest in specifically protecting the status of their property *as* original—indicates how inverted this situation is. The writer of this essay also speaks of the market as playing some role in the story she has to tell. "As the public's interest in the art of this period grows," she says, "and the market pressures increase, the issues that arise when works are refabricated will no doubt gain prominence as well." But what the nature of either "the issues" or the "market pressures" might really be, she leaves it to the future to decide.

In the bridge I am setting up here, then, we watch the activity of markets restructuring the aesthetic original, either to change it into an "asset," as in the case outlined by the first article, or to normalize a once-radical practice of challenging the very idea of the original through a recourse to the technology of mass production. That this normalization exploits a possibility *already* inscribed in the specific procedures of Minimalism will be important to the rest of my argument. But for now I simply point to the juxtaposition of a description of the financial crisis of the modern museum with an account of a shift in the nature of the original that is a function of one particular artistic movement, to wit, Minimalism.

2. The second bridge can be constructed more quickly. It consists merely of a peculiar rhyming between a famous remark of Tony Smith's from the opening phase of Minimalism and one by the Guggenheim's Director, Tom Krens, made last spring. Tony Smith is describing a ride he took in the early 1950s on the New Jersey Turnpike when it was still unfinished. He is speaking of the endlessness of the expanse, of its sense of being cultural but totally off the scale of culture. It was an experience, he said, that could not be framed, and thus, breaking through the very notion of frame, it was one that revealed to him the insignificance and "pictorialism" of all painting. "The experience on the road," he says, "was something mapped out but not socially recognized. I thought to myself, it ought to be clear that's the end of art." And what we now know with hindsight on this statement is that Tony Smith's "end of art" coincided with— indeed, conceptually undergirded—the beginning of Minimalism.

4. See *Art in America* (March and April 1990).

The second remark, the one by Tom Krens, was made to me in an interview and also involves a revelation on a turnpike, the Autobahn just outside of Cologne.[5] It was a November day in 1985, and having just seen a spectacular gallery made from a converted factory building, he was driving by large numbers of other factories. Suddenly, he said, he thought of the huge abandoned factories in his own neighborhood of North Adams, and he had the revelation of MASS MoCA.[6] Significantly, he described this revelation as transcending anything like the mere availability of real estate. Rather, he said, it announced an entire change in — to use a word he seems extremely fond of — *discourse*. A profound and sweeping change, that is, within the very conditions within which art itself is understood. Thus, what was revealed to him was not only the tininess and inadequacy of most museums, but that the encyclopedic nature of the museum was "over." What museums must now do, he said he realized, was to select a very few artists from the vast array of modernist aesthetic production and to collect and show these few in depth over the full amount of space it might take to really experience the cumulative impact of a given oeuvre. The discursive change he was imagining is, we might say, one that switches from diachrony to synchrony. The encyclopedic museum is intent on telling a story, by arraying before its visitor a particular version of the history of art. The synchronic museum — if we can call it that — would forego history in the name of a kind of intensity of experience, an aesthetic charge that is not so much temporal (historical) as it is now radically spatial, the model for which, in Krens's own account, was, in fact, Minimalism. It is Minimalism, Krens says in relation to his revelation, that has reshaped the way we, as late twentieth-century viewers, look at art: the demands we now put on it; our need to experience it along with its interaction with the space in which it exists; our need to have a cumulative, serial, crescendo towards the intensity of this experience; our need to have more and at a larger scale. It was Minimalism, then, that was part of the revelation that only at the scale of something like MASS MoCA could this radical revision of the very nature of the museum take place.

Within the logic of this second bridge, there is something that connects Minimalism — and at a very deep level — to a certain kind of analysis of the modern museum, one that announces its radical revision.

<p style="text-align:center">*</p>

5. The interview took place May 7, 1990.
6. MASS MoCA (The Massachusetts Museum of Contemporary Art), a project to transform the 750,000 square feet of factory space formerly occupied by Sprague Technologies Inc. into a museum complex (that would not only consist of gargantuan exhibition galleries, but also a hotel and retail shops), proposed to the Massachusetts Legislature by Krens and granted funding in a special bill potentially underwriting half its costs with a $35 million bond issue, is now nearing the end of a feasibility study, funded out of the same bill, and being conducted by a committee chaired by Krens. See Deborah Weisgall, "A Megamuseum in a Mill Town, The Guggenheim in Massachusetts?" *New York Times Magazine* (3 March 1989).

Now even from the few things I've sketched about Minimalism, there emerges an internal contradiction. For on the one hand there is Krens's acknowledgement of what could be called the phenomenological ambitions of Minimalism; and on the other, underscored by the dilemma of contemporary refabrication, Minimalism's participation in a culture of seriality, of multiples without originals — a culture, that is, of commodity production.

That first side, it could be argued, is the aesthetic base of Minimalism, its conceptual bedrock, what the writer of the *Art in America* article called its "original meaning." This is the side of Minimalism that denies that the work of art is an encounter between two previously fixed and complete entities: on the one hand, the work as a repository of known forms — the cube or prism, for example, as a kind of geometric a priori, the embodiment of a Platonic solid; and on the other, the viewer as an integral, biographically elaborated subject, a subject who cognitively grasps these forms because he or she knows them in advance. Far from being a cube, Richard Serra's *House of Cards* is a shape in the process of forming against the resistance, but also with the help of the ongoing conditions of gravity; far from being a simple prism, Robert Morris's *L-Beams* are three different insertions within the viewer's perceptual field such that each new disposition of the form, sets up an encounter between the viewer and the object which redefines the shape. As Morris himself wrote in his "Notes on Sculpture," Minimalism's ambition was to leave the domain of what he called "relational aesthetics" and to "take relationships out of the work and make them a function of space, light, and the viewer's field of vision." [7]

To make the work happen, then, on this very perceptual knife-edge — the interface between the work and its beholder — is on the one hand to withdraw privilege both from the formal wholeness of the object prior to this encounter and from the artist as a kind of authorial absolute who has set the terms for the nature of the encounter, in advance. Indeed, the turn towards industrial fabrication of the works was consciously connected to this part of Minimalism's logic, namely, the desire to erode the old idealist notions about creative authority. But on the other hand, it is to restructure the very notion of the viewing subject.

It is possible to misread a description of Minimalism's drive to produce a kind of "death of the author" as one of creating a now all-powerful reader/interpreter, as when Morris writes: "The object is but one of the terms of the newer aesthetic. . . . One is more aware than before that he himself is establishing relationships as he apprehends the object from various positions and under varying conditions of light and spatial context." But, in fact, the nature of this "he himself [who] is establishing relationships" is also what Minimalism works to put in suspension. Neither the old Cartesian subject nor the traditional biographical subject, the Minimalist subject — this "he himself establishing relationships"

7. Robert Morris, "Notes on Sculpture," in G. Battcock, ed., *Minimal Art*, New York, Dutton, 1968.

—is a subject radically contingent on the conditions of the spatial field, a subject who coheres, but only provisionally and moment-by-moment, in the act of perception. It is the subject that, for instance, Maurice Merleau-Ponty describes when he writes: "But the system of experience is not arrayed before me as if I were God, it is lived by me from a certain point of view; I am not the spectator, I am involved, and it is my involvement in a point of view which makes possible both the finiteness of my perception and its opening out upon the complete world as a horizon of every perception."[8]

In Merleau-Ponty's conception of this radically contingent subject, caught up within the horizon of every perception, there is, as we know, an important further condition. For Merleau-Ponty is not merely directing us towards what could be called a "lived perspective"; he is calling on us to acknowledge the primacy of the "lived *bodily* perspective." For it is the immersion of the body in the world, the fact that it has a front and a back, a left and a right side, that establishes at what Merleau-Ponty calls a level of "preobjective experience" a kind of internal horizon which serves as the precondition of the meaningfulness of the perceptual world. It is thus the body as the preobjective ground of all experience of the relatedness of objects that was the primary "world" explored by the *Phenomenology of Perception.*

Minimalism was indeed committed to this notion of "lived *bodily* perspective," this idea of a perception that would break with what it saw as the decorporealized and therefore bloodless, algebraicized condition of abstract painting in which a visuality cut loose from the rest of the bodily sensorium and now remade in the model of modernism's drive towards absolute autonomy had become the very picture of an entirely rationalized, instrumentalized, serialized subject. Its insistence on the immediacy of the experience, understood as a bodily immediacy, was intended as a kind of release from the forward march of modernist painting towards an increasingly positivist abstraction.

In this sense, Minimalism's reformulation of the subject as radically contingent is, even though it attacks older idealist notions of the subject, a kind of Utopian gesture. This is because the Minimalist subject is in this very displacement returned to its body, regrounded in a kind of richer, denser subsoil of experience than the paper-thin layer of an autonomous visuality that had been the goal of optical painting. And thus this move is, we could say, compensatory, an act of reparations to a subject whose everyday experience is one of increasing isolation, reification, specialization, a subject who lives under the conditions of advanced industrial culture as an increasingly instrumentalized being. It is to this subject that Minimalism, in an act of resistance to the serializing, stereotyping, and banalizing of commodity production, holds out a promise of some instant of

8. Maurice Merleau-Ponty, *Phenomenology of Perception*, trans. Colin Smith, London, Routledge and Kegan Paul, 1962, p. 304.

bodily plenitude in a gesture of compensation that we recognize as deeply aesthetic.

But even if Minimalism seems to have been conceived in *specific* resistance to the fallen world of mass culture — with its disembodied media images — and of consumer culture — with its banalized, commodified objects — in an attempt to restore the immediacy of experience, the door it opened onto "refabrication" nonetheless was one that had the potential to let that whole world of late capitalist production right back in.[9] Not only was the factory fabrication of the objects from plans a switch from artisanal to industrial technology, but the very choice of materials and of shapes rang with the overtones of industry. No matter that plexiglass and aluminum and styrofoam were meant to destroy the interiority signalled by the old materials of sculpture like wood or stone. These were nonetheless the signifiers of late 20th-century commodity production, cheap and expendable. No matter that the simple geometries were meant to serve as the vehicles of perceptual immediacy. These were as well the operators of those rationalized forms susceptible to mass production and the generalized ones adaptable as corporate logos.[10] And most crucially, the Minimalist resistance to traditional composition which meant the adoption of a repetitive, additive aggregation of form — Donald Judd's "one thing after another" — partakes very deeply of that formal condition that can be seen to structure consumer capitalism: the condition, that is, of seriality. For the serial principle seals the object away from any condition that could possibly be thought to be original and consigns it to a world of simulacra, of multiples without originals, just as the serial form also structures the object within a system in which it makes sense only in relation to other objects, objects which are themselves structured by relations of artificially produced difference. Indeed, in the world of commodities it is this difference that is consumed.[11]

Now how, we might ask, is it possible that a movement that wished to attack commodification and technologization somehow always already carried the codes of those very conditions? How is it that immediacy was always potentially undermined — infected, we could say — with its opposite? For it is this always

9. This analysis of the contradictions internal to Minimalism has already been brilliantly argued by Hal Foster in his genealogical study of Minimalism. See Hal Foster, "The Crux of Minimalism," in *Individuals, A Selected History of Contemporary Art: 1945–1986*, Los Angeles, The Museum of Contemporary Art, 1986. His argument there, that Minimalism simultaneously completes *and* breaks with modernism, announcing its end, and his discussion of the way much of postmodernism in both its critical modes (the critique of institutions, the critique of the representation of the subject) and its collaborative ones (the transavant-garde, simulation) is nascent within the Minimalist syntax, both spatial and productive, is a complex articulation of the logic of Minimalism and anticipates much of what I am saying about its history.

10. This argument was already suggested by Art & Language's critique of Minimalism. See Carl Beveridge and Ian Burn, "Donald Judd May We Talk?," *The Fox*, no. 2 (1972). That Minimalism should have been welcomed into corporate collections came full circle in the 1980s when its forms served as the, perhaps unwilling, basis of much of postmodern architecture.

11. Foster, p. 180.

already that is being tapped in the current controversy about refabrication. So, we could ask, how is it that an art that insisted so hard on specificity could have already programmed within it the logic of its violation?

But this kind of paradox is not only common in the history of modernism, which is to say the history of art in the era of capital; it could be said to be of the very nature of modernist art's relation to capital, a relation in which, in its very resistance to a particular manifestation of capital—to technology, say, or commodification, or the reification of the subject of mass production—the artist produces an alternative to that phenomenon which can also be read as a function of it, another version, although possibly more ideated or rarified, of the very thing against which he or she was reacting. Fredric Jameson, who is intent on tracing this capital-logic as it works itself out in modernist art, describes it, for example, in Van Gogh's clothing of the drab peasant world around him in an hallucinatory surface of color. This violent transformation, he says, "is to be seen as a Utopian gesture: as an act of compensation which ends up producing a whole new Utopian realm of the senses, or at least of that supreme sense—sight, the visual, the eye—which it now reconstitutes for us as a semi-autonomous space in its own right."[12] But even as it does this, it in fact imitates the very division of labor that is performed in the body of capital, thereby "becoming some new fragmentation of the emergent sensorium which replicates the specializations and divisions of capitalist life at the same time that it seeks in precisely such fragmentation a desperate Utopian compensation for them."[13]

What is exposed in this analysis is then the logic of what could be called cultural reprogramming or what Jameson himself calls "cultural revolution." And this is to say that while the artist might be creating a Utopian alternative to, or compensation for, a certain nightmare induced by industrialization or commodification, he is at the very same time projecting an imaginary space which, if it is shaped somehow by the structural features of that same nightmare, works to produce the possibility for its receiver fictively to occupy the territory of what will be a next, more advanced level of capital. Indeed, it is the theory of cultural revolution that the imaginary space projected by the artist will not only emerge from the formal conditions of the contradictions of a given moment of capital, but will prepare its subjects—its readers or viewers—to occupy a future real world which the work of art has already brought them to imagine, a world restructured not through the present but through the next moment in the history of capital.

An example of this, we could say, would be the great *unités d'habitation* of the International Style and Le Corbusier, which rose above an older, fallen city fabric to project a powerful, futuristic alternative to it, an alternative celebrating

12. Jameson, p. 59.
13. Ibid.

the potential creative energy stored within the individual designer. But insofar as those projects simultaneously destroyed the older urban network of neighborhoods with their heterogeneous cultural patterns, they prepared the ground precisely for that anonymous culture of suburban sprawl and shopping-center homogeneity that they were specifically working to counter.

So, with Minimalism, the potential was always there that not only would the *object* be caught up in the logic of commodity production, a logic that would overwhelm its specificity, but that the *subject* projected by Minimalism also would be reprogrammed. Which is to say that the Minimalist subject of "lived bodily experience" — unballasted by past knowledge and coalescing in the very moment of its encounter with the object — could, if pushed just a little farther, break up entirely into the utterly fragmented, postmodern subject of contemporary mass culture. It could even be suggested that by prizing loose the old ego-centered subject of traditional art, Minimalism unintentionally — albeit logically — prepares for that fragmentation.

And it was that fragmented subject, I would submit, that lay in wait for the viewer to the Panza Exhibition in Paris — not the subject of lived bodily immediacy of 1960s Minimalism, but the dispersed subject awash in a maze of signs and simulacra of late 1980s postmodernism. This was not just a function of the way the objects tended to be eclipsed by the emanations from themselves that seemed to stand apart from their corporeal beings like so many blinking signs — the shimmering waves of the floor pieces punctuating the groundplan, the luminous exhalations of the light pieces washing the corners of rooms one had not yet entered. It was also a function of the new centrality given to James Turrell, an extremely minor figure for Minimalism in the late 1960s and early 1970s, but one who plays an important role in the reprogrammation of Minimalism for the late 1980s. The Turrell piece, itself an exercise in sensory reprogramming, is a function of the way a barely perceptible luminous field in front of one appears gradually to thicken and solidify, not by revealing or bringing into focus the surface which projects this color, a surface which we as viewers might be said to perceive, but rather by concealing the vehicle of the color and thereby producing the illusion that it is the field itself which is focusing, that it is the very object facing one that is doing the perceiving *for* one.

Now it is this derealized subject — a subject that no longer does its own perceiving but is involved in a dizzying effort to decode signs that emerge from within a no longer mappable or knowable depth — that has become the focus of many analyses of postmodernism. And this space, which is grandiloquent but somehow no longer masterable by the subject, seeming to surpass the reach of understanding like an inscrutable emblem of the multinational infrastructures of information technology or of capital transfer, is often referred to in such analyses as "hyperspace." It, in turn, is a space that supports an experience that Jameson calls "the hysterical sublime." Which is to say that precisely in relation to the suppression of the older subjectivity — in what could be called the waning of

James Turrell. **Blood Lust.** *1989.*

affect — there is "a strange compensatory decorative exhilaration."[14] In place of the older emotions there is now an experience that must properly be termed an "intensity" — a free-floating and impersonal feeling dominated by a peculiar kind of euphoria.

The revision of Minimalism such that it addresses or even works to produce that new fragmented and technologized subject, such that it constructs not an experience of itself but some other euphorically dizzy sense of the museum as hyperspace, this revisionary construction of Minimalism exploits, as we have seen, what was always potential within Minimalism.[15] But it is a revision that is, as well, happening at a specific moment in history. It is happening in 1990 in tandem with powerful changes in how the museum itself is now being reprogrammed or reconceptualized.

*

The writer of "Selling the Collection" acknowledged that the Guggenheim's deaccessioning was part of a larger strategy to reconceive the museum and that Krens himself has described this strategy as somehow motivated or justified by the way Minimalism restructures the aesthetic "discourse." What, we might now ask, is the nature of that larger strategy, and how is Minimalism being used to serve as its emblem?

One of the arguments made by analysts of postmodern culture is that in its switch from what could be called an era of industrial production to one of commodity production — an era, that is, of the consumer society, or the information society, or the media society — capital has not somehow been magically transcended. Which is to say, we are not in either a "postindustrial society" or a "postideological era." Indeed, they would argue, we are in an even purer form of capital in which industrial modes can be seen to reach into spheres (such as leisure, sport, and art) previously somewhat separated from them. In the words of the Marxist economist Ernest Mandel: "Far from representing a 'postindustrial society' late capitalism thus constitutes *generalized universal industrialization* for the first time in history. Mechanization, standardization, over-specialization and parcellization of labor, which in the past determined only the realm of

14. Ibid., p. 61.

15. The various 1970s projects, organized by Heiner Friedrich and sponsored by the Dia Foundation, which set up permanent installations — like de Maria's *Earth Room* or his *Broken Kilometer* — had the effect of reconsecrating certain urban spaces to a detached contemplation of their own "empty" presence. Which is to say that in the relationship between the work and its context, these spaces themselves increasingly emerge as the focus of the experience, one of an inscrutable but suggestive sense of impersonal, corporatelike power to penetrate art-world locales and to rededicate them to another kind of nexus of control. Significantly, it was Friedrich who began, in the mid-1970s, to promote the work of James Turrell (he is also the manager, for the Dia Foundation, of Turrell's mammoth *Roden Crater*).

commodity production in actual industry, now penetrate into all sectors of social life."[16]

As just one example of this he gives the Green Revolution, or the massive industrialization of agriculture through the introduction of machines and chemicals. Just as in any other industrialization, the old productive units are broken up—the farm family no longer makes its own tools, food, and clothing—to be replaced by specialized labor in which each function is now independent and must be connected through the mediating link of trade. The infrastructure needed to support this connection will now be an international system both of trade and of credit. What makes this expanded industrialization possible, he adds, is the overcapitalization (or noninvested surplus capital) that is the hallmark of late capitalism. It is this surplus that is unlocked and set in motion by the falling rate of profit. And it in turn accelerates the process of transition to monopoly capitalism.

Now noninvested surplus capital is exactly one way of describing the holdings—both in land and in art—of museums. It is the way, as we have seen, that many museum figures (directors and trustees) are now, in fact, describing their collections. But the market they see themselves responding to is the art market and not the mass market; and the model of capitalization they have in mind is the "dealership" and not industry.

Writers about the Guggenheim have already become suspicious that it is the one exception in all this—an exception, most would agree, that will be an extremely seductive pattern for others to follow once its logic becomes clear. The *New York Times Magazine* writer of the profile on MASS MoCA was, indeed, struck by the way Tom Krens constantly spoke not of the museum but of the "museum industry," describing it as "overcapitalized," in need of "mergers and acquisitions" and of "asset management." And further, invoking the language of industry, he spoke of the museum's activities—its exhibitions and catalogues—as "product."

Now from what we know from other industrializations, we can say that to produce this "product" efficiently will require not only the break-up of older productive units—as the curator no longer operates as combined researcher, writer, director, and producer of an exhibition but will be increasingly specialized into filling only one of these functions—but will entail the increased technologization (through computer-based data systems) and centralization of operations at every level. It will also demand the increased control of resources in the form of art objects that can be cheaply and efficiently entered into circulation. Further, in relation to the problem of the effective marketing of this product, there will be the requirement of a larger and larger surface over which to sell the

16. Ernest Mandel, *Late Capitalism*, London, Verso, 1978, p. 387, as cited in Foster, p. 179; and in Jameson, "Periodizing the '60s," *The Ideologies of Theory*, Vol. II, Minneapolis, University of Minnesota Press, 1988, p. 207.

product in order to increase what Krens himself speaks of as "market share." It takes no genius to realize that the three immediate requisites of this expansion are 1) larger inventory (the Guggenheim's acquisition of three hundred works from the Panza collection is a first step in this direction); 2) more physical outlets through which to sell the product (the Salzburg and Venice/Dogana projects are potential ways of realizing this, as would be MASS MoCA);[17] and 3) leveraging the collection (which in this case most specifically does not mean selling it, but rather moving it into the credit sector, or the circulation of capital;[18] the collection will thus be pressed to travel as one form of indebtedness; classically, mortgaging the collection would be the more direct form of leveraging).[19] And it

17. Projects at different stages of realization include a Salzburg Guggenheim, in which the Austrian Government would presumably pay for a new museum (designed by Hans Holein) and endow its operating expenses in return for a New York Guggenheim-managed program, part of which would entail the circulation of the Guggenheim collection into Salzburg. In addition, there are negotiations for a Venice Guggenheim in the quarters of the former Customs House (the Dogana).
18. That as part of its industrialization the Guggenheim is willing to deaccession not just minor objects but masterpieces is a point made by "Selling the Collection," where Professor Gert Schiff is quoted as saying of the deaccessioned Kandinsky, "It really was a centerpiece of the collection—they could have sold almost anything but not that," and former director, now trustee, Tom Messer, is described as "uncomfortable with the transaction" (p. 130). Another detail in this report is the extraordinary spread between Sotheby's estimate on this Kandinsky ($10–15 million) and its actual sale price ($20.9 million). In fact, on the three works auctioned by the Guggenheim, Sotheby's underestimated the sales by more than 40 percent. This raises some questions about "asset management" in a domain, like the Guggenheim's, of increasing specialization of professional roles. For it is clear that neither the museum's staff nor its director had a grip on the realities of the market, and relying on Sotheby's "expertise" (not, of course disinterested), they probably deaccessioned one more work than they needed to in order to accomplish their target, which was the purchase of the Panza collection. It is also clear—not only from Schiff's comment but also from one by William Rubin to the effect that in thirty years of experience he had never seen a comparable Kandinsky for sale, and that chances are that in the next thirty years there will not be another—that the separation of curatorial from managerial skills is wildly skewing the museum's judgment in the favor to those who stand to profit—in the form of fees and percentages of sales—from any "deal" that takes place: auctioneers, dealers, etc.
19. In August 1990, the Guggenheim Museum, through the agency of The Trust for Cultural Resources of The City of New York (about which more later), issued $55 million of tax-exempt bonds to J. P. Morgan Securities (who will presumably remarket them to the public). This money is to be used for the museum's physical expansion in New York City: the annex to the present building, the restoration and underground expansion of the present building, and the purchase of a warehouse in midtown Manhattan. Counting interest on these bonds, the museum will, in the course of fifteen years, have to pay out $115 million to service and retire this debt.
 The collateral for these bonds is curious, since the issuing document reads: "None of the assets of the [Guggenheim] Foundation are pledged for payment of the Bonds." It goes on to specify that the museum's endowment is legally unavailable to be used to meet the obligations of the debt and that "certain works in the Foundation's collection are subject to express sale prohibitions or other restrictions pursuant to the applicable gift instruments or purchase contracts." That such restrictions apply only to "certain works" and not to all works is also something to which I will return.
 In light of the fact that no collateral is pledged in case of the museum's inability to meet its obligations on this debt, one might well wonder about the basis on which Morgan Securities (as well as its partner in this transaction, the Swiss Bank Corporation) agreed to purchase these bonds. This basis is clearly threefold. First, the Guggenheim is projecting its ability to raise the money it needs (roughly $7 million per year over and above its current [the date in the bond issuance document is for

also does not stretch the imagination too much to realize that this industrialized museum will have much more in common with other industrialized areas of leisure—Disneyland say—than it will with the older, preindustrial museum. Thus it will be dealing with mass markets, rather than art markets, and with simulacral experience rather than aesthetic immediacy.

Which brings us back to Minimalism and the way it is being used as the aesthetic rationale for the transformation I am describing. The industrialized museum has a need for the technologized subject, the subject in search not of affect but of intensities, the subject who experiences its fragmentation as euphoria, the subject whose field of experience is no longer history, but space itself: that hyperspace which a revisionist understanding of Minimalism will use it to unlock.

FY 1988] annual expenses of $11.5 million [on which it was running a deficit of about 9 percent, which is *extremely* high for this kind of institution]) through, on the one hand, a $30 million fund drive and, on the other, added revenue streams due to its expansion of plant, program, markets, etc. Since its obligation is $115 million, the fund drive, even if successful, will leave over $86 million to raise. Second, if the Guggenheim's plans for increasing revenue (added gate, retail sales, memberships, corporate funding, gifts, plus "renting" its collection to its satellite museums, among others) by the above amount (or 70 percent above its current annual income) do not work out as projected, the next line of defense the bankers can fall back on will be the ability of members of the Guggenheim's board of trustees to cover the debt. This would involve a personal willingness to pay that no trustee, individually, is legally required to do. Third, if the first two possibilities fail and default is threatened, the collection (minus, of course, "certain works"), though it is not pledged, is clearly available as an "asset" to be used for debt repayment.

In asking financial officers of various tax-exempt institutions to evaluate this undertaking, I have been advised that it is, indeed, a "high-risk" venture. And I have also gleaned something of the role of The Trust for Cultural Resources of The City of New York.

Many states have agencies set up to lend money to tax-exempt institutions, or to serve as the medium through which monies from bond drives are delivered to such institutions, as is the case with The Trust for Cultural Resources. But unlike The Trust for Cultural Resources, these agencies are required to review the bond proposals in order to assess their viability. The review carried out by agency employees is clearly made by people not associated with the institutions themselves. The Trust for Cultural Resources, although it brokers the money at the behest of the government like the state agencies, has no staff to review proposals and therefore has no role in vetting the bond requests. What it seems to do instead is to give the proposal its bona fides. Given the fact that the members of the trust are also major figures of other cultural institutions (Donald Marron, for example, is president of the board of trustees of The Museum of Modern Art), the trust's own trustees are, in fact, potential borrowers.

Postscript on the Societies of Control*

GILLES DELEUZE

1. Historical

Foucault located the *disciplinary societies* in the eighteenth and nineteenth centuries; they reach their height at the outset of the twentieth. They initiate the organization of vast spaces of enclosure. The individual never ceases passing from one closed environment to another, each having its own laws: first, the family; then the school ("you are no longer in your family"); then the barracks ("you are no longer at school"); then the factory; from time to time the hospital; possibly the prison, the preeminent instance of the enclosed environment. It's the prison that serves as the analogical model: at the sight of some laborers, the heroine of Rossellini's *Europa '51* could exclaim, "I thought I was seeing convicts."

Foucault has brilliantly analyzed the ideal project of these environments of enclosure, particularly visible within the factory: to concentrate; to distribute in space; to order in time; to compose a productive force within the dimension of space-time whose effect will be greater than the sum of its component forces. But what Foucault recognized as well was the transience of this model: it succeeded that of the *societies of sovereignty*, the goal and functions of which were something quite different (to tax rather than to organize production, to rule on death rather than to administer life); the transition took place over time, and Napoleon seemed to effect the large-scale conversion from one society to the other. But in their turn the disciplines underwent a crisis to the benefit of new forces that were gradually instituted and which accelerated after World War II: a disciplinary society was what we already no longer were, what we had ceased to be.

We are in a generalized crisis in relation to all the environments of

* This essay first appeared in *L'Autre journal*, no. 1 (May 1990) and was included in *Negotiations, 1972–1990* by Gilles Deleuze. Copyright © 1995 Columbia University Press. Reprinted with permission of the publisher.

enclosure—prison, hospital, factory, school, family. The family is an "interior," in crisis like all other interiors—scholarly, professional, etc. The administrations in charge never cease announcing supposedly necessary reforms: to reform schools, to reform industries, hospitals, the armed forces, prisons. But everyone knows that these institutions are finished, whatever the length of their expiration periods. It's only a matter of administering their last rites and of keeping people employed until the installation of the new forces knocking at the door. These are the *societies of control*, which are in the process of replacing the disciplinary societies. "Control" is the name Burroughs proposes as a term for the new monster, one that Foucault recognizes as our immediate future. Paul Virilio also is continually analyzing the ultrarapid forms of free-floating control that replaced the old disciplines operating in the time frame of a closed system. There is no need here to invoke the extraordinary pharmaceutical productions, the molecular engineering, the genetic manipulations, although these are slated to enter into the new process. There is no need to ask which is the toughest or most tolerable regime, for it's within each of them that liberating and enslaving forces confront one another. For example, in the crisis of the hospital as environment of enclosure, neighborhood clinics, hospices, and day care could at first express new freedom, but they could participate as well in mechanisms of control that are equal to the harshest of confinements. There is no need to fear or hope, but only to look for new weapons.

2. Logic

The different internments or spaces of enclosure through which the individual passes are independent variables: each time one is supposed to start from zero, and although a common language for all these places exists, it is *analogical*. On the other hand, the different control mechanisms are inseparable variations, forming a system of variable geometry the language of which is *numerical* (which doesn't necessarily mean binary). Enclosures are *molds*, distinct castings, but controls are a *modulation*, like a self-deforming cast that will continuously change from one moment to the other, or like a sieve whose mesh will transmute from point to point.

This is obvious in the matter of salaries: the factory was a body that contained its internal forces at a level of equilibrium, the highest possible in terms of production, the lowest possible in terms of wages; but in a society of control, the corporation has replaced the factory, and the corporation is a spirit, a gas. Of course the factory was already familiar with the system of bonuses, but the corporation works more deeply to impose a modulation of each salary, in states of perpetual metastability that operate through challenges, contests, and highly comic group sessions. If the most idiotic television game shows are so successful, it's because they express the corporate situation with great precision. The factory constituted individuals as a single body to the double advan-

tage of the boss who surveyed each element within the mass and the unions who mobilized a mass resistance; but the corporation constantly presents the brashest rivalry as a healthy form of emulation, an excellent motivational force that opposes individuals against one another and runs through each, dividing each within. The modulating principle of "salary according to merit" has not failed to tempt national education itself. Indeed, just as the corporation replaces the factory, *perpetual training* tends to replace the *school*, and continuous control to replace the examination. Which is the surest way of delivering the school over to the corporation.

In the disciplinary societies one was always starting again (from school to the barracks, from the barracks to the factory), while in the societies of control one is never finished with anything—the corporation, the educational system, the armed services being metastable states coexisting in one and the same modulation, like a universal system of deformation. In *The Trial*, Kafka, who had already placed himself at the pivotal point between two types of social formation, described the most fearsome of juridical forms. The *apparent acquittal* of the disciplinary societies (between two incarcerations); and the *limitless post-ponements* of the societies of control (in continuous variation) are two very different modes of juridical life, and if our law is hesitant, itself in crisis, it's because we are leaving one in order to enter into the other. The disciplinary societies have two poles: the signature that designates the *individual*, and the number or administrative numeration that indicates his or her position within a *mass*. This is because the disciplines never saw any incompatibility between these two, and because at the same time power individualizes and masses together, that is, constitutes those over whom it exercises power into a body and molds the individuality of each member of that body. (Foucault saw the origin of this double charge in the pastoral power of the priest—the flock and each of its animals—but civil power moves in turn and by other means to make itself lay "priest.") In the societies of control, on the other hand, what is important is no longer either a signature or a number, but a code: the code is a *password*, while on the other hand the disciplinary societies are regulated by *watchwords* (as much from the point of view of integration as from that of resistance). The numerical language of control is made of codes that mark access to information, or reject it. We no longer find ourselves dealing with the mass/individual pair. Individuals have become "*dividuals*," and masses, samples, data, markets, or "*banks*." Perhaps it is money that expresses the distinction between the two societies best, since discipline always referred back to minted money that locks gold in as numerical standard, while control relates to floating rates of exchange, modulated according to a rate established by a set of standard currencies. The old monetary mole is the animal of the spaces of enclosure, but the serpent is that of the societies of control. We have passed from one animal to the other, from the mole to the serpent, in the system under which we live, but also in our manner of living and in our relations with others. The disciplinary man

was a discontinuous producer of energy, but the man of control is undulatory, in orbit, in a continuous network. Everywhere *surfing* has already replaced the older *sports*.

Types of machines are easily matched with each type of society—not that machines are determining, but because they express those social forms capable of generating them and using them. The old societies of sovereignty made use of simple machines—levers, pulleys, clocks; but the recent disciplinary societies equipped themselves with machines involving energy, with the passive danger of entropy and the active danger of sabotage; the societies of control operate with machines of a third type, computers, whose passive danger is jamming and whose active one is piracy and the introduction of viruses. This technological evolution must be, even more profoundly, a mutation of capitalism, an already well-known or familiar mutation that can be summed up as follows: nineteenth-century capitalism is a capitalism of concentration, for production and for property. It therefore erects the factory as a space of enclosure, the capitalist being the owner of the means of production but also, progressively, the owner of other spaces conceived through analogy (the worker's familial house, the school). As for markets, they are conquered sometimes by specialization, some-times by colonization, sometimes by lowering the costs of production. But, in the present situation, capitalism is no longer involved in production, which it often relegates to the Third World, even for the complex forms of textiles, metallurgy, or oil production. It's a capitalism of higher-order production. It no longer buys raw materials and no longer sells the finished products: it buys the finished products or assembles parts. What it wants to sell is services and what it wants to buy is stocks. This is no longer a capitalism for production but for the product, which is to say, for being sold or marketed. Thus it is essentially dispersive, and the factory has given way to the corporation. The family, the school, the army, the factory are no longer the distinct analogical spaces that converge towards an owner—state or private power—but coded figures—deformable and transformable—of a single corporation that now has only stockholders. Even art has left the spaces of enclosure in order to enter into the open circuits of the bank. The conquests of the market are made by grabbing control and no longer by disciplinary training, by fixing the exchange rate much more than by lowering costs, by transformation of the product more than by specialization of production. Corruption thereby gains a new power. Marketing has become the center or the "soul" of the corporation. We are taught that corporations have a soul, which is the most terrifying news in the world. The operation of markets is now the instrument of social control and forms the impudent breed of our masters. Control is short-term and of rapid rates of turnover, but also continuous and without limit, while discipline was of long duration, infinite and discontinuous. Man is no longer man enclosed, but man in debt. It is true that capitalism has retained as a constant the extreme poverty of three quarters of humanity, too poor for debt, too numerous for confinement:

control will not only have to deal with erosions of frontiers but with the explosions within shanty towns or ghettos.

3. Program

 The conception of a control mechanism, giving the position of any element within an open environment at any given instant (whether animal in a reserve or human in a corporation, as with an electronic collar), is not necessarily one of science fiction. Félix Guattari has imagined a city where one would be able to leave one's apartment, one's street, one's neighborhood, thanks to one's (dividual) electronic card that raises a given barrier; but the card could just as easily be rejected on a given day or between certain hours; what counts is not the barrier but the computer that tracks each person's position—licit or illicit—and effects a universal modulation.

 The socio-technological study of the mechanisms of control, grasped at their inception, would have to be categorical and to describe what is already in the process of substitution for the disciplinary sites of enclosure, whose crisis is everywhere proclaimed. It may be that older methods, borrowed from the former societies of sovereignty, will return to the fore, but with the necessary modifications. What counts is that we are at the beginning of something. In the *prison system*: the attempt to find penalties of "substitution," at least for petty crimes, and the use of electronic collars that force the convicted person to stay at home during certain hours. For the *school system*: continuous forms of control, and the effect on the school of perpetual training, the corresponding abandonment of all university research, the introduction of the "corporation" at all levels of schooling. For the *hospital system*: the new medicine "without doctor or patient" that singles out potential sick people and subjects at risk, which in no way attests to individuation—as they say—but substitutes for the individual or numerical body the code of a "dividual" material to be controlled. In the *corporate system*: new ways of handling money, profits, and humans that no longer pass through the old factory form. These are very small examples, but ones that will allow for better understanding of what is meant by the crisis of the institutions, which is to say, the progressive and dispersed installation of a new system of domination. One of the most important questions will concern the ineptitude of the unions: tied to the whole of their history of struggle against the disciplines or within the spaces of enclosure, will they be able to adapt themselves or will they give way to new forms of resistance against the societies of control? Can we already grasp the rough outlines of these coming forms, capable of threatening the joys of marketing? Many young people strangely boast of being "motivated"; they re-request apprenticeships and permanent training. It's up to them to discover what they're being made to serve, just as their elders discovered, not without difficulty, the telos of the disciplines. The coils of a serpent are even more complex than the burrows of a molehill.

Like the difference between Autumn/Winter '94/'95 and Spring/Summer '95

PETER EISENMAN and SILVIA KOLBOWSKI

2

3

4

In the spring of 1995, The Architectural League of New York and Minetta Brook, a private organization that coordinates art projects in New York City, commissioned a group of artist/architect teams to devise projects for an exhibition entitled "Architectures of Display." The projects, to be installed in five non-art sites in SoHo, were to consider issues of display in architectural terms, with the term "display" defined broadly to include divergent scales, from the urban to the domestic, "from the screen of the laptop to the anthropology museum, to the objects and fashions encountered on the street. . . .Recent years have seen a wide range of cross-disciplinary experiments involving architecture, in which the interface of architecture and artistic practice has begun to be explored. 'Architectures of Display' attempts to extend such explorations, but it does not take the value of cross-disciplinary experimentation for granted. It seeks to examine more closely the nature of such activity, by focusing it onto a question which has significance across disciplinary boundaries." (Curatorial statement, Reinhold Martin.)

We were assigned the clothing boutique Comme des Garçons, on Wooster Street in SoHo.

Site conditions
—a "high" fashion store in a "high" art neighborhood
—the perpetual "newness" of seasonal fashion in a bell jar neighborhood
—glass as a membrane between perpetual change and preservation
—a late 20th-century shift from shallow storefront display space housing object narratives to transparency and non-narrativity
—a historical change from lateral scenography to a depth-of-field scenario
—the intervention of "fine art" into a commercial site

—objects on display for sale and objects on display

The project: a title, a wall, a poster, a videotape
A white wall was to be introduced into the location, dividing the space of commerce. The shape of the wall was derived from the overlay of sketches of clothing from two seasons of Comme des Garçons designs. These sketches were then "morphed"—each to the other—by computer in order to arrive at an incidental shape that was the result of calculating the "difference" between the two seasons. This shape was divided to house an entry corridor. The resulting walls are neither background nor foreground, neither backdrop for display nor autonomous object of display, neither wall nor art object.

A poster situates the title in the photographic site of preservation; a videotape loop presents the runway shows from the two seasons, electronically superimposed one onto the other, music and image.

1. View of model: the difference between seasons of Comme des Garçons designs, arrived at by morphing two clothing sketches. (Photo: Dick Frank Studios)

2. Elements of installation "walls" being cut on a table saw at Hudson Scenic Studio. The table saw is directed by information from a floppy disk generated on computer by the office of Eisenman Architects. (Photo: Silvia Kolbowski)

3. Typical view of SoHo, showing newly installed cobblestone street and replica of historic lamppost. (Photo: Kevin Noble)

4. Detail view from inside Comme des Garçons, showing divided structure through which clients must walk in order to view or purchase merchandise. (Photo: Silvia Kolbowski)

5. Sketches of two articles of clothing from two different seasons of Comme des Garçons designs.

6. The two sketches, morphed one to the other. The computer rendering is in wire-frame form.

7. View from outside. (Photo: Michael Moran)

8. Frame from video loop of two seasons' runway shows, superimposed.

9. Computer rendering of walls, originally proposed to be sheathed in sheetrock/plaster to look like distorted white walls. Budget limitations required a less expensive alternative.

10. Horizontal contour-line axonometric. Budget restrictions compelled the development of a less expensive structure.

11. Axonometric frame devised from vertical contour lines; *one* way of finding a form for the idea.

12. General view of installation. In the installed project, every other "rib" was deleted from the model, due to budget strictures. (Photo: Michael Moran)

13. Detail view of installation, showing video monitor on floor. (Photo: Michael Moran)

14. Poster, based on one of Comme des Garçons's advertising formats. Proposal to put overlapped view of models on other side was not approved by Comme des Garçons.

15. Detail view of installation. (Photo: Silvia Kolbowski)

16. Video frame.

17. Frame from video loop of two seasons' runway shows, superimposed.

5

6

7

9

10

11

12

13

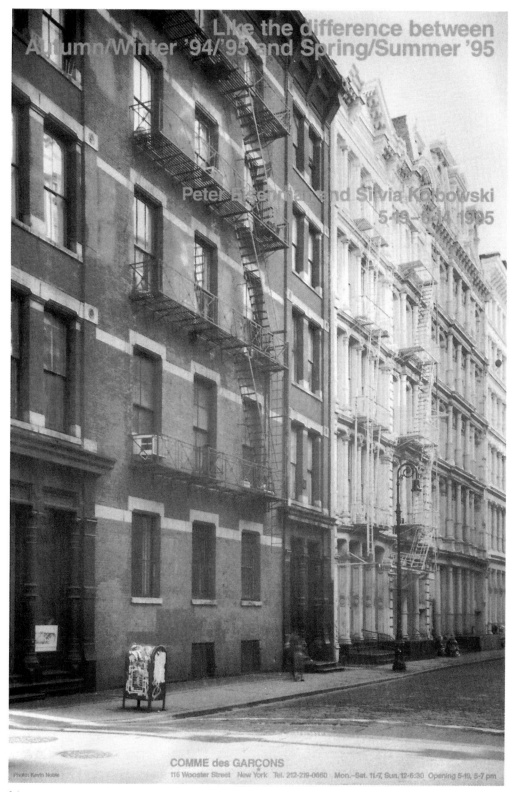

Like the difference between
Autumn/Winter '94/'95 and Spring/Summer '95

Peter Fend ... and Silvia Kolbowski
5-19 – ... 1995

COMME des GARÇONS
116 Wooster Street New York Tel. 212-219-0660 Mon.–Sat. 11-7, Sun. 12-6:30 Opening 5-19, 5-7 pm

Photo: Kevin Noble

14

15

16

17

Credits

Clients: Comme des Garçons, New
York; The Architectural League,
New York; Minetta Brook, New York.
Associate, Eisenman Architects:
Richard Rosson.
Project Architect: Sergio Bregante.
Project Assistants: Jefferson Ellinger,
Jan Jurgens, Rudolph Kammeri,
Michael Schmidt, Lisa Torris,
Alexander Siedemann, Marcus Witta.
Construction: Hudson Scenic Studio,
Inc., New York.
Printer: Milner Bros., New York.
Exhibition organizers: Kadambari
Baxi, Rosalie Genevro, Laurie
Hawkinson, Reinhold Martin,
Diane Shamas.
*Additional participants in "Architectures
of Display":* Merril Elam and Group
Material (Duggal); Tom Burr and
Toshico Mori (Hot & Crusty);
Renee Green and Laura Kurgan
(Portico Home); Sulan Kolatan/
William MacDonald and Krzysztof
Wodiczko (Angelika Film Center).
Poster project: John Knight.
OCTOBER 75, Winter 1996, pp. 83–98.
*© 1996 October Magazine, Ltd. and
Massachusetts Institute of Technology.*